Classical Pasts

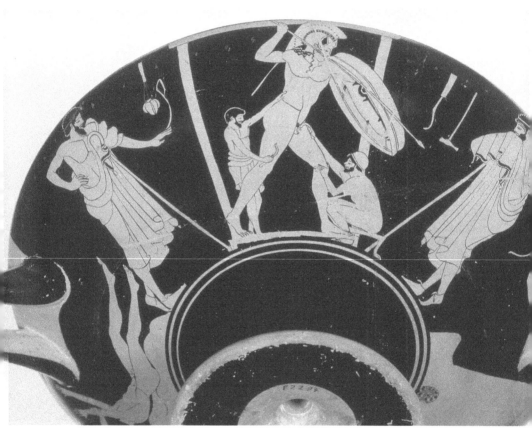

Frontispiece. Side B of a red-figure kylix from Vulci, Italy, by the Foundry Painter (Berlin F 2294) showing an oversized nude hoplite being made in a bronze foundry. Ca. 490–480 B.C.E. Photo: Ingrid Geske, Antikensammlung, Staatliche Museen zu Berlin. Bildarchiv Preussischer Kulturbesitz / Art Resource, NY.

Classical Pasts

THE CLASSICAL TRADITIONS OF
GREECE AND ROME

Edited by James I. Porter

PRINCETON UNIVERSITY PRESS
PRINCETON AND OXFORD

Copyright © 2006 by Princeton University Press
Published by Princeton University Press, 41 William Street, Princeton,
New Jersey 08540
In the United Kingdom: Princeton University Press, 3 Market Place,
Woodstock, Oxfordshire OX20 1SY

All Rights Reserved

LIBRARY OF CONGRESS CATLOGING-IN-PUBLICATION DATA

Classical pasts : the classical traditions of Greece and Rome / edited by James I. Porter.

p. cm.

Includes bibliographical references and index.

ISBN-10: 0-691-08941-8 (cl : alk. paper)—ISBN-10: 0-691-08942-6 (pb : alk. paper)
ISBN-13: 978-0-691-08941-6 (cl : alk. paper)—ISBN-13: 978-0-691-08942-3 (pb : alk. paper)

1. Civilization, Greco-Roman. I. Porter, James I., 1954–

DE71.C495 2005

938—dc22 2004060759

This book has been composed in

Printed on acid-free paper.

pup.princeton.edu

Printed in the United States of America

1 3 5 7 9 10 8 6 4 2

CONTENTS

List of Illustrations and Table	vii
Acknowledgments	ix
List of Abbreviations	xi

INTRODUCTION
What Is "Classical" about Classical Antiquity?
James I. Porter ... 1

PART I *The Deep Past: Bronze Age Classicism*

CHAPTER 1
"No Greater Marvel": A Bronze Age Classic at Orchomenos 69
Susan E. Alcock and John F. Cherry

PART II *Classical Innovations*

CHAPTER 2
Intimations of the Classical in Early Greek *Mousikē* 89
Armand D'Angour

CHAPTER 3
Rehistoricizing Classicism: Isocrates and the Politics of
Metaphor in Fourth-Century Athens 106
Yun Lee Too

PART III *Baroque Classics*

CHAPTER 4
Baroque Classics: The Tragic Muse and the *Exemplum* 127
Andrew Stewart

PART IV *Latin Letters*

CHAPTER 5
From ΦΙΛΟΣΟΦΙΑ into *PHILOSOPHIA*: Classicism and
Ciceronianism ... 173
John Henderson

CHAPTER 6
The Concept of the Classical and the Canons of Model
Authors in Roman Literature
Mario Citroni 204

PART V *Roman Art*

CHAPTER 7
Greek Styles and Greek Art in Augustan Rome:
Issues of the Present versus Records of the Past 237
Tonio Hölscher

CHAPTER 8
Classicism in Roman Art 270
Jaś Elsner

PART VI *Imperial Prose*

CHAPTER 9
Feeling Classical: Classicism and Ancient Literary Criticism 301
James I. Porter

CHAPTER 10
Quickening the Classics: The Politics of Prose in Roman Greece 353
Tim Whitmarsh

CODA *Looking Back and Beyond*

CHAPTER 11
Athens as the School of Greece 377
Glenn W. Most

Bibliography 389

Contributors 431

Index 433

LIST OF ILLUSTRATIONS AND TABLES

Illustrations

Frontispiece.	Cup (side B) by the Foundry Painter. Ca. 490–480 B.C.E.	ii
1.1.	The façade and stomion of the Treasury of Minyas.	70
1.2.	Photograph of the Treasury of Minyas from the west, at the time of Bulle's early-twentieth-century investigations.	76
1.3.	Rectified plan of the Treasury of Minyas.	77
4.1.	Ajax preparing to commit suicide. Attic black-figure amphora by Exekias.	156
4.2.	Procne preparing to kill Itys. Marble group dedicated and perhaps made by Alcamenes. Ca. 430 B.C.E.	157
4.3.	Blind Homer, Boston. Roman copy of a Hellenistic original.	158
4.4.	"Pasquino" (Ajax and the body of Achilles). Cast in Basel, after a reconstruction by Bernhard Schweitzer of the Hellenistic original.	159
4.5.	Head of Ajax, Vatican. Roman copy of the group, figure 4.4.	160
4.6.	Achilles and the body of Penthesilea. Cast in Basel, after a reconstruction by Ernst Berger of the Hellenistic original.	161
4.7.	Head of Achilles, Malibu. Roman copy of the group, figure 4.6.	162
4.8.	Head of Penthesilea, Antikenmuseum Basel. Roman copy of the group, figure 4.6.	163
4.9.	Photomontage of the Hanging Marsyas group, using the Uffizi Knifegrinder and the Louvre Marsyas ("White type"). Partial reconstruction of the Hellenistic original.	164
4.10.	Hanging Marsyas ("Red type"), Karlsruhe. Roman copy of a Hellenistic original.	165
4.11.	Head of the Hanging Marsyas ("Red type"), Karlsruhe.	166
4.12.	Head of the Hanging Marsyas ("White type"), Louvre. Roman copy of a Hellenistic original.	167
4.13.	Laocoön, Vatican. Late Republican–early Imperial original by Hagesander, Polydorus, and Athanodorus of Rhodes, or a later copy.	168
4.14.	Laocoön, reconstructed by Erin Dintino and the author.	169
4.15.	Head of the Laocoön, Vatican.	170
7.1.	Statue of Augustus from Prima Porta. Ca. 17 B.C.E. Rome, Vatican Museum	260
7.2	Statue of Doryphorus by Polyclitus. Roman copy of a bronze Greek original of ca. 440 B.C.E. Naples, Museo Nazionale Archeologico.	261

7.3.	Statue of Augustus as Diomedes, from the Basilica of Otricoli. Ca. 40 C.E. Rome, Vatican Museum.	262
7.4	Statue of Diomedes. Roman copy of a Greek bronze original of ca. 430 B.C.E. Naples, Museo Nazionale Archeologico.	263
7.5.	Statuette of Alexander. Roman statuette, perhaps copy of a life-size portrait statue. Hellenistic period. Cambridge (Mass.), Fogg Art Museum.	264
7.6.	Statue of a boy. Augustan. From the illegal market.	265
7.7.	Ara Pacis Augustae, great procession. 13–9 B.C.E.	266
7.8.	Caryatids from Forum of Augustus, dedicated 2 B.C.E.	266
7.9.	Marble crater. Mahdia shipwreck. Beginning of the first century B.C.E. Tunis, Musée du Bardo.	267
7.10.	Ara Pacis Augustae, southwest panel with Aeneas. 13–9 B.C.E.	267
7.11.	Relief with Apollo, Diana, Latona, and Victoria. Augustan. Rome, Villa Albani.	268
7.12.	Relief with Victoria (of Salamis) and Trophy. Augustan. Rome, Villa Albani.	269
8.1.	Framed Egyptianizing motif from the predella of the third-style frescoes of the Black Tablinum, Room 2, in the Villa of the Mysteries. Pompeii. Ca. 15 B.C.E.–15 C.E.	279
8.2.	Casa del Frutteto, Cubiculum 8. View of the room and its surviving wall decoration, looking east. Pompeii. Ca. 40–50 C.E.	280
8.3.	Casa del Frutteto, Cubiculum 8. View of the upper section of the south wall. Pompeii. Ca. 40–50 C.E.	281
8.4.	Casa del Frutteto, Cubiculum 8. Central section of the west wall. Pompeii. Ca. 40–50 C.E.	282
8.5.	Casa del Frutteto, Cubiculum 8. View of the south wall. Pompeii. Ca. 40–50 C.E.	283
8.6.	Antinous as Bacchus.	285
8.7.	Antinous. From Hadrian's Villa, near Tivoli.	286
8.8.	Intarsio panel showing Hylas and the Nymphs. From the Basilica of Junius Bassus, Rome. Ca. mid-fourth century C.E.	296
11.1.	Raphael, *School of Athens*. Ca. 1509–10. Fresco in the Stanza della Segnatura, Vatican, Rome.	378
11.2.	Gennadeion, The American School of Classical Studies, Athens.	388

TABLE

4.1.	"Pasquino," Achilles-Penthesilea, and Marsyas: Distribution of the Copies	152

ACKNOWLEDGMENTS

FOR INDISPENSABLE COMMENTS on various aspects of this project and on my own contributions to it, I wish to thank Benjamin Acosta-Hughes, Alessandro Barchiesi, Mario Citroni, Joy Connolly, Eric Downing, Mark Fullerton, Erik Gunderson, Jaś Elsner, Richard Neer, Alan Shapiro, and Tim Whitmarsh, as well as audiences at the universities of Oxford (Corpus Christi College), Colorado (Boulder), Duke, Ohio State, Bristol, Pennsylvania, and Princeton, and at Dartmouth College. The project first came to life in a conversation with Chuck Myers of Princeton University Press, whose enthusiasm for the idea of the book proved to be a sustaining force behind the idea itself. Kendra Eshleman lent her sharp editorial eye to my portions of this book; Brenda Longfellow helped prepare the final manuscript; Barbara Glassman provided meticulous copyediting and Sara Lerner was a model production editor. Tom Broughton-Willett prepared the index. Finally, my deepest thanks go to the contributors to this volume, from whom I have learned the most, and without whom the book simply would not exist at all.

LIST OF ABBREVIATIONS

A&A	*Antike und Abendland*
AAA	*Archaiologika analekta ex Athenon. Athens Annals of Archaeology*
AB	I. Bekker, ed., *Anecdota Graeca,* (Berlin G. C. Nauckium, 1814–21; repr., Graz: Akademische Druck- und Verlagsanstalt, 1965)
AH	*Acta Hyperborea*
AHR	*American Historical Review*
AJA	*American Journal of Archaeology*
AJP	*American Journal of Philology*
AM	*Mitteilungen des Deutschen Archäologischen Instituts, Athenische Abteilung*
AnalRom	*Analecta Romana Instituti Danici*
ANRW	*Aufstieg und Niedergang der römischen Welt*
Anth. Lat.	A. Riese, F. Buecheler, and E. Lommatzsch, eds., *Anthologia Latina* (Leipzig: B. G. Teubner, 1869–1926); D. R. Shackleton Bailey, ed., vol. 1, *Carmina in codicibus scripta* (Stuttgart: B. G. Teubner, 1982)
Anth. Plan.	*Anthologia Planudea*
AR	*Archaeological Reports.* Society for the Promotion of Hellenic Studies
ArchDelt	*Archaiologikon Deltion*
ArtB	*Art Bulletin*
BABesch	*Bulletin antieke beschaving. Annual Papers on Classical Archaeology*
BCH	*Bulletin de correspondance hellénique*
BÉFAR	Bibliothèque des Écoles françaises d'Athènes et de Rome
BICS	*Bulletin of the Institute of Classical Studies of the University of London*
BSA	*Annual of the British School at Athens*
BullCom	*Bullettino della Commissione archeologica Comunale di Roma*
CA	*Classical Antiquity*
CAH	*Cambridge Ancient History* (Cambridge 1923–39, 2nd ed. 1961–)
CEG	P. A. Hansen, *Carmina Epigraphica Graeca* (Berlin 1983–39).
CErc	*Cronache Ercolanesi*
CHCL	P. E. Easterling, W. V. Clausen, E. J. Kenney, and B.M.W. Knox, eds., *The Cambridge History of Classical Literature* (Cambridge: Cambridge University Press, 1989)

CJ	*Classical Journal*
CQ	*Classical Quarterly*
CSCA	*University of California Studies in Classical Antiquity*
Epigr. Gr.	G. Kaibel, *Epigrammata Graeca ex lapidibus conlecta* (Berlin, 1878)
FGE	D. L. Page, ed., *Further Greek Epigrams* (Cambridge: Cambridge University Press, 1981)
FGrH	F. Jacoby, *Die Fragmente der griechischen Historiker* (Berlin: Weidmann, 1923–)
FuB	*Forschungen und Berichte, Staatliche Museen zu Berlin*
G&R	*Greece & Rome*
GRBS	*Greek, Roman and Byzantine Studies*
GRF	G. Funaioli, ed., *Grammaticae Romanae Fragmenta* (Leipzig: B. G. Teubner, 1907; repr. Stuttgart: B. G. Teubner, 1969)
HSCP	*Harvard Studies in Classical Philology*
HTR	*Harvard Theological Review*
IC	M. Guarducci, ed., *Inscriptiones Creticae opera et consilio Friderici Halbherr collectae*, I–IV (Rome: Libreria dello Stato, 1935–50)
ICS	*Illinois Classical Studies*
IG	*Inscriptiones Graecae* (Berlin: G. Reiner, 1873–)
IGR	*Inscriptiones Graecae ad res Romanas pertinentes* (Paris, E. Leroux, 1901–27)
JdI	*Jahrbuch des Deutschen Archäologischen Instituts*
JHS	*Journal of Hellenic Studies*
JÖAI	*Jahreshefte des Österreichischen Archäologischen Instituts*
JRA	*Journal of Roman Archaeology*
JRS	*Journal of Roman Studies*
LIMC	*Lexicon Iconographicum Mythologiae Classicae* (Zurich: Artemis, 1974–)
LSJ	Liddell-Scott-Jones, *Greek-English Lexicon*, 9th ed., revised and augmented (Oxford: Clarendon Press, 1996)
LTUR	E. M. Steinby, ed., *Lexicon Topographicum Urbis Romae* (Rome: Edizioni Quasar, 1993–)
MAAR	*Memoirs of the American Academy in Rome*
MÉFR	*Mélanges d'archéologie et d'histoire de l'École française de Rome*
MÉFRA	*Mélanges de l'École française de Rome, Antiquité*
MH	*Museum Helveticum*
MüJB	*Münchener Jahrbuch der bildenden Kunst*
Der neue Pauly	H. Cancik and H. Schneider, eds., *Der neue Pauly: Enzyklopädie der Antike* (Stuttgart: J. B. Metzler, 1996–2003)

OCD	*The Oxford Classical Dictionary* (Oxford: Clarendon Press)
OED	*The Oxford English Dictionary* (Oxford: Clarendon Press)
P&P	*Past & Present*
PAPS	*Proceedings of the American Philosophical Society*
PBSR	*Papers of the British School at Rome*
PCG	R. Kassel and C. Austin, *Poetae Comici Graeci* (Berlin: Novi Eboraci, 1983–).
PCPS	*Proceedings of the Cambridge Philological Society*
PMG	D. L. Page, *Poetae Melici Graeci* (Oxford: Clarendon Press, 1962)
RE	A. Pauly, G. Wissowa, and W. Kroll, *Real-Encyclopädie der klassischen Altertumswissenschaft* (Stuttgart: J. B. Metzler, 1894–1978)
RÉL	*Revue des études latines*
RhM	*Rheinisches Museum für Philologie*
RM	*Mitteilungen des Deutschen Archäologischen Instituts Römische Abteilung*
SH	H. Lloyd-Jones and P. Parsons, eds., *Supplementum Hellenisticum* (Berlin: Walter de Gruyter, 1983)
SVF	H. Von Arnim, *Stoicorum veterum fragmenta* (Leipzig: B. G. Teubner, 1903–24), 4 vols.
TGF	A. Nauck, *Tragicorum Graecorum Fragmenta*, 2nd ed. (Leipzig: B. G. Teubner, 1889); Suppl., B. Snell (Hildesheim: G. Olms, 1964)
ZPE	*Zeitschrift für Papyrologie und Epigraphik*

Introduction

WHAT IS "CLASSICAL" ABOUT CLASSICAL ANTIQUITY?

James I. Porter

> What seemed a single escalator, a perpetual recession into history, turns out, on reflection, to be a more complicated movement: Old England, settlement, the rural virtues—all these, in fact, mean different things at different times, and quite different values are being brought into question.
> —Raymond Williams, *The Country and the City*

In 1930 the field of classical studies experienced an insurrection. Werner Jaeger, in apostasy from his teacher and predecessor at Berlin, Ulrich von Wilamowitz-Moellendorff, convened a conference in Naumburg called "The Problem of the Classical" ("Das Problem des Klassischen"). The apostasy was open and calculated. Thirty years earlier Wilamowitz had boasted that he helped put paid to the word *classical*, which he found meaningless, and in his *Geschichte der Philologie* from 1921 he notoriously (and audibly) omitted the time-honored epithet of his discipline. (In English the title ought to read, *History of* [] *Philology*. The published English and Italian translations spoil the title's symbolics by reinserting the missing word *classical*.)[1] As Wilamowitz later wrote to Wolfgang Schadewaldt, one of the participants in the conference and a former pupil, "Whenever I read *Die Antike* [Jaeger's neohumanist journal founded in 1925], a millstone starts turning in my head. But the stone grinds no meal, not for me at least.—I have an idea what classical physics is, and there is classical music. But besides that?"[2] *Das Klassische* was a problem indeed, and Jaeger's conference aimed at making classics a *classical* discipline again, one firmly rooted in classical and humanistic values true for all time and in the

[1] See Wilamowitz-Moellendorff 1921, 1, for the justification. On Wilamowitz's boast, see Porter 2000b, 269–72 (to which add Wilamowitz-Moellendorff 1900, 52 n. 1: "der Bann des Classizismus"; his article on [viz., against] Atticism, to be discussed below, is in fact premised on a critique of the classical ideal).

[2] Letter to Schadewaldt, December 1930 or January 1931, reproduced in Calder 1975, 455 (my translation). The journal's subtitle reads, "Zeitschrift für Kunst und Kultur des klassischen Altertums"; see Jaeger's programmatic preface to the first number (Jaeger 1925).

tradition of Winckelmann, Humboldt, and Goethe, as against its being a compilation of dry historical data.[3]

We have a good idea of what the conference was about because Jaeger published its proceedings a year later. But what went on behind the scenes? Luckily, in the days before tape recorders there was Alfred Körte, who offers an invaluable first-hand account of what he saw and heard: "A number of speakers in the discussion at Naumburg sharply disputed the claim that Aeschylus was a classical author of the first rank (*ein Klassiker*).... As the discussion progressed, it turned out that actually none of the first-class luminaries of world literature had any rightful claim to the label *classical*, or at most they had only a qualified claim to it—neither Homer nor Aeschylus nor Shakespeare nor even the young Goethe. Sophocles and Virgil fitted the classical ideal best of all."[4]

It is obvious that the scholars Jaeger surrounded himself with had painted themselves into an intellectual corner, but it does not follow from their failure that the classical should be any less of a problem today than it was in 1930. The term and the idea it names are as common as they ever were. *Classicists* teach in departments of *Classics*, they study *classical* literature and culture (commonly known as *the classics*), the books they write, and more often buy, appear on the shelves of stores and libraries under the rubric of *Classical Studies*, and so on. But does anyone stop to ask what these labels mean?

Rarely, and with good reason.[5] In the first place, this kind of inquiry seems dated, and embarrassingly so. Passionate defenses of the classical were once in vogue, but consensus was never reached, and anyway there is something musty and distasteful about the question, which smacks of belletrism or of antiquarianism and a dated aesthetics. What have the concerns of a Boileau, a Goethe, or a Werner Jaeger to do with us today? The quarrels of the Ancients and Moderns are dead, and postmodern chic requires that the word *classical* should at most appear with a knowing nod and in inverted commas.[6] Outside of art history, where the term still carries a strong periodizing charge and are occasionally felt to be troubling, and occasionally in Germany where *das Klassische* continues to evoke an important aspect of the modern German identity and so continues to find historical relevance at least, classicists for the most part are content to submit to the dictates of usage and to leave well enough alone. And no doubt wisely so, for if anything was learned from the once raging but now weary and exhausted debates of the past centuries, it is surely the conclusion that the terms formed around the idea of the classical can have no satisfactory

[3] See Jaeger 1925. For background, White 1992.

[4] Jaeger 1931; Körte 1934; quotation from p. 13 with n. 2.

[5] In addition to the various works and items cited below, see Peyre 1965, Voßkamp 1993, Forestier and Néraudau 1995, Stenzel 2000.

[6] In postmodern art and architecture, classicism lives on in the mode of pastiche, but sometimes in a more earnest vein. Cf. Jencks 1980, id. 1987, id. 1996.

definition. Nobody likes pressing after insolubles, and this is no exception. Faced with the premonition of failure, classicists (even of the postmodern variety) naturally shy away from analyzing the terms too closely. But there may be more practical premonitions at work here.

Even as we lurch into the twenty-first century, with its shimmering promises of strange new worlds transformed by changes in technology and in global economies, the idea of the classical has a cachet that continues to translate into cultural prestige, authority, elitist satisfactions, and economic power—less so than in the past, to be sure, but with a residual effect that is far from negligible. What is more, the idea of the classical conveys an allure that is no less powerful for being all the more indefinable. Indeed, to decide its meaning once and for all would be to surrender some of this power—a sure disincentive to looking too long and hard at the meaning of the term. On the other hand, the very fact that the terms *classical*, *classicism*, and the rest are mutually implicated, linguistically, historically, and institutionally, ensures that a quiver of uncertainty felt in any one of the terms will be felt across them all. So, quite apart from the difficulties that the notion of the classical poses at the level of diction and dictionaries, the motivation for defining this extended family of terms and ideas appears to be rather minimal, at least within the circle of classical studies. (Just try proposing a change of name in your local department of Classics and watch the reactions you will draw.) Thus, while historians of modern literature and art have shown an interest in defining, with a backward-looking regard, the nature of the classic or in analyzing the phenomenon of classicism in its modern forms, classicists are frequently the last to question the meaning of the terms that currently define, for good or ill, the entirety of their fields.[7] One of the ironies of this situation is that simply by promoting their studies and by confirming their reach, classicists are witting or unwitting *classicizers*. But surely there is something odd about this conclusion. Classicists are not classical, and their writings are not classical. It is only the objects of their study that purportedly are. So what makes a classicist a *classicist*?

How "Classical" Is Classical Antiquity?

At issue in questions about classicism is plainly the very label by which we designate the cultures of Greece and Rome as classical, and so too the disciplines that seek to grasp them. The label, inherited and ubiquitous, is for the most part taken for granted rather than questioned even among those who study it.[8] It is a fair question to ask whether the presumptive epithet *classical* in

[7] This deficiency was noted by Gelzer in 1979, nor have things changed substantially since.
[8] *OED, New Edition*, s.v. "classic" on the "extension [of the word] to the ancient authors generally, as studied in school or college. . . . The extension has probably been in the main unthinking and unanalyzed."

classical studies or *classical antiquity* is justified, or even what it would mean for the terms to count as justified at all. The aim of the present volume is to open an investigation into this very issue. The problem is to confront our nomenclature with our epistemologies, to measure what we say against what we know. Accordingly, the premise of *Classical Pasts* lies at the intersection of two related questions: First, are classicism—briefly, an awareness of and appreciation for what is classical—and the classical (however that comes to be defined) part of what we today call "the classical past," namely the worlds of ancient Greece and Rome? And second, if so, how would we recognize this sensibility? That is, by way of what, and especially by *whose*, criteria would we point to the existence of classicism and the classical in Greco-Roman antiquity? These two questions can be summed up by way of a third: Was classical antiquity *classical*?

Even judging by existing criteria, the answer to this last question cannot be an unqualified Yes. Although some classicists write on classical texts, and some classical archaeologists investigate classical sites and ruins, not all of them do. Not all of the works to survive from Greco-Roman antiquity are recognized "classics" (treatises on architecture are not, even if many of the works they describe are), and not even all of antiquity is considered equally classical. Conventionally, classical antiquity comprises not one comprehensive classical expanse but two isolated classical moments: fifth- and fourth-century Athens, and Augustan Rome. Nor are these strictly symmetrical: most of the prestige gets handed—again, conventionally—to Athens, while Roman culture, at least in the modern era, has often been felt to be a shadow or knock-off of the Greek original, when it was not seen as basking serenely in a borrowed, earlier glory.[9] On either side of these strictly classical phenomena are the outlying extremes: preclassical Greece (Greece of the Bronze Age and the subsequent "Dark Age") and postclassical antiquity (however we choose to date this). And there are the debated middles, which are commonly thought, respectively, to lead up to, fall off from, or recapture—at least in aspiration—the glories of high classical Greece: the archaic period (ca. 800–500 B.C.E.); the diasporic Ptolemaic or Hellenistic period (323 to the first century B.C.E.); and the Second Sophistic period (ca. 50–250 C.E.), when Greeks were Romans and Romans, it often seems, sought to be like Greeks.[10] Nor is classical Greece itself consistently classical. On the contrary, that era—or its idea—is riven into three conventional

[9] On Athens, see Pollitt 1972 and Stewart 1997; on Rome, Zanker 1988a (esp. chs. 6–8) and Bryson 1990, 52–53. Attempts to de-center Athens exist (Beard and Henderson 1995, Feeney 1998, Zetzel 2003, and the chapters on Roman art and literature below), but these are bucking the prevailing trend.
[10] Hadrian, for example, was called *Graeculus* (*SHA* 1.5); but cf. already Cicero, who says of Titus Albucius, an orator with strong Epicurean leanings, that "you could call him almost a real Greek (*paene Graecus*)" (*Brut.* 131). Often, though not always: see the sobering reminders of Woolf 1994 (and as Cicero's own disparaging ironies already suggest). On the archaic period, see Hurwit

periods, mapping within itself the same rising and falling curve as the surrounding arc of history: the so-called Early Classical (480–450 B.C.E.), High Classical (450–400 B.C.E.), and Late Classical or incipiently classicizing (400–323 B.C.E.) periods.[11] The disparities are wide indeed.

A classicizing view of classical antiquity is objectionable on a number of counts. It is known and occasionally acknowledged that not even all of mid-fifth-century Athens at its zenith is equally classical. Everyday banausic artifacts—products of the so-called minor arts—bear none of the traits of so-called classical objects, which reminds us of an ascending ladder of values in any cultural paradigm.[12] Foreign influences like Orientalism and Egyptianism as well as various forms of hybridity impinge upon all presumptions about cultural purism, ancient and modern, qualifying them if not also throwing them into question (see especially Elsner, this volume).[13] And there are countless internal challenges to the idea, or ideal, of a hegemonic classical Athenian or Roman culture, starting with the questionable applicability of the label, which is in essence an aesthetic rubric, to the diverse domains of these two cultures. Can we truly identify the classical in intellectual and political life, in social relations, or in religious practices? Is Gorgias, the devious sophist, a classical thinker just by virtue of being a rough contemporary of Phidias? Or the atomist Democritus, for that matter? To assume a positive answer in any of these cases is to underestimate the inherent difficulties of the term *classical*, the uneven distribution of patterns and perceptions within and not only across various domains of culture, and the likelihood of their mutual untranslatability. The only other genuine alternative, inserting ancient Greece and Rome into the contact cultures of the wider Mediterranean world in an area-studies approach, is in the decided minority, and for the same reasons. Western culture remains predominantly under the spell of Hellenism.[14]

The conventional and still dominant view of Greek and Roman classicism is, in a word, Hellenocentric. Its epicenter is Athens from the end of the Persian War in the early fifth century down to its collapse at the hands of Philip of Macedon in the fourth. All of which is to say that *classical antiquity is divided, not unified, by claims to its classicism*, at the very least by the presence of two classical periods inhabiting it from within, and by a series of contenders for the

1985 (for art), Dougherty and Kurke 1998 (for culture), and Most 1989 and Morris 1997 (for its modern definition); on the Hellenistic period, see Stewart 1979, Pollitt 1986, and Stewart 1997, 205–30 (and this volume); on the Imperial era, see Hölscher 1987, Zanker 1988a, Elsner 1995 (for art), and Goldhill 2001 (for literary culture).

[11] On this standard periodization, see Fullerton 1998a, 69 with n. 6.

[12] Vickers 1985, Vickers and Gill 1996, Lapatin 2003.

[13] Vickers 1990, Beth Cohen 2000, Adams 2003, with the review of Adams by Mary Beard in the *Times Literary Supplement* of June 13, 2003, 5–6.

[14] Momigliano 1975, Horden and Purcell 2000, Dougherty 2003.

title which, for the most part, are considered to be either losers or nonstarters (the "pre-" or "post-" classical eras, from the Bronze Age to later antiquity).[15] And because classical antiquity has been treated as divided from within, the study of classical antiquity has had to be divided from within as well. The consequences for this view of Greek and Roman antiquity have been vast, from the highest reaches of the art world and its markets, where the culture of copies and originals looms large, to the most mundane details of the classroom, where textbooks, translations, editions, and curricula have all been affected in both selection and availability.[16] And while the view of classical culture as an organic entity that rises and falls along a sweeping parabola has been contested, the main points of reference and the picture as a whole remain pretty much intact, even as the cracks and divisions are everywhere to be felt and seen.

Classical antiquity is not consistently classical primarily because it has not been felt to be so in the past, but also because opinions about the question of where particular classical values are to be sought and found have varied. Thus, while consensus seems to cluster around Athenocentric values, the consensus splinters around particular instances (as the Naumburg discussion showed). Examples of debated items from Greece alone have historically included Homer, Euripides, and the Parthenon. Are these more or less classical than the Temple of Apollo on the Palatine, the Augustus of Prima Porta, or Hadrian's classical theme park at Tivoli?[17] We can point to facts about symmetry and proportionality in architecture and to standards of decorum and clarity (or the demands for both) in literature and in criticism. But do these facts point to a classical sensibility? What justifies the assumption that they do? Pressed to this kind of extreme, the label *classical* seems more of an encumbrance than a convenience.

SEEING AND SAYING: CLASSICAL EPISTEMOLOGIES

How do we know or recognize when something is or is not classical? Looking at the history of classics, one is tempted to conclude that the idea of the classical is an ideal that is at most suggested but not confirmed by concrete objects. So strong are the assumptions about what the classical and classicism are, we tend to forget that objects do not surface from the ground or from ancient

[15] See Paul Friedländer, "Vorklassisch und Nachklassisch," in Jaeger 1931, 33–46, with its typical prevarications: "Whether Herodotus is to be called late archaic or early classical may look like a quibble. But. . . ." (34). Pindar is "mature archaic (*reif archaisch*)" (33). And of Statius: "This is classical, . . . these verses are not" (42).

[16] Beard and Henderson, 2001, ch. 2, esp. pp. 73–74. On the role of the market, which in cases has actually changed scholarly visions and aesthetic perceptions of the classical past, see the articles by Vickers (1985, 1987, 1990) and the fundamental work by Reitlinger 1961–70.

[17] Most recently Fullerton 1998a, id. 1998b, id. ms., querying classicism in Roman art. On Hadrian's Villa, see Beard and Henderson, 2001, 102–5.

libraries with the label *classical* written across their faces.[18] Confusions are bound to result. To take only one instance, consider the Parthenon sculptures. When they were first brought to England in 1806 the sculptures were not universally received as classical, and it would take a decade for the British Museum to buy them from Lord Elgin. On the contrary, as strange as it may sound to us today, the initial reactions to the marbles were mixed and their artistic and cash value were disputed: did they rank with the better known (and heavily restored) Vatican marbles, the Apollo Belvedere and the Laocoön? Were they even Greek? It was only gradually, after considerable debate, interpretation, and eventual validation, not to mention "remedial" scraping, bleaching, and polishing, that they acquired the luster they now unquestionably enjoy.[19] Meanwhile, the fate of the Vatican marbles went the opposite way. In the generation after J. J. Winckelmann, who popularized them, they became an embarrassment to the history of art (possibly because Winckelmann had become this too): products of a later age (Roman, or worse still, Neronian), they were no longer deemed classical, and were at most classicizing. And they were judged so according to the very same criteria that had established themselves through the same, but by then discredited, marbles from the Vatican. As copies or embellishments of lost originals, with pretensions that reached no further back than the Hellenistic period, they no longer could belong to the sublimest rank of ancient sculpture.[20]

So just where do the cues to what is classical come from? Presumably they come from a combination of factors, ranging from features that objects have or suggest to acquired expectations, although in practice claims for classicality tend to be made through example and assertion ("This is classical, that is not."). But as the interminable history of disputes over what is or is not classical in fact shows, being classical is not a property an object can have, like specific gravity or being red or standing six feet tall. It is the suggestion that an object has this kind of property, which is why one needs to determine just where in any given case the suggestion originates.[21] Indeed, the strongest argument for

[18] See Shanks in Pearson and Shanks 2001, 114, for a parallel point: "What is found is not naturally 'authentic'; its 'original' context is not natural.... What is found *becomes* authentic and valuable because it is set by choice in a new and separate environment with its own order, purpose and its own temporality."

[19] Jenkins 2001, Beard 2002, 18–20 and 155–73, Webb 2002. The frieze from the temple of Apollo at Bassae, which was hung in the British Museum shortly afterwards, met with similarly divided responses; see Beard and Henderson 1995, 81.

[20] Winckelmann 1972, 366–69; Haskell 1976, 6; Haskell and Penny 1982, 106–7 and 150, who however somewhat downplay the damage that Raphael Mengs and others had done to the reputation of the Apollo Belvedere. Apart from Feuerbach (see below), compare Hazlitt [1826] 1930, 222: "The Apollo Belvedire [*sic*] is positively bad, a theatrical coxcomb, and ill-made." Further, Stewart (this volume).

[21] *Pace* an account like that by Tatarkiewicz 1958, which vacillates in a way that is symptomatic

something's being classical seems to be the very act of ostension itself, while the strongest evidence for the classical is usually that of self-evidence. Schadewaldt believed, for instance, that when we are confronted with Sophocles or the Parthenon, "we remain who we are in the face of that form, which is entirely itself"; for "classical is what—for us—counts as classical."[22] Such is the sheer *tautology* of classicism. What is more, or less, the label *classical* is a selective screen: it excludes at least as much as it includes in the perception of an object, and it typically excludes *more* than it includes. As we shall see below, to take in a classical form is a bit like closing one's eyes. Finally, we should not underestimate the extent to which the idea of the classical is rooted in an experience of pleasure, which is the true accomplice of the ideal. Indeed, the very act of filtering, which produces the blinding fantasy of a classical object, of an object with a certain inestimable value, owes everything to the work of enjoyment that makes this fantasy succeed unnoticed.[23]

How much investment and disavowal must go into the making of the perception of a classical body? A considerable amount, if we take any of the German classicists as our guide. The history of the classical ideal in Germany, but also elsewhere in Europe, is the history of attempts to grapple with the elusiveness of this ideal in Winckelmann's wake. Winckelmann's writings, but above all his passion for Greek art, provoked a century-long obsession with the classical ideal that has left its indelible imprint on even our most recent past. The Nazi adoration of the classical form and the obsessive appropriation and musealization of antiquities, especially of classical stamp, over the past century and a half or more are just two instances that can be and have been named in this connection.[24]

Which is not to deny that the modern views had antecedents in antiquity. However Athens came to be seen as the zenith of classical culture, this myth of cultural plenitude was destined to become the model for the classical world and for our own. This was, after all, the premise of the first known etymology of the

of the tradition it resumes (e.g., p. 20: "Si on n'aboutit pas a une définition du classique, on peut au moins en enumérer les propriétés").

[22] Schadewaldt in Jaeger 1931, 16 ("Bleiben wir wir selbst im Anschauen jener Gestalt, die ganz sie selber ist"); 21. A *locus classicus* of this idea is found in Hegel, for whom the classical is "that which signifies itself and thereby interprets itself" ("das sich selbst Bedeutende und damit auch sich selber Deutende"), viz., is both sign and its interpretation (Hegel [1820–29] 1975, 1:427; trans. modified). Tautology, self-evidence, and self-enclosing totality go hand in hand in this tradition.

[23] The same holds for the criterion of "pure Greek," which is assumed to be self-evident, until a definition is asked for, and even afterwards, when none can be agreed upon; cf. Sext. Emp. *Math.* 1.176 (cf. 1.184), and below on *hellenismos*. In ways, classical properties are susceptible to the kind of analysis Marx applied to commodity fetishism, which creates a "mist through which the social character of labour [read: "the classical"] appears to us to be an objective character of the products themselves" (Tucker 1978, 322). Classical properties are fetishistic in at least this sense. Further, Žižek 1989, 16.

[24] Mosse 1996 for the former; Beard and Henderson 1995 and Marchand 1996 for the latter.

term *classicus* from antiquity and one of its earliest (and only) attestations, according to which what is classical is tied to a conception of exclusive affluence and influence, based on an analogy to property ownership and class standing: "Not all those men who were enrolled in the five classes were called *classici*, but only the men of the first class, who were rated at a hundred and twenty five thousand *asses*" (Gell. *NA* 6.13.1, citing Cato the Elder's usage from the early first century B.C.E.; trans. Rolfe). A military connotation does not lie far off (*classis* is also a levy or a fleet of warships, and its adjective is likewise *classicus*).[25] The point would not be quite so relevant if Fronto and Gellius, antiquarians with classicizing interests, had not connected the word more closely to *classical* in the modern sense in a later, more famous passage, a point we will want to come back to below. Thus, if we are willing to grant an initial coherence to the notion of classicism, it seems fair to say that Greek and Roman antiquity produced a form of classicism internal to itself, at the very least by the time of the Second Sophistic, but conceivably earlier.[26]

The very fact that classicism seems to emerge from a background in which the term goes unexpressed until very late in the day, in the second century C.E., is part and parcel of this fascinating problem: *classical* seeks to label something that as yet had no name. The problem is not unique by any means: it is a common enough issue in studies of antiquity, where missing names can at different historical moments include such diverse and problematic entities as *body, self, will, justice, class, race, homosexuality*, and even *literature*.[27] Names aside, the myth of cultural plenitude that has insinuated itself into the meaning of *classical* no doubt originated in Athens's own self-definition, its political patronage buttressing its cultural hegemony. To be sure, fifth-century Athens never called itself *classical* in quite so many words, and ironically its claims to this title could only grow in proportion to the ever-widening distance to the political and cultural achievements of the Athenian fifth century. Considerations like these help draw attention to the underlying ideological dimensions of the label *classical*. Unpacking the historical mechanisms of classicism is a good way to observe and discover how ideologies come to function and take hold of subjects, most of all through finely spun webs of implication that take effect precisely because they are *not* named.

Whether classicism in antiquity is any more coherent than in its modern descendants and counterparts, this much at least is certain: things classical succeed most of all in conveying their classicality because they occupy a space

[25] On the resonances of *class* in *classical*, see Curtius 1953, 249–50; Stallybrass and White 1986, 1–6. On the difficulties of searching for an equivalent in *archaios*, see Porter, this volume (at n. 73).
[26] See Körte 1934.
[27] Body: Porter 1999; body/soul: Williams 1993 and M. Clarke 1999; will: Vernant and Vidal-Naquet 1988; justice: Havelock 1978; class: De Ste. Croix 1981 (with Finley 1983, 10); race: Hall 1997 (esp. pp. 34–37) and Hall 2002; homosexuality: Dover 1977, Foucault 1980–86; literature: Arist. *Poet.* 1.1447a28–b9; Dupont 1999.

that is simultaneously real and ideal. Ideals have a way of seducing us with their very nonlocatability. That is their chief source of power, which is purely ideological: they present the requirement, and the illusion, of consensus, which in turn masks over a good deal of uncertainty, contestation, and difference. More will be said about this below. First we need to consider the question of how classicism and the classical came to be identified and named.

HISTORY OF THE PROBLEM — HISTORICIZING THE PROBLEM

The question of when classical culture as we know it came into existence is a vexing problem, and the motivating impulse behind the present project. It is a problem of genuine historical dimensions, and it is a problem of a conceptual kind that exists for us today each time we try to formulate it. These two kinds of difficulty are linked, no doubt because the question of what is classical is at one and the same time so thoroughly overdetermined (it is contaminated, historically, with layers of attempts to put the question) and so thoroughly underdetermined (no answer, empirical or theoretical, can ever satisfy the demand, so to speak, that is written into the question). The question itself can be traced back to antiquity, long before Fronto, the early-second-century Roman orator who seems to have established the term *classicus* as a marker of cultural production of a high and elite order (*classicus scriptor, non proletarius*), and specifically literary cultural production of a certain antiquity (*cohors antiquior vel oratorium vel poetarum*), as Gellius testifies.[28] Though restricted to a Latin *cohors*, or canon, this notion of the classical is in fact modeled on the Greek paradigm of classical culture,[29] and it has strong resonances with Gellius's contemporary world: Gellius is very much a product of his backward-gazing age (see Citroni, this volume).[30] The term had been used earlier in Latin literature in a similar vein, but seemingly casually and never so specifically as here, and then it went underground until the Renaissance, when it was attached to *auctores*.[31] Finally,

[28] Gell. *NA* 19.8.15; cf. id. 6.13.1 (cited above, where however the term is not applied to writers but merely to first-rank *homines*).

[29] Horsfall 1993, esp. 61–62. The title of Gellius's work, after all, is "*Attic* Nights." Its composition, he tells us, was begun during long winter nights "spent in the countryside of Attica" (Praef. 4)—a symbolic *incipit*, to be sure.

[30] Further, Langlotz 1960; Gelzer 1975, 154–55, 161; Settis 2002, 44; Citroni 2003c. Fronto's and Gellius's antiquarianism, a frequent preoccupation after the Augustan age (see Gell. *NA* 2.16.5 on Caesellius's *Commentario Lectionum Antiquarum*), is strongly classicizing (cf. Körte 1934, 4–6). And the hunt for rare words and correct usage is part of a larger aesthetic quest, which includes melodiousness, rhythm, other aspects of euphony (ibid., 1.4.4, 1.7.19-20, 2.3.1, 4.17.12; see Biffino ms.)—in short, it is part of a desire for *Latinitas* parallel to the desire for *hellenismos* (on which, see below; and see also n. 116).

[31] Cicero employs the same metaphor (*quintae classis*) to single out the philosopher Democritus as superior to the Stoics Cleanthes and Chrysippus, but not in a literary sense (*Acad.* 2.23.73). For the

classical came to be applied to the whole of Greek and Roman antiquity in the sense that is current today. That sense ultimately rests, as Nietzsche once noted, on "an *aesthetic* judgment," and in at least two ways: to speak of *classical antiquity* is to delimit historical developments and to grasp them as a unified whole; and it is to confer on them a value, which is one of unqualified prestige.[32]

Indeed, classicism and the classical rely upon an aesthetic bias in more surreptitious ways still. The view that classicism was available in antiquity, retrospectively, once the Golden Age of Greece had passed, tends to set up questionable teleologies according to which art and culture are seen as having groped towards, and then drifted away from, what would eventually emerge as a canonically classical ideal, whether this emergence is found in the human form (Phidias) or in the conception of humanity that this form was meant, or said, to embody (the free, self-standing, typically male individual in control of his own political and expressive destiny). But how likely is this story, in fact? One could just as easily and convincingly argue that the idea of the classical is of necessity an empty concept, a placeholder for something that never in fact transpires. For according to the standard account, later expressions of classicism are never classical but only *classicizing*, while appearances of the classical can by definition never be "classical" in their initial appearance but only in a retrospective light. The classical thus *never is* but always *only once was*. The unrelenting abstraction and idealism, not this time of what the classical picks out—this or that classical object—but of the way in which the classical appears in history as a graspable form, ought to give us pause. Here, it is no longer a question of disputed instances: it is *the very phenomenon of the classical* that has been idealized and made into an abstraction. In theory the epitome of self-contained identity, in fact the classical never seems to be equivalent to itself. Small wonder that pointing out individual instances of the classical in practice is as problematic as it is: it is *the very idea of the classical* that is problematic.

A good deal of this uncertainty has to do with the for the most part disguised function of the classical in social and political life, both ancient and modern. As a consequence, classicism and the classical are generally doing several things at the same time, nor is it always easy to prise apart these functions. What is the exact relation between the aesthetic claims of the classical and its privileged place in the realm of cultural production? One possibility is that both the allures of high culture and the aims of the political realities underlying them are *facilitated* by the aesthetic qualities that are conferred upon them through the classical, and in two ways. At times the aesthetic connotations may serve to deflect from the ideological pressures of classicism and the classical:

term's reappearance at around 1500, see Rizzo 1986, 389–90, and Pfeiffer 1976, 84 n. 4 . Our sense of the term takes its cue from here. (I owe the reference to Rizzo to M. Citroni.)
[32] Nietzsche 1967–, 2.1:341.

busying ourselves with timeless beauty, we are permitted to ignore the hard contingencies that make this perception possible. At other times classical aesthetics serves precisely to enhance our experience of what is at bottom an ideological formation, which now can be felt as uplifting, sublime, sacred, and so on. Aesthetics and cultural ideology are on this latter scenario indivisibly fused: the allures of classicism *just are* an ideological pleasure. Aristides, the second-century C.E. orator from Pergamum and eventual chronicler of his lifelong physical ailments, swooning over the incomparable greatness of a bygone Athens worthy of a classical shrine ("the whole Acropolis was like a dedication, or rather like a statue"), illustrates the grip that classicism can have on the ancient political imagination. It is in good part thanks to the Aristides' of the past that in the modern view of things classicism and classical antiquity form a closely knit unity that is hard to dislodge.[33]

Classicism and *classical* bespeak a proudly venerable past, yet histories of the terms, one of the conventional ways scholars have tried to get at their meaning, reveal how recent their usage in fact is in the modern vernaculars. The *Oxford English Dictionary* gives 1613 for the first appearance of the word *classic* in English, meaning "of the first rank" (as in Fronto), and 1628 for the first application of the term to Greco-Roman culture, while *classical* appears in the same senses just a few years earlier (1599 and 1607). *Classicism*, a later neologism that was initially spurned, appears in Italian in 1818 and in English for the first time in 1830.[34] *Klassizität* and *Klassik*, German abstractions for the concept of the classical and its incarnations, are of eighteenth-century derivation.[35] *Das Klassische* may date from the start of the next century,[36] even if the adjectives *classique* and *klassisch* appear earlier (1548 and 1748, respectively), if only sporadically, while *classical* was combined with *antiquity* only in 1797 in Germany.[37] Indeed, it is largely to the German eighteenth century, which was one of renewed attention to classical antiquity, that modern and current notions of the classical trace their lineage, starting above all with Winckelmann (1717–68).

To acknowledge Winckelmann's place in this history is to begin to make an initial dent in the problem of the classical, because surprisingly he appears to

[33] The Acropolis is the incarnation of Athenian political, economic, and cultural hegemony, all rolled into one: Aristid. *Or.* 1.191; cf. ibid., 348, and passim.

[34] *OED, New Edition*, q.v. These dates are slightly earlier than those given in Levin 1957, Luck 1958, and Wellek 1970 (who supplies the Italian example from 1818). But as Tatarkiewicz 1958, 6–7, well underscores, coinages and usage are distinct things: despite the precedents, Bayle's *Dictionnaire historique et critique* (1695–97) fails to mention *classique*, while the dictionary of the Académie Française of 1814 begrudgingly mentions the term; only afterwards did the word enjoy any currency in France.

[35] Wellek 1970, 74, 77–78.

[36] As in Wilhelm von Humboldt's essay "Latium und Hellas" (1806/7).

[37] See Stroux in Jaeger 1931; Gelzer in Flashar 1979, 4; Müri 1976, 286 and 288 (on F. Schlegel's German coinage of *klassisches Altertum* and its gradual acceptance in Germany).

be ignorant of the term and its extensions. On the one hand, there can be little doubt that it was Winckelmann who inaugurated the modern fury of classicism, stamping it as a pursuit of an idea of aesthetic beauty and purity that, abstractly conceived and barely embodied, would haunt the centuries to come in the form of "the classical ideal." But so far as I am aware Winckelmann himself nowhere makes use of the word *classical* or any of its cognates, and instead is content to speak either of "Greeks" and "Romans" or of "antiquity" (*das Altertum*) and its phenomena *tout court*—a stretch of history that begins with Egypt, Phoenicia, Persia, and Etruria, and ends in Rome, but which achieves its pinnacle only in Greece. While Winckelmann was following good precedents, his presumptive bias is the same as in later writers, for whom the word *antiquity* stands for classical antiquity at its best, which is to say for an embodiment of values that stem from classical Greece.[38] Plainly, the thought or concept of what is classical had already occurred to Winckelmann and is in full force in his writings. Only the word is missing. If so, then just how significant can the history of words be?

Histories of words can take us only so far. It is not merely that such histories tend by their nature to be incomplete. Even a complete history of terms would not give us a handle on the history of the concepts that the words seek to name (Winckelmann, for instance, would not figure in such a history).[39] Nor do histories like these necessarily bring us any closer to definitions. What histories of words and concepts reveal is at best the history of struggles over definition. This was never more true than in the case of a word like *classical*, which can have *no* agreed-upon definition, if only because the concepts it represents have themselves historically been a matter of contention. The reason for this disagreement is not far to seek: the concept of the classical names something that is not merely ineffable, but is arguably also incoherent to the core, being fashioned out of mere ideals and aspirations with no clear embodiments in reality and not even any clear articulations in language. More significant than words and the concepts they name are the patterns of logic that underlie the deployment of both. Only by reconstructing this logic and its history can one hope to come to grips with the notion of the classical. That history has yet to be written.

Anatomies fare little better than histories of words and ideas. While they may be comforting in their apparent systematicity, anatomies can at most offer

[38] On these precedents, see Müri 1976, with examples from, e.g., Roger de Piles (1635–1709), "le siècle des grands hommes," viz., "les merveilleux ouvrages," "ces beaux ouvrages de l'antiquité," and Caylus, "la belle Antiquité." This acceptation entered the German language as *die Antike* around 1760 (ibid., 253–54). *Alt*, *ancien*, and *ancient* and their substantivals exhibit the same bias today, as in *Altphilologie* for *classical philology* and *ancients* for Greeks and Romans. *Philology* is another imperious shorthand.

[39] Another case in point is the term *Renaissance*, which was adopted as a periodizing term only in the nineteenth century by Michelet and then by Burckhardt (although Balzac may have coined the term in 1829).

a summation of past uses of a term, but not its definition, and they fail to touch the logic or illogic of the term's uses. To be sure, anatomies of *classicism* and *the classical* are available. Michael Greenhalgh's *What Is Classicism?* (1990) is a recent example, as are, in classical art history, the opening pages of J. J. Pollitt's *Art and Experience in Classical Greece* (1972).[40] And there are a number of (qualified) defenses of the utility of the terms, for example, Harry Levin's "Contexts of the Classical" (1957), Frank Kermode's *The Classic* (1983/ 1975), Italo Calvino's "Why Read the Classics?" (1999), and J. N. Coetzee's "What Is a Classic?" (2001), all in the wake of two milestone essays, Sainte-Beuve's *Qu'est-ce qu'un classique?* (1850) and T. S. Eliot's "What Is a Classic?" (1944). The most honest of these throw up their hands in despair,[41] and the best of them turn this despair into a productive source of inquiry by asking how we got to this point and what the gaps in our frameworks mean (see Schmalzriedt's once scandalous and now little-cited *Inhumane Klassik: Vorlesung wider ein Bildungsklischée* [1971], Beard and Henderson's *Classics: A Very Short Introduction* [1995], Guillory's *Cultural Capital: The Problem of Literary Canon Formation* [1993], and Settis's "Der Klassizismus und das Klassische" [2002]).[42] And so, while it might be desirable to enumerate the various meanings that the terms *classical* and *classicism* can have, based on their historical usages, all such anatomies miss the crux of the problem. Let's see why.

Anatomies of the term *classical* typically list the following uses:

1. Designating or pertaining to the whole of Greek and Roman civilization in antiquity
2. As a periodizing term, designating the two periods of less than half a century each that are commonly regarded as high points within the Greek and Roman classical civilizations (Periclean Athens, Augustan Rome). In the case of Athens, this period is sometimes extended by another half century or more into the age of Plato, Isocrates, Demosthenes, and Aristotle.
3. As a paradigmatic quality or feature or set of features of aesthetic, moral, or intellectual excellence or perfection, whether of style, content, or attitude, often modeled on phenomena from classical antiquity (normally, those of its classical periods [2]) and felt to exhibit qualities of measure, restraint, and order, in addition to clarity, simplicity, unity, balance, symmetry, harmony, and the like
4. Developments in other cultures and civilizations parallel to but often autonomous of those meanings listed above, for instance, *classical French literature* produced during the period of French classicism, which need not

[40] See also Hölscher 1993b.
[41] Cf. Langlotz 1960, 639: "Nonetheless . . . a classic style per se does not exist," etc.; cf. ibid., 641.
[42] Now expanded and developed in Settis 2004, which I discovered too late to make any use of in this Introduction.

imply a direct reference to Greek and Roman classical models, or *classical Chinese art*, which as an appellation may be no more than the extension of a set of analogies across cultures, or *classical Malaysian literature*, a category invented under British colonialism and aimed against Islamic "contamination" of the Malay culture that was assumed to have been indigenous[43]
5. As a contrast with *romantic* or *popular*, or *gothic* and *baroque*, especially in the realm of music, often drawing upon the classical aesthetic in (3) above, and identified with specific stylistic and thematic features or qualities[44]

While this list captures some of the different terrains in which *classical* has come to be applied, the kinds of meaning it describes are disparate, being partly theoretical and partly historical, or else partly descriptive and partly normative. There are no rules governing the uses of the term, and little agreement on its application either. The lines get crossed easily and the categories mingle freely. A case in point is category (3), which can be raided at will to invoke any form or appreciation of the classical. As a consequence, anatomies like these are as contestable and as much a matter of momentary convenience as are the individual elements they comprise. And because they presume a level of coherence to the applications in question, when it ought to be the very applicability of the terms that is in question in any given instance, lists of this kind are uncritical by their very nature.

The term *classicism* brings with it a related and derived set of difficulties. A typical anatomy of *classicism* will include the following meanings:

1. That which pertains generally to what is perceived to be classical (e.g., the classicism of the Parthenon)
2. A style that is based on what are felt to be classical models
3. A tradition perpetuating the authoritative norms of what is felt to be an original classical moment, whether by imitation, emulation, revival, adaptation, reference, or critical enshrinement. The term in this sense can be either approving, which is its majority meaning (as in the self-proclaimed classicism of seventeenth-century France or in the new classicisms of modernism and of postmodernism, in the latter case sometimes termed "Free-Style Classicism"),[45] or derogatory,

[43] For China, see Powers 1991, ch. 5 ("Classicism"), where the terms *classical* and *classicism* and the criteria (e.g., "simplicity and grandeur") are a conscious importation—but also where the analogies are less obviously relevant to Augustan Rome than to the Second Sophistic, unbeknownst to the author (see p. 158: "the anachronistic dress, affected mannerisms, and archaic speech of the literati," etc.), although the historical and cultural particulars are, to be sure, at another level incommensurable. For the Malaysian example, see Maier 1988.
[44] Pollitt 1972; *Art Journal*, Spring 1988; Greenhalgh 1990.
[45] Jencks 1987, esp. p. 151 on "the classical sensibility" of the new classicism: "Less than an ideology and more than a reigning style, it can be thought of as a sensitivity in conveying particular shades of feeling or attitudes to life"; and id. 1996, 38, on "Free-Style Classicism." The contemporary Seaside community in Florida was designed around a neoclassical aesthetic that was celebrated in a symposium called "Classical Visions" in February of 2001 (http://www.classicist.org/symposia_visions.html).

when it is used to emphasize derivativeness (as when *classicismo* was first introduced into Italian in the nineteenth century)[46]
4. "A way of perceiving the world and using the arts to persuade others to see it in a similar fashion," viz., "a state of mind and a 'world view'" that represents "classical" values of the sort listed above (simplicity, harmony, rationality, etc.), but which is frequently felt to take on a life of its own independent of any Greek and Roman inspirations, as in Italian Renaissance devotional art (e.g., Michelangelo's Sistine Chapel fresco) or in the program of the École des Beaux-Arts in nineteenth-century France. This attitude often assumes the dimensions of an ideology, no doubt owing to its programmatic reach; and at the very least it is a view with ideological implications[47]

In the first of these senses, *classicism* merely describes what is elsewhere evaluated as *classical*, but we cannot say where this evaluation takes place. I can speak of Sophocles' classicism without having to impute the intention of being classical to him. The use is an invitation to further querying. In the remaining senses, we are having to do with a conscious reflection on the past. Here, classicism is a retrospective phenomenon, which is one of its most common acceptations, although in the fourth case there is a tendency to detach classicism from its historical context and from particular values, and so too, presumably, to see classicism as standing free of any retrospective views. The problem is that this last separation is difficult to make in theory and in practice: the values of classicism in senses 1–3 constantly intrude upon descriptions of any such "universal" classicism (T. S. Eliot), which for the most part looks to be a mere hypostasis of the essence of Greco-Roman classicism, that is, of classicism in its classic form. The different senses of *classicism* are less easily disentangled than one might wish them to be.[48]

[46] See Wellek 1970, 67, who suggests that in French *classicisme* "was felt as an ugly neologism," and notes the remarkable fact that as of 1965 the dictionary of the Académie Française refused to acknowledge the term. Cf. also the famous opening salvo of Wölfflin's *Die klassische Kunst* (1st ed. 1898): "The word *classical* has a chilling quality for us. . . . 'Classical art' appears to us as the eternally dead, the eternally ancient, the fruit of academies, a product of doctrine, not of life," etc.
[47] Greenhalgh 1990, 8 and 11. In the extreme, one might feel entitled to conclude that "as a universal category rather than a specific historical occurrence, classicism means nothing more than an assertion of authority, of power under whatever form" (Zerner 1988, 36).
[48] See Greenhalgh 1990, 10: "We must also distinguish between *Classicism* and the *classical tradition*—the former being a state of mind that can exist without reference to any supporting traditions, the latter a conscious assimilation or re-working of characteristics imitated from earlier art and based ultimately on the perceived qualities of antique art." I doubt that a clean separation can be made (see ibid., 10–11), any more than Gelzer's "typological" (viz., "value-free," "purely formal and classificatory," i.e., "historical") definition of classicism can be detached from the "evaluative" sense of the term, which he stipulates as a separate entity (Gelzer 1979, 9–10; see Görler in Flashar 1979, 43, with Gelzer 1975; and Gadamer 1986, 290–95). Tatarkiewicz 1958 likewise runs into trouble when he seeks to rescue a core of atemporal classical values and properties from history. Nonetheless, these are plainly derived: classical Greek art he declares "perfectly" realized,

Each of the uses of the term *classical* or *classicism* enumerated above involves a problem of attribution, which inevitably brings time and history back into the picture of timeless value that both words summon up. One problem the words disguise is the uncertainty and imprecision of any retrospective glance. Is eighteenth-century neoclassicism (Gabriel's Petit Trianon or his Place de la Concorde) an allusion to antiquity or a sign of Louis XIV revivalism?[49] Are the classicizing elements of the Great Altar of Zeus at Pergamum quotations from the Parthenon or a Baroque reworking of that model?[50] Similar questions can be put in relation to the Pasquino group and other Hellenistic Baroque sculptural compositions, both of which contain prominent archaic and classical-period elements in their makeup. The choice is misleading: hybridity is inevitable, and inherently unstable (see Stewart, this volume). But attributions bring problems of a different kind as well. Given the relative tardiness of the terms *classical* and *classicism*, are we not obliged to award both the words and their corresponding ideas to an age that no longer felt itself to be classical but instead felt itself to be only postclassical? In other words, don't we have to admit that the postclassical era in some sense *invented* the classical age? If so, then to speak of the classical properties of classical objects or attitudes from, say, Periclean Athens is to speak of projections by a later age. But also, if we allow that a postclassical era invented its ancestry in what came to be labeled a "classical" age, must we not also acknowledge that that later era simultaneously invented itself *as* postclassical?[51] The historical intricacies of this kind of projection and invention are mind-boggling, not to say hard to establish, let alone to date. The problem is not that this kind of double invention is inconceivable in the end, but only that it is conceivable as a strategy the usefulness of which never ends. As a marker of historical realities with determinable boundaries, it is unreliable.[52]

When were the classical era and its significant properties first recognized? Late-fifth-century Athens, Hellenistic Alexandria, Hellenistic Athens, Augustan

and Aristotle is "*the* classical philosopher" (pp. 21, 22). Here, classical values are no longer simply "real" (cf. p. 15): they have become *surreal*.

[49] Honour 1968, 25.

[50] Stewart 1993a, 166–72.

[51] See Gelzer 1975, 166–70, on the logical and chronological primacy of classicism vis-à-vis any prior classical age, which (he claims) is merely a back-projection of the former.

[52] Compare the creation on the spot of archaic predecessors, entailing that one is in some sense modern, as Ennius did to Livius Andronicus and Naevius, and as Virgil, Horace, and Seneca did to Ennius (Hinds 1998, 55–74). But other readings and other strategies of invention are possible too. See Habinek's reading of the invention of literary Latin: "The very artificiality of the new language [of the generation of Ennius and others] guaranteed its inaccessibility and its timelessness—so much so that even today Terence is regarded as the quintessence of *Latinitas*" (Habinek 1998, 44; cf. ibid., 48, on Cato). Virgil, too, was given to archaism, which is to say, to inventing himself, not as classical, but as *antique* (Quint. *Inst.* 8.3.24–28; cf. 1.6.39–41; Gell. *NA* 12.2.10; Bettini 1984).

Rome, Second Sophistic Rome and Greece, and neoclassical Europe are frequent contenders, but these remain generalities and, their obvious incompatibility aside (they cannot all give the correct answer—or they can, in which case none of the answers is "correct" in the ordinary sense of the term), addressing the problem in this way merely defers the question of when the exact moment of invention or discovery arrived.[53] This kind of solution likewise suggests a power of agency that is, to say the least, incredible. And the idea of an isolated moment when classicism in the retrospective sense came about—say, at four o'clock on a sunny afternoon in Hellenistic Alexandria—seems *prima facie* unlikely. If it can be shown that something resembling the thought of classicism and the classical can have occurred in antiquity itself, it is far more likely that classicism in its "classic" form will prove to have been a gradual phenomenon that emerged quietly over several generations and even more probably over several centuries, but with tentative anticipations originating already in the classical era itself, if not earlier. On this view one can point, as some have done, to Aristophanes' reflections on tragedy (especially in his play *Frogs*, from 405 B.C.E.), and then in the next century to Lycurgus's legislation concerning revivals of the three "classic" tragedians.[54] As classicism evolved, so did its functions. But the focus and structure of classicism remained fixed, more or less along lines that are familiar to us today, with a privileging of Athenian cultural achievements of the fifth and fourth centuries and of some of their more impressive predecessors and, eventually, as the centuries wore on in the *translatio imperii* of cultural hegemony, with a privileging of analogous equivalents in the Roman sphere. But if that is the case, then what is of interest is not the final result of this process but the process itself and its adaptive logic, which is to say the long and complex journey of a set of concepts and assumptions on the road to their being named.

Which is not to say that this conceptual journey has a well-defined terminus. How do we know once we have arrived at the destination? The problem is that there may be no clear destination. At the end of the road we find the terms *classical* and *classicism* and a series of attempts to claim and to purify their meaning. But the attempts are never definitive—the central concepts and their referents are at no point uniformly agreed upon. Surely it is not the case that with Fronto or Gellius, once the term *classicus* is established for the first time, there is any more certainty about the meaning or definition of what the classical is. If there is a moral to draw here, it is perhaps this: inquiring into the meaning of *classical* needn't involve the search for a definition. At its best, the question need only be "a prompt to explore the many ways" in which an object

[53] The problem is especially acute if the concepts of the classical and classicism are specifically "modern," viz., post-antique (Gelzer 1975, 154–55, 161). If so, then in what sense can they also be ancient (as Gelzer allows, e.g., pp. 167–70)?

[54] See Schadewaldt 1931, 25: "Aristophanes, selber ein Klassiker, in dem das Wesen des Klassischen zuerst seiner selbst bewußt geworden ist. . . ."; Körte 1934, 9–10.

or phenomenon comes to be labeled "classical," and possibly loses its label, in the course of its history.[55] The meaning of the term is ultimately irrelevant in itself. What matters is less its dictionary meanings than how those meanings were made and remade, how they came to be conceived, institutionalized, and in various ways challenged. To think of the classical in this way is not to posit something that is immutably classical, but rather to conduct a cultural history of the classical as something that is posited in this way. It is to *historicize* classicism, or rather to historicize the classicizing imagination, and to explore how whatever is or once was deemed classical "engages through time with its tradition and with its changing environment."[56] It is fair to say that the meanings of the terms built on the radical *classical* are undergoing change today, at a time when the very relevance of the "classic," "the classical," and antiquity in its Greek and Roman forms is coming under fire in an increasingly diverse, globally expanding, and multicultural world.[57]

The present volume may well be a symptom of this unease with inherited concepts. However, the primary motivation for *Classical Pasts* is to discuss the largely buried unease that the past itself has experienced in its own dealings with things classical. The only satisfactory history of the classical and of classicism would have to be a history of this discomfort. Most students of antiquity who deploy the terms *classical* and *classicism* today are scarcely aware of this troubled past, while those few who actually investigate the terms tend to assume an unwarranted coherence in the concepts that underlie them.

THE STATE OF THE QUESTION

When did antiquity discover itself? The very idea of the classical world is a cultural artifact, not a historically given entity, although to say this is not to say all that much, for just when was the artifact "made"?[58] As it happens, the inquiry into "classical pasts" today is timely. Historicism, guided by the nineteenth-century imperative to know the past *wie es eigentlich gewesen*, has gradually turned in on itself in the field of classics. The guiding problem is no longer simply to know what the past is or was, but also to know what it is or was to have a past. More and more, scholars are turning to the way antiquity conceived its own history. And more and more, it is becoming apparent that our sense of the past is shaped by *its* sense of its own past. Witness the recent explosion of

[55] Beard and Henderson, 2001, 74.
[56] Beard and Henderson, 2001, 74. Cf. Tatarkiewicz 1958, 13: "The problem ... is not one of criticism and aesthetics, but of history, social psychology, and sociology"—a position he all but recants a few pages later: "but history leads to an idea, which is the general idea of aesthetics," which gives credence to the "natural" affinity of man to the idea of the classical (16).
[57] The fiery debates surrounding Martin Bernal's *Black Athena* have been one of the rare points of contact between contemporary and classical studies. See Bernal 2001.
[58] See Vercellone 1988, for one suggestion.

studies on antiquarianism, nostalgia, pilgrimage and tourism, cults and revivals, of new forms of palimpsestic histories, not to mention the booming interest in the history of (the history of) classical studies.[59] No longer unidimensional, linear, and progressive, history appears like a cascade of Chinese boxes, each moment containing its own tightly packed historical pasts within itself. Classical studies and the history of those studies are increasingly becoming inseparable. The logical next step is to inquire into the history of the classical.

Art historians, attuned to the aesthetics of Winckelmann, have been the first and last to observe the effects of classicism in antiquity.[60] They are followed, at some remove, by historians of literature, criticism, and philology, who have shown less of an investment in the meanings of the terms used as periodizing labels but still assume the general validity of the concepts, which are rarely called into question. (Students of history, religion, philosophy, science, and so-called ancillary fields, such as papyrology, epigraphy, and numismatics, are less susceptible to problems of these labeling concepts, possibly due to the influence of the more positivist traditions from which they have emerged.) Two significant exceptions are Egidius Schmalzriedt's *Inhumane Klassik: Vorlesung wider ein Bildungsklischée* (1971), a short essay that takes a cynical view of the relevance of the term *classical* to antiquity, with a long appendix of revealing quotations from mainly German literature, philosophy, and classical scholarship, and Tonio Hölscher's *Die unheimliche Klassik der Griechen* (1989), which contests the value of the term for the age of Pericles and seeks to replace it with a more politically nuanced and at times rather Nietzschean account of the period.[61] The present volume features several further exceptions, five of which particularly stand out for their bold heterodoxy: the essays by Alcock and Cherry, D'Angour, Stewart, Hölscher, and Elsner, each of which seeks in its own way to challenge the limits of the current understandings of *classicism* and *the classical*, and to stretch them in new and productive directions. This dissonance, in relation to the field and within this volume, is both provocative and healthy.

Outside of art history, notable exceptions include research on Roman contexts, such as the collection of essays, *Le classicisme à Rome* (Flashar 1979), in addition to a series of essays by Mario Citroni,[62] and also some of the recent

[59] E.g., Alcock et al. 2001, Boardman 2002, Alcock 2002, and on the modern side Barkan 1999 and Schnapp 1996.

[60] Recent accounts of the classical include Pollitt 1972, covering the High Classical period; Stewart, 1979, esp. chs. 2 ("The Magnet of Classicism") and 6 ("Time and Style"), treating the Hellenistic diffusion of classical ideals, and id. 1997, revisiting the High Classical period; half of the essays in Pöhlmann and Gauer 1994; Zanker 1974 and id. 1988a; and Elsner 1998, on the transformation of classical models of art in later antiquity.

[61] An exhibition from 2002 in Berlin, *Griechische Klassik—Idee oder Wirklichkeit* ("Greek Classicism—Idea or Reality"), was likewise critically aimed. See the catalogue volume ([Anon.], ed. 2002). See further Wallace-Hadrill 1989, taking critical exception to the application of *classicism* to Roman art in Zanker 1988a.

[62] Citroni 1998, id. 2003c.

work on the Second Sophistic.⁶³ This last is perhaps only to be expected, given the heightened presence of classicism in the imperial era, an age of sustained tension between the Greek and Roman worlds. Indeed, as research on the Second Sophistic intensifies, a convergence of visual and cultural analysis is inevitable and questions about classicism are bound to come increasingly to the fore. Moving beyond some of the reflex assumptions of the earlier models and perceptions will be of paramount importance in future scholarship. Is the category of the classical a product of later classicisms or does it preexist them? The new scholarship on Rome and especially on Greece under Rome, forcing this very kind of question, is already beginning to put renewed pressure on the meaning of *classical*.⁶⁴

And yet, while ancient art history is attuned to the problem of the classical, at another level it tends to be at the mercy of this evaluative label. Privileged media, works, styles, and features that historically have been labeled "classical" all too quickly become representative of an entire era and its alleged *mentalité*.⁶⁵ A conceptual tyranny results. Analyses such as these tend to leave unqueried the historicity and the theoretical underpinnings of judgments about the classical aesthetic that they simultaneously deepen and usefully nuance in its various manifestations. In particular, attempts to restrict the traffic of terms like *classical* in later periods from the Hellenistic age on suffer from a willingness to tolerate the term's unrestricted applicability in the earlier periods.⁶⁶ In what way, one might wish to ask, does the much-touted naturalism of fifth-century sculpture and painting, or the alleged balance between stillness and motion in the same art forms, apply to architecture of the same period?⁶⁷ Or consider the radical experimentations within the various art forms, not least of all in Attic red-figure vase-painting, which is susceptible of a disruptive, ironic, and playful reading, one that subverts the narrative progression of a culture on the road to a rational construction of space and depiction, as Richard Neer has recently shown.⁶⁸ That a similar, radical experimentation took place in the more official and public art forms of monumental sculpture and architecture is

⁶³ Swain 1996, Schmitz 1997, Connolly 2001, and Whitmarsh 2001.

⁶⁴ E.g., Alcock 2002.

⁶⁵ Brown 1973, 57, is typical: "Obviously, [fourth-century art] taps a mentality which is quite different from the dominant one, and this kind of mentality also continued later, in the Hellenistic period and afterward." For a general critique of such modeling, see Lloyd 1990.

⁶⁶ Cf. Palagia 1997, 82, on Attic sculpture after the sack of Athens by Sulla in 86 B.C.E.: "Whereas free-standing statuary was conceived in a fourth-century manner, the Pheidian tradition was maintained in relief copies." From the contemporary parallel world of ceramics, things have a different look altogether, and even then there are differences between, say, the practices of lamp-makers and of potters (Rotroff 1997). Similar patterns of unevenness can be found in the "Classical" and neoclassical periods as well. On the latter, see below at n. 170.

⁶⁷ Sensitive to many of the fallacies of classification, Andreae 1994a, 304–5, nevertheless settles on this last criterion—the balance between stillness and motion—as the defining feature of classical art in general and plumps for a progressivist picture of Greek art.

⁶⁸ Neer 2002.

not unthinkable, although this awaits demonstration.[69] Are such tendencies to be counted as classical or as counterclassical? The question may be badly formed, and the alternatives too restricting.

An overly narrow and potentially partisan rendering of the climate of life in fifth-century Athens runs the risk of distortion, and of smothering the rich variety and sheer polyphony of values that are being worked out in that culture, and the same is true for Augustan Rome as well—and for any cultural moment in ancient Greece and Rome, for that matter. At the very least, if one wants to cling to the notion that these cultures are classical, one should acknowledge either that what is classical is the product of discrepant tensions that run deeply through a culture, or else that the classical is whatever is left over once those tensions have been artificially removed from view. This is a point that will be driven home repeatedly in all of the essays that follow.

Cultures are never harmonious wholes, and any view that represents them in this way is, quite simply, reductive and misleading. It is not just that norms are the result of clashes and conflicts that belie the equilibrium of what we call the norm. It is that ideological norms typically are honored only in the breach but not in actuality: they may have no essential positivity.[70] Whether classicism and the classical are one such norm and source of meaning in the ancient world, and if so how their mechanisms actually functioned in practice, are matters that still need to be shown, not assumed. For the same reason, it is doubtful that the point of reference for something "classical" can ever be isolated except in a context of contestation and of plural (and never fully concordant) identifications, which is to say that *the label "classical" is never fully justified*. The likelier outcome is that what we will discover in antiquity is not a single form of classicism, but rather a series of *classicisms* in the plural, imperfectly matching each other and the modern conceptions as well.

A comprehensive account of the problem of ancient classicism, set within the broadest available understanding of Greco-Roman culture, is still lacking. The present volume offers a modest start in this direction. But in order to get off the ground, any such study must look closely at the logic, or illogic, of the classical.

The Logic and Illogic of the "Classical"

There Are No Classical Properties

Do classical properties exist? As a test case of the proposition that they do not, let us take a well-known instance of an uncertainty from the so-called High Classical period. The question of whether Euripides belongs in the same

[69] See, however, Osborne 1987 and Stewart 1997, both of whom come close to pressing for such an account.
[70] Cf. Cohen 1991, id. 1995, and Hölscher 1998, 153–54.

league as Aeschylus and Sophocles has been debated at least since Aristophanes, but it surfaced with renewed vigor in the nineteenth century, in the socalled *damnatio memoriae* that was inaugurated with Friedrich Schlegel in 1794, with knock-on effects that can still be felt. Euripides' tarnished status lingered on into the next century, as is evident from Werner Jaeger's Naumburg conference from 1930, where Euripides was considered barely worthy of mention—a silence that was overdetermined, to be sure, by the unresolved debate between Nietzsche and Wilamowitz.[71] Euripides' classicism was hard to square with the going paradigms of the classical sensibility: he was too intellectual, too calculating and rational, but also too common and plebeian, too violent and irrational, to be reckoned a perfect classic. The difficulty of placing Euripides in some kind of neat succession within Greek tragedy today continues to reflect an earlier generation's unease with Euripides' classicism.[72]

One argument that was historically used to exclude Euripides from the most exclusive heights of the classical canon is that the playwright arrived too late on the scene to be considered fully classical: he was already a symptom of the classical period's inexorable decline. The problems with this kind of winnowing are almost transparent. One immediate consequence is that the range of purely classical Greek authors quickly gets narrowed to a field of one—normally, Sophocles, as we saw, or rather one defining aspect of him, "the eternally cheerful amiability of Sophocles, in harmony with himself and the whole world," as Wilamowitz put it in his tract against Nietzsche, perpetuating a myth from the ancient biographical tradition (*Vit. Soph.* 7 and 20).[73]

Euripides may be a debatable quantity, but what about Homer? Homer always bore an uncomfortable relation to modern classicism, and his disputed place in the list of classical authors at the Naumburg conference is no exaggeration by Körte. In some ways prototypically classical,[74] in others Homer could be felt to be both more and less classical than the classical authors of the fifth century—more authentically and more pristinely classical, if also representing a simpler, more naïve, less developed form of classicism.[75] Origins are plainly troublesome things. If Homer could not fit the classical paradigm, one has to wonder what could. That was precisely the *reductio ad absurdum* revealed by Körte in his brief report on the discussions at Naumburg. And it was a problem noticed during the first generation of classicizers in modern Germany, for example, by the satirist Jean Paul in his *Vorschule der Ästhetik*

[71] Schlegel 1979, 60–63; Körte 1934, 13–14 with n. 2, and compare Schadewaldt 1931, 25.

[72] E.g., Dodds 1951 and Arrowsmith 1963. For a good survey of classical scholarship around this issue, see Michelini 1987.

[73] Wilamowitz in Gründer 1969, 51.

[74] Cf. Strab. 8.3.30: Phidias derived the inspiration for his majestic Zeus at Olympus from Homer's Zeus of *Il.* 1.527ff.

[75] Humboldt 1960–81, 2:22; Jebb 1905, 38: "The Homeric Greek exhibits all the essential characteristics and aptitudes which distinguish his descendant in the historical [i.e., classical] age."

from 1804: "Seeing how being classical resembles those card games in which whoever loses no hand wins, then not a single writer judged to be a classic by the critics is classical, Sophocles included."[76]

Suppose, however, that we do come up with an undisputed candidate for the classical ideal. Here the troubles only begin. Once we try to pin down what is specifically classical about, say, an author like Sophocles, we drift off again into the vagaries of harmony, order, symmetry, rationality, balance, and other features that for the most part have been borrowed from the discourse of the plastic arts but which are mere metaphors when applied to texts.[77] Beyond that, one enters into the metaphysics, or depths, of defining the *je ne sais quoi* of the classical, and we already know where this leads. But just *where* is this element to be found? Attempts to locate it in this or that verse can only end in disaster: such location is by definition illicit, for the trait in question is spiritual and not material. One might perhaps think that concrete classical objects fare better, but do they?

Consider the debates over the Parthenon, not the pediments, friezes, and metopes that were lifted off its face now, but the structure that was left standing in Athens. Today the Parthenon is frequently said to exhibit the purest traits of classicality. And yet attempts to explain just where these virtues lie not only conflict with one another but also trail off into vagueness once again. Here the problem lies in translating putative physical properties back into language. What we would call classical traits, but the Greeks and Romans might have termed order, harmony, rationality, and the rest, are again mere metaphors. But metaphors for what? At issue is not only the question, Which properties of the object are classical? but also the question, Where are they found? The answer is not in the object, or at least not unequivocally so. Close examination of the physical structure of the Parthenon reveals "subtle and intentional variations from mathematical regularity which run throughout [it]."[78] It is generally thought that these irregularities are somehow responsible for making the Parthenon the quintessential classical object it is so commonly celebrated to be. But how?

The three most common answers to have been advanced, from antiquity to the present, are the compensation theory, the exaggeration theory, and the tension theory, each taking into account different mathematical properties and their possible aesthetic effects. The first, found already in antiquity, is that variations in regularity exist to compensate for the optical illusions of the architectural form: Greek architects wished to ensure that buildings looked "'regular' and

[76] Paul 1959–63, 5:354.

[77] See Schadewaldt in Jaeger 1931, 23, on "the power of the surface," comparing Sophocles and the Parthenon. He goes on to discuss Sophocles' classical virtues in terms of formal "harmony" and "visible order."

[78] Pollitt 1972, 74. The quotes that follow are from Pollitt's account, which remains the best, because it gives the clearest articulation of the issues and the problem.

'correct'—e.g. horizontals should look horizontal, verticals vertical, columns should appear to be the same size," and so "the function of the refinements was to make the appearance of the temple fit their mental conception of it." The second possibility (exaggeration) has been understood "to make the temple look quite different from what it actually was." In this case, the object had "to amplify normal optical distortion so that the temple appeared to be more immense than it actually was"; horizontals, for example, will impressively appear to "bow upward," thanks to *entasis* or the swelling of lines and proportions. The third interpretation is that the refinements are "intentional deviations from 'regularity' for the purpose of creating a tension in the mind of the viewer between what he expects to see and what he actually does see." Expecting to find geometrical equivalences and norms, what the eye sees is a varied, irregular display. A struggle ensues, "and from this struggle arises a tension and fascination which makes the structure seem vibrant, alive, and continually interesting." Which of these interpretations is right?

The problem is that none of these proposals appears to answer the problem definitively, and agreement has never been reached.[79] So uncertain is the consensus, one has to suspect not merely a difference of opinion here but an underlying ignorance about the nature of the problem, let alone its solution. One would like to know why we cannot verify *which* experience of the Parthenon is the one that is *actually had*. It is not even clear why they are not all mutually exclusive, as one might think they should be. For as some accounts paint things, the experiences are all equally available, equally possible, and equally unverifiable. But perhaps this way of putting the problem is unfair: in question, ultimately, is not the experience we have but that of "the age" of classical Athens. But how verifiable is that? The assumption of possible experiences, for all its would-be historicism, is an extrapolation from philosophical and other texts. It is not an extrapolation from the structure of the Parthenon, and it cannot be: otherwise, there would be no question to solve, and we would be faced with the additional problem of accounting for the divergent explanations once the problem seemed to have been solved. If we seem to be going in circles, we are. But equally troubling is the joint implication of these hypotheses, namely that in question is not a classical property of an object per se, but an appearance of being classical. Is the experience of the Parthenon an experience of a reality or of a reality's presentation to the mind? More emphatically, is classicism a *trompe l'oeil*? The problem, again, is not only *what* are the classical properties of the monument, but also just *where* are they supposed to be found? There is

[79] The most recent discussion (Hurwit 2004, 121–22) repeats the dilemma by resorting to an unstable combination of comfortable relativism (or agnosticism) and unflinching objectivism (and classicism). "The effect of the refinements is very much in the eye of the beholder: the experience is subjective." Yet, "*however we read them*, the refinements give the Parthenon an extraordinarily 'plastic' or sculptural quality," and so the Parthenon is very much "a sculptor's temple" that obeys a Phidian aesthetic (italics added).

a disturbing vagueness, if not incoherence, to this account of a classical object. But this lack of focus is in fact a *characteristic* of classicality.[80]

Our aesthetic vocabulary, concepts, and responses may simply be too impoverished to capture the distinctions that are being sought after. The terms of our description are, to an extent we too rarely acknowledge, vague and unhelpful, merely blunt instruments for gesturing at a phenomenon we barely understand. Just as it is unclear what is classical about Classical art, it would be a fair question to ask what is archaic about Archaic art.[81] It is doubtful the answers to that will be any clearer than the conflicting views of the classical. What is classical does not define itself; "it" exists only in the form of an incomplete contrast. There is an inherent *inarticulateness* to the problem of the "classical" at its origins, which never rests on anything other than its own self-evidence. Such is the burden of expressing, and of analyzing, "this spiritual *more* in meaning," which the classical ideal tends to radiate.[82] The point goes to the defining inarticulateness of the classical ideal in *any* form whatsoever, linguistic or other. This incoherence has played itself out historically.

The Historical Incoherence of Classicism

The contemporary hypostasized (and still vague) meanings of *classical* and *classicism* are signs of a messy and troublesome past. Just how far back that past extends is open to question, but below we shall see that there are good reasons to trace some of these troubles back into early Greco-Roman antiquity. The immediate source of the contemporary dilemmas lies in modern classicism, which is to say the form of classicism that prevailed in Europe from the eighteenth century onward. If it is true that modern classicism often lays stress on the conditions of perfection and harmony, on visual beauty, and on the childlike naïveté of early Greece, in point of fact violence, passion, and irrationality are not ignored or suppressed in classicism even on this picture. Winckelmann's aesthetics, which could ascribe tranquility and quiet grandeur to Laocoön while serenely acknowledging him to be "the picture of raw pain"[83] or classic, "sublime" wholesomeness to the severely mutilated Belvedere Torso,[84] inaugurated classicism as a delicate form of disavowed consciousness. Indeed, in many ways, classicism was a *self-willed illusion*.

[80] Cf. Gelzer 1975, 157–58, and Schmidt in Jaeger 1931, 90.

[81] Cycladic and geometric forms are a good counterexample. The fact that naturalism was not (yet) practiced does not mean either that it was unavailable as an idea or that it had not yet been "achieved": preclassical art enjoyed its own aesthetics. To assume the opposite is a distortion and a bias. See Hurwit 1985 for suggestive remarks on the self-awareness of archaic art.

[82] Himmelmann 1985, 41; Himmelmann 1990, 26; cf. Hölscher 1993b, 525. A Lacanian critique of this surplus value would be apt (see Žižek 1989).

[83] Winckelmann 1972, 167; cf. ibid., 324.

[84] Winckelmann 1972, 346. For a critique of this kind of spectatorship from the perspective of disability studies, see Davis 1997.

This was noticed by Anselm Feuerbach in *Der vaticanische Apollo* of 1833 (2nd ed. 1855). His book, once influential but now all but forgotten, is a meditation on the illusions of classicism in the realm of sculpture, and in particular on the illusions of the classical aesthetic. The Apollo from the Vatican idealized by Winckelmann, Feuerbach writes, is no better than "an empty figment of the imagination," *ein leeres Phantasiegebild*—basically, a fantasy.[85] "The beguiling prospect of an image is held up to our imagination where the object cannot be given in corporeal actuality: in place of a palpable reality there is a play of light and shadow, a deception of the eye, a painterly appearance and illusion (*Schein*)."[86]

Needless to say, the object in question is not the statue as a physical thing (which Feuerbach insisted was Neronian in manufacture, but classicizing in spirit), but whatever the object represents in all of its quintessential classicality, glimpsed in an instant of visual illusion.[87] It is that which is made to *appear*—in Nietzsche's terminology, which is also Feuerbach's, in the form of an Apollonian "dream."[88] To look at a classical statue is a bit like closing one's eyes. Feuerbach's book is about the agonies of this location. Classicism's construction of the classical ideal is shaped in response to the very impossibility of discovering it in the works that are beheld. Incidentally, for what it is worth, Feuerbach's admissions resemble no ancient theory more than that of Lysippus, the great sculptor from the end of the fourth century B.C.E., at least on one construction of that theory. Lysippus seems to have recognized that classical effects are produced by their illusion; they have their place in the mind of the beholder, in her *phantasia*, not in the object itself: he is said to have held that the aim of sculpture is to present an object not as it really is, but as it *appears* to be.[89] Whether this phenomenalism, which might also be called illusionistic, reflects a new rhetorical view of art or not is unclear. The evidence is too sparse to permit more than the slimmest of speculations.[90] But the Lysippan aesthetic does serve to remind us of the centrality of *deception* to ancient views and practices of art, a fact that modern views of classicism are all too keen to overlook.[91]

Secondly, classicism in its modern form never went unchallenged. It was accompanied from the very start by resistances to its readings of antiquity and

[85] Feuerbach 1855, 120.
[86] Feuerbach 1855, 168–72.
[87] Feuerbach 1855, 10.
[88] In Feuerbach's lapidary formulation: "Tranquility"—the appearance of rest and quiet in statues—"is the happy truth of the deceptive dream" ("Ruhe ist die glückliche Wahrheit des täuschenden Traumes") (Feuerbach 1855, 261; cf. 254–57).
[89] Plin. *HN* 34.65.
[90] Schweitzer 1932, Protzmann 1977; Stewart 1990, 1:186 (" 'phenomenal' idealism"). One might also compare Aristoxenus's own version of phenomenalist aesthetics (*Harm*. 8.23, 9.23); but the tradition goes back to the sophists (see next note).
[91] Gorg. fr. 11 D.-K.; Pl. *Soph.*; [Anon.] *Dialex.* 3.10–12. Cf. Vickers 1985, 122; Vickers and Gill 1996, 84–85.

to charges of willful blindness, a fact that its exponents were fully conscious of, not least because they were usually the first source of this resistance. Classicism is thus a *knowing* illusion: it is constructed on the disavowal of this self-knowledge, in an attitude that runs, "I know very well that the classical is a falsification, an illusion, the misapplication of an ideal, but I will act as if I believed in it just the same."[92] This attitude was perhaps inevitable. Resistances to the label *classical*, to its viability and even its coherence, were palpable from the very start of the modern classicizing traditions. From the *Querelle des Anciens et Modernes*, which racked early modern France over the meaning and privilege of classicism, and which rested on a tradition that reached back to the early Middle Ages (when *antiqui* often did duty for *classical*, though neither idea went unchallenged),[93] to the wounded sensibilities of Bentley and Addison in the face of the unclassical epic poetry of Milton, to Voltaire and other Enlightenment figures who could militate powerfully against classicism,[94] to the classical scholar F. A. Wolf, who explicitly weighed and then rejected the word *classical* as a historical label, but not as an inspirational concept, when he was groping for a term by which to name a science—classical studies—that as yet had no name (he settled for *Altertumswissenschaft*),[95] classicism was continually contested. Classicism has always had a troubled past, even when it was the values of classicism, rather than the lexical term, that were being thrown into question.

A third complicating factor in the modern worship of the classical is its elevation of the idea of the classical into an *ideal*. This tendency puts all kinds of impossible pressures on classicism, which responds in different forms. Totalization, organicism, and vitalism are just some of the ways in which moderns have sought to smooth over the intractabilities of the concept of the classical. Translated into history and into classical studies, this means that the idealism of the Greeks is not merely found, as an ideal to emulate, but invented, as ideally unreachable.[96] Against this background, the wished-for holism of the classical ideal is more than a little suspect. And, in fact, there has to be something wrong with any view of antiquity that can hold the following, which comes from one of Wilhelm von Humboldt's early writings:

[92] Mannoni 1969.
[93] Haskins 1927; Blunt 1971.
[94] Johnson 1970, 123–36.
[95] In his *Darstellung der Alterthums-Wissenschaft* (1807): "The label *classical learning* [Wolf reproduces the English term here] which is common in England, is too limited in another way: in our field we deal with many writers and branches of knowledge that no one would want to call *classical* (*classisch*) in the old sense of the word" (Wolf 1869, 2:814–15 n.). Cf. ibid., 817–19 and 892 on the exclusive and totalizing definition of Greco-Roman civilization, a judgment that Wolf knows to be sanctioned in part because it was formerly cast by this civilization on itself. Further, Wolf 1831–35, 35, on the classical traits of this culture.
[96] Humboldt 1960–81, 2:29: "The road from the finite to the infinite is [itself] always only ideal (*idealisch*)," and therefore infinite.

More of a sensuous than an intellectual nature, the Greek loves only that which fits together effortlessly, and the idea of infinite organic parts that contain within themselves further organic parts, all of which easily join one to another, and of a whole that easily dissolves into such parts, is extremely fruitful for the description and explanation of what is characteristically Greek.[97]

How such a conception could be descriptive of anything, let alone of Greek antiquity, is scarcely apparent. The abyssal image, thankfully, does not recur, even if the vague organicism behind it occasionally does. The anomaly, however, is but the most extreme symptom of a project that superimposes its ideals, organized by a Romantic vitalism and a corresponding metaphysics, upon the ever supple and forgiving mythology that is classical antiquity.

Classicism in Antiquity

Questioning the truth of classicism is by no means a new gesture, although trying to understand its historically contingent nature perhaps is. When do the claims of classicism begin? The assumption, or rather the hypothesis, that the contributors to this collection will be testing is that there was indeed a notion of the classical and of classicism at work in antiquity, existing not as a unified phenomenon (and with no clear name attached to it) but only as a set of attempts to retrieve, reproduce, and so too to produce a hegemonic cultural signature that is for the most part recognizable today under our modern rubric of *classical.* Modern classicism, of the sort forged in the antiquarian Renaissance and later institutionalized in eighteenth- and nineteenth-century Europe, however anachronistic it may be, *is* responding to *something*. Only, that something may turn out to be less the eternal truth of the claims of classicism (the evidence of classical features or styles or works) than simply the historical fact of those claims, or rather their corresponding attitudes, in the predecessor phenomena that we continue to conjure up with the term *classical antiquity*.

Inherited Incoherence

What follows is a preliminary sketch of how one might go about tracing the emergence of the concepts of classicism and the classical in antiquity. What we have begun to find is that modernity inherited not only the *concept* of classicality from Greco-Roman antiquity, but also its fundamental *incoherence*. One of the basic ingredients of this incoherence is the fact that classicism cannot be traced to some originary object or moment, as we have seen. Classicism displays a logic that is less retrospective than it is consistently *regressive*: it has no way of halting its backward-regarding search for a classic original. Homer is a

[97] Humboldt 1960–81, 2:32.

case in point: the archetypal classic, he ruins the paradigm, coming as he does either too early or, paradoxically, too late in the sequence to supply a classical original. (Homer's own sense of tardiness in a tradition of established "classics" is well brought out by D'Angour in the present volume.) But there are other peculiarities to the logic of the classical that a return to antiquity can help to foreground. That is, in place of anatomies and definitions of concepts, what we need is an anatomy of the *procedures* by which the appreciation of what is classical comes to be *generated*. And many of these latter are more visible in Greek and Roman antiquity than they are in the mainly backward-gazing logic of modern classicism, in large part because of the very absence of a name for classical in Greek or Latin. Instead, our attention has to turn to an array of practices and behaviors that, as it happens, will prove to be definitive of later practices of classicism, especially in their modern forms.

Nietzsche's critique of the methodological complexities implied by the mere naming of the classical is a good starting point for a critical and independent reevaluation of the problem today. A note from *Wir Philologen* (1875) reads: "One cannot understand our modern world unless one recognizes the immense influence that the purely fantastic has had on it. . . . One imitates something that is purely chimerical, and chases after a wonderland that never existed." The problem, on Nietzsche's construction of it, is to find an instance of antiquity that does not exhibit the same structure, if not the same sense, of transferential loss. Not only is the chimerical appearance of antiquity itself a myth that was inherited from the Alexandrians and then from the next surge of Greek cultural belatedness, the so-called Second Sophistic movement of the Roman Imperial period (at times figured in terms of a never-ending free fall from poetry into prose; see Whitmarsh, this volume). Looking backward also seems to be a constitutive element of Greek culture from the age of Homer on: "The same impulse [to veneration] runs through classical antiquity: the way in which the Homeric heroes were copied, the entire traffic with myth has something of this [impulse]. Gradually, the whole of ancient Greece was made into an object worthy of Don Quixote."[98]

There is more than a good bit of truth in this little parable of classicism, which remains tellingly vague. It is pointless to look for a point of origin in this notion of a past within the past: the phenomenon described by Nietzsche conceivably typifies the whole of (any given) later antiquity's attitude to its own past(s). In one of its predominant forms, this attitude recalls or anticipates what today goes by the name of classicism. But veneration of the past in all its forms tended to be internally contaminating, a hodgepodge of practices. Thus, ancestral worship could follow classicizing patterns or earlier forms of cultural remembrance, while various modalities, from nostalgia to strategic identification with the past to some combination of the two, could operate on or across all of these practices, whether in the name of local or Panhellenic identity,

[98] Nietzsche 1988, 8:121.

accommodation or resistance to Rome, or whether motivated by political and economic self-interest, opportunism, elitism, and so on.[99] Thus, while Plutarch preaches the use of classical Greece "as a model of grace under submission," Dio Chrysostom makes a more resistant use of the same paradigms,[100] and Dionysius of Halicarnassus finds a middle ground of pride or contorted disavowal. Classicism is by no means *the* dominant pattern of remembrance in Greco-Roman antiquity, even if it is so for us today. One need only recall that the ancient world knew a kind of multiculturalism of its own, which sat badly alongside any classicizing bias, and which at the very least gave rise to tensions in any attempt to assert classical ideals.

Even so, classicism, the perpetuation of classical values, is a clearly marked element of Greek culture in the time after Alexander, particularly under Rome, and to a large extent this is also true of Greek Alexandria under the Ptolemies, at least if one looks at the official activities of the Museum, however Egyptianizing the Alexandrian scholar-poets may have been in their poetic practices.[101] Hellenocentrism, and indeed Athenocentrism, with a strong bias for the fifth and fourth centuries, are an undeniable part of Greek culture from even before the time of the Library in Alexandria to the end of the Second Sophistic.[102] Thus a straight line connects the epitaph of Euripides, of unknown date (though ascribed to Thucydides), which proclaims Euripides a denizen of "the Hellas of Hellas," i.e., Athens, to Aristides' Panathenaic Oration (ca. 170 C.E.), which places the Acropolis at the geographical and spiritual center of Athens and at the center of all of Greece, which in turn lies "at the center of the whole earth."[103]

The methods of classifying culture developed at the end of the fourth century B.C.E., thanks largely to the energies of Aristotle's school, helped pave the way for a formalized and institutionalized classicism.[104] The Library, a powerful engine of the tradition, was organized around a classicizing palette that

[99] Woolf 1994, Cajani and Lanza 2001, Boardman 2002, Alcock 2002, and Momigliano 1990, 54–79, an important predecessor.

[100] Connolly 2001, 361 and 365.

[101] Pfeiffer 1968, 3, for the former; Koenen 1993, Selden 1998, and Stephens 2003, for the latter. See esp. Stephens 2003, 249–57, on the productive tension in these two faces of Alexandrian erudition. Macedonian politics also played a gravitational role, as the new Posidippos fragments have helped to underscore.

[102] Even Socrates succumbs to the concept (Pl. *Ap.* 29D; *Cr.* passim).

[103] [Thuc.] *AP* 7.45; Aristid. *Or.* 1.14–16; trans. Behr (1981): "For this reason [Athens] alone has entire taken over the glory of the Greek people, and is to the greatest degree distinct from the barbarians. . . . It lies in the very center of a central land. . . . Greece is in the center of the whole earth, and Attica in the center of Greece, and the city in the center of its territory, and again its namesake [sc., the Acropolis] in the center of the city." For an ingenious attempt to decenter Athens from within, see Dougherty 2003.

[104] Aristotle's *Poetics* is steeped in the atmosphere of wistful decline (e.g., 1450a25–26), and it is as much an epitaphic monument to fifth-century tragedy (domesticated, to be sure, by his doctrine of the mean: see Stewart, this volume) as it is a defense against Plato's criticism of art. See, generally, Pfeiffer 1968.

fixed the tastes and canons of scholarship, editions, and curricula for the foreseeable future. The survival of the bulk of classical works was determined by this act of *egkrinein*, or inclusion, in the catalogues (*pinakes*) or in special lists, thus settling the destiny of the classical canon at an institutional level and in ways that could not help but be self-reproducing for all of posterity.[105] While the official lists appear to have been immutable once they were established, supplements to the classical canon were made, thanks in part to the efforts of individual scholars, some of them drawing their paychecks from the Library, and in part thanks to a stubborn popularity among the cultured elite, but either way along lines that—not inexplicably—correspond closely to our own.[106] Whether out of modesty or out of aesthetic and cultural commitments, the severe winnowing of canonical authors by the Alexandrian librarians, which excluded all living authors, ensured that works after the fourth century, and some works from that century, would never enjoy the same status as literature from prior generations.[107] On the other hand, if, say, no tragedies from the fourth century or from the Hellenistic era have survived, it is also likely that the Lycurgan legislation of the 330s had a hand in this.[108] Thus, selections were already in motion well before the arrival of the Alexandrians, who may have been canonizing canons rather than creating them *ex nihilo*.[109]

Works of art met with much the same fate, as is shown by Pliny's judgment that art more or less had ceased to be produced (*cessavit ars*) after the first decade of the third century B.C.E., and only revived (*revixit*) after 156/53 B.C.E., in what is now considered a "neoclassical" or classicizing phase of art.[110] The first half of Pliny's remark is probably drawn from Hellenistic connoisseurs in the wake of Xenocrates (third century B.C.E.), who believed that sculpture had reached its pinnacle in Lysippus at the end of the fourth century and that painting had culmi-

[105] The verb *egkrinein* derives from athletics, whereby competitors are admitted into a contest upon examination. For an example of self-reproducing canons, see Lucian *Ind.* 2 on the later publishers of deluxe editions (such as those by Atticus, publisher of the well-known *Atticiana*), which to judge by the same dialogue consisted entirely of "reprinted" classical works.

[106] Pfeiffer 1968, 203–9; Blum 1991, 204–8. Theognis, Solon, Tyrtaeus, and Corinna are cases in point of noncanonical favorites, as is the canon of ten Attic orators, which for whatever reason seems to have formed only by the second century C.E. (Douglas 1956). But one should use extreme caution with terms like "canon" here: comparison of Plato and Demosthenes is canonical well before the canon of orators is stabilized (as is also stressed by Kroehnert 1897, 35).

[107] Dion. Hal. *Orat. Vett.* 1–2; Quint. *Inst.* 10.1.54.

[108] Seidensticker 2002, 528.

[109] This is evident in part from Aristotle's *Poetics*. Nagy 1998, 209, evokes the Library of Alexandria as "a concept" and a "virtual reality . . . that can now subsume all earlier patterns of canonization or classicism." And he advances (Nagy 1989, 44–46, 68, 73–77) the interesting possibility that the canon of lyric poets was already established in educational practice by the fifth century and prior to that in the process of "pan-Hellenization" of song and poetry before it came to receive the official sanction of the Alexandrians.

[110] Plin. *HN* 34.52; Schweitzer 1930; Coarelli 1970–71; Preisshofen 1979; Donohue 1995, 343; cf. Stewart 1990, 1:82.

nated in a string of artists (Parrhasius to Nicias) that likewise ended with the age of Alexander. The second half of the remark, if it indeed signals an approval of "neoclassicism," merely echoes the late Hellenistic bias in favor of classicism.

Thus it happened that a powerful bar was drawn across Greek cultural production, which henceforth was comfortably ensconced on a pedestal as a collection of "classics." Later achievements in culture did little to upset this monumentalizing of an earlier past, the burden of which artists, antiquarians, and cultural historians learned to cultivate and to exploit to their own advantage. Thus, Pausanias's boast that he will describe "all things Greek" in his *Description of Greece* (1.26.4) is as implausible as it is conceivable only within the selective and aestheticizing framework of classicism, which recognized a clearly delimited boundary encompassing archaic to fourth-century Greek culture.[111] And writers of the Second Sophistic generally followed the same pattern of taste, as their collective name implies: they were cultivating a kind of renaissance of their Greek heritage, a "second" sophistic era.[112]

Within these confines, which are at once rigidly narrow and conceptually blurry, the idea of a classical past did have a certain reach in antiquity. So enshrined, hyperbolized, and literally incredible was the bias it represented (in ways comparable to Hegel's edict about the end of art in the modern romantic age), this narrow conception of the past lay beyond refutation. But qualifications are needed. The classical past so understood was not a burden, much less an inflexible pattern of norms to be followed slavishly. On the contrary, conceiving and imagining the past was an opportunity for cultural expression and for exercising cultural power. Here, elites could find an avenue for claiming a privilege within the framework of a widely accepted heritage. Artists of all kinds could find a common language in which to innovate or to mount a challenge. Tendencies that are sometimes qualified as anticlassical or counterclassical, though perhaps they are merely unclassical (such as realism, the grotesque, the baroque, the regional, the parodic, and the minor), draw their salience from here.[113] Communities could rally around a shared past, whether in concert or in competition with one another. And Roman responses to the classical heritage of Greece could run a full gamut of possibilities, from admiration and voluntary assimilation to free but uncommitted (viz., strategic)

[111] Porter 2001a.
[112] Philostr. *VS* 481; Schmid 1898; Bowie 1974; contra, Brunt 1994.
[113] Fourth-century art, particularly sculpture, has been typified as "anticlassical," by which is meant unclassical (Brown 1973), but opinions vary. Some see this century as a prolongation of the classical style in art; others see it as a changed Late Classical period. The idea of anticlassicism has been adopted in the description of popular (non-elite-based) Italic art, e.g., by Pirro Marconi (see Marconi 1930–31, providing fascinating documentation of one scholar's reluctant lapse into primitivism: "non potendo approvarle esteticamente, pure non potevo negarle," etc.) and Bianchi Bandinelli. These last two examples doubtless reflect nationalistic fervor. Further, Settis 2002, 32–34. Johnson 1970, 137–51, detects in Ovid what he calls a "counter-classical sensibility"; but see n. 203, below.

appropriation and adaptation to outright refusal and rejection (especially where vulnerability loomed large), with deep ambivalence frequently occupying the middle ground between the extremes.[114] Classicism is an undeniable element of Greco-Roman antiquity and one of its more recognizable tendencies. There is nothing wrong with singling it out for discussion, and nothing inherently anachronistic about doing so either. Nonetheless, a complacent acceptance of ancient classicism is open to criticism on a number of counts.[115] Several qualifications are needed.

Atticism and Hellenismos

Classicism in Greek and Roman antiquity, as we have seen, had no name, and it was hardly a recognized "movement." Classicism was not a systematic program, it was not rigorously implemented, and it by no means took hold of all aspects of classical culture, or even with the same degree of intensity or fidelity where it did take hold. In the arts of language from the Hellenistic period onward, the criterion that comes closest to marking classicism or its refusal, at least at first glance, is the distinction between Asianism and Atticism. Atticism or "hyperatticism," the deliberate reproduction of an assumed, albeit contested and varying, core of pure fifth- and fourth-century Athenian language, was an attempt to reproduce the authentic sound and style of a perished Greek and to police linguistic habits. In its most extreme expression, Atticism could take the form of fetishlike word lists compiled by antiquarians, such as the *Selection of Attic Nouns and Verbs* by Phrynichus of Bithynia from the second century C.E.[116] Establishing correct authentic usage like this was a step in the direction of appropriating it as one's own. Lucian and others mock these practices, which at most produced a vaguely Attic-sounding speech or writing, or else the spectacle of the desire to do so. Crudely put, the debate was between the virtues of pure and simple writing, exemplified by classical prose authors of the Athenian fifth and fourth centuries, and bombastic writing, typified by Hellenistic authors. But there are innumerable problems with the distinction, and these are mirrored by the chaos of the scholarship on it, which has recently

[114] See esp. Woolf 1994, Henrichs 1995, and Habinek 1998.

[115] Cf. Schindel 1994, id. 1997, detaching classicism from archaism, and insisting on the narrow lexical meaning of the term *archaismos*, rather than the practice (though focusing on the term *archaios* would yield different results; see, e.g., Phryn. *Ecl.* 357); contra (implicitly), Saïd 2001, esp. p. 291, following Bowie 1974; and now, Holford-Strevens 2003, 354–63.

[116] See the edition by Fischer (1974). This word-list (*eklogē*) was polemically constructed in answer to a critique of Atticism by the so-called "Antiatticist," but both were drawing upon earlier Hellenistic traditions of Atticizing scholarship, and not least on the word-list of Caecilius of Caleacte (Test. [= Suda, s.v. "Caecilius"] and XII, fr. 155 Ofenloch), who also devoted a treatise to the difference between Atticism and Asianism (Suda, ibid.); see Latte 1968; Fischer 1974, 39–47; Hidber 1996, 41–42 n. 184. Dionysius of Halicarnassus likewise endorses classical imitation through word-selection (*eklogai*) in the *De imitatione*.

been described as a "jungle."[117] Stating the reasons for the confusions, both ancient and modern, will help to illuminate the difficulties of any easy characterization of classicism, here exemplified in the arena of language.

To begin with, the nature of Atticism is unclear, as is its chronology. Was it a movement or a trend? Did it originate in the Hellenistic period among the Alexandrians, among the Greeks in Rome in the circles of Caecilius and Dionysius of Halicarnassus, or a generation earlier among the Romans in the circle of Calvus?[118] Can Atticism be understood on its own or only in contrast to Asianism? The problem is that the distinction between Atticism and Asianism is anything but clear-cut. Nor are the poles necessarily coordinated with classicism, even if writing in traditional Attic is a frequent but not an automatic sign of classicism in later eras.[119]

That the label of Atticism is not always a guarantee of classical credentials is evident from the quip by the second-century C.E. philosopher Numenius of Apamaea: "What is Plato if not an Atticizing Moses?"[120] Attic could never simply stand for classical literature. If it did, a good portion of the canon of classical authors would no longer qualify as "classical." No less important to the preservation of traditional linguistic virtues is the broader and more tolerant category of *hellenismos*, or "pure" and correct Greek.[121] Indeed, historically the two categories of Atticism and *hellenismos* tend to blur together: they seem to share the same Hellenistic roots,[122] while *hellenismos* is the more inclusive and older category (the first attestation of the phrase *to hellēnizein*—speaking Greek as Greek should be spoken—occurs in Plato),[123] although lineages for both ideas can be traced to the fifth century, while the more encompassing fact that

[117] Wisse 1995.
[118] For the former possibility, see below; for the latter theory, see Wisse 1995.
[119] That this distinction is so coordinated is the underlying assumption of the major literature on the subject, from Schmid to Swain (who, however, notes how even the Antiatticist appears classicizing; Swain 1996, 53; similarly, Latte 1968, 620); further, Wisse 1995, 71–72. For a brief overview of the evolution of Greek from the age of Alexander to Rome, see Horrocks 1997, ch. 4; Versteegh 1987; Dihle 1994, 53–60, 67–69.
[120] Fr. 8 des Places.
[121] An example is Heliodorus ap. Schol. in Dion. Thrax 446.12–17, according to whom *hellenismos* is correctness of Greek in its local (regional) variations. See further *De hellenismo et atticismo*, a fragment preserved in the scholia to Aristophanes (Koster 1975, 19), which rattles off ten ways in which *hellenismos* and Atticism differ. Cf. also the lexicon by Moeris (Hansen 1998), which is premised on this very contrast: Moeris assembles terms and expressions, listing first how the "*Attikoí*" put them and then how the "*Hellēnes*" do so. On the other hand, a certain conflation of Atticism and *hellenismos* was inevitable, given the Attic basis of *koinē* (cf. Choerob. *in Theod.* 1:201.20–21 Hilgard: the κοινὴ συνήθεια is μᾶλλον ἀττικίζουσα). On the gradual historical convergence of *koinē* and *hellenismos*, see Versteegh 1987.
[122] Wilamowitz-Moellendorff 1900, 42; Dihle 1977, 168; Bowie 1974, 195.
[123] E.g., Pl. *Prt.* 328a; Xen. *An.* 7.3.25; Aeschin. *In Ctes.* 172; Arist. *Rh.* 3.5 1407a19; id. *SE* 182a34. The term *hellēnismos* is a later coinage. The stylistic predicates of Asianism— essentially, Gorgianism—are already available in the fourth century. See Norden 1898, 138, 379 (Aristotle's criticisms of Alcidamas); Radermacher 1899, 359 (on Demosthenes); and Wilamowitz-Moellendorff

"the original criterion of Greekness was linguistic" is deeply entrenched: it reaches back to Homer.[124] But again, as with Asianism, it would be unthinkable to align oneself with the cause of solecism or barbarism: *hellenismos* was everyone's to claim, and no one's to own.[125]

Nonetheless, the bias towards Attic as the depository of pure Greek grew increasingly entrenched. It was only once the impact of Alexander's political reach and Athenian cultural hegemony were symbolically fused that Atticism became synonymous with "standard high Greek," to the point that Homer and even the Alexandrian dialect could be claimed, absurdly, as "Attic."[126] Of a piece with this kind of linguistic imperialism is the belief held by Philoxenus, a powerful exponent of grammatical Atticism in the first century B.C.E., that Latin was a Greek dialect akin to Aeolic.[127] The roots of Atticism thus lie in the history of the evolution of *koinē*, the universal form of the language that spread throughout the Greek-speaking world after Alexander. *Koinē* happens to have been based on Attic—a historical contingency, to be sure, but not quite an accident. And Atticism is (in a word) *koinē* elevated to a new level of refinement and elegance: it became the universal language of education and privilege. As a result, a certain practical dimension was at work in the adoption of Atticism or its revival, and this never changed over the centuries.

Rejection of Ionicisms or Doricisms, for instance, is not tantamount to a rejection of Herodotus or tragedy. It is merely a pragmatic decision about how to conduct oneself in political prose writing, be this in court, at the business table, or in other public arenas of the Greco-Roman world.[128] Indeed, the very application of the labels *Asianist* or *Atticist* in literary and rhetorical circles

1900, 24 n. 1 (reiterating Norden's point), 33 (Aristotle's treatment of Thrasymachus), and 42 (on Aristophanes). See Casevitz 1991 on the early history of the term; and see generally the essays in Saïd 1991.

[124] Hall 1989, 166; cf. 4. Thus, Sophocles' Philoctetes is tearful at the sound of his beloved Greek after so many years (Ἕλληνές ἐσμεν. . . . ὦ φίλτατον φώνημα, *Ph.* 225–35) and Thucydides notes, in effect, how the Athenians were already proto-Atticists, at least ideologically (7.63). See Hall 1989 for these (p. 177) and other examples.

[125] To claim that *hellenismos* was a "movement" that finally triumphed (Latte 1968, 625) is thus misleading.

[126] Dihle 1977, 168–69; Latte 1968, 623, 626; Broggiato 2001, xlii–iii. Aristarchus's acceptance of the Athenian recension helped strengthen the illusion that Homer was of Athenian origin (cf. Sext. Emp. *Math.* 1.202–208), as the scholia to Homer repeatedly claim (see Dihle 1977, 169 n. 29).

[127] Fr. 323 Theodorides (= Choerob. *in Theod.* 1:34.8–9 Hilgard); *GRF*, pp. 443–46 Funaioli; cf. *RE* 20.1:195, Gabba 1963, Dihle 1977, 170.

[128] Cf. Phryn. *Ecl.* 235: Herodotus's usage is fine and unimpeachable—for Herodotus and cf. 357 (and passim), where the emphasis falls upon practical language-use (*chrēsis*), viz., the language of political administration (cf. 42: ἀλλ' ὁ πολιτικὸς . . . λεγέτω), not upon poetic diction (ibid. 157, where a poeticism by Sophocles is inferior to Menander's usage, which in this case is more prosaic, as is generally the usage of the Older Comedians [24, 114, etc.]; cf. Dio Chrys. 18.6–7 for the same pragmatic bias). But see Phryn. *Ecl.* 394, for an unqualified put-down of Menander and the proponents of his diction, which is too "new" (304, 391, etc.).

rests on a pragmatic bias that renders their distinction problematic. *Asianist* is a polemical term of abuse rather than a positive stylistic category: it is not a label that anyone willingly assumed.[129] Hegesias of Magnesia, the much-maligned third-century orator who was frequently targeted as the paradigm of Asianism at its utter worst, claimed to be imitating Lysias, the poster boy of Atticism.[130] Plainly, Asianists (so-called) could be as classicizing as any full-fledged Atticist.[131] But neither is the canon of Atticizing authors undisputed, which suggests how uncertain the criteria of Atticism are (a fact that did not escape its critics).[132] Phrynichus, the compiler (ca. 160 C.E.) of a list of mistakes to avoid in Attic Greek culled from past and contemporary authors, faults Lysias for his bad form and praises Demosthenes instead.[133] Caecilius found fault with Demosthenes, but not with Lysias. Longinus praised Demosthenes and disparaged Caecilius—but the Longinian sublime, with its baroque excesses, is suspiciously Asianist in appearance.[134] Others had their own views.

Just how deeply symptomatic of wider cultural developments was Atticism? Parallels to the rise of Atticism in Hellenistic Alexandria and its resurgence in Rome during the last century B.C.E. have been proposed, most prominently the Neo-Attic style in art and a kind of philosophical classicism (an exegetical return *ad fontes*, to the writings of the founders of the Peripatos and the Academy), respectively.[135] And in general, virtually wherever you look after the fourth century, and the farther out in time you go, the more likely you are to encounter a fascination with the "true and pure Greece" (Pliny) that seems to exist in the mind alone.[136] But the connections among the various spheres of

[129] For the same point, Wilamowitz-Moellendorff 1900, 24.

[130] At least in its Roman form: Cic. *Att.* 12.6; *Brut.* 286; *Orat.* 226; Plut. *Mor.* 42d-e; Wisse 1995, 67. A complication, which merely underscores the inherent difficulty of these terms, is that charges of Asianism could be used to label either grammar (chiefly, lexical reach) or style, and the latter usage appears to be the later one (see Dihle 1977, 177). An interesting parallel is to be found in the eighteenth-century dispute between Baroque and classicizing artists, such as the architects Borromini and Fréart de Chambray, who seem to have viewed classical works in different ways, and not only to have derived their images from different places, such as the Asiatic East, the source of some of Baroque art (see Blunt 1971).

[131] Bowie 1974, 170.

[132] Cf. Cic. *Brut.* 285, militating against a narrow construal of Attic imitation, given the diversity of style in Attic writers—a claim comparable, in different form, to Ael. Herod. (cf. n. 142, below); and to Sext. Emp. *Math.*1.229–40, addressing the multifarious *sunētheiai* (usages) of good Greek available and valid at any given time, viz., registers, context-bound and dialectal variations, archaisms, etc.: "It is not possible to follow them all, since they often conflict." Sextus's final position seems to be that the only constant in the matter of usage is its constant changeability.) And see the gibe by the comic poet Posidippus (fr. 30 *PCG*): "You [sc., Athenians] speak Attic, they [the rest of the Hellenes] speak *Greek*."

[133] Swain 1996, 53 n. 43, for the date.

[134] See Porter (this volume), at n. 119.

[135] Dihle 1977, 175 n. 51; id. 1994, 59–61; Fullerton 1998b; Frede 1999, 783–85.

[136] Plin. *Ep.* 8.24.2; cf. Cic. to Quintus, *Ep.* 1.1.16.27–28; Vitr. *De arch.* 2.8.12.

culture (grammar, art, philosophy) must for the most part remain speculative, not least because of the very elusiveness of "Atticism" itself.[137]

An instability and surely an incoherence adhere to the ideas of Atticism and *hellenismos*, and not just to that of Asianism alone.[138] An underlying anxiety over the basic—and at bottom unanswerable—question as to just what constituted correct Greek, and possibly the vertigo of cultural belonging in a Greek world that felt itself to be increasingly diasporic, are to be suspected, far more than a growing sense that Greek usage was no longer in touch with the language of the old classics.[139] Is Ionic, the language of Homer and Herodotus, Asiatic? The question is an uncomfortable one, and local allegiances could override Panhellenic sentiments at will.[140] "Only Homer among the older writers (*tōn archaiōn*) practices correct Greek (*hellēnizei*)"—so Telephus of Pergamum (second century C.E.).[141] Yet the appeal to Homer could cut both ways, in favor of Atticism or of antiatticism (the latter term gives the title to one surviving ancient tract)[142]—further proof, if it be needed, that Homer could both found and confound all categories and labels, including our own, placed as he is at the origins of Greek literature and so too both within and outside the limits of the classical. In a word, Atticism is too problematic a term to be a useful index of classicism, save as an index of the constitutive uncertainties of the phenomenon. Its translation into Roman contexts is even more fraught with problems.[143]

If positive evidence for classicism is hard to come by, negative evidence is correspondingly scarce. No *Querelle* between classical Ancients and unclassical Moderns ever took place in Greece or Rome, and anticlassicizing tendencies or movements are hard to detect, even if anticlassicizing gestures can be found here and there, for instance in the rejection of Polyclitus's *Canon* in favor of Asiatic castrati sculpture, in Galen's rejection of Atticism, or in

[137] See Wilamowitz-Moellendorff 1900, 43–44, on rhetoric and philosophy, where in some cases connections can be ascertained, in others not; Preisshofen 1979, 269–72; and esp. Bowie 1974 and Fullerton 1998b, 98 n. 21, for the broader point.

[138] Wilamowitz's famous article from 1900 attacks the incoherence of Asianism as a meaningful label (esp. pp. 4 and 26), but leaves the coherence of Atticism intact.

[139] For the latter reason ("*eine Unsicherheit des Sprachgefühles*"), see Latte 1968, 622. Further, Swain 1996, 43. Many of the practitioners and exponents of Atticism happen to be Asiatics, geographically speaking, for instance Dionysius of Halicarnassus, who rails against the linguistic habits of the Cilician, Carian, and Phrygian Greeks (*Rh.* 1). Sextus states the underlying uncertainty well: the definition of speaking Greek well "is not self-evident" (*Math.* 1.184).

[140] As with Posidippus above (n. 132). Contrast Phryn. *Ecl.* 332, where linguistic purity means firmly excluding dialects foreign to Attic.

[141] Suda s.v. Τήλεφος.

[142] *AB* 1:75–116 (*Antiatticista*); cf. Ael. Herod. *Sol. et barb.* 311.5–10 Nauck (Homer represents *hellenismos* best because he incorporates all the Greek dialects); Swain 1996, 55–56, for further sources.

[143] Despairing of any way to make sense of the distinction in Rome, Wallace-Hadrill 1989, 162, decides that "the contrast on which the ancient debate centres is a geographical, not a chronological one: Asia versus Attica." But see n. 139 above.

Lucian's critiques of the pompous affectations of *recherché* classicism and in his adoption on occasion of a pseudo-Ionic Greek.[144] But even these moments of rebelliousness are for the most part not directed against classicism per se, but only against its adoption by particular parties in particular circumstances and in particular ways.[145] Analogously, critiques of Homer, whether in the seventh century (of the sort that Theagenes of Rhegium rose to counter) or in the fourth (Zoilus, Plato) or later (Eratosthenes), are hardly to be taken as critiques of classicism, any more than defenses of Homer should be automatically construed as defenses of some kind of classical ideal. On the contrary, these debates are the sign of lively intellectual ferment. Most of the time, Homer is merely a convenient peg on which to hang an argument and a way to find an instant audience, given his status as an undisputed source of leverage, if not authority, in the Greek and Roman worlds.

The Classical Ideal

Anyone who would dispute the relevance of the concept of classicism to antiquity might stress, and rightly so, that the evidence for the phenomenon itself in antiquity is contestable. But then, short of manifestoes, what *would* constitute evidence for classicism in our sources? The evidence for classicism is always going to be a matter of dispute, as we have already seen. And it is no argument against classicism that the phenomenon lacks definition or its exponents fail to produce identifying credentials. In ways, the ancients seem to have been blithely indifferent to classicism, or at least to naming classicism in some sharply defined sense. At the very least they were more tolerant of its various declensions than we might wish to assume. And so too, while many expressions of classicism in antiquity do bear a close resemblance to classicism in its modern forms, there are important differences. If we lose sight of these, the historical specificities of classicism in its various forms will be lost.

One major difference between classicism in its ancient and modern forms lies in the degree of *purported* definition that the term and the concept enjoyed. The idea of classicism had a specific, if indefinite, meaning for the moderns that it lacked in antiquity at least in one crucial respect: it was tied to what,

[144] See Wilamowitz-Moellendorff 1900, 31 and n. 2, with Quint. *Inst.* 5.12.21, Reinach and Reinach 1985, §§ 210, 281, and 469 (on castrati-sculpture, an apparent fashion statement in sculptural taste, but which may have been merely a tendentious and momentary critique); Brown 1973; von Staden 1997; Vegetti in Cajani and Lanza 2001. See Lucian's *Lexiphanes*, *Pseudologista*, and *Pseudosophista*. There was no *Querrelle*, that is, unless one wishes to characterize the Callimachean aesthetic or the Roman equivalent (neoterism) in this way (which would be misleading); cf. Citroni 1998, 15; Schwindt 2000, ch. 8.

[145] The treatise by the so-called Antiatticist and the critique of Atticism, or rather of its overly narrow understanding, attributable to the Pergamene critic Crates of Mallos (F 106–21* Broggiato), are two cases in point: far from undermining classicism, they are at most rejecting certain linguistic pretensions made by various grammarians. Further, Swain 1996, 63–64.

early in the nineteenth century, would come to be known as *the classical ideal*. Utterly absent from antiquity, this concept emerged, as we saw, in the wake of Winckelmann, wherever the idea of "the classical" was in play (itself already an ideal and an abstraction). And it was given canonical expression by Hegel in his *Lectures on Aesthetics*, for example, in his discussion of beauty, which for him was the locus of the classical ideal, the balancing middle term in a tripartite historical scheme comprising the Symbolic (Oriental), the Classical (Greek), and the Romantic (modern):

> Classical beauty has for its inner being the free independent meaning.... This inherently free totality remaining equal to itself in its opposite which becomes its own self-determination, this inner life which relates itself to itself in its object, is what is absolutely true, free, and independent, displaying in its existence nothing but itself.... [It] lifts the spiritual to the higher totality where it maintains itself in its opposite, posits the natural as ideal, and expresses itself in and on the natural. In this sort of unity the essential nature of the classical art-form is grounded.[146]

And yet despite its obvious deficiencies (its lack of definition, its abstractness, and so on), some of which reflect Kant's strictures on rational determination in aesthetic contexts (and which therefore might be considered a conceptual strength),[147] as a watchword and a slogan the classical ideal was endowed with

[146] Hegel [1820-29] 1975, 1:427, 431–32. The ideal (sc., of art) seems to be an exponentially purer or at least more particularized form of the idea of beauty, beauty being the sensuous manifestation of the idea generally, the classical ideal being the most adequate and truest, and the most particular and most beautiful manifestation of the idea possible in a sensuous medium, a condition that is attained most of all in the medium of classical sculpture. Cf. ibid., 1:73–75, 85, 110, 299–301; 2:718. But this is only a rough approximation of what for Hegel is a dynamic and restless process: the ideal, we would have to say, discovers itself in the beautiful, and then surpasses beauty (the classical ideal of beauty), abandoning it to a higher form of truth; at that point, Spirit exits from the history of art and enters into the maturest phase of philosophy, which is that of philosophical idealism. Hegel thus consummates Winckelmann's classicizing program, as well as its ambivalence towards the classical ideal and its sensuous condition.

[147] Thanks to Robert Pippin for reminding me to stress this qualification (which he deems paramount). As both he and Richard Neer have pointed out in correspondence, Hegel's account would need much more of an elaboration, and probably a more sympathetic hearing, than is possible in this abbreviated form. But I am thinking not only of Hegel, but also of his predecessors, for instance, Humboldt, whose classical ideal significantly anticipates Hegel's by a decade or two (see Humboldt 1960–81, 2:71–72 [1806/7]; and cf. n. 96, above). Kant's own ambivalence towards the classical ideal would need to be thrown into the equation here. See *The Critique of Judgment* §32, where Kant notes that the very idea of classical standards, to which he adds his assent (cf. also §§17 and 47, cited in n. 194, below), creates an antinomy in his theory of the autonomy of aesthetic judgment (a dilemma that would repay further study). Strikingly, but no less symptomatically, indeterminacy in contour (*Unbezeichnung*—"lack of delineation" or "of indication") is for Winckelmann a *defining* feature of ideal beauty: for all their arresting clarity, classical statues must be daubed in a gauzelike haze and clothed in the blur of a higher degree of generality—for particularity *stains*, like matter itself, and so must be avoided at all costs (Winckelmann 1972, 150; cf. p. 151: "*idealisch*").

sufficient powers of articulation to create a focus around which vast stretches of thinking and expostulating—in a word, the full reach of the aspirations of modern classicism—could be organized.

Now, exponents of classicism in antiquity never arrived at such a degree of articulated abstraction, even if the modern concept owed much to the influence of Neoplatonism in such predecessors as Giovanni Pietro Bellori, the author of a Renaissance treatise on aesthetics (1672), who belonged to a tradition with roots in Cicero, Seneca, and ultimately in Plato.[148] It was not for want of any power of abstraction that the ancients never arrived at a transcendental concept of the classical. Plato's own definition of ideal beauty in the *Symposium* is strange, and strangely abstract:

> Nor will the beautiful appear to him [sc., the lover] in the guise of a face or hands or of anything that belongs to the body. It will not appear to him as one idea or one kind of knowledge. It is not anywhere in another thing, as in an animal, or in earth, or in heaven, or in anything else, but itself by itself with itself, it is always one in form (ἀλλ' αὐτὸ καθ' αὑτὸ μεθ' αὑτοῦ μονοειδὲς ἀεὶ ὄν); and all other beautiful things share in that. (211a-b; trans. Nehamas and Woodruff)

How classical is Plato's definition of beauty? The denial of beauty's (ideal) involvement in matter may disqualify it altogether on any definition of classicism, ancient or modern.[149] Still, ancient classicism has been described as a kind of Platonism prior to Plato,[150] although this may be no more than a reflection of the entrenched Platonism of the modern classicizing tradition, even if Winckelmann appears, surprisingly, to have been looking more to Epicurus than to Plato for inspiration.[151] But while it may vie for strangeness with Humboldt's definition of organic classicism cited earlier, Plato's language does not

[148] Panofsky 1924, esp. p. 62: "Diejenige Ideenlehre, die bisher nur in den gelegentlichen und letzten Endes unreflektierten Äußerungen der Alberti, Raffael und Vasari ihren Ausdruck gefunden hatte, jetzt in der Zeit des Klassizismus zum '*System*' erhoben wird.... *Erst damit ist die Umgestalung der Idee zum 'Ideal' ausdrücklich besiegelt*" (italics in original), and thus was the road paved ahead for Winckelmann and his succession. (An excerpt on "*l'Idea*" from Bellori's treatise appears as an appendix to Panofsky's study.) But Bellori's was a theory of beauty, not of *classical* beauty; and it was classicizing only in an extended sense of the term (ibid., 61).

[149] Plato's definition of beauty in the *Phaedrus* (250d6–8) as that which is clearest (*enarges*) and most phenomenally perspicuous (*ekphanestaton*), and most desirable and most erotically attractive (*erasmiōtaton*), is more typical of Greek thinking, but not of Plato. Kierkegaard, incidentally, felt that Plato's sensibilities were tilted against the classical ideal (see Kierkegaard 1989, e.g., 75).

[150] Pollitt 1972, 6: "Greek artists tended to look for the typical and essential forms which expressed the essential nature of classes of phenomena in the same way that Platonic 'forms' or 'ideas' expressed essential realities underlying the multiplicity of sense perception. A geometric statuette of a horse is an attempt to get at the 'horseness' which lies behind particular horses," and later high-classical art intensifies this search for pure form (cf. ibid., 87 and 106–7), while "the divorce of the apparent and the ideal in Platonic thought" presages the degeneration of classicism (ibid., 171). Hegel would have agreed completely (while applauding this divorce).

[151] Zeller 1955, with Porter 2000b, 402 n. 150.

give a definition of the classical ideal: it is merely a theory of beauty in general. This is not to deny that elsewhere Plato's invocations of measure and symmetry as criteria of beauty come closer to the modern classical ideal,[152] and to some ancient definitions of beauty as well (such as those of Polyclitus or Vitruvius).[153] Nor is it to deny that Plato's writings themselves, especially his style, could be taken as a paradigm of classicality in later antiquity (and in modernity)—a separate matter, to be sure.[154] But this does not by itself make alleged classical properties Platonic or Platonic metaphysical properties classical. And so, while studies in terminology are obviously limited, as we saw, here the absence of an organizing term among Greek and Roman thinkers seems to have been decisive. Ancient classicism, even as it achieved its effects through the force of a repeated consensus, never arrived at an explicit, comprehensive account of itself. For that, it would have to wait for over a millennium and a half.

There is no single reason why this should be so. Historical distance, allowing for greater retrospection, may be partly responsible, but it need not have been. Hellenicity and Latinity could be roughly named and imagined in antiquity, and ideals and idealizations of all kinds could be variously conceived, both in theory and in practice, not least of all in art. Statues and other works of art were regularly conceded to transcend human beauty,[155] and this same insight brought with it an insight into the unattainability of all such ideals, for instance Isocrates' claim that "no one can make the nature of his body resemble statues or paintings," whereas emulation of character as found in writing or speeches is an attainable ideal (*Evagoras* 75); Isocrates may be quoting Alcidamas (*C. soph.* 27), who observed that "real bodies are less attractive in appearance than beautiful statues." Thus, the ancient literary tradition shows an acute awareness of idealism in art, but also of its unreality, as does the visual tradition itself.

One might compare the Foundry Cup dating from around the 480s, wherein play is the image of image making itself—that of a bronze foundry in which arti-

[152] Pollitt 1972, 3–6, esp. p. 4 (citing Pl. *Phlb.* 64e). Cf. Arist. *Metaph.* 1078b1–5, singling out "order, symmetry, and definiteness" as the three main constituents of beauty: "The chief forms of beauty are order and symmetry and definiteness *(taxis kai summetria kai to horismenon)*, which the mathematical sciences demonstrate in a special degree. And since these (e.g. order and definiteness) are obviously causes of many things, evidently these sciences must treat this sort of cause also (i.e. the beautiful) as in some sense a cause" (trans. Barnes). Also, id. *Eth. Nic.* 1106b9–14 (on the mean).

[153] Gal. *Plac. Hipp. et Plat.* 5.3.16 (3.16 Kühn): Polyclitus defined beauty as the "commensurability *(summetria)* of all the parts of the body with one another."

[154] Walsdorff 1927 and Strobel forthcoming 2005 n. 18 (Plato in antiquity and among the lexicographers); Stadler 1959, 41, 165 (W. von Humboldt on Plato).

[155] Xen. *Mem.* 3.10.2; cf. Gorg. 82B11(18) DK; Artist *Po.* 15.1454b8–11; Plin. *HN* 35.64; Lucian *Im.* 5–9 (e.g., 9, on a "spectacle transcending all human beauty"); Stewart 1997, 93 (reading such tales in the light of fetishism); Cic. *Inv. rhet.* 2.1; id. *Orat.*, passim (on Demosthenes as the closest approximation to a rhetorical ideal, the *summus et perfectus orator*).

sans, seemingly pygmylike, are at work finishing a gargantuan nude hoplite *à la* the *Iliad* (see frontispiece). With its marked and insistent contrasts, organized around artisans dwarfed by the towering object of their labors, the bowl shows just how *un*realistic, *un*natural, and idealizing (early) classical monumental sculpture in its pretensions in fact is.[156] It also shows us that it knows this to be the case. The image thus affords precious documentation of a contemporary perception, entirely consistent with the textual documentation just cited. It gives us a graphic equivalent of an ironic awareness—of just how constructed ideal art is. And yet, for all this awareness, for whatever reason no clear notion of the classical ideal emerged in antiquity. One suspects sheer contingency to have been decisive here. Surely another factor is that classicality is, at least formally, an aesthetic notion; and aesthetic abstractions such as form, content, aesthetics, imagination, or naturalism tended to go undeveloped in antiquity, or at most they developed slowly, lacking, so far as we can tell, the scope, the intensity, and the pretension of modern aesthetic thought, which is when aesthetics as a separate branch of philosophy first emerged.[157] Thus, for whatever reason, until the late eighteenth century the classical ideal remained a background concept that never took on a firm contour.[158] At most it was attached to notions of the beautiful and the sublime, which could be as unfocused as their conventional modern counterparts. At times, ancient criticism descended to the level of desperate prescriptions: not "too much" or "too little" of this or that feature; preserve harmony, balance, and the delicate mean. Here, the remains of ancient treatises on poetics, rhetoric, and art, which Winckelmann and others avidly read and repeated,[159] in addition to scattered offhand remarks of an aesthetic nature found in various nonaesthetic writings, are our best bet for reconstructing the ancient vocabulary of taste. But they do not give us all we need to understand the qualitatively distinct experiences of classicism in the ancient and modern worlds.

[156] See Neer 2002, e.g., pp. 77–85, a brilliant reading of the Foundry Painter. Although the piece's conjectural date would locate it on the eve of the Early Classical period (Beazley 1989, 78, puts it "between 490 or a little before and 480 or a little after"), in question are pretensions and vectorial directions, not precise and measurable effects. See further Beazley 1989, 79–80: "The workmen are realistic; . . . the central figure is ideal." As Alan Shapiro points out (*per litt.*), the fact that larger than life-size bronze statues were not produced in this period suggests a further way in which the image subverts realism.

[157] See Kuhn 1931, Cassirer 1955, ch. 7, and Kristeller 1990 for three views of this development.

[158] See Tatarkiewicz 1958.

[159] Schweitzer 1932, 44: "Thus our theory [viz., inherited from Mengs, Winckelmann, and Goethe] is itself nothing less than the *theory at work in late Hellenistic idealism*" (italics in original); similarly, Stewart 1990, 1:29–32 and 78–83. On Winckelmann and ancient rhetoric, see Donohue 1995; Macr. 5.13.40 is the probable ancient source of the formula *edle Einfalt und stille Grösse* (*acriter enim in Homerum oculos intendit, ut aemularetur eius non modo magnitudinem sed et simplicitatem et praesentiam orationis et tacitam maiestatem*), and Epicurus has been discussed above. (I am indebted to Gregor Vogt-Spira for the reference to Macrobius.)

The Fantasy of Classicism as a Practice and as an Experience

In one respect, at least, a sense of distance did help to shape differently the classicisms of antiquity and modernity. The ancient views of the classical are less shaped around an abstract ideal than they are expressed in a series of concrete practices. Or perhaps one should say that these practices did not include the typically modern practice of intensely abstract idealism. Humboldt's idea of classicism necessarily differed from ancient classicism just by virtue of its greater historical distance and its greater illusion of objectivity: classical antiquity was something he felt entitled to grasp as a self-enclosed entity. Objectivity was fostered in other ways as well. Here it is worth recalling how many of the greatest representatives of Hellenism, from Winckelmann to Nietzsche, never set foot on Greek soil. Their view of the ancient past was a heavily mediated one. (Not that the ancient views weren't heavily mediated in their own way, as we shall see in a moment.) Conversely, in antiquity classicism could in a sense be taken for granted merely by virtue of its proximity to "the visible past."[160] The classical past was something you could touch and feel on a daily basis in Greek and Roman antiquity: it was not a foreign country. Or rather, we should say, the *illusion* of proximity to the past was more easily had than in later centuries. As Marcus Piso remarked to the youthful Cicero about Plato upon their visit to the Platonic Academy at Athens in 79 B.C.E., "Indeed the garden close by over there not only recalls [Plato's] memory but *it seems to bring the actual man before my eyes*."[161] For a Roman to make this kind of remark may have been an emphatic claim to identity (as it would have been for a Greek under the Empire, albeit differently), but it was hardly an oddity.

Makers of statuary could revive distant classical models in the contemporary present; they could literally bring the past to life in a palpable experience in the present. Roman "copies" of Greek originals seem to do just this. One could surround oneself with physical reminders of the distant past, decorating rooms and entire villas with objects, styles, and other reminders of bygone eras. Alternatively, one could travel through time and visit the past by means of tourism and pilgrimage. Tombs and grave stelae, such as those found in Roman Attica, could be marked with classical motifs, drawing the present into the past. Revivals of Athenian tragedies, not to mention other kinds of performative recreation and reenactment (revived rituals and other observances, poetic recitals, rehearsed *controversiae*, and *ex tempore* harangues by crowd-pleasing sophists on classical *topoi*, all bringing the past audibly to life again), would have had much the same effect. Here one could come as close as was imaginably possible to having a full-bodied visualization of the past: one could thrill to its effects. Disappointment was bound to ensue; neither past nor present could

[160] Anderson 1989, 140–42.
[161] Cic. *Fin.* 5.2; trans. after Rackham; italics added.

live up to the expectation for long.¹⁶² But failure, whether acknowledged or half acknowledged, merely acted as a further incentive to recreate the conditions for contact with the past. Indeed, a veritable memory industry in Greece and Rome seems to have fostered these very kinds of reaction, which were vital to political, social, and cultural life. The moderns merely followed suit.¹⁶³

Proximity and Habitus

Classicism in any age involves its practitioners in more than an intellectual or visualized approximation to the past, because it involves them in a multiply layered experience of that past.¹⁶⁴ To borrow back a term from sociology, one that any ancient at least from Aristotle on would have understood, classicism entails that individuals take on a *hexis* or a *habitus* and that they make it their own: one no longer merely inhabits the past like a tourist; one comes to be inhabited by it. The identification between past and present, self and other, is immediate, or at least it is imagined and felt (or pretended) to be so.¹⁶⁵ Putting on the habits of the Greek classical past, whether you are an emperor like Hadrian or an orator of slightly less distinction, or simply a Hellenophile no matter what your ethnicity, can leave its signature on your appearance, on your coiffeur, your dress and gestures, gait and demeanor.¹⁶⁶ But even if it does none of this, it surely will leave its mark on your choice of language (Greek, if you are Roman), mannerisms of

[162] Gunderson 2000 brings this out well. For two modern counterparts (the Acropolis, Troy), see Porter 2002, 66–67.

[163] See Nagy 1989, 76, on reperformances of Pindar, which had attained the status of "classics" already in his lifetime (reperformances here carry the force of "a remaking of an original poetic event"); see below on Aeschylean revivals; and Webb 2001, 308–9, on later declamation. Further, Swain 1996, 65–100, and now Alcock 2002, on the production of memory, especially Greek classical memory, during the Roman era. Alcock is especially good on "the revival of ancient institutional practices and observances," some of these focused by a veritable Persian War mania (pp. 72, 74–81). The Greek fifth century (cf. Hdt. 8.143–44) paves the way for all of these self-identifying practices.

[164] As will soon become clear, what I have in mind is different from the idea of "close encounters," which is aimed primarily at numinous "sightings" and other epiphanic experiences; the phrase originates with Lane Fox 1986, 102–67, and is usefully expanded by Zeitlin 2001 (see esp. p. 215) to include cultural contacts of any imaginary but still visualized kind between past and present.

[165] Weber 1920 (*Gesamthabitus*: p. 182); Bourdieu 1984 and Bourdieu 1990, esp. p. 73: "The body believes in what it plays at: it weeps if it mimes grief. It does not represent what it performs, it does not memorize the past, it *enacts* the past, bringing it back to life," although I would put more stress on the *disavowal* of illusion than Bourdieu does in his related concept of *illusio* (cf. ibid., 69); Arist. *Eth. Nic.*, passim; Dion. Hal. *Dem.* 52, cited n. 195, below. Further, Gleason 1995.

[166] Cf. Ammianus's epigram in *Anth. Pal.* 11.157 with Swain 1996, 46 n. 16; Philostr. *VS* 541 on "solecisms" of the body; Ap. Ty.[?] *Ep.* 63, 66, 69–71, with Bowie in Saïd 1991, 203; Gal. *De diff. puls.* 8:585–86 Kühn for a similar sensitivity; Plut. *Mor.* 26b, 53c-d, warning against habit-forming impersonations (as with those who mimicked Aristotle's lisp, Plato's stoop, or Alexander's twisted neck and harsh voice). Further, Saïd 2001, 290, and Goldhill 2001, with explict reference to "Greekness," but also implicitly to classical paradigms of Greek identity.

speech (Atticism, the "authentic" language of the fifth and fourth centuries), not to mention what you know and how you think—the connections you draw, the repertoire of facts at your fingertips, the range of your cultural references, the kinds of books you have stored in your mental library. Regardless of the degree to which it affects outer demeanor, classicism as a *habitus*, we can safely say, affects the whole of one's inner life. Thus, a notional speaker in Favorinus's *Corinthian Oration*, a persona that represents Favorinus himself, can claim he is

> not a Lucanian but a Roman; not one of the rabble but a man of equestrian rank who has cultivated not only the language of the Greeks but their thought, life and dress as well, and all this so competently and so manifestly (οὕτως ἐγκρατῶς καὶ περιφανῶς) that not a single Roman before me—or even any Greek of my own time (οὔτε τῶν καθ' αὑτὸν Ἑλλήνων)—has equaled me.

As a consequence, he reasons, bronze statues ought to be set up for him

> in your own city because, though a Roman, I have been Hellenized, just as your own city has been; in Athens, because I speak Attic [or: "because I Atticize," ἀττικίζ[ω] τῷ φωνῇ]; in Sparta, because I am an enthusiast for athletics—and everywhere, because I am a philosopher who has already inspired many Greeks to follow me and not a few barbarians as well. For I seem to have been endowed by the gods for this very mission: to show the Greeks that culture (*paideia*) is just as important for a man's reputation as birth; to show the Romans that they should not cocoon themselves in their own reputation and ignore the role that *paideia* must play in it, and to show the Gauls that no barbarians should despair of attaining Greek civilization (*paideia*) when they look at my example. ([Dio Chrys.] *Or.* 37.25–27; trans. Crosby)[167]

So confident is the speaker of his habituation to Greekness, a Greekness not only of the present but also of the past, that he can claim to be more Greek than contemporary Greeks. The contest he has erected for himself is around "a professional standard based on the past."[168] It is thus a contest over a patrimonial Greek identity, and not merely over an ethnic or contemporary cultural identity: it is a contest in *becoming classical*, which simultaneously implies a complete *mastery* of the classical past. Greek identity has been refigured here as the ability to embody and control the resources of Greek culture in its finest dimensions. And this assimilation to an ideal has to be complete, down to the last atom of one's self.

[167] Anderson 1989, 181–82. Excellent discussion in Gleason 1995, 13–17; Connolly 2001, Whitmarsh 2001; esp. pp. 170–80. See Lucian *Rh. Pr.* 18, 20: "Mention Marathon and Cynegeirus everywhere, . . . pack in Salamis, Artemisium, and Plataea, [and the crowds will marvel at] your appearance, voice, gait, your striding about, your sing-song tone, your sandals, and those 'divers things' of yours" (quoted in Connolly 2001, 357); cf. Plut. *Mor.* 813e–14c.

[168] Anderson 1989, 182. *Paideia* standardly has this connotation of classically based knowledge; cf. Lucian *Somn.* 10.

The case of Favorinus is perhaps extreme, but it is a valid illustration nonetheless, and a useful reminder. We need today to recover a sense of classicism in antiquity as a practice and a *habitus*, and not just as an attitude, a style, or a pedigree. Outward behavior is one indicator of classicism, but so are intellectual positions conceived as practices and as framed by *habitus*. Here, what comes into focus is a stance towards classical values that can be read off even a theoretical engagement with the past (for instance, a grammarian's attitude towards verb forms). Habits of mind are a kind of lived experience and need to be treated as such. They are, in the words of Raymond Williams, "specifically affective elements of consciousness and relationships: not feeling against thought, but thought as felt and feeling as thought: practical consciousness of a present kind, in a living and interrelating continuity," where in question at any moment are not hidden, private feelings but decidedly *social* feelings tied to "specific kinds of sociality" and ultimately destined, at some level, for public consumption.[169] This is not to say that we should try to discover some one correct and all-inclusive *habitus* of classicism, nor that we should assume a naïve, gut-level attachment to the values of classicism among its practitioners. Rather, we can expect to find a range of practices, with varying degrees of commitment and engagement, all of them recognizably classicizing, but each shaped differently according to the different conceptions of the classical that will have been available at any one time and in any given cultural milieu.

Nor should we imagine that classicism was ever an exclusive trait even among its practitioners. These were involved in a range of activities, not all of which were classicizing. In art, classicism was but one element in a range of styles that could be blended or juxtaposed at will, and the same holds for cultural behaviors.[170] Eclecticism, syncretism, and an improvisational approach to styles of cultural belonging conceived as a palette are typically to be found in Greco-Roman antiquity, in much the same way that contemporary studies of identity allow for multipositional identifications ("subject positions"), which need not be harmonized or consistent but which can be antagonistic and unresolved in a subject.[171] What will differentiate classicism in the ancient and modern worlds are, *inter alia*, the various social, moral, and political problems to which the adoption of the posture of classicism constitutes a response, if not a solution. Thus, we should conceive of classicism as a strategically assumed, and probably we need to say strategically *naturalized*, identity (set of practices,

[169] Williams 1977, 132–33. Cf. Rosaldo 1989, 117, on the peculiar twin aspects of social feelings, which can "manifest authentic and deeply felt sentiments"; yet even so, "such moments of 'pure subjectivity' do not remain untouched by social force[s] and dominant ideologies."

[170] See Hölscher 1987, 62, and Pollitt 1986, 165, on the sculptural group from the temple of Despoina at Lycosura in Arcadia by Damophon of Messene from some time in the first half of the second century B.C.E., where classical Phidianism and Hellenistic baroque mannerism sit comfortably side by side. Further, Zanker 1988a, 254–58, and Hölscher (this volume) on the eclecticism of Roman visual culture under Augustus.

[171] Laclau and Mouffe 1985.

fantasies, habits, and attitudes), the assumption of which is designed to answer a specific problem in specific historical circumstances.[172] One of the net effects of this identification is that it allows its practitioners to approximate the classical past in the intimate realm of their feelings and experiences: they can actually "*feel* classical" (Porter, this volume). Classicism has the native advantage that it can easily mask the "work" of problem solving that it is doing, which allows it to "provide simultaneously a social use and a denial of the social basis of that use."[173] The inculcated *pleasures* of classicism play no small role in this effacement.

The interpretative task for us today thus shifts from identifying the objective features of classicism to locating the problem its adoption was meant to face, once its clues and indices (the stances of classicism) have been detected. To do this is to undertake a *symptomatic* reading of classicism, or its "phenomenology." For all its dreamy idealism, there is a pragmatism to classicism, even if, or more likely just because, classicism presents so many insoluble problems of its own. The paradigms of slavish subservience to a past, or melancholic nostalgia, secondariness, and inferiority are doubtless overstated and overdramatic. A sounder approach is to credit the exponents of classicism with consciously adopting poses and strategic identities so as to manipulate and negotiate with rather than to serve the past. But one should also allow for the possibility that these same exponents could be as much manipulated by their assumed positions as they could manipulate them.[174] *Habitus* implies habituation; and habit has a force of its own.[175] One good example of the compulsory logic of *habitus* would be what Renato Rosaldo has called "imperialist nostalgia," whereby a subject assuming a dominant perspective adopts, paradoxically, a nostalgic yearning for what the dominant culture has caused to perish—in this case, the former superiority of Greece.[176] But there are other kinds of self-manipulation at work in classicism that would need to be explored.

Let us highlight just a few of the ways in which the practice of classicism is brought to bear in different historical circumstances. In Egyptian Alexandria, classicism is bound up with the difficulties of a Greek-educated elite in the throes of cultural dislocation, who have been characterized, probably over-

[172] Excellent parallels in the classical revival of Emperor Ming (58–76 C.E.) are to be found in Powers 1991, ch. 5.

[173] Bourdieu 1984, 73 (with special reference to the "reading of the 'classics'"); cf. ibid., 68, on naturalization.

[174] Cf. Dio Chrys. 18.12, noting the way in which contemporaries' critical faculties become "enslaved" to classical texts; and ibid., 13.29. Yet Dio is willing to exploit and encourage identifications of this kind (cf. ibid., 43.3 with Connolly 2001, 365).

[175] Cf. Hinds 1998, 90, moving beyond "sanitized" literary formalism: "Recognition of the tropes of literary history does not entail denial of their status as lived experience."

[176] Rosaldo 1989; see Alcock 2002 for its application to Rome. It should be added that nostalgia in this form—identification with the perspective of the "victor"—could affect both Greeks and Romans.

dramatically, as "a society of displaced persons" agonizing over their "rupture" with the past.[177] In Pergamum and in other parts of the Hellenistic Greek East, classicism is a way of exploring connections to, *inter alia*, the Athenian past (see Stewart, this volume, along with Stewart 1979). Among Romans at different points in their history, classicism is a way of expressing proximity to or distance and autonomy from Greece, and often both of these things at once.[178] During the Second Sophistic era, classicism is a way of articulating identity vis-à-vis Rome (see Whitmarsh, below).[179] In later antiquity, an era regrettably only glimpsed in this volume (see Elsner), classicism comes to stand for a newly defined paganism.[180] At the end of the eighteenth century in Europe, classicism in the form of Hellenism is a way of revolting against, but also a way of accommodating, the values of Christianity (and especially of Pietism in Germany), in addition making new claims about class, national identity, sexuality, and various Enlightenment values, such as freedom and autonomy.[181] Cruder acquisitive and exploitative interests are a factor as well, given the economic attractions of the classical and its direct ties to market activity, not to mention the politics of symbolic control and domination as powerful motives in their own right.[182]

The list of the defining constraints on classicism and its uses can be multiplied and localized at will, which is exactly what a more thorough study of the phenomenon ought to bring out. The classicism of the poet-scholar Callimachus in third-century Alexandria will in principle be different from the classicism of Theocritus, reflecting his third-century Syracusan origins, which in turn will have contrasted with that of Moschus in second-century Syracuse.[183] Responses to Athens once it was turned into a cultural museum under Rome will have varied, and even clashed, at any single historical moment, depending

[177] Bing 1988, Selden 1998; cf. Bulloch 1993. Stephens 2003 steers well clear of this kind of language, which seems to be a residue, or refinement, of nineteenth-century prejudices against Alexandrianism. Further, Cameron 1995, 26–30 and 42–44.

[178] See Horsfall 1993, Woolf 1994, Habinek 1998, 60–68, Hinds 1998, Farrell 2001, Alcock 2002, Zetzel 2003; further, Bowersock 1995, focusing on Hellenism, rather than on classicism. There is more work to be done on the Roman side of the equation, especially in pre-Republican literature, and in material culture beyond the visual realm (though see Elsner and Hölscher, this volume).

[179] Bowie 1974, Anderson 1989, Schmitz 1997, Goldhill 2002.

[180] See Auerbach 1965, Kaster 1980, id. 1988, Cameron 1984, Schindler 1988, the chapters by Consolino and Schmidt in Voßkamp 1993 (with further bibliography), MacCormack 1998, and Gasti in Cajani and Lanza 2001. The Byzantine era is practically an entity unto itself.

[181] Cassirer 1932, Hatfield 1964, Elias 1994, Potts 1994, Marchand 1996.

[182] For market-driven classicism, see Lucian, *The Ignorant Book-Collector* (classicism as fetish); Vickers 1987 on the vase trade during the eighteenth century, a splendid example of the market producing classical value where none existed hitherto. This is strategic classicism in a potent form; but the irony is that calculation becomes encoded as cultural reflex (it is rendered "unconscious," ibid., 104) once the fashion for vases takes off. For power plays, disguised (to us) as connoisseurship, see Alcock 1994, 100–101.

[183] See Hunter 1996, 28–39, 116–122, on Theocritus.

upon the interpretative perspective of the beholder.[184] Classicism is in some ways a poor indicator of its own constraints simply because of its superficially uniform appearances. Nuances are needed.

As the contributions to the present volume demonstrate, we are evidently having to do not with a single form of classicism but with a variety of *classicisms* in the plural, each differently conceived, some less "purely" than others, and more often than not in polemical dialogue with contemporaries and predecessors, among whom the very standards of purity will be up for debate. Indeed, insofar as classicism is a backward-looking phenomenon, we have to accept that there is no such thing as a singular classical past, but only a multiplicity of *classical pasts*, each supplying and contesting the criteria by which the past is imagined as classical and rendered whole. The very idea of a so-called classical past is itself the product of a series of such attempts to unify what came before. To look for anything more than that in the idea is to look for a mirage. The mutability of classical canons in literature and in art is one index of this variety. Established *sub specie aeternitatis*, such notional "lists" evolve dynamically over time.[185]

Classics and Canons

It is important to realize that there were no unified views about questions of classical value in antiquity, any more than there have been in modernity.[186] A case in point is the field of literary criticism, where classical values take an unusually articulated form, and where our evidence for aesthetic reflection in Greece and Rome also happens to be best preserved. Instead of critics presenting a united front, what we find is each critic variously defining his own stance towards the past in a series of acts of self-positioning within a highly contested field. As a result, views quickly get quite nuanced and, what is of even greater interest, they end up complicating the stance of reverence or adoration towards classical values that it would be wrong to attribute to the literary critics *en bloc*. Scanning the field, what we find is not some essential classicism that is everywhere alike but rather a variety of *classicisms*, each differently conceived and for the most part contesting contemporary and predecessor versions. Not only were there considerable disagreements over literary value, with authors being either promoted to or demoted from the top of the critical hierarchies of "best"

[184] See Alcock 2002, e.g., 69, on the likelihood of this spectrum and the difficulties of documenting it.

[185] On the ancient lists, see Kroehnert 1897, Steinmetz 1964, Most 1990, O'Sullivan 1997, Connolly 2001, 348, Citroni 2003c. For a theoretical critique of canonicity, see above all Guillory 1993.

[186] One need only think of the fluctuations in the classical canon among national traditions and over different stretches of time (e.g., France during the Enlightenment, with its Roman-based classicism, vs. the Hellenism of German and much contemporary neoclassicism); or the rise and fall of Plutarch's symbolic capital in Europe (see at n. 210, below).

writers from the past, depending upon a critic's choice. There were also deep disagreements over the criteria by which such choices were to be made.

If literary classicism is a discursive genre, not to say practice, unto itself in antiquity (as it arguably is), then it is a much-contested and polyphonous one, full of shifting alliances and often fierce polemics that are unified only in its most general outlines of a vague reverence for things vaguely classical, albeit within a fairly fixed framework of (high) genres and periods (archaic to fourth century). So it can happen that the fate of Demosthenes, say, or of Plato, Lysias, or Isocrates will rise and fall with changing fortunes over time, while the range of choices will remain predictably constant: one or the other of these authors will come out on top as the (disputed) winner (Lysias for Caecilias of Caleacte; Isocrates and Demosthenes for Dionysius; Homer, Demosthenes, and to a lesser degree Plato for Longinus), while the disputes will be limited to the question of which of them is to be accorded the highest honors, and why. Interestingly, the truly "classical" authors comprise a thin sliver of the "canon": Lycurgus and Dinarchus, while eventually enshrined among "the Ten" (viz., Attic Orators), rarely come into contention for the rhetorical ideal, and the others fade away before the brighter lights of the usual suspects.[187] The canon of sculptors is likewise volatile, and not only at the top: in a field that stretches a century and a half, Phidias, Polyclitus, Praxiteles, and Lysippus all contend for highest honors in the ancient notices. Did literature and art peak or decline after the fifth century? Much depended upon the criteria that were used to rank works.[188] Were the best works beautiful or sublime, charming or austere, a blend of these traits or a predominance of one or the other? However hotly

[187] Cf. Dio Chrys. 18.11, recommending Lycurgus: he has a somewhat "lighter touch" than the other orators. The recommendation is rare. Not even Dionysius of Halicarnassus can muster up much enthusiasm for Dinarchus (see *Din.*). Dionysius's stylistic writings, outside of *Comp.*, cover only four (albeit standard) orators and one historian (Thucydides).

[188] So, for example, Phidias remained unchallenged whenever he was judged by narrow formalistic criteria (Schweitzer 1932, 44), of which *summetria* was not one: both Phidias and Lysippus excelled in symmetry (Lucian *Im.* 6; Plin. *HN* 34.65), which is a catch-all criterion typical of aesthetic language in antiquity, often signaling no more than artistic orderliness (proportionality, commensurability of the parts). On the term and its uses, see Pollitt 1974, 256–58. As for Polyclitus's various fortunes, see Cic. *Brut.* 70 (Polyclitus is perfection itself) and Quint. *Inst.* 12.10.7–9 (critics find him lacking in *pondus*, or grandeur, in contrast to Phidias and Alcamenus). A narrative line that—somewhat remarkably—places the peak of Greek literature, aesthetically speaking, in the Hellenistic period is the Aeschylean *Vita*, which finds Aeschylus lacking in *leptotēs*, or refinement, an aesthetic value that according to Aristophanes was introduced into tragedy by Euripides, who in the process rendered his elder rival old-fashioned (cf. Ar. *Ran.* 939–43; "*archaios*" in the *Vita* [331.18 Page], a quality evidently *sought for* by Aeschylus, according to the *Vita*). If this account were true, would that make Euripides unclassical? Perhaps it would, for Aristophanes in 405 B.C.E., but not necessarily later on. It is worth noting that even this revisionist literary history from a Hellenistic perspective is to an extent classicizing: it seeks a fifth-century legitimation in Euripides and Aristophanes, and it finds a forerunner of the refined style in elegy, and in particular in Simonides, who was said to have worsted Aeschylus on one occasion when both competed to honor the dead at Marathon (*Vit. Aesch.* 332.7–10 Page). See further Scodel 2003, 134–35.

contested the lists are, in the end it is a matter of weighing "gold against gold" (Dion. Hal. *Pomp*. 1.7).[189]

In its own rhetoric, classicism is a practice that generates "the only true reading, the reading of the nonperishable, the reading of the eternal, of the classic(al), of that which cannot be thrown away" (Bourdieu).[190] Despite the rhetoric of permanence, which is the rhetoric of classicism, the classical is necessarily a moving object because it is an object constituted by its interpreters, variously and over time. There is little point to adopting a positive notion of the classical as an agreed-upon item (this particular artist, this work) endowed with (these) fixed features. That was the fallacy of previous generations.[191] The absence of a rigid designator like *classical* in Greek or Latin, let alone a clear set of positive properties that could be used even by a single author to define the essence of a classical object, is itself an index of the freedom of judgment the ancients were accustomed to adopt in their attitudes to the past. There is a lack of determinacy to the idea of the classical in antiquity that deserves our attention, and even to be taken seriously. Classicism, particularly in its modern form, is the wish to negate all of this variety.

The general terms and criteria of classicism sometimes change (although they roughly correspond to eternal and imperishable value, which ironically must be rescued and recuperated *lest it perish*), but the objects of classicism change all the time, and most of all whenever they least appear to do so. Plutarch's Homer is not Longinus's—and he is: Homer may be forever, but is he ever the same? Similarly, Cicero's steady value as a stock reference can betray less visible patterns, whereby his name acts more like a convenient foil, a bit of "classic kitsch." Yet is the classic(al) ever anything but a kind of kitsch, however refined?[192] It is precisely this indeterminacy of and within the notion of the classical that helps explain why the notion eludes definition. Indeterminacy can be cashed in for ineffability, which contributes to the apparent unassailability, and the allure, of classicism, a quality that nowhere gets defined but is rather assumed, or felt. As the object of contestation, these attractions are variously conceived in antiquity: no ancient author can define the qualifying attributes of a classical object, and the attributes we do find (in literature: simplicity and charm, *charis*, or else sheer power, *deinotēs*) are coupled with a fundamental inarticulateness about what it is they attach to—rightly so, because it is inconceivable that any one thing that we would describe as classical could correspond to such a sheer variety of descriptive terms. Were the ancients possibly *protecting* their ideas of the classical by surrounding them with so much

[189] Cf. Hidber 1996, 66 n. 287.

[190] In Chartier and Paire 1985, 225.

[191] See n. 15, above.

[192] In Wollheim's terms, classical objects are "permanently at cognitive risk through changes in culture, convention, and perception" (Wollheim 1980, 180–83; here, 183). For the opposite view, Hume 1998, 139. On Cicero as "classic kitsch," see Kaster 1998.

imprecision? Modern definitions arguably do just this. And as we shall presently see, the incoherence of the modern definitions is a direct heir to these practices from antiquity. The incoherence of classicism does not come from all this variety, which is to say from the attempt to locate classical features in this as opposed to that style, sculpture, or temple, but only from the attempt to locate classical features in any supposed *single* instance of classicism. This incoherence is ideological.[193]

Mechanisms of Classicism

What we have been describing so far is the illusion of received classicism. Classicality turns out, on this view, to be something like the *je ne sais quoi* quality of certain works, whatever it is that cannot be named but that causes them to be admired as unsurpassed. It is quite literally their "cause"—the cause of their positive attributes (permanence, value, etc.). In itself, this quality is empty, possessing no positive attributes of its own. Part of the illusory power of classicism is its seeming "rightness" in the face of the very lack of evidence for its claims, which is to say its essential elusiveness. Classicism, in other words, operates according to a logic of misrecognition. And so, while classicism and the classical are always *retroactive* effects read, as it were, backwards into the phenomena to which they are applied, it is not the case that classicism and the classical are simply *retrospective* effects. Given that this is so, our most pressing task ought to be to describe the mechanisms by which classicism comes into existence rather than simply describing the way it appears to us or to its exponents, and least of all in the form of anatomies and definitions.

What follows is a rough first attempt at naming the mechanisms that produce/identify classicism and the classical. "Producing" here stands for an *identification of*, and frequently an *identification with*, the classical object in question. Only, as we shall see, different objects can come to be produced and identifications can occur in unexpected ways, which is to say through unexpected byways. Consider the following alternative scenarios:

- *Retrospective classicism.* One normally thinks of classicism as a *retrospective* phenomenon. Classicism here is viewed only as existing after the fact, as though it were unavailable and invisible to its original producers. Here, classicism is like an object that is enjoyed in a kind of unwitting immediacy at the time of its origin and that is visible and identifiable only *après coup*. What is more, the coming into view of something classical occurs here apparently without the help of any mediating agency: what is classical simply becomes

[193] That ideology is a repository of incoherencies of all kinds is one of Karl Marx's most penetrating insights. Further, Žižek 1989; and Rosaldo 1989, 110: "Just as no ideology is as coherent as it tries to appear, no single voice remains without its inconsistencies and contradictions." The inner diversity, and consequent flexibility, of Greek Hellenism is nicely captured by Woolf 1994, 128–29.

available at some point to later observers, who suddenly recognize it and then recognize themselves as occupying a postclassical condition. This is by far the most common way of accounting for classicism today, which easily shades off into a musealizing attention to the past.[194] Schematically, we might represent this mechanism as follows:

Classical Object (C) ← Beholder (B)

Another name for this kind of production/identification of classicism might be *transferential classicism*, whereby a set of properties is retrojected and then "discovered" in the past. The arrow, on the transferential model, thus marks not merely the direction of a gaze but also the productivity of that gaze. (This is akin to what Too, below, calls "redescribing reality.") On this model, classicism's features are retrojected onto the past and then construed as inhering in it. But, in fact, classicism scarcely comes about so spontaneously as this, if it ever does at all. Classicism is not a spontaneous effect but a practiced gesture, repeated over historical time, and a cultivated attachment; it is learned, not discovered; it comes secondhand, and (as with all public pleasures) the image of a classical past is, like twice-breathed air, *enjoyed* secondhand.[195]

- *Regressive classicism*. Classicism here offers a staggered look, whereby the classical presents itself in receding steps: one age's classicism is another age's postclassicism. An example: Athens in the fourth century appears to later centuries in a classical light. But for fourth-century Athens, it is Athens of the fifth century (from Marathon to the end of the century) that appears classical, as Karl Jost and Nicole Loraux have made abundantly clear. (We can call this "the invention-of-Athens syndrome.")[196] Yet, late-fifth-century Athens, that of Aristophanes' *Frogs*, looks back to an earlier past as its *own* classical and idealized past (the age of Marathon and Aeschylus).[197] But that is not all. The first revivals of Aeschylus took place after his death in 456, which is one more index of the way in which classical Athens could look back to its earlier self.[198] Martin Robertson describes Polyclitus's Doryphorus, which was modeled on his classical "Canon," or theory of proportions, as marking "a return to an

[194] Cf. Kant (among many others): "Only those models can become classical which are written in the ancient, dead languages, now preserved only as scholarly languages" (*Critique of Judgment*, §47; trans. Pluhar).

[195] Cf. Dion. Hal. *Dem.* 52, recommending to the aspiring reader and future writer "long training (ἄσκησις)," which will induce "a great empirical skill [or "disposition": *hexis*] in whatever he has been studying/practicing (τῶν αἰεὶ μελετωμένων)," etc. (trans. Usher; modified).

[196] Jost 1936; Loraux 1981 (explicitly addressed as a problem/construction of "classicism" on p. 4).

[197] For this linkage, which is conventional, see the Aeschylus epigram (*Vit. Aesch.* 332.24–27 Page); Ar. *Ran.*; Paus. 1.14.5; and Scodel 2003. But it should be underscored that while the classical commands respect, it need not command popularity or total assent: it is frequently *musty* (*archaion* and *vetus* capture this ambiguity; see below).

[198] Ar. *Ach.* 9–12; sch. in Ar. *Ach.* 10; Philostr. *V A* 6.11 (Csapo and Slater 1994, 11–12); *Vit. Aesch.* 331.1–2 Page; Seidensticker 2002.

archaic ideal after the experiments of the early classical period."[199] And as Jeffrey Hurwit points out, sounding a theme that will be repeated in the chapter by Alcock and Cherry below with respect to Hellenistic and Roman practices at Orchomenos, "every major element of the Periclean building program was materially, thematically, or compositionally bound to at least one [archaic and early classical] predecessor," creating the overall effect of "a landscape of memory" and a "conscious . . . display of the past."[200] What did early-fifth-century Athens look back to as *its* precursors? Were these merely ideal or were they also (incipiently, or *already*) classical (again, as in the Foundry Cup shown on the frontispiece to this volume)—and if the latter, according to what, and whose, standards?

According to Demosthenes, fourth-century reverence for Athenian ancestors is at the same time a reverence for reverence itself: it is a prolongation of an earlier practice, inherited from the generation whom the fourth-century orators adored, and who in turn honored themselves and their own forerunners (20.113–19).[201] And though Demosthenes gives no indication as to how far back the practice can be traced, this indeterminacy may be part of the point. Whether the *epitaphios logos*, or genre of the funeral oration, originated in 480/79 or in 465/4, the impulse to praise and idealize one's ancestors is deeply ingrained in Greek culture.[202] In poetry, the incorporation of the archaic lyric poets into the classical canon (Sappho, Pindar, etc.) already in the fifth century, and the ever-looming presence of Homer, who became the dominating paradigm for all of Greek culture and the first classic author (a position he achieved probably well before the sixth century), suggests that there may be no way of halting the regression into the past at all: the *preclassical* here becomes the *protoclassical*, if not altogether classical.[203] Where does the regression end? Homer, after all, is not the beginning of the chain. Our Homer is acutely aware that he comes at the *end* of a tradition, or at least that he stands at its most

[199] Robertson 1975, 330, cited with approval by Hallett 1986, 82 n. 57; cf. ibid., 74 n. 27.
[200] Hurwit 2004, 60, 84.
[201] Cf. the passages collected in Loraux 1981, 1 n. 3 (Athenian authors in effect praising the established genre of the funeral oration).
[202] Jost 1936, Strassburger 1958, Hall 2002.
[203] Burkert 1987; Nagy 2001, esp. p. 75, on the incorporation of preclassical and classical phenomena into a single "classical system" that recognizes only classical (or protoclassical) and unclassical (or anticlassical) instances: thus, Archilochus's victory odes are for Pindar "nonclassical or even anticlassical." An advantage of this conception is that it is not tied down to fixed classical properties, such as "the world of affirmation and celebration" that "counter-classical poetry suggests that we mistrust" (Johnson 1970, 127). On the contrary, as the system evolves, or else, depending on the perspective taken, the points of reference (the values) shift correspondingly. Thus, one could well imagine *difficulty* and *complexity* being reassigned as proper, or rather properly appreciated, traits of a classical author for once, *pace* Winckelmann's dictate of "noble simplicity" (as, for example, Arrowsmith 1963, 54, argues on behalf of Euripides—except whenever he slips back into the paradigm he would resist: "the wholeness of the old hero is now represented divisively" and is "fragmented," ibid., 40).

recent cutting edge (a view the ancients likewise shared).[204] And for all we know there may be a kind of classicism at work in preclassical periods—a geometric classicism, a Homeric or a Bronze Age classicism,[205] even a Cycladic classicism, not to mention regional and local classicisms, possibly radically at odds with the Athenian model or models (Corinthian, Spartan, and Syracusan classicisms).[206] And at each point along the chain, the projection of a classical antecedent is conceivable, while the inclusion of Homer in the paradigm, indeed as its seemingly unequalled exemplification, guarantees that the line of classical instances can be neither halted nor definitively located at some clear point of origin, whether for us today or in the eyes of the ancients.

Whenever it may have occurred, the emergence of a "monumental" Homer, sometimes described as "an absolute classic," presumably codifies an attitude, more than a judgment, that was antecedently available and in the making. Homer—whoever he was—merely occupied the gap left open by this expectation or wish. Indeed, current thought would suggest that Homer was invented just in order to occupy this gap.[207] This opens up the possibility that the perception of classical traits, or at the very least of traits that later come to be recog-

[204] Cf. Arist. *Poet.* 4.1448b28–30; Cic. *Brut.* 71; Plin. *HN* 7.205.

[205] The Panathenaic festival (566/5) limited the rhapsodic contests to a corpus of two works, the *Iliad* and the *Odyssey* (Lycurg. *Leocr.* 102; Isocr. *Paneg.* 159; Pl. [*Hipparch.*] 228b). How these works were chosen and why is unknown, but the process of selection was almost certainly a long one, extending back a century or more, and crystallizing a process that went back to the beginnings of epic. That this process was paralleled in the realm of ritual observances seems likely, as the Dark Age hero cults around Bronze Age sites suggest (Coldstream 1976; Snodgrass 1980, 18, 68–78; Humphreys 1981; Vermeule 1986; Crielaard 1995, 266–73; Antonaccio 1998; Boardman 2002).

[206] Are Polyclitan and Phidian classicisms regionally marked (Argive *versus* Athenian)? One could easily spin out the speculations (rigidity of proportions, austerity, and hardness of features, reflecting Argive traditionalism *versus* softer, grander, more majestic, and more imposing lines and features, better suited to the brash imperialism of Pericles' Athens), but the point is simply that our term *classical* lumps together what are in fact (here, two) considerably distinct sculptural aesthetics. A further complication: later local traditions could revise earlier ones. Thus, according to Polybius (4.20.8–9), Timotheus of Miletus and Philoxenus of Cythera, who were controversial exponents of the "new music" in late-fifth-century Athens (and spurned the older traditions), became classroom "classics" in second-century Arcadia; and inscriptional evidence shows that Timotheus enjoyed the same status elsewhere (Priansos and Cnossos: *IG* 2².3055; *IC* 1:66, no. 11, 1:280, no. 1).

[207] The phrase "absolute classic" is from Burkert 1979, 57, and Burkert 1987, 55, who notes that the (as it were) invention of Homer by the poet of the *Hymn to Apollo* is a calque on an epic idiom for futurity (*metopisthen*, "in future generations"). See at n. 220, below. The newly focused attitude towards Homer is likewise a calque on an antecedent attitude of reverence to an epic past (see previous note), transferred now (or at some point) to Homer. It is not inconceivable that the epic singers were eager to appropriate some of this reverence to themselves, most recognizably by way of the figure of the internal bard in the epics (on which see Segal 1992) and by way of other devices of self-conscious attention to the medium and value of epic poetry, as at *Il.* 6.357–58: "hereafter (ὀπίσσω), . . . a song for men to come." Schmalzriedt 1971, 22 adds: "One can say, somewhat provocatively, that Greek literature was classicistically oriented from the beginning and in its essence." On the sixth-century "invention" of Homer, see West 1999; and cf. Graziosi 2002.

nized as classical, originates early on in the history of literature, as it arguably does in other arenas, for instance in music or visual art (see D'Angour, this volume). At any rate, the fact of regression typically goes unnoticed by observers situated in later classical pasts, for whom the earlier ages can either be glorified in a kind of temporal blur with no clear periodizations drawn (say, between what are now known as Archaic and Early to Late Classical) or, at another extreme, be deemed preclassical and not protoclassical ("rude" or "archaic"), even as their cachet as pristine origins is preserved and the "system" of classical authors is amalgamated into an undifferentiated, idealized whole. Where these two attitudes collide, ambivalence towards the archaic past sits uncomfortably alongside reverence. Pausanias's well-known comment on archaic statuary forms (2.4.5)—that for all their inartistic qualities and strangeness, "there is nonetheless (ὅμως) something divine (τι ἔνθεον) in them"—is typical of this mixed perception. The ambivalence is deceptive. In fact, in most cases the (still) ill-thought category of the archaic constitutes or instantiates what is most venerable, but also what is most foreign and puzzling (and thus, *unclassical*), *about the classical itself*, whence the dogged persistence of archaism in classicism.[208] The persistence throughout later antiquity of what could be fairly called "Bronze Age classicism" is another of its expressions (see Alcock and Cherry in this volume). Schematically, regressive classicism looks something like this:

$$C\ (\leftarrow B) \leftarrow C\ (\leftarrow B) \leftarrow B$$

- *Mediated classicism.* Perhaps the most interesting but least noticed aspect of classicism, this model is suggested by the foregoing one, which introduced into the picture a series of observers, each looking back upon the past, but each also being looked upon by a later generation. What this complication adds is the possibility that classicism here is not an unmediated glimpse of a classical past by a postclassical observer, but is rather filtered by the imaginary vision of an intervening stage. On this model, what the observer "sees" and identifies, and identifies *with*, is not a classical phenomenon but *another observer's view* of that phenomenon. Here, *identifying* a classical moment often involves *identifying with* an intervening age's identification of (and possibly also with) that moment. Classicism here comes, as it were, secondhand. It is arguable that this mechanism—*identifying with a prior identification*—is the most common way of generating retrospective classicism. And it is quite likely that the greatest debt of classicism in modernity is not to classicism in some unmediated form, say, the direct apprehension of classicism in the fifth century, but to the postures of later generations who sought, and found, an identification of or with fifth-century classicism, the canonical instance of ancient classicism (but by no means its only expression, as we just saw).

[208] Porter 2000b, 226–48; Porter 2001a, 71 and 85–86; Settis 2002, 30 (on the symptomatic place of Dorianism in the classicism of modern architecture), though differently ibid., 34 ("vacillation"). See above, on Aeschylus; and compare Aristophanes' ambivalence towards him in *Frogs*; and see further at n. 199 above.

Identification, evidently, is a complex process. An example of a later generation's identification *of* fifth-century classicism would be Hellenistic art, which works with and against classical models. An example of a later generation's identification *with* fifth-century classicism would be the classicism of fourth-century Athens. An example of *a later generation's identification with a prior age's identification* with a classical moment would be the way a literary critic like Dionysius of Halicarnassus in the last century B.C.E. conceives of classicism. True, Dionysius often goes back directly to classical authors of the archaic and high classical eras (Homer, Sappho, Pindar, and so on). But his *attitude* of classicism is defined by an intermediary stage, whether implicitly by the Alexandrian scholars who consolidated the classical canons during the third and second centuries, or, more interestingly for present purposes, in his adoration of the fourth-century orators like Demosthenes, whose attitude to the past directly models his own.

Oddly, it is for the prose writers and especially the orators of the *post-*Periclean era that Dionysius's greatest praise is reserved, and the same is true for other late arbiters of literary taste, such as Hermogenes and Longinus, in both of whose eyes Demosthenes is of equal or greater rank than any classical poet. Astonishing as this may sound to our ears, the reason ought to be quite simple. One explanation is proximity: rhetorical writers are naturally (professionally) aligned with rhetorical predecessors and models. But a further factor is surely at work: Demosthenes is among the earliest *classicizers* who revered an idealized fifth-century Athens and who consequently were the most eloquent spokespersons of the classical idea known to later antiquity. Being the most proximate avatars of the classical, they themselves came to be considered classical as well—a powerful combination that sufficed to put later readers in an unrivaled state of classical ecstasy (*Dem.* 22). In Dionysius's eyes, Demosthenes is skillful in "comparing the behavior of his contemporaries with that of his ancestors" from the generation of Marathon, when "the Acropolis was full of silver and gold" and the Athenians risked life and limb rather than hire mercenaries to fight for their freedoms against barbarian intruders (*Dem.* 20, 21). Classicism here consists in the identification, not with an originary moment in the production of classical value, but *with the attitude of classicism itself*. Both Dionysius and Demosthenes are at home, and at one, in the *epigonal* experience of being postclassical. Something of the same kind must be at play in the love for Athens professed by Atticus, but depreciated by Cicero, in Cicero's *Laws* (2.4), and from which it can be deduced that "Atticus actually takes pains to deny that he loves Athens as a center of culture, but rather insists that *he loves it because*, like [Cicero's native] Arpinum, *it was loved by men he loves*."[209] For

[209] Farrell 2001, 19 (italics added). Farrell's sequel comments are equally apt to the problem of classical attachments: "The love felt by Atticus is an acculturated love, something learned—the kind of attachment that an individual might feel to a place with which he has no natural connection at all."

all of these reasons, mediated classicism belongs both to the foregoing and the following models of classicism.

This, one suspects, is the attitude that most readily defines classicism in its modern forms, which is modeled directly on the second-order classicism of the late Hellenistic and Roman imperial voices that transmitted their veneration to us, and who in turn were nourished by the perceptions of the fourth century. (The once privileged place enjoyed by such writers as Plutarch and Lucian is symptomatic of the same focus: they were read and appreciated precisely as transmitters of an adoring veneration.)[210] Already in the eyes of the fourth-century opinion makers, the past is infinitely brighter than the present, and even the worst of the present goes well beyond what the past knew at its worst.[211] This is a topos, indeed the inherited premise, of later classicizing criticism. The language of hyperbole, put in the service of cultural glorification, is a stock rhetorical trope for later critics. But it was already in place even in the fourth century (for instance, in the mythical heroization of the Marathon warriors), as was the language of purity and cultural supremacy they both share.[212] And the language of imitation and of ideological pleasure—the calls to imitate one's ancestors and to take pleasure in their heritage—was likewise in place already in the fifth century.[213]

Mediated classicism naturally raises intriguing and difficult questions about how many layers of mediation are ever at play in any given identification, and

[210] In Mary Shelley's *Frankenstein* (1818), even a monster is susceptible to these pulls: Plutarch "elevated me above the wretched sphere of my own reflections, to admire and love the heroes of past ages" (quoted in Goldhill 2002, 247). Further, Goldhill 2002, chs. 2 and 5; Settis 2002, 36.
[211] Dem. 22.52; 24.163–64. Cf. Jost 1936, 215.
[212] Cf. Pl. *Menex.* 245c-d; Jost 1936, 215–17. On purity as an aesthetic ideal with political resonances, see Porter, this volume.
[213] Cf. Thuc. 7.63.3 (the general Nicias addressing his allies in 413 B.C.E.): "Think of the pleasure (ἡδονήν) and how much worth preserving it is (ὡς ἀξία ἐστὶ διασώσασθαι) that all this time, through knowledge of our language (φωνῆς) and imitation (μιμήσει) of our way of life, though not really Athenians, you have been considered as Athenians and been admired for it throughout Hellas" (trans. Warner; modified). The topos is carried over into the orators (e.g., the Isocratean formula, "imitate your ancestors," *mimeisthai tous progonous*, or *homoioi gignesthai*, which can also be expressed as a kind of emulation (*zēlōsis*); see Jost 1936, 151–52; cf. οὓς νῦν ὑμεῖς ζηλώσαντες, Thuc. 2.43.4). The passage from the use of *mimesis* in an ideological sense to a strictly literary sense is seamless. See Hall 2002, 205–28, on other later continuities; also Loraux 1981, 260–65, a rather disparaging reading of P. Aelius Aristides' *Panathenaicus*, as though the speech were somehow out of touch with the realities described (when in fact they were only rhetorized) by its predecessors (ibid., 265: "L'histoire du genre [sc., the *epitaphios logos*] finit par une sorte de 'perte' du discours"; differently, Strassburger 1958, 25; and Saïd 2001). Tropes that enter into the discourse of the sublime, such as heroism, danger, grandeur, nobility of freedom, value, identification, timeless perspectives on the future (*di' aiōnos*), a general epitaphic-elegiac stance towards the past, an ecstatic, self-forgetting posture, and even a self-awareness that the past is being idealized nonetheless (in contrast to a decadent present), are likewise inherited (cf. Lys. 34.11; Isoc. 4.30, 6.42–43, 7.16, 12.149–50; Dem. 60.6; Pl. *Menex.* 235a7–c5; Lycurg. *Leocr.* 50–51; Jost 1936, passim and, e.g., 212–20, 231–34; Loraux 1981, 269–70, 278).

about how regressive the identifications may in fact be, but also about whether identification can ever take the reflexive form of *self*-identification, that is, to what extent its sponsors take themselves to be classical. We should never underestimate the prestige that accrues to anyone in the ambit of the classical: there is a privilege, and prerogative, to closing the circle of the past and awarding, or simply reaffirming, the value of what has come before, while arrogating to oneself the title of "classicizer," "classicist," or simply "classical." This is what Henderson in the present volume calls "the double twist of all 'classicism,' " taking Cicero as his example.[214] The diagram for mediated classicism would look something like this:

$$(C \leftarrow B) \leftarrow B$$

- *Prospective (proleptic) classicism.* The commonplace that classicism is only a retrospective phenomenon is misleading for an additional reason. It is usually based on the further assumption that exemplars of the classical do not conceive of themselves as classical. This assumption is not so much wrong as it is empty and untested with regard to classicism in antiquity: the question cannot be decided until a set of criteria for expressing classicism in the absence of a commanding term has been agreed upon. There is no reason why any age cannot imagine itself as being classical, not even one in the grip of a classicizing reverence for the past. Similarly, if it is true that an author or artist cannot be reckoned a "classic" or "classical" before passing the test of time (a rather arrogant premise that says more about the privilege of conferring honor than about the conferee), there is nothing to bar an author from aspiring to this status. Thus, if we accept that Longinus is projecting a standard of classicism with his theory of the sublime, then it is obvious that he expects would-be writers to wish to be sublimely classical (and not just classicizing). And if above I suggested that Dionysius of Halicarnassus identifies with Demosthenes first and foremost as a fellow epigone, this is not to imply that Dionysius does not also aspire to classical status (any less than Demosthenes, for that matter): the two self-perceptions are at odds, but not beyond the inventiveness of the classical imagination to hold together. Indeed, this bifocal vision is characteristic of classicism after the fifth century, wherever imitation and emulation are its preferred expressive means (as opposed to, say, collecting). Winckelmann's prescription for classical greatness is made of the same paradoxical stuff: "the only way for us to become great, and indeed—if this is possible—inimitable, is by imitating the ancients," who are themselves inimitable.[215]

Now, the interesting case comes into view when we return to the presumed source. The usual move is to make the classical an epiphenomenon of classicism—classicism comes first, then the classical follows in its wake as its

[214] Modern classical philology has frequently rested on this custodial premise, as, for example, in the cases of F. A. Wolf and his pupil August Boeckh (see Porter 2000b, 180 and 267).

[215] In Nisbet 1985, 33. The sequel runs: "One must become familiar with their [sc., the ancients'] works as with a friend in order to find the Laocoon group as *inimitable* as Homer" (italics added).

retrospective product.²¹⁶ But while catchy, the logic is as wrong as imagining that the classical is a self-invention, while classicism is *its* epiphenomenon. Indeed, it is just as likely that the classical is invented retroactively in an anticipated (prospective) retrospective light, and that classicism is born along with the classical simultaneously. For who is to say that Periclean Athens, in its official ideological form, was not itself consciously classical, let alone self-consciously *classicizing*—that it sought not only to project itself as classical, but also to *affect* its classicism? If so, we will have to acknowledge that prospective classicism shares an essential feature with retrospective classicism, namely that both come in a heavily mediated form: the projection of classicism involves imagining a *future beholder* of one's accomplishments; it is to see oneself being seen and approved of in the future. Only, on this model, what is projected into the future is in fact a *retrospective* gaze: one sees oneself as *having been seen* at some future point. Nor need this gaze belong to a future peer: the gaze can be constructed as both backward turning and upward looking (admiring). This is a posthumous gaze, inasmuch as the self one projects is a self that no longer is but once was—it is the self as it will have appeared to a later age. Another name for this later age is "posterity." Needless to say, this mechanism of forward projection is distortive and idealizing: like the image of oneself in a mirror, it tends to efface one's least desirable features and to universalize others, not least because the imagined audience is never particular but is itself (benevolently) ideal. Prospective (or proleptic) classicism thus takes the following form, whereby a beholder (B^1) imagines a future beholder (B^2) that gazes in turn upon B^1 (or B^1's works) as a classical object of its gaze:

$$B^1 \rightarrow (B^2 \rightarrow [B^1 = C])$$

The last of these categories may be the most controversial of them all, but unnecessarily so. It ought not to be terribly controversial that Athens under Pericles was aware of its classicism. That the same Athens was aware of itself as somehow different from the past is a commonplace in most accounts of the period, which is typically described as an exuberant age bursting with pride and a newfound sense of possibilities and achievements as well as risks and dangers (Thuc. 1.70.2–3).²¹⁷ In art, the newly achieved naturalism and idealism

²¹⁶ So, e.g., Gelzer 1979.

²¹⁷ On the exuberant self-awareness of the Periclean age, which only seems to have intensified in the course of its reception, see Winckelmann 1972, 133–34; Jost 1936; Vogt 1968, 290–91; Guthrie 1971, 17–18; Pollitt 1972, 64–65; Protzmann 1972–73; Protzmann 1974; Hallett 1986; Hölscher 1989a, 13, 16–17; Edward Cohen 2000; Hall 2002, 201–5, who speaks of new "self-confident and culturally supremacist" attitudes and rightly notes how "Athenian linguistic chauvinism . . . prefigures the 'Atticizing tendencies' of intellectuals in the period of the Second Sophistic"; Borbein 2002, who actually allows for the possibility of prospective classicism and even speaks of a Periclean "will to classicality" (*der Wille zur Klassizität*), by which he understands both "the intention to create something normative and lasting" but also (rather dubiously) "a certain independence of the formal, . . . as well as a sensuous radiance, 'beauty'" (ibid., 15 and 23).

(or better, a certain idealization of the natural) became lodged in the proud consciousness of the period, as contemporary reports indicate beyond a doubt. These two developments somehow paired up with the new Athenocentrism and the sense of cultural originality that were combining potently in politics and culture at large. And so, when Thucydides declares his *History* to be "a possession for all time" (1.22.4), he is proudly projecting himself into a distant, if vaguely conceived, afterlife that (in his mind) was in turn already gazing back upon him. His gesture inevitably has the same valence as Pericles' famous claim in the Funeral Oration about Athens being the school of Greece: "Mighty [and "imperishable" (ἀίδια)] indeed are the marks and monuments of our empire which we have left. Future ages will wonder at us, as the present age wonders at us now" (2.41.4–5; trans. Warner; cf. 1.10.2), and the sentiment is echoed in fourth-century orators (Hyp. *Epit.* 18; Pl. *Menex.* 241c8–9).[218] As Most demonstrates in the final chapter of this collection, and the ironies of Isocrates' reception in antiquity suggest this as well (Too, this volume), the local, parochial, and politically fraught interests of Athens and of individual Athenians would later be projected onto a world stage and so transformed beyond recognition, resulting in the form of classicism known to us today. But the seeds of that transformation, and its ultimate pretension, are arguably already in place in the fifth century.[219]

Our immediate concern, however, is with the projective logic of proleptic classicism. Consider Thucydides' text again, the assertion that "future ages will wonder at us." Thucydides (or Pericles) may have Homer in mind here, or at least the author of the Delian *Hymn to Apollo*, "the blind man of Chios" (v. 172) whom Thucydides took for the Poet (3.104.5) and who claims for himself that "all of his songs are the very best among posterity (μετόπισθεν)" (v. 173).[220] Walter Burkert (1987) has good reason to paraphrase the claim as he does: "The best poet of all times, the absolute classic: this is meant to be Homer." That the claim is in all probability a fabrication made in "Homer's" name, possibly by the guild of Delian rhapsodes (*Homeridae*), or whoever it was who put the last, finishing touches on the Homeric poems that have come down to us today, merely indicates the high degree of manipulation that is involved in the gesture of projecting a validating gaze—as does Pericles' assertion that Athens has no need of Homer to sing its praises: "Future ages will wonder at us.... We do not need the praises of a Homer, or of anyone else whose words may delight us for the moment (τὸ αὐτίκα τέρψει), but whose

[218] For the argument that Thucydides intended his work to stand like a monumental inscription visible to onlookers, see Moles 1999. Moles's point seems to be strengthened by the parallels in 2.41 (not discussed by him).

[219] See Hall 2002, 205–20, on "Panhellenism and the 'School of Hellas,'" tracing the increasing organization of "Greekness" around the idea of cultural as opposed to ethnic identity in the latter half of the fifth century.

[220] Translation as in Burkert 1987, 55.

estimation of facts will fall short of what is really true" (Thuc. 2.41.4; trans. Warner).[221] And it is plain that Longinus has Thucydides in mind when he says that sublimity, which "makes a strong and ineffaceable impression on the memory" beyond "the moment of hearing" (7.3)—arguably the mark of what we call the classical (Porter, below)—requires thought for the future. Vying with Homer and Demosthenes, who are to be imagined as standing nearby as one's private audience ("We ask ourselves, 'How would Homer or Demosthenes have reacted to what I am saying, if he had been here? What would his feelings have been?'"), the writer aspiring to greatness must at the same time ask, "'How will posterity take what I am writing?'" (14.1–2; trans. Russell). These two questions are in effect one: to look ahead is to look behind; retrospective views are (of) prospective views, and vice versa. Classicism has this circular appeal, which gives it its paradoxical temporal structure, and its vertiginousness as well.[222]

The various mechanisms of classicism sketched out above—*retrospective, transferential, regressive, prospective* (or *proleptic*)—appear in shifting combinations and never occur in isolation. Both retrospective and prospective classicism are mediated by a projection of a validating instance, that of a beholding gaze. As Pericles' statement above shows, to anticipate a posterity is to project the present into the future as a past, while to vie mimetically with the past is, as Longinus shows, to project the past into the present and then to imagine a future reception for oneself in the light of this prior validation. All of these are ways of generating historical perspective, or at least the illusion of such a distancing effect. Nietzsche knew well the allures of this kind of distancing: "Only [the artists] have taught us the art of viewing ourselves as heroes—from a distance and, as it were, simplified and transfigured—the art of staging and watching ourselves.... Without this art we would be nothing but foreground."[223] A better definition of the motivations for classicism may never be found. In any event, having seen how central a role mediation plays in the classicizing gaze, we are entitled to return to our point of departure, namely the

[221] Cf. Hyp. *Epit.* 18. Predecessors go back to Homer, whether this is to be felt in the bard's own implicit sense of his place in the ever-flowing streams of memory (cf. *Il.* 6.357–58) or in the heroic ethos of *kleos apthiton* (immortal fame). This last expectation is particularly well exemplified in the Homeric τις-formulas, which encapsulate an imagined futurity (often, imagined future *kleos*) projected from the present, rendering the present a retrojected past, as at *Iliad* 7.87–91. the epigraphic tradition perpetuates this same posture; cf. *CEG* 1.264, 286, 399, 824(i).10, and 784. See below, ch. 9 at n. 80.

[222] Cf. Loraux 1981, 83 and 122 ("l'invention des successeurs"); Arist. *Rh.* 1.3 1358b17–20. Aspiring to classical status was a standard element of the classical model in Rome (on which, see Citroni 1998, esp. pp. 30–32).

[223] *The Gay Science*, §78; trans. Kaufmann. Cf. Nietzsche, *Beyond Good and Evil*, §269. This kind of perspectival illusion suffices to satisfy the requirement stressed recently by Gumbrecht 2003, 61: "Therefore, we cannot really appreciate as *klassisch* what we have not first identified as historically remote." (Cf. Kant, n. 194, above.)

simple backward-looking gaze, and to ask whether it possibly constitutes an exception to this rule. Can retrospective classicism look directly, without any middle terms, into the past?

Hardly. In reinventing and reidealizing the fifth-century past, at a time when the achievements of Periclean Athens towered off in the distance even as Philip of Macedon was dismantling the former Athenian Empire, Demosthenes and his age were not gazing directly upon a classical past in a way that Dionysius of Halicarnassus could no longer do. The knowledge of the fourth-century admirers of the past cannot have been at first hand. A century stood between the two ages. At the very least, fourth-century orators like Demosthenes were inventing both an ideal object *and* an ideal fifth-century observer of that object, as is partly conceded by Isocrates when he notes how vulnerable to objection his claims to direct knowledge of the fifth century are. He knows very well that his knowledge is a transmitted one (παραδεδομένοις ἡμῖν), that it has come through hearsay (διὰ τῆς ἀκοῆς) rather than through direct observation (διὰ τῆς ὄψεως): "But perhaps some may object—for nothing prevents me from breaking into my discourse—that it is absurd for me to presume to speak as though I had exact knowledge of events at which I was not present when they happened," etc. (12.149–50). He naturally denies that this indirectness prejudices his view of the past, but all that matters here is his acknowledgment that his view comes secondhand, mediated by the views of others, be they the contemporary inhabitants of fifth-century Athens or the city's envious onlookers from around and beyond the Greek world. Such is the peculiar temporal logic of classicism, which invariably obliges one to identify with the present or the past proleptically, in the future past, which is a future perfect. Classicism is in this sense more than just a fantasy. It is an imaginary identification that, far from being a static property inhering in an object, has to be produced and reproduced each time it is expressed.

Classicism has the delusive appearance of appearing like itself in its various forms, resulting in a superficial similarity that reinforces its ideological claims to truth. Could it be that the modern forms of classicism share a fantasy that is *structurally similar* to that of the ancient Greeks and Romans—the fantasy, say, of an idealization that needs no other context than itself to be understood? Or is this apparent similarity merely the effect of a wished-for identification? Whatever the case, across the various modes of classicism's appearances, one fundamental point remains the same. *Classicism is a transferential experience*, and it is mediated by a middle term. The classical is never directly apprehended: it always comes indirectly and secondhand, which is to say that it is the transference, not merely of a perception, *but of an illusion*, or fantasy, about the past. Only, the fantasy that is had is always courtesy of *another's* fantasy, triangulated around some imaginary object. In retracing the history of classicism(s), it is essential to retrace the history of these identifications, which are embedded in the tradition. *They* are primarily what constitute classicism, and

B^1=Beholder1; B^2=Beholder2; C=Classical Object

Figure 0.1. A classical subject (B^1) takes in a classical object by way of *another's* (B^2's) perception, or rather fantasy, of that object, *but with the illusion of a direct apprehension of and/or identification with* that object.

not the objects of the respective appreciations that we have come to know, and dispute, as "classical."[224]

Obviously, any notion, or "intimation" (D'Angour), of the classical that, say, the fifth-century Athenians may have had will not have been identical with or as fully developed—or perhaps we need only say, as marked with historical sedimentation—as our own. But this does not mean that our own view of the classical has not in some way been shaped (here) by fifth-century Athens's prospective view of itself. And indeed we ought to expect the evolution of ideas like the classical to run in two directions at once, through a kind of mutual suggestion. As modern views of the classical change, what counts as classical comes to be revised. New features come into view and old features are viewed differently. In this way, later views actually change the way earlier phenomena appear. The past is not only seen differently, but it is to all intents and purposes actually changed.

[224] It is for this same reason that classicism, or the history of the classical fantasy, has a specificity that cannot be simply collapsed into other seemingly like concepts, for instance other period or style terms (the medieval, the modern), or other fantasies and practices of transference and identification (triangulated desires of various kinds), however many formal, structural, or other similarities they may appear to share, and however useful these analogies may prove to be. Differently put, these various forms of thought and behavior cannot all be collapsed into the *same* incoherence: each has its own sedimented history.

PART I

The Deep Past: Bronze Age Classicism

Chapter 1

"NO GREATER MARVEL":
A BRONZE AGE CLASSIC AT ORCHOMENOS

SUSAN E. ALCOCK AND JOHN F. CHERRY

THE RELATIONSHIP of the ancient Greeks to classicism is dizzyingly complicated. Now promoted, now assailed for their paradigmatic status, they themselves often turned to retrospection, seeking identity, reassurance, power, judgment—something—in a privileged, or a "classical" past. This complex engagement with tradition and history is a hallmark of Hellenic culture, and constitutes one of the more powerful reasons we find that culture classic.

Yet just how unusual is such backward-looking assessment, such retrospective behavior? Just how far is it quintessentially Greek or antique? In recent years, anthropological and historical studies have increasingly come to appreciate the rampant power of the past in shaping conduct in the present, while recognizing that these processes are manifest in vastly different idioms from case to case. It is clear, however, that material traces and places—monuments, heirlooms, *lieux de mémoire*—frequently play a central role in the recall and reuse of things past. One area of particularly productive recent research, among a number that we might highlight, is archaeological investigation in prehistoric Britain and Europe that emphasizes the recurrent importance of monuments and sites as crucial repositories of memory and as physical links to an ancestral time. Just as crucially, such studies also observe—if often only in impressionistic and imperfect fashion—how their uses vary over time, as conditions and communities alter and evolve.[1] Yet we tend to shy away from calling all such phenomena classicism, a term generally reserved for the specific purities of the ancient world.

There is something to be gained, however, by knocking down that particular barrier—not so much to make Stonehenge a classic site (which, of course, in one sense it already is!), but rather to ensure that our notion of Greek classicism is sufficiently capacious and dynamic, and our methodological approach to it sufficiently wide-ranging. This essay explores that territory by taking on a single and somewhat marginal case: the changing fortunes and shifting perceptions of the so-called Treasury of Minyas in Boeotian Orchomenos (fig. 1.1).

[1] The literature is substantial: see, in particular, Bender 1998; Bradley 1993; Bradley 1998; Bradley 2002; Bradley and Williams 1998; Edmonds 1999; Tilley 1994. More generally, see O'Brien and Roseberry 1991; Van Dyke and Alcock 2003.

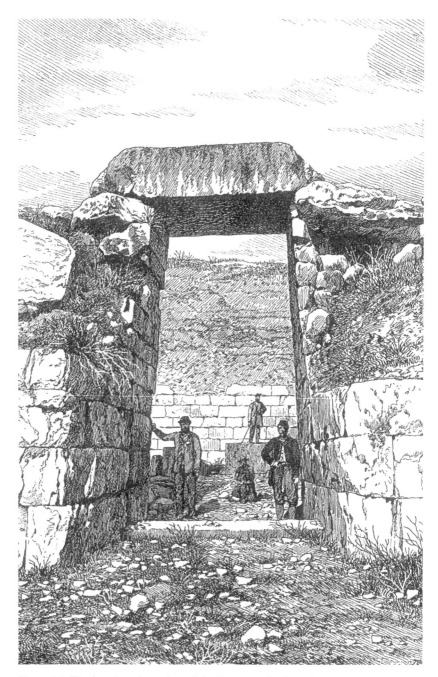

Figure 1.1. The façade and stomion of the Treasury of Minyas in a sketch made ca. 1894. After Perrot and Chipiez 1894, 506, fig. 190.

The Treasury, in archaeological parlance, is a Late Helladic IIIB tholos (or beehive) tomb, with all the attributes of these major Mycenaean mortuary structures: vaulted roof, entryway (stomion) with relieving triangle, entrance passage (dromos), and monumental individual blocks. The only tholos known from Boeotia,[2] the Treasury is a remarkable example of the type, of particularly noteworthy size and ornate decoration—not least the famous and much-reproduced schist ceiling (adorned with an interlaced spiral and papyrus design, in low relief) of the tomb's unusual side-chamber, or thalamos.[3] Scholars and guidebook writers alike have praised the Treasury of Minyas highly, frequently associating it with, or comparing it to, the (slightly larger) Treasury of Atreus at Mycenae.[4]

This tomb, in other words, could be hailed as a Bronze Age classic. In one definition, of course, its sheer impressiveness earns it such an accolade, and certainly the Treasury appears in almost every standard textbook of Aegean archaeology.[5] The context of this volume, however, requires more complicated and productive uses of the term "classic," as do the lessons taught by other studies dealing with the retrospective use of monuments. And here the Treasury has another story to tell, one of use and reuse, of appropriation, of sentiment, and of confusion. It is a story largely told through ruins, and through a long-term history of investigation and interpretation of material culture (one point of departure from most other contributions to this volume). In the end, our most useful contention may well be that a classic monument can earn that title for many different reasons, which change from audience to audience, and from epoch to epoch—and that there is nothing exclusively Greek about that.

"No Greater Marvel"

One key text anchors the Treasury to a specific literary and rhetorical moment in time—the *Periegesis* of the Greek traveller Pausanias, written over a number of years during roughly the third quarter of the second century C.E. Pausanias

[2] For the distribution of LH IIIA-B tholos tombs in mainland Greece, see Cavanagh and Mee 1998, fig. 6.2 (Orchomenos appears in this map as site 293); the tholos tomb closest to Orchomenos (and far less impressive) is at Medeon in Phocis.

[3] For reproductions of the side-chamber's ceiling, and discussions of comparanda for its designs, see Buchholz and Karageorghis 1973, 42 and pls. 163–65; Hood 1978, 76, fig. 58; Schuchardt 1891, 302–3 and fig. 290.

[4] Guide books: Mee and Spawforth 2001, 323; Rossiter 1977, 385; Runnels and Murray 2001, 105, fig. 4.43. Pelon 1976, 385 n. 2, 414–16, and subsequently Hope Simpson 1981, 61, assign the two structures to either the same architect or team of builders; see also Tsountas and Manatt 1897, 126.

[5] See the references in n. 2, *supra*; also Hope Simpson and Dickinson 1979, 236–37; Stubbings 1972, 15–16; Taylour 1983, 70–72; Vermeule 1972, 121–23; Warren 1975, 46. Interestingly, the Treasury seems less popular in recent treatments of the Bronze Age past; it is not highlighted in either Dickinson 1994 or Preziosi and Hitchcock 1999.

makes more than one highly complimentary remark about this monument in the course of his passage through the town and territory of Orchomenos, and his comments have been quoted in almost every extended treatment of the tomb, from Schliemann onwards:

> Chryses had a son Minyas, after whom the people he ruled over are still named Minyans. So great were the revenues of Minyas, that he outdid his predecessors in riches, and he was the first man we know of who built a treasury to store his wealth in. It appears to be a characteristic of the Greeks to admire what they see abroad more than what they see at home. For while distinguished historians have given us the minutest descriptions of the Egyptian pyramids, they have not even mentioned the treasury of Minyas and the walls of Tiryns, which are not a whit less wonderful (*ouden onta elattonos thaumatos*). (Paus. 9.36.4–5)

> The Treasury of Minyas, than which there is no greater marvel (*thauma*) either in Greece or elsewhere, is constructed as follows:—It is made of stone: its form is circular, rising to a somewhat blunt top, and they say that the topmost stone is the keystone of the whole building. And there are graves of Minyas and Hesiod. They say that they recovered the bones of Hesiod in the following way. (Paus. 9.38.2–3)[6]

Pausanias, in other words, found the Treasury a surpassing wonder (his description leaves us in no doubt that he here refers to the tholos tomb we see today). He compared it both to the foreign site *par excellence*, the Egyptian pyramids, and to the walls of prehistoric Tiryns, chiding Hellenes for their automatically greater respect for foreign sights—itself a provocative twist on the presumed prevailing classicism of Pausanias's second-century milieu. He identified the structure, unequivocally, as a treasury, a storehouse for the famed riches of the line of Minyas, adding that it was the first such structure ever built for that purpose. The succeeding text is not entirely clear (as Schachter frets, it is "telegraphic"), but the reference to a tomb of Minyas and of Hesiod does not seem to indicate that Pausanias, at least, associated them with the Treasury.[7]

In the second century C.E., then, the Treasury evidently still stood intact, right up to its keystone probably some 42 feet above the floor; and—although not freestanding, but set into the southeastern slope of a spur of Mount Dourdouvana (the ancient Akontion)—it cannot but have constituted a very conspicuous mark in the civic landscape, an in-your-face, everyday reminder for

[6] All translations from Pausanias are from Frazer 1898.

[7] For another ancient reference to the wealth of the line of Minyas, once again mentioned in relationship to Egypt (the "treasures in greatest store" of Egyptian Thebes), see Hom. *Il.* 9.381–82. Others (including Schliemann himself) have tried to connect the "graves of Minyas and Hesiod" to the Treasury, notably Paul Wallace, who argued that the recovered bones were placed within "the only visible remnant of a glorious past": Wallace 1985, quote at 168. Few seem to have found this convincing, and suggestions have been put foward that Hesiod and/or Minyas were buried, rather, in the city's agora (Lauffer 1974, 317–18; ; see Perrot and Chipiez 1894, 440 n. 1; Schachter 1986, 143–44, 144 n. 1).

the Orchomenians of their own storied past. This, precisely, is Pausanias's view, as Jaś Elsner has emphasized in his recent sophisticated reading of this section of the *Periegesis*. There are, to be sure, various well-worn tropes on display: the notion of *thaumata* (marvels), the theme of excess in the form of astonishing wealth, an elegiac strain of disappointment as one contemplates a history of decline, the backward-looking nostalgia for an earlier age of mythic grandeur, and so on.[8] But the whole passage is constructed as a narrative myth-history of "the people . . . still named Minyans" (9.36.4),[9] and the descriptions of the tholos/treasury and the legends about its builder "are used textually as the frame" for this narrative.[10] For local viewers of Pausanias's own age, the very existence in their midst of this surviving monument automatically indexed Minyas himself, and thus their own identity and history as Minyans. It is remarkable, when one thinks about it, that a retrospective state of mind should have fixed upon a structure already 1,500 years old, whose very function (i.e., as a tomb) was not understood, as the peg on which to hang notions of selfhood.

Oddly, apart from the praise of the *Periegesis*, no further ancient references to the tholos appear to survive. Although various other sources tell of Minyas, the legendary ruler of Orchomenos and the eponymous leader of the Minyan peoples, as well as of the mythic movements and struggles of the Minyans, we have no other direct testimony about the massive structure associated (in the second century C.E., at least) with his name, or about how it was viewed and put to use over the millennia.[11] For that, we must turn to the *archaeology* of the monument.

"I EXCAVATED THIS TREASURY . . . IN COMPANY WITH MY WIFE"[12]

The status Pausanias granted the Treasury—the *thauma* of the monument itself, its fabled wealth, its myth-historical connections—no doubt did much to attract the early antiquarian and archaeological attention it received, despite the

[8] For an exploration of the rhetoric of belatedness and nostalgia as a fundamental ingredient of most travel writing (including that of Pausanias), see Cherry 2001.

[9] The reason being given in 9.36.6: Minyas's son was Orchomenos, after whom both the town and its people were thereafter named, but the additional name "Minyans" served to distinguish them from the Orchomenians of Arcadia.

[10] Elsner 1994, 244–52, with quote at 245.

[11] For a review of the mythology of Orchomenos, see Lauffer 1974, 331–33.

[12] Schliemann 1881a, 136.

[13] For some sense of the powerful and long-lasting influence of Pausanias in dictating archaeological and historical concerns in Greece, see the papers in Alcock 2001, especially those by Alcock, Beard, Elsner, and Sutton. Wood 1985, 71, speaking of early-nineteenth-century travelers wishing to search out the place, mentions the "five-hour horse ride from Athens, along the malarial plain of Copais." For the conditions of nineteenth-century and earlier travel in Boeotia, see Roller 1988 (whose coverage, unfortunately, does not extend as far west as the Orchomenos region).

obstacles such a visit presented.[13] Cyriac of Ancona was poking about the site already in the 1440s. Very early in the nineteenth century, Lord Elgin sent a team of artists to explore; we are told by no less an authority than Colonel William Martin Leake that they were "deterred from making much progress by the huge masses of stone which presented themselves and which they had not the means of removing."[14] Leake himself, and many other nineteenth-century travellers besides, commented on the by then collapsed structure. The next reported attempt at excavation, however, was essentially a raid for building material in aid of a new church, organized in 1862 by the demarch of the village of Skripou (as Orchomenos was called in medieval and early modern times). Almost the entire dromos was robbed out, before official word from Athens stopped the enterprise.[15]

Then comes Heinrich Schliemann. His best-known work, at Troy and Mycenae, began in 1870 and 1874, respectively; but he was forever casting about for Greek sites, rich in legend, to explore by excavation, and his choices were hardly accidental—the appeal of Ithaka to Schliemann's Homeric agenda, for instance, speaks for itself. Schliemann first viewed the Treasury of Minyas on a trip to Orchomenos in late July 1875, complaining about the mosquitoes that plagued his overnight stay at the local monastery of the Theotokos. Exactly a year later, he could write in a letter: "I have permission to excavate Tiryns, Mycenae and Orchomenos. . . . Never fear, in these three sites I will find monuments of capital interest." It was in the fall of 1876 that he made his spectacular discoveries in the Shaft Graves at Mycenae, and it cannot have escaped his attention that Homer uses the epithet *polychrysos* (rich in gold) in relation to just three of the hundreds of places mentioned in the *Iliad*—Troy, Mycenae, and Orchomenos—the first two having already richly fulfilled his expectations. And then there is, once again (as noted above), Pausanias, singling out and linking Tiryns and Orchomenos in his glowing description of the walls of one and the treasury of the other (9.36.5). All these sites were *loci classici*, before Schliemann ever sunk his spade.[16]

[14] Leake 1835, II, 148; see also Stoneman 1987, 158. For references to the tholos in other nineteenth-century travel literature, see Bulle 1907, 1–3; Frazer 1898, 186; Wallace 1979, 161. Arthur Evans, with his wife, journeyed through Boeotia in 1883, specifically to visit the site, before proceeding on to Attica: MacGillivray 2000, 63.

[15] Leake 1835, II, 143–54; for the destruction, see p. 149. Schliemann 1881a, 135–56, noted this act of vandalism with asperity, "The village was already blessed with two churches, each of which is large enough to hold all the inhabitants, not only of Skripu, but also of the neighboring village." A sketch of the stomion and part of the dromos, made in 1805 by Edward Dodwell, shows it already in a quite ruinous state (Dodwell 1834, pl. 13; reproduced in Fitton 1995, 97).

[16] The latest and by far the most authoritative account of Schliemann's career is Traill 1995, supplemented by more specialized (and acerbic) studies in Traill 1993. For the 1875 visit and 1876 letter, see Traill 1995, 131, 143. For other accounts of Schliemann's work at Orchomenos, see Wood 1985, 70–72; Fitton 1995, 97–98. On Schliemann's reading of Pausanias, see Belger 1899.

Schliemann and his wife, Sophie, dug at Orchomenos in three separate campaigns (in 1880, 1881, and 1886), on the last occasion accompanied by Wilhelm Dörpfeld. Despite complete excavation of the main chamber and thalamos, the results were disappointing, at least for Schliemann at the time, yielding tantalizingly few traces of the legendary wealth that he had expected Homeric Orchomenos to produce, and, despite numerous test shafts, no sign of rich Bronze Age graves, let alone another Mycenae-style grave circle. He gave up quickly and, uniquely among the sites he excavated, did not devote a full-scale book to publishing his results.[17] This did not prevent the usual breathless, colored-up accounts of the excitement of discovery:

> Last Monday (22 November [1880]) at 3 p.m. . . . Mrs. Schliemann called out joyfully, "Heinrich, Heinrich, look! the doorway!" It was the moment when the pick of Elias Kanouses, a workman from Petromagoulas, struck into the void of the sumptuous side-chamber that was coming to light. Soon the top part of the doorway was uncovered. It was beautifully worked. . . . I officially summoned and notified the mayor and the head of the gendarmerie, Apostolos Andzolinos, who immediately placed the treasury under constant guard.[18]

Heinrich Bulle subsequently restudied the tholos (published as *Orchomenos* I in 1907), focusing especially on the stratigraphy of its environs. Its romantically ruinous appearance at this time is strikingly depicted—indeed much played up by the human figures—in a photograph from this campaign (fig. 1.2). Anastasios Orlandos partially restored the tomb in 1914, producing what is today the canonical floor plan (see fig. 1.3). In each wave of investigation, the tomb's dimensions and decoration were rethought and reargued, and most aspects of the tomb's original architectural design now seem relatively clear.[19] Curiously enough, however, its construction date still remains somewhat imprecise. Typologically, of course, its striking resemblance to the Treasury of Atreus places the Orchomenos tholos in broadly the same period—namely, the thirteenth century B.C.E.[20] But no sure chronological markers came to light as finds in the excavation of what was, after all, a tomb long since thoroughly robbed out.

[17] Schliemann's book *Orchomenos* (1881b) is merely a German translation of his *JHS* article of the same year (Schliemann 1881a); see also Schuchardt 1891, 299–301.

[18] On this occasion, however, the prose is not Schliemann's, but a report in a Greek newspaper by the engineer, G. Ioannides; cited in Traill 1993, 242; 1995, 205.

[19] Bulle 1907; Orlandos 1915; subsequent attempts to restudy the data, however, have found the documentation that survives from their fieldwork somewhat wanting: Mountjoy 1983, 10. The size of the tomb varied slightly from measurement to measurement, but the final word (of Orlandos) is that the tomb's diameter was a perfect circle of 14 m, with a height probably about the same. The dromos, much destroyed, has been estimated as 20 m (perhaps even 30 m) long and a little over 5 m wide at the stomion; the side-chamber measures 3.8 x 2.8 m. See Pelon 1976, 233–37 and pls. CX-CXV, CLXIX-CLXX for a detailed description, with drawings and photographs, of the tomb.

[20] Pelon 1976, 237; Hope Simpson 1981, 61.

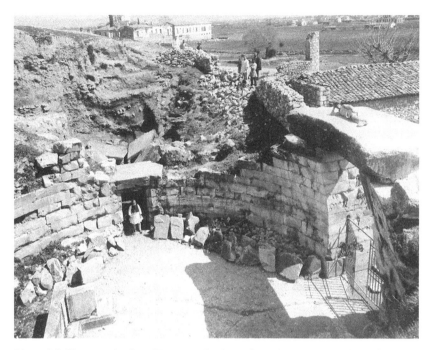

Figure 1.2. Photograph of the Treasury of Minyas from the west, at the time of Bulle's early-twentieth-century investigations. Note the recumbent figure atop the enormous lintel-block of the stomion, the individual in traditional Greek costume standing in the doorway to the side-chamber, part of the pi-shaped structure in the foreground, and the Church of the Virgin at Skripou in the middle distance. Photo: Bulle 1907, Tafel XXVII.1.

That is not to say that the tomb was "empty." Indeed, to anyone but an archaeologist seeking an originary date, the Treasury would seem full to overflowing:

> The accumulation of earth and débris in the treasury was, on the average, thirty feet deep, followed by very large masses of smaller and larger stones, which must have lain on the outside of the horizontally and vertically curved blocks of which the building was composed, and can have had no other purpose than to keep, by their lateral position and ponderous weight, these latter in their position. Below these layers of stone, which must have fallen when the large treasury was destroyed, and the large blocks were taken out for building purposes or to burn lime, I found sixty to eighty of these large blocks, which appear to have escaped the spoilers' hands, and probably could not be taken out easily. Below these large blocks I found successive layers of ashes and other burned material, perhaps the

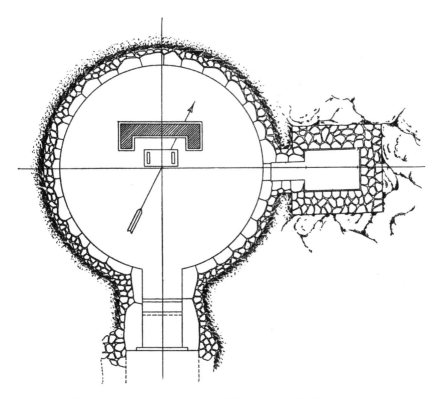

Figure 1.3. Rectified plan of the Treasury of Minyas by A. K. Orlandos, based on a sketch by Dörpfeld (Perrot and Chipiez 1894, 441, fig. 160). After Orlandos (1915, fig. 3).

residue of sacrifices, on an average twelve feet deep. On the smoothed rock I came upon a large number of perfectly rectangular marble slabs as well as cornices, which can have had nothing to do with the treasury itself, and must have belonged to some sort of monument—perhaps a sanctuary—which once stood within it.[21]

Traces of iron clamps in these cornices emboldened Schliemann to posit that the "sanctuary can hardly belong to a higher antiquity than the Macedonian time," a date confirmed, to his mind, by a "curiously sculptured marble slab" and a mutilated draped female statue.[22] A layer of wood ash, from one to four inches thick, separated the cornices and slabs (associated with the putative

[21] Schliemann 1881a, 137; the findings are recapped in numerous publications, from Tsountas and Manatt 1897, 127–28, to Wallace 1979, 155–61, and Antonaccio 1995, 127–30.
[22] Schliemann 1881a, 137–38.

sanctuary) from the actual floor of the tomb, on which were also found marble pedestals with holes for bronze attachments. One of the pedestals, bearing the marks of feet, was definitely identified as a statue base. With his final campaign in 1886, Schliemann refined his vision of the tholos interior; in sketches made for him by Dörpfeld, a pi-shaped base (5.7 m in length) now appears set at the center of the tomb, with an offering table before it (see figs. 1.2 and 1.3).[23]

All of these architectural elements (pedestals, cornices, slabs) demonstrated "most evident marks" of burning, and Schliemann hypothesized that the sanctuary monument must have been destroyed in a great fire, thus explaining the layer of wood ash between these various components. Finally, he reported (in no particular order) the following items: two marble columns, a horse hoof of marble, an Ionic capital, plates of crumbling marble, millstones of trachyte, a hand and a sandaled foot in white marble, a murex shell, some astragali, boar's tusks, whorls of stone and terracotta, disks of slightly baked clay, a glass vase-cover (apparently Roman), bronze nails (which affixed decorative bronze attachments to the ceiling of the Mycenaean tomb), and "masses of both hand-made and wheel-made monochrome prehistoric pottery, mixed with painted pottery like the Mycenian [sic], as well as later Hellenic, and even Roman pottery." The side-chamber, by contrast, offered slim pickings: "I expected to find in the *thalamos* a sarcophagus, or at least marks and indices of its having been a tomb, but I was disappointed," wrote Schliemann (it contained nothing but black earth, a broken tile, and a pierced round piece of terracotta).[24]

This mixed and complicated stratigraphy (which, traced in detail, becomes ever more intricate) somewhat puzzled Schliemann, and even more so those who followed him. He assigned the presence of ash layers to sacrificial activity, and the presence of later material to the fact that the treasury was open in the Macedonian and Roman periods; adding to this, Dörpfeld believed that the extant threshold of the stomion, as well as that of the side-chamber, was of Roman date.[25] As for the prehistoric pottery, Schliemann assumed this fell in from the outside when the tholos collapsed. Earlier habitation clearly surrounded the locale of the tholos, as Bulle later confirmed; indeed Bulle believed that the thick (ca. 12 feet) layer of burned material came from such a prior, external source, and was thus not the detritus of sacrificial activity. Wallace went a step further in reevaluating the problem, suggesting that the tomb was used as a furnace in Byzantine times, with the tholos chamber serving as a receptacle for ashes. Antonaccio reviews all this evidence, and concludes that

[23] Schliemann 1881a, 137–38; Bulle 1907, 86 and n. 1; Orlandos 1915, 52–53; Perrot and Chipiez 1894, 439 and n. 1.

[24] Schliemann 1881a, 138–39, 149.

[25] Cited by Pelon 1976, 235 n. 4; Pelon's view is that the threshold "semble à tout le moins correspondre aux constructions élevées à l'époque hellénistique ou romaine à l'interieur" (Pelon 1976, 235 n. 4); "le seuil d'ailleurs n'a pas été retravaillé à époque hellénistique ou romaine mais bel et bien remplacé par un seuil nouveau" (325 n. 1).

the whole mass of pottery (and presumably at least some of the remainder of the material) is probably intrusive.[26]

From this mélange of opinions, nonetheless, there does emerge an argument that commands general assent—namely, that the tomb was turned to some new and different purpose, quite probably in Hellenistic times (if one trusts Schliemann) and certainly in the Roman period. Apart from the numerous architectural fragments and the large pi-shaped base, two partial inscriptions somewhat reduce the material ambiguity about just what that activity might be. The first, found by Schliemann near the tomb's entrance, appeared on a broken marble slab, reading:

ΕΙΣΗΡΑΤΕΛΕΙΑ

A dedication to Hera Teleia, a deity with rich Boeotian associations, is here identified; the name of Zeus Teleios has also been restored at the beginning of this inscription. The fragment has been assigned no particular date; Schliemann allied it with the later Hellenistic/Roman constructions in the chamber, but others are less certain.[27] The other fragmentary inscription, discovered by Orlandos in the accumulated fill of the tomb, reads:

ΣΕΒ [αστ . . .]

The generally accepted restoration—Sebastos or Sebasta (i.e., Augustus or Augusta)—points to some aspect of imperial cult practice in the Treasury's interior. Orlandos believed this fragment formed part of what had once been a "large inscription," and associated it with the central pi-shaped base, the offering table before it, and the elements of statuary found by Schliemann, dating all of it to the Roman imperial period.[28]

"THE PEOPLE . . . ARE STILL NAMED MINYANS"[29]

The history of the tomb between its construction and use in Mycenaean times, and activity there in the Macedonian (presumably later fourth century or Hellenistic) and Roman periods, at this juncture appears hopelessly blurred, masked by the confusions of its stratigraphy and by lack of specificity in the publication of excavated material (Schliemann, for instance, provided no illustrations

[26] Schliemann 1881a, 139; Bulle 1907, 86; Pelon 1976, 237 n. 8, 374 n. 7; Wallace 1979; Antonaccio 1995, 129.

[27] *IG* VII.3217; Schliemann 1881a, 139; Antonaccio 1995, 127, 129; Schachter 1981, 242. On the uncertainty about this dedication's connection to the architectural elements within the tomb, see Lauffer 1974, 320; Schachter 1994, 123.

[28] Orlandos 1915, 52–53. The inscribed marble fragment is 0.30 m long, with letters 0.07 m high. See also Kahrstedt 1954, 110; Lauffer 1974, 314.

[29] Paus. 9.36.4.

at all to show what he meant by "later Hellenic" pottery). Orchomenos has been suggested as the site of Iron Age hero or tomb cult, of the type seen in many other parts of Greece, but no definite indications of any such activity (e.g., a clear-cut cult of Minyas) have emerged. The very inclusion of the tholos in such discussions may be more a matter of disbelief that so striking a monument, still standing, could have been ignored in the following centuries.[30] How the Treasury of Minyas—if, indeed, it was even thus recognized—was perceived and appreciated throughout Archaic and Classical times likewise remains a mystery.

Apart from evidentiary and publication problems, there is another lurking explanation for this uncertainty: the fact that each and every one of the archaeologists involved over the years in excavating and restoring the Treasury has had an overriding interest in its Bronze Age utilization, thereby occluding serious study of its long *Nachleben*. As a discipline, indeed, archaeology has tended to privilege origins, foundations, earliest documented cases, and so on, and it is an implicit, but unchallenged assumption of much archaeological writing that interest and significance increase *pari passu* with age itself. In Greece, the originary status of Homer in Greek literature and of Schliemann in Greek archaeology have proved to be a very powerful combination in pushing Bronze Age sites to the fore in terms of research agendas, and in giving precedence to the prehistoric phases of multiperiod sites or regions. This too, of course, is a form of classicism—the tendency, for no very good intellectual reason, to emphasize a particular period of the past, simply because it is of higher antiquity, or because it is thought in some sense to be more resonant, or because it is regarded as a key formative era, or because of the clout of early pioneers who opened up its study. The prime example, naturally, is Crete, where a century-long overenthusiasm for all things prehistoric has until recently constituted a serious impediment to the archaeology of all post-Minoan periods on the island.[31]

Despite this bias, as we have seen, the post-Classical fate of the Treasury was marked too firmly to be completely ignored, but it needs to be set in historical context. The documented history of Orchomenos during the Classical epoch was that of a major Boeotian center, whose rivalries with Thebes more than once, in the fourth century B.C.E., led to its destruction and the disruption of its citizen body. Philip II restored the city, for the final time, after his victory at Chaeronea in 338 B.C.E. The textbook political narrative then goes on to report that Orchomenos, following a brief Hellenistic florescence, thereafter declined in prosperity, becoming in Roman times an "unimportant place."[32]

[30] Coldstream 1976, 11 and nn. 27–28; Antonaccio 1995, 127–30.

[31] The point is elaborated in Morris 1992, esp. 183; Alcock 2002, ch. 3.

[32] See, for example, the entries in the second and third editions of the *OCD*: in the second edition, Orchomenos "declined continually" (p. 550); in the third its prosperity "declined in the Hellenistic period, and under Rome it became an unimportant place" (p. 1073).

This is part of the perceived background against which post-Classical activity at this "marvel" of Pausanias must be viewed. Other material evidence from the later fourth century and the Hellenistic epoch sketches in a picture of urban renewal and new building—at least as far as our limited, and prehistorically prejudiced, archaeological perspective can attest. The massive wall system on the acropolis, whose final major stage is assigned to the later fourth century B.C.E. (early Hellenistic), was enthusiastically described by Frazer as "amongst the finest specimens of ancient Greek fortification in existence"—a qualitative classification rather similar to Pausanias's treatment of the Treasury itself. Very near the Treasury, there was constructed a theater (excavated completely only in the early 1970s), which remained in use through Roman times; a series of Hellenistic choregic monuments was recovered in the vicinity, some of which are now stored close to the tholos. Inscriptions of the later Hellenistic period testify to the active worship of deities such as Artemis Eileithyia, Asclepius, Meter, and the Graces (Charites). Recent work by German archaeologists suggests that the so-called Asclepius temple (its attribution is not totally certain) also belongs to the late fourth century.[33]

The territory of Orchomenos, like much of Boeotia, was pulled severely into the conflicts of the last centuries B.C.E.; indeed the crucial meeting between Sulla and Archelaus in 85 B.C.E. is known as the Battle of Orchomenos. The city also lost a famed statue of Dionysus by Myron, taken by Sulla for dedication on Mount Helicon: "what the Greeks call worshipping God with other people's incense" (Paus. 9.30.1). The precise impact of such events is unclear; more apparent is a long entrenched tendency, justified or not, to consider most Greek cities in decline in the Roman epoch—which, of course, only encourages a backward-looking scholarly nostalgia for earlier, "classical" ages. This trope is frequently fed by our literary sources for the period.[34] Of Orchomenos, for example, Pausanias remarks: "They were driven from their homes by the Thebans, but restored to Orchomenus by Philip, son of Amyntas. But it was their fate to sink ever deeper into decay" (9.37.8).

Pausanias's description of the "things seen" in the town proper—highlighting (apart from the Treasury of Minyas) the "oldest sanctuary" to the Graces—is

[33] Walls: Frazer 1898, 180–84, quote at 180–81; Lauffer 1974, 298–99; cf. Scranton 1941, 90–91. The theater remains to be fully published, see *AAA* 6 (1973) 392–93, 395; Amandry and Spyropoulos 1974, 172. Antonaccio (1995, 130 n. 493) notes an intriguing parallel with Mycenae, where a Hellenistic theater also was located very near the Tomb of Clytemnestra, in which a form of Hellenistic tomb cult appears to have been practiced. Asklepios temple: *AR* 1998-9. The goal of the German Archaeological Institute to "investigate and document the monuments of historic times" should augment our understanding of the post-prehistoric site: *AR* 1997-8. Cult activity: for an overview, see Lauffer 1974, 315–22; Schachter for specific references (Schachter 1981, 101, 108–9, 140–41; 1986, 131). For a review of the scarce archaeological finds from the Hellenistic and Roman city, see Lauffer 1974, 313–14; for an overview of the history of Orchomenos, see Hennig 1974.

[34] Alcock 1993, 24–32.

indeed relatively modest, and he also notes how the waters of Lake Kopais encroached upon its territory (a problem traced back, he dubiously reports, to the intervention of Heracles). Yet our other, very scanty sources of evidence for the Roman city indicate continuing cult activity in the city; lists of "solidly Boeotian" names (including a first-century B.C.E. dedication to the gymnasiarch, Alceste Pythonus) suggest the existence of that class of local magnates who elsewhere ran the provincial cities of the east. Territorial settlement and drainage projects involving the cities of the Kopais, notably under Hadrian, include the city of the Minyans.[35] Orchomenos may thus emerge as no major force in the imperial province of Achaia, but the assumption of an unusual decline—enunciated first in Pausanias and spilling into modern verdicts—seems to owe more to its past renown than to its actual condition.

What, then, made the Treasury of Minyas, in the particular social and political contexts of Hellenistic and Roman Orchomenos, an attractive locale for renewed ritual performance? For the more immediately postrestoration (late-fourth-century/Hellenistic) period, a desire to rebuild and redefine a broken and scattered community is evident, most obviously to be seen in the work invested in city walls and the construction of a civic theater. Renewed engagement with the tholos—right next to which, after all, the new theater was placed—suggests that reconnection with the past played some part in this effort. If the dedication to Hera Teleia can be assigned to this period, then the tholos was also annexed to a deity with established Boeotian links.[36] There remains a possibility, given the proliferation of tomb cult in other Hellenistic contexts, that other renowned figures were venerated here, but the evidence remains inconclusive.[37]

As for the presence of the imperial cult within the tholos, a phenomenon we cannot date more precisely than Roman, Antonaccio remarks flatly: "the predilection of Roman imperial families to identify themselves with various divinities is well known and needs no explication."[38] On one level, that is certainly true. We know of the interpolation of imperial figures in numerous existing cult centers or public monuments.[39] Yet the insertion of the emperor in a tholos tomb (unparalleled as far as we are aware) requires further deliberation.

What is an emperor (or, at least, some manifestation of the imperial family) doing in such a place? It might seem a simple enough thing to draw a single connecting line between the Heroic Age and the Roman empire—between Minyas, legendary leader of the Minyans, and the new imperial ruler. This, of

[35] Fossey 1979, 575–78; Hennig 1974, 345–46; Boatwright 2000, 84, 113–16. On drainage projects, and their supposed connection to Herakles, see Knauss 1991; Salowey 1994.
[36] There was a major temple to Hera, with the epithet of Teleia, at Plataia as well (Pausanias 9.2.7). Schachter (1981, 242) posits (but does not insist on) a connection with Hera of the Daidala, a periodic pan-Boeotian festival.
[37] Alcock 1991, esp. 462–63 (no. 10).
[38] Antonaccio 1995, 130.
[39] Price 1984, 146–56; Alcock 2001.

course, presupposes a contemporary correlation between the Treasury and Minyas, a link that can be documented, with Pausanias's testimony, at least for the second century C.E. The Treasury, in this view, becomes a home for the juxtaposition and assimilation of heroic and authoritative figures in civic history.

Such an interpretation seems to us fairly straightforward and, we suppose, not susceptible to serious objections; but it may be possible to suggest a more nuanced reading. Richard Bradley, discussing the venerable monuments of prehistoric Britain, has rightly observed that archaeologists tend to divide up the long lives of monuments into manageable chunks, which they study in isolation and always from the perspective of the present.[40] So, for example, in explaining the imperial presence in the Treasury of Minyas, moderns leap immediately to what seems (to us) most meaningful and memorable about the monument—namely, its Bronze Age associations. Yet other layers of usage and of memorial content were contained in the Treasury, confused as they are to our eyes. It is impossible, with the archaeological evidence currently available, to say much more than this: for all we know, the placement of the imperial cult may have had as much to do with the presence of Hera Teleia, or of yet other, still invisible figures connected with the tholos, or perhaps even with the complex's civic location (for example, its proximity to the theater), as it did with specifically Minyan associations.

Another way to complicate our understanding of this phenomenon is to ask who set the emperor in such a place. We have no direct information about what lay behind the decision-making process at Orchomenos, but the preponderance of evidence from other parts of the imperial east points clearly to the dominant families of the city, the selfsame people we glimpse faintly in the epigraphic record. Such elite support of the imperial cult—to demonstrate external loyalty, to encourage internal order, to adapt to altered political and religious circumstance—is familiar, so that the appearance of such ritual in Orchomenos is hardly surprising. Yet the place selected for it is not routine, but indicates a marked concern to nest the practice into an existing web of myth-historical associations. Such a spatial ordering—placing him within a "marvel"—certainly honored the emperor, but honored him as a part of Orchomenos's own long history, assimilated now within the scope of civic memory. This emphasis on the civic past is entirely in keeping with commemorative strategies observed in other Greek polities of the early Roman empire, strategies working to maintain elite influence, urban standing, and local pride.[41]

[40] "[M]onuments feed off the associations, not only of places, but also of other monuments. Monuments are enhanced and rebuilt; they are reinterpreted and changed; and new constructions are created around old ones. We tend to lose that dimension of the archaeological record as we become immersed in chronological analysis": Bradley 1993, 129.

[41] Alcock 2001; Alcock 2002, ch. 2. Civic antiquarianism in Orchomenos is also witnessed in the treatment of the "oldest sanctuary" of the Graces, which received new images in Pausanias's own time: Paus. 9.38.1; Schachter 1981, 140–44, esp. 141.

The past to which those cities most frequently turned, of course, was the more canonic High Classical past of the fifth and early fourth century B.C.E. Yet we would argue that, in both Hellenistic and Roman times, the Treasury of Minyas was similarly embraced by the inhabitants of Orchomenos as a classic site. It offered itself as a source of antiquity and authority; it served as a landmark of the city and a benchmark of civic identity. The phenomenon of classicism, in the sense of adopting a bastion from the past for self-definition, self-protection, and self-promotion, in Orchomenos took forms other than the strictly Classical.

"Brought to nought by the hand of God"

Such creation of identity through the creative use of monuments is certainly one central strand in Pausanias's treatment of the Treasury of Minyas and of the city of Orchomenos. Yet if the Treasury of Minyas became a compelling weapon for the residents of Orchomenos (especially its elite members), serving as "embodiment of an identity"[42]—ironically it also seems to have summoned and called down the assumption of especial decline upon that city:

> Megalopolis, the foundation of which was carried out by the Arcadians with the utmost enthusiasm, and viewed with the highest hopes by the Greeks, now lies mostly in ruins, short of all its beauty and ancient prosperity. I do not marvel at this, knowing that ceaseless change is the will of God, and that all things alike, strength as well as weakness, growth as well as decay, are subject to the mutations of fortune, whose resistless force sweeps them along at her will. Mycenae, which led the Greeks in the Trojan War; Nineveh, where was the palace of the Assyrian kings; Boeotian Thebes, once deemed worthy to be the head of Greece: what is left of them? Mycenae and Nineveh lie utterly desolate, and the name of Thebes is shrunk to the limits of the acropolis and a handful of inhabitants. *The places that of old surpassed the world in wealth, Egyptian Thebes and Minyan Orchomenus, are now less opulent than a private man of moderate means*; while Delos, once the common mart of Greece, has now not a single inhabitant except the guards sent from Athens to watch over the sanctuary. At Babylon the sanctuary of Bel remains, but of that Babylon which was once the greatest city that the sun beheld, nothing is left but the walls. And it is the same with Tiryns in Argolis. All these have been brought to nought by the hand of God. (Paus. 8.33.1–3, emphasis added)

As he would also do in the next book (9.36.5), Pausanias here invokes Orchomenos and Tiryns together, commenting now not on their wondrous monuments (the Treasury, the walls), but on the ineluctable processes of decay to which they were subject. Many have cited this passage as an expression of

[42] Elsner 1994, 245.

Pausanias's attitudes toward Fate and the relationship of political entities, indeed of the very purpose of the *Periegesis*. Elsner, for one, takes this as a key moment in Pausanias's "narrative of decline," his means of chronicling and negotiating Greece's transformation from past glory to Roman domination through his description of *panta ta hellenika*.[43]

It would seem, then, that at least two compulsions here emerge, both treating the Treasury of Minyas as a classic site. For Pausanias, it offered itself as a stable gauge by which subsequent events, even painful decline, could be measured and reported, and never forgotten. For the people of Orchomenos, it became a monument to anchor Minyan existence. The same site, during the same historical epoch, was thus put to multiple uses: as a source of symbolic power and contemporary pride for the local inhabitants, as an object of admiration, but also as a harbinger of regret for the external visitor. Both uses invoke the Treasury as an archetypal point of reference, but in remarkably different fashions.

CONCLUSION

This evolution in what lends meaning to the Treasury is continually ongoing.[44] No ancient observer could ever have dreamed of the additional and alternative ways in which the Treasury of Minyas has gone on to assume classic status in modern times. Identification and classification of the tholos-type, from the hindsight perspective of Aegean archaeology, for example, has generated the incontestable truth that aspects of the tomb at Orchomenos—its sheer scale, the decoration of its interior with bronze ornaments attached to the ceiling, the construction of a thalamos, the use of the saw in cutting its vast building blocks—all place it side by side with the Treasury of Atreus at Mycenae as the very quintessence of the form, built at the acme of Mycenaean civilization.[45]

[43] Elsner 1994, 250. See also, for example, Bowie 1996, 217; Habicht 1985, 163–64; Hartog and Casevitz 1999, 49–51; Musti 1996, 11; Porter 2001a, 73.

[44] Neighboring monuments also add relevant pendants to this study. For example, the eighth-century C.E. church of the Virgin at Skripou offers a wonderful architectural collage of selective reuse of material from various antiquities of Orchomenos, in an attempt to claim Hellenic legitimacy through stone and spolia. The church lies less than 200 meters away from the Treasury; it does not seem that material from the tholos itself was here employed, but its ruins must have possessed the same sense of appeal, and danger, to the Christian community: Papalexandrou 2003.

[45] So grand a funerary monument would be expected (as at Mycenae, Pylos, and elsewhere) to be closely associated with a palatial center, the evidence for which at Orchomenos has remained, ever since Schliemann, frustratingly elusive. Linear B writing (whose use is very strongly correlated with administrative centers elsewhere in the Mycenaean world) is known on an inscribed stirrup-jar found (but perhaps not even made?) at Orchomenos (Catling et al. 1980), while excavations west of the Skripou church in 1970–73 revealed a Mycenaean complex containing three units of a megaron-style building (Spyropoulos 1974), taken by its excavator as part of a palace—perhaps with some justice, given that finds of fresco fragments comparable in themes and quality with those from Mycenaean palaces are associated with it (Immerwahr 1990, 195).

(That, nonetheless, the Treasury of Atreus almost always receives pride of place is not only a function of better preservation, but perhaps chiefly a reflection of the name-recognition value of its eponymous inhabitant: Atreus carries far more classical authority than Minyas.)

If this makes the Treasury of Minyas classical in the *OED* sense of "deservedly held in high estimation," so too its status has been greatly enhanced by the tomb's entanglement with a cast of characters that reads like a veritable *Who's Who* of early pioneers of Classical Archaeology: Elgin, Leake, Schliemann, Dörpfeld, Bulle, Orlandos. The historiography of the nascent discipline cannot be told without these practitioners, each of whose story takes them, and us, to the Treasury.[46]

As we noted at the start of this essay, these attributes—size, splendor, and good company—are enough, at least for some, to acclaim the Treasury of Minyas as classic. Yet what can our study of the Treasury suggest about other ways to approach and to define that term? First, the contribution here of material evidence must be recognized not only as vital, but as valid in its own right. In more instances than we perhaps choose to realize, the material record alone will be all we have to understand just how, and when, a site or object came to be somehow privileged, just how and when it assumed the burden of being classic. Second, we can stress the dynamic character of the Treasury's history, as revealed by its archaeology, and the tomb's celebration, neglect, and reuse in quite diverse ways over time. To privilege a snapshot of any single classical moment is also to fragment that history—and quite probably to misrepresent even that singular moment. For, third, even within a single time-horizon, the role of being a classic can assume (or be assigned) more than one form: for example, the decidedly positive resonance of the Treasury for contemporary Minyans, versus the pessimistically nostalgic view of Pausanias.

Openness to alternative (e.g., material) methodologies, to dynamic readings, to multiple, simultaneous interpretations: the strictures which here have been applied to the Treasury of Minyas could be replicated in many other places, in many other epochs. In the end, such reflections behoove us to take a very catholic attitude towards the phenomenon of classicism in the ancient world. The object selected as classic may not always be predictable (always Classical), the answers about its uses and meanings are rarely transparent and never singular. After all, we have argued here that a material product of the Bronze Age could and did serve as a vehicle for what we have no real difficulty in thinking of as classicism. Finding an emperor in a tholos tomb is at first fairly startling, but can be made to make interesting sense. So too, we suggest, can the seemingly oxymoronic phrase "a Bronze Age classic."

[46] On the development of a sense of a Bronze Age past on the Greek mainland, and the role of these and other individuals in the growth of its archaeology, see McDonald and Thomas 1990; Fitton 1995.

PART II

Classical Innovations

Chapter 2

INTIMATIONS OF THE CLASSICAL
IN EARLY GREEK *MOUSIKĒ*

ARMAND D'ANGOUR

THE SURVIVAL of *the* classics is at least partly due to the concern of ancient listeners and readers to select and transmit in written form what they considered worthy of special attention and preservation as models for posterity. But no ancient Greek term corresponds to the complex of qualities connoted by our words "classical" and "classic." These words embrace a cluster of potentially inconsistent notions, such as that of a composition or artifact of the highest quality, one that serves or should serve as a model, one whose status is sanctified by tradition or by a general positive evaluation, one that seems to transcend the passing of time, and so on. For something to be called a classic, one or more of these qualities will be present; and if a sense of the classical is to be found in characteristically Greek expressions and practices, some intimations of the notion, and of its ambiguities and complexities, are likely to emerge in the musico-literary sphere from the time of its earliest exemplars, the poetry of Homer and Hesiod. The identification of classics in this context will have included an assumption of qualitative hierarchy, with the classical partaking in some way in the ubiquitous Hellenic striving for *aretē*, the ideal of excellence; a sense of the value attached or ascribed (for reasons that may not be shared or acknowledged by all ages and cultures) to the accomplishments of earlier generations and to poetic and artistic products of the past; and the paradigmatic status, if not explicit exemplarity of form or content, accorded to specific models and predecessors in art and literature.

In attempting to bring any such inklings of classicism *avant la lettre* into clearer focus, we must acknowledge that conditions in archaic and classical Greece will have tended towards the elevation of certain kinds of composition, or to the construction of a canon, in a manner widely at variance from those periods in which our own concept of classicism developed. In the sphere of literature, the central consideration will be our understanding of the dominantly oral and performative contexts of poetic production and publication in the early Greek world—the world of song culture.[1] The Greeks of the archaic and classical periods engaged in *mousikē*—poetry, music, and dance—both as

[1] Herington 1985; Ford 2003, 15–20.

members and representatives of their communities and as private individuals. There were numerous occasions for public music-making, including participation in choruses in a range of ritual and religious events, and musical contests at local and Panhellenic festivals. Private or semiprivate occasions for the expression and performance of music and poetry are mainly represented by upper-class gatherings in courtly settings or at symposia. While most of the words and music that will have been heard and sung by participants at these events, whether traditional or innovative in form and content, is lost, the surviving corpus of early Greek poetry demonstrates clearly enough the impulses outlined above, both in compositional structures and in the explicit terms of self-appraisal used by Greek poets. Compositional features include more or less self-conscious associations with recognized models of excellence, through techniques ranging from direct allusion and repetition of evocative words and themes, to the adaptation and reworking of familiar poetic and literary tropes, in genres both avowedly traditional and defiantly novel; while terms of poetic self-promotion range from assertions of the power of song to confer *kleos* and immortality to claims of personal skill and virtuosity. Thus the sixth-century poet Ibycus of Rhegium rounds off an ode listing heroes of the Trojan War with an address to his patron, the tyrant of Samos, "You too, Polycrates, will have undying *kleos*, as my song and my *kleos* warrants."[2] In seeking to assert their claims to excellence and to identify with models of excellence, the producers of such poetry appear to invite listeners and readers to make their own judgments about their potential to endure as classics.

Competitive engagement is a spur to excellence and innovation, and an *agōn* of both diachronic and synchronic dimensions is fundamental to the formation of the classical canon.[3] From the time of the earliest surviving Greek poetry, formal competition is the characteristic mechanism for establishing an artistic hierarchy. Thus Hesiod tells of his success at the funeral games for Amphidamas (*Op.* 654–59); the author of the shorter Homeric *Hymn to Aphrodite* prays for "victory in this contest" (19–20); and musico-literary competitions such as the Pythia and Carneia, which drew competitors from a wide area and involved a formal process of judging (*krisis*), will have resulted in an increasing determination of the sort of music that might be considered "of the first rank" (the idea underlying the the later term *classicus*).[4] The value attached to such "prized" products was bound to encourage their preservation for posterity. In due course, classic status was to be conventionally marked by the establishment of wholesale, public, and official reperformances of favored candidates from the domains of music and poetry. This took place at different times and in different arenas. One may consider nodal points for the creation and institutionalization of classics to include the identification and naming of tunes (*nomoi*)

[2] Ibyc. fr. 282A, lines 47–48.
[3] Nagy 1989.
[4] Segal 1989, 125. *Classicus*: see Porter, Introduction (this volume).

such as those performed by instrumental and vocal soloists at musical competitions from the seventh century on;[5] the creation in the course of the following century of choral dithyrambs identified by specific titles, reportedly for the first time by Arion at Corinth;[6] the institution in the same period of rhapsodic performances of Homer at the Panathenaia, requiring some fixing of the text of the epics (the "Peisistratean Recension");[7] the officially sanctioned reperformance of Aeschylean tragedy, and subsequently the restaging of an Aristophanic comedy (*Frogs*) in the course of the fifth century;[8] and the fourth-century practice of presenting "old" tragedies at dramatic competitions, followed by Lycurgus's establishment of the texts of the classic tragedians.[9]

Greek audiences, within and outside of the framework of institutional determinations, defined for themselves a sense of the classical through their regular engagement with their preferred products of poets and musicians, both bygone and contemporary. Before the ascendancy of the scholar and the critic, judgment of what constitutes a classic is more likely to have been that of a wider audience, for whom a supposedly timeless model is of less relevance than something well suited to its moment or occasion.[10] At the start of his *Symposium*, Xenophon proposes that "not only are the serious activities of fine individuals worthy of record (*axiomnēmoneuta*), but also what they do in play (*ta en tais paidiais*)."[11] Participants in symposia were expected to make their own poetic and musical contributions in an atmosphere of relaxed competitiveness with their peers, recalling not only the works of Homer and the lyric poets, but also familiar songs of more local and immediate import. "Take one of the *skolia* of Alcaeus or Anacreon and sing it for me," urges a character in Aristophanes' *Banqueters*;[12] and a scene in *Wasps* (1208ff.) demonstrates improvisational capping as well as citations of familiar lyric passages. Songs of exhortation and triumph such as the elegies of Theognis and Solon, and Attic *skolia*, repeated down the decades long after they had outgrown any direct political relevance, appear to have acquired a canonical status.[13]

In these circumstances, it might be expected that we should find ancient Greek counterparts of informal evaluations of what constitutes a classic—a term often applied nowadays to products of less exalted status than those of traditional musical, artistic, and literary canons. We speak of "modern" classics

[5] *Nomoi*: [Plut.] *De Mus.* 1132d with Barker 1984, 249–55.
[6] Hdt. 1.23; evaluations of Arion's contribution are discussed in D'Angour 1997, 347–50.
[7] Nagy 1996a, 67f., 93f.
[8] Pickard-Cambridge et al. 1988, 100; Sommerstein 1996, 21. The injunction on the tragedian Phrynichus not to restage his *Capture of Miletus* (Hdt. 6.21) implies that the possibility of reperformance in the fifth century may have been more common than generally supposed.
[9] Easterling 1997, 213; [Plut.] *Vit.Orat.* 841f.
[10] Ford 2003, 23–24.
[11] Xen. *Symp.* 1.1.
[12] Fr. 223 *PCG*.
[13] Athenaeus 694c–695f; Campbell 1989, 180.

and even "instant" classics, extending the terminology of classicality to a point where the privileging of time-honored cultural products is obscured or even reversed. "Classic" may be applied to a popular song, nursery rhyme, hackneyed proverb, even an impromptu witticism. That these no less than a Shakespeare play or Beethoven symphony qualify for such a description underlines the importance of popular impact and immediacy, qualities which vie with the recognition of lasting worth and the appreciation of tradition by audiences schooled in "higher" culture.[14] "Instant classic" is a self-consciously proleptic term for a composition that is apt to evoke some quality familiar from antecedent "classics" to suggest, if only half-seriously, its status as a model for the future. But in seeking ancient approximations to the notion of the classical, a paramount consideration is that the earliest surviving products of *mousikē*, the epics of Homer and Hesiod, were composed in verse rather than prose, sung rather than spoken. Their form and organization testify to the care expended on making them noteworthy and memorable in a song culture; but unlike words on a page, the impact of sung words may seem immediate and transitory, and the degree to which they are appreciated depends less on the opportunity for leisurely analysis of structure and content than on aural sensitivity, musical memory, and cultural familiarity with traditions and contexts of performance.

From this perspective, the hexameter couplet scratched on an eighth-century drinking cup from Pithekoussai after the introductory line—"I'm Nestor's cup, good for drinking"—might be identified as the most ancient candidate for the status of an "instant classic":

> Whoever drinks from this will straight away . . .
> Fall under fair-crowned Aphrodite's sway.[15]

Barry Powell has suggested that the couplet was the result of impromptu versification at a symposium, taking its point of departure from the Homeric reference suggested by the naming of Nestor as the cup's owner. The first verse of the couplet sets up the expectation of a threat or curse, which is diverted into benign jocularity by the cap of the second verse.[16] Whether or not the resulting hexameter couplet inscribed on "Nestor's Cup" was destined to be repeated and appreciated on future occasions, it was considered worthy to be recorded in writing for posterity. What is evident is both the immediacy of its composition and the way it wittily evokes a time-honored Homeric antecedent. Part of that evocation derives from its vocabulary and formulaic expression, but part of it

[14] The idea of "high" versus "low" cultural products may reflect a head/body dichotomy, and is perhaps first explicit in the comically paradoxical dismissal by Aristophanes of his rivals' "lowbrow" (*phortikon*) comedy: Wise 1998, 102f.

[15] *CEG* 454.

[16] Powell 1991, 165–67. The couplet seems to hint that even an old warrior like Nestor can succumb to the aphrodisiac power of wine.

will have come from its music—the rhythm of the hexameter combined with the style of melodic incantation of the words—the precise sound of which is lost to us but whose contours may have been related to the familiar pitch-accents of the spoken language.[17]

The classical sound of Homer—the rhythm and melody of epic, its pace and pulse—would have been readily identifiable to ancient ears. In the context of song culture, a well-formed melodic strain may itself perhaps impart an aura of classicality to a novel expression. Aristotle was later to describe the epic meter as the "stateliest and weightiest" (*Poet.* 1459b34); but when all that survives are written words, the absence of *melos* leaves only metrical and stylistic criteria to evaluate that expression. The *melos* of improvised Homeric epic may have required a degree of differentiation, but is unlikely to have espoused wide melodic variation;[18] a repetitive lyre accompaniment, *tophlattothrat tophlattothrat*, appears to have characterized its traditional recitation, forming the basis of the Aristophanic parody of Aeschylus's "citharodic" style.[19] Oral transmission inevitably entails some textual and musical fluidity, and the lack of fixed written texts will have provided a strong impetus to continuous reshaping and improvisation by professionals and nonprofessionals alike.[20] However, the indications are, as I shall discuss below, that the *aoidoi* themselves considered that they were perpetuating a tradition requiring, at best, innovation rather than repetition. As a result, their poetic successors were inclined to identify novelty explicitly as a feature of their own work, and key to its success and its excellence. Accordingly, it may be that a desire to fix in writing the most innovative, rather than the most traditional, products of musical culture betokens a consciousness of paradigmatic classicality on the part of audiences as well as practitioners. "Commend a wine that is old, but the bouquet of songs that are new," proposes Pindar.[21] A classic wine may require age, but a song that has aspirations to classic status should be fresh.

There is consequently a sense of paradox in acknowledging the existence of the notion—or a notion—of the classical in the living song culture of ancient Greece. The moment a classical tradition has begun to be articulated or identified, partly at least on the evident basis of the striking novelty of its components, is by that token the moment that art broadly speaking begins to look backwards rather than forwards, to pay homage to and to acknowledge the influence of the prime exemplars of creative inspiration. What follows may be an "anxiety of influence" (in the phrase coined by Harold Bloom), memorably

[17] West 1981.
[18] In this respect, the singing of Serb oral songs may bear comparison with Homer; Lord 2000 (with CD).
[19] Ar. *Frogs* 1285f. with Sommerstein *ad loc.*
[20] Nagy 1996a.
[21] Pind. *Ol.* 9.53.

expressed by the early fourth-century epic poet Choerilus of Samos: "Oh lucky that man who was skilled in *aoidē* in those days when the field of poetry was as yet untilled."[22] When novelty yields to traditionalism, when the artistic and imaginative striving for the *new* begins to yield to caution and reverence for the old, the tradition itself seems in danger of losing its vitality, and the inspiration behind its formation and development—the apparent access of classical authors to vital, ever-renewed springs of truth and beauty—risks yielding to academic artifice and formalism, attributes antithetical to those that arguably give rise to the impulse underlying the formation of the classical canon.

Value and Novelty

Inherent in our concept of the classical is a notion of preservation across successive generations for the sake of retaining what is valuable in the old. Wherein was such value thought to lie? One indicator is Greek educational practice: a prime means of preserving music and poetry is through structures of education, using the resources of oral and written communication to define the domain of what is considered worthy to be handed down to future generations, and thence to study, evaluate, and criticize it.[23] "All from the beginning have learned from Homer," claims the sixth-century Xenophanes (fr. 10). By the fifth century, Homer had been subjected to close analysis from different angles by rhapsodes, sophists, and allegorists such as Theagenes of Rhegium.[24] Practices of this kind serve to establish those products recognized as special or outstanding. But specific aesthetic features that were subsequently to be associated with classicism—balance, harmony, dignity, and so on—may not have been detected in, and may not emerge from, an analysis of texts so preserved. That such features are in fact to be observed in classical works may indicate their origins in ancient conceptualizations of the *ēthos* of poetry and music: compositions are regularly evaluated in terms of what is fitting (*prepon*), and early education laid stress on training boys to understand the use of correct modes and styles in *mousikē*.[25] Evidence for a critical approach directed at the literary evaluation of such qualities prior to the fourth century is remarkably slight: and terms of approbation such as *hēdus* (sweet), which Aristophanes uses to describe the songs of the tragedian Phrynichus, relate to an auditory rather than a literary aesthetic.[26]

What we tend to find instead is moral or social evaluation of works that may be designated "classics" insofar as they were considered worthy of continued preservation and performance. Thus Xenophanes and Heraclitus deplore the

[22] Choerilus fr. 1 Kinkel (-fr. 2 Bernabé).
[23] Ford 2003, 24–30.
[24] Ford 2002, 68–72.
[25] Ford 2002, 13–22.
[26] Ar. *Wasps* 220, *Birds* 748f.

immorality of poetic subject matter rather than any technical deficiency: "Homer and Hesiod have ascribed to the gods all things that are a shame and a disgrace among mortals, stealings and adulteries and deceivings of one another" (Xen. fr.11); "Homer deserves to be flung out of the contests and flogged, as does Archilochus" (Heraclitus fr. 42). In Aristophanes' *Clouds* (1353ff.), old man Strepsiades describes how he came to blows with his son Pheidippides after the latter refused to sing to the lyre a "classic air" by Simonides or to declaim a passage from Aeschylus. Pheidippides initially refuses the former on the grounds that it is old-fashioned (*archaion*) to play the lyre and sing at a symposium—"like an old woman hulling barley" (1358); smart youths in late-fifth-century Athens did not consider it cool to give such a performance.[27] Subsequently Pheidippides declares Simonides to be a bad poet (*kakon poiētēn*, 1362), and Aeschylus to be a "classic ... windbag" (*prōton en poiētais ... stomphaka*, 1366–67). In turn, the young man's choice of a speech (*rhēsis*) by Euripides is criticized by Strepsiades for its shocking content, not its style. In *Frogs*, Aristophanes goes further along the lines of what has come to be thought of as genuine literary criticism, of the kind that might contribute to a better understanding of the principles of poetic classicality.[28] But here too, the selection of authors named by the character of Aeschylus alludes to didactic rather than literary excellence: "Look at how from the very beginning the finest of poets have conferred benefits on us. Orpheus revealed mystic rites and taught us to refrain from killings, Musaeus gave us oracles and cures for disease, Hesiod taught us farming, the seasons for crops, times for ploughing, and the divine Homer, where did he get his honour and renown if not from giving good advice about tactics and brave deeds and arming of soldiers?"[29]

If excellence is the hallmark of the classic, familiarity and repeatability are ways of demonstrating that excellence. Expressions of a less solemn nature than didactic instruction might fall readily enough into the category of the familiar and repeatable. "Shall I tell one of those classic gags (*ti tōn eiōthotōn*)," asks the slave Xanthias at the beginning of Aristophanes" *Frogs*, "that always (*aei*) get a laugh from the audience?"[30] Against the pleasure of the familiar is set the acknowledgment that repetition can pall. Later in the play, the classical Aeschylus is attacked by the modernist Euripides, first for "saying the same thing twice" (*dis t'auton*), and subsequently as "a bad musician who is always composing the same music" (*kakon / melopoion onta kai poiounta t'aut' aei*).[31] The occurrence of *aei* in these passages, with the connotation "time and again," strikes a bathetic echo of its more elevated significance in Thucydides'

[27] *Archaion* is invariably a pejorative word in comedy: Eupolis (*PCG* 148) uses it similarly to designate "the songs of Stesichorus, Alcman, and Simonides" as old-fashioned.
[28] See further Porter, ch. 9.
[29] Ar. *Frogs* 1030–36.
[30] Ar. *Frogs* 1–2.
[31] Ar. *Frogs* 1154, 1249–50.

ringing boast, "My work is not a competition-piece designed for the immediate occasion, but a possession for all time (*ktēma es aei*)."[32] The historian here seems to establish a retrospective view of what should count as classical: a work intended to provide *timeless* models of human action and thought. Aristotle famously observes that "poetry is more philosophical and elevated than history in that it tends to express the universal, history the particular."[33] While he names Herodotus as the archetypal historian, it is notable that the particular example he gives of historical discourse—"what Alcibiades did and suffered"—is particularly Thucydidean subject matter. With its appeal to mythical precedents, flowing narrative style (arguably oral rather than writerly), and breadth of reference, Herodotus's work may have been more easily judged a classic in the mold of Homer. Whereas Thucydides disdains the romantic element (*to muthōdes*) in his predecessor, for "Longinus" Herodotus is *homērikōtatos*, a term of high critical approbation, used in the same breath as for the acknowledged masters of narrative lyric, Archilochus and Stesichorus.[34]

Religion is the domain *par excellence* in which the use of repeated, traditional expressions tends to be the rule rather than the exception. It might be supposed that the classic expressions and formulas of the Greeks' religion and cult—their myths, hymns, and prayers—should evoke solemn and dignified associations. But would they have been thought of as classics? The sacrality and authority of such expressions can mean they do not easily lend themselves to being judged by aesthetic categories: one may draw an analogy with the Daedalic *xoana*, which despite their archaic oddity (*atopia*) seemed to Pausanias to exude a kind of divinity.[35] It may be more appropriate to speak of classic religious practices than to apply the term to the songs that accompanied such practices: "sing to the Lord a new song" (Psalm 96) is applicable to ancient Hellenic as well as to Jewish worship. The worship of Dionysus is a case in point, as suggested by a processional song of Sicyonian *phallophoroi*:

> For you, Bacchus, we adorn this music
> pouring forth a simple rhythm in varied song,
> fresh and maiden (*kainan apartheneuton*), never used
> in earlier songs: but virgin-pure (*akēraton*)
> we raise our hymn.[36]

The chorus in Euripides' *Bacchae* warn that Dionysus, though dismissed by Pentheus as a new god (*neōsti daimōn*, 219), should be perceived as part of the divine order of conventional Greek belief (*nomimon*): "For it costs little to

[32] Thuc. 1.22
[33] Arist. *Poet.* 1451b.
[34] [Longinus] 13.3.
[35] Paus. 2.4.5; Morris 1992, 248. Cf. Plato's judgment on Tynnichus of Chalcis, "who never composed a memorable poem except the paean that all sing, perhaps the most beautiful of songs" (*Ion* 534d).
[36] *PMG* 851b.

suppose that these things have power: whatever is divine and over the long course of time is held holy unceasingly (*nomimon aei*), and rooted in nature."[37] An analogy may be drawn with the openness to novelty of Greek religious thought: in like fashion, musico-poetic genres used in religious contexts might acknowledge and tacitly adapt to innovation.[38] Some traditional practices might indeed more easily be perceived as antiquated rather than classical—"reeking of Kronos," "fusty (*archaia*) like the festival of Dipoleia, covered in cobwebs."[39]

The second of Pindar's dithyrambs (a Dionysiac genre in origin) offers a further perspective on the notion of innovating classicality. It begins by drawing a contrast between the earlier (*prin men*) processional form and the contemporary (*nun*) circular structure of dithyrambic performance:

> Previously the singing (*aoidē*) of dithyrambs proceeded in a straight line
> and untidy sibilants emerged from men's lips,
> but now the young men are arrayed in well-coordinated circles,
> in due knowledge of how the Olympian gods
> also, near the sceptre of Zeus,
> perform the Bromios-revel in their halls.[40]

The ode goes on to describe in greater detail the circular dance with which the Olympians conduct their Bacchic revel. The implication is that the *kuklios choros* is indeed the classic form of the genre, not because it is traditional in earthly terms, but because its new circular form may be seen to be modelled on a celestial Form, that of the original Olympian dance circle. Despite the historical comment Pindar placed at the start of this dithyramb, it did not take long before the new circular form was widely considered to have been the defining aspect of the genre.[41]

Melos, Concern, and the Latest Song

The nature of the classical impulse replicates the operation of, and no doubt owes its existence to, a deep-rooted human instinct: the urge to discriminate between good and bad, consequent on our attachment to and identification with good objects and our desire to preserve them.[42] In the sphere of the aesthetic

[37] Eur. *Bacch.* 893–96. "What is good," concludes the chorus, "is dear *always*," *hoti kalon philon aei* (901 etc.; for the emphasis see Seaford *ad loc.*).

[38] Burkert 1985, 176–79: "Polytheism is an open system."

[39] Ar. *Clouds* 398, 984–85. "Covered with cobwebs" translates *tettigōn anamesta*, literally "full of cicadas," creatures symbolic of antiquated dress (cf. Thuc. 1.6.3 on golden cicada brooches) and old-fashioned singing (cf. *Clouds* 1360).

[40] Pind. fr. 70b; for the reconstruction of lines 3–4, *diapeptantai de nun euomphalois kukloisi neaniai, eu eidotes*, see D'Angour 1997, 343–46.

[41] D'Angour 1997, 339f.

[42] The term "good (and bad) object" originates in the ideas of Freud, but has been more intensively theorized by Melanie Klein and her followers; Petot 1991.

and literary, these instincts are mediated and shaped by cultural factors so that their unconscious origins in the demands of the psyche are mediated by the operation of specific, self-conscious, and collective decisions about the preservation and choice of artistic products. The songs of Homer and Hesiod, with their originary status in the Greek canon (and that of Western literature as a whole), manifest the cultural attribution of value to heroic ideals and narratives, and to traditional wisdom about theogonic myth and peasant life. They also embody specific instances of such poetry, ascribed to individual originators whose authoritative excellence seemed to lend them an aspect of the divinity, as inspired *theioi*, of the sphere of the Muses from which they claim inspiration, or of the gods and heroes with whom their songs engage. We recognise the songs of Homer and Hesiod to be the culmination of centuries of orally improvised song and poetry. But what ensured that they, as inheritors of a centuries-old oral tradition, were uniquely to become the models for much of the subsequent literary tradition, was the general recognition that they constituted foremost exemplars of their kind. The impulse to preserve them as monuments of high skill in their own time and beyond found ways of fulfilling itself through the resources of oral memory and written record. The urge to discriminate on grounds of excellence ensured the survival of products that were considered qualitatively superior to their predecessors and contemporaries in ways that would become defining for the future of the classics and of the idea of the classical.

An orientation of *care*—an identifying feature, for the existentialist philosopher Heidegger, of human *Dasein*—is thus implicated in cultural as well as purely existential concerns.[43] If the classical presupposes—even before its elaboration into notions of canonicity, ideality, excellence, and exemplarity—such a perspective on the past and towards the act of discrimination itself, we might expect to recognize expressions of this orientation in Greek antiquity. In fact, one of the earliest references to a classic occurs in a brief phrase that seems to propose, in a casual yet telling epithet, an orientation of care about the singing of a famous song and the telling of a gripping tale. In Book 12 of the *Odyssey*, the hero recounts the predictions given to him by the sorceress Circe on his departure from her island. She gives him a dire warning about the wandering rocks (*Planktai*), which not even doves can fly past unscathed:

> Nor has any ship carrying men ever come there and gone its way in safety; the ship's timbers, the crew's dead bodies are carried away by the sea waves and by blasts of deadly fire. One alone among seagoing ships did indeed sail past on her way home from Aeetes' kingdom—this was Argo, whose name is on all men's tongues (*pasi melousa*).[44]

[43] Heidegger 1962.
[44] Hom. *Il.* 12.66–70 (trans. Shewring).

The Argo, and by extension the story of the Argonauts, is here described as *pasi melousa*, literally "of concern to all." For Homer's audience, the story of the Argo may be described and thought of as a heroic tale of universal interest and concern, even if the Argonautica is at that moment just a fleeting image of remembered music evoking a (variable) narrative involving certain characters and episodes. One may go further in interpreting the phrase, and exploit (as Homer appears to do *en passant*) the aural association of *melousa* with *melos*, melody.[45] This is a tale that almost literally strikes a chord in the heart of every listener. Both elements of the unusual epithet *pasi melousa* seem important for the definition of the status of classic: the notion that a song can be famous for the affecting impact of its music, and the supposition that the impact will be felt collectively or universally (*pasi*). That the effect is aroused by *melos* reminds us that such works will be recognizable and repeatable in musical strains rather than as prosaic discourses, and appreciated as an aural process rather than as written artifacts.

The existence and survival of such songs does not, at this stage, depend on writing and notation, but on their repetition and performance. By referring to a poetic predecessor in these terms, the author of the *Odyssey* positions the lost epic tale of the Argo as a classic, just as any song or work of literature may seem to position as classical an earlier work within their tradition or genre to which it makes reference, explicitly or otherwise. By the same token Homer indicates the terms on which his own poem may come to be judged as a classic. The ironic corollary is the way that the *Odyssey*, even as it anticipates its future attainment of classical status, thereby locates itself as postclassical.[46] This double-edged perspective may be considered further in relation to what we learn about the bardic perception of the newest song, a perception lodged in the consciousness of later Greek musicians and poets who attempted to present themselves as part of a tradition of poetic excellence and thus to position themselves proleptically as classics.

The earliest indication of the idea of musical novelty appears in the first book of the *Odyssey*, where we find Phemius entertaining the suitors in Odysseus's palace with a song about the "Return of the Achaeans." His tale makes Penelope grieve for Odysseus, who alone of the Achaean heroes has yet to return. She requests that the minstrel change his tune:

> Phemius, you know (*oidas*) many other pieces to enchant mortals (*thelktēria*),
> deeds of men and gods that minstrels celebrate (*kleiousi*) in song.
> Sing one of those as you sit here amongst these men, and let them
> drink their wine in silence. But stop this song, this
> unhappy song that always (*aiei*) breaks my heart,

[45] Cf. perhaps Alcman fr. 37 (*meloi/melos*), Mimnermus fr. 1.2, Ar. *Frogs* 224, Pl. *Symp.* 215D3; the joke in Ar. *Wasps* 1410–11 may involve a similar pun.
[46] Cf. Porter 2002.

seeing as I more than any am racked by constant grief.
I pine for one so dear, always (*aiei*) reminded of
my husband, whose fame (*kleos*) is broad in Hellas and in Argos' centre.[47]

Penelope's words have a bearing on how we will understand the subsequent description of Phemius's song as "newest." She implicitly excludes this song, which so upsets her, from the many other enchantments (*thelktēria*), the more enjoyable classics that she knows the bard has in his repertoire (*oidas*, an unusual form for "you know," puns on *a-oidos*). That Phemius's song always (*aiei*) reminds her of Odysseus implies that she has heard something of the kind before: she will already know this song too well, in its effect if not in its specific style and structure.

Telemachus intervenes to contradict his mother's request: "Don't scold Phemius for singing of the Danaans' tragic fate. People give greater acclaim (*mallon epikleiousi*) to that song that is newest (*neōtatē*) in the ears of listeners."[48] Telemachus here has been described as "the poet's spokesman in his plea for artistic freedom and his emphasis on the importance of poetic novelty."[49] There are also important social and performative implications in the young man's "pronouncing about poetry."[50] We may attribute a yet more personal dimension to his intervention at this juncture: fresh from his meeting with Mentes, Telemachus will have a particular interest in hearing, and in allowing the suitors to hear, an account of the return of Achaean heroes which raises the prospect of Odysseus's own *nostos*. His expressed aesthetic rationale for defending Phemius's choice is convincing enough to be taken at face value, but may also be heard as masking other feelings—anger at his own helplessness and his mother's passivity, and resentment of the suitors' assumption (and hope) that Odysseus will never return. At the same time, it is evident that the praise accorded to the newest song reflects Homer's view of his own audience's likely response to his *aoidē*. Audiences, we are told, accord greater applause to the new, *mallon epikleiousi*; literally, they attach more *kleos* (glory, renown) thereto. The terms in which Homer's perception is expressed resonate with a central concept of heroic song, that of *kleos* (a moment earlier, 344, Penelope has proudly remarked on the extent of Odysseus's *kleos*). *Kleos* is the raison d'être of the epic hero, the recognition and celebration of his *aretē*, and is also "linked in a fundamental way to the poet's voice."[51] The bard's virtuosity aims for something of the *kleos* sought by and invested in the legendary warriors of whom he sings.[52] In this case, the originality of the singer, whether Phemius or

[47] Hom. *Od.* 1.337–44.
[48] Hom. *Od.* 1.350–52.
[49] West 1988, 119.
[50] Ford 2002, 6.
[51] Goldhill 1991, 69.
[52] Nagy 1990, 147–52.

Homer, is assimilated to the heroic virtue of his subject. Pindar will of course do the same in his *epinikia*: classic deeds make for classic poetry, even if the narrative content is itself new and unfamiliar.

It is precisely such a creative synthesis that the bard's *aoidē* represents: Phemius's song is a tale that features anew characters and situations in the familiar epic mode. And we know that for Phemius and his hearers there remains a song so new that it has yet to be sung, the *nostos* of Odysseus himself. "In this case, Odysseus is both a prime figure in the myth and about to become a prime figure in the here and now narrated by the poem. His *nostos* is literally in the making, which is precisely the subject of the singer."[53] Homer's readers and listeners should recognize that the song *we* are listening to, via a curious conflation of present time and mythical time, is to be identified as the newest and most "glorious" song of all. Through the mouth of Telemachus, the monumental composer proudly draws attention to his own novel choice of theme and its original treatment: it is destined to become a classic by virtue of the very novelty that makes it memorable.

Some degree of innovation must in any case be present in extempore oral composition of the kind that epic composition represents—in the manipulation of epithets and formulas, in adapting new words and names to the meter of the hexameter, in varying the flourishes of the lyre accompaniment. "The Homeric *aoidos* was an oral poet who made new songs every time he sang, depending on traditional stories, traditional themes, and traditional language, but always adjusting his story to his audience and the needs of the moment."[54] Innovation comes about, then, through the reordering of inherited material; the imposition of order (*kosmos*) on unformed matter, recapitulating the imagined creation of the cosmos itself, is a way of creating something new. Here, the newness of the newest song is focalized in Telemachus's words from the viewpoint not of the bard, but of the audience (*akouontessi*). The context most naturally suggests to us that what makes the song newest is above all the novelty of its narrative content. Insofar as a song deals with recent events, it will include incidents and depictions previously unsung and unfamiliar to its listeners. It is new partly because it offers new information to its listeners, information about people, events, or even divine actions communicated by the Muse to her inspired minstrel. Phemius's newest song, then, is not imagined to constitute a wholesale departure in tone or content from the bard's classic repertoire, his many other *thelktēria*. The reworking of a familiar theme to embrace relatively recent and unsung events is likely to exhibit a novel focus and structure, and a new song may also arouse an unpredictable emotional response in the listener. Phemius's song, as a *thelktērion* that causes pain, has the capacity to arouse a mixed response associated by Homer's words with the very novelty that is intended to draw applause.

[53] Nagy 1990, 69.
[54] Powell 2002, 141.

Telemachus's dictum about the newest song, repeated and debated in later centuries, laid down a marker to which numerous subsequent claims to musical innovation were to appeal. In the minds of later poets and their audiences, Homer himself did not merely sanction musical novelty, he required it. Classical music and poetry were henceforth to be judged in large part by their novelty quotient. Homer's influence meant that the pursuit of or claim to originality was bound to become a constantly articulated feature of Greek (and thence Roman) literary culture. The domain of *mousikē*, embracing the sphere of practices and techniques applied in the composition and performance of what we know as Greek literature, provides continuing explicit manifestations of such a consciousness of the importance of novelty.

Classical Music and New Music

Musicians and poets lay claim to novelty for a number of reasons. They may be drawing attention to genuine innovations in their work, seeking to impress their audiences or fellow professionals, or simply imitating a trope of the genre. The complex nature of *mousikē* means that claims to musical novelty may relate to departures in narrative or myth, to verbal ingenuity, to melodic, structural, or ethical variation, or even to the mere fact that an existing song is being sung on a new occasion. Alcman begins a song with the invocation "Come, clear-voiced Muse of many tunes and everlasting song (*aien-aoide*), begin a new strain (*melos neochmon*) for maidens to sing":[55] here again we find a negotiation between what is new and what is timeless. Alcman's words find a much later echo in Horace's claim to originality: *carmina non prius / audita Musarum sacerdos / virginibus puerisque canto* ("I, priest of the Muses, am singing for maidens and boys songs never heard before").[56] The Roman poet elsewhere neatly articulates the meaning of novelty for the creation of classics: *Quod si tam Graecis novitas invisa fuisset / quam nobis, quid nunc esset vetus?* ("If novelty was as offensive to the Greeks as it is to us, what would now exist of the classical?")[57]

In early Greek poetry, the terminology of novelty is largely confined to the word *neos* (which essentially means "young") and variants and compounds of *neo-*. Thus Alcman's term is *neochmos*, while Pindar uses the compound *neosigalos*:

> The Muse stood by my side
> as I found a gleaming new mode (*neosigalon tropon*)
> whereby to yoke the Dorian dancing-sandal
> to the glorious processional.[58]

[55] *PMG* 30.
[56] Hor. *Carm.* 3.1.2–4.
[57] Hor. *Epist.* 2.1.90–91.
[58] Pind. *Ol.* 3.4–6.

Whatever the intended effect of such claims on performers, hearers, or readers, for some at least they will have spurred the acknowledgment that novelty was to be sought and approved. The quality of newness comes into sharper focus with the growing use in Greek of *kainos*, a word encountered in texts only from the fifth century on. Its first secure attestation (in Bacchylides) relates to *mousikē*: "Weave something brand new (*ti kainon*) in much-adored, blessed Athens."[59] *Kainos* famously recurs in one of the most forthright claims to musical novelty by the late-fifth-century performer Timotheus of Miletus:

> I don't sing the old songs (*ouk aeidō ta palaia*),
> my new (*kaina*) ones are better.
> Now young (*neos*) Zeus is king:
> In the old days (*to palai*) Kronos held sway.
> Go away, ancient (*palaia*) Muse.[60]

The use of uncontracted *aeidō*, its initial syllables forming the word *aei*, seems to mock the timeless pretensions of *aoidē*, the ancient bards' claims to sing songs "for *aei*"; in Timotheus's view, their day is done. Distanced from purely temporal significations, the attribute of *kainotēs* holds the promise of unexpectedness, and proposes the existence of an intrinsic quality of novelty. The new no longer appears to depend on the old, but to oppose it, no longer bound to yield to age, but to carry with it a persistent, and to some alarming, freshness. But the usage may also prompt the recognition that some products are simply new-fangled (a common connotation of *kainos*), while others, perhaps foremost the songs of Homer, are old but do not age—a classic formulation of the classic.

Timotheus, doyen of the movement that has come to be known as the New Music, was considered the acme of a succession of innovative musicians beginning with Lasus of Hermione and including Phrynis, Melanippides, Cinesias, and Philoxenus. From the fifth-century comic poet Pherecrates comes a passage of classic *double entendres* depicting an unholy succession of Music-violators culminating with Timotheus, as narrated by the Muse herself:

> Melanippides was the first, grabbing and pulling me down, and loosening me up with his twelve-incher [*chordais dōdeka*, literally "twelve strings/sausages"]. I suppose he was tolerable—at any rate, compared to what came next: that damned Athenian Cinesias has utterly savaged me with his exharmonic twists and turns. His dithyrambs are all over the place, upside down and inside out. Well, I could put up with that too. But then Phrynis shoved in his peg [*strobilos* = tuning peg/dildo?] bending and twisting me into a complete wreck with his tireless versatility [literally "with twelve tunings in his pentachords"]. All the same, he was tolerable; he knocked me about, but made up for it later. As for Timotheus [. . .] he behaved worse than all the others put together, with his perverted tickling and wriggling.

[59] Ba. *Dith*. 19.8–10.
[60] *PMG* 796.

> When he caught me unaccompanied [by words and dance] he loosened my stays and undid me with his twelve-incher.[61]

Even in this context, each of the earlier musicians named for their violations becomes tolerable (*apochrōn*) to the Muse; only Timotheus remains beyond the pale. But in fact Timotheus's songs too attracted the reward due to their originality: in following centuries his works were reperformed as classics, and we are told that his *nomoi* continued to be sung, along with those of Philoxenus, by choruses in Arcadia.[62]

The question of how the *sound* of music changed over this politically and culturally turbulent period is not easy to pin down. Our sources for the narrative of early musical history, Athenaeus's *Deipnosophistai* and the Plutarchan *De Musica*, draw heavily on Greek authors of the fourth century from Heraclides to Aristoxenus, who followed Plato's lead in identifying a classical style of melody and rhythm from which they considered the modern style of music to diverge. In Aristoxenus's ears, the classic sound involved the use of the enharmonic genus (which employed microdivisions of the whole tone), whose invention he attributed to the aulete Olympus: "nowadays, however, people have rejected the finest of the genera, the one most appreciated in ancient times because of its noble dignity, so that most people do not have even a casual understanding of enharmonic intervals."[63] He echoes Plato's lament that "musical *aristokratia* has been replaced by a degenerate *theatrokratia*" (*Laws* 701a), claiming that "we few in isolation recall what music used to be like."[64] In their pursuit of more exciting sounds, Greek audiences were losing touch with the essence of classical music. The terms of the debate, though often couched in technical language, centers on a notion of musical ethos—the dignity and appropriateness of traditional uses of modes and rhythms, versus the moderns' unrestrained rhythms, inappropriate use of modes, and modulations.[65]

Plato, with his espousal of changeless norms and his explicit disavowal of novelty in virtually all spheres, was vehemently opposed to the New Music:

> The alteration of music to a new style must be guarded against as heralding danger in the wider sphere. I agree with Damon, who says that innovation in musical style invariably means major social and political upheaval.[66]

For Plato, the true classic would have to approximate to an unchanging ideal, something diametrically opposite to a fluid text:

[61] Pherecrates fr. 155 ([Plut.] *De. Mus.* 1141c–42a).
[62] Polyb. 4.20.8-9; West 1992, 370–72.
[63] [Plut.] *De Mus.* 1145a.
[64] Aristox. fr. 124.
[65] Csapo 2004.
[66] Pl. *R.* 424c.

If one could grasp the nature of correctness in melodies, one should boldly subject them to law and regulation. For pleasure and pain, in their constant pursuit of new music to indulge in, have little power to destroy a choric art that is sanctified, just by deriding its antiquity. In Egypt, at any rate, they don't seem to have been capable of destroying it—quite the opposite.[67]

The idea of a work of art worthy of preservation without alteration is further exemplified in the fourth century by Lycurgus's legislation on dramatic texts; and the notion of fixing texts may also have been a factor in the development of musical notation in this period. By the beginning of the fourth century, the classic is more than ever to be located in the past, rather than in the present or future. Plato's philosophical influence (even before the development of the formal study of poetics by his pupil Aristotle) may thus be considered key to the development of the notion of the classical—its effective redefinition as a set of formal ideals attributable to timeless exemplars from the past, rather than a ceaseless quest for novelty and for the creative expression of vital contemporary concerns.

The concerns that link *melē* ("songs") to *melei* ("it matters") also link the classical past to the classical present. As classicists, we care about products of the past. A classic thrives on competition, and can withstand criticism, analysis, and political suppression; it less easily survives disinterest and neglect, that is, the withdrawal of care. If we choose to speak of classics, it is because we care to recognize and classify those products (literary, artistic, material, and so on) to which we attach value, to promote their survival in our own minds and in the public sphere, to privilege some over others, and of course ultimately to criticize and contest the form and nature of that privileging. If we make the effort to appreciate the products of the past, it is not just because we take an interest in them, but also because we understand that they matter, that it is *in* our interest to engage and preserve them. They belong to the past, but also to the present and to the future. We value them partly because they were considered of value by those who preceded us; and we care about what our predecessors valued because we care about who we are now and who we will become, and about what those who succeed us will care about. Those elements of the past with which we invest the locus of our present cares thus constitute a vital element in our personal and cultural self-identifications. What we consider to be classical is part of our self-definition as discriminating persons. The function of the classicist, one may conclude, differs in this respect from that of the antiquarian and museologist. We seek not just to preserve the products of the past, but to engage creatively with and devote our innovative energies to the vital objects of our concern.

[67] Pl. *Laws* 657b.

Chapter 3

REHISTORICIZING CLASSICISM: ISOCRATES AND THE POLITICS OF METAPHOR IN FOURTH-CENTURY ATHENS

Yun Lee Too

THIS ESSAY considers the relation of an author of the classical Greek period—Isocrates—to the idea of classicism. It shows that what a subsequent age regards as the classical ideal, an act that in large part constitutes classicism, was in fact a discomforting fit for the classical individual who otherwise had his eyes set on a prior era as a better and more perfect age. Classicism becomes a rehistoricizing gesture, one which obscures a series of actual discontentments about the author's present time.

One of the most acute issues for political writers from the late fifth century onwards was how to ensure the stability of the Greek city-state, assuming that stability was to be desired over chaos and change. Change is, at the least, uncomfortable for the classical Greek *polis*. This condition of transformation, of instability, of chaos, of what is perceived as deterioration is denoted by the verb νεωτερίζειν, which also means "to engage in (political) revolution," and its cognates, and by τὰ καινά, which stands against the revered τὰ ἀρχαῖα.[1] My intention in this paper is to explore how one individual, the rhetorician Isocrates, addresses the issue of political change where Athens in the late fourth century is concerned, or more accurately, where Athens, as represented in a late-fourth-century text, is concerned as an issue of language: λόγος is the basis of the social and political infrastructure and λόγος has the capacity both to make and unmake the community. I shall argue that linguistic and political instability is a problem, above all, of μεταφορά or "metaphor," which in the work of this author and his contemporaries denotes the transfer and shift in usage of language such that it acquires "new" meanings or values. The agenda of Isocrates is to arrest linguistic transformation by unwriting metaphorical language and so to restore Athens to a more pristine age, one that stands for a community unspoiled by contemporary rhetoric and its practitioners. In offering this reading, I rehistoricize Isocrates' role in the history of ideas as the foremost rhetorical author of classical Athens by showing that the "classical

[1] See Too 1995, 54–58.

Athens" which he presents himself as belonging to is a community that produced him despite itself, for it is to be viewed as a dysfunctional society that has degenerated from a better Athens of previous generations. Isocrates idealizes the past, and not in a manner that we might regard as classicizing: the past is better above all because it was static and unchanging.

Why Logos Is Important

To understand how Isocrates has become a "classical author" of a "classical Greece" it is important to comprehend the role he grants to language in society, for this—and its subsequent distortion—is key to the operation we currently denote as "classicizing." For writers in the fifth and fourth centuries, λόγος— both language and reason, as the Greek word denotes—is what distinguishes humankind from other living beings, and what ensures the superiority of this race in the order of things, despite its physical disadvantages.[2] If λόγος is the defining condition of humanity, it is furthermore specifically what makes possible the existence of civilized society, namely the political community. In sections 5–9 of *Nicocles*, the once pupil of Isocrates and now Cypriot king, Nicocles, is made to declare that through λόγος men persuaded one another, associated with one another, created cities, established *nomoi*, the cities' conventions or laws, educated, disputed with one another, and invented the arts. The encomium of λόγος, as the passage is conventionally described, reappears verbatim at *Antidosis* 253–56 with a significant reframing in the author's own voice. Λόγος is the public discourse that both constitutes and announces the deliberate strategies that individuals use to devise images—good, bad, beautiful, ugly, truthful, misleading, and so on—of their societies. Rhetoric is at the essential core of any orderly, civilized community; it institutionalizes morality, makes possible debate, persuasion, and the instruction of others.

To rhetoric and the culture of rhetoric Athens owes its political and social greatness among the Greek states, as Isocrates makes apparent on several occasions in the *Antidosis*. In section 171 the rhetorician declares that the city is responsible for many good things (ἡ γὰρ πόλις ἡμῶν πολλῶν ἀγαθῶν αἰτία), offering a statement of Athens's cultural superiority that is a claim for her hegemonic status at the political and military level, given the author's overall political agenda. The specific point of Athens's standing as one that is due to rhetoric is made again in sections 293–95, where the rhetorician presents the city as a "teacher" (διδάσκαλος) of the rest of the world in oratory and its instruction (cf. also Isoc. *Or*. 4.50 and Thuc. 2.41.1). Earlier, in section 235 Isocrates refashions Athenian history into one of rhetorical accomplishments when he declares that none of Athens's historical statesmen—whether Solon,

[2] E.g., Soph. *Ant*. 332–75 and Isoc. *Antid*. 293–94.

Cleisthenes, Themistocles, or Pericles, neglected "speech"/ "rhetoric" (οὐδεὶς λογῶν ἠμέλησεν) and makes explicit the importance of the attention that these men paid to λόγος. As the leader of the people (archon 594/3 B.C.E.), Solon established laws for the city-state, which are a consequence of λόγος, as the reader learns from section 254, ordered their affairs, and made them adore the city (section 232). Solon was also the human agent who realized the capacities of λόγος as a structuring medium for sociopolitical reality. According to the rhetorician, they in fact devoted themselves more to rhetorical discourse than anything else. If Solon is the human embodiment of λόγος, then Cleisthenes, who also engaged in constitutional reforms, persuaded (λόγῳ πείσας) the Amphictyon council, an association of states for the purpose of protecting worship of Apollo at Delphi, to lend him money from the treasury of Apollo in order that he might expel the tyrants;[3] Themistocles, who commanded the Athenian navy at the battle of Salamis, is presented as someone who gave good counsel and excelled in oratory (συμβουλεύσας . . . πολὺ τῷ λόγῳ διενεγκών) (233). Through his eloquence he persuaded the Athenian ancestors to abandon the city in the Persian War,[4] while Pericles, described as a "good demagogue and the best rhetorician" (δημαγωγὸς ὢν ἀγαθὸς καὶ ῥήτωρ ἄριστος) (234), decorated the city with temples, monuments, and other fine things so that visitors to Athens would think the πόλις worthy to rule the Greeks and the rest of the world (sections 233–34). With these prosopographies Isocrates offers four aetiologies of Athens's power, each of which ultimately credits it to the λόγος of a sophist.

But for the rhetorician, and indeed any Greek rhetorician, λόγος is perceived to be a medium not just of creation, but also of possible endless verbal *re*-creation. Isocrates declares the nature of λόγος to be such that what is great is made base, what is grand becomes small, and what is old becomes new in *Panegyricus* (4) 7–8:

ἐπειδὴ δ' οἱ λόγοι τοιαύτην ἔχουσι τὴν φύσιν, ὥσθ' οἷόν τ' εἶναι περὶ τῶν αὐτῶν πολλαχῶς ἐξηγήσασθαι, καὶ τὰ τε μεγάλα ταπεινὰ ποιῆσαι καὶ τοῖς μικροῖς μέγεθος περιθεῖναι, καὶ τά τε παλαιὰ καινῶς διελθεῖν καὶ περὶ τῶν νεωστὶ γεγενημένων ἀρχαίως εἰπεῖν . . .

Since speeches have such a nature that it is possible to write in different ways about the same things, and to make the great base, and to grant grandeur to the small, and to narrate old things in a new manner and to speak about things that have happened recently in an archaic fashion . . .

Rhetoric makes it possible for the same topics to be presented again and again for rhetorical treatment for the reason that it has the capacity to articulate these topics in different and opposite manners. This definition of rhetoric is a stan-

[3] See Isoc. 5.74 and Dem. 21.144.
[4] ὃ τίς ἄν οἷος τ' ἐγένετο πεῖσαι μὴ πολὺ τῳ λόγῳ διενεγκών.

dard one, and is itself restated in a number of other texts. Tisias and Gorgias are given the same powers of verbal transformation in Plato's *Phaedrus* (267a), while much later Pseudo-Plutarch has his "Isocrates" answer the question "What is rhetoric?" (τὶ ῥητορική;) with "to make small things great and great things small" (838f.), clearly citing *Panegyricus* 7–8.[5] Language is an account of reality, but because language is not static or fixed, it is also an articulation of *a* reality among several other possible ones.

Why the Community Is in Trouble

Isocrates offers one of the most explicit accounts of λόγος as the basis for the political community in the fourth century, and his account of political structure is given a venerable pedigree by one later author. According to Plutarch's *Life of Solon*, the ancient Athenians were observed to disguise unpleasant or difficult situations with euphemisms (cf. ὀνόμασι χρηστοῖς): so "prostitutes" (τὰς πόρνας) are "companions" (ἑταίρας); "taxes" (τοὺς φόρους), "contributions" (συντάξεις), and "a prison" (τὸ δεσμωτήριον) becomes "a room" (οἴκημα) (15.2–3). Plutarch states that the first person to use this technique of redescription was Solon, who called the cancellation of debts a "disburdenment" (σεισαχθεία). So, in effect, the city's ancestors redescribed reality, using more positive or neutral words in place of those with clearly negative connotations, in an effort to make it more bearable, and by doing this, they built up the city into the democracy that it would become.

But in the fourth century the recognition that rhetorical constructions are inherently mutable and liable to transformation is to be contextualized within a very specific, conservative ideology that rejects linguistic change. The point that commentators make is that the capacity of rhetorical discourse for transformation is not just a result, but more worryingly a cause, of political upset, threatening the stability of the civic community, or more accurately of a possible civic community, and this is due to the fact that Athens is in a post-Periclean age and so a city of words in which litigation and sycophancy are the privileged discourses. In Plato's *Republic*, Socrates demonstrates his adherence to such an understanding of public language when he speaks of the way in which oligarchy declines into democracy. According to him, when this happens, false and boastful words run up to occupy the space held by other terms, displacing the older, traditional order. So, what was once called "shame" (αἰδώς) is now "foolishness" (ἠλιθιότης); "moderation" (σωφροσύνη) becomes "cowardice"; "balance" or "the mean" (μετριότης) and orderly expenditure (κοσμία δαπάνη) are redescribed as "boorishness" (ἀγροικία) and "meanness" (ἀναλευθερία)

[5] Cf. Demosthenes et al. 1889, ii.278, no. 9: cites also Max. Planud. V. p. 455, 10, W; Hermog. III. p. 363, 15; John of Sicily VI, p. 132, 17, p. 133, 13, 459; Longin. 39, 2; Ep. Socr. 30.9; Harp. p. 36, 3. 105, 3; Suda, s.v. ἀρχαίως and καινῶς.

(560c-d).⁶ Behaviors that one would name as virtues are now redescribed as vices, or as behavior that is less than ideal in Socrates' account of political change. Language, especially the language of morality, changes, in the Platonic account, because there are no authoritative constraints to prevent its shift—and certainly not in democracy, where individuality, individual desires, and implicitly, individual usages of language are permitted and encouraged. The shift in language use both accompanies a moral decline and is also responsible for it in this account of constitutional devolution, and Plato's description of "shame" (αἰδώς) as a "fugitive" (φυγάς) insists upon the political nature of what is happening to words in the scenario that Socrates describes.

One of the other observers of political change as/in terms of verbal change in classical Greece is Thucydides, who employs the discourse of moral redescription more radically to denote the breakdown of community in the much-studied narrative of *stasis* at Corcyra. *Stasis*, civil war and unrest, produces a shift in the value and function of language, which the author describes in 3.82.4–5. "Daring" (τόλμα), poignantly described as ἀλόγιστος, "irrational" and literally "without" λόγος, is now deemed "partisan courage" (ἀνδρεία φιλέταιρος); "premeditative hesitation" (μέλλησις δὲ προμηθής) is regarded as "cowardice" (δειλία εὐπρεπής), "moderation" (τὸ σῶφρον) is redescribed as a "pretext for lack of nerve" (τοῦ ἀνάνδρου πρόσχημα), while "trying to understand every side of the matter" (τὸ πρὸς ἅπαν ξυνετόν) becomes "thorough laziness" (ἐπὶ πᾶς ἀργόν). Words change and stand in for each other, and as this happens, the way in which the city-state is constituted is also radically altered. This assignment of new values to familiar words now calls into question the usefulness of language as a precedent to deed, which the author has earlier established as critical for rational decision-making. Indeed, Thucydides is emphatic that λόγος has its counterpart in πρᾶξις, political and social reality, but by permitting words to be transferred into new usages the citizens of Corcyra reject precisely the continuity between word and deed. Λόγος and the knowledge derived from λόγος ideally inform action (ἔργον) in the symbouleutic paradigm associated elsewhere in the *History* in particular with the general and leader Pericles, who praises Athens for submitting action first to discussion and deliberation so that the city does not rush to deeds or regard speeches as an obstacle to its aims:

καὶ οἱ αὐτοὶ ἤτοι κρίνομέν γε ἢ ἐνθυμούμεθα ὀρθῶς τὰ πράγματα,
οὐ τοὺς λόγους τοῖς ἔργοις βλάβην ἡγούμενοι, ἀλλὰ μὴ

⁶ κλῄσαντες οἱ ἀλαζόνες λόγοι ἐκεῖνοι τὰς τοῦ βασιλικοῦ τείχους ἐν αὐτῷ πύλας οὔτε αὐτὴν τὴν συμμαχίαν παρᾶσιν, οὔτε πρεόσβεις πρεσβυτέρων λογους ἰδωτῶν εἰσδέχονται, αὐτοί τε κρατοῦσι μαχόμενοι, καὶ τὴν μὲν αἰδῶ ἠλιθιότητα ὀνομά ζοντες ὠθοῦσιν ἔξω ἀτίμως φυγά δα, σωφροσύνην δὲ ἀνανδριαν καλοῦντες τε καὶ προπηλακίζοντες ἐκβάλλουσι, μετριότητα δὲ καὶ κοσμίαυ δαπάυην ὡς ἀγροικίαυ καὶ ἀυελευθερίαυ οὖαν πείθοντες ὑπερορίζουσι μετὰ πολλῶν καὶ ἀνωφελῶν ἐπιθυμιῶν;

προδιδαχθῆναι μᾶλλον λόγῳ πρότερον ἢ ἐπὶ ἃ δεῖ ἔργῳ ἐλθεῖν.
(2.40.2).

> We ourselves either judge or perceive deeds correctly, not thinking speeches a source of harm to deeds but rather [that harm comes from] not having learned before through speech to what deeds we must come.

The general identifies Athens as a site of deliberative discourse and affirms that this is no hindrance to their military and political success as the Athenians do not regard risk taking and calculation (ἐκλογίζεσθαι) as being at all mutually exclusive (e.g., 2.40.3).

Beyond this, the disordering of language at Corcyra presents the self-dissolution of the community. The episode stresses the discontinuity between the past, present, and future, setting the scene for the breakdown of historical consciousness. Thucydides remarks that in the case of cities which came into a state of *stasis* later in the war, knowledge of what had happened previously was responsible for a *new* mindset characterized by unheard-of methods of acquiring power and acts of revenge (3.82.3). Here knowledge of the recent past produces further unprecedented atrocities rather than informing the cities of how to avoid civil war. In this disintegrating world, people no longer respect the gods. Deliberation, foreknowledge, and anticipation are valued only with regard to effecting private concerns and advantages. The function of forethought is now to ensure that one gets the better of one's enemies before being victimized.[7] It is entirely logical that the destabilizing of language, that is, of the basis of community, should culminate in the suicide of the members of the city-state (cf. 4.48).

As far as Isocrates is concerned, redescription is also a feature of contemporary Athens, and it is precisely redescription of a kind which precipitates a crisis that he perceives the city to be in, one of signification and description. Verbal change is the basis for political transformation for the worse.[8] For instance, "democracy" and its cognate terms, e.g., "democratic" (most often, δημοτικός), have plural significations, as a text like Isocrates' *Areopagiticus* demonstrates. One might speak of the historical, conservative democracy, that is, the constitutions of Solon and Cleisthenes, and still speak of democracy as Isocrates does in *Areopagiticus* 15–16; but one might also speak of the contemporary democracy of the new politicians and sycophants. In a diachronic narrative, what distinguishes them most effectively are temporal markers such as "then," "once," and "now." Likewise, the vocabulary attached to democracy—"moderation," "justice," "gentleness"—remains constant while its actual reference has undergone change, whether subtle or marked.

[7] Cf. ἁπλῶς δὲ ὁ φθάσας τὸν μέλλοντα κακόν τι δρᾶν ἐπῃνεῖτο,καὶ ὁ ἐπικελεύσας τὸν μὴ διανοούμενον, 3.82.5; cf. 3.82.3 and 8.
[8] For a broader perspective on the instability of the language of morality, see Skinner 1994.

The most detailed and acute analysis of Athens as the logocentric city in difficulty comes in the *Antidosis*. The rhetorician details the city-state as one characterized by verbal instability in *Antidosis* 283–85. Here he declares that Athens is turned upsidedown and everything has been mixed together. People no longer employ words in their natural senses (οὐδὲ . . . κατὰ φύσιν)—the phrase κατὰ φύσιν is undoubtedly a loaded one, constructing the past as "natural" and so as normative, perhaps as "autochthonous." In *Antidosis* 283 he employs the verb μεταφέρουσιν ("they transfer") to describe how people use words that previously described the "finest deeds" (καλλίστα πράγματα) now to designate the "basest activities" (τὰ φαυλότατα τῶν ἐπιτηδευμάτων).[9] For instance, those who are able to play the buffoon (βωμολοξευομένους), those who have the capacity to jest (σκώπτειν), and those who can imitate are currently and also mistakenly regarded as talented (εὐφυεῖς). Yet this adjective should more fittingly be used to denote those who are the best with regard to virtue, τοὺς ἄριστα πρὸς ἀρετὴν πεφυκότας, rather than individuals who engage in less than notable behavior (284).[10] Isocrates corrects language by offering an archeology of the word εὐφυεῖς.

In this section of the speech, there are other attempts to reclaim an earlier use of language in order to shift public perception of what terms mean. In 281 Isocrates turns to the topic of advantage (πλεονεξία) in order to demonstrate another notable misuse of language. People mistakenly think that advantage lies in theft (cf. ἀποστεροῦντας), the falsifying of accounts (cf. παραλογιζομένους)—which is in some sense what the present liturgy trial entails—or wrongdoing. Such perceptions suggest the degeneration of morality in contemporary Athens, for crime is viewed as an individual advantage. Yet the rhetorician shows that such individuals are actually at the least advantage, suffering from bad reputations and living with the greatest lack of resource (cf. ἐν πλέοσιν ἀπορίαις). True πλεονεξία in contrast comes into being from devotion to the gods and from dealing in the best possible way with the members of one's household and community (282). How πλεονεξία should signify is in some sense the issue of the work as a whole. The fictional prosecutor Lysimachus accuses the rhetorician of seeking to enrich himself and indeed, of having too much wealth for his own good through his teaching, which is to be understood as a mode of πλεονεξία.

There are further suggestions of moral upheaval in Athens. If wealth was once something to be admired such that people affected greater affluence than

[9] Such improper use of language is what Aeschines also observes as afflicting the law courts. Cf. Aeschin. *In Tim.* 167.1.6; *De False Legatione* 96; *In Ctes.* 142 and 220 (cf. stasis-theory and Calboli 1986).

[10] Aristotle speaks of the buffoon as being inferior to the comic (γελοῖος) (*Eth. Nic.* 1128a33–34). Buffoons exceed the limits of comedy, are base, boorish, and rough (1128a5–9), and are to be aligned with those who are slavish in nature and uncultured, and are also defined by distinction from the free, the reasonable (ἐπιεικής), and the cultured citizen (*Eth. Nic.* 1128a18–22; also 1128a30–31).

they actually had, being rich (τὸ πλουτεῖν) is now regarded as if it were the worst of crimes, and being suspected of being wealthy entails that the citizen is ruined in the law courts (159–60). This is precisely the situation that has landed the rhetorician in a liturgy suit. The perception that Isocrates owes the city-state a debt in taxes has any weight is a consequence of the envy and the material lack of some of the inhabitants of Athens. Isocrates' associate warns the rhetorician that his listeners are afflicted by their own perceived material lack (ἀποριῶν), and this renders them ill disposed to the socially privileged litigant (*Antidosis* 142). Yet the rhetorician and his community understand resource as being nonmaterial, and their anxiety is about not having enough to say rather than about insufficient wealth. Thus Isocrates mimes the fiction of dicanic innocence, claiming that he is at a loss (ἀπορῶ) for words (140), or else that he is in great perplexity (ἀπορία) (153). There is a deliberate and poignant play on the notion that the defendant is hardly as "resourceful"—whether rhetorically or materially—as his fellow citizens might think (cf. section 154). Yet, Isocrates is precisely the individual who finds himself in perplexity (ἀπορῶ) because he has too much to say at the end of this long oration (310).

In the rhetorician's Athens, honest and respectable (ἐπιεικεῖς) men find themselves oppressed and made base (ταπεινοί), while those who are actually wicked have the licence to do and say what they want (164). Isocrates compares the city to a torrent which engulfs everything such that things and indeed individuals are given reputations that are entirely inappropriate for them. People have a dysfunctional relationship to language. They neglect what is necessary for the city-state, and they adore the verbal tricks of the ancient sophists—Isocrates means Gorgias, Zeno, and Melissus, as *Helen* 3 makes apparent—as if they were practising philosophy (φιλοσοφεῖν), while withholding that description from those who truly devote themselves to this discipline. The narrative of verbal transformation is one where words with a positive or neutral moral connotation are derogated, and those with negative connotations are rehabilitated as being acceptable or even good. Such verbal inversions signify a radical shift in the moral values that, according to *Antidosis* 253–55, λόγος had originally established as part of the infrastructure of Athens, the verbal community, and what it marks is a shift from within the community itself: the people are the ones who use language differently from before and distinctly from nature, according to Isocrates' representation.

Likewise, also in *Areopagiticus* 20 Isocrates emphasizes his point about linguistic transference in fourth-century Athens. Here he observes that the original democracies of Solon and Cleisthenes were not merely the most communal and gentle in name alone, but were such in deed as well to those who experience them.[11] He goes on to draw a contrast between this historical democracy, and what the audience is to regard as contemporary Athens, where the citizens

[11] Cf. οὐκ ὀνόματι μὲν τῷ κοινοτάτῳ καὶ πραοτάτῳ προσαγορευομένην.

are taught to regard insolence (ἀκολασία) as democracy (δημοκρατία), lawlessness (παρανομία) as freedom (ἐλευθερία), outspokenness (παρρησία) as equality under the law (ἰσονομία), and freedom (ἐξουσία) to do everything as happiness (εὐδαιμονία). In this case, a behavior that marks the breakdown of order and virtue in the city is reinterpreted and renamed as a democratic virtue: the contemporary city is accordingly the community that hates and penalizes its best and most moderate members. In the *Areopagiticus*, civic language deteriorates due to the waning influence of the Areopagus Council, the authoritative "teacher" of the Athens established by Solon, whereas in the *Antidosis* language shifts because the original rhetoric of community—of which (as we shall see) Isocrates claims to be teacher—has been displaced by a rhetoric of personal interest.

Political Metaphor

Illuminating the politics of this communal rhetoricity, or conversely, the rhetoricity of this politics, as these authors do, is a significant engagement in the public sphere. In book 2 of the *Topics* Aristotle concerns himself with what he terms "universally constructive and destructive problems" (*Topics* 109a3–4).[12] Under the topic of destructive methods beginning at *Topics* 112a32 he draws attention to a method of verbal attack (cf. τὸ ἐπιχειρεῖν) whereby a word is referred back to its original meaning as distinct from its current usage. For instance, the adjective εὔψυχος should mean not "courageous" (ἀνδρεῖος) as it now does but "having a good soul/a soul in a good condition" (τὸν εὖ τὴν ψυχὴν ἔχοντα), while εὐδαίμων likewise might be made to mean quite literally "an individual whose fortune (δαίμων) is good/noble (σπουδαῖος)," where the adjective σπουδαῖος has clear aristocratic connotations. The basis for this understanding comes from a fragment from Xenocrates, who says that a "εὐδαίμων person is someone who has a noble soul" (cf. τὴν ψυχὴν ἔχοντα σπουδαίαν): the point is that the soul is the δαίμων of each person (*Top.* 112a34–40). Aristotle offers verbal archeology as a strategy for argumentation, and the technique of verbal archeology is named here as "transferring" (μεταφέροντα). The tactic involves *re*placing words that have been *displaced*; and here the notion of verbal location and *dis*location is central to the philosopher's discussion. And, indeed, one might remark that rhetoric regards language as spatialized, especially and foremost by understanding it as the discourse of the public, political sphere. The title of his work *Topics* denotes "spaces" or "places," while in the account of the destructive strategy at 112a33ff. common usage causes words to "lie" (κεῖται) in a place (it is implied) that is other than their etymological space. In the case of etymology

[12] τῶν προβλημάτων κοινὰ τὰ καθόλου κατασκευαστικὰ καὶ ἀνασκευαστικά.

the speaker "transfers" (cf. μεταφέροντα) a word back to its meaning, sense, or definition as the phrase κατὰ τὸν λόγον might suggest (112a33–34). Bruno Snell recognizes a return to verbal origins as one of the functions of metaphor, for in his discussion of metaphor in *The Discovery of the Mind* he regards this figure as helping to define an abstraction by recalling the actual physical origins of an object and also as reflecting the progress of civilization. For instance, the words "shoe horn" recall the substance from which a shoe horn was *once* made.[13]

Aristotle's vocabulary of "transference" (μεταφέρειν) is both prior to and also contemporary with the apparently disinterested literary-poetic significations that become affixed to the discourse of μεταφορά, largely due to the discussions of metaphor in the *Rhetoric* and *Poetics*. In these two texts, Aristotle declares that good use of metaphor entails considering what is (a)like (τὸ ὅμοιον); good metaphor is an appropriating and assimilating of the "other" to what already is (*Poet*. 1459a7–8) to the extent that metaphor will be something unusual (ξενικός) and will be unnoticed for what it is (*Rh*. 1404b35–36). Improper use of metaphor leads to the ridiculous (τὰ γελοῖα), which in Aristotelian usage has implications of social baseness (*Poet*. 1458b13–15; cf. also Isoc. *Antid*. 286 and *Areopagiticus* 49). Yet even the analyses of poetic metaphor are notable in highlighting metaphor as a process of verbal displacement. Aristotle declares that language which is ξενικόν, that is, unusual or literally "strange"/"foreign," includes such things as dialectical or rare forms (γλῶττα), metaphors (μεταφορά), lengthenings (ἐπέκτασις), and anything else that departs from what is authorized or proper (πᾶν τὸ παρὰ τὸ κύριον) (*Poet*. 1458b22–23). In *Poetics* 1458b17 he again draws attention to metaphor as use of language that does not hold priority of place. Here he notes that when one exchanges the proper words (τὰ κύρια ὀνόματα) for dialectical forms, for metaphors, or the other figures, then all becomes clear. Metaphor, together with the other verbal forms mentioned, is not a proper or "natural" usage, where τὸ κύριον connotes what is authoritative, established, and perhaps original. It is rather an example of unusual linguistic usage, where ξενικόν connotes what is strange, foreign, alien. Aristotle's account of metaphor is not idiosyncratic. Indeed, where Isocrates is concerned, metaphor is about introducing the strange, the unusual, and the novel into the community. He speaks of the exotic (ξένα) words, the newly coined ones (καινά), and the metaphors (μεταφοραί) that are available to poets but not to prose writers in *Evagoras* 9. Metaphor is a verbal structure that introduces the "other" into a community's language; and since λόγος is the basis of community, it is one that necessarily must transform it in some fundamental way.

[13] See Snell 1953 [= *Die Entdeckung des Geistes* (Hamburg, 1948)]. Aetiology is what resurrects the otherwise "dead" metaphor, a category whose existence George Lakoff and Mark Turner have questioned precisely because a "dead" metaphor is one that has become conventionalized and so, no longer perceived as unfamiliar. See Lakoff and Turner 1989, 129.

Aristotle's accounts of metaphor in the *Rhetoric* and *Poetics* do not address, or perhaps they repress, anxieties about verbal difference either as a cause or symptom of a larger political instability. Perhaps, I might speculate that to locate the discussion of metaphor in the public, political realm—something that Aristotle is not averse to doing explicitly as his discussion of literature in the *Politics* shows—would be to admit a series of concerns that would leave the poetic and the literary unspeakable. For it would be to acknowledge that literary discourse—poetry and tragedy—contains language that is other and foreign, and so compromises its status as articulations of civic ideals and ideology, which Plato may have recognized only too well when he banished literature from his imaginary state in the *Republic*. Despite the nonpolitical location of the discussions of metaphor in the *Rhetoric* and *Poetics* Aristotle still helps us in retrospect to excavate and to name the figurality involved in the narratives of political transformation in Plato, Thucydides, and especially Isocrates. They valorize negatively the contemporary rhetoric of transformation, suggesting not the progress of civilization (as Snell optimistically suggested in his discussion of metaphor in *The Discovery of the Mind*) but rather its decline. If metaphor is in any way central to the understanding of self, culture, and the world at large, then the marking of verbal shift by these authors might be regarded as pointing to the perception of the changing relationship between the individual and his or her world.[14]

Resisting Metaphor

Isocrates is an antimetaphorical writer. He admits language a certain mobility where geographical space is concerned, but not where its significance is concerned, and where language has shifted from its original and originary meanings, he seeks to reverse this movement. He achieves this above all in the *Antidosis*, a work that declares itself as providing an image (εἰκών) of himself, his life, and his character,[15] in response to a fictional accusation regarding his career as a teacher of rhetoric to young men. The verbal image offered by the *Antidosis* is one that simultaneously celebrates the mobility of λόγος on one level, and arrests it on another, at the level of meaning. How it achieves this is illuminated by a discussion of the written text in the *Evagoras*. In this work, an encomium of the deceased Cypriot king Evagoras, the author declares that the verbal image is superior to bodily effigies (τὰς τῶν σωμάτων εἰκόνας) because it *alone* has the capacity to represent deeds and thoughts (διανοίαι), which are the concern of noble men, and because statues and the like must remain where they have been set up, while speeches may be conveyed throughout Greece to be published (διαδοθέντας) amongst wise individuals. Writing

[14] See Lakoff and Turner 1989, 214.
[15] Cf. 6–7, 13; 28; 44; 54; 69; 141; 143–44; 152.

constructs identities that have validities both in and beyond the boundaries of an individual's own πόλις (see *Evagoras* 73–75).[16]

If the *Antidosis* is a mobile text in that it has the capacity to be published throughout the Greek-speaking world, it is nonetheless a mobile text that seeks to fix meanings. This is apparent in a number of different ways. The speech is one that appropriates a number of other texts to itself, Plato's *Apology of Socrates* and also passages from the author's own prior works (*Panegyricus, On the Peace, To Nicocles, Against the Sophists, Nicocles*), to disseminate them again as the components of the textual assemblage that is the speech's verbal image. But rather than demonstrate the capacity of language to signify differently in different contexts, these citations present portions of earlier texts without changing their explicit meanings.[17] Isocrates states before quoting his own works that the audience should not expect "new speeches" (καινοὺς λόγους) (*Antid.* 55)—after all, "newness" also has a connotation of political turmoil and upset—and then, he proceeds to explicate his original intentions in writing each of the texts. The defense of his writing seeks in part to fend off attempts to reinscribe and misinterpret his own texts, an activity that he observes taking place in his later speech, *Panathenaicus*. Here he complains that people abuse his speeches, reading them badly, misdividing them in reading, and ruining them in every way (*Panath.* 17).

Isocrates' attempt to protect his own discourse, which is such a central project to the establishment of his own self-image in the *Antidosis*, is only one part of a larger attempt to revise the language of Athens. And at this point I note that writing of the self, especially in the context of the law court, which was a privileged space for the depiction of selves, can never admit the naive production of identity. It entails fashioning the public self, that is, performing the "I" within a social and political frame and the expectations created by this. Accordingly, the *Antidosis*, a portrait of the author as a teacher of rhetoric, is as much a portrait of the Athenian city-state in the fourth century: it is the self-representation of the rhetorical agent in a rhetorical state, or rather, against this public sphere. If there is a depiction of Athens as a linguistically and politically dysfunctional state, then the speech also offers the possibility of a community where language, and presumably political relations, can function well through Isocrates' linguistic corrections.

Rhetoric becomes a tool of conservatism and rhetoric's advocate, a spokesperson for a prior rhetorical culture. If contemporary rhetorical culture has caused wealthy, respectable citizens to be involved in trials motivated by

[16] Alcidamas had earlier, however, characterized the written oration (ὁ γραπτὸς λόγος) as less responsive than the extemporized speech (*Soph.*13).

[17] See also *Areopag.* 49 and *Antid.* 284, for verbatim citation. Trédé-Boulmer perceptively observes, "De cette confrontation des parole jadis prononcées avec les paroles présentes doit ressortir l'image d'un homme toujours semblable à lui-même—*semper idem*—, fidèle, du premier au dernier jour, au même idéal de noblesse et de dévouement à sa cité"; see Baslez et al. 1993, 18.

personal grudges and jealousy, then Isocrates seeks to remind his audience that rhetoric was originally, and is ideally, the discourse that constitutes the basis of the community. Thus he proposes the recovery of rhetoric as a discourse of community, and to do this, he has to deny authority to the verbal wranglings of the professional teachers, the sycophants, the "new politicians," as part of a strategy of radical rehistoricization. In *Nicocles* 4 the speaker Nicocles defends rhetoric by observing that it is hardly fair to criticize virtues because some people misuse them or to transfer—again the verb used is μεταφέρειν—the wickedness of individuals to actions, which may in themselves be good, ἀλλὰ γὰρ οὐ δίκαιον . . . οὔθ᾽ὅλως τὴν τῶν ἀνθρώπων πονηρίαν ἐπὶ τὰ πράγματα μεταφέρειν. Instead, blame should be assigned to the individuals who misuse good things. Significantly, in *Antidosis* 215 he uses the participle μεταφέροντας, "transferring," to denote the process by which individuals *mis*attribute the evils of the so-called sophists to those who do nothing resembling contemporary sophistry, which in the rhetorician's account is a con game. The argument is that the infamy of the sophists should not be conflated with the reputation of sophistry—which is itself poignantly under contention.

And it is exactly the denial of what I am terming "political metaphor" that is at the core of representation in the *Antidosis*. By depicting himself as a teacher of rhetoric at Athens, Isocrates poses particular problems to be negotiated. For in the fourth century, "teacher" (διδάσκαλος) most immediately implies "sophist," the professional teacher who makes unrealistic promises about his ability to pass on knowledge and skills in order to gain a personal fortune. The contemporary sophist is a distasteful figure who encourages the sycophantic activity of the law courts. *Against the Sophists* is a powerful polemic against current rhetorical pedagogy and its practitioners, and elsewhere in his speeches, individuals who would be perceived as sophists, because they participate in Athens's verbal culture, are criticized for their greed, ambition, and unscrupulousness (cf. also *Helen* 2–6).[18] The contemporary sophist is responsible for the misuse of language, but if this figure is caricatured as irresponsible and mean-spirited, his villainy should not be underestimated. Given that language is the basis of community, the sophist is necessarily the enemy of the city-state. But Isocrates does not entirely reject the term "sophist," and certainly, not as a description for himself. The rhetorician acknowledges that the word is now a derogatory term, and in his own writing, it certainly functions that way. But he also proposes to the fictional "jury" of the *Antidosis* that the sophist might be something quite other. He is adamant that he is not a sophist in the sense conventionally understood as he rejects the usage current in popular discourse and iconography. The *Antidosis* unwrites metaphor. It is a text that

[18] See Owen 1986. At *Bus.* 43 "sophists" becomes a generic title for impotent and ineffectual individuals, while in the *Panath.* the sophists are individuals who hold and act out personal grudges, misrepresenting the author's work, breaking it up and ruining it (see sections 5 and 16–17).

seeks to redefine and reinflect "sophist," by reestablishing and by reframing the term and its significations within a historical context.[19]

The rhetorician seeks to reappropriate the term "sophist," and in so doing, to constrain the word's sphere of signification in the classical city. In an earlier democratic Athens, the noun was a term of commendation: people admired sophists and their students, and faulted the sycophants for the city's woes (313). The rhetorician rehabilitates the sophist and rhetorical culture by demonstrating that verbal ability has been responsible for many of the things that made and now continue to make Athens a great city. Athens's original democratic founders were "sophists," where the term denoted them as wise rulers. These are the men who freed the city-state from her various historical troubles—whether tyranny, slavery, or Persian invasion—by means of their verbal abilities. So Solon, Athens's lawmaker and paradigmatic political teacher, was originally known as a sophist and as such, responsible for making Athens into the city that deserved to rule all of Greece (*Antid.* 235 and 313).

In the *Nicomachean Ethics* (1180b35ff.) Aristotle speaks of the false claims of contemporary sophists to engage in politics. If Isocrates is to be regarded as a sophist, it is as Solon's direct heir; he is Athens's self-appointed political saviour and wise man, and not the disruptive political troublemaker of present-day Athens. The *Antidosis* in part seeks to combat what the author depicts as the crisis of attribution in Athens, and the εἰκών that he announces himself as offering of his life, character, and work has the function of stabilizing, by historicizing, language in this world. The aitiological narratives, which trace civilized community to λόγος (cf. *Antid.* 253–56 and *Nicocles* 5–9), and the nostalgic celebration of Solon in *Areopagiticus* 16 are the means of patently establishing this genealogy. But what has occurred here is a curious slippage that is too easy to overlook amidst the glorfication of the past and its chief representative. Solon is the democratic figure who transformed Athens through his economic policies in the service of justice, who redeemed its enslaved poor by bringing them back to the city, and who maintained a political equilibrium (see Solon 4 West) with the result that power in the state was more widely shared; Isocrates is in contradistinction the political ideologue with evident oligarchic tendencies, who complains about the overdemocratization of the state and who seeks to limit political participation to the wealthy few, as was indeed the case in Solon's Athens. If the rhetorician's goal is to return to a city-state in which decision-making is a much more restricted process, his intentions are the contrast of Solon's more liberalizing ones.

So verbal derivation becomes the basis of a deceptive intellectual continuity. The rhetorician is after all the individual who insists that he writes nothing but

[19] Cf. Mestre and Gomez 1998, on Philostratus, who sees ancient sophistics as treating the same subject as philosophy.

λόγος πολιτικός, or political discourse, which deals only with matters of significance and of benefit to the city-state (cf. *Antid.* 45–47; also *Panath.* 2, 11).[20] The *Antidosis* is specifically also a didactic text through which the author instructs his fellow citizens in the true functions of rhetoric/philosophy and its practitioners (see section 29 and discussion in the commentary, 59, etc.). Elsewhere in the *Areopagiticus* the rhetorician asks his audience to "learn thoroughly" (καταμαθεῖν) what the city-state's historical constitution was, the lesson provided by this text (see *Areopagiticus* 28). Isocrates is also to be regarded as the professional teacher who in his turn bequeaths this reinterpreted Solonic mantle upon his students. His pupils have included orators, generals, kings, and monarchs, the sort of people who ideally benefit their communities, above all Athens, one assumes, by keeping power amongst the privileged few who have been born to it (*Antid.* 30).

The overall utility of λόγος, especially as practised by Isocrates, is what absolves him of any liturgic obligations. The point is that the teacher of philosophy, that is, rhetoric, is the individual who teaches the community about its purported origins and true identity.

CLASSICISMS

Language shifts as the community revalorizes terms and what they signify. One might understand this process as progression, as an advance in political understanding, or one might—as Isocrates and his similarly conservative contemporaries—regard this as a form of communal corruption, which threatens to make the city-state *other* than it was founded to be. And so, an author like Isocrates seeks to arrest the development of language in the state and more than this, to return language and what it means to a historical past that is associated with political and cultural power, with hegemony in the Greek world, and even with the creation of the state as such. The rhetorician is a conservative, and as such, he offers a stark contrast between an Athenian past, which is orderly (after all, κοσμιός is one of the key buzz words of Solonic propaganda[21]) and stable and ideally, identified with Solon, Cleisthenes, and Pericles, and an Athenian present, which is chaotic and morally corrupt. His rhetoric is not that of classicism, for Isocrates' Athens is no less "classical Athens" than the fifth-century city that he idealizes. Rather his rhetoric is not unlike that of the poet of the *Theognidea*, who laments the political changes that have happened in his city-state, Megara. The poet writes that although his πόλις is the same, the people have changed, knowing neither justice nor law,

[20] Too 1995, 10–35.
[21] Too 1995, 106.

and those who were previously good (ἐσθλοί) are now wretched (δειλοί) (vv. 53–58). Moral and class categories have shifted, as the author's language demonstrates, and it is now the case that good is completely mixed in with the bad, σὺν γὰρ μίσγεται ἐσθλὰ κακοῖς (v. 192). And Isocrates' rhetoric is that of the fourth-century conservative, whose critiques of contemporary democracy are the sum of classical Greek political theory. His rhetoric is, furthemore, a discourse that after all reinterprets and palimpsests the past, for Solon, who so perfectly emblematizes an ideal bygone era, sought the greater political enfranchisement of the Athenian people while Isocrates' own project is by contrast the limiting of political participation to the elite few.[22] If Isocrates' backwards look to Solon is to be called a classicism insofar as classicism is retrospective, then classicism is one which rewrites and reinteprets the past in marked distinction from its original intentionalities and meanings.

To discuss Isocrates as a proponent of classicism as this term is more commonly understood, that is, as a standard and norm of aesthetic ideals—in this case, Atticism, we need to go to the Roman period, where authors treat the rhetorician as a paradigm of Greek prose writing, and in doing so, efface the political dimensions of Isocratean discourse. Cicero speaks of Isocrates as *ille pater eloquentiae* (*De or.* 2.10), as *magister* (*De or.* 2.57; *Orat.* 151), as *doctor singularis* (*De or.* 3.36), as *princeps* (*De or.* 3.173), and as *magister istorum omnium*, who produced a line of important Greek orators, including Theopompus, Ephorus, Philistus, Naucrates, Demosthenes, Hyperides, Lycurgus, Aeschines, and Dinarchus amongst others from his school, which the Roman author compares to a Trojan horse (*De or.* 2.94). In the *Brutus* Cicero speaks of the home of Isocrates, a *magnus orator et perfectus magister*, as a school (*ludus*) of all Greece, which lay open and was a factory of speech (*officina dicendi*) (*Brut.* 32). In the historicization of rhetoric offered by the Roman writer Isocrates is presented as the "father" and the teacher of a whole succeeding generation of Athenian orators; he is the beginning of classical Greek, that is, Athenian, speech, although Socrates is presented as the "leader" (*princeps*) of the generation including Gorgias, Thrasymachus, and Isocrates in *De oratore* 3.59–60. And in the *Brutus* the history of classical Greek rhetoric is a distinctly Athenian one, for speech was not a common concern for all of Greece. As Cicero asks, who knows of any orator from Argive, Corinth, Thebes, or Sparta at that time? It is from Athens that the art of speech spread into the other Greek islands and then, into all of Asia, where it lost the Attic qualities of pure and healthy speech (*Brut.* 50–51).

For Greek writers of the Roman period Isocrates' classicism is pronounced through his canonization as one of the ten Attic orators. Pseudo-Plutarch produces a biography of the rhetorician's life in his work *Lives of the Attic*

[22] The work of my talented student Brian Beck has made this very apparent to me.

Orators, offering details that are in large part derived from the author's own original writings.[23] In his analysis of Isocrates Dionysius of Halicarnassus notes that the Athenian rhetorician has a style which is as pure (καθαρά) as Lysias's and that his language conforms to ordinary and familiar usage (cf. τὴν τε διάλεκτον ... τὴν κοινὴν καὶ συνηθεστάτην) (Dion. Hal. *Isoc.* 2). Later on, he again speaks of the writer's purity of expression (cf. τὴν καθαρὰν ἑρμενείαν), and declares that Isocrates held to the dialect of his day (cf. τὴν ἀκριβείαν τὴν διαλέκτου τῆς τότε συνήθους) (11). Dionysius's account of Isocratean writing is one that espouses the ideals of Roman Atticism, in implicit contrast with the Asiatic style, and it offers "purity" as a quality of Athenian prose without realizing that for the fourth-century author, this entails exclusion of the foreign, the unnatural, and the exotic. Yet Dionysius's analysis is in the end not merely a formal or stylistic one, for he also observes the effect of reading the author on his audience. So he states that Isocrates' works make one serious in nature (cf. τῇ ἤθη σπουδαίους) and useful to one's home, to one's state, and to the whole of Greece (cf. οἴκῳ τε καὶ πόλει καὶ ὅλῃ τῇ Ἑλλάδι χρησίμους). Isocrates can help one in the pursuit of the "true philosophy" (τὴν ἀληθινὴν φιλοσοφίαν), which Dionysius clearly understands to be an activity that assists its practitioner in public and political life, and enables one to become useful to the state (4). Dionysius observes the political agendas of some of the author's works, noting, for instance, that the *Panegyricus* will make one a supporter of democracy (5) while the *Areopagiticus* is seen as recommending the restoration of the historical constitutions of Solon and Cleisthenes (8).

The Roman author locates his essay on Isocrates within a larger work that offers appreciations of the canonical Attic "orators," who are Lysias, Isocrates, and Isaeus, from an earlier generation, and Demosthenes, Hypereides, and Aeschines, from the next generation—the analyses of Hypereides and Aeschines are missing. Dionysius thereby presumes a history of rhetoric that excludes all but fourth-century Athenian representatives as paradigms of Greek rhetorical discourse, and in fact, his introduction to this overall work makes explicit the exclusiveness of this treatment of Greek rhetoric. Here he offers a narrative in which the old philosophic rhetoric, the speech exemplified by the succeeding studies, was abused and fell into decline, to be replaced by a new rhetoric that offered its practitioners civic honors and high offices. Now the older sober rhetoric (cf. τῇ μὲν ἀρχαίᾳ καὶ σώφρονι ῥητορικῇ) has been restored to its place of honor, and has displaced the new rhetoric in all places except a few Asian cities (*Introduction* 1–2). The cause for this change is the power of Rome (3), a statement which makes the point that the triumph of what has become Atticism is a Roman phenomenon. To ask and, presumably, to

[23] Too 1995, 76–81.

answer who were the best orators is, according to Dionysius, the greatest thing for mankind (4).

The ideal of Atticism, which embraces Isocrates as one of its paradigms, writes out of existence rhetoric prior to the fourth century and the sophistry and litigation that was so prevalent in the fourth century. It also effaces even the rhetoric that Isocrates claims to have been so beneficial to the well-being of Athens, namely the public discourse of Solon, Cleisthenes, Themistocles, and Pericles, but in a different manner, for it erases this prior rhetoric by denying that any difference exists between the language produced by Isocrates and his predecessors. (This move will be repeated in the eighteenth and nineteenth centuries, as then Hellenism meant the Periclean, Isocratean, and Spartan ideals in such a way that the temporal and cultural specificities of these ideals were denied.)[24] Classicism has a synecdochical quality in that it transfers the name of the Athenian rhetorician to the public, political discourse of the fourth century and indeed to that of all of classical Greece, fifth and fourth centuries, such that he comes to stand for all of them. The classicism that idealizes Attic rhetoric focuses on such a select number of writers, proposing them as the sum total of the history of Greek prose of a prior era and fantasizing about them as paradigmatic representatives for Greek writing and oratory in the present. But classicism also has a metaphorical quality. If metaphor, in the Aristotelian definition, involves the transfer (ἐπιφορά) of a term from one context to another one so that something similar but strange (cf. ἀλλοτρίου) is introduced (cf. *Poet.* 1457b6–20), then classicism involves the transfer of language from one temporal context into a later one in the hope that the qualities of the earlier world may be brought into the later one. Classicism indirectly resurrects the metaphorical move of the Solonic period, where individuals name a less ideal reality by euphemisms (cf. Plut. *Sol.* 15.2–3). And most importantly and also paradoxically, it enables the triumph of Isocrates' own original antimetaphorical strategies, for the metaphorization of the Isocratean in the Roman period ensures that the rhetorician's discourse is solidly identified with fourth-century Athens.

Conclusion

Isocrates may be the most significant thinker of classical Athens, but the Athens in which he finds himself is anything but an ideal. For him, it is the past, the earlier days of Solon, Cleisthenes, and Pericles, that misleadingly (in light of their more democratic impetuses and Isocrates' own less democratic ones) offers the paradigm for the present-day society, and this past is to be recovered

[24] See Swain 1996, 36.

by arresting the ways in which language might signify and mean within the community: a pristine discourse is the basis for a better democracy as far as Athens is concerned. According to Isocrates, Athens in the classical age is not a paradigmatic *polis*; it is a city that to its own detriment flees from precedent, from its father figures, from its origins, which together are its ideals. The Isocratean critique of the contemporary Greek city-state of the fourth century thus removes from it its status as classicizing ideal: the Athenian rhetorician archaizes in order to depart from the classical present, which perverts λόγος and, with this, the basis for the political infrastructure. For him, the classical age is antitype and anti-ideal, and this rejection of the present is what the subsequent tradition must celebrate if it is to classicize in a manner that remains true to this writer.

PART III

Baroque Classics

Chapter 4

BAROQUE CLASSICS: THE TRAGIC MUSE

AND THE *EXEMPLUM*

ANDREW STEWART

Sunt lacrimae rerum et mentem mortalia tangunt
There are tears that connect with the universe, and things
mortal touch the mind
—Vergil, *Aeneid* 1.462

FROM CLASSIC TO BAROQUE

It would be easy to produce a potboiler account of classical revivals in Greco-Roman sculpture. Pliny furnishes the basic recipe with his notorious contention that the art of bronze casting "stopped" after the 121st Olympiad (296–293 B.C.E.), "then revived again in the 156th Olympiad (156–153 B.C.E.) when there were the following, far inferior it is true to those mentioned above, but nevertheless artists of repute: Antaeus, Callistratus, Polycles of Athens, Callixenus, Pythocles, Pythias, and Timocles."[1]

At least two of these men certainly worked in a classicizing style, and the rest probably did so. Add Pasiteles' lost book on the *Opera Nobilia* or "classics" of ancient sculpture; the conservative tastes of Cicero, Dionysius of Halicarnassus, Quintilian, Pausanias, and others; the culture of *otium*; the preferences of the Roman art market; and of course the mass of Roman classicizing statuary, "Neo-Attic" reliefs, and copies. At this point the basic character of the final dish—bland and all too predictable—is clear.

Instead, I want to try something bolder: to abandon this somewhat insipid fare for the spicier cuisine of the Hellenistic and Roman baroque. Shamelessly

I am most grateful to Jim Porter for the opportunity to contribute to this anthology, and to him, Bernard Andreae, Christopher Hallett, Chrystina Häuber, Michael Koortbojian, Ann Kuttner, Paolo Liverani, Donald Mastronarde, Brunilde Ridgway, Eric Varner, and especially Mark Griffith for their generous help on particular points. I would also like to thank seminar audiences in Sydney, Macquarie, and Hobart for their interest and their comments. The translation of the Vergil epigraph is used by kind permission of Gregory Nagy. All responsibility for what follows, however, attaches solely to myself.

This chapter is dedicated to Tom Rosenmeyer, *Tragoedia et Graeca et Latina doctissimus*.

[1] Plin. *HN* 34.52.

exploiting the semantic ambiguities of the word "classic" (see Porter, this volume), I want to explore two seemingly paradoxical questions and a third more straightforward but apparently neglected one. First, how far did the Hellenistic baroque style ultimately become a kind of classic one—an exemplary or definitive mode of presenting certain particular subjects to Greek and Roman audiences? Second, how far can some individual baroque sculptural groups qualify as classic—exemplary or definitive—realizations of classical Greek culture's supposedly most classic artifact, namely, Attic fifth-century tragedy? And third, since most of these baroque groups were often replicated in Roman times, how far can one marshal them under the sign of the *exemplum* itself—Roman culture's classic depository of political and moral guidance?

In short, like Jaś Elsner (this volume) I want to detach the notion of a "classic" from the high classical (Phidian/Polyclitan) sculptural style and its later imitations. In particular, I want to see how far I can stretch this notion to embrace other works that seem equally exemplary but are universally agreed to be largely or wholly unclassic in style. My definition of the phenomenon of classicism thus comes close to Elsner's: "the emulation of any earlier set of visual styles, forms, or iconographies, which in the very fact of their being borrowed are established as in some sense canonical (or 'classic')."

Melpomene Joins Calliope

Over a decade ago, in a study of the Nike of Samothrace and the "epic" narrative of the Gigantomachy of the Great Altar of Pergamum, I proposed that Hellenistic "baroque" sculpture and the so-called Asian style of Hellenistic rhetoric were intimately related. Living in cities like Pergamum, Ephesus, or Magnesia, the sculptors would often have encountered this kind of rhetoric, and some key characteristics of their work can easily be described using its terminology.

Specifically, one thinks of its favorite stylistic devices of *auxesis* (amplification), *makrologia* (extended treatment), *dilogia* (repetition) *palillogia* (recapitulation), *megaloprepeia* (grandeur), *deinosis* (intensity), *ekplexis* (shock), *enargeia* (vividness), *antithesis*, and *pathos*. All of them were gleefully exploited by Asian rhetoricians and (as convenient) more cautiously utilized or loudly derided by their critics. By adopting them the sculpture offers a reprocessed image of its classical past that is filtered through the lens of the baroque and tuned to a visually and historically sensitized audience.[2]

But rhetoric is a tool. It is a means to an end, not an end in itself. If the Pergamene Gigantomachy is in some sense the equivalent of an Asian-style epic poem, what of the great baroque two- or three-figure groups—the Pasquino (figs. 4.4–5), Laocoön (figs. 4.13–15), and others (figs. 4.6–12)?

[2] Stewart 1993a, 133–37, 169–72, summarized here with some additions and corrections.

Some of them certainly tackle tragic themes in what seems *prima facie* to be a strongly "tragic" manner, and (unlike the Gigantomachy) they definitely conform to the Aristotelian demand that a good tragedy should be *eusynoptos*, easily grasped by eye and mind.[3] Like tragedy itself, they condense the themes and concerns of epic into a compact, dramatic format. So can we now ask Melpomene, the tragic Muse, to join Calliope, the epic one, at center stage? The following considerations may help her on her way:

1. The appearance of a tragic vein in Greek painting with Exekias in the sixth century and in sculpture with Alcamenes in the fifth (figs. 4.1–2), and Attic tragedy's popularity with Apulian vase painters in the fourth.[4]
2. Aeschylus's observation that the themes of Greek tragedy were but "slices from Homer's banquet," and Aristotle's observation that whereas the characters of fifth-century tragedy spoke politically, their fourth-century successors spoke rhetorically.[5]
3. Antiphanes' assertion (see below) that every Athenian knew the tragic plots by heart, and Lycurgus's canonization in the 330s of Aeschylus, Sophocles, and Euripides as classics of the genre.[6]
4. The Hellenistic world's increasing cultural Athenocentrism (see Most, this volume).
5. The boom in theater-building in Hellenistic Asia Minor and the striking success there of Attic-style drama and its professional practitioners, the Dionysiac Artists.[7]
6. The wide dissemination in Hellenistic mythographical handbooks of these tragic plots and the tales they drew on, offering a kind of *Reader's Digest* or *Cliff's Notes* for the average reader.[8]
7. The use of these tales as *paradeigmata* in Hellenistic schools.
8. Pliny's numerous notices of works on tragic themes by Hellenistic artists, and the many Philostratean *ekphrases* of Old Master paintings in this vein.[9]

[3] Arist. *Poet.* 7, 1450b34–1451a6; briefly explored apropos the Laocoön by Andreae 1994b.
[4] Amphora with the Suicide of Ajax, Boulogne 558: Beazley 1956, 145 no. 18; *LIMC* 1 (1986), s.v. "Aias I" no. 214, pl. 245. Group of Prokne and Itys (after Sophokles" *Tereus*?), Akropolis 1358: Paus. 1.24.3; Stewart 1990, fig. 399 (but Prokne's head may not belong). Apulian vases: Trendall and Webster 1971, with important qualifications by Small 2003, 37–78.
[5] Aeschylus: Athen. 8, 347d; Eust. *Il.* 1298, 56. Aristotle: *Poet.* 6, 1450b6–8.
[6] Antiphanes fr. 191 Kock (Athen. 6.222A); [Plut.] *Mor.* (*Vit. dec. Orat.*) 841F.
[7] See *CAH* vol. 7.1 (2nd ed.), 319–20; Hansen 1971, 460–64; Stephanis 1988. For this and what follows see, in general, Bieber 1961; Simon 1982; Green 1994.
[8] See, e.g., Plut. *Mor.* 14E; Marrou 1956, 165, 263, 281; Henrichs 1986; *OCD* (3rd ed.) s.v. "Mythography"; Cameron, 2004. My thanks to Donald Mastronarde for alerting me to this genre's importance.
[9] Plin. *HN* 34.140 (Athamas by Aristondas); 35.144 (Orestes, Klytemnestra, and Aigisthos, by Theon of Samos); 35.139 (Herakles and Deianeira, and Herakles on Oeta, by Artemon); and especially 35.136 (Ajax, Medea, Orestes, and Iphigeneia in Tauris by Timomachos of Byzantion); Philostr. *Imag.* 1.4 (Menoikeus), 7 (Memnon), 11 (Phaethon), 24 (Hyakinthos); 2. 4 (Hippolytos),

9. The well-known theatricalization of Hellenistic visual culture in general.[10]
10. And finally, the Romans' enthusiastic, indeed relentless appropriation of all of the above.

In Rome, the first Latin tragedy was performed in 240 B.C.E., and from Ennius onwards, Roman dramatists regularly translated the Greek classics into Latin. In the realm of images the Roman response was equally strong. Witness Lucullus's dedication of a tragically dying Hercules Tunicatus at the Rostra—"a *simulacrum* of so many battles and such great *dignitas*"; the obsession of Brutus's wife, Porcia, with a tragic picture of Hector leaving Andromache; and Pompeian houses like that of the Tragic Poet with its eclectic array of epic-tragic *exempla*. And last but not least, Vergil's famous line quoted in my epigraph.[11]

Among these, it is worth quoting the Porcia incident in full:

> [In the summer of 44] Brutus resolved to abandon Italy and traveled overland through Lucania. His wife Porcia was obliged to return from there to Rome. She tried to conceal her distress at parting from Brutus, but the sight of a painting broke down her noble resolve. The subject was drawn from Greek legend—the parting of Hector and Andromache—and the picture showed her taking from his arms their little son, while her gaze was fixed upon her husband. As Porcia looked at it, the image of her own sorrow which it conjured up made her burst into tears, and she went to see the picture time after time each day, and wept before it. On this occasion Acilius, one of Brutus's friends, quoted the verses from Homer which Andromache speaks to Hector:
>
>> "Hector, to me you are all: you have cared for me as a father,
>> Mother and brother and loving husband . . ."
>
> Brutus smiled at him and said, "But I shall not give Porcia the answer that Hector gave,
>
>> 'Work at your loom and your distaff, and command your servants.'
>
> "She may not have the strength for the exploits that are expected of a man, but she has the spirit to fight as nobly for her country as any of us." We have this story from Porcia's son, Bibulus. (Plut. *Brut.* 23, trans. Ian Scott-Kilvert)

7 (Antilochos), 9 (Pantheia), 10 (Kassandra), 29 (Antigone and Polyneikes), 30 (Evadne); Philostr. *Imag.* 2 (Marsyas—see below); 17 (Philoctetes); Callistr. *Stat.* 13 (Medea).

[10] See Webster 1966 for a classic account, with, e.g., Pollitt 1986, 4–7, on "the theatrical mentality" and Ridgway 2000a, 284, on "epic" and "tragic" strands in the Hellenistic baroque.

[11] On the theater and Roman culture see note 6, above, with Tarrant 1978; Rawson 1985b (reprinted in Rawson 1991, 508–45); Beacham 1991; and Easterling, ed. 1997, 211–27; Brilliant 2000, 15–16. Cicero (*Att.* 16.5.1; *Fam.* 7.1.3) remarks on the poor audiences for the original Greek plays vis-à-vis their Latin counterparts. Hercules and Hector-Andromache: Plin. *HN* 34.93 (looted from the East and later restored by an aedile); Plut. *Brut.* 23 (both kindly brought to my attention by Ann Kuttner). House of the Tragic Poet: Bergmann 1994.

Yet to go one stage further, this Hellenistic and Roman canonization of Attic tragedy was itself an illusion and a distortion of history (see Porter, this volume). For classicism attempts to identify and to recuperate an unblemished, exemplary past that never was. Driven by a sense of historical belatedness, it is both idealist and intertextual: chasing the mirage of a past utopia as glimpsed through a contemporary filter and often too through others in between. In the present case, Aristotle's *Poetics*, Hellenistic mythography, and the Hellenistic versions and Roman translations of the classics come immediately to mind as mediators, plus whatever contemporary performance practice contributed to the mix.

So I want to argue that the sculptures of figures 4.4–15 seek to resurrect this already mediated, utopian classical past in a kind of monumental epiphany, forging in their own way a contemporary, neoclassic present that was itself soon canonized through replication. "They . . . literally bring the past to life in a palpable experience in the present, while simultaneously projecting the present back into time" (Porter, this volume). Or to frame the question in a Bakhtinian way, they are double double-imaged: offering both an image of a genre (tragedy) that is itself an edited image of a stylized reality (myth), and an image of the world "out there" (contemporary reality, tragic revivals, mythography, etc., included) as it appeared to the artists who created them.[12]

Finally (though beyond my present scope), this ongoing process of sculptural dialogue, resurrection, and replication must have made some impact, however small, upon the Hellenistic and Roman reception and staging of the tragedies, setting up expectations and creating standards for audiences and actors alike.

Yet there are also two things that I do *not* want to do. I do not want to suggest that any of these sculptures *illustrate* particular (but now lost) Greek tragedies, and I do not want to imply that their makers either knew Aristotle's *Poetics* or conceived their work in relation to it. Not only does at least one of them (the Laocoön, fig. 4.13) narrate events that could never be shown on stage, but as far as we know, Aristotle's book was little read by Hellenistic and Roman literary critics, let alone by laymen in the world at large.[13]

Instead, I base my argument on four main propositions.

First, though a tragic sensibility is present even in Homer, it was through the influence and authority of Attic fifth-century tragedy that it gradually came to pervade much of Greek life. It became one of the main ways in which the Greeks instinctively came to stylize reality. True, Attic tragedy's arousal of pity and fear, its exploration of character and emotion, and its key plot devices of ignorance, self-destructiveness, capitulation to passion, and transgression

[12] For this Bakhtinian reading, see Stewart 1993a, 171–72.
[13] The bibliography on the *Poetics* is vast: I have found Halliwell 1986, Halliwell 2002, Janko 1987, and Rorty, ed. 1992 most useful, with Else 1986 and the relevant chapters in Grube 1965 and Russell 1982.

against the law and the gods were not its own invention. But the particular ways in which it employed them gave them special focus and authority. Tragedy's emergence in the world of late archaic Greek literature augured the eventual emergence of a scion in the world of Greek art.

Second, the Hellenistic and Roman dissemination, study, and occasional revival of the classic plays themselves, supplemented by new tragedies, translations, and the mythographical/tragic handbooks mentioned earlier, reinforced tragedy's authority and created a fertile breeding ground for a counterpart to it in the visual arts. Indeed, these latter-day versions, adaptations, and synopses must have been far more influential than the originals themselves, whose archaic Greek must have been all but incomprehensible to many. One of the most important of the mythographers was Dicaearchus of Messana (fl. ca. 320–300), a pupil of Aristotle, whose *Tales from Sophocles* and *Tales from Euripides* summarized the plots of the classic plays (reducing them to a simple matter of *peripeteia*) and furnished what one might call the basic narrative envelope that the general reader needed in order to make full sense of them. These texts were regularly used in Greco-Roman schools.[14]

So although artists and the public shared a common tragic *paideia* on several levels, their experience of the plays was largely or wholly mediated, as *a fortiori* were any artworks that emerged from this experience. Such encounters were not "unmediated glimpse[s] of a classical past ... but ... rather filtered by the imaginary vision of [this] intervening stage. On this model, what the observer 'sees' and identifies, and identifies *with*, is not a classical phenomenon but *another observer's view* of that phenomenon.... Classicism here comes, as it were, secondhand" (Porter, this volume). Of course, all of this merely exemplifies in somewhat belabored fashion the principle that it is not the writer but his or her audience that ultimately determines the text. With apologies to Heraclitus, one can never experience the same text twice, nor the same artwork either.

Third, although Aristotle's *Poetics* was seldom read and is somewhat classicizing, idealizing, and dismissive of much of the passion, extravagance, and sheer irrationality of fifth-century tragedy,[15] his comments are valuable to us insofar as (a) they reflect or intellectualize popular ideas about the genre, and (b) *qua* classicizing, they may anticipate what later, conservative critics might have thought about it. In particular, Aristotle singles out some key features of Attic tragedy that were often noted by contemporaries and in some cases were explicitly cultivated by Greek artists. These features include its exploration of

[14] On Dicaearchus see *RE* Suppl. 11, 526–34; *OCD*, q.v.; *Der neue Pauly* 3, 564–66; Wehrli 1967, frr. 78–84; and on Greek mythography in the Roman world, see Cameron 2004. For Dicaearchus's theory of *peripeteia*, see esp. Sext. Emp. *M.* 3.3 (fr. 78W). Compare the situation in England and the U.S. today, where performances of Shakespeare are barely comprehensible to most audiences.
[15] Eliminating the irrational: Arist. *Poet.* 15, 1454b6–8; 24, 1460a11–14; 24, 1460a26–1460b2; 25, 1461b19–24; cf. Halliwell 1986, 107–8 and 146.

character (*ethos*) and emotion/suffering (*pathos*)—tragedy's very essence; its fondness for bringing down a hero via a mistake (*hamartia*) of some kind, resulting in a dramatic change (*metabole/metabasis*) and particularly a reversal (*peripeteia*) of fortune; and last but not least its dedication to "swaying the soul" of its audience with pity (*eleos*) and fear (*phobos*).[16]

And fourth, these basic and (at this level) quite straightforward concerns can help us in turn to probe the tragic dimension of our sculptures and to envisage their public's reactions to them. For ancient critics universally assumed that everyone could and would read "beyond the frame." Thus Antiphanes, in the verses mentioned earlier:

> Now Tragedy's a lucky sort of art
> The audience knows the plot before you start;
> You've only to remind it. "Oedipus,"
> You say, and all's out—father Laius,
> Mother Jocasta, daughters these, sons those,
> His sin, his coming punishment. Or suppose
> You say "Alcmaeon"; in saying that, you've said
> All his sons too, how he's gone off his head
> And killed his mother, and how Adrastus next
> Will enter, exit, and re-enter, vexed.
> Then when a playwright's tired of his play,
> And simply can't find any more to say,
> As easy as winking up goes the trapeze,
> And everyone's content with what he sees.[17]

Thus, too, with narrative artworks. Our sources take it for granted that one would know the stories; would naturally engage the artwork's implied narrative envelope; and (like Porcia) would react to it accordingly. All this is a *sine qua non* of epigram and ekphrasis and the ancient equivalent of the kind of response

[16] On *ethos* and *pathos* in tragedy (N.B. Halliwell 1986, 146 n. 14 on the latter as the "essence of tragedy"), cf., e.g., Arist. *Poet.* 1, 447a28 with Hdt. 5.67.5; Pl. *R.* 2.19, 380a; 10.8, 605c–606; Men. *Aspis* 329–42; and in art, e.g., Xen. *Mem.* 3.10 and the many other passages collected in Pollitt 1974, 30–31, 184–89, 304–6. On tragic *hamartia* cf. Arist. *Poet.* 13, 1453a10–16; 16, 1454b35; and 25, 1460b15 with Pl. *R.* 3.8, 396d; *Leg.* 8, 838c; Isoc. 2.33. On tragic *metabole/metabasis* (synonyms: Halliwell 1986: 206 n. 7) cf. Arist. *Poet.* 4, 1449a14; 5, 1449a37; 10, 1452a14–11, 1452a31; 13, 1452b34 and 1453a9; 18, 1455b26–29 with Eur. *Fr.* 554N; Pl. *R.* 8.8, 553d-e; Isoc. 16.48; Dem. 2.13. On *peripeteia*, cf. Arist. *Poet.* 6, 1450a33–35; 10, 1452a14–18; 11, 1452a11–1452b13; 16, 1454b28–30 with Hdt. 8.20; Xen. *Mem.* 4.2.27; Isoc. *ad Nic.* 33 (through a *hamartema*); Dicaearchus fr. 78W (Sext. Emp. *Math.* 3. 3); in art, cf. Strabo 1.2, 8 (quoted below). On tragic *eleos* and *phobos/ekplexis*, cf. Arist. *Poet.* 6, 1449b24–28; 11, 1452a34–b3; 13, 1452b30–1453a7; 14, 1453b12; and 19, 1456a38, with Gorg. *Hel.* 8–9; Pl. *Ion* 535b; *Phdr.* 268c-d; *R.* 3.2, 387b-d, and 10.8, 605c–606b; *Phlb.* 48a; Isoc. 4.168. The continued currency of these ideas in the Hellenistic period is secured, e.g., by Polyb. 2.56 in his extended attack upon Phylarchus and the "tragic historians," and Strabo 1.2, 8.

[17] Antiphanes fr. 191 Kock (Athen. 6.222A; trans. Edmonds, slightly adapted).

elicited by Christian art in the Middle Ages and Renaissance. Many ancient writers remark on the emotional and psychological impact of the visual arts, and others state explicitly that particular images are either tragedies in a capsule, or provoke pity, sorrow, or other recognizably tragic responses.[18]

But we need to set up some criteria. At the risk of multiplying lists, three obvious ones come to mind:

1. The artwork's *theme* should be tragic. Achilles and the dying Penthesilea (fig. 4.6), for example, meet this criterion; a satyr molesting a nymph does not.
2. The artwork's *emplotment* should be tragic. It should represent or strongly imply a moment of tragic climax. Achilles and the dying Penthesilea (fig. 4.6) meet this criterion; Orestes and Electra greeting each other do not.[19]
3. The artwork's *style* should be capable of rendering tragic emotion. The classical style and *a fortiori* the baroque both meet this criterion; archaism, the "rococo," and a frigid neoclassicism do not.

Yet even so, in some respects art and theater will always remain incomparable. In particular, by opting for the moment *before* the climax, for example, Exekias (fig. 4.1), Alcamenes (fig. 4.2), and some of our sculptors manage to create a powerful sense of tragic tension. But they thereby deny us a performed tragedy's strong "sense of an ending" and thus any feelings of tragic *catharsis*—whatever exactly this emotion might be.[20] And in general, different media and genres seldom mature at the same time, at the same pace, or in the same manner. So an achievement in one medium may not be matched in another until much later and using means that might well have upset contemporaries or latter-day purist devotees of the first.

[18] Reading artworks beyond the frame: cf. Hom. *Il.* 18.490–540 with, e.g., *Anth. Plan.* 16.135–38 (Medea); Philostr. *Imag.* 1.22.2 (Midas); 1.30.1 (Pelops); 2.4 (Hippolytos); 2.34.3 (Horai); Callim. *Ia.* 13.1 (Medea); cf. Plin. *HN* 35.74 on Timanthes. A guiding principle of Western narrative art since antiquity, it was challenged by the Impressionists and Cubists and has been successfully ironized by Cindy Sherman *inter alios* in her *Untitled Film Stills* (1977 and 1979). On the emotional and psychological impact of the visual arts see, e.g., Arist. *Poet.* 4, 1448b5–12 and *Rhet.* 1.11.22–23, 1371b5–10 (on visual pleasure); 6, 1450b16 (in the tragic theater, the *opsis* is *psychagogikon*); id. *Pol.* 8.5.7, 1340a33–40 (Polygnotus and Pauson), with, e.g., Gorg. *Hel.* 17–19 (where they can inspire fear); Pl. *R.* 3, 401; Strabo 1.2, 8; etc.; cf. Pollitt 1974, 41–52. For a truly tragic response see Verg. *Aen.* 1.453–93 (including the epigraph to this essay) where Aeneas weeps at the Trojan war pictured on Dido's temple, "though it was only a lifeless picture"; and Plut. *Brut.* 39 (Porcia, mentioned earlier); cf. Philostr. *Imag.* 1.18.3, 2.9.5; *Anth. Plan.* 16.132 (pity); Philostr. *Imag.* 2.4.1 and 3; *Anth. Plan.* 16.140; cf. esp. Philostr. *Imag.* 2.10.1 where a painting of Kassandra enacts a tragedy in a capsule, but in its vividness surpasses drama. Brilliant 1986, 7, justly remarks upon the difficulty of reading sculpture this way.

[19] See Smith 1991, figs. 330–31; and most recently Fuchs 1999, 59–64, pls. 46–49. I use "emplotment" after Ricoeur 1984–88.

[20] Kermode 2000. *Katharsis*: Arist. *Poet.* 6, 1450b24–28; 17, 1455b12–15; *Pol.* 8.7.4–6, 1341b39–1342a17; the bibliography is huge but by definition need not be addressed here.

So let us allow for differences in media; keep in mind all those extreme and irrational features of Attic fifth-century tragedy that Aristotle sidelines; focus on some of its key concerns; factor in the wide dissemination of its themes, plots, and basic techniques in the Hellenistic and Roman periods; recall that in these periods one could only have experienced the plays themselves through a contemporary filter; and attempt to read our images *all' antico*.

Pasquino, Penthesilea, Marsyas

To show that the baroque style itself soon became a kind of classic is not difficult. One only has to recall its wide currency in the Hellenistic east; its glorious afterlife in grandiose marble displays like the Laocoön (figs. 4.13–15), the Sperlonga marbles, the Large and Small Gauls, and the sculptures from Caracalla's Baths; its periodic revival in Roman imperial relief sculpture (e.g., in the Flavian baroque of the first century C.E.; in Lucius Verus's second-century altar at Ephesus, and in the great second- and third-century battle sarcophagi); and its ongoing dissemination in multiple copies (such as those of the Blind Homer, "Pseudo-Seneca," "Pasquino," Achilles and Penthesilea, Hanging Marsyas, and perhaps the Laocoön itself: figs. 4.3–15). So from the mid-Hellenistic period the baroque was the norm for subjects of violence, passion, and suffering—in short, of *pathos*. In this role it easily infiltrated the connoisseurial pantheon of *opera nobilia* and assumed a prominent place in the Roman Empire's representational landscape.[21]

Yet at this point the simple parallel that is often drawn between ancient artistic and literary classics begins to break down. For while the elite could order books copied and recopied, and classic literary styles and genres could always be revived at will, only schoolboys were actually compelled to *read* any of these works, and then only a restricted selection of them. Most of the others just moldered away in libraries, forgotten and unread. (*A fortiori*, of course, texts deemed unclassical or anticlassical often fared worse; thus, Hellenistic tragedies were almost never copied, and—after a brief vogue in the late Republic—Asiatic rhetoric went completely out of fashion and its products all but vanished from sight.) But unless physically removed or destroyed, the sculptures stayed stubbornly on view. A permanent part of the Greco-Roman visual landscape, they remained an insistent presence in the public eye until the end of antiquity.

[21] For illustrations and commentary see Bieber 1960; Pollitt 1986; Stewart 1990; Smith 1991; and cf. Kleiner 1992. The Laocoön, too, may have been diffused in copy, but the evidence is circumstantial and not encouraging—unless the Vatican statue is one: cf. Settis 1999, 19–25; Koortbojian 2000, 204–6.

But it is important to keep the Hellenistic world and imperial Rome distinct, at least for the present. So this section and the next will offer a Greek-style interpretation—in essence, a tragic reading—of some of these sculptures; and the fourth will sketch the outlines of an *interpretatio Romana*.

The lost bronze original of the so-called Pasquino, known today in at least fourteen copies, must have been a masterpiece (figs. 4.4–5). Its nickname comes from the use of the copy outside Rome's Palazzo Braschi as a bulletin board for lampoons or *pasquilli*.[22] The original group was clearly Hellenistic (it is usually dated around 250–150 B.C.E.) and is always described as baroque. But it also exhibits all the "classic" properties of classicism (see Porter, this volume): unity, consistency, clarity, balance, and a lucid formal design. Its composition is triangular and strong, adhering emphatically to the frontal plane; its antitheses are bold and clear; its modeling is powerful and vigorous; and it evokes the heroic enterprise in a forceful and compelling way.

The Pasquino thus presents an image of the classical hero as seen through Hellenistic eyes: a worthy successor to (for example) the fifth-century Riace Warrior A—a cousin to Sophocles' Ajax—and perhaps (though these are lost) the heroes whose *dignitas* was allegedly first properly conveyed by Euphranor.[23] Its main nonclassical trait is its baroque exaggeration (*auxesis*) of the contrast (*antithesis*) between the bearded warrior's craggy, expressive head and muscular neck (fig. 4.5) and his dead companion's lolling, youthful, and almost epicene one.

Recent opinion has abandoned the traditional identification of the group's two heroes as Menelaus and the dead Patroclus (after *Il.* 11.786–87) in favor of Ajax and Achilles (after *Little Iliad* fragment 2 Kinkel). This better fits the dead warrior's emphatic youthfulness and prominent chest wound. It is also supported by a version on a late antique bronze plaque that certainly represents Ajax and Achilles (with Odysseus following behind), and by the sculpture's appearance twice over as a pendant to the Achilles-Penthesilea group (fig. 4.6). One of these displays stood in Herodes Atticus's villa at Loukou, where another copy was found in the nineteenth century and a mosaic version in the 1990s. And all this in classicism's very *dulce domum*, the rural retreat of the self-proclaimed voice of classical Athens![24]

To explain this plethora of Herodian Pasquini, it may be no coincidence that Herodes named his three beloved foster sons (*trophimoi*) after epic heroes. All

[22] On the Pasquino see *LIMC* 8 (1997), s.v. "Menelaos" no. 32 (L. Kahil); cf. Hausmann 1984; Ridgway 1990, 275–78; Wünsche 1991; Himmelmann 1995, 13–19; Weis 1998 (examining the findspots of the copies); and Weis 2000, 117–25, with comments and rebuttal by Green 2000, 180–85.

[23] Riace A: Stewart 1998, 275–78, re Soph. *Aj.* 1067–83. Euphranor: Plin. *HN* 35.128.

[24] On the Loukou groups see Spyropoulos 2001; on Herodes' voice, see *Epigram. Gr.* 1046.38; *IGR* 1.194.

three died tragically young, and the second of them was called Achilles. We shall resurrect him later.[25]

Peter Green clinches the case for Achilles as follows:

> As early as the *Little Iliad* we find a curious tradition that the ghost of Achilles demanded the sacrifice of Polyxena on his tomb (cf. Eur. *Hec*. 35–44; Ov. *Met*. 13.445–48; Tzetz. *ad* Lycophr. 323; Serv. ad *A*. 3.322) and that the request was duly carried out. A Tyrrhenian amphora of about 570 BCE and an Archaic relief sarcophagus from the Troad illustrate the sacrifice: Achilles' son, Neoptolemus, cuts her throat over the burial mound. What was the reason for this? To satisfy the hero's honor, we are told: as a blood offering to the dead. But in what respect had Achilles' honor been offended, and why did Polyxena have to be the victim? There is one necessary answer to this, and one only: the mention of the sacrifice in the *Iliou Persis* (followed by that Tyrrhenian vase painting and the Trojan sarcophagus relief) offers sufficient guarantee of its antiquity. . . .
>
> In this version of events, Achilles fell in love with Polyxena when Hector's body was ransomed by Priam (Philostr. *Her*. 19.11; cf. *VA* 4.16). He was, in fact, prepared to stop fighting, even to negotiate a peace settlement, if Priam would give him Polyxena in marriage. He received the old man's consent, but on coming to the precinct of Thymbraean Apollo to meet with the herald Idaios to discuss terms, was treacherously killed there by Paris and Deiphobus (schol. Eur. *Hec*. 41; Serv. ad *A*. 3.322; Hyg. *Fab*. 110; Dictys Cretensis 4.10–11), either from ambush, or run through by the one while the other held him. His body was removed from the precinct by Ajax, with Odysseus. . . . The motive for Achilles demanding Polyxena's sacrifice now becomes all too clear.[26]

Even more tellingly, in Seneca's *Troades* Calchas specifies that Polyxena must be sacrificed to Achilles *as his bride*:

> In the garb in which Thessalian brides are wed,
> Or Ionian, or Mycenaean,
> Let Pyrrhus lead his father's bride to him.
> Thus shall she be given duly.[27]

[25] Pendants: Weis 1998, 264. Plaque (so-called Tensa Capitolina): see *LIMC* I s.v. "Achilleus," pl. 143 no. 896; Wünsche 1991, fig. 39; Himmelmann 1995, pl. 22b; Weis 1998 overlooks it and in 2000, 118, dismisses it. Herodes' pupil Achilles: Philostr. *VS* 558–59; *IG* ii². 3977 (lamenting his death) and 13195; cf. Tobin 1997, 33, 96–99, 113–14, 132 no. 14, 139, 270–71, 277–78, figs. 14–16.

[26] Green 2000, 184, to which add Hellanicus *FGH* 4 F 151, the earliest hint of the assignation; and Sen. *Tro*. 191–97 and passim; cf. the useful discussion by Gantz 1993, 628.

[27] Sen. *Tro*. 362–65: *Sed quo iugari Thessalae cultu solent / Ionidesve vel Mycenaeae nurus, / Pyrrhus parenti coniugem tradat suo. / Sic rite dabitur.*

Whether or not the last sentence alludes to the original arrangement's furtive character and disastrous outcome, the macabre wedding ritual is duly performed some eight hundred lines later:

> ... the Trojans
> Throng their own funeral and with quaking fear
> Look on the last act of the fall of Troy;
> When suddenly, as at a wedding, the torches lead the way
> And Tyndareus's daughter, the bride's attendant, with sad
> And drooping head.[28]

This scenario immediately explains the Pasquino's most puzzling iconographic feature. If the dead youth is truly Achilles, why is he wearing no armor? Because he has come to parley, not to fight.

The artist has selected the plot's crisis point, after Achilles' murder but with Ajax still marooned behind enemy lines and in dire peril. This is classic Hollywood *avant la lettre*.[29] As remarked earlier, such narrative stasis represents sculptural tragedy's main difference from the theater and perhaps its major advantage over it. As Exekias and Alcamenes had seen (figs. 4.1–2), this very *lack* of resolution pushes us to supply an ending yet still leaves us in suspense at the crossroads. And Ajax's instinctive reaction, to look about for danger, seems so natural that it is easy to forget that it too is a convention of the late- and post-classical tragic stage. Thus, for example, Polynices in Euripides' *Phoenissae*:

> So I must turn my eye every way
> hither and thither, lest some treachery lurk.[30]

So the Pasquino explores the consequences of a classic Aristotelian *hamartia*. Although this word was long thought to mean a character flaw, it must signal a failure, fault, or error of some kind. For it often designates something that seemed a good idea at the time but sooner or later turns out to have been a disastrous mistake. This mistake may be culpable (e.g., ignoring a divine command or sign; challenging the gods) or not (e.g., killing a *hybristes*; detecting a ruse), or something in between. So "it is the space between full moral guilt and mere subjection to chance." Here, Achilles' uncontrollable passion has led to his fatal *hamartia*—a classic *Leitmotif* of Greek and Roman tragedy. The motif's recurrence in both Ovid and Seneca's tragedies (where it translates more narrowly as *error*) shows that it retained its potency through the Hellenistic period and well into the Empire.[31]

[28] Sen. *Tro.* 1129–34: *Nec Troes minus / suum frequentant funus et pavidi metu / partem ruentis ultimam Troiae vident; / cum subito thalami more praecedunt faces / et pronuba illi Tyndaris, maestum caput / demissa.*

[29] *Black Hawk Down* (2002).

[30] Eur. *Phoen.* 265–66; on the later history of the convention, see Tarrant 1978, 247–49.

[31] Arist. *Poet.* 13, 1453a7–23; Ov. *Trist.* 2.103; Sen. *Herc. F.* 1237–38; *Herc. O.* 886–89, 900–901;

But one can go further. For the scene's implied narrative envelope fits a classic, oft-repeated tragic story pattern.[32] This pattern may be diagrammed schematically as follows:

Eutychia → hamartia → metabasis/peripeteia → dystychia

The Pasquino focuses on the results of Achilles' *hamartia* and the *metabasis/peripeteia* that followed: the change/reversal in the hero's fortunes from good to bad. A short while ago, Achilles was the Best of the Achaeans and secretly betrothed to the most beautiful girl in Troy. He was the very epitome of good fortune or *eutychia*. Now he is dead—the ultimate misfortune or *dystychia*—and his faithful comrade, Ajax, looks likely to suffer the same fate.

So by resurrecting a classic moment of tragic climax, the Pasquino satisfies a prime function of classic tragedy by provoking us simultaneously to pity and fear. Remembering the story, we instinctively pity Achilles, whose brilliant life has been snuffed out so prematurely and so needlessly; we feel great pity and fear for Ajax, now bereft of his comrade and marooned behind enemy lines; and we feel considerable pity and fear for the Achaeans in general, now bereft of their greatest champion. We come away—if we have any imagination at all—with a *phantasia kakou*, an impression of disaster.[33] And of course as good, red-blooded Greeks we also thrill to the erotic charge of the young hero's beautiful, limp body cradled by the older, superbly muscled Ajax, for all the world like an *eromenos* in the arms of his *erastes*. The Hellenistic "tragic" historians and Seneca's tragedies furnish ample proof that these notions flourished through the Hellenistic period into the early Empire, but embellished—like the Pasquino itself—in a highly rhetoricized way.[34]

It is time to confront this baroque rhetoric head-on. Clearly by the mid-Hellenistic period it was certainly the classic (i.e., exemplary, canonical, or definitive) way to render *pathos*.[35] But compared with, for example, Alcamenes' Procne (fig. 4.2) it is hardly classic in the more accepted and restrictive sense

Eur. *Phoen.* 515, 539, 553–55; cf. Stinton 1975; Halliwell 1986, 212, 215–25, with quotation on 220.

[32] Arist. *Poet.* 11, 1452a23–1452b13; 18, 1455b24–1456a10.

[33] Arist. *Poet.* 6, 1449b24–28; 11, 1452a34–b3; 13, 1452b30–1453a7; for fear as a *phantasia kakou* see *Eth. Nic.* 2.5, 1382a21–23. On pity and fear see Schadewaldt 1970, 194–236; Halliwell 1986, 170 n. 3; Nussbaum 1992; Nehamas 1992, esp. 301 apropos Aristotle's remark at *Eth. Nic.* 2.8, 1386a24–26: "The relation [*sc.*, between the two] is symmetrical: we fear for ourselves what we tend to pity others for, and we pity others for what we would fear for ourselves"; and Halliwell 2002, 186–87, 206–233.

[34] On the "tragic" historians, the *locus classicus* is Polyb. 2.56, offering a virtual glossary of our key terms (*peripeteia, eleos, sympatheia, ekplexis, psychogogia,* and *pathos*); cf. also 3.47.6–9; 10.2.5–6; 15.34.1–2; 15.36. 1–11; 16.18.2. For a measured appraisal of these writers see Walbank 1955 and 1960 (I thank Erich Gruen alerting me to these articles).

[35] Cf., e.g., Demetr. *Eloc.* 2.36 and 2.240–304 on the "forcible" style (*deinotes*); cf. Quint. *Inst.* 6.2.24.

of manifesting the standard classical virtues of unity, balance, and moderation—of maintaining a façade of classical decorum.[36] Fourth-century tragedy and Hellenistic tragic history with their alleged capitulation to rhetoric and spectacle (*opsis*) come immediately to mind, but both are postclassical and precisely the kind of "impure" writing that Aristotle, Polybius, and other classicizing authors disdain.[37]

Of course, both Aristotle and Polybius explicitly acknowledge the tragic power of several of the baroque devices catalogued at the beginning of this essay, such as *ekplexis* (shock) and of course *pathos* (suffering).[38] Yet they would surely have argued that like most later tragedians and the Hellenistic tragic historians, the Pasquino exploits these devices in an exaggerated and thus degenerate way. *Caveat spectator!* This corruption would irremediably debase and corrupt any tragic responses of pity and fear that they might evoke.[39]

Yet as remarked earlier, in his classicizing zeal Aristotle willfully glosses over much of fifth-century tragedy's passion, extravagance, and irrationality. This is partially because his literary theory is an outgrowth and logical extension of his own ethical philosophy of the Mean, predisposing him to tragedies that reject such extremes. He even wants to exclude the divine completely as a causative tragic agent and favors an ideal plot type that actually *avoids* irreversible suffering. So much for most fifth-century tragedies—and for the Pasquino (figs. 4.4–5)!

Moreover, we can assert that the Pasquino indeed does maintain a sort of classical decorum, since its baroque style is deployed economically (cf. fig. 4.5) and in a way that is precisely tailored to its subject. The end result is clear (*saphes*) and appropriate (*prepon*), thus meeting Aristotle's two main criteria of rhetorical excellence.[40] Indeed, most contemporaries would probably not have seen the group as baroque but merely as up-to-date and exciting, while nevertheless sensing in it something of the *habitus* of classicism and thus experiencing the feeling of being "in the ambit of what is classical" (see Porter, this volume). And finally, its numerous copies show that its brilliant

[36] See, e.g., Pl. *Phdr.* 268d4; *Cra.* 425a; Arist. *Metaph.* 13.3.8, 1078a36–b7; *Poet.* 7–8, 1450b21–1451a35.

[37] Arist. *Poet.* 6, 1450b6–8 (rhetorical tragedy); 6, 1450b16–20; 14, 1453b1–14; perhaps 18, 1456a1–5 (corrupt); cf. Halliwell 1986, 64–69, 337–43; with Polyb. 2.56; 3.47.6–9; 10.2.5–6; 15.34.1–2; 15.36.1–11; 16.18.2 on "tragic" historiography.

[38] Arist. *Poet.* 14, 1454a4; 16, 1455a17; 25, 1460b25 (*ekplexis*); 1, 1447a28; 11, 1452b11; 14, 1453b20; 14, 1454a13; 18, 1455b34; 19, 1456a38; 24, 1459b9 (*pathos*); Polyb. 2.56, etc.

[39] The same would be true *a fortiori* of Longin. 3.1–3, who excoriates the Asiatics for histrionics of precisely this kind; yet even so, he himself is very interested in *auxesis* (11–12) and *pathos* (44.12, where the manuscript breaks off); on the former see also *Rhet. Her.* 2.30, 47; Quint. *Inst.* 8.4.

[40] Eliminating the "irrational": Arist. *Poet.* 15, 1454b6–8; 24, 1460a11–14; 24, 1460a26–1460b2; 25, 1461b19–24; cf. Halliwell 1986, 107–8, 146; Halliwell 2002, 195–200. Best plot: Arist. *Poet.* 14, 1454a2–9. Excellence in rhetoric and the *prepon/decor* theory: Arist. *Rh.* 3.2.1–3, 1404b1–25; cf. Pollitt 1974, 59–60, 68–71, 217–18, 341–47.

Hellenistic-style restaging of a classic tragic moment was indeed judged to be successful, that it was seen as a true classic of its genre.

So as we contemplate the Pasquino and work out its story, its direct representation and indirect evocation of pitiable and terrifying events (its narrative envelope) engage our emotions of pity and fear in classically tragic fashion. They sway our souls. These complex responses mature as we first apprehend the work; then start to decipher it; explore its narrative envelope; and finally comprehend it in its full narrative, tragic, and aesthetic significance. But in the end it leaves us in suspense.

Having formulated our thesis, let us now test it on other examples of the genre.

The group of Achilles and the dying Penthesilea (figs. 4.6–8), preserved in seventeen copies (none complete and some of them statuettes), takes us back to the *Aethiopis* and an earlier stage of the Trojan War. The hero has fallen in love with the Amazon queen at the very moment he strikes the fatal blow. Expiring, she sinks limply to the ground while he, looking around in desperation, manfully supports her sagging body. Although the composition borrows from both the Pasquino (fig. 4.4) and the high baroque Suicidal Gaul, the style is more emphatically neoclassic (in the traditional art-historical sense). The original may date to the second century B.C.E. or even the first.[41]

Chaeremon dramatized the story in the fourth century B.C.E. and an anonymous Latin tragedian followed suit several centuries later.[42] Though, like the Pasquino (fig. 4.4), this group also illustrates the plot's crisis point, the change of subject introduces a new element. Once more we find an exploration of the consequences of unrequited passion, and witness a classic *metabasis* or shift of fortune due to tragic ignorance. But now it is the hero's belated *anagnorisis* (recognition) of his love that has triggered the *peripeteia* (reversal) in his fortunes. In the blink of an eye these "greatest and most moving features of tragedy," as Aristotle termed them, have precipitated him from triumphant victor to devastated lover, from the greatest *eutychia* to the most wrenching *dystychia*.[43]

And once more we react with pity and fear, albeit differently balanced and differently directed than before. As Stephen Halliwell has noted of Aristotle's discussion, "Our pity for others' undeserved suffering depends in part upon our sympathetic capacity to imagine, and imaginatively fear, such things for ourselves; and fear for ourselves (though this is not the main element in tragic fear) can in turn be created by the sympathetic experience of others' misfortunes."[44]

[41] See Gantz 1993, 621–22; and on the group, *LIMC* I (1981), s.v. "Achilleus" no. 746 (A. Kossatz-Deissmann) and s.v. "Amazones" no. 188 (P. Devambez and A. Kaufmann-Samaras); *LIMC* 7 (1994), s.v. "Penthesileia" nos. 59–61, 65–67 (E. Berger); cf. most recently Himmelmann 1995, 58–60; Grassinger 1999, 322–30. Did anyone in antiquity ever notice that by referencing the Suicidal Gaul the sculptor was hinting that Achilles had now killed his own chances for happiness?

[42] *TGF* p. 782 Nauck2 (= Chaeremon 71 F 1a–3 Radt); *Tragicorum Romanorum Fragmenta* 271.

[43] Arist. *Poet.* 6, 1450a33–35; see especially Halliwell 1986, 212–15.

[44] Halliwell 1986, 177.

In this case, we certainly pity the beautiful queen for her heroic but inevitable death, and Achilles for his undeserved suffering. Held in suspense by this frozen tragedy, we wonder what this volatile hero will do next and what repercussions will ensue for his comrades. Yet perhaps we fear for ourselves more than for him and the Achaeans, lest (*mutatis mutandis*) one day we suffer a similar misfortune. And not least we thrill to the erotic charge of love and death that courses through these two conjoined, classically beautiful bodies, as the handsome, muscular hero grips the yielding flesh of the limp, collapsing young woman, his powerful hand so tantalizingly close to her innocently bared breast. A potent image, whose rapid ascent to classic status is again attested by its plethora of copies, including one (as mentioned earlier) at Loukou.

Next, the Flaying of Marsyas (figs. 4.9–12). Here the monumental tradition is more lopsided, complex, and troublesome. Moreover, at first sight the subject looks inappropriate in the present context, nearer to melodrama than tragedy.

First, there is the massive imbalance in the numbers of copies. Almost sixty full scale ones remain of the Marsyas—it was a copyist's favorite—but only one of the Scythian Knifegrinder (who does, however, appear in several versions in relief and in the "minor" arts). Next, Marsyas himself survives in two different versions. These are the baroque, bestial, agonized, and hysterical Red type (figs. 4.10–11), so called after the red *pavonazetto* marble of several of the copies and an epigram in the *Anthologia Latina*; and the more classical (or classicizing), somber, and resigned White one (figs. 4.9 and 12).[45] And finally, reproductions of the group on reliefs, coins, and gems include a third figure: a seated, lyre-playing Apollo. The god also appears in a Trajanic inscription recording a bronze Marsyas group at Apameia in Syria and in the Younger Philostratus's *ekphrasis* of a painting of the scene, but has left no echo in marble at all.[46]

Although the Red type is normally believed to predate the White, some now think that the latter is not a proper type at all but a series of independent, classicizing recensions of the other. Yet the two types differ slightly in their basic motif. In both, Marsyas's hands have been forced behind his back, tied, and hoisted up the tree, dislocating his arms at the shoulders in the process. (Variously called *la corda*, *la garricha*, *l'estrapade*, *strappado*, or *Anbinden*, this torture was practiced in the Austrian army as late as 1918 and also—needless to say—in Nazi concentration camps.)[47] Yet in the White type each arm is hung separately from the tree, while in the Red one they were first bound together with the wrists crossed, then hoisted aloft. This extra bit of sadism, markedly

[45] *Anth. Lat.* 173. On the group and its problems see most recently Smith 1991, 106–7; Weis 1992; Wünsche 1995; Meyer 1996; Maderna-Lauter 1999, 115–40; Ridgway 2000a, 283–84.

[46] *LIMC* 6 (1992), s.v. "Marsyas" nos. 61–64 (A. Weis); Weis 1992, 88 n. 423 (inscription: Marsyas, Scyth, Apollo, and Olympos); Philostr. *Imag.* 2.

[47] On the torture, see Weis 1992, 64; Meyer 1996, 94; on its later history, see Philipp Fehl's discussion of Titian's *Marsyas*: Fehl 1992, 133 n. 26, on p. 373.

increasing the satyr's agony, may indicate that the Red type is the later one. Hung in this excruciatingly painful position the satyr now waits for the Scythian to flay him.

In my view, Apollo was present in each group but was omitted by the Roman copyists, who with one exception (the sculptor of the Knifegrinder, fig. 4.9) wanted to focus exclusively on the victim. The Uffizi Niobids and so-called Large and Small Gauls offer exact parallels, whose wider implications I have explored elsewhere.[48] This clever tactic substitutes the Roman spectator for the avenging gods and mortals, forcing him to complete the composition in his own imagination. As Quintilian remarks, Greek rhetoricians called such exercises *phantasiai* (Latin, *visiones*). "We . . . should call them mental pictures or *impressions* for they represent images of absent things to the mind in such a way that we seem to discern them with our eyes and to have them in front of us. Whoever best perceives these will be able to generate the most powerful emotions." In short, *omne ignotum pro magnifico est*: "the unknown is always more impressive."[49]

But to return to the original Hellenistic composition, although the White type (figs. 4.9 and 12) probably preceded and was the springboard for the Red (figs. 4.10–11), each has a definite meaning of its own. For whereas the latter seems to represent a classic case of barbarian *hybris* requited by divine *nemesis*, the former displays a sensibility that one can only call stoically tragic.

The Red type (figs. 4.10–11) justifies—or attempts to justify—the satyr's horrible punishment by his savage features and crazed reaction to his fate. A grotesque affront to civilization, a monster of *hybris*, he suffers in proportion.[50] Justice—of a sort—has been done. (Was the group originally dedicated in a sanctuary of Apollo?) The White type (figs. 4.9 and 12), however, challenges the god's brutal revenge by Marsyas's endurance in the face of unbearable pain and the prospect of worse to come. Here we witness a tragic *metabasis* in action, the first stage of the satyr's two-stage descent into *dystychia*, as his fatal miscalculation as to his place in the world condemns him to

[48] Stewart 2004, 147–52; cf. Bieber 1960, figs. 253–65, 281–83, 424–37; Pollitt 1986, 84–97; Ridgway 1990, 82–84, 284–304; Stewart 1990, 205–7, 210, figs. 667–75, 685–91; Smith 1991, 99–104, 107–8, figs. 118–32, 140–41; Meyer 1996, 94–96. On the Gauls see most recently Marszal 2000; and on the Niobids see Brilliant 1986, 7–10; republished in Brilliant 1994.

[49] Quint. *Inst.* 6.2.29: *Quas phantasias Graeci vocant nos sane visiones appellemus, per quas imagines rerum absentium ita representantur animo ut eas cernere oculis ac presentes habere videamur. Has quisquis bene conceperit, is erit in affectibus potentissimus*; cf. Tac. *Agr.* 30.3. The classic study of this visual *topos* is Blanckenhagen 1975 (attributing it to the Hellenistic period, in my view mistakenly); cf. also Pollitt 1974, 52–55, 293–97; Brilliant 1986: 11; Fattori and Bianchi, eds. 1988; Meyer 1996, 95; Watson 1988; Manieri 1998 (some of these references kindly supplied by Kristen Seaman and Jim Porter); Zanker 2004, 72–123; Stewart 2004, 151–52. The translation of *phantasiai* or *visiones* as "impressions" is taken from Long and Sedley 1987, I: 72–86, 236–53, 460–67.

[50] Ov. *Fast.* 6.706–8 and Apul. *Flor.* 3.6–14 certify this reading, with, e.g., Plut. *Alc.* 2.5; on the sources in general see esp. *LIMC* 6 (1992), s.v. "Marsyas" 367 (A. Weis).

torture and soon to death. He arouses our pity at the utter disproportion of his punishment, and our fear at its ghastly, impending climax; and also makes us tremble for our own future in the face of such implacable sadism, especially since its source is none other than the god of light and reason, Apollo.

Several ancient accounts of the incident show that this reading is not anachronistic. According to Diodorus, Apollo was so ashamed at his excess that he even broke his lyre strings in remorse and for a time abandoned music altogether. Traces of this tradition also appear in Nonnus, and in Ovid the entire human and divine population of the countryside and even the earth itself all bemoan Marsyas's cruel fate. This theme recurs in the *Greek Anthology* and in Lucian and Philostratus.[51] Since divine vengeance is seen to be grossly disproportionate to the crime, we instinctively identify with the victim's stoicism in the face of it. And if the original group were dedicated in Phrygia or its environs then public sympathy for the hapless satyr was assured from the start, for the Phrygians believed that he had come back from the dead to drive off the hated Gauls.[52]

Although a subhuman from a bygone, primitive, and barbaric world, this Marsyas has overcome his intemperance and pain (vividly recalled for us by the Red type) to achieve a certain heroic dignity and even a kind of immortality. Whereas Jupiter translated the dying Hercules to heaven, Marsyas got his immortality either by Apollo's metamorphosis of his own blood or (in Ovid's version) by the spontaneous transformation of his friends' tears, into the most limpidly clear river in all Phrygia. The Phrygians' subsequent reverence for him as savior and benefactor would have made his tragedy doubly poignant.[53]

And now to the Laocoon (figs. 13–15).

Laocoön's Eyes

The Laocoön, Pliny tells us, stood in the house of Titus (reigned, C.E. 79–81) and was "superior to any painting and any bronze. Laocoön, his children, and the wonderful clasping coils of the snakes were carved from a single block in accordance with an agreed plan by those eminent craftsmen Hagesander, Polydorus, and Athenodorus, all of Rhodes."[54]

[51] Diod. Sic. 3.59.5, cf. 5.75.3; Nonnus, *Dion.* 19.323–34; Ov. *Met.* 6.382–400; *AP* 7.696; Lucian *Dial. D.* 18.2; Philostr. *Imag.* 2; cf. Gantz 1993, 95.

[52] Sen. *Herc. O.* passim; Plin. *HN* 34.93. Cf. Sen. *Dial.* 2.2.1–3; 9.16.4. Gauls: Paus. 10.20.9. Meyer 1996, 108–10, offers a different interpretation, which I cannot follow.

[53] Hyg. *Fab.* 165; schol. Pl. *Symp.* 215b; Ps.-Plut. *De fluv.* 10; Nonnus, *Dion.* 19.317–48; Ov. *Met.* 6.382–400; Paus. 10.30.9 (showing that the Red type, at least, cannot have been dedicated *in* Phrygia: Smith 1991, 106).

[54] Plin. *HN* 36.37: *opus omnibus et picturae et statuariae artis praeferendum. Ex uno lapide eum ac liberos draconumque mirabiles nexus de consilii sententia summi artifices Hagesander et Polydorus et Athenodorus Rhodii.* As Laocoön devotees will notice, this translation of *de consilii*

Yet the Laocoön is a threefold enigma. For it is not clear (1) when the three Rhodians carved their masterpiece (Pliny fails to tell us); (2) whether they reproduced an earlier Hellenistic composition or created a new one; and (3) exactly what is going on in the Vatican group (compare fig. 4.14).[55] Suggested dates range from ca. 150 B.C.E. to ca. 70 C.E., though recent opinion gravitates to late republican-early imperial Rome, and specifically to ca. 40–20 B.C.E.[56]

Faced with this daunting snake pit of possibilities, Richard Brilliant has constructed a gallery of no fewer than six Laocoöns. His Laocoön A is Pliny's statue; Laocoön B is its possible mid-Hellenistic prototype; Laocoön I is the Vatican group, discovered in 1506 and subsequently restored by Montorsoli; Laocoön II is Winckelmann's and Lessing's; Laocoön III is the twentieth-century restorer Filippo Magi's; and Laocoön IV is Brilliant's own. He boldly calls this intersubjectively constructed historico-critical response to it *My Laocoön*.[57] On these terms, we shall be adding a seventh, Laocoön V (fig. 4.14).

Two hundred and fifty years ago, Winckelmann compared the Vatican Laocoön to Sophocles' Philoctetes, and in his *Laocoön* of 1766 Lessing enthusiastically took up the comparison.[58] More paradoxically, Winckelmann even argued that the group's "noble simplicity and quiet grandeur" made it a truly classic work of the age of Alexander (see Porter, this volume). Lessing, on the other hand, thought it was Roman and based on Vergil's *Aeneid*.[59]

sententia implicitly rejects an ingenious alternative: "by decision of [the emperor's] council." This was first proposed in 1845, refuted by Mommsen, championed again by Andreae, and refuted again by Settis (in Winner et al., eds. 1998, 145–46; but see most recently Andreae 2001b). For it seems strained; violates the context, which stresses sculptural collaboration; and is problematized by the sculpture's possible pre-imperial date.

[55] Laocoön's right arm, discovered in a Roman stonemason's shop at the foot of the Oppian hill in 1906, does not join physically with his body; the snake's head at his thigh is restored; and the elder son's fate is unclear.

[56] *LIMC* 6 (1992), s.v. "Laocoön" no. 7 (E. Simon); cf. most recently Rice 1986; Albertson 1993; Andreae 1994b; Kunze 1996; Winner et al., eds. 1998; Settis 1999; Strocka 1999; Lahusen 1999; Brilliant 2000; Koortbojian 2000; Ridgway 2000b; Pollitt 2000, 99–102; Andreae 2001a, 2001b; Spivey 2001, 25–36 (with a largely negative judgment on its tragic status, overlooking Andreae 1994b). As Häuber and Schütz 2004, 115–36, have shown, the Laocoön was discovered on the east side of the Esquiline *near* (not in) the holding tanks (the so-called Sette Sale) of Trajan's Baths, in the Gardens of Maecenas. Furthermore, Pliny's designation of Titus as *imperator* undercuts all attempts to show that because the Flavian emperors lived on the Quirinal (S.H.A. *Tyr. Trig.* 33; cf. Suet. *Dom.* 1), our Laocoön is not the one made by the three Rhodians (so, e.g., Albertson 1993; Koortbojian 2000). In 77, however, when Pliny published his *Natural History* and dedicated it to Titus, the latter was indeed *imperator* ("crown prince") and not yet emperor, so he could have been living anywhere; indeed, when Tiberius returned from exile in 2, he lived in the Gardens of Maecenas (Suet. *Tib.* 15.1).

[57] Brilliant 2000, 18.

[58] Winckelmann [1755] 1987, 21–22; Lessing [1766] 1962, 7–11. Brilliant 2000, 16, summarizes the traditional view: "The marble figure of Laocoön sighs, noiselessly, but does not appear to scream, thereby retaining the control of self that distinguishes civilized man despite the contortions of his body, which, in bending, absorbs pain and comes to grips with terror."

[59] Plin. *HN* 34.52; Lessing [1766] 1962, 138–49.

These antithetical proposals inaugurated a gradual shift in the scholarly debate from interpretation to the archaeological concerns that have dominated Laocoön scholarship ever since. Yet a recent discovery urges a reappraisal. For it is possible that Laocoön is neither "seeking help from a higher power" as Winckelmann thought nor callously turning away from his stricken sons as other scholars then argued. He may well be blind.

Two early-sixteenth-century pictures of the group show the irises of Laocoön's eyes half covered by their upper lids and their pupils hidden, and photographs of the stone in raking light reveal corroborating traces of paint. Furthermore, in ancient sculpture the priest's narrowed eyes and distended lower lids typically signal blindness—the baroque Blind Homer type (fig. 4.3) being both the best parallel and the classic example of the genre.[60] And as one scholar has argued independently of these startling discoveries, Laocoön's pose and agonized demeanor best fit the only extant text that describes him as blinded: Quintus of Smyrna's third-century C.E. epic the *Posthomerica*, where his condition is described so clinically that the poet is clearly talking about a sudden onset of glaucoma. If one shifts the snake's head at Laocoön's thigh—a Renaissance restoration, but necessary somewhere in the ensemble—to the apex of the composition (see fig. 4.14), then the convulsive sideways jerk of his head becomes instantly comprehensible. Unable to see the snake's fangs but hearing its deadly hiss, he is recoiling in utter terror.[61]

In a long passage (12. 389–497) that must be based on some earlier but still unidentified source, Quintus attributes his blindness to a vengeful Athena. She first blinds him, then, when he continues to rail against the Horse, summons the snakes to kill his sons:

> Then even as from destruction shrank the lads,
> Those deadly fangs had seized and ravined up
> Them both, outstretching to their father dear
> Their pleading hands: no power to help had he.
> Far off, the Trojans watched from every side
> All stunned and weeping.
> (12.474–78; Loeb translation, adapted)

[60] Queyrel 1997, figs. 1–2; Queyrel 2002; Queyrel forthcoming; see also Winner et al., eds. 1998, 133 fig. 6, 172 fig. 10. The paint traces are most clearly visible in Andreae 1988, pls. 13 and 40.

[61] Although Pliny, the Laocoön myth, and the fragments of the Vatican group itself all mandate a second snake, only one snake's head (under the younger son's left hand) and one tail (on the elder son's drapery) survive. Magi 1960, 17, thought he saw traces of teeth on Laocoön's thigh and so retained Montorsoli's restored second snake's head; but to me and others these marks look like the remains of a *puntello* or support. Furthermore, as Erika Simon remarks, both heads and tails must have been clearly visible; Magi's 1950s restoration produced two heads but only one tail. There is a growing consensus that the second head must hover above Laocoön's, ready to strike, and the second tail must replace Montorsoli's restored head, as in fig. 14: see Simon in *LIMC* 6.1 (1992), 199–200 and fig.; cf. Lahusen 1999, 300–301, fig. 1 (from R. Hampe).

Yet Quintus cannot be describing the Vatican statue itself, for while his blinded Laocoön escapes with his life, the marble one evidently will not (figs. 4.13–14), and his elder son may be escaping. Indeed, if the Vatican Laocoön is indeed blind, the group now fits *no* extant text, for those authors that kill Laocoön off along with one or both of his sons keep him sighted to the last. Specifically, it probably sidesteps Sophocles' lost tragedy *Laocoön*, for the play's few extant fragments say nothing about the hero's blindness and hint that he survived the serpents' attack but both of his sons died.[62]

Of course, a robust independence from literary models is nothing new in Greek sculpture and painting, and if true in the Laocoön's case would only reinforce its claim to be the supreme *exemplum doloris* in the visual arts.[63] Moreover, a blind Laocoön would also open up exciting new avenues of interpretation. He would be a seer who cannot see; a prophet of doom whose prophecy dooms him; and a truth-teller whose insistence on speaking out is a classic misstep (*hamartia*) that ensures his own destruction. And while he may be blind to what is going on, we, the audience, most certainly are not.

All this would catapult Laocoön's exemplary status to an entirely new level, comparable to that of Sophocles' Oedipus in Attic drama. (What if Winckelmann and Lessing had been aware of it?) Despite the group's divergence from Sophocles' *Laocoön* and its unabashed depiction of a violent dénouement that on the Attic stage could only have been reported secondhand by a messenger, this is the stuff of tragedy at its most classic.

But to complicate matters further, the ancient sources offer two quite different accounts of Laocoön and his downfall. Either he was Apollo's priest and was supposed to remain celibate but failed to do so, provoking the god's wrath, the serpents, and his children's death; or he was Poseidon's priest, guessed the contents of the Wooden Horse, and had all but persuaded the Trojans to destroy it and thus to thwart the workings of Fate, compelling the Olympians to intervene.[64]

Two South Italian vase painters seem to opt for the Apolline version by setting the scene before the god's cult statue.[65] But although the sculptors of the Vatican group could have characterized its context quite precisely by including on the altar a relief featuring Apollo or Poseidon, they either presumed that the spectator would know it already or blithely let it remain ambiguous. Surely the former. Any post- or even pre-Vergilian Roman audience would inevitably

[62] Verg. *Aen.* 2.40–227; Soph. fr. 370–77 Radt (with bibliography on the problem of exactly who got killed); Arist. *Poet.* 23, 1459b7 also mentions a tragedy entitled *Sinon* but gives no further details about it. For a judicious discussion of these sources see Gantz 1993, 646–69; cf. *LIMC* 6 (1992), s.v. "Laokoon" (E. Simon).

[63] See especially Ettlinger 1961.

[64] Marriage: Hyg. *Fab.* 135; Serv. *Aen.* 2.201 (where he makes love to his wife in Apollo's very sanctuary). Guessing the horse's contents: Apollod. 5.16–19; Verg. *Aen.* 2.77–144; Q. S. 12.389–94. Spivey 2001, 32–33, conflates the two, ascribing the entire package to Sophokles.

[65] *LIMC* 6 (1992), s.v. "Laocoön" nos. 1–2 (E. Simon); Settis 1998, figs. 15–16.

think of the dramatic and portentous story of Troy's fall long before recalling the other, far less momentous one.

As it happens, in this scenario Laocoön's moral state, as a moderately virtuous character who moves from good fortune to bad (whether by his own fault or not), fits Aristotle's definition of the perfect tragic hero. Both his foolhardy marriage and his attempt to frustrate the acceptance of the Horse qualify as classic Aristotelian *hamartiai*. But the latter—sensible and shrewd but carried out in fatal ignorance of the wider picture—is quintessentially tragic.[66]

So the Vatican group's implied narrative envelope fits our classic tragic story pattern from *eutychia* to *hamartia* to *metabasis/peripeteia* to *dystychia*.[67] It focuses on the *peripeteia* itself: the instant that the hero's fortune changed from good to bad. In Laocoön's case this reversal coincided exactly with a violent, catastrophic onset of *dystychia* or misfortune. A minute ago he was blessed with two sons, and was strong, sighted, and (presumably) happy. Now bereft of one and perhaps both of his children, blind, and helpless, he will very soon be dead. Like the plot's earlier stages, its dénouement—his death, his elder son's fate, the dragging of the Horse into Troy, and all that followed—is left to our imagination.

Viewed in this way, this sculpture too satisfies a prime function of classic tragedy by provoking us simultaneously to pity and fear. We weep at the punishment's staggeringly disproportionate cruelty, and worry that through some equally inadvertent or foolish mistake we could suffer the same fate. And again we come away with a *phantasia kakou*, a powerful impression of disaster.

Yet what of the group's depiction of a moment that could not be shown on stage, and the unbridled extremism of its style?

The first is easily addressed. An array of fourth-century (i.e., late classical) South Italian vases that reference fifth-century Attic tragedy to various degrees offer excellent precedents for it.[68] By shifting our attention to the story's violent climax or to the moments immediately preceding or following it, they simply translate their tragic subject matter into Greek art's preferred *modus operandi*.

The Laocoön's stylistic and emotional extremism is more problematic. For all their highly wrought *pathos*, the Pasquino, Penthesilea, and Marsyas groups achieve a certain closure. Their well-structured antitheses of robust hero and lifeless youth, of young warrior and dying girl, and of serene Olympian and tormented satyr both frame one's response and ensure that it oscillates between these respective poles. They steer the tragedy along certain clear-cut paths.

[66] Arist. *Poet.* 13, 1453a7–12; Andreae 1994b; contra (but overlooking Andreae), Spivey 2001, 32–33. Now Virgil's version of the Laocoön story dominated the Roman imagination from the moment of its publication in 19 B.C.E. and the three Rhodians evidently worked in Italy for Romans. This leaves two possibilities: the greater, that the Vatican statue's blindness makes it pre-Virgilian; and the lesser, that the sculptors postdated the poet and were "improving" upon his account.

[67] Arist. *Poet.* 11, 1452a23–1452b13; 18, 1455b24–1456a10.

[68] See most conveniently Trendall and Webster 1971, with important qualifications by Small 2003, 37–78.

The Vatican group lacks such closure. Its composition is loose in the extreme (one critic aptly calls it "ragged");[69] the anatomy is massively distorted (Laocoön's torso is impossible, especially the ribs and *serrati*); the rhythms centrifugal and jagged; the violence explosive; the *pathos* unconstrained; and the outcome at least partly ambiguous. And—*pace* Winckelmann and others—Laocoön's facial expression almost approaches the Red Marsyas's (cf. figs. 4.11 and 15). "Torture in marble"; "unendurable agony of body and soul"; "pain and suffering that transgress the limits of the medium"—these critical responses over the centuries all point in the same direction. The Laocoön bursts the bounds of classicism and even (to some) of art itself.[70]

It is time to cut the Gordian Knot. At least one Greek critic of the imperial period, "Longinus," felt pity and fear to be too "mean" and constraining. He specifically excluded them from his definition of the sublime, substituting a rush of "genuine" and "transporting" emotion (*gennaion pathos*; *enthousiastikon pathos*) that carries one to the heights (see Porter, this volume). He averred that the Colossus of Rhodes could indeed eclipse the Doryphorus. So he might well have thrilled to the Laocoön somewhat as Pliny did, as an open-ended exercise in the powerful, awe-inspiring, and terrible (*deinotes, ekplexis, to phoberon*). To someone of this persuasion and perhaps even to the three Rhodians what mattered was terror itself, sheer *ekplexis* with no redemption, pure rhetoric that is agonizingly sublime and put on permanent unresolved display.[71]

To this view, then, the Laocoön would be not only the supreme *exemplum doloris* but the supreme example of sculptural tragedy's great advantage over the theater. For it not only lacks closure but celebrates and relentlessly exploits that lack to the full in a never-ending tragic crescendo. But this mention of *exempla* brings us, finally, to our *interpretatio Romana*.

Exempla Exemplorum

In Latin, *exemplum* is a powerful term. To quote two recent studies, "an *exemplum* [is] anything from the past that serves as a guide to conduct"; such "examples [from myth and history] were the basic means of moral instruction in the ancient world from the earliest times."[72] In Greece, examples or *paradeigmata* drawn from the poets (particularly Homer) were basic to any freeborn child's education, and in Rome these were joined by *exempla* from Roman history. By the early first century C.E. Livy had published his "exemplary history" of Rome and Valerius Maximus his comprehensive handbook of

[69] Lawrence 1972, 250, with a succinct catalogue of the group's "defects."
[70] For a convenient synopsis see Brilliant 2000.
[71] [Longinus] 8.1–2; cf. 8.4, 10.4–5, 14.2.
[72] Chaplin 2000, 3; Skidmore 1996, 3.

exempla, which found a bigger market in the Middle Ages and Renaissance than any other ancient prose work.[73]

For as Livy advised his readers, "This is the most salutary and fruitful aspect of the study of history. You can gaze at *exempla* of every kind displayed on a conspicuous monument, some of which you should imitate for your own benefit and the state's, and others—bad through and through—you should avoid." Quintilian remarks that orators in particular must possess a rich store of them, both historical and poetical. "For while the former have the authority of evidence or even of legal decisions, the latter either have the warrant of antiquity or are regarded as having been invented by great men to serve as lessons to the world." And they must be vivid: "Exemplification renders a thought . . . more vivid, when expressing everything so lucidly that it can, I may almost say, be touched by the hand."[74]

So good *paradeigmata/exempla* were classic, gripping tales of moral and thus political/military instruction. They were the stuff of Roman cultural memory, classics that helped to anchor and validate its values and behavioral norms (see Hölscher, this volume). But monuments too could serve this purpose. As Strabo writes (1.2, 8), combining our two themes:

> In the case of children we employ pleasing myths to spur them on and frightful ones to deter them, such as the myths of Lamia, Gorgo, Ephialtes, and Mormolyke. Most citizens are incited to emulation by the myths that are pleasing, when they hear the poets narrate mythical deeds of heroism such as the Labors of Hercules or of Theseus, or hear of honors bestowed by the Gods, or even when they see paintings, carvings, or modeled images which signal some such mythical reversal of fate (*peripeteia*). But they are deterred from evil when either through descriptions or images of things they cannot see, they learn of divine punishments, terrors, and threats—or even when they merely believe that men have met with such reversals.

In the Roman public sphere, historical *exempla* were vividly displayed, particularly in the form of triumphal spoils and imposing statues of the Republic's great men (*summi viri*) in the city's public spaces, complete with extended descriptions (*elogia*) of their deeds.[75] But what of *exempla* from Greek myth?

Here we return to Lucullus's Hercules Tunicatus at the Rostra, "a *simulacrum* of so many battles and such great *dignitas*"; Porcia and her picture of Hector and Andromache; the House of the Tragic Poet and its array of epic-tragic *exempla*; and last but not least, our baroque groups. Endlessly appropriating, redeploying,

[73] Skidmore 1996, xi, 3–21, and Chaplin 2000, 1–31, give useful histories of the use of such examples in Greece and early Rome, with extensive bibliography; cf. also Stemmler 2000; Barton 2001, 70–71, 213; Koortbojian 1995, 34–38 and passim; Stewart 2004, 150.
[74] Liv. *Praef.* 10; Quint. *Inst.* 5.11.1–21; 12.4.1; *Rhet. Her.* 4.49, 62.
[75] Plin. *HN* 34.17; cf., e.g., Zanker 1988a, 210–15; and Chaplin 2000, 14–15.

and recontextualizing Greek models in order to serve contemporary Roman needs, they largely or even completely obliterate these models' original contexts and functions in favor of those of the Roman present (see Hölscher, this volume). Resurrecting an exemplary golden age of heroic achievement for Roman consumption and edification, they bypass the Hellenistic world entirely.[76]

Viewed from this Roman perspective, the Laocoön seems the odd man out. *Pace* the Renaissance sources, the group may be a *unicum* (the lack of true copies is not encouraging) and Laocoön's designation as the supreme *exemplum doloris* is purely modern. Romans did not regard *dolor* as a moral or political imperative that required exemplification—in fact, the reverse. And two centuries of literature to the contrary, it is not clear that Laocoön displays a resistance to pain sufficient to graduate him from an *exemplum doloris* to a Stoic *exemplum virtutis*.[77] Supporters of this view and of Winckelmann's peculiar idea that he is merely "sighing" must explain why his facial expression resembles that of the Red Marsyas (fig. 4.11). Indeed, if the second snake's head is shifted as in figure 4.14, then his reaction becomes one of (literally) blind panic and nothing else. So a skeptic might wonder whether he exemplifies anything except the gods' limitless capacity to destroy everyone who gets in their way and the gut-wrenching horror that inevitably follows.

Of course, the group's very complexity and perhaps also its location may have inhibited reproduction (as with the three Rhodians' Scylla group at Sperlonga), and the incident's status as *the* turning point in the story of the Fall of Troy was enough to guarantee its centrality in Roman ideology. Furthermore, its location in the Gardens of Maecenas along with sundry other statues (including a Homer and a red Marsyas) could suggest a wider sculptural program that might explain some of these enigmas. But why is Pliny's encomium of it embedded in a list of artists *deprived* of their proper recognition because they collaborated, often on imperial commissions?[78] Often overlooked in the current Laocoön scholarship, the encyclopedist's remarks suggest that he was motivated more by his desire to rescue what he regarded as an underrated masterpiece and to flatter its current owner, Titus, than by any widespread contemporary valuation of it as a real classic.

By contrast, copies abound of the Pasquino, Achilles-Penthesilea, and Marsyas. Indeed, the Marsyas was more popular than the Doryphorus and the

[76] Plin. *HN* 34.93; Plut. *Brut.* 23; Bergmann 1994; cf. Koortbojian 1995, 34–38; Stewart 2004, 150. Perhaps this is why, *inter alia*, the original Greek locations and subjects of such acknowledged classics as the Doryphorus and Diadoumenus of Polyclitus, the Discobolus of Myron, and the Apoxyomenus of Lysippus are still a matter of conjecture: the Romans simply did not care.

[77] Supposed copies: Settis 1998, 133–36; Koortbojian 2000. Exemplary status: Ettlinger 1961; Brilliant 2000, 16, restating the traditional view that although Laocoön is being bitten in the side, he "sighs but does not appear to scream."

[78] Plin. *HN* 36.37–38.

Homer (fig. 4.3), not to mention the Phidian Neo-Attic reliefs! Here we might expect that as the direct impact of Greek culture and Greek letters waned, the exemplary function of these baroque copies might begin to eclipse their emotive (tragic) one.[79] And we might also expect that this process would be uneven, for the Latin West had far less investment in tragedy than the Greek East, and might well have judged the moral status of some of its protagonists quite differently. Achilles, for example, was certainly the prime *exemplum fortitudinis*, but in the West his anger and subsequent refusal to fight would have unsettled a Stoicized culture that believed, with Cicero (*Leg.* 3.8), that "public safety is the supreme law."

The copies' distribution, as far as one can ascertain it from the information available, is tabulated below. Unfortunately many have no secure provenance, and in Marsyas's case many either willfully conflate the two types or are small and generic.

So the "Pasquino" and the two Marsyas subtypes were more popular in the West than in the East, which preferred hybrid and miniature versions of the Marsyas to full-sized ones; and the Red Marsyas was apparently somewhat more popular than the White, particularly in the West.

What responses would they and the Achilles-Penthesilea group have provoked? By Hadrianic times, as mentioned earlier, copies of the Achilles-Penthesilea and Pasquino groups (figs. 4.4, 6) were sometimes displayed as pendants. Examples have appeared in the Hadrianic baths at Aphrodisias and Herodes Atticus's slightly later villa at Loukou. At Aphrodisias the two groups stood on opposite sides of a pool. Here the bathers could ponder the figures' nakedness, beauty, and strength; their contrasting ages and genders; and their

TABLE 4.1
"Pasquino," Achilles-Penthesilea, and Marsyas: Distribution of the Copies

Type	Reference	Total	West	East
"Pasquino"	*Antike Plastik* 14 (Berlin 1974): 87–90; Weis 1998, figs. 4–5	14	7	3
Achilles-Penthesilea	*LIMC* 7 (1994) s.v. "Penthesilea" nos. 59–61, 65–67, figs. 6–8	17	6	6
Marsyas, all copies	Weis 1992, 145–213, figs. 9–12	59	24	25
Red Marsyas	Weis 1992, 145–213, figs. 10–11	13	11	2
White Marsyas	Weis 1992, 145–213, figs. 9, 12	10	7	3

[79] In Cicero's day, at least, the original Greek plays attracted poor audiences: Cic. *Att.* 16.5.1; cf. *Fam.* 7.1.3.

stirring evocation, sharpened by the stark tragedy of premature death, of a vital, heroically active life—as *paradeigmata aretēs* or *exempla virtutis*. And since Achilles' uncontrollable passion sparked both tragedies, moralists could see them as *paradeigmata epithymias* or *exempla cupidinis* too.

At Loukou, all this would have acquired particular force. Steeped in the classics and a leading intellectual of his age, Herodes had named his three young *trophimoi*, as he called them—Memnon, Achilles, and Polydeukion—after epic heroes. One can easily imagine him lecturing his guests upon the life and tragically early death of his young Achilles, "beautiful, good, well-born, and eager to learn."[80] He and his audience would surely have savored the two sculptural groups' classic exposition of epic/tragic fortitude and folly, of passion's catastrophic role in each, and of the cause-and-effect sequence they triggered. For if the Homeric Achilles' rush of desire for Penthesilea had not been so tragically thwarted (fig. 4.6), then in his grief and loneliness he would not have conceived his fatal infatuation for Polyxena, provoking the tragedy of the Pasquino (fig. 4.4). What a contrast with the character and aspirations of Herodes' own, latter-day Achilles!

In Italy, two more factors might also have come into play: the Romans' pro-Trojan bias and their neo-Stoicism. The former might have provoked some complex and surely conflicting reactions to the two Achaeans and their respective fates, and neo-Stoic ideas about suffering might have added an extra dimension. For not only did Roman Stoics apostrophize Ajax and Achilles as the epitome of anger (*ira*) and bravery (*fortitudo*) respectively, but their view that suffering is mitigated if shared would have turned the two men into classic *exempla* of this kind of consolation and its polar opposite, represented respectively by Ajax, soon to be back among his Achaean comrades, and the ever solitary and inconsolable Achilles.[81] Thus, again, Seneca, blithely contradicting today's received wisdom:

> Sweet to the mourner is a host of mourners,
> Sweet to hear multitudes in lamentation;
> Lighter is the sting of wailing and tears
> Which a like throng accompanies.[82]

Other viewers might have added Vergil's Nisus and Euryalus to the mix; perhaps some of the copies displayed in Italian contexts provoked discussion and

[80] Philostr. *VS* 558–59: καλοὶ μάλιστα καὶ ἀγαθοὶ ἦσαν γενναῖοί τε καὶ φιλομαθεῖς. Philostratos adds that Herodes set up statues of them hunting, about to hunt, and having hunted, all over the estate, and that when criticized for this, retorted, "What business is it of yours if I amuse myself with my poor marbles?"

[81] Sen. *Dial.* 4.36.5; 9.2.12; *Ben.* 4.27.2.

[82] Sen. *Tro.* 1009–12: *Dulce maerenti populus dolentum, / dulce lamentis resonare gentes; / lenius luctus lacrimaeque mordent, / turba quas fletu similis frequentat.*

comparison along these lines. And every Vergilian could understand the Pasquino as a quintessential *exemplum pietatis*.[83]

As to Marsyas, the statistics scotch any idea that the Greek East preferred the more tragic White type, and the Latin West the more brutally censorious Red one. Instead, they suggest that Westerners—who felt just as ambiguous about Marsyas as did the Greeks, but for different reasons—liked *both* of them. For on the one hand they condemned Marsyas for his ambition, pride, foolhardiness, and impiety, and used him to celebrate the avenging power of one of their favorite gods, Apollo. So the Red type might be referencing his status as (to paraphrase Ov. *Fast.* 6.706) a perfect *exemplum superbiae*. But on the other hand, a heterodox tradition had him escaping to Italy to become king of the Marsi, and some of his Roman republican images apparently cast him as a champion of the plebs. This more favorable tradition could suggest that the White type presents him more positively, perhaps as a Stoic-style *exemplum patientiae*.[84]

For in Stoic terms both the White Marsyas and the Hercules Tunicatus mentioned above would have achieved *virtus* and *dignitas* and thus victory in the ongoing, titanic struggle against the vice of susceptibility to passion. Here and in Seneca's *Hercules Oetaeus*, "the magnitude of [the protagonist's] victory is conveyed by exaggerating the intensity of his physical and mental pain." By contrast to the Laocoön, they too thereby become classic *exempla virtutis*, teaching us how we may profit from the experience of personal tragedy and the supposedly "indifferent" Stoic category of pain.[85]

RECUSATIO

To conclude: Having detected what I believe to be a tragic and then an exemplary vein in the body of surviving baroque sculptures, I am emphatically not attempting to force these readings upon all of them, and not even upon all of the copies of my four selected examples in all contexts. As to the other baroque tours de force, the Artemis-Iphigenia group, for example, is obviously taken from Euripidean tragedy but clearly is not per se tragic at all, while the Sperlonga marbles are much closer to the heroic scenarios of Greco-Roman epic.[86] The Laocoön, Pasquino, Achilles-Penthesilea, and Marsyas groups (figs. 4.3–15)

[83] Verg. *Aen.* 1.10; 9.176–502; cf. 10.813–32 on Aeneas and Lausus; yet with Green 2000, 180–85, I cannot follow Weis 2000 in identifying the subject of the *original* composition as a Roman myth.
[84] Hostile tradition: Ov. *Fast.* 6.706–8; Stat. *Theb.* 1. 709; Plut. *Alc.* 2.5; Apul. *Flor.* 3.6–14. Favorable one: e.g., Sil. 8.502–4. Cf. Small 1982; Rawson 1987; Weis 1992, 118–20; *LIMC* 6 (1992), s.v. "Marsyas" 367, 376–77 (A. Weis).
[85] Pratt 1983, 125, 127; cf., e.g., Sen. *Ep.* 82.10–11.
[86] On these see Bieber 1960, figs. 268–71 (Artemis-Iphigeneia); Stewart 1990, figs. 732–41 (Sperlonga); Smith 1991, figs. 139, 144–47 (both).

do, however, seem to form a subset that references classical tragedy in a quite robust way.

But as Plato and Aristotle observed, and after them Lessing, Goethe, and their modern successors, the relationship between word and image is complex, awkward, and deeply problematic. Indeed, the Bakhtinian reading of our groups suggested earlier only complicates this relationship further.[87] So although some of classical tragedy's goals and Asianism's rhetorical devices do seem to resonate in these four groups, in the final analysis each art form must be judged on its own terms, according to its success or failure at the task it has set itself. And in this respect, *mutatis mutandis*, figures 4.3–15 surely matched the literary classics that apparently—at whatever level and to whatever extent—inspired them.

Indeed, one wonders whether the very success of these works at making present these tragic tales may have tended to thrust the classical tragedies themselves into the shadows, in much the same way that the copies illustrated in figures 4.3–12 would later steal the stage from their own originals. In any case, two long-held notions in the field are now questionable at best: first, that the "classics" of ancient art comprised only the "best" creations of the fifth and fourth centuries B.C.E., their replicas, and their somewhat epicene Roman "rivals"; and second, that these latter-day products of all types were primarily conceived in nostalgia for this vanished classical past.[88]

[87] See Pl. *Cra.* 422E–23D, 430A–34A; Arist. *Poet.* 14, 1453b1–14; Lessing [1766] 1962; Goodman 1976; Wollheim 1980, 104ff., esp. 137–43; Mitchell 1986, 7–159; Stewart 1993a, 169–72 (Bakhtin); for a convenient synopsis see Mitchell 1996.

[88] For which see most recently Fuchs 1999; contrast Hölscher, this volume.

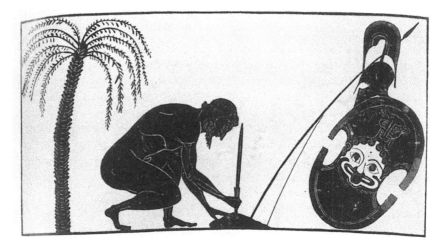

Figure 4.1. Ajax preparing to commit suicide. Attic black-figure amphora by Exekias. After E. Pfuhl, *Malerei und Zeichnung der Griechen* (Munich 1923), vol. 3, 234, pl. 59.

Figure 4.2. Procne preparing to kill Itys. Marble group dedicated and perhaps made by Alcamenes. Ca. 430 B.C.E. Photo: DAI, Athens.

Figure 4.3. Blind Homer, Boston. Roman copy of a Hellenistic original. Photo: Museum of Fine Arts.

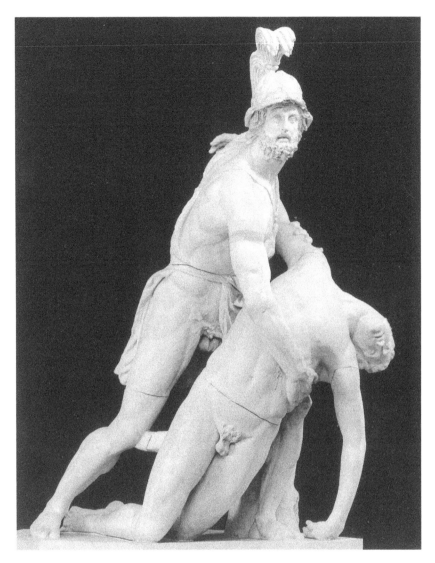

Figure 4.4. "Pasquino" (Ajax and the body of Achilles). Cast in Basel, after a reconstruction by Bernhard Schweitzer of the Hellenistic original. Photo: Antikenmuseum Basel.

Figure 4.5. Head of Ajax, Vatican. Roman copy of the group, figure 4.4. Photo: Musei Vaticani.

Figure 4.6. Achilles and the body of Penthesilea. Cast in Basel, after a reconstruction by Ernst Berger of the Hellenistic original. Photo: Antikenmuseum Basel.

Figure 4.7. Head of Achilles, Malibu. Roman copy of the group, figure 4.6. Photo: J. Paul Getty Museum, Malibu.

Figure 4.8. Head of Penthesilea, Antikenmuseum Basel. Roman copy of the group, figure 4.6. Photo: Antikenmuseum Basel.

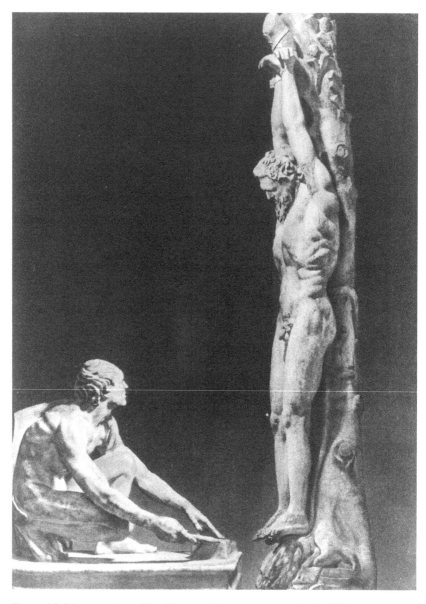

Figure 4.9. Photomontage of the Hanging Marsyas group, using the Uffizi Knifegrinder and the Louvre Marsyas ("White type"). Partial reconstruction of the Hellenistic original. Photo: After Jean Charbonneaux, *Hellenistic Art* (New York 1973), figs. 283–84.

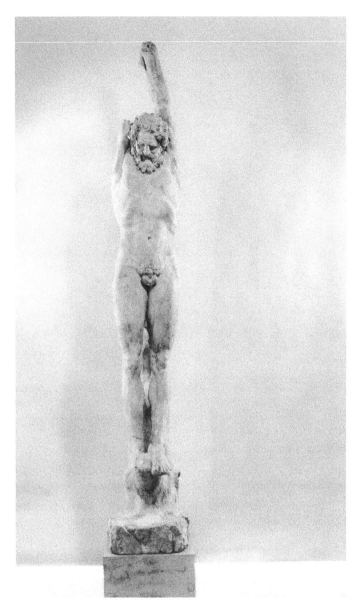

Figure 4.10. Hanging Marsyas ("Red type"), Karlsruhe. Roman copy of a Hellenistic original. Photo: Badisches Landesmuseum, Karlsruhe.

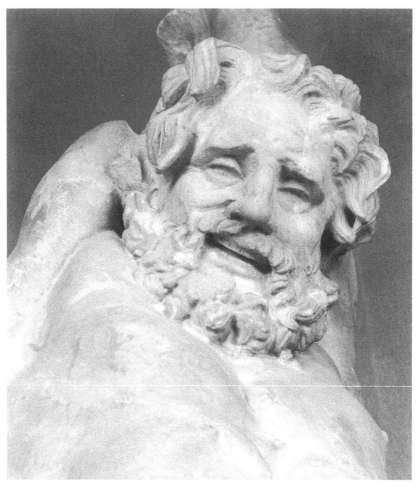

Figure 4.11. Head of the Hanging Marsyas ("Red type"), Karlsruhe. Photo: Badisches Landesmuseum, Karlsruhe.

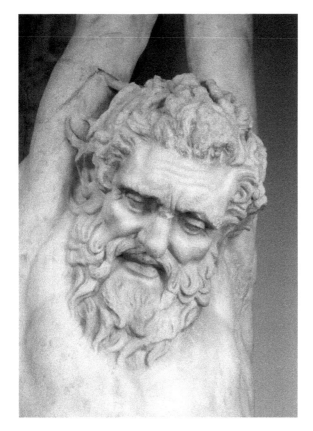

Figure 4.12. Head of the Hanging Maryas ("White type"), Louvre. Roman copy of a Hellenistic original. Photo: Réunion des Musées Nationaux/Alinari-Art Resource.

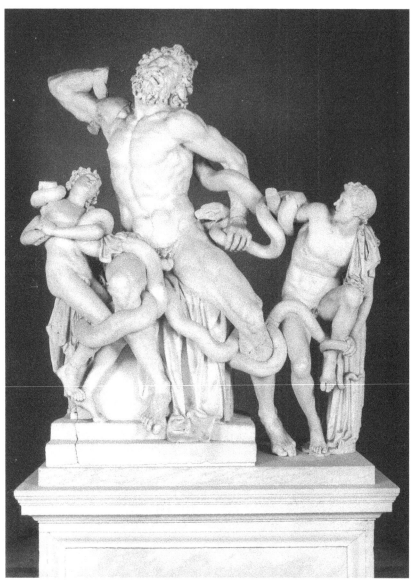

Figure 4.13. Laocoön, Vatican. Late Republican–early Imperial original by Hagesandrus, Polydorus, and Athanodorus of Rhodes, or a later copy. Photo: Musei Vaticani.

Figure 4.14. Laocoön, reconstructed by Erin Dintino and the author.

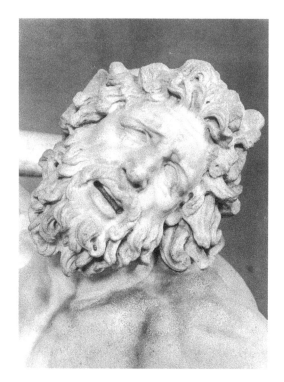

Figure 4.15. Head of the Laocoön, Vatican.
Photo: Musei Vaticani.

PART IV

Latin Letters

Chapter 5

FROM ΦΙΛΟΣΟΦΙΑ INTO *PHILOSOPHIA*: CLASSICISM AND CICERONIANISM

JOHN HENDERSON

> If we are not committed to any view of the universe as
> grounded in its intrinsic nature, we can be seen as free of
> the vices of partisanship, as outside the arguments that
> beset others. But . . . we can never stand outside the views
> with which we have grown up and through which we
> engage with our contemporaries.
> —Don Fowler

> You cannot simply resist as you please, for there are norms
> of fairness, decency, and dignity that entail that this is bad
> behavior. But then we have to articulate those norms.
> —Martha C. Nussbaum

CICERO IS a "we" theorist, thinker, and operator. In this scatterbrained essay I shall take together as a suite the (lost) *Hortensius* (*Hort.*), the (schizopalimpsestic) *Academica* (*Acad.*), the (unEnglishable) *De Finibus* (*Fin.*) and the (apophatic) *Tusculan Disputations* (*Tusc.*).[1] This sack of philosophical writings precisely reposes on norms of fairness, decency, and dignity.[2] Specifically, the (lost) *Consolation* is set before us as the insistent pledge and icon of Cicero's seriousness: the writer writing to himself for "us."[3]

The death of daughter Tullia figures as Cicero's equivalent of the death of Socrates in Platonic self-authorization; it opens a wound *between* the performativity of mourning rites within the norms of Romanness, and the therapeutic ambitions of Hellenistic philosophy to regulate grief and condolence. While vindicating the father's humanity (and through her infant son's death,

[1] For this strategy, in line with Cicero's directive, *prooemiantis in medio*, at *De Diuinatione* 2.1–2, see Schofield 2002, esp. 99–103. By then, everyone knew what Brutus had done and what *Brutus* would mean (22). "Scatterbrained": the poetics (prosaics) of Ciceronian philosophy turn on the textuality of *self*-presentation, whatever projections it uses, whatever its shifters' formal positionality.
[2] For elegant characterology of the philosopher at work in his work, see Miller 2001, esp. 6–62, on J. L. Austin (as "Oxford [into] Philosophy").
[3] *Tusc.* 1.66, 76, 83, 3.70, 76, 4.63, 5.121: White 1995, 223–24.

Tullia's postpartum decease stands as gentilician quasi-oblivion for M. Tullius Cicero), the personal catastrophe challenges the philosopher's capacity to handle his own case. Some of Tully has died, his purer self, immaculate love and self-love; and he has lived on to feel this death, the pain, distress, stress, and menace to his manliness (*uirtus*).[4] *Mores* and ethics pull in different directions: they were supposed to; yet their friction powers an ongoing competition in mutual intertranslatability: the crisis of bereavement was the proving ground for tradition and radicalism, it brought the self closest to sampling its own finitude. In Latin culture, Greek thought met a massive limit to its purchase on credibility insofar as that might depend on generalizability across cultural divides. If applicability, let alone universalizability, mattered to φιλοσοφία, then norms for grief in bereavement posed amongst the stiffest of tests; if *philosophia* were to matter "beyond Athens," then it must bridge the intercultural chasm, cross every impasse into the empire of Latinity. Cicero staked out his own writerly self-cure programme as a brainstorming thrash-out between the imperatives of Rome and the Academy: life handed him an eloquent mise-en-scène: a death.

At the same time, dominant address to Brutus as the absent-present interlocutor in Cicero's thought and between his every line,[5] bonded the project to Roman gravity in terms of both political and philosophical imperatives.[6] Through his revolutionary ancestor L. Brutus,[7] this twinning of (like-minded) "friends" makes of Cicero a "we" that takes in the entire founding establishment of Rome as the free Republic normed to an aristocratic ethos that by definition included the parsimonious incorporation of meritorious recruits. Assimilation of Cicero could never be completed, but his combination of regular qualifications (senior consular) and unique distinctions (career success through advocacy, oratory, and authorial self-promotion) emboldened him to twin his lessons on *uirtus* with those of the unquestionably fundamental authority of Brutus to sign for SPQR.[8] In a crisis, a Cicero could always be finessed out of determinative participation, as had happened in the case of his bid for glory in saving the state from Catiline, and was so soon to happen in the reckoning with first Caesar, finally with Antony and Caesar's heir. But the power of the writing that eternalizes the Roman myth of Cicero harnesses his political sidelining and extrusion to the cause of martyrdom: Rome failed, not its victim—hero of fairness, decency, and dignity. Brutus would act decisively,

[4] For the conciliatory style of the philosophers figured as "a young girl, innocent, modest, and somehow unspoilt": Cicero, *Orator* 64.
[5] *Acad.* 1.12, *Fin.* 1.1, 3.1, 5.1, 8, *Tusc.* 1.1, 5.1, 12, 34, 121.
[6] Dead daughter, subjected Rome: esp. *Acad.* 1.11.
[7] Esp. *Fin.* 2.66, *Tusc.* 1.89, 4.50.
[8] Brutus, *De uirtute*: esp. *Fin.* 1.8, *Tusc.* 5.12, cf. Sen. *Helv.* 8.1, 9.4, Cic. *Brut.* 250; dedicated to Cicero: *Tusc.* 5.1.

obliged to kill another friend, Caesar, for Rome; before his vocational moment arrived, when another Brutus must remove another "king" from Rome, his own praxis had authorized pondering of norms for duty and value in terms of philosophical writing. Cicero entwines his own predicament as warden of Roman freedom with Brutus's legitimating investment in ethical rumination. These acts of writing even *ordain* the double commitment ahead of these two Latin ponderers to heroic self-sacrifice in the cause of revolutionary resistance to political change. Just a matter of months down the track, two exemplary ways to act out (and complicate) Academic freedom: *philosophia* in Rome.[9]

To write about the purpose of life with the prospect of death looming is to put pressure on every page. The self-consecration of Stoicism through the suicide of Cato (Brutus's uncle[10]) was just a matter of months past; the last stand of senatorial Rome against Caesar was news just in. Whatever mind business is conducted here, whichever the chosen idiom of cerebration/however staged the rhetoric, a "race against the clock" frames each bid for textual satisfaction in closure: no Hellene (no Greek) could ever have translated εὐδαιμονία as *uita beata*.[11] No Latin treatise out of Rome 45–44 B.C.E. could stand proud of convulsive terminality. It was a time/it was no time to come to terms.[12]

Yes, philosophy's turn. The turn to philosophy in Cicero's lost protreptic *Hortensius* enthused away to first base. Each paragraph was Cicero guaranteeing this was precious time well spent (*Hort.* fr. 91):[13]

> *placuit enim Ciceroni nostro beatum esse qui ueritatem inuestigat, etiamsi ad eius inuentionem non ualeat peruenire.*

> Our Cicero's position was that the seeker for truth is already blessed, even if s/he can't go the whole distance and find it.

Indeed the moral philosopher is never not doing what he is discussing, if that involves conducting a *life*. The writer is committed to submitting his own performativity as that supervenient instance of the set that it aims to include. Whatever Hellenistic philosophy had been, it was now grist to the milling of Cicero.[14] His self-positioning as searcher for the truth in philosophy operated the double twist of all classicism: drawing a line of canonicity seals the

[9] For noise on the line in aligning philosophy and politics: Griffin and Barnes 1989.

[10] *Tusc.* 5.4. Also his father-in-law (deceased), since Porcia's wedding a month before the *Tusc.* scenario.

[11] See Annas 2001 on this cultural crux.

[12] Outlines of Cicero's philosophical productivity: André 1977, 55–101; for the context: Rawson 1985a, 282–97.

[13] August. *C. acad.* 1.7 (Straume-Zimmermann et al. 1990, 94, 96). Published as Tullia perished (i.e., written before that).

[14] Zetzel 2003, on the rate of cultural exchange between Greece and Rome.

corpus; the classicist emerges the other side, to adjudicate the worth of the greats. The sects are plotted; the options covered. Now the revisionary reckoning can begin. What the participants could never produce was a synoptic review of the part they played in the whole scheme of their institution. To play the [post-]classical card is to move in on the [meta-]classical stakes.

Ciceronianism thus orchestrates a performance of a search for truth among the truths of the ancients. The worth of the performance will be its self-fulfilling pledge of the quest to learn. Reanimating the syllabus of preexistent lessons is itself both a self-subordinating rite of obeisance and an unprecedented hunting with the ancestors. What in Greek wisdom can Cicero not write?/What Roman will not listen as Cicero's life ticks away? Given the Sitz im Leben, these frantic scribbles could only smooth into a serene certitude by crossing over into a presumptuous partisanship. Backing a winner from among the competing sect(or)s of the encyclopaedic system would oblige the reviewer to forget himself—and parade the rest all losers. Attaining "the" truth is beside the point; which is, pursuit. But *mere* pursuit is trivial in the face of anxious urgency (trope for serious investment). One way or another, this *philosophia* demands instant, continual, credible appreciation of its inheritance. Every bid to capture insight could foul up by trespassing into the audacity of intervention at the expense of duly respectful receptivity to wisdom. Good behavior, we expect, at all costs. Proof that the game is worthwhile is bound to take the form of a self-curtailed discrimination between what prove the most enriching among the richest stores in the library. Fairness, decency, and dignity are the warrant of the respect entailed by any classicism. Vital (mortal, painful, distressed, stressful, virtuous) need for psychic salvation drives Cicero's well-mannered tooling of a nonpartisan investment in as much of the wisdom he hallows as the exorbitant track of his argument can accommodate. This brings all the more impact to his self-inventing construal of *philosophia*. Poignant seduction by clarion calls for heroic bravery melds with meek distrust of any hint of shameless or shameful cop-out. The permutations revolve too high and too low expectations for such as ourselves. Dissatisfaction with his own instincts and responses amounts to a normative profile for caring integrity at work. Ciceronianism must be a linguistic philosophy because his classicism risks itself to the ethics of its own rhetoric: here discussion of morality depends on its credibility as itself moral discourse (*qualis oratio, talis ratio*). *Some* Academic methods fold *a measure of* skepticism about their own validation into the excavation of a *reassuringly* affirmative courtesy towards their prestigious bibliography: always argumentative, resistant to allcomers—but ("we" like [us] to think) without rancor and in vocational devotion to pursuit of truth (*Acad.* 2.7),

nos autem quoniam contra omnes dicere quae uidentur solemus, non possumus quin alii a nobis dissentiant recusare: quamquam nostra quidem causa facilis est,

qui uerum inuenire *sine ulla contentione uolumus idque summa cura studioque conquirimus.*

Take us. We studiously contradict everyone else as seems right, so we can hardly ban others *disagreeing with us. And yet. Our bottom line is a cinch: "We mean to find the truth* without engaging in disputation; we seek truth at all costs, with all our heart."

The sanctions are posted most strikingly of all at the threshold of *De natura deorum*:

tam uariae sunt doctissimorum hominum tamque discrepantes sententiae, ut magno argumento esse debeat causam et principium philosophiae esse inscientiam, prudenterque Academicos a rebus incertis adsensionem cohibuisse: quid est enim temeritate turpius? aut quid tam temerarium tamque indignum sapientis grauitate atque constantia. . . ?

The views of the top professors cover such a wide range in such incompatibility, it must count for a powerful argument that the originary basis of Philosophy is ignorance, and so Academics have known what they were at when they quarantined assent away from non-determined aspects of reality. What's more demeaning than plunging in (what's as much of a plunge, what's as degrading for that impassive imperious figure, The Philosopher). . . ?

Very likely. Only "learned" views are worth our contestation; without fair caution, respectable seriousness, lived coherence, you can keep it.

Latinity set to look after Rome can take no chances with alien dogma; the world's wealth belongs in the cosmopolis. All blessings (all honorable blessings), templates for happiness, recipes for good fortune, and any eudaemonism deserve positive testing for their potential contribution of truth for living the *uita beata*.

Chicken; egg. A particular praxis of affiliation to Academic φιλοσοφια, a discursive decorum for Roman *philosophia*. Assassination, execution; martyrdom, self-canonization. Whichever end you look at it/look from, these breakneck books of suave eloquence set up a classic and classical canon; transmitting this as already self-constituted, they promote it as foil to their own perilous plot to instal themselves as the classic*izing* paradigm for every uncertain future.[15] So they functioned for centuries. More recently, a brute cult of Hellenism rode roughshod over this stand for fairness, decency, and dignity in, and as, (unGreek) philosophy. I shall here offer a cursory revaluation of Cicero's campaign to tool a moralized *philosophia*, a "we" for "us" in the word war for civility.[16]

[15] Cf. Smith 1995.
[16] Ideological targeting of Cicero's *philosophica*: Habinek 1995.

Was it his lapse into chauvinism of Cicero's first open day for the Academy that made him rewrite his *Academic Books*? Something had lured him on into trumpeting proud freedom for roamers such as "us," freer spirits than the rest, all of them bound to their guru's precepts like recruits to an army (2.8).[17] First time out, everything had ended where "we" unconstrained voyagers could probably guess it would, each to his own (148):

nos ad nauiculas nostras descendimus.

We went down to board our boats.

The (original) coronis here was jovial commitment to get moving—weigh anchor, drop the plank, knock the shit out of that: *Tollendum*, the Hortensius in us punned ("chocks away"/"This must be taken on board"), as prompt to the nonclinching clincher yelp from y/our Cicero (ibid.),

teneo te ... nam ista Academiae est propria sententia.

Gotcha. ... *That*'s the Academy's own-brand pitch.

But to judge from what escaped Cicero's shredder, the first ed.'s shot had put itself over high fences of indignity. Lucullus-Cicero set up (our) projection into Antiochus's response to Philo's apostasy as a tirade recapturing the original rage (*stomachari*, 11).[18] The keynote was rough-house imaging of the schism in terms of tribunician crises of sedition from the annals of Rome, a mise en scène resented by "Cicero" in his finale (13–15, 63, 72). His provocateur had nettled him with othering (*absurdum... perabsurdum...*, 58–60, "loco, plumb loco"), and wound up smearing him with intellectual *maiestas* (62, "treason"). When Hortensius clapped in glee, asking Cicero to back down, and "we" couldn't tell if he was joking or not, this hit Cicero's keynote for "us" (63):

non enim satis intellegebam.

See, I wasn't satisfied I got this.

Indecent wrangling in the forum, dirty washing in the school. Opening up Academy debates to scrutiny, and fresh debate, must discredit neither debate nor the Academy.[19] Cicero found the decency to tear it up and the gravity to assert the requisite urgency: the second voyage fast-forwards us to Sibylline Cumae, *only recently* (*In Cumano... nuper, Acad.* 1.1). The whole enterprise is launched by annexation of Varro for protatic figure. With him comes the mutual admiration society of solidary friendship (Atticus is there to say as much). Laying out the heart/h of the contemporary Academy in light of its

[17] On *allegiance* in the schools: Sedley 1989; *affiliations*: Glucker 1988.
[18] Glucker 1978, Barnes 1989, Brittain 2001.
[19] Striker 1997.

recent history made for a ticklish project. The chosen milieu of congenial interchange serves as a regulatory frame for the whole exposition, in four books, to be delivered by Varro-Cicero-Varro-Cicero (*Fam.* 9.8.1):

> *[libros] non nimis uerecundos—nosti enim, profecto os huius adulescentioris Academiae—ex ea igitur media excitatos misi.*
>
> [Books] not *terribly* long on modesty (you know perfectly well the cheek of the laddish Academy concerned) I've posted you, see: hustled up from the core of it.

As Cicero played Philo to the august polymath's Antiochus (ibid.),[20] exactly the challenge of controversialism in philosophy was for acting out between Athens and Rome. The voices twin yin to yang for us. That is why they ventriloquate. Cicero can wait no longer for the dedication to him of *de lingua Latina*, a "slow (i.e. intensively researched)" *magnum opus* (ibid.; *Acad.* 1.2):

> *sunt magna sane et limantur a me politius.*
>
> Epic scale, you bet, and given the extra high-grade finish *I* can do.

Cicero has got in first with the gift of *Academica*: he has his own take on the urgency/magnitude equation (read on). Our heroes combine to team-teach Rome some more culture, and their text o-so-gently pressgangs "Varro" into surrendering to "us." Against his own long-pondered judgment, he will cooperate to co-produce, not a myriad of introductory come-on sketched entrées to philosophy, but a full-blown manual (4, 9). This in the name of putting on record the lessons Varro and Cicero were taught together (3):

> *res eas quas tecum simul didici mandare monumentis, philosophiamque ueterem illam a Socrate ortam Latinis litteris illustrare.*
>
> To enshrine a lasting record of the lessons I learned alongside you. To light up grand old Philosophy, brain-child of Socrates, in literary Latin.

Old or New Academicians, loyal or heretic, they agree there is one story worth telling. And telling it pays their debt to teaching, proselytizes for a dutiful pupillage. They acknowledge the same problem with the project: in the ring already are Scylla-and-Charybdis competition from (i) the cheap Latin of plain-talking vulgarists in Roman Epicureanism, and (ii) the fiendish sophistry, hyperintellectual bullishness of hard-liner Stoic obscurity (4–7). Academics must take their color from their sparring partners, so the best policy is. . . ? To pack learners off to Athens? "We" agree with Plato, philosophy is sacred; it should make life cohere and rejoice the mind (7). Our heroes' (signal) modesty apart, both mean to "bring Rome home" by wising us up to "our" cultural identity. Filling the Latin library with a complete encyclopedia of stylish Latinity—

[20] For the Antiochus/Philo facts on psychodynamics: Cicero 2002, esp. xxiv–xxv.

lang. (see Varro, forthcoming) & lit. (read on). For if poetry, why not Philosophy? Throw in Rome's greatest orator and rhetorician (see Cicero, work in progress), and Bob's your uncle (18):

sus Mineruam, ut aiunt.

The proverbial hamster showed Einstein.

This Academic show gets on the road in exemplary amicability. Edge does elbow into the picture, but takes the form of a narrat*ed* division between professor and protegé successor which allows our two narrat*ing* disciples to put their education to work *in tandem*. On behalf of the firm, they will push its product by showing how to resist what they learned there. Working together to teach us how to join in. The battleground? Was, and is, there a truth to find, not in a dispute between the New Academy and the Old, but in the dispute between them as to whether there is a doctrinal difference or there is not between the new Old and the old New. Like as not. "We" start up provocatively: domestic unity is at stake. Un-Academic presumption marks the wind-up (1.13):

certe enim recentissime quaeque sunt correcta et emendata maxime.

For sure, every New Wave puts things straightest, irons out most mistakes.

Whatever difference there is between old Varro's devotion to the (most recent) Old and Cicero's graphically (textually) self-enacting assuredness that the latest thoughts (ahead of reader disputants) are "put straight and most checked-out," all is contained within agreement that Socrates is both where to start and where it all starts (15):[21]

ita exorsus est, "Socrates mihi uidetur, id quod constat inter omnes, primus a rebus occultis . . . auocauisse philosophiam et ad uitam communem add-uxisse."

This is how he got started: "Socrates. Seems to me—as is unanimously agreed—to have been the first person to whistle Philosophy away from the mysteries of reality . . . and shepherd it over to the life we all share."

For Varro, post-Platonic Academy and Peripatos are at one in deriving an anti-Socratic gospel from Plato's oeuvre:[22]

ars quaedam philosophiae et rerum ordo et descriptio philosophiae.

A species of technical philosophy, a programmed syllabus, "Philosophy" as per the handbook brochure website.

[21] Essential briefing on Ciceronian "Socrates": Glucker 1997.
[22] Socrates/Plato in Cicero: Long 1995. "Aristotle" and "The Peripatetics" were filtered to Cicero "through later and far less distinguished thinkers": Cicero 2002, xvii–xix, q.v.

Above all, their common position amounts to a fundamental consensus where it matters most (22):

> *omnis illa antiqua philosophia sensit in una uirtute esse positam beatam uitam, nec tamen beatissimam nisi adiungerentur et corporis et cetera . . . ad uirtutis usum idonea.*

> All this classical Philosophy realized that the life that is a blessing lodges with Virtue alone, though the blessing is imperfect if not associated with physical, etc., attributes . . . conducive to practising Virtue.

The whole crescendo through *Fin.* and *Tusc.* will amplify both elements in this resonant formula: (i) the tough line "All you need is *uirtus*, *uirtus* is all you need" will be idealized by everyone in classical philosophy past and present (bar the Epicurean outsiders); but (ii) some brethren will need the Extras (= "Get real. Life can fuck anyone up a treat"). Varro's lecture soon names the tough guys in the fold as Zeno's Stoics, and Cicero soon corrects him only to object that, according to the old view of Varro's guru, rather than t/his new one, the Stoics are but a correction of the Academy, *not* a new splinter group (35, 43).

"Cicero" responds to the charge against a Philo-fan of defection[23] from the onward marching church by conceding that it *did* amount to a battle when Zeno crossed words with Arcesilas—most likely all in the right spirit (44):

> *certamen . . . non pertinacia aut studio uincendi, ut mihi quidem uidetur.*

> A battle royal . . . —not, as it seems to me at least, for mulishness. Not because he just had to be on the side that's winning.

Yet even this tussle was another version of Socrates' (and his predecessors') skeptical fix, which made Arcesilas espouse the method of counterargumentation, so as to withhold assent to partial-partisan views, which had come to be called New, but seems to some of Us to match the Platonic Socrates' approach, and so to be Old, quite likely less of a departure from Plato's Academy than the New Academy had thought, or so the new Old faction deemed probable. Whatever the record might show in the Academic camp/s, the point is that its recapitulation lays out an exemplary recouping of the spirit at work in its praxis. This latest, Latin, exchange fictionalizes *philosophia* as bonhomie. Centuries' worth of chords, harmonics.

Our Varro's model "précis, lucidity perfected" (*breuiter sane minimeque obscure*, 43) did much more than tee up the riposte. His review reads us a Roman lesson in good behaviour inside the story of Academic φιλοσοφία. In the process, *philosophia* delivers its scholarly lesson on how appreciative pupils should behave toward each other and to their teachers old and new. For the story he updates *p.p.* Antiochus is a story that separates sheep from goats (33–42).

[23] Cicero's desertion from Old to New Academy: see Glucker 1988, esp. 42.

The legacy of Plato was the blueprint trivium of physics, ethics, logic. Modifications ensued (*immutationes*):

- Aristotle first "r-r-r-attled" Plato's darlings—the Forms (*labefactauit*).
- Theophrastus was a sweet-talker whose character advertised honest-to-goodness, the real McCoy. He "smashed" the hold of the old system, "stripped" *uirtus* of grace and "neutralized" her (*fregit, spoliauit, imbecillamque reddidit*).
- *His* pupil Strato had a sharp mind. He quit the firm by self-confinement to physics.
- Speusippus and Xenocrates defended the faith and passed it on.
- After them, Polemo, Crates, and Crantor did the same.
- Polemo had for pupils Zeno and Arcesilas. The older one, Zeno, argued with finesse and found razor-sharp inspiration. He tried to correct the school. He was no Theophrastus. Far from "hamstringing" ("unmanning") *uirtus*, he pioneered the tough line (*neruos . . . inciderit*).

This doxography (first in a line of differently modulated/manipulated potted histories) briskly traces Zeno's approved management of a *positive* "breakaway counter-movement, . . . a schism" (*commutatio . . . dissensioque*), which "consisted entirely of distancing from *uirtus* and wisdom everything alien to firm and coherent assent." This favorite rebel's conduct is itself entirely distanced from any hint of disloyalty, contentiousness, opinionation.[24] By contrast, the bad boys of Epicureanism are, we saw, legitimate prey for Ciceronian invective to harry. No kudos in anaemia. But the tales told to make the tale he tells *all* confirm that good behavior matters to this new/old creed of resistance to dogma. Especially our own dogma.

Augustine's gibe bespeaks another contrariness in Academia—eschewing the compromise candidate produced by negative selection: not Xianity's cup of tea—but the backhanded compliment hits the spot well enough (*C. acad.* 3.15–16):

> *locus quidam, ut mihi uidetur [!] mira urbanitate conditus, ut nonnullis autem, etiam firmitate roboratus. difficile est prorsus ut quemquam non moueat quod ibi dictum est, Academico sapienti ab omnibus ceterarum sectarum qui sibi sapientes uidentur secundas partes dari, cum primas sibi quemque uindicare necesse est; ex quo posse probabiliter confici eum recte primum esse suo iudicio qui omnium ceterorum iudicio sit secundus.*

[24] *Acad.* 1.35–42 *verb*alizes Zeno's *immutatio* thus: (i) ethics = *ponere, numerare, appellare, dicere, numerare, docere, relinquere, ponere, appellare, commutare, ponere, putare, ponere, disserere, uelle, adsentiri, putare*; (ii) physics = *sentire, statuere, discrepare*; (iii) logic = *mutare, dicere, appellare, adiungere, uelle, adiungere, inquit, appellare, ducere, dicere, uti, appellare, nominare*; (iv) conclusion = *collocare, numerare, dicere, tribuere, remouere*. Here is the professional applied theorist at his purist work.

One particular passage ... composed with stunning geniality, so it seems to me [!], plus, so it seems to a fair number of people, ferroconcreted with stunning solidity. It's really hard for what gets said there not to move anybody: the Academic Philosopher is made runner-up by all those in the rest of the schools who regard themselves as Philosophers, given the inevitability of each claiming top spot for themselves. From which it can be concluded with all probability that the right one to top the bill in his own chart is the one who polls second in the voting of everyone else.

In *Tusc.*, Cicero is ready to step out of the shadows, and play lecturer, respondent and audience, all in his head. In the end, we Ciceros will give our selves (our lives) a rousing send-off. The behavior of our host will outline how a Roman sage could look. In practice. In *Fin.*, Cicero had just moved out to traverse the range of philosophies at large. Still personating and conversing, he sets us off at an extended diptych of two polarized exchanges with the main rivals to mainstream options within Academicism. These bring on two heroes of Republican resistance, recently deceased. *Both* pitted their blessed lives against Caesar in the recent African wipe-out . Torquatus and Cato: two hallowed names in the hall of Roman fame. Cicero writes their parts, then responses for himself. The quintessential finale folds the lessons we probably learned into a compact flashback to Cicero's student days back in his spell in Athens taking cover from the *Sullan* tyranny. Before brother Quintus had turned his hand to Sophocles, before Pomponius had stayed long enough to become *Atticus*, before M. Piso or Cicero had made it to the Roman top. Off they had gone to lectures by Antiochus; when a young (short-lived) cousin, Lucius Cicero, leaning toward oratory and politics, provided a catch for protreptic to philosophy. Book 5 showcases two Academics doing it together. Just the spot—on a par with the senate-house in Rome (5.3)—to make their pitch for a Roman pupil (*hortatio*, 6), in a no-lose duet of mutual courtesy. Here is more protreptic, in the company of friends divided in affiliation but united in devotion to culture. No hitches here: "we" are right on, we head right on; processing to Pomponius's (96),

perreximus omnes.

We all headed straight there.

The company walk us in afternoon solitude through the unbounded association-saturation of bombsite-website Athens (*infinitum*, 5), to preach Academic philosophy from the (ruined) Academy—feel the goose bumps: spot Carneades' nook *over here*.[25] "We" travel over there not to learn about the classics but to

[25] Sulla's Roman soldiers had sacked Athens not a decade before; the city's schools were shut down (Annas 2001, xvii). In 45 B.C.E., Cicero's son was being packed off for *his* shot at soaking up Culture.

imitate them (6). Piso gets to incarnate Antiochus by imitating his critique: this relied on (= recycled) Carneades' perfected matrix of possible positions tenable in the vital *quaestio de finibus bonorum et malorum*.[26] These strategies for in-fighting advertise the masterful parasitism of Academicians on their own procedures and so on others' misplaced chauvinisms. By the time we reach Piso-Antiochus's panoramic review of the history of worthwhile thinking on the Point of It All, we will have long been acculturated to appreciate his businesslike analytic dispassion. Here "we" are exonerated from the "engaged" praxis of a mainstream Peripatetic or skeptical Academic (arguing pro and con; arguing against all positions: 10) by the pedagogic function of the précis. The point is to draw a line round "our" philosophy (our world)—with exclusion orders out for rejects (Pyrrho, Aristo, Erillus, 23):

> *iam explosae eiectaeque sententiae ... quod in hunc orbem quem circumscripsimus incidere non possunt, adhibendae omnino non fuerunt. ... sic exclusis sententiis reliquorum, cum praeterea nulla esse possit, haec antiquorum ualeat necesse est. igitur instituto ueterum quo etiam Stoici utuntur, hinc capiamus exordium.*

> The long discredited and rejected views ... —because they can't step into this magic circle we've drawn—have had to be completely kept out of the reckoning. ... Given this exclusion of the views of the rest, and since there can be no view besides them, it's inevitable that this classical view must prevail. Accordingly, we *shall* make our entrée from this point, according to the method of the ancient tradition, as practised by Stoics, too.

The conformism rolls out a carpet of first principles. Nature's way shows the "end" of our existence in our beginnings (24–41). It was noted as/at the start (Piso notes) that our nature only becomes known to us on maturation, when we appreciate "what we are born *for*" (41). The mind grants knowledge of nature; it is our nature to use the mind. The temperature rises, Homer's Sirens rouse "lust for learning." But discrimination reins us in: hierarchy rules here, as always (49),

> *omnia quidem scire cuiuscumquemodi sint cupere curiosorum, duci uero maiorum rerum contemplatione ad cupiditatem scientiae summorum uirorum est putandum.*

> Think of it this way: wanting to know the lot, whatever sort of such, is for busybodies; being drawn to want knowledge by contemplating the higher realities, is for humanity's heroes.

The blood is up: Archimedes ... Aristoxenus ... Aristophanes ... Pythagoras ... Plato ... Democritus ... —just think how stirred "we" are by astronomy, and by history, not fiction. ... In the good old days, this is how paradise was

[26] For Carneades' map tabulated: Annas 2001, xxiv, Figure 1.

imagined; in oppressed modernity, this is the dream that eases pain. As "we" fire up the boy (the student) in us, our account warms to Peripatetic science, in a classic version of exegesis minus eristics. Piso enthuses over enthusiasm for living the life of intellectual enquiry. He is living it (up). The crescendo cements all mankind into one heaving united mass of energetic pursuit of their aims and objectives—their ends: the speech extols the extolling of *uirtus* (72). In paradise there was unanimity; the fall brought fragmentation, as "the rest of the schools tried to rip off a bit of the old system for their own" (72). Epicurean voluptuaries and Stoic thieves took their piece of the action, but the classic scheme is proof, still (74):

ita relinquitur sola haec disciplina digna studiosis ingenuarum artium, digna eruditis, digna claris uiris, digna principibus, digna regibus.

So it is that this remains the sole programme that befits liberal arts enthusiasts, befits scholars, befits public figures, befits statesmen, befits royalty.

This is the end of the classicist speech given Piso: a seductive bid to steal Master Cicero away (doctrinal kidnapping, 75). Irenic banter ensues, over the coherence of *Cicero*'s right as a New Academic to find probable whatever he finds probable (76):

non est ista . . . magna dissensio.

No, not much . . . to fall out about here.

He is with Piso's Peripatos,[27] at odds with the Stoa. He means to put pressure on the watchword of self-sufficiency of *uirtus* for the *uita beata*. It is a technicality (83):

non enim quaero quid uerum sed quid cuique dicendum sit.

I'm not after what's true but what each sect has to say.

Zeno's tough line is squeezed out of the grand coalition of post-Socratics, while the Peripatetic cousins are just ribbed for equivocation: the new recruit can go either way (86),

erit enim mecum si tecum erit.

See, if he's with you, he's with me.

Piso is prompted to a ringing peroration, as he insists that the end of worthwhile philosophy is the attainment of *beata uita*, a quest started by Socrates in Athens, then shifted to the Academy, forever "reposing all hope of happiness in *uirtus*." The final thoughts find Stoics less Peripatetic than the sceptical Academy (94):

[27] Cf. Gigon 1989.

Arcesilas tuus, etsi fuit in disserendo pertinacior, tamen noster fuit.

Your Arcesilas, even if he was a bit mulish in seminar, was still one of us.

One of us. Book 5 has been the Academy's book. *Fin.* ended up smuggling a rousing climax into its own write. Piso's Peripatos has healed the classical tradition of philosophy, infusing dispassionate scientific reasoning into ethics, making brothers of cousins, charming "us" with wide-eyed uplift. "We" can feel the self-restraint in Cicero's muttered withholding of assent. Quite likely, the boy can wait for the countercritique. First, the classical status of the grand tradition inculcates fairness, decency, and dignity.

You should not miss this after the ragging meted out to Torquatus and Cato in *Fin.* 1–4. Cicero does not loathe Epicurus but disapproves. Not his flat writing but the boobs. He does deplore his rough treatment of the only teacher he ever owned (1.21: Democritus). But when their young Third Man, Triarius (yes, another Pompeian casualty), crowed that Cicero had expelled this declared foe of culture from "the philosophers' ball," this closes the rivals' ranks (26),

> *dissententium inter se reprehensiones non sunt uituperandae; maledicta, contumeliae, tum iracundae contentiones concertationesque in disputando pertinaces indignae philosophia mihi uideri solent.*

. . .

> *prorsus . . . assentior, neque enim disputari sine reprehensione nec cum iracundia aut pertinacia recte disputari potest.*

When they disagree with each other, the criticisms shouldn't be damned; slanging, insults, plus bad-tempered wrangling and mulish shoving in discussion, all seem to me *not* to befit Philosophy.

. . .

I completely agree, it's as impossible to have discussion without criticism as to have proper discussion with bad temper or mulishness.

Both partners claim to aim by speaking their mind to provoke the other to speak their mind (28, 72). Be Torquatus never so courteous, however, his chosen *form* of philosophical communing brands him a dogmatist deserving a taste of his own medicinal gall (29):

> *uti oratione perpetua malo quam interrogare aut interrogari.*

I prefer to operate the uninterrupted lecture rather than question-and-answer.

This is Cicero's first riposte: he has no time for the "philosopher's lecture." Un-Socratic, sophistic, antidialectical. Arcesilas (n.b. for what is in store) had reanimated the method by having pupils argue their corner, while he countered them and they fought back. The new Old Academy lets students put up an irritant problem to provoke demolition in "a set speech" (*perpetua oratione*, 2.2).[28] Just like Torquatus, except that *he* believes in his oration, for good. But his nonstop uninterruption is a tactic to overwhelm criticism—the "river in spate" technique (*quasi torrens oratio*, 3; cf. *ruit in dicendo*, 18). It is a blatant cover-up: Epicurus-Torquatus refuses to abide by the basic rules for reasoning. For a start, this lot won't *define* problems or terms; nor will they *divide* categories properly (away with Logic—break on through to the other side: 26, 30). In a word, they point beyond argument to the evidence of the senses. They insist that words mean what they tell them to mean, jargon trading on obscurity and extraordinary meanings foisted on ordinary-looking words. In short, they YELL (*clamat*). Five fine minutes of torment, and the Epicurean is not enjoying the ride. "End it, no more questions; I started by telling you my preferred way—short of the traps of dialectic" (*finem ... interrogandi, si uidetur*, 17).

The dogmatist makes the opponent an (Arcesilaesque) Academician. *Obliged* to fight fire with fire (ibid.):

"*Rhetorice igitur,*" inquam, "*nos mauis quam dialectice disputare?*"

"So. You prefer our discussion in debating mode rather than cut-and-thrust?"

Mind-parasite Cicero will take his cue from the other, infiltrate and disembowel the know-all. Who plays into Cicero's hands by insisting he play him at his own game: as Zeno mimed it, "Oratorical power splits down the middle into the *palm* of rhetoric and the *fist* of dialectic." And he's asking for it, too: Cicero of all interlocutors, king of the courts and now freed up to *use* the cutting edge that he has to blunt a bit for the public ... "We" have been warned. Expect parodic caricature from the champion professional chameleon. The antiphilosophical cuckoos in Plato's nest have it coming. A taste of their own medicine. And yet, the demolition will still be an Academic performance for the Triarius-juror, since it will be a fair test for the maestro's quest for truth through contrariety: through assimilative exposure of caddish flouting of "our" rules for reasoning, will there emerge fitful shafts of (counter)intuition? There will. Not least, we might tentatively propose, in the form of withering vindication of *mores* in the forms of conduct in *philosophia*. Recall (*Acad.* 1.5), opiate Epicureanism has swept up the Italian masses. Now to unmask this unRoman activity. Time for a drop of Stoic grief. A drop, mind.

[28] See Douglas 1995, 7.

If these phonies think they only have to say loud and often that pleasure is *not* absence of pain in order to abolish the difference, they have another think coming.[29] Ouch—that hurts? For a would-be philosopher to engage in defining desire by positing finite pleasure is definitionally the embarrassing end of his game (2.22, 30). Self-confuting decrees provoke the stigma of shaming sarcasm— "A philosopher so grand and noble. . . ." "We" should call in the police plus a minder to deal with this fast and loose rabble-rouser (30: the *censor*; the height of *idiocy*, 34). Epicurus can raise his voice for Pleasure all he likes (51), but this simply provokes showdown eristics where he cannot win. No, Torquatus can't shout down the orator's favorite trick, borrowed voices of power and knowledge: *Ratio* ("Reason," 37), and ineluctable *Virtus* ("Virtue," 65). *Voluptas* ("Pleasure") would, if she could, own Herself trounced—trespassing beyond Her limits (*Fin.*, 3.1).

Reason-Cicero roll-calls philosophical consensus solid against Epicurus, naturally defining the natural naturalness and comprehensively mapping the set of systems (2.34, 39). The pressure piles up, until "we" trope the voluptuary as a perplexed Xerxes ludicrously "launching his armada for a long-awaited taste of Hymettian honey" (*mellis causa . . . tanta molitum*, 112).[30] For peroration, the lecture then turns tables on the dogmatist. Biter bit, the Epicurean gets a new master's voice to obey: "Believe me, Torquatus . . . ; read the age-old Roman encomium, Torquatus . . . ; read your clan's" (113–16). When Cicero smeared the sect by wheeling on Roman scoundrels, he got personal with Torquatus. If his eponymous ancestor Torquatus *Imperiosus* could only hear him now (64). . . . This family demanded ultimate sacrifice to obedience, as Cicero had twitted his adversary through both the books they share.[31] Its naming for violent patriotism beyond the call of duty suited Pleasure's votary not one jot (16):

> hic est uim afferre, Torquate, sensibus, extorquere ex animis cognitiones uerborum quibus imbuti sumus.

> Torquatus! This amounts to extorquating from our minds the understanding of words we were baptized in!

Now "we" soften him up by deploring (decoupling) *Greek* bad manners (80):

> de ingenio eius in disputationibus, non de moribus quaeritur. sit ista in Graecorum leuitate peruersitas, qui maledictis insectantur eos a quibus de ueritate dissentiunt.

> This point in the discussion asks about his intellect, not his ethics. Butterfly Greeks can keep this upsidedown business of hounding with insults anyone they disagree about the truth with.

[29] Stokes 1995.

[30] "The sentence is perplexing because of its length and the number of . . . subordinate clauses involved" (Cicero 1896a, id. 1896b, 102).

[31] *The* Torquatus (and his poor son): *Fin.* 1.23–4, 34–5, 2.60, 73, 105; (strict) T. Torquatus: 1.24; cf. (resolute father) A. Torquatus: 2.62, 72.

Was he ... *dumb*? No, we cannot be sure. It's not our way (*nihil enim affirmo*). But (look, 81):

> *ita enim uiuunt quidam ut eorum uita refellatur oratio.*
>
> See, some people live lives that refute all they say.

The satire will snap shut. Epicurus tells us not to live in the past—forget! This takes an *imperious philosopher*, or worse (*nimis imperiosi philosophi*, 105):

> *uide ne ista sint Manliana uestra aut maiora etiam, si imperes quod facere non possim.*
>
> Watch it. Don't let yourself do a Manlius, or outdo the G.O.M.—giving me orders I *can't* obey.

Roman *Virtus* is ordering Torquatus about, in the name of the ancestors, the unitary old consensus of atavistic *imperium* (116):[32]

> HVNC•VNVM•PLVRIMAE•CONSENTIVNT•GENTES
> POPVLI•PRIMARIVM•FVISSE•VIRVM
>
> HERE•LIES•A•MAN•NATIONS•AGREE
> THE•PEOPLE'S•NO.1•HERO•WAS•HE

the archaic plaque had read, down by the city gate. The day is done, Torquatus faced down (119):

> *finem fecimus et ambulandi et disputandi.*
>
> We combined walking and discussing in one *finis*
> [for Book 2].

Brutus knows the enemy is within. *Fin.* 3–4 will put to work at Tusculum every move that Torquatus-Pleasure made at Cumae in order to get "us" thinking *like* Epicureans. Each performative thrust and counterthrust ahead responds and reacts to what we just read. So "we" are warned at the outset (3.2):

> *itaque quamquam in eo sermone qui cum Torquato est habitus non remissi fuimus, tamen haec acrior est cum Stoicis parata contentio.*
>
> That's why, although we didn't slack in the interchange had with Torquatus, still this show-down with the Stoics is a set-up with some edge.

It's absolutely no use reading *Fin.* 1+2 as if anything at all that gets recounted therein is not always already responding/resisting something that is ordained to follow in *Fin.* 3+4; let alone, I choose to think, vice versa. Cato's iron fist will

[32] Cicero has just held *imperium* as proconsul of Cilicia (51 B.C.E.); our Torquatus gets to hold *imperium* as praetor in the last year of the *res publica libera* (50 B.C.E.) (Wright 1990, 115).

napalm off Cicero's ironic twist. Stoics use and evoke "subtle, spiky" rhetoric and reasoning. Where wilful Antitheory would make off with the sense of "our" words, these master logicians were (remember) inventors of new terminology, but purveyors of old wisdom. Cue that crisis of φιλοσοφία now redoubled in *philosophia*: J-A-R-G-O-N. For modality, the Stoic strains for drama—frustrated by arid "Physics for Beginners" (19):

> *cum de rebus grandioribus dicas, ipsae res uerba rapiunt; ita fit cum grauior, tum etiam splendidior oratio.*

> When you're speaking on grandiose themes, the stuff takes the words along for the ride, and so the rhetoric gets both added weight and extra gloss.

Need "we" say—"plain and clear will do a clued-in thinking man" (ibid.). Besides, Cato knows, the delight of Stoicism is its stark pursuit of simplicities—"the end of life is natural living" (26, 29):

> *beate uiuere . . . id est, cum uirtute uiuere.*

> Living a blessed life . . . i.e., sharing life with Virtue.

Again, rhetoric *could* go to town on this—but (26):

> *potest id quidem fuse et copiose et omnibus electissimis uerbis grauissimisque sententiis rhetorice et augeri et ornari; sed consectaria me Stoicorum breuia et acuta delectant.*

> This point can be oratorically amplified and embellished, open the floodgates, heap a pile, ransack the dictionary and bulk in the sound-bites. But *I* enjoy the Stoics' syllogisms. Short 'n' sharp.

Step up. These are the master technicians of the syllogism. Cicero claps his hands—Cato teaches *Philosophia* to speak Latin, sorta makes her one of "us" (*quasi ciuitatem dare*, 40).[33] But this is all barbed: neat deployment of lucid logic is the pitch; but Carneades' Academic quarrel (battle royal) is that Stoics make a "verbal, *not* actual, difference." The argument *may* very likely boil down to a difference of opinion about whether it can be known if there is or is not a difference between Stoa and Academy. But if it does, this will be a victory for some, at least some, Academies. A soaring gospel of rousing, strenuous, systematicity blows the speaker away. Ecstasy upon ecstasy, heavens (74–75):

> *admirabilis compositio disciplinae incredibilisque me rerum traxit ordo; quem per deos immortales nonne miraris? . . . quam grauis uero, quam magnifica, quam constans conficitur persona sapientis?*

[33] Tusculum was the first Latin town granted *ciuitas Romana* (Wright 1990, 118). Just the place to fend for *libertas*.

The stunning system of the school's teaching, its unbelievable curriculum's modular programme has sucked me in. By the eternal gods, doesn't it just knock you out? . . . How weighty, heroic, steadfast the role they get sorted for The Philosopher!

Considerably holier than thou, this saint crowns the transcendent vision of human goodness in religious rapture (76):

> *quid philosophia magis colendum aut quid est uirtute diuinius?*

> What demands more devotion than Philosophy? What is nearer to god than Virtue?

That is IT (4.1):

> *finem ille.*

> *Finis*, from him.

"We" have been toughed out of this one (contrast the hinge at *Fin.* 1–2). The congratulations are (also) a complaint: "It's not easy to learn the whole lesson . . . —is it true? Too soon [always too soon for an Academic?] to dare to say it is *not*" (4.1). Cato won't let go: Cicero must plead *in defense*, without adjournment. Now the boot's on the other foot: Stoicism don't agree with "us"—but far from shaming the pleasure-seekers (2),

> *pudore impedior; ita multa dicunt, quae uix intellegam.*

> I'm blocked by the shame, they're saying so many things I can't hardly understand.

On one hand, Cicero comes out sparring: Stoic syllogizing is crusty, prickly, jejune (psychologically unconvincing; 7) . . . but the cruelty in this theory will be infuriating insistence that Stoics are but Peripatetics with changed number plates (21, 60):

> *correctio philosophiae ueteris et emendatio.*

. . .

> *nulla mihi tecum, Cato, potest esse dissensio.*

> Classical Philosophy straightened up and weeded out.

. . .

> There can be no parting of the ways between me and thee, Cato.

Cruel gibe: no use fighting us, champ—fighting "we" don't do. But Zeno didn't smuggle pleasure in under cover of absence of pain; he hid behind

jargon to tell us all other blessings matter not a jot to living the *beata uita*. The difference he made to philosophy was to claim (bizarrely) that there is *no* difference between degrees of failure to be wise. How could *Cato defect*? Wheel in the apostolic succession of Plato (61). Why? What is the point of it all? (68):

> *gloriosa ostentatio in constituendo summo bono.*
>
> Self-heroizing p. r. in defining the Greatest Gift.

Evening descends; we part ways (*discessimus*, 80). Infuriatingly, I shall be content to point out the ratio of *Fin.* according to which "1 : 2 :: 3 : 4" sets up "dialectical" foil for congenial 5, and underline that this scheme subtends the pentangular version of a canonical brotherhood. High and mighty Stoic purism vs. low-brow Epicurean philistinism *leaves the rest of us* incontrovertibly/uncontroversially within the magic circle of Socrates. Cato, of course, is not done. He is not amused, he wants a shot at refutation (80):

> *memento te quae nos sentiamus omnia probare. nisi quod uerbis aliter utamur, mihi autem uestrorum nihil probari.*
>
> Don't you forget that whereas you approve everything that we reckon, I on the other hand approve of not one of your lot's. Apart from the fact that we use words differently.

But we resist Cato's parting gauntlet; head for Athens, way back when: finally, *de finibus* ends up in Academe. Showing you who philosophize how to. All we should ever ask?

One's a crowd. In *Tusc.* text outs itself, there never was anything of the Socratic *ratio* in Ciceronian *oratio*. Not really: it was always fiction, staged narrative. Change the record now, and (mock-)fight "our" corner (*sic eas exponam quasi agatur res, non quasi narretur*, "I shall present them as if it's live, not reportage," 1.8). For the interchange of dialectic is irreconcilable with authorial signature. (Live y/our one life.) And this is catch-up time: those personae (Varro through Cato, Cicero upon Cicero) were never even voices in one noddle; the words issued from one mouth, styled by a single stylus. "We" give ourselves a week: let's use it (119). *This week*, granted by life: *nuper* ("recently," 7). Among friends (*familiares*) in the Academy again—but this one we go down to, is "our own Academy" (*in Academiam nostram descendimus*, 2.9).[34] Five down-home afternoons in Tusculum; after the morning workout to keep the rhetoric in fighting trim. Each book in this latter pentateuch (5.121: *ad finem*) hands us today's watchword: "Brutus," *lege: Virtus*. The self-sufficient ipseity of autarchic uirtus looms over every para of pomposity. In this penum-

[34] See now Cicero 2002, xv–xvii, "The format of the discussion."

bra, sorry: his aura, philosophy quails and quibbles, rhetoric squeaks and squabbles. Yet any auditor drowning in all the doxology who feels fastidiously peeved at repetition has yet to learn the place of this *philosophia* in life. For the terrain of Ciceronianism is even staked out *as* repetitiousness. (Name me an improvisation that is not.)

- A. *Tusc.* 5 is going to explain *ob iter* what *Tusc.* 1 through 5 practise, and why. "Sitting or perambulating" (1.7), they are *practice* philosophy, they *practise* philosophy, and they stake their all (our all, they venture) on philosophy as *praxis*. They star the practitioner of philosophy. Work on the self.
- B. *Tusc.* 2 through 4 *theorize* this praxis. The teleology is therapy; the modality is mantra. Every word *intones treatment*. This talking cure treats topics so as to treat "us." Constant interlingual intercultural interactivity materializes its language as psychodynamic tonic and karma.[35] You see.

Cicero the orator now plays the philosopher. So *think* "Aristotle" = "practical wisdom plus gift of the gab in one" (*prudentiam cum eloquentia iungere*, 1.7).[36] These "Greek-style lectures" dare recapitulate "our" education (*scholas Graecorum more* ... ; *senilis declamatio*, ibid.: links back to *Fin.* 5).[37] The régime will be the standard contemporary Academy line, that it is in line with the classical line back to the source (8: cf. *Fin.* 2.2 above):

> *ita ut cum is qui audire uellet dixisset quid sibi uideretur, tum ego contra dicerem. haec est enim, ut scis, uetus et Socratica ratio contra alterius opinionem disserendi.*

> On the lines that when someone who wanted to listen had said what they thought, then I'd counterargue. See, this is the classical Socratic method, as you know, of countering the other guy's opinion in discussion.

Probably the easiest way, ran the creed, to find probability (*ueri simillimum*).[38] A first sample elenctic interrogation whips all too fast through a kindergarten routine, obliging consent before winning assent (1.14). "We" really are going to put ourselves through it—the set speech, preferably uninterrupted by questions (*continentem orationem*, 16). This is prefatory disclaimer, cueing doctrinal modesty (17):

> *nec tamen quasi Pythius Apollo, certa ut sint et fixa quae dixero, sed ut homunculus unus e multis, probabilia coniectura sequens. ultra enim quo progrediar quam ut ueri similia uideam non habeo.*

[35] The Loeb note on *Tusc.* 3.74, *mediocritates*, is suckered into this game: "μεδιοπαθειαι" [sic].
[36] See esp. Michel 1961 for *Tusc.* as rhetorical philosophy/philosophical rhetoric. Cicero 1985, 17, argues that "the [relative] absence of the 'confrontational' form is directly relevant to the substance of the work. [TD show] an evident desire to seek reconciliation ... rather than controversy."
[37] "Form and content" of *Tusc.*: Douglas 1995.
[38] Glucker 1995 is the essential study of this family of concepts/terms.

No, not like Delphic Apollo, as if what I say will be immutable destiny, but as one hominid of thousands, pursuing probabilities by guestimation. See, I've nowhere further to push on apart from spotting what looks true.

Today's sermon is DEATH. The easiest of live topics not to know about; and to collect resistances. Wanting a soul, an immortal, aetherial soul puts you in vast and good company (all known societies; Plato). Precisely: contrary views are banned from our thoughts (55). Who could really withhold assent to ascent? What would we be saying of our aspirational selves? Here where counting heads, cultures, and authorities is so obviously apt, we are (own up) bound to overconfident predisposition (78, 81).[39] Hear Socrates out (97–99: Plato, *Apology, ad finem*, translated = . . . ἄδηλον παντὶ πλὴν ἢ τῷ θεῷ):

sed tempus est, inquit, hinc abire me, ut moriar, uos, ut uitam agatis. utrum autem sit melius di immortales sciunt: hominem quidem scire arbitror neminem.

"But now," he said, "the time has come for me to leave here, to die, and for you, to live your life. Which alternative is better, the eternal gods know. No human being knows, I rule."

Look to the end, feel the skeptic last the course (ibid.):[40]

> *suum illud, nihil ut affirmet, tenet ad extremum.*
> *nos autem teneamus—*
>
> He holds to that tenet of his, "to insist on nothing," to the very end.
> Now let us hold on tight . . .

Hammering away at Death's ~~Sting~~ as if from On High is, however, *vital*.

To fortify humans, ourselves included. Eloquent coruscation strengthened the self, it still does, even in the shamefacedly self-conscious lecturer's school assembly routine of lining up the gods (112–19). *Amen.*

"Tomorrow" is another day. But *Tusc.* 2 starts from reflection on the peak scaled "yesterday" (see below in *Tusc.* 3, 4, 5). The times oblige Cicero to *jouer le philosophe* (*philosophari*, 1). As such, his work is up there for people to take a pop at (*contra . . . dicturos*, 3). So too, please, the suite of *Hort.* followed by *Acad.* (4):

tantum abest ut scribi contra nos nolimus ut id etiam maxime optemus.

It's so wide of the mark that we don't want countering in print that that's just exactly what we should put top on our wish-list.

[39] See esp. "68–69. These sections consist of one vast sentence . . . Cic. seems to have thought this an effective way of extolling the splendour of the Universe" (Cicero 1985, 115).
[40] See Burnyeat 1997, 290–300, on the ?knowing? Socrates.

For controversialism has been the lifeblood of φιλοσοφία, and *philosophia* needs saving from has-been Greece (4–5). The trade-off is that dogmatists are (i) nailed to their dogma, so (ii) embarrassed in the cause of consistency, where probabilists (i) cannot advance beyond verisimilitude, but—*so*—(ii) "are equipped for good-tempered cut-and-thrust" (*et refellere sine pertinacia et refelli sine iracundia parati sumus*, 5). *Think* "Philo," this time around—he too alternated rhetoric and philosophy, à la Lyceum.[41] Taught Cicero most all he *knew*.

Pain is the problem. The hardest *not* to know about; most resistant to *intellectualization*? Far, far worse than last session, this war is over before battle is joined: "PAIN: the worst evil? What, worse than disgrace?" "That's *shameful*: to be dislodged *that fast* from a thesis!" (14). One instant shimmy later: to show pain isn't *an* evil is so tough a nut, "*we* shall need a mind that puts up *no* resistance" (*animo . . . opus est non repugnante*). The library of literary pain is tipped out on the page: tragic quote after tragic quote to sabotage our case (26). Classic technique from the lecturing manual, this: student classes back in Athens (link back to *Fin.* 5) taught just such appropriation of "educative" art for philosophy. Where the Stoic guru, naturally, read bad, our Philo made sure to get it right—"rhythm, quality, pertinence" (26):

> :*itaque postquam adamaui hanc quasi senilem declamationem, studiose equidem utor nostris poetis.*
>
> So it is that ever since I fell for this so-to-speak Debating Society for Fogeys, I put Latin poetry to work like a true fan.

But *poets bring trouble*. Like wrong-headed philosophy—(i) Epicurus stuck in the shame we dismissed on sight (28 ~ 14); (ii) the Stoa trotting out sillygisms to fool us: saying "pain is not-evil" doesn't make it so (30):

> *definis tu mihi, non tollis dolorem . . . ; optare hoc quidem est, non docere.*
>
> You define my pain, you don't lift it. . . . This is a wish and a prayer, not a teacher instructing.

Here is our prompt, in this typical "neither-nor*ist*" maneuver, to perform a showcase of psychagogically pressurizing rallies (42), with a flood of classic exempla both Greek and Roman (34–62). Pile today's emphasis on bravery—*appellata est enim ex uiro uirtus* ("Virtue is named for Virility," 43)—and bid us "meditate round the clock" (66). *Tell* y/our self "Pain's no evil; or it's so eclipsed by *Virtus*, it vanishes." *Keep* telling yourself.

[41] Brittain 2001, 296–98.

Same shit, different days.[42] Death and pain evoked different strategies. Cicero knew exactly what was becoming of philosophy as he made/let his speaker dilate with soul on eternity, with heart on heroics. Day Three at once hits us with PSYCHIATRY (3.1, 6):[43]

> *animi autem medicina* ...
> ... *est profecto animi medicina philosophia.*
>
> Mind healing ...
> ... For a fact, Philosophy is the healing of the mind.

To decide whether "The sage can hurt" *aegritudo*[44] invites us to juggle bald astringent argumentation (Stoa) with those nagging modifiers of (New Academy) provisionality mixed in: *necesse est/ueri simile est* ..., *uidetur esse* ("it must be so/it looks like the truth ... seems so" 14–17). Proof gets the ball rolling: but tangled logic fails to satisfy. "Our" license to roam wherever whenever (*uagabimur*, 13; cf. *aberrauit* ... ; *edocuit tamen*, 80) entertains the mind, as in the two sermons we have studied, by touring Greek culture and Rome, theories and traditions, drama and history, from dawn till today. The massage instantiates a chosen bedside manner. Mental health resists reasoning. Strategies for *engaging* patients are indispensable; *interesting* patients matters: to deal with "hurt," kick poets, Epicurus, Stoics around some more,[45] as if you've only just thought of it in the doing, and plug in familiar litanies of human fortitude, as if they only just occur to us. Why would anyone ever bother with Classics if they were not looking for a place to think? Why read "a *self-contained* treatise on the nature and management of human emotion" as if the place of emotional*ism* in the containability of the self were in study in the study?[46] These *self-styled* transcriptions are no lectures—Cicero writes us *essays*.[47]

I claimed at the outset that nobody can lay down the law when it comes to mourning; and that is the point of featuring the topic.[48] Here probabilist circumspection can *look* like fairness, decency, and dignity. Cicero's own *Conso-*

[42] Of course every preface rests on the preceding laurels. (This is crucial, as we shall see.) Of course the prefaces start afresh.

[43] On "Academic therapy" and *Tusc.*: Schofield 2002, esp. 103–5, and White 1995; for the history: Nussbaum 1994.

[44] Cicero 2002 "ha[s] rendered *aegritudo* as 'distress' throughout both books [3–4]" (xxxviii, q.v., xxxvii–xxxix, "About the translation"). Psychoanalytic "Melancholy" would get the role played by *aegritudo* as Cicero's master-syndrome best of all?

[45] The Peripatetics get an unusually rough ride in *Tusc.* 3: Classen 1989.

[46] Quote from Cicero 2002, vii, ushering in *Tusc.* 3–4. *My italics.*

[47] So (e.g.): "Here Cicero loses the thread of his subject in a tirade against the views of Epicurus, (36–51)" (Dougan, ed. 1934, 12).

[48] Cf. Erskine 1997 on *Tusc.* 3, esp. 46, "The problem [Cicero] is posing is essentially his own—how do you cure grief?" [where "his own" means reaching out towards uncharted territory for philosophy: in the calqueing of λύπη with *aegritudo*, language as bearer of culture looses a grievous wound in theory].

latio put *him* in jeopardy: the hurt of bereavement hurt him so much, he tried the works (76):

> *erat enim in tumore animus et omnis in eo temptabatur curatio.*
>
> My mind it was exploding, and there was no cure I didn't try to deal with it.

The Sage recedes; philosophizing Cicero speaks as patient. Alongside—*and* "for"—the rest of us. Looking in the lost forgotten years / for Dignity.

The upshot is a move "outside the arguments that beset others." For the next session rubs in the moral. There *is* an "outside" to the bizz. Φιλοσοφία into *philosophia* forces liminal kataskope: Philosophy is a technical subdepartment within the governing apparatus of Rome; its typological antecedent, *sapientiae studium*, "lived, more than it wrote, the Good Life syllabus" (4.5). Excentricity from "the true-and-stylish φιλοσοφία from Socrates through Peripatos and Stoa to Academy" left Italy wide open to "occupation by cheapo Epicureanism." To open Roman lives to importing the best Hellenist technology for annexation is a decision for wisdom to make, from within the ancestral heritage of independence: "we" must stay free—free to think (7):

> *defendat quod quisque sentit. sunt enim iudicia libera.*[49]
>
> Everyone has to defend what they reckon: liberty consists in making your own mind up.

Today's lesson fights some more to beat fractious partisanships. The topic is a corollary of *Tusc.* 3. The strategy will be a complement of *Tusc.* 3 (8): unpacking *aegritudo* should likely carry the sackful of *perturbationes* in its caboose (as Trauma to traumas).[50] But the problematically plurivalent multifariousness of (the) emotion(s) will shift the target from the fix of humanity undone by self-sanctioned hurt (pain valorized as grief), to the valiance of optimal *homo sapiens* besieged by the bewildering barrage of psychopathologies within: what difference shall we hypothesize between sorted Sage (the best that Man can get) and the whole sick crew of us clinically Disturbed Patients? Is mind-doctoring itself a hybristic mockery? Fancy thinking to neutralize the arsenal of neuroses—

This time the therapeutic timetable is up front: first, Stoic oars row hard past the dark-blue clashing rocks of the Syllogismoes, only as usual their zappy niceties forfeit goodwill (4.9 through 23). Hoist sails (34) to cruise round Cicero's winsome (lose some) anfractuosities. Winning and winding, we get to paint and meet a Good Guy, so much less pompous than that unreal(izable)

[49] Glucker 1988, esp. 63–64, on Cicero's ?eclectic? freedom.

[50] *perturbationes animi*: Cicero 2002, 80 on 3.7, "'emotions' ... chosen to suggest violence and disarray"; 139–48, "The definition and classification of emotions (4.14–22)." For the "Table of the *Perturbationes* and their Effects, to illustrate IV 5, 11ff.": Dougan, ed. 1905, xxxi.

Sage (36–37). Steps out into his limelight: the consul who cracked down but kept his cool; the orator in court and writing up in tranquillity; and, again, Cicero in mourning—"matching scale of medicine to scale of pain" (63). *This* is the Good Guy telling us that the Good Guy tells us the way Good Guys tell us what they are [telling us]. He practises what he knows; he knows that that is his practising, and, accordingly, tells us what we know, namely that we want to know about us. The Sage was "for" us: his substitute, the Good Guy, tropes his trope: "we suspect (sc. *know*) that the Sage was, and is, [always already] a figleaf for us" (58, 59),

> *simulas enim quaerere te de sapiente, quaeris autem fortasse de te.*
>
> You're passing it off that you're after the Philosopher. But *maybe* you're after your self.

(Did I say "know"? The Good Guy softsells with another charming, disarming, challenging "perhaps.") The course of psychotherapy recommended now faithfully follows up the full lexicon of psychosis; but looks through this (exponentially expandable) tabulation for *general* remedies. To concentrate on getting us to concentrate on what disturbs minds, rather than the disturbed patient. Resistance will be easier (who needs it? 60). Yet *resistance* to the legion of neural subversives cues fortitude, and this is (unarguably) the Stoic heartland (53):

> *metuo ne soli philosophi sint.*
>
> I'm worried that they may in fact be the only philosophers there are.

It takes the Good Guy to own up for real, that the way for a Good Guy is to idealize the impossible Sage.

Sanity, the sanity of the philosopher, faith-healing as philosophy, the lecturer as patient. More than patent, the mis-match between the lessons of *Tusc.* 4 and Brutus's ultimate theme that "VIRTUE is enough unaided for the *beata uita*" (5.1). "We" rally, pull ourselves together: humans are fragile, but Stoicism's hymnal hype helps us look down on us blaming the world, not ourselves (3–4, 5–6),[51]

> *o uitae philosophia dux, o uirtutum indagatrix expultrixque uitiorum.*
>
> O, Philosophy! Guide through Life! Trackeress of Virtues! Exorsister of Vices!

The same sort of dynamics as in the earlier books in the set still applies: Stoicism is high proof in alcoholic percent, but better a sip than a gulp (13). Essayistic extravagance will get us nearer goodness by adhering close as we

[51] "These feminine nouns in *-trix* were invented by Cic. for this passage" (Cicero 1990, 145).

can to the aspiration of self-sufficient *Virtus*. In the Socratic-Plato faith we (Academies) return ever again to endemic rivalry within and between Peripatetic-Stoic goodspelling for our Good Book's b(l)est guide to good living (120):

> *hunc locum ceterarum disciplinarum philosophi quem ad modum obtinere possint, ipsi uiderint:* mihi tamen gratum *est quod de sapientium perpetua bene uiuendi facultate dignum quiddam philosophorum uoce profitentur.*

> The other schools' philosophers can see how to get their take on this topic. *I, however, find pleasure* in the fact that on the continuous option open to Philosophers to live good lives, their declaration bespeaks something that befits a philosopher's voice.

The price of hitting this sticking point (for Brutus heads out to decide his life tomorrow, so this week's work is done and dusted[52]) will have been a tortu(r)ous tour, for this ultimate topic impales "us" on painfully *un*welcome gladiatorial pitting of friend against friend. For all that (the unlikely peacemaker)[53] Carneades, whose *mos* of Socratically ironic en-counter-ing of the views of others has become the model for the *consuetudo* enacted by Cicero's *Tusculans* (10),[54] handed down our favourite panacea for friction between Peripatos and Stoa, that their difference is "verbal not actual" (120), our lecture now dramatizes the ineluctably actual-verbal nature of reckoning φιλοσοφία into *philosophia*.

Virtus of itself*; uirtus* alone*; uirtus per se (ad infinitum)*
vs.
the specifics of fair treatment, decent conditions, dignified quality of life, within the ethical parameters of *Virtus* (ever-renegotiable politics of self-in-community, morality in *mores*).

(i) Sage or (ii) Good Guy? Virtue induces . . . Vertigo. We hate sides, we resist siding, we wriggle, we want (a way) out, sure, but *in the end*, sorry, it matters, which side are "we" on? In the end—

Hold fast! As I read it, the agonized spin Cicero puts "us" in through *Tusc.* 5 is itself focalized as the principal problem/lesson for this essay's thought for THE day. We serve on ourselves a *tu quoque*, and reel. The own-goal move goes like this. When that nagging voice demanded (i.e., signalled) "inventive improvisation" (*noua aliqua conquiras oportet*, 13), "we" complained (i.e., emphasized) that this pressurized Lecture Five's relations with One through

[52] Brutus is off to salute Caesar's triumphant return from the last battle, Munda in ultimate Spain: Dougan and Henry, eds. 1934, 12.
[53] *tamquam honorarius arbiter*, 5.120.
[54] Long 1995, 52–58, Cicero 1985, 93.

Four: demand for innovation instantly provokes the retort that the previous improvisations (the lectures) have solved today's problem before it could be proposed (15),

> *quaero utrum aliquid actum superioribus diebus an nihil arbitremur? :: actum uero et aliquantum quidem. :: atqui si ita est, profligata iam haec et paene ad exitum adducta quaestio est.*

> My question is: was anything achieved in the past few days or nothing at all, do we reckon? :: Sure it was, a good deal, in fact. :: Well if that's so, then this question has already been given a good bashing and pretty well brought to a conclusion.

So, in a trice, it is proved (18): "The previous lectures (i.e., *Tusc.* 3, 4) established the Sage's undisturbed psyche :: So the present enquiry must be over, the problem seems to have come to solution :: Pretty well"—

Hold fast! "This is how mathmos work, not philosophers" (18):

> *cum aliquid docere uolunt, si quid ad eam rem pertinet eorum quae antea docuerunt, id sumunt pro concesso et probato, illud modo explicant de quo ante nihil scriptum est: philosophi, quamcumque rem habent in manibus, in eam quae conueniunt, congerunt omnia, etsi alio loco disputata sunt.*

> When they want to teach some lesson, if anything on the course they have already taught relates to the topic, they take it for granted, as demonstrated, and only explicate things that haven't appeared so far on the hand-out. Whatever subject philosophers have on hand, however, they gather together everything, even if discussed in another context, for application to the topic of the meeting.

This stand for perpetual revisionism forces "our" skepticism into the dock. Our critique demands consistency from our victims (28, 32):[55]

> *acute autem disputantis illud est non quid quisque dicat, sed quid cuique dicendum sit uidere.... non igitur singulis uocibus philosophi spectandi sunt, sed ex perpetuitate atque constantia.*

> It's up to a sharp seminar member to watch not what each speaker says, but what they each should be saying.... Philosophers are not to be inspected one word at a time, but over the long haul, see how steadfast they are.

And this commands assent. BUT (32):

> *sed tua quoque uide ne desideretur constantia.*

> But just you watch it, don't let your own steadfastness go missing.

[55] Cf. *Fin.* 5.83 above.

In *Fin.* 4, we showed difference between Stoa and Peripatos to be a verbal matter. Now *Tusc.* 5 is driving an actual wedge between them: Peripatetic (not the usual Epicurean Aunt Sally) softening of Stoic heroism bears the brunt of today's purg(ativ)e. Insofar as the *Virtus* lecture aspires to monological monothetic monography, essayist roaming militates against its own integrity. "We should look to actual, not verbal, reality," we goad ourselves, and for retort descend into chauvinist (reflex-action) deflection (33):

> *tu quidem tabellis obsignatis agis mecum et testificaris quid dixerim aliquando aut dixerim. cum aliis isto modo, qui legibus impositis disputant:* nos in diem uiuimus; *quodcumque nostros animos probabiliter percussit, id dicimus, itaque soli sumus liberi.*

> You, now. You're giving me the sealed documents treatment, bringing witness that I once said, I mean *wrote*, "X." Try out that line on other people, whose discussions are bound by rules. *My sort, we live by the day*; anything that strikes our minds as a probability, that's the view we express. That's why we are the only people who are free.

With which "we" shrug ourselves off the hook, and slam into abjuring our Peripatetic-Old Academy Good Guys in order to screw ourselves, inspired, to the Stoic sacrament.

So (i) trust me when I say (75):

> *balbutire aliquando desinant aperteque et clara uoce audeant dicere beatam uitam in Phalaridis taurum descensuram.*

> Let 'em finally give over their hemming and hawing, and find the nerve to tell openly and clear as a bell that a life that's blessed will get on down into Phalaris's bull.

But (ii) how can I trust me when I say it (82):

> *libere dicere auderent sapientes esse semper beatissimos.*

> [T]hey should find the nerve to tell freely that Philosophers are always and forever the most blessed of all.

For I should like to know how this would be consistent for them, when "we" have raised many counters to their (Peripatetic) position that were driven home by Stoic syllogizing? (ibid. 83):[56]

> *utamur igitur* libertate, *qua nobis solis in philosophia licet uti, quorum oratio nihil ipsa iudicat, sed habetur in omnes partes, ut ab aliis possit ipsa per sese nullius auctoritate adiuncta* iudicari.

[56] Cf. Glucker 1988, 64–66.

So. Yes, let's use the freedom that is exclusively available for us in all Philosophy, because our position statements deliver no judgment of their own, but incorporate all sides so that judgment can be made by others in its own right and on its own terms, and *nobody*'s authority attached.

The consultant in "us" must rise to the occasion with the feel-good peroration that clinches perfectibility for (ideal) Humanity. When we splice that merger between Peripatetic-Stoic goodspelling for our good guide to blest living (120, above), all we shall finally declare about our own positioning in the faculty of Philosophy is that "we like it—it's *nice*":[57]

mihi tamen gratum est.

I, however, find pleasure.

Sure, it feels good (this is our disposition? our predisposition?) when friends articulate norms of fairness, decency, and dignity. But can we be seen as free of the vices of partisanship, as outside the arguments that beset others, when we can never stand outside the views with which we have grown up and through which we engage with our contemporaries?

Tusc. 5 adores its telos: *Virtus ipsa per se* ("Virtue, neat," 17, cf. 1).

Tusc. 5 worships a whim: *Libertas ipsa per sese* ("Liberty, pure and simple," 82).

> Freedom of thought is life well lived—
> You cannot simply resist as you please.

in [perpetua peregratione] aetates suas philosophi nobilissimi consumpserunt, Xenocrates, Crantor, Arcesilas, Lacydes, Aristoteles, Theophrastus, Zeno, Cleanthes, Chrysippus, Antipater, Carneades, Clitomachus, Philo, Antiochus, Panaetius, Posidonius, innumerabiles alii . . .

In [unending travel abroad] the finest philosophers of them all have spent the time of their lives: Xenocrates, Crantor, Arcesilas, Lacydes, Aristoteles, Theophrastus, Zeno, Cleanthes, Chrysippus, Antipater, Carneades, Clitomachus, Philo, Antiochus, Panaetius, Posidonius, etc. till you lose count . . . (*Tusc.* 5.10)

Today's freedom is set by the constraints on today's freedom. (For Cicero in 45–44 B.C.E., dictated by the dictator: *Cum defensionum laboribus senatoriisque muneribus aut omnino aut magna ex parte essem aliquando* liberatus (*Tusc.* 1.1). "When I was completely (or at least mostly) *set free* from energetic work on behalf of defendants, from the range of obligations that fall to those in the senatorial class." There is no possibility of articulating "our" ethics

[57] Reid 1885, 12–13, shows how indignantly defenseless (indefensible?) this Academic freedom is: *De natura deorum* 1.12 has us squirming, *non sumus ei quibus nihil uerum esse uideatur.* Betrayed by our own trademark cadence for all seasons: the classic *esse uideatur* of Ciceronianism.

except by reference to the Philosophy which grounds philosophical literacy. But morality can never repose on secondary argumentation.[58] Yesterday's genealogy—division and definition, doxology and "cradle" anthropology[59]—demands re-presentation and re-appraisal.

So the classicizing strategy in Ciceronian ethics worms normative routines of Hellenism inside the views with which Romans had grown up, and through verbal-actual countersuggestibility engages with contemporaries in articulating norms for a real idealism. It does it again today.

[58] There can only be "secondary philosophy" in classicism. There is no such thing as "secondary philosophy" in classicism. "Our" heteronomy.

[59] "Doxology": Cicero inculcates the constant, perpetual, daily turning and revolving of stemmata, for schools, affiliations and schisms, succession and mapping, syncretism and eclecticism, arguments and counter-arguments. They are the body of his *philosophia*. "Cradle": see Brunschwig 1986.

Chapter 6

THE CONCEPT OF THE CLASSICAL AND THE CANONS OF MODEL AUTHORS IN ROMAN LITERATURE

Mario Citroni

Among the various implications of the modern concept of the classical, one which was fully functional in Latin culture, irrespective of the terms in which it was expressed, was that of canonicity, that is to say, that of belonging to an exclusive group of authors (or works) that were considered to be emblematic of a certain genre. The first two sections of this paper only concern themselves with this aspect. The third section will examine the effect on Latin culture of another aspect of the concept of the classical: that of the correspondence to a formal typology characterised by balance, symmetry, etc., and we shall consider the problematic relationships between these two different aspects in Latin literature.

Scriptor classicus (Gell. 19. 8. 15)

In order to establish whether, and to what extent, a concept similar to the modern idea of classicism was included among the intellectual tools used by Roman culture in the interpretation, evaluation, and classification of literary production, it may be useful to start by considering the question, often posed but still not entirely resolved, of the meaning and the use of the adjective *classicus*. It was the Latin culture of antiquity that took responsibility for creating and transmitting this term to modern western culture. Over the centuries, the word has proved capable of assuming a range of nuances so complex, and with such a density of meaning, as to become highly problematic and controversial. And still it remains irreplaceable, in spite of its insurmountably complicated nature.

In his *History of Classical Scholarship*, Rudolf Pfeiffer stated, in agreement with the opinion previously expressed by other authors, that the word *classici* was used as the Latin equivalent for ἐγκριθέντες, that is to say, the technical expression of the Greek language of literary criticism, which indicated the writers included in the lists of model authors.[1] This statement is also repeated

[1] Pfeiffer 1968, 207. Stroux 1931, 2, had already supposed that *classicus* had been created as the equivalent of ἐγκρινόμενος; similarly Körte 1934, 7; Curtius 1948, 253f., and cf. Luck 1958,

in the two most important reference works recently published in the field of the sciences of antiquity, and it may therefore be considered the generally accepted view at present.² According to this hypothesis, *classicus* was close to the modern-day "classic" in its restricted, yet fundamental meaning of "canonical." In actual fact, as we shall see, the documents that are at our disposal suggest that the Latin term did not share the technical meaning, or the usage in the language of literary criticism, that are attested for the Greek ἐγκριθέντες; furthermore, in the only truly relevant case, *classicus* has a meaning rather different from the Greek expression, and consequently also from our concept of canonical.

Pfeiffer confined himself to quoting the passage in which Cicero (*Acad.* 2. 73) disparagingly uses the term *quintae classis* ("fifth class," a reference to the lowest censual class in Roman society) to define Cleanthes, Chrysippus, and other more recent philosophers, who are contrasted with the greater dignity of Democritus. This passage, which does not include the term *classicus*, only shows that it was possible to refer to the different levels of prestige of social classes in order to define prestige in other fields, for example, in intellectual activities. In actual fact, Pfeiffer did not bother to quote any example of the use of *classicus*, which, according to him, expressed the idea "of the first class, *primae classis*, in political and military language," and subsequently became the usual term to indicate the ἐγκριθέντες, considered as writers of the first class. In reality, *classicus* is used, strictly speaking, to indicate the citizens *primae classis* only in a fragment of a speech by Cato (p. 55. 1f. Jord.; fr. 160 Malc.), which Gellius (6. 13) quotes, specifically as an illustration of this particular meaning of the term. There is another possible, but uncertain, attestation of this use in Arnobius 2. 29.³ *Classicus*, in the sense of *primae classis*, is attested in two other cases in a figurative use. The first is a gloss of Festus

152. Ἐγκρίνειν recurs with this meaning ("to include in the list") with reference to the "canon" of orators in late texts (Phot. *Bibl.* 20 b 25; Suda s.v. Δείναρχος and cf. οἱ κεκριμένοι s.v. Ὑπερίδης; in Iambl. *VP* 18. 80 οἱ ἐγκριθέντες refers to the pupils chosen by Pythagoras). Its opposite, ἐκκρίνειν ("to exclude from the list"), is already found in Diod. Sic. 9. fr. 7 in connection with the list of the Seven Sages. These data are taken from Kroehnert 1897, 34f., and from Pfeiffer 1968, 207. Cf. also the use of ἐγκρίνειν in Pl. *Leg.* VII 802 b, referring to the sections of ancient music that were "approved" as suitable to be reproposed in the new state (but in this case there is no idea of inclusion in a "list"). Too 1998, 144f., quotes the use of the same verb in Pl. *Resp.* II 377 c., where it refers to the choice, made by rulers, of the stories that mothers and nurses can tell their children; she also quotes the use of ἀναγράφειν in Athen. 336 d-e with reference to a comedy by Alexis that Aristophanes of Byzantium, Callimachus, and the librarians of Pergamon refused to include in their catalogues.

² Cf. Easterling 1996, 286 (*OCD*): "The Alexandrians ... seem to have used the term ... οἱ ἐγκριθέντες, for the select authors; in Latin the favoured term was *classici*"; Riemer 1999, 494 (*Der neue Pauly*): "klassische Mustern (lat. *classici* = griech. ἐγκριθέντες, oder πραττόμενοι)."

³ The reading *classicus*, which does not give any meaning, has been emended to *classicis* or *classibus*. The expression is parallel to *primis ordinibus* and in opposition to *proletarius* and to *capite censi*: that is to say, to the citizens excluded from the *classes*.

(preserved by Paulus) that reports the use of *testis classicus* in the sense of a "reliable witness" (just as a wealthy citizen who is a member of the highest censual category is reliable). The other case is the famous passage in which Gellius (19. 8. 15) remembers hearing Fronto use the expression *scriptores classici* ("first class," "sure," "reliable") when talking about those writers who are to be taken as reference points for a correct use of language.[4]

The totally isolated character of this attestation of *classicus* referring to authors of the highest level had already been pointed out.[5] But there is a further consideration, I believe, which should lead us to conclude that this was not a term in current use: the fact that the use of *classicus* in the sense of *primae classis* in the political and social field is likewise attested with certainty only once, and was considered to be rare, or archaic, and not easy to understand at the time of Gellius, who considers an explanation necessary, stating expressly that "questions are often raised" about its meaning (6. 13 *quaeri solet quid sit*).[6] In the absence of any other attestations, it would be unwise to think that a term no longer used in its normal sense was common in a figurative sense. Furthermore, the expression *testis classicus* must have been rare and figurative in juridical language, seeing that Festus took pains to explain it in his glossary; and as regards the figurative term *scriptor classicus*, I believe it is important to notice that when Gellius (19. 8. 15) reports Fronto's words, he does not present it as a well-known, common expression, but on the contrary as a metaphor, which needs a suitable context in order to be understood; in particular, it needs the support of other more common and familiar terms taken from the same metaphorical environment:

> *quaerite, an "quadrigam" et "harenas" dixerit e cohorte illa dumtaxat antiquiore vel oratorum aliquis vel poetarum, id est classicus adsiduusque aliquis scriptor, non proletarius.* (Aulus Gellius 19. 8. 15)

> Check and see whether anyone has ever used *quadriga* in the singular or *harenae* in the plural: anyone, I mean, belonging to the older cohort of orators or poets, that is to say, a writer who is *classicus* and *adsiduus*, and not *proletarius*.

[4] Pfeiffer did not deem it necessary even to quote this single passage on which the idea is based that *classicus* was used to indicate the ἐγκριθέντες, undoubtedly because he considered it too well-known.

[5] Körte 1934, 5f.; Curtius 1948, 253f., and cf. Langlotz 1958, 700.

[6] Gell. *NA* 6.13.1–3: *"Classici" dicebantur* (note the verb used in a past tense: according to Gellius, this use was no longer current) *non omnes, qui in quinque classibus erant, sed primae tantum classis homines.... "Infra classem" autem appellabantur secundae classis ceterarumque omnium classium, qui minore summa aeris... censebantur. Hoc eo strictim notaui, quoniam in M. Catonis oratione, qua Voconiam legem suasit, quaeri solet, quid sit "classicus," quid "infra classem."* ("Not all those who were registered in the five classes were called *classici*, but only the men of the first class.... Members of the second class and of all the other classes, who were rated at a lower figure, were defined as *infra classem*.... I have briefly noted this, because in connection with the speech made by Marcus Cato in support of the *lex Voconia*, questions are often raised

Before introducing the word *classicus*, which must have struck his readers as new and original, Gellius explains the concept in a fully transparent manner, in order to avoid any possible ambiguity: *aliquis e cohorte illa antiquiore vel oratorum vel poetarum*; he then uses the term *classicus*, but he immediately takes care to make the metaphor clear by adding the word *adsiduus*, which was also felt to be archaic, but was apparently better known: the latter was the term that had traditionally been used to designate the members of all tax-paying classes in the Servian order, as Cicero too reported in his *De republica* (2. 40 and cf. Charisius *Gramm. Lat.* I p. 75. 9ff.), and in fact this term was known to be present in the laws of the XII Tables (in a passage quoted in Gell. 16. 10. 15 and cf. Varro, fr. Non. 94L.; Cic. *Top.* 10). Apparently, it conveyed the idea of stability in the possession and management of real property, and consequently as a taxpayer. The etymology proposed by Aelius Stilo, who suggested that it derived from *ab asse* (or *aere*) *dando*, is often mentioned, even in texts that are not strictly grammatical,[7] and this confirms that the word must have been fairly well known. However, all ambiguity regarding the meaning of *classicus* is dispelled when, at the end, Gellius adds the clarification *non proletarius*: this term was immediately understandable, and was used in a sense opposite to *adsiduus* in the above-mentioned law of the XII Tables, as well as in the passage from Varro quoted above, and in Cicero *De republica* 2. 40; thus, on the basis of this opposition, *non proletarius* is sufficient to clarify, once and for all, the meaning of *classicus*.

The combined use (in Gellius, or already in Fronto) of terms taken from the same metaphorical field, with the clear intention of leading the reader to interpret the meaning of *classicus* correctly, demonstrates that this is a novel, original use of the word, and not a metaphor that has already been "lexicalized." Even if it was not unusual, as is shown by the above-quoted passage from the *Academici*, to exploit the metaphor of social classes in order to attribute values in other fields, the adjective *classicus*, which was archaic and rare in the sense of *primae classis*, was probably used with reference to writers for the first time by Fronto, as an elegant archaic-sounding stylistic preciosity.[8] The fact that, as we shall see below, Quintilian uses *ordo*, which is a similar concept to *classis*,

about the meaning of *classicus* and *infra classem*.") The fact that Gellius speaks of *classicus* as a term that is no longer used is noted by Sblendorio Cugusi, ed. 1982, 311.

[7] In the two passages by Cicero and the one by Charisius quoted in the text, and also in Paul. Fest. p. 8 L.; Quint. *Inst.* 5. 10. 55; Gell. *NA* 16. 10. 15; Prisc. *Gramm. Lat.* II p. 118. 18; Isid. *Or.* 10. 17 and cf. Caper *Gramm. Lat.* VII p. 108.5. In Gellius and in all the grammarians quoted here, Stilo's etymology is contrasted with, and almost always preferred to, the correct one (from *adsideo*).

[8] Thus also Uría Varela 1998, 57f., who, however, considers the expression *classicus adsiduusque scriptor* as a single unit, and as the fruit of Fronto's refined reuse of two adjectives that are both archaic and rare. Of course, it is possible that Fronto himself, before Gellius, was surrounding his innovative use of *classicus* with expressions that oriented the reader towards a correct interpretation, such as *adsiduus* and *non proletarius*.

but never uses either *classis* or any of its derivatives to indicate the series of authors whose excellence was recognized, confirms that, at least in his period, *classicus* was not used with this meaning.

After Gellius, throughout the Late Latin and Medieval periods, the use of the word *classicus* in this sense is no longer found: evidently this innovation, probably introduced by Fronto, did not find favor in the terminology of schools and circles of grammarians. It was long believed that the earliest post-Gellian use of the word was to be found in Melanchthon, who used it in a dedicatory letter for an edition of a treatise by Plutarch, dated 1519, in order to define Plutarch as a *classicus auctor*.[9] However, Pfeiffer indicated a slightly earlier example in a letter of Beatus Rhenanus dated 1512, and declared that he was convinced that "the ancient term was revived in the circle of Erasmus," even if he was not able to indicate examples in the works of Erasmus himself, but only in a Spanish correspondent of his (Fonseca, bishop of Toledo), who used the word in a text of 1528 to refer to Augustine.[10] But Silvia Rizzo has drawn attention to two examples in Filippo Beroaldo the Elder, dated 1496 and 1500: the "revival" of the use of *classicus* thus proves to be even earlier, and is situated in an Italian environment.[11]

Even if some scholars seem to admit a continuity in the use of the word *classicus* between the ancient period and the Renaissance and modern ages,[12] the lack of attestations in late antiquity and medieval ages has in fact generally led to the belief that the Renaissance usage originated as a conscious recovery of an ancient usage that had been interrupted.[13] The passages indicated by Rizzo offer solid, and perhaps decisive, support for this hypothesis, seeing that in both of them Beroaldo uses *classicus* clearly alluding to the passage by Gellius: in the *Commentarii Quaestionum Tusculanarum* (Bologna 1496, f. 89 r.) he speaks, like Gellius, of a linguistic usage (the word *passio*) and comments, in language modelled on that of Gellius, that *non Livius, non Quintilianus, non Plinius non Celsus, non quispiam ex illa cohorte scriptorum classicorum hoc vocabulum usurpant*; in the *Commentarii* on Apuleius (Bologna 1500, f. 177 r.), he judges Fulgentius to be *inter* proletarios *minutosque scriptores magis quam inter* classicos *numerandus*, making use of the same opposition as Gellius between *scriptor classicus* and *proletarius*. And Rizzo also points out that *proletarius scriptor* is an expression frequently found in Beroaldo. Thus, in his reuse of the term *classicus* in the sense in which Gellius and Fronto had used it, Beroaldo was not referring to a tradition of technical or scholastic language that had somehow come down to his period, but he was consciously reusing a metaphor that he found in Gellius, and, together with

[9] The passage was indicated by Kübler 1889, 2629.
[10] Pfeiffer 1976, 84 and n. 4.
[11] Rizzo 1986, 389f.
[12] Stroux 1931, 2.
[13] Körte 1934, 5; Curtius 1948, 253f.; Langlotz 1958, 700ff.; Wellek 1970, 63–64; Pfeiffer 1968, 207.

the metaphor, he was also recovering the precious, refined term used by Fronto, which was subsequently destined to a glorious future.

Extant documents thus lead us to believe that the term was only used in antiquity by Fronto, and possibly by a limited circle of Fronto's pupils, friends, and cultural heirs, who, like Gellius, quoted his teachings and imitated his language; and we are thus led to believe that the Renaissance usage (and subsequently, the modern usage) derives from the ancient Latin term, not through a continuity of use, albeit limited to the scholastic environment, from antiquity to the Renaissance, but as a learned reuse, in the humanistic context, of a specific metaphorical expression used by an ancient author.[14]

At this point, we must inquire whether, leaving aside its isolated character, the expression *scriptor classicus* found in Gellius really refers to a concept corresponding to the Greek expression ἐγκριθέντες, and to what extent, therefore, Fronto's meaning of *classicus* may be considered to correspond to the concept of "canonical."

The significance of a term that indicates the inclusion in a list depends on the nature of the list to which it refers. There were many different kinds of lists in ancient culture.[15] In some of these, the aim may be said to have been systematic completeness, and in others, selection. The former category includes lists of a bibliographic nature, such as the Πίνακες by Callimachus and others modelled on them, and also lists of a historical-biographic character, in which, after the determination of the εὑρετής and a short prehistory of a certain genre, there followed a largely chronological series of quick profiles of all the genre's known exponents.[16] A certain procedure of selection was presupposed in these types of lists, in the sense that it was presupposed that the works collected in the library, or the authors included in chronological order in the

[14] What happened in the case of *classicus* would thus be similar to what happened in the case of *plagium*: the term indicated the fraudulent subjugation of a free person or of another person's slave; in the context of a metaphorical play on words (inherited from Horace and Ovid) in which the book is represented as a slave of its author-*dominus*, Martial used the definition *plagiarius* for a poetaster who falsely claimed to be the author (*dominus*) of his epigrams (Mart. 1. 52. 9). There is no other ancient or medieval work in which *plagium* is used to refer to the theft of intellectual achievements. As pointed out by Ziegler 1950, 1961f., Valla used the term with this meaning in *Elegantiae* (II *praef.*), clearly demonstrating an awareness of its metaphorical character, and equally clearly referring to the passage by Martial. The modern use of "plagiarism" derives from this humanist's learned reuse of an original, and isolated metaphorical term used by an ancient poet. I have discussed the question in Citroni, ed. 1975, 177. Rizzo 1986, 390, also refers to the analogy with the case of *plagium*.

[15] There is a detailed description of the types of lists in Regenbogen 1950.

[16] Probably Aristotle's lost Περὶ ποιητῶν was the archetype of this typology, which continued to flourish in the peripatetic tradition, and was imitated at Rome by Varro: late extant examples include *De grammaticis* and *De rhetoribus* by Suetonius, and the *Lives of Philosophers* by Diogenes Laertius (an excellent reconstruction of this tradition is found in Dahlmann 1953 and Dahlmann 1962). Even Cicero's *Brutus* may be considered to be a variant of this typology, albeit quite exceptional in the originality of its elaboration and its wealth of contents.

historical-systematic description of a genre, were the only appropriate works and authors: it is clear, however, that these types of lists do not reveal so much the principle of selection on the basis of the criteria of artistic excellence, as, on the contrary, that of exhaustiveness: we are led to conclude that they usually tended to include all the authors of any importance who fell within the field of the reference criteria assumed. The lists that conferred on their members the recognition of an exemplary authority, and consequently a dignity that in modern terms we might define as classical, were of a wholly different nature: these were the exclusive lists of the few excellent authors in each literary genre, of the kind established by the great grammarians of Alexandria, and in particular by Aristophanes of Byzantium and Aristarchus of Samothrace (as we learn with certainty from Quint. *Inst.* 1. 4. 3; 10. 1. 54 and 59)—the restricted lists that we usually call "canons," forcing somewhat the ancient meaning of this Greek word, which continued to be produced by Greek and Latin culture from the times of the great grammarians to late antiquity.[17] This is the kind of restricted, exclusive list (in particular the late canon of orators, or the list of the seven sages) that the extant attestations of the Greek ἐγκριθέντες refer to, and consequently, by identifying the canonical authors, these lists actually expressed one of the meanings that are typical of the modern term, "classic."

On the contrary, the expression *scriptor classicus* in Gellius (and in Fronto) refers to an ideal list of authors that is not at all exclusive: indeed, it is considered, as Gellius himself says, to be a *cohors*, and consequently a large body. What is meant here is not the limited number of authors identified as the emblematic representatives of the main types of artistic creativity, but rather the whole group of authors considered to be reliable as regards the correct use of language.[18] The function and the responsibility attributed to them is thus far more limited, and cannot be compared with that of the few great legislators of the literary genres. The *scriptores classici* of Fronto and Gellius simply guarantee a good linguistic usage. The tendentially limited character expressed by the image of the cohort does not necessarily mean that what was intended was a group selected in accordance with criteria of a high artistic quality. The limited character simply derives from the fact that this cohort, in line with the "archaicizing" ideology of Fronto and Gellius, must necessarily be composed of ancient writers (*antiquiore cohorte*), and is therefore a group that is already closed. In actual fact, for the purposes of linguistic documentation in their treatises, Fronto and Gellius make use of a large number of authors, above all archaic ones: they considerably enlarge the list of authors previously consid-

[17] Among the studies of a general nature on the canons of Greek writers, Kroehnert 1897, Radermacher 1919, Regenbogen 1950, Pfeiffer 1968, Nicolai 1992, 250–339 (with an ample bibliography), and Rutherford 1998 are particularly useful.

[18] A brief comment on the range of the Gellian concept of *classicus* compared with the modern idea of the exemplary nature of what is considered to be a "classic" may be found in Häussler 1991, 147.

ered as reference points for the various literary genres, transforming it into a veritable cohort. Their *scriptores classici* tend to coincide with the *antiquiores* authors who enjoy a certain prestige and whose texts and testimonies they succeed in recovering; the *antiquiores* for Fronto and Gellius are the Latin authors from the origins to the whole of the Augustan age—but no more recent than that.[19] But not all the various *antiquiores* mentioned as reference points for linguistic and stylistic uses possess the truly exemplary value that is associated with a limited list of classics, and Gellius finds himself forced to make distinctions between different levels of authoritativeness and quality, case by case.[20]

Latin Literary Canons

While, therefore, the term *classicus* did not indicate, even in the only case in which it refers to literature, the concept of belonging to an exclusive series of authors recognized as emblematic of their genres, it is, however, true that this concept played a fundamental role in the perception that Roman culture had of literary production; indeed, I would say that the idea of belonging to an exclusive canon of exemplary excellence is a sort of obsession that continually emerges in Latin literary culture, at the level of the production of texts (texts are written with the explicit intention of becoming canonical), at the level of their reception by the public and by critics (new texts are compared with the canonical texts), and at the level of literary historiography and the perception of the production of the past (literary tradition is organized into series of

[19] In Gellius, the series of authors (scholars and grammarians excluded) considered to be an authority in the field of language and style considerably enlarges the so-called archaic canon: besides the well-known canonic authors (Ennius, Accius, Pacuvius, Plautus, Caecilius, Terence, Afranius, Lucilius, Cato, Gaius Gracchus), it also includes the historians Coelius Antipater, Gnaeus Gellius, Lucius Calpurnius Piso, Sempronius Asellio, Claudius Quadrigarius, Valerius Antias, Sulla, Sisenna; the orators Scipio Aemilianus, Quintus Caecilius Metellus Numidicus; the poets Livius Andronicus, Naevius, Licinius Imbrex, Iuventius, Valerius Aedituus, Porcius Licinus, Lutatius Catulus, Furius Antias, Matius, Laevius, Pomponius, Novius, Atta. Also the list of the authors of the ages of Cicero and Augustus is not limited: besides Cicero, Virgil, Sallust, Lucretius, it includes Varro (prose-writer and poet), Nigidius Figulus, Aelius Tubero (both not only as scholars, but also as prose-writers), Catullus, Calvus, Cinna, Caesar, Publilius Syrus, Laberius (who, however, is at times harshly criticized), Asinius Pollio. In Fronto the series is largely similar, but a smaller number of poets are included. There are a few authors who are quoted as valid reference points by Fronto and not by Gellius: the poet Titius, Horace, Cornelius Nepos. On the authors quoted and used by Fronto and Gellius, see, above all, Marache 1952, 152–79 and 226–45, whose list, however, is not complete. Cf. also Steinmetz 1982, 178–84 and 288f., and La Penna 1992, 514–26, who underlines the ideological character of the outright condemnation of all the literature of the first century of the empire by Fronto and Gellius.

[20] Cf., e.g., Gell. *NA* 4. 16. 8; 5. 21. 6–12; 6. 3. 53; 9. 13. 4; 10. 1. 4; 10. 3; 10. 21; 11. 13. 2; 18. 7. 8 and the divergent judgments on Laberius (cf. the previous note). A few authors considered as positive reference points in Gellius are, on the contrary, harshly criticized in Fronto: this is the case with Valerius Antias and Sisenna.

excellent authors and texts in the different genres: into series of canonical authors or texts).

Even if a precise term to express such an important concept was lacking, all the same a fairly stable Latin terminology existed: this can be found in Quintilian, who refers to the lists of authors drawn up by the Hellenistic grammarians using expressions such as: *in ordinem redigere* (*Inst.* 1. 4. 3), *in numerum redigere* (10. 1. 54), *ordinem dare* ("to draw up a list of authors," used of the grammarians, *ibid.*), *in ordinem venire* ("to be included in a list," used of the authors, *ibid.*); *numero eximere* (1. 4. 3). It will be noted that the terms which recur in Quintilian to indicate the series of excellent authors are *ordo* and *numerus*, whereas the most widely used Latin term for the tendentially complete lists, like the Πίνακες of Callimachus, seems to have been *index*.[21] In Quintilian we also find *recepti scriptores* (10. 1. 59), whereas in Seneca, in a generic context without any explicit reference to the activity of the grammarians, we find *auctores improbati* (*Tranq.* 9. 6). In all these cases, these are expressions that clearly refer to the same concept expressed by the Greek ἐγκρίνειν. But the most significant attestation of a Latin expression corresponding to ἐγκρίνειν is found at the end of Horace's first ode: in the words *quod si me lyricis vatibus inseres*, Horace expresses his hope of being included in the canonical list of lyric poets (which up to that time only included Greek poets), and thus of becoming a canonical, or, as we may say, a classic author of lyric poetry.

As is known, Roman culture did not create an autonomous reference system in terms of categories, concepts, or genres, as regards literary activity: apart from marginal areas, such as those of satire and the Atellana, the Greek system was adopted. The reason for what I have defined above as an "obsession for canonicity" in Latin literature lies in the fact that the Greek literature, which was taken as a reference point in Rome by authors, critics, and the public from Livius Andronicus onwards, appeared to them as a series of authors and texts that had already been selected as exemplary in the various literary genres: towards these authors and texts Roman writers adopted an attitude of emulation. The excellence of Homer was obvious from time immemorial (apart from the fact that for a certain period, it was not clear which texts were to be considered authentic works by Homer[22]); the excellence of the three tragedians is already presupposed in the *Frogs* by Aristophanes.[23] In the course of less than a century following the first representation of a Latin drama modelled on a Greek play, the activity of Aristophanes of Byzantium (d. about 180) and Aristarchus of Samothrace (d. shortly after 150) came to an end: these were the

[21] Cf. Cic. *Hort.* fr. 8 Grilli (Non. 636 L.) *quare velim dari mihi, Luculle, iubeas indicem tragicorum, ut sumam qui forte mihi desunt*; Sen. *Epist.* 39. 2 *sume in manus indicem philosophorum*; and Quint. *Inst.* 10. 1. 57 *indicem ex bibliotheca sumptum*.

[22] Cf. Pfeiffer 1968, 73; 117; 204f.; 230.

[23] Körte 1934, 9f.

two Alexandrian philologists whom the ancient tradition held responsible for compiling the Greek canonical lists.[24] And naturally, the lists compiled by the Alexandrian grammarians will largely have confirmed the evaluations of excellence that had long become consolidated among the learned public. It is considered certain, at this point, that the early Latin authors were deeply involved in the contemporary Hellenistic culture: but they were able to derive from this same Hellenistic culture (even if it was searching for new approaches to the composition of poetry) the conviction of the superior canonical prestige of Homer, the triad of tragedians, and the most illustrious representatives of Attic comedy: these, above all, were the Greek authors whose fame was known to the Roman public of the time. The early Latin poets were called to compose their works, in every case, in accordance with some work of these authors who were considered to be exemplary in their literary genre, each time with the aim of creating a native substitute for the benefit of the Roman public.

Ennius had claimed to be a Homer reborn, thus affirming his desire to be the Homer of the Romans: in this way, he had advanced his candidacy as a canonical (or, we might say, as a classic) writer, long before the *critici* (at least from the time of Lucilius on) classified him in the Latin canon as an *alter Homerus*.[25] Livius Andronicus and subsequently Naevius had already clearly expressed the desire to give Rome a Homer, and thus to become canonical writers themselves. And in actual fact, it was long recognized that these poems, in particular the *Annals* by Ennius, performed the function of a fundamental text consecrating the tradition and the national identity that Homer's poems had fulfilled for the Greek public. At the time of Horace, schoolchildren were still educated on the parallel basis of Homer's Greek text and these Latin poems,[26] each of which had been written to give Roman culture its Homer. In this sense, they may be said to have been composed to give Roman culture a text that we might define as classic, both in the sense of a canonical text, corresponding to

[24] The main source as regards the determination of canons of excellent authors in the different literary genres by Aristophanes of Byzantium and Aristarchus of Samothrace is, as is known, Quint. *Inst.* 10. 1. 54 and 59.

[25] It may be deduced from Hor. *Epist.* 2. 1. 50f. *Ennius et sapiens et fortis et alter Homerus, /ut critici dicunt* . . . that the qualification of *alter Homerus* was still commonly attributed by critics to Ennius several years after the death of Virgil. The expression *Homerus alter* had already been used by Lucilius with reference to Ennius: cf. 1189 M. (= Hieron. *In Mich.* 2, 7) *Homerus alter ut Lucilius de Ennio suspicatur*, probably in order to bring into question (or so the problematic *suspicatur* would lead us to believe) a qualification that was commonly attributed to him, as a confirmation of his boast that he was a new Homer; cf. Brink 1963–82, 3:95–97; Prinzen 1998, 113f. In Lucil. 342 f. M. and subsequently in Varro, *Sat. Men.* 398 (= fr. 96 *GRF*, p. 224 Funaioli), we see that the *Annales* was the Latin work which it was considered normal to compare to the *Iliad* as a typical example of *poesis*, that is to say, a continuous, unitary poetic work. Cf. the ample note by Marx, ed. 1905, on verses 338–347 of Lucil.; Brink 1963–82, 1:60–74 and 76f.; Prinzen 1998, 115f. and 152–55 (with bibliography).

[26] Hor. *Epist.* 2. 2. 41f. (the reading of Homer in the Roman school); 2. 1. 69–71 (the reading of Livius Andronicus at school); 2. 1. 50–54 (the general appreciation shown for Ennius and Naevius).

Homer's text in that it was emblematic of that literary genre, and in the sense of a text on which to base the education of young people, and consequently also in the sense, often attributed in the modern age to the term "classic," of an author who is a stable element in the reading programmes in school "classes." Suetonius reports that Livius Andronicus and Ennius practised a method of teaching by interpreting Greek texts, and Latin texts composed by themselves.[27] It has been correctly observed that it would be wrong to state that Livius Andronicus intended to write the *Odusia* as a teaching aid, rather than as an original work of poetry.[28] And yet there is an intrinsic connection between the creation of Latin works that aspire to a canonical dignity and the creation of a kind of teaching that, in actual fact, was for a long time founded on these works. The idea that led Roman culture to create for itself a national literature modelled on the great canonical texts of Greek literature is part of a wider desire for an assimilation to the culture, lifestyles, and thinking of the Greek world, and for the creation of a "Latin Hellenism."[29] An essential part of this wider intention is the foundation of an educational system that, like the Greek system, included the study of great poetic texts with an identity-shaping significance.[30] But in Rome, these texts needed to be created: they did not exist, as in Greece, in a remote tradition. And they were in fact created by those same poets who were also the most ancient masters of this kind of teaching. The affirmation that these texts were written with a view to their use in education does not undermine their cultural and artistic awareness: on the contrary, it exalts their ambition to occupy a canonical role parallel to that of Homer, to establish themselves, so to speak, as classics.

The birth of the regular Latin theater was due to the decision to offer the Roman public a substitute for the Greek theater, adapted to its requirements. And just as Ennius hoped to be recognized as an *alter Homerus*, so too the Latin dramatic authors probably nourished the ambition to be included one day in a limited canon of Latin authors corresponding to the Greek canon, as actually happened for some of them.

At least from the end of the second century B.C.E. on, we find confirmation of the fact that the Roman critical tradition constructs canons of excellence for Latin literary production, clearly imitating the traditional custom of Greek critics and grammarians. And these Latin lists, as we shall see, are often clearly

[27] Suet. *Gram.* 1. 2 *antiquissimi doctorum qui idem et poetae et semigraeci erant—Livium et Ennium dico, quos utraque lingua domi forisque docuisse adnotatum est—nihil amplius quam Graecos interpretabantur, aut si quid ipsi Latine conposuissent praelegebant.*

[28] Mariotti 1986, 14.

[29] Thus Momigliano 1975, 11.

[30] Initially, this education was only accessible to the sons of families belonging to the ruling class: however, by means of this tenuous channel, epic poems, for which probably no common form of oral communication existed, reached beyond the limited circles of grammarians and learned people to the general public of citizens: cf. Citroni 1995, 33–35.

intended to be parallel to the analogous Greek lists: they serve to organize the Latin literary tradition in accordance with rational criteria, and they also serve to convince others and themselves that in any particular genre Roman culture has produced a series of excellent works corresponding to those recognized in the Greek literary system.

The most ancient Latin list known to us is that of the ten best authors of the *palliata*, in descending order of merit, compiled (in verse) by Volcacius Sedigitus probably around the year 100 B.C.E.[31] The title of the work by Volcacius in which this canon was included was *De poetis*. Consequently, it must have contained similar lists referring to other poetic genres. Perhaps it also contained the other lists that are attributed to Volcacius himself: the *index* of the genuine plays by Plautus (Gell. 3. 3. 1) and the *enumeratio* of the plays by Terence (Suet. *vita Terenti* 3), which may have been classified in the order of the artistic merit attributed to each of them.[32] In the extant fragment, Volcacius alludes (vv. 1ff.) to various lively debates over which comic poet is the best, and polemically proposes his list of merit as the only one that is valid, in contrast with all other opinions: he thus seems to take it for granted that in his time, the classification in limited canons of outstanding authors was already the normal way of considering the literary patrimony of the past.[33] In approximately the same period as Volcacius we may place the activity of Aurelius Opillus, who was the author of a Πίναξ, a title that recalls the lists of authors (not necessarily the canonical lists of excellence) drawn up by the Alexandrian grammarians.[34] One way of seeing the Latin authors of the past in terms of canons is attested during the same period by the coincidence between a youthful memory of the great orator Crassus, in Cicero's *De oratore* (1. 154) and the *Rhetorica ad Herennium* (4. 2): in both texts, which testify to the opinions that were current in the schools of rhetoric at the end of the second century and the beginning of the first, it is taken for granted that Ennius and Gaius Gracchus are the two main representatives of Latin poetry and prose. That they are, so to speak, the Homer and Demosthenes of Rome. And as we have seen, the correspondence between

[31] This dating is based on the presupposition that the list does not include any living writers: the most recent author is Turpilius, who, according to Hieronymus, died in 103.

[32] Thus Courtney 1993, 94ff.

[33] The canon of Volcacius is relatively broad, but it is limited to a round number. An initial triad of truly excellent poets can be distinguished within the series (Caecilius, Plautus, Naevius); the others are added as an appendix, which could be left out: 8 *Si erit quod quarto detur*. Six authors are added, in the order of their quality, to the first triad (Licinius, Atilius, Terence, Turpilius, Trabea, and Luscius: two triads?). This enlarged canon of nine (the number of the Muses; the number of the lyric poets in the Alexandrine canon) is integrated with Ennius as a further appendix, with the specification that he is included in the list, not for reasons of merit, but only *antiquitatis causa*.

[34] This work by Opillus contained an acrostic (Suet. *Gram.* 6), and must therefore have been in verse. It probably included the *index* of the authentic comedies by Plautus, attested in Gell. *NA* 3. 3. 1 both for Volcacius Sedigitus and for Opillus. Also on these points, I follow Courtney 1993, 96.

Ennius and Homer is attested in Lucil. 342–43 and subsequently in Varro.[35] We know that Varro created triads of the Latin comic poets considered excellent in different respects,[36] and he probably proceeded in the same way also as regards other genres, creating further correspondences between excellent Latin poets and canonical Greek poets, besides that between Ennius and Homer.[37]

In Cicero, the Latin literature of the past, up to Accius, appears to be organized into brief series (sometimes triads) of authors who excelled in the various genres: a correspondence is often explicitly created between these series and the analogous Greek lists. And each time, Cicero presents the excellence of these series of authors as an evaluation commonly recognized in the prevailing current opinion. The same series of authors will probably have featured in the critical works by Varro, which probably resulted in an authoritative confirmation of judgments that were already largely shared by the public and critics. In actual fact, it is clear for Cicero that Rome finds its Homer in Ennius,[38] and that it has its triad of tragedians in Ennius, Pacuvius, and Accius, whom he explicitly compares to the triad of Attic tragedians on two different occasions.[39] As regards comedy, it does not appear to be possible to speak of a firmly consolidated Latin triad of excellence: the group of three who are found at the beginning of the canon of ten comic poets listed by Volcacius Sedigitus (Caecilius,

[35] See above, n. 25.

[36] In Varro, fr. 40 *GRF*, p. 203 Funaioli: Titinius, Terence, and Atta are judged to be the best in ἤθη; Trabea, Atilius, and Caecilius in πάθη; in Varro, *Sat. Men.* 399 (= fr. 99 *GRF*, p. 225 Funaioli) Caecilius is judged to be the best in plots (*in argumentis*), Terence in ἤθη, and Plautus in dialogue (*in sermonibus*).

[37] But no fragments remain to confirm this hypothesis. Fr. 60 *GRF*, p. 212 Funaioli, perhaps says that Plautus imitated Epicharmus, but it definitely does not say that he was equal to him; fr. 301 *GRF*, pp. 316–19 Funaioli, shows that according to Varro, Terence surpassed the text that he had taken as his model on one point, but not that he was equal to, or even surpassed, Menander overall. Brink 1963–82, 3:85, recalls the nationalistic spirit that must have inspired Varro's literary criticism, and which might have led him to propose these correspondences. Dahlmann 1953 and 1962 confirms that Varro reconstructed the events of Latin literature under the influence of the reconstructions of the events of Greek literature elaborated by Greek philology.

[38] Cicero explicitly compares Homer and Ennius in *Orat.* 109 and cf. *Fin.* 1. 7. The perfection and canonical exemplarity of Ennius are confirmed in Cic. *Brut.* 70f. and 75f, where the upward-rising series (from an immature art to a perfect art) of the Greek sculptors Canachus, Calamis, Myron, and Polyclitus is compared with the series of Latin epic writers, Livius Andronicus, Naevius, and Ennius: Livius Andronicus corresponds to the most primitive phase of Greek sculpture, and Naevius to the phase represented by Myron; as he has surpassed Naevius, Ennius is implicitly placed at the level of Polyclitus, who represents the full maturity in sculpture. In Cic. *Div.* 1. 23 Ennius, Apelles, and Scopas are considered to be the authors who excel in their three different arts, and in *Opt. Gen.* 2 Ennius for epic poetry, Pacuvius for tragedy, and Caecilius for comedy represent, according to common opinion, the list of the three excellences in the three main Latin literary genres.

[39] Cic. *Acad.* 1. 10 and *De Or.* 3. 26f.: in the first passage, the Latin triad of tragedians is compared also to the triad of philosophers, Plato, Aristotle, and Theophrastus, and to the couple Hyperides and Demosthenes; in the second passage, they are compared to the canonical triads of sculptors, Myron, Polyclitus, and Lysippus, and of painters, Zeuxis, Aglaophon, and Apelles. The Latin triad of tragedians also appears in *Orat.* 36 and in *Off.* 1. 114. Elsewhere, Latin tragedy in Cicero is rep-

Plautus, Naevius, in the order of precedence)⁴⁰ does not correspond to any of the triads attributed to Varro, which vary depending on the aspects considered (Titinius, Terence, and Atta; Trabea, Atilius, and Caecilius; Caecilius, Terence, and Plautus).⁴¹ In Cicero, Latin comedy is represented once emblematically, at its best level, by the same triad judged to be the best in Volcacius (*Rep.* 4. 11); on other occasions, by Plautus and Naevius (*De Or.* 3. 45), or by Plautus alone (*Off.* 1. 104), or Caecilius alone (*Opt. Gen.* 2). Cicero judges that the most authentic imitators of Menander in Latin are Caecilius and Terence (*Fin.* 1. 4; *Opt. Gen.* 18), or Terence alone (fr. 2 Morel), or Afranius (*Fin.* 1. 7). Although Caecilius sometimes appears to take precedence over all the others (*Opt. Gen.* 2), on other occasions Cicero criticizes him severely for his style (*Brut.* 258 and cf. *Att.* 7. 3. 10, where he contrasts him on this level with the excellence of Terence). The triad Caecilius, Terence, Afranius in Velleius Paterculus (1. 17. 1) may be conditioned by a chronological "cut" that leaves out Plautus: this triad is introduced to support the hypothesis that excellent authors tend to occur together in the same period of time.

Apart from these variations as regards the identification of excellent writers in the art of comedy, it is clear that Cicero and Varro share the conviction that a limited series of Latin authors composed works that may be considered to be the worthy Latin equivalents of the great works of the Greek canon taken as reference points of the literary system. These Latin works, in turn, become emblematic of their literary genre, and thus exemplary, canonical, or, we might say, classics in the system of Latin literature.

Cicero is acutely aware of the embarrassment caused by the widespread recognition of the cultural superiority of Greece over Rome, but as far as poetry is concerned, he believes, or asserts that he believes, that thanks to the worthy Latin imitators of the Greek canonical writers in the fields of epic poetry and theater, Rome has substantially achieved a parity with Greece. The lack of qualified representatives in the domain of lyric poetry, which was a fundamental genre in the Greek canon, does not appear to worry him. Considering that in the field of rhetoric Rome is not inferior to Greece, Cicero indicates only philosophy and historiography as the remaining frontiers for the achievement of a complete cultural equality, an equality that he describes as the moment when the Romans will finally be able to do without the Greek libraries—that is to say, the moment when the Roman public will be put in a position to enjoy literary experiences in their own language, comparable to those offered by the great texts of the Greek heritage.⁴²

resented by Ennius and Pacuvius (*Opt. Gen.* 18; *Acad.* 2. 20; *Fin.* 1. 4) or only by Pacuvius (*Opt. Gen.* 2), who, however, is criticized for his style in *Brut.* 258.

[40] Above, n. 33.

[41] Above, n. 36.

[42] Cic. *Tusc.* 2. 5f. The other most important texts that refer to what I say in this section are *Tusc.* 1. 1–3; 4. 1–7. On this subject, see Citroni 2003a. For Cicero and lyric poetry, see Citroni 2003b, 105f.

This canon, which we may conventionally define as archaic, and which includes also Lucilius, the canonical author of the only genre without any Greek equivalent, was considered the embodiment of valid, current artistic values by Cicero, by Varro (the authors of this canon are basically those that are studied and quoted in what remains of his works), and undoubtedly by most of the critics and the majority of the public, who were of necessity conditioned by the critics. We find attestations of the highly authoritative character of this canon in Horace: both in Satire 1. 10, which illustrates the scandal that had been caused by the poet's criticism of the style of Lucilius contained in the previous Satire 1. 4, and, above all, in the *Letter to Augustus*. This text was written after the year 15 B.C.E., when all the great works of Augustan poetry, except the *Metamorphoses*, had been known to critics and to the public for years. In a very short time, these works would in turn be considered the only ones truly worthy of comparison to the corresponding exemplary Greek texts in the various genres, and were to form the new Latin canon. And yet, at the date of the composition of the *Letter to Augustus*, Horace is forced to report the fact that the scale of literary values recognized by critics (*ut critici dicunt*, v. 51), and accepted by current public opinion, continues to be limited to the usual few names of the past, who are recognized as the only true equivalents of the Greek models: in epic poetry Ennius, considered to be the Latin Homer, but also Naevius and Livius Andronicus, both still widely read; in tragedy, Pacuvius and Accius, who are undoubtedly meant to be added to Ennius himself, with whom they make up the Latin triad of tragedians; in comedy, the triad Plautus, Caecilius, and Terence, with the addition, however, of Afranius, who is recognized as the Latin Menander, and Atta (vv. 50–89).[43] There is a clear correspondence between this canon, which was current at the time of the *Letter to Augustus*, and that of Cicero (and Varro), including the uncertainties regarding the foremost writers of comedy.

The list of the great Latin authors was tendentially imagined as closed, seeing that it was meant to correspond to the already definitive list of the Greek canon. It was difficult to attribute true perfection in Latin epic poetry to more than one poet, seeing that Homer had been assigned a solitary position in the Greek canon.[44] Likewise, it would have been difficult to recognize more than

[43] Here Plautus is assigned the merit of being the Latin Epicharmus: it should be remembered that for one part of the Hellenistic tradition, Epicharmus was considered to be the founder of ancient comedy, and that Plato (*Tht.* 152e) considered him to be the paragon (ἄκρος) of the comic genre, on a parallel with Homer, who was the paragon of the "tragic" genre: as regards the problematic coincidence between εὑρετής and ἄκρος cf. Citroni 2001 (as regards Epicharmus: p. 290). In any case, Horace himself, in the famous opening of Satire 1. 4, confirms the renown in Rome of the triad Aristophanes, Eupolis, and Cratinus, as a canon of exemplary authors of ancient comedy (cf. also Vell. Pat. 1. 16).

[44] The Alexandrine canon of epic writers probably included Homer, Hesiod, Antimachus, and Panyassis, as can be deduced from the identical series of Quint. *Inst.* 10. 1. 46–54 (who explicitly

three truly excellent tragedians. And the same goes for the writers of comedy: the triads proposed by Varro, which varied depending on the qualities taken as criteria,[45] are to be considered as a compromise solution that allowed a greater number of appreciated authors to enter into the canon, while maintaining the principle of the closed triad. In a section of the above-quoted passage (*Epist.* 2. 1. 55–59), Horace confirms in a clearly ironic manner that these compromises were widely practised by critics. Evidently, they tried in this way to achieve the difficult aim of finding an agreement over a limited, closed number of excellent writers, without leaving out authors who had actually gained considerable prestige. Horace is not referring, in this case, to the definition of triads like those attested for Varro, but rather to the definition of absolute priorities, but the criterion is the same: "Every time that the question is raised of which of the two is superior, Pacuvius is recognised as an elderly sage, and Accius as elevated; people say that the toga of Afranius would have been well suited to Menander, that Plautus has the racy style for which the model is the Sicilian Epicharmus, that Caecilius is the best for seriousness, and Terence for art."[46]

This canon, which appears to be so firmly consolidated between the age of Caesar and that of Augustus, was formed, in reality, over a period of time. It is possible to enter into the canon either by occupying a position considered vacant among those established by the structure of the Greek canon, or by taking the place of an author previously recognized as canonical. Accius, the most recent author included in the canon, had been an affirmed author since 140, but he was still alive during Cicero's early youth. In the case of comedy, it is clear that various poets had succeeded in conquering a canonical prestige, but not the certainty of the position as a member of a stably recognized triad. Other

refers to the canon fixed by Aristophanes of Byzantium and Aristarchus of Samothrace) and the one found in Dion. Hal. *De imit.* But it is clear from the discussions of Dionysius and Quintilian, as well as from a number of other confirmations, that the prestige of Homer was recognized as incomparably greater than that of the other epic writers. In this connection, it would appear to be likely that the number of four, in the Alexandrine canon of epic writers, is to be interpreted as the sum of Homer, who occupied a solitary supreme position, plus a triad of epic writers whose value was recognized, although they could not be placed on the same level as Homer. Later sources (from Proclus on: cf. Kroehnert 1897, 19f.) add to these four names that of Pisander, who is also mentioned by Quintilian, but is incongruously placed by him not among the major epic poets, but among the Hellenistic writers of minor epic genres, as a kind of appendix.

[45] Above, n. 36.

[46] Hor. *Epist.* 2. 1. 55ff. *Ambigitur quotiens, uter utro sit prior, aufert / Pacuvius docti famam senis, Accius alti, / dicitur Afrani toga convenisse Menandro, / Plautus ad exemplar Siculi properare Epicharmi, / vincere Caecilius gravitate, Terentius arte.* Cf. the important discussion of this passage in Brink 1963–82, 3:83–97. Unlike Brink, I believe that in all this section dedicated to canons (verses 50–89), Horace is not referring specifically to Varro, but to typical ways of proceeding of contemporary literary criticism, of which Varro was naturally the most illustrious and emblematic exponent.

poets could hope to enter the canon by taking over positions that were more or less stably occupied. In presenting himself as the Roman Homer, Ennius was explicitly denouncing the inadequacy of Naevius,[47] who evidently had already aspired to this recognition, like Livius Andronicus before him (with a certain success, seeing that he still occupied an important position in the Roman school at the time of Horace: cf. *Epist.* 2. 1. 69–71).

Although the basic structure is already provided by the Greek canon, and consequently, in a certain sense, it precedes the Roman production, the names of the authors included in the canon vary in time. The attribution of a canonical exemplary status implies stability, and every time it is intended to consecrate a greatness destined to endure, but in actual fact, the evolution of production, taste, and criteria of judgment means that certain authors who were once canonical subsequently appear obsolete, and other writers take their place. The archaic Latin canon, which had been formed in time, and had remained substantially stable and highly authoritative up to the period of Horace, was soon to be largely supplanted.

The point which I would like to underline is that from Livius Andronicus to the early imperial age, the aim, explicitly or implicitly, of every Latin writer who is confident about the quality of his work is to be recognized as the worthy imitator of a great author of the Greek canon, and thus to enter into the Latin canon, occupying one of the positions established by the Greek canon. In a word, the aim and the ambition of every self-confident Latin writer is to become canonical, or in modern terms, to become a classic.

The prestige that the archaic canon continues to maintain in the Augustan age appears to Horace to be totally unjustified, the fruit of a short-sighted, anachronistic attitude that shows a biased prejudice towards contemporary production. To the eyes of a—still limited—part of writers and the public, the neoteric stylistic revolution had, for the first time, made the great authors of the Latin canon seem archaic, that is to say, distant from the artistic tendencies that were considered to be modern.

Although Catullus and his friends had denounced the inadequacy of the current canon, they had not taken it upon themselves to substitute for it, or even to integrate it. Catullus had not declared an ambition to be the Latin equivalent of any canonical Greek author. His production, like that of the other neoteric poets, had been irregular and capricious, precisely because their intention was to criticize the system of a national literature as a canonized patrimony of venerable texts, and not to contribute to it. The Augustan poets, who feel that they are the heirs of the neoteric poets on the level of style and a sensibility for the world of the private feelings of the individual, share with them the rejection of the archaic canon, but at the same time, unlike Catullus, his poet friends, and

[47] I am referring, of course, to the proem of Book VII of Enn. *Ann.* (verses 206–10 Sk.), on which see Skutsch, ed. 1985, 369–78 and Citroni 2001, 270–72.

his numerous superficial contemporary imitators, they feel the responsibility of giving the national literature, in the various genres, a new series of great works, which will correspond to more mature artistic criteria, and will thus be more truly suitable for comparison with the great canonical Greek models.

Horace sustains most forcefully the need to put aside the current canon: he decidedly denies that the authors that it includes may be considered to be the emblem of perfection, and therefore worthy of the Greek reference models. On the contrary, he believes that they represent a stage of artistic elaboration that is still underdeveloped. Indeed, he already proclaims in Book I of the Satires (*Sat.* 1. 10. 7–19), and then again in the late literary epistles (*Epist.* 2. 1. 159–67; *Ars P.* 263–69), that only by means of a renewed effort in the study of the great Greek writers will it finally be possible to create Latin works that are worthy of these models.

In these passages, Horace clearly represents the critical position common to the poetic movement that had gathered around Maecenas and Asinius Pollio: in Book I of the Satires, we find that he already presents a team of poet friends, engaged in the task of producing new works in the various poetic genres (*Sat.* 1. 10. 40ff.). Mario Labate has recognized in this passage the testimony to a group project aiming to build up a canon.[48] What I would like to underline here is that for these poets, the construction of a canon meant substituting a preexisting canon, which was already consolidated and prestigious. The new canon outlined in this passage by Horace is still incomplete and temporary: a large number of the positions that are defined in it were soon to be occupied by others. At that date (about 35 B.C.E.), however, Roman literature is already considered to have a new "modern" representative for satire with Horace, who subsequently was always regarded as a model for this genre; for epic poetry with Varius, who is confirmed in Horace, *Odes* 1. 6, as the Roman Homer, but is soon destined to be replaced in this role by Virgil; for comedy with Fundanius, who, on the basis of the typically Menander-like (and Terence-like) names of the characters in his comedies, is presented here as the Latin Menander, but in reality is no longer mentioned afterwards; for tragedy with Asinius Pollio, who is indicated by Virgil, too, in *Eclogues* 8. 10, as the Roman Sophocles, and who is praised as a tragic poet also in Horace, *Odes* 2. 1. 9–12: however, he is soon destined to be accompanied, with greater prestige, by Varius, with his *Thyestes*, and subsequently Ovid, with his *Medea*.

In this early stage of the elaboration of the new canon, Virgil is the representative of excellence in the only genre that he has so far composed: bucolic poetry, considered here as a specific genre of epic poetry: v. 44 (*epos*) *molle atque facetum*, in opposition to the *forte epos* in which Varius excels. The new Latin canon is enlarged to include genres that had not been taken into consideration in the archaic canon: after neoterism, a new prestige is acquired in

[48] Labate 1990, 952. Cf. also Citroni 1995, 214f., and Citroni 1998, 28–30.

Rome by the genres expressing an individual subjectivity, which are at the same time emblematic of the new, more refined and elegant way of elaborating the artistic form. These include bucolic poetry, the love elegy, and the epigram: genres which are typically Hellenistic, but were not included in the Greek canon established by the grammarians of Alexandria, because, as we know from Quintilian (*Inst.* 10. 1. 54), they had excluded contemporary writers from their lists. The new Latin canon also includes lyric poetry, a prestigious genre of the Greek canon, which was not represented in the "archaic" Latin canon, although Cicero did not appear to feel the lack of it.

The space of a few years witnessed the production of many new works that were recognized as having canonical dignity, either in areas that were still not represented, or in those previously occupied by other Latin poets. And the programmatic declarations of the Augustan poets clearly demonstrate that they too, like the archaic poets, intended their works to be recognized, in every case, as the equivalent of a Greek work possessing canonical prestige. It is not necessary to reexamine here the famous passages containing the claim of Virgil to be the Roman Theocritus in the *Bucolics* and the Roman Hesiod in the *Georgics*, the claim of Horace to be the Roman Alcaeus in lyric poetry and the Roman Archilochus in iambics, that of Propertius to be the Roman Callimachus, and slightly later, that of Phaedrus to be the Roman Aesop.[49] Or the passage in which Propertius welcomes the *Aeneid* as the new *Iliad* of Rome, written by the author who had already proposed himself as the new Hesiod of Rome.[50] The point that I would like to underline is that behind these various professions of an identification with a certain canonical Greek model, we find the continuous presence of the project of an overall reconstruction of the Latin canon by means of a systematic correspondence with the main positions of the Greek canon. The awareness of a collective involvement in the creation of a new canon is confirmed by other passages, besides the one mentioned above (Hor. *Sat.* 1. 10). In this text, at the end of the first work that he published, Horace gives us an indication of the state of advancement of the project, which was still in an early stage, in which, however, as we have seen, the circle of Maecenas considered that Rome already possessed new canonical writers in all the genres contemplated by the Latin canon as Cicero saw it (epic poetry, theatrical genres, and satire). Horace, too, in his letter to Florus dated about fifteen years later, ironically represents the contemporary poets, including the mediocre ones, as proudly engaged in the task of filling up the shelves of the library attached to the temple of Apollo Palatinus.[51] This library was a great

[49] Verg. *Ecl.* 4. 1; 6. 1; 10. 1; *G.* 2. 176; Hor. *Carm.* 1. 32; 2. 13. 26–40; *Epist.* 1. 19. 23–25.; 32f.; Prop. 3. 1. 1.; 4. 1. 64; Phaedr. 2 *epil.* 8f.

[50] Prop. 2. 34. 65f. and 77f.

[51] Vv. 92–94: *aspice . . . / quanto cum fastu, quanto molimine circum- / spectemus vacuam Romanis vatibus aedem.* As stated by Labate 1990, 942, with reference to the programmatic awareness of the poets of the neoteric and postneoteric generations: "The great libraries, organized into two

institution of the regime, destined to house the entirety of qualified literary production, both Greek and Roman. As we have seen, Cicero thought that thanks to the great authors of the archaic canon, the Romans could already "do without Greek libraries" as regards the field of poetry. For Horace, on the contrary, and for the poets of his generation who considered the archaic canon to be by now inadequate, the Latin section of this great library still appeared to be empty: the archaic canon was a thing of the past, while the modern canon was still being prepared. And it may be noted that in Horace's caricature, the presumption of the poets who feel that they are involved in the work of completing the Latin library, as if it were a great, patriotic task, is expressed in the desire to be a new Mimnermus, a new Callimachus, or, like Horace himself, a new Alcaeus: and everybody expects a lyric poet to aspire to becoming an Alcaeus, for example, and an elegiac poet to aspire to becoming a Callimachus, for example, or a Mimnermus.[52] Leaving aside the irony, and the self-irony, that Horace reveals in the construction of this scene, the passage confirms that the various individual claims of identification with one of the great authors of the Greek canon that we find in the Augustan poets are to be interpreted as part of a collective project to fill up the spaces in the Latin canon: a project in which every author takes part with an ambition to occupy a stable position in the canon, and thus to become a classic.

Again, five years later, in the letter to Augustus, the desire of the *princeps* to give Rome and his regime the prestige of a great literary production is formulated by Horace as the desire to fill up the library of Apollo with books (*Epist.* 2. 1. 216f. *si munus Apolline dignum / vis complere libris*). For Horace, therefore, and for those who were not satisfied with the archaic canon, twenty years after the first indication of the state of advancement of the project in Satire 1. 10, the work that remained to be done so that Rome could have its library of classics worthy of the Greek library was still considerable. Horace had wanted to become the Roman Alcaeus, and had openly declared that he intended to conquer a position in the Latin canon—the position for lyric poetry which was still vacant (*Carm.* 1. 1. 35 *quod si me lyricis vatibus inseres*). But in the Alexandrine canon there were nine lyric poets, and thus there were still several places to assign for Latin poets. Above all, there was no equivalent for the place occupied by Pindar, who was unanimously considered to be the most prestigious of the lyric poets. Even if Horace was highly attracted by this sublime model, not only had he never used the form of the Pindaric ode, but he had expressly declared that Pindar was inimitable, thus

separate sections, exposed emblematically a lacuna which needed to be filled" (Labate is referring to the two passages of Horace mentioned above). Cf. on this subject also Horsfall 1993 (who does not take into consideration the archaic canon) and Citroni 2003a, 151–53.

[52] Hor. *Epist.* 2. 2. 99ff. *discedo Alcaeus puncto illius; ille meo quis? / quis nisi Callimachus? si plus adposcere visus, / fit Mimnermus et optivo cognomine crescit.*

leaving the way open for other more daring poets than he, who actually attempted to achieve the ambitious aim of filling this gap (*Carm.* 4. 2. 1ff. and 33ff.; *Epist.* 1. 3. 9–11; Ov. *Pont.* 4. 16. 28; Stat. *Silv.* 1. 2. 101), without, however, succeeding in convincing posterity to assign them the rank of the Roman Pindar.

In the third proem of the *Georgics*, when announcing the project of a new epic-historical poem about Augustus, Virgil advances his candidacy for the role of the new Ennius—that is to say, the new Roman Homer—when he presents himself as the one who will bring the Muses from the heights of Helicon to Rome, a task which had been that of Ennius.[53] With a visionary boldness, Virgil presents this great work of the future, in Pindaric terms,[54] as a temple built by him in honor of Augustus in the plain surrounding his hometown, Mantua, and consecrated in a triumphal ceremony celebrated by himself. Virgil imagines that in order to celebrate this triumph, the contests of Olympia and Nemea, which were celebrated by Pindar, and now symbolically represent all Greek agonistic activity and, to a certain extent, the whole literary and artistic culture of the Greek world, are transferred to Mantua, in Italy. This vision recalls the different vision, outlined by Cicero in the *Tusculanae*, of a Latin culture which can do without the Greek libraries. In the same way, Virgil sees his own role as a poet leading towards a collective goal in which the competition for the recognition of artistic excellence is no longer held in Greece, but in Italy.

In actual fact, after the death of Virgil and Horace, Roman culture soon becomes aware of the fact that it has a new, prestigious canon of classics worthy of the great Greek models.[55] And from this point on, the exemplary reference point for Roman writers and their public is not so much the Greek canon, even if this continues to maintain its prestige unaltered, but rather the new canon of the great Augustan writers, integrated by a few famous personalities of the ages of Caesar and the triumvirs: Cicero, who openly proposed himself as the emulator of Demosthenes, and was immediately recognized as his worthy Latin equivalent; Sallust, who is considered by Velleius Paterculus and

[53] Skutsch, ed. 1985, 144–46; Suerbaum 1968, 173f.; Hinds 1998, 52–63.

[54] Or, perhaps, in Callimachean terms: cf. Thomas 1983, 97–99.

[55] In Ov. *Am.* 1. 15 the series of Greek and Roman poets considered immortal also includes two authors of the archaic canon, Ennius and Accius: but in reality, Ennius is branded as inadequate on the level of the artistic form (*arte carens*), and as for Accius, we will see that as regards the dramatic genres, the archaic canons were never considered to be truly surpassed. The other Latin authors included in this list are Varro Atacinus, for his *Argonautica*, Lucretius, Virgil (for all three of his works), Gallus, and Tibullus. The Greek list includes Homer, Hesiod, Sophocles, Menander, Aratus, and Callimachus. The fact that the epic Ennius was surpassed by Virgil is suggested, for the same reasons of the formal harshness of the archaic poet, in Ov. *Tr.* 2. 259–62. There is not enough room here to discuss all the lists of authors presented, for different reasons, in Latin poets and prose-writers, such as the lists of love poets in Prop. 2. 34. 85ff.; Ov. *Ars am.* 3. 329ff.; *Rem. am.* 757ff.; *Tr.* 2. 363ff.

Quintilian to be the Thucydides of Rome (Vell. Pat. 2. 36. 2; Quint. *Inst.* 10. 1. 101), together with Livy, who is described by Quintilian (ibid.) as the Herodotus of Rome; Catullus, recognised as the model of the Latin epigram, together with Callimachus, the model of the Greek epigram according to a tradition that runs from the Augustan Domitius Marsus to Martial;[56] Lucretius, mentioned as one of the great poets of Rome by Ovid (*Am.* 1. 15. 23; *Tr.* 2. 425), Velleius (2. 36. 2), and Quintilian (*Inst.* 10. 1. 87), and taken as a literary model by Manilius.[57] From this point on, Roman writers feel the responsibility of emulation and comparison more with this new Latin canon than with the Greek one: they measure themselves against the yardstick of Virgil, Horace, and Cicero, much more than that of Homer, Theocritus, Alcaeus, or Demosthenes.[58]

In two fundamental genres, however, tragedy and comedy, the archaic canon, although considered obsolete, had not been superseded. As a result, before the new archaism of the second century C.E. brought the archaic canon back into fashion for a certain period, the Latin canon remained in a certain sense incomplete. The list of Greek and Latin authors in Quintilian, integrated by other references to the authors commonly considered exemplary in the imperial Latin culture, shows us that the success achieved by Varius and Ovid, each with a single tragedy (respectively, *Thyestes* and *Medea*), and the non-unanimous recognition given to the tragic poetry of Asinius Pollio (Tac. *Dial.* 21), had not been sufficient to give Roman culture the sense of having acquired a new triad of tragedians (Quint. *Inst.* 10.1. 98; Tac. *Dial.* 12, 20, 21). In the field of comedy, after Terence, there had not been any other author whose prestige was recognized. The authors who were emblematic of the Latin dramatic genres thus remained those of the archaic canon also for Quintilian, who, however, states that they are clearly insufficient on the artistic level (*Inst.* 10. 1. 97 and cf. Tac. *Dial.* 20 and 21), and denies them the status of exemplary writers, which is a qualification that he does not attribute to any author before or after the ages of Caesar and Augustus. And while Pliny still considers Plautus and Terence as possible models for a friend of his who desires to compose comedies of the kind written by Menander (*Ep.* 6. 21. 4), Martial refuses to indicate the outdated models of Pacuvius and Accius to a friend composing a tragedy, and, as he is

[56] Catullus is identified as the *auctor* of the Latin epigram, and Callimachus as the *auctor* of the Greek epigram in Martial 4. 23 and in Plin. *Ep.* 4. 3. 4. On this question, see Citroni 2004. Cf. also Vell. 36. 2. 3.

[57] An important position in the lists of great Roman poets is also occupied by Varro Atacinus, who is mentioned together with Lucretius in Vell. Pat. 2. 36. 2 and in Quint. *Inst.* 10. 1. 87 (albeit with considerable reservations about his value), and is mentioned as an epic writer in Ov. *Am* 1. 15. 21f. and both as an epic poet and a love poet in Prop. 2. 34. 85f. and Ov. *Tr.* 2. 439f.

[58] This new awareness of the autonomous dignity of the Latin literary tradition has been pointed out by Mayer 1982, 310–14; 317f., who dates its beginning to the age of Nero, and by Labate 1990, 961, who more correctly traces it back to Ovid, who sets his elegiac production in a wholly Roman tradition, and does not claim to aspire to being recognized as a Roman Callimachus, even in the *Fasti*, which truly represent the new Roman *Aitia*.

unable to indicate an authoritative Augustan model either, he invites him to become a new Sophocles (5. 30. 1). In the same way, when his above-mentioned friend intends to write Aristophanes-type comedies, that is to say, a genre unattempted in Rome, Pliny suggests that he should become the model of this genre for the Romans: the Roman Aristophanes (*Ep.* 6. 21. 2). Thus the models of the Greek canon were still invoked in cases where the Roman canon presented some places that were still vacant, or where the positions were occupied only by archaic poets, for whom in actual fact there was no longer a generally shared appreciation.

The authoritative, cumbersome status of classics, in the sense of indisputable exemplary models, was thus, in reality, attributed only to the great authors of the ages of Caesar and Augustus. The sensation of the incomparable superiority of those great Latin models immediately creates a profound, widespread sense of epigonism among post-Augustan writers, a sense that they find it difficult to avoid: we find currents of imitation, which have often been defined as classicistic, and especially in the age of Nero we find reactions tending towards innovation and a breakaway, which already under Nero's reign[59] and during the subsequent Flavian age, give rise to new classicistic reactions, largely marked by a profound unrest and consequent distortions of the form of expression, which have often been described as manneristic: these are movements that we cannot examine here, but they offer confirmation of the fact that Roman culture is aware, at the close of the age of Augustus, that it possesses a body of exemplary, canonical authors, or classics, a canon that had supplanted the archaic canon, and which is not destined to be superseded by another canon of new Latin authors of a higher prestige in the various genres.

It is said at times that the culture of the second century replaced the Ciceronian-Augustan canon with a recovery of the archaic canon, whereas subsequently, in late antiquity, there was an unequivocal return again of the Ciceronian-Augustan canon, and an almost complete removal of the archaic canon.[60] However, in the case of Fronto and Gellius, the two authors who are reference points for us as regards the literary ideas of their period, we cannot directly extend to them what the *Historia Augusta* says of Hadrian (*Hadr.* 16. 6): "He preferred Cato to Cicero, Ennius to Virgil, Coelius to Sallust" (*Ciceroni Catonem, Vergilio Ennium, Sallustio Coelium praetulit*). Virgil, it is true, is never mentioned in Fronto, but both Cicero and Sallust have great importance in

[59] I do not agree with Mayer 1982, who believes that the great Augustan writers began to be considered as models, and consequently as "classics," only in the age of Nero: in my opinion, the sense of epigonism with respect to the great Augustans is already present at the end of the Augustan age, in Ovid's poetry from exile (Citroni 1992, 387–89). But Mayer has the merit of pointing out the centrality of the Augustan poets, during the age of Nero, as exemplary reference points of contemporary production, and in particular the fact that they replace the poets of the Greek canon in this role: cf. the previous note.

[60] Thus Eigler 2003, 96f.

his writings. And Virgil, Sallust, and Cicero are all considered highly prestigious in Gellius. Fronto and Gellius, the two authors to whom the use of *classicus* is traced back, take into consideration, as linguistic authorities, both the writers of the archaic canon and those of the canon of the age of Cicero and Augustus: in reality, as mentioned above,[61] their collection of classics goes beyond the limited, consolidated list of the archaic canon known to us from Cicero, and it has a different function: it is a wide-ranging list of writers who may be taken as reference points, with varying degrees of authoritativeness, for linguistic uses that are not obvious, or are even anomalous compared with the standard use, but which are based on an authoritative tradition.

Literary Canons and Classical Form

In my opinion, a significant contribution to the debate about the definition of the concept of the classical, was made by a study by Thomas Gelzer, in which the different senses that the term has assumed in modern languages are traced back to two basic meanings: the axiological meaning of exemplary excellence, and the typological meaning of conformity to certain formal characteristics, such as balance, symmetry, measure, and control of the resources of expression.[62] I believe that a large part of the ambiguity in the use of the term derives from the various combinations and interactions of these two basic meanings in the use of the word "classical." In the following pages, I will propose a brief reflection, which is necessarily very concise, on the functional character of, and the relationship between, these two aspects of the concept of the classical in Roman literary tradition. In this tradition, as we shall see, for a long time a canon was accepted in which the characteristics of the formal typology that we call classical were absent: this supports the hypothesis, which I believe corresponds to the truth, that the connection between the two aspects is not due to intrinsic reasons, which would make only works possessing a harmonious, measured composition suitable to be recognized as exemplary and perfect,[63] but is rather due to historical and cultural reasons which have meant that in certain key periods of the European cultural tradition the greatest prestige has been given to works that were more or less arbitrarily attributed characteristics of composition marked by an intrinsic rationality.

As we have seen in the preceding two sections, the concept expressed by the first meaning of "classical"—the exemplary, axiological sense—was of paramount importance in Roman literary culture, even if it was not expressed

[61] Above, n. 19.

[62] Gelzer 1979. I believe that finer distinctions of the various meanings of "classical," such as the deeply pondered one of Tatarkiewicz 1958, can fundamentally be traced back to the two basic meanings pointed out by Gelzer.

[63] An interesting argument in favor of this hypothesis is to be found in Assmann 1992, 108.

by the term *classicus*. It is far more difficult to say whether, and to what extent, Roman literary culture contemplated a concept comparable to the one expressed by the typological meaning of the modern term "classical," and what relationship, if any, existed between the status of canonical text and the so-called classical formal typology. The typological connotations connected with the concept of the classical comprise a somewhat vague, uncertain spectrum that was formed, above all, during the period of its opposition to the romantic: this is, therefore, a typically modern cultural elaboration, even if the reference point of these typological qualities, in the modern construction of the concept of classical in the artistic and literary field, has been certain characteristics, and a formal idea, a poetics, attributed to the great canonical works of Greek and Latin antiquity. In the case of Greek and Roman architecture and sculpture, the isolation of characteristic formal qualities such as symmetry, balance, harmony, and naturalness was a generalization that, even if debatable, had certain clear motivations. In the case of literature, the reduction of the texts of Homer, Sophocles, or Virgil to emblems of a rational, measured, balanced art meant making a largely arbitrary selection of certain characteristics of these authors, and ignoring others that might have made them emblems of completely different, or even opposite, artistic models and ideals—which has actually happened in the history of the interpretation of these authors. Homer, the ancient author who has enjoyed the most stable recognition of a superior greatness, and who therefore deserves more than others the qualification of "classical" in its first, axiological meaning, has often appeared to be somewhat unsuitable to represent the classical formal typology, and indeed he has also been taken as an emblem of irregular art, or even barbaric primitivism.

This more or less arbitrary reduction of the most prestigious authors of Greek and Latin literature (the classics, in the sense of "the authors recognized as excellent") to a formal typology of balance, harmony, naturalness, etc. (a typology called classical by modern critics because emblematically represented by the authors of antiquity subsequently defined as classics), is an elaboration that is not only a modern one: Aristotle had already analyzed Homer and the tragedians on the basis of categories such as the necessary or verisimilar connection between the parts, and the analogy with the living organism as regards the correct proportions between the whole and the parts, and the functionality of every part for the whole. These are rational categories identified by Aristotle as aesthetic qualities, which are shown in his analysis to be always present in an exemplary manner in Homer, and to an extent that is sometimes perfect, but other times imperfect, in the Attic tragedians.[64] Homer's text had in

[64] Aristotle mentions the text of Homer only twice in the *Poet.* (1454 b 2 and 25–29) as an example of incomplete correspondence to the aesthetic principles that he is laying down; elsewhere he always takes it as a paradigm of perfect correspondence. He points out defects far more frequently in the works of the tragedians, even in the three canonical: cf. 1453 a 28; 54 a 28–33; 54 b 31–37; 56 a 27; 58 b 19–24; 60 a 29–32; 61 b 20–22.

reality already been recognized as canonical for a series of historical and cultural reasons: it would have been difficult for Aristotle not to share the common judgment about the superior quality of Homer, and in a certain sense he was forced to discover an optimal presence in Homer of those formal characteristics that represented aesthetic excellence for his way of thinking, and for the tradition of reflection within which his thinking had developed.

In his *Poetics*, Aristotle united the two aspects of exemplary excellence and a balanced, harmonious formal typology, seeing that he fixed the necessary criteria for the achievement of artistic quality as those of rationality in the construction of the plot, and an organic appropriateness in the connection of the parts, and indicated a *corpus* of existing texts of recognized prestige (Homer and a part of the Attic production of tragedies of the fifth and fourth centuries) as examples of the achievement of quality through the respect of these criteria. In this way, he laid the basis for the future forms of classicism, which were largely to take their inspiration from him, directly or indirectly (for example, through the mediation of Horace's *Ars poetica*), both in the subsequent ancient culture and in that of the Renaissance and the modern age.

Aristotle had fixed the requisites for the perfect literary work, at the end of a great season of Greek literature. But in the period immediately following Aristotle, the tendencies of literature and the arts undergo a substantial change of direction, compared with that intrinsic connection, posited by Aristotle, between artistic perfection and typological-formal characteristics such as the unitary and organic nature of the work. In Hellenistic culture, the veneration for Homer does not die out; indeed it develops into a sort of cult.[65] But there is also a new sense that the most important things have already been said, that certain literary genres have been exhausted, at least in the form in which they had so far been practised, and in particular the great epos of the Homeric kind,[66] that is to say, the genre which for Aristotle was the fundamental criterion of artistic greatness. Instead of aiming to conform to rules of composition taken from works recognized as exemplary models, there is an attempt to find new approaches in poetry and in prose, as also in the figurative arts; a wide range of highly innovatory formal experiments are implemented, which move in various, sometimes contrasting directions, with results that have often been qualified by modern critics as Baroque or Mannerism, in order to contrast them with a previous classicism, a previous tendency to elevate to the dignity of principles of artistic beauty qualities such as organic coherence, a rational connection between the parts, a harmonious balance, qualities that were considered, more or less rightly, to have been fully achieved in a corpus of prestigious works of the past. These innovatory experiments, which in turn propose new

[65] Brink 1972, with the integrations, and the important correction of the orientation, of Cameron 1995, 273–77.
[66] I am using here a formulation of Wülfing-von Martitz 1972, 257.

conventions and new rules for perfection in art, are accompanied and followed by reactions and by classicistic revivals in different periods that it is not always easy to identify, in rhetoric, poetics, and the figurative arts.[67]

In the case of Latin literature, which concerns us here, the authors who were included in what we have called the archaic canon were extremely distant from the formal characteristics that Aristotle had indicated as normative, and consequently also from the typological characteristics that modern culture has qualified as classic. The literary texts that possessed a full canonical value up to the time of Cicero and during the Augustan age, and which were therefore the classics of Latin literature, were characterized by a superabundance of means of expression, an exasperation of pathos, and an attempt to obtain spectacular verbal effects, and the term Baroque is sometimes used to describe this archaic production: a modern terminology is thus employed, which indicates a distant, or clearly contrasting, formal typology, compared with the one considered typical of classicism. It is not clear what formal traditions led archaic Latin poets to develop the Greek models in this stylistic direction. Perhaps this is to be connected with Roman and Italic traditions of verbal expressiveness, which may go back to the so-called pre-literary phase. But it has also been hypothesized that these Latin poets who had a good knowledge of Greek culture, and who created the Latin poetic language and the rules for poetic composition in Rome, might have been influenced by contemporary Hellenistic literature, which, unaffected by the poetic choices of Callimachus, might have developed a taste for the grand and the pathetic, and for the monumental character found in a part of the sculpture and the painting of that period.[68] However, as has been observed above, the attribution to Homer and to Attic drama of typological qualifications that may be connected with the modern concept of classical was largely arbitrary: it might therefore be observed that the archaic Roman poets developed in a direction towards the grand and pathetic, elements of vivid expressiveness that they actually found in Homer and Attic drama, and which they may have considered as typical of the expressive art of those models. Clearly, we do not possess any statements of poetics or expressions of

[67] Much has been said about the determination of the moment when, in Greek culture, the need begins to be felt, with a critical awareness, for a "classicistic" return to the pre-Hellenistic artistic forms. The contributions on this subject included in Flashar, ed. 1979 remain of fundamental importance. As regards rhetoric, a useful critical review of the long debate on the origins and the characteristics of Atticism can be found in Calboli 1986, 1050–73 (and cf. 1111–36).

[68] Ziegler 1934. As regards the formal aspects that might have characterized the lost Hellenistic epic, the debate has been continuing ever since Ziegler. Cameron 1995, 263–302, recently claimed that there is no proof of the existence of large-scale epic poetry in the Hellenistic age, and that we should therefore conclude that it did not exist: the many extant attestations of poems in hexameters are to be referred to short encomiastic poems, or works of an antiquarian or mythological character. But while this is probably true for various compositions that, from Ziegler on, were considered as cases of Großepos, it is probably not true of all the cases attested. There is a useful discussion in Lehnus 1999, 213–25.

contemporary literary criticism that allow us to understand whether what we consider to be excessively vivid or weighty forms of expression were intended by the poets themselves, or by their public, as a correct interpretation of the stylistic intentions of Homer and the tragedians, or as an innovatory deviation.

Towards the mid-second century, a tendency developed in the figurative arts in Greece, which has been defined as classicistic, seeing that it appears as a reassertion of measured, sober, and harmonious forms. An analogous tendency has been shown to be present in Rome already in the second half of the second century.[69] In literature, it is not possible to speak of classicistic tendencies, in the sense of a change in taste towards more sober attitudes, until the age of Cicero.[70] In poetry, the literary alternative to the emphatic, spectacular approach of the archaic style comes from the poetics of Callimachus, which was originally adopted by the neoteric poets. It is thus a particular kind of Hellenistic poetics that teaches Roman poets to thin out and refine their means of expression, and to use them sparingly: this is an essential basis for the future classicality, in the formal, typological sense, that is attributed above all to Augustan poets. But the Callimachean model did not immediately lead to a recovery of sobriety and a measured style at Rome. The earliest imitators of Callimachus that are known to us, the so-called pre-neoteric poets of the period of Lutatius Catulus, and subsequently Laevius in the age of Sulla, take from Alexandrine poetry the brevity of form, the sentimentality, and the taste for elegant literary technique. But in turn, they reveal, in these different directions, an exuberant overuse of expressive effects, in the form of an erotic pathos and an excessive stylistic affectedness. It is only with the generation of Catullus that the poetics of Callimachus becomes a lesson of sobriety and measure in style at Rome. As regards prose, and in particular the prose of rhetoric, there is an explosion of Atticistic classicism at Rome in the same period: endless discussions have been held about the origins and the birth date of this current, which consciously proposes a return to the more sober forms of pre-Hellenistic eloquence. It is probably not by chance that the major representative in Rome of this rhetorical current, which refused the Baroque tendencies of the so-called Asian style, considered to be characteristic of the Hellenistic age, was Licinius Calvus, who was at the same time one of the leading neoteric poets. In reality, the neoteric movement does not contain anything that is similar to classicism, and has little or nothing in common with rhetorical Atticism. It is a movement that contests the classics of the national literature for their themes and their form, choosing brevity of form and private themes as a challenge against the dominant concept of literature as a canonized patrimony of authoritative texts, in which the community recognizes the highest level of expression of its values, and thus radically refuses every canonical dimension. And the literature

[69] Coarelli 1990, 643ff. (= 1996, 55ff.), and Coarelli 1970–71.
[70] Cf. La Penna in Coarelli 1970–71, 268.

produced by Catullus and his friends is irregular, experimental, and unpredictable—the opposite of every kind of classicism, however it is intended. But we have seen that the patrimony of canonical texts of the national literature, against which neoteric writers react so radically, possessed, on the level of its formal typology, characteristics that were to a certain extent Baroque. The neoteric reaction, which opposes a lighter stylistic measure, thus opens the way, in practice, to a taste for a typologically different style. In this way, it opens up the way to the stylistic typology later defined as classical.

When referring to the authors of the archaic Latin canon, in spite of the great prestige they enjoyed for a long time as exemplary authors and most worthy emulators of the canonical Greek writers, we are not used to speaking of them as classics. Without a doubt, this is because they were supplanted in this role, and as a result their texts were lost, and they did not acquire the role of classics for modern readers. But perhaps it is also because we perceive them as too distant from the formal typology that we usually call classical. They appear to us to be immature, compared with the more refined art of the classics of the new canon, and it is only by making a certain effort that we succeed in accepting the idea that for a long period they were not considered to be archaic in the Roman cultural awareness, but on the contrary, they were fully recognized as canonical authors, and classics in the axiological sense.

The great literary season that followed the neoteric stylistic revolution is commonly called Augustan classicism. In actual fact, as we have seen above, the great texts of the new Augustan (and partly Caesarian) canon were never to be truly supplanted in the role of canonical authors, and maintained this role also for the succeeding generations, who inherited them and considered them not only as the canonical writers of ancient Latin literature, but among the canonical authors ("classics" in the axiological sense) of the entire western literary tradition. In the case of these classics of the new Latin canon, it is undoubtedly possible to sustain their general conformity to a so-called classical typology of harmony, balance, sparing use of expressive resources, etc., even if it is clear that for them also this is a rough generalization, and several reservations and specific differentiations need to be made, and have been made at length by critics, above all since the late twentieth century. It may be said, however, that conformity to the classical typology is more arguable in these Latin texts than in Homer and the great texts of Attic drama. Furthermore, in the case of the Augustan poets, we possess, in the *Ars poetica* and in other texts by Horace, the explicit testimony that, consciously following Aristotle and a Hellenistic Greek and Roman tradition that stemmed from Aristotle, they truly considered the great authors of the Greek canon as models of organic structure, measure, balance, and the harmonization of differences, and they felt they were involved in creating texts that corresponded to these formal connotations, or in other words, to a classical typology. The *Ars poetica*, a work with a substantially Aristotelian character, appears to us as a manifesto of the principles

of measure and rationality in art. And also Cicero's theory of rhetorical prose assigns great importance to balance, the harmonization of differences, an organic structure, and appropriateness.

It is debatable, however, whether the classical formal typology assumed by the great classics of the new Latin canon is to be considered essentially the fruit of a conscious recovery of literary forms of the canonical Greek patrimony interpreted globally, in accordance with a deceptive classicistic point of view, as a model of measure, harmony, and organic structure, under the influence of contemporary Greek rhetorical classicism, which we see theorized by Dionysius of Halicarnassus, and under a more direct influence of contemporary classicistic tendencies in the figurative arts. This consciously classicistic recovery would appear, in a certain sense, to go beyond the most recent irregular neoteric experimentation. As a reaction against the overwhelming canonical prestige of Ennius, the neoteric poets had taken their inspiration from Callimachus and minor Hellenistic poetry, which in turn had similarly attempted to find a new poetics as a reaction against the overwhelming prestige of Homer. The Augustan poets, who, it is true, benefited from the neoteric stylistic lesson, would appear to go back, on the contrary, to the more ancient Greek models, which possessed a more elevated authority and dignity, interpreting them in the light of a Greek critical tradition that saw in them the realization of a formal typology of organic structure, harmony, and appropriateness, to be contrasted with the uncontrolled Hellenistic experiments.

In reality, the elaboration, carried out by the Latin writers of the age of Caesar and Augustus, of the formal typology that modern critics have described as classical cannot be considered primarily to be an intellectual operation guided by theoretical and rhetorical principles aiming to achieve a classicistic recovery of particular formal typologies of the past. The realization of a classical typology, which is expressed in the new canon of Latin classics, represents, in reality, a wholly original synthesis of proposals and influences that come to the authors of this age from the whole of the previous tradition of Greek and Latin poetry, and this cannot be explained by the theoretical framework at the basis of such a limited phenomenon as, for instance, contemporary Atticism. Nor should we overestimate the importance of the theoretical and doctrinal aspect in the elaboration of the new style. It cannot be by chance that the *Ars poetica* is situated *at the end* of the great season of Augustan poetic production, almost like the final settlement or theoretical rationalization, on the basis of Greek theories inherited from Roman culture, of a varied, complex formal research project that had been carried out through the concrete practice of the poetic production of several decades in the works of authors with extremely different individual characteristics, who had synthesized in their own original forms the various influences coming from the whole of Greek and Latin literary tradition. The Aristotelian principles expounded by Horace in the *Ars* express a poetics that was without doubt largely shared in the environment of the poet

friends of Maecenas, but they are completely insufficient to account for all the complexity of the search in the field of artistic expression of the Augustan poets, and of Horace himself, which clearly cannot be imprisoned in simplified formulas of a classicistic rationalism. Greek Atticistic classicism of the second and first centuries B.C.E. had succeeded in bearing fruit of a certain importance, on the level of literary production, only in the field of rhetorical prose. On the contrary, in the age of Augustus for the first time in Latin literature, the characteristics of measure, organic structure, balance, idealization and nobility that we consider to be distinctive of the typology of classicism, consciously taken from a complex Greek and Latin poetical and critical tradition of the preceding ages but re-proposed in the context of a literary experience characterized by a tormented attempt to search for a new balance of an aesthetic and moral nature, were taken not as a theoretical, rhetorical, and critical rule, but as an ideal reference point for a great, original, varied, complex literary production, deeply involved in current affairs. This production, achieved within the framework of a programme of systematic coverage of all the most significant literary genres with texts that were worthy Latin representatives of the canonical Greek works, displayed a confidence that in turn it would be recognized as canonical, and worthy of being considered exemplary—in a word, as classical. And it was soon to achieve this recognition, and to maintain it stably. Hence the great value of the texts admitted into the new Latin canon, in concurring to give posterity an idea of classicism that unites canonical prestige and typological qualities connected with the ideals of measure, rationality, and organic structure.

TRANSLATED BY R. A. PACKHAM

PART V

Roman Art

Chapter 7

GREEK STYLES AND GREEK ART IN AUGUSTAN ROME: ISSUES OF THE PRESENT VERSUS RECORDS OF THE PAST

Tonio Hölscher

QUESTIONS

ROMAN ART, as we have known since Winckelmann, was to a large extent shaped by "classical pasts," by the inheritance of Greek art of various periods. In this, visual art corresponds to other domains of Roman culture, which in some respects can be described as a specific successor culture. Archaeological research has observed and evaluated this fact from controversial viewpoints.[1] As long as the classical culture of Greece was valued as the highest measure of societal norms and artistic creation, no independent Roman strengths could be recognized in Roman art next to the Greek traditions; this was the basis for the sweeping negative judgment against "the art of the imitators." Then, from around 1900, beginning with Franz Wickhoff and Alois Riegl,[2] as the new archaeological art history developed a bold concept of cultural plurality and within this framework discovered and analyzed genuinely Roman forms and structures in visual art, the inherited Greek traditions were often judged to be a cultural burden and an interference in the development of an original Roman art. In neither case was the Greek inheritance seen as a productive element of Roman art. From the negative perspective, Roman art was of inferior importance *because of* its dependence on Greek models. On the positive side, it retained its originality and independence *despite* its occasional Greek overlay. At best, on a broad humanistic horizon, Rome's world-historical role in the preservation and development of Greek culture and art for the West could be appreciated and celebrated.

This essay was written during a stay as a research professor at the German Archaeological Institute in Rome, for a project on "Bilderwelt-Lebenswelt im antiken Rom und im Römischen Reich," financed by the Gerda Henkel Stiftung, Düsseldorf. My warmest thanks are due to Jennifer Trimble for her powerful translation of my German text.

[1] Hölscher 1987, 11–12. Hölscher 1993a.
[2] Riegl 1893. Wickhoff 1895. Riegl and Zimmermann 1901.

None of these concepts has been refuted, and indeed they hardly allow themselves to be falsified in the strict sense. But to a large extent they have lost their interest: one does encounter them here and there, but more implicitly than explicitly, and hardly anyone would fight for them anymore. In a postmodern context, Roman creativity versus Greek tradition is hardly a real question any longer. Roman independence versus foreign Greek influence raises the political problem of "national" cultures, which today arouses legitimate skepticism.[3] Roman transmission and dissemination of Greek values in the spirit of humanism did not stand up well to the test of the threats of the twentieth century. And, in the main, general and abstract concepts about a definitive Roman art and its relationship to a definitive Greek art have been discredited. In its culture of personal experience, today's society is oriented more toward the encounter with individual, tangible artworks rather than the construction of overarching historical phenomena and connections.

However, the question of classical pasts in Roman art has gained new relevance from a different direction: from the perspective of a memory culture, of "cultural memory."[4] According to this concept, every society has its cultural foundation in a monumental past in which it prefigures its models, representations of values, and behavioral norms as exemplary, thereby legitimizing them. Culture, in this sense, *is* memory: "We are what we remember."

From this starting point—part explicit, part semiconscious or unconscious—the way in which Roman artworks refer back to Greek models has once again become an interesting and attractive subject. Classicism as collective cultural *habitus* and selective intertextual appeals to individual classical masterpieces are receiving increasing attention. In this there are, in principle, two variants. One variant concerns the heavyweight question of cultural identity, the collective anchoring of historical societies in a foundational past, widely sought today as a remedy that can provide a self-referential feeling of "us" against the globalized world community. In this sense, the diagnosis is the foundation of classical identity through the appeal to Greek models. The other concerns a more erudite proof of the cultural interaction of historical elites with the representatives and products of earlier periods; it concerns the relationship of authors and works to precursors or antipodes: citing learnedly or alienating playfully, taking up, carrying forward or responding. In this, Roman culture becomes a more or less entertaining intellectual parlor game.[5]

Two questions of considerable importance arise here. One is for the historian: are these applicable concepts for Roman culture and art? The other is a question for the critic of his or her own time: is this general idea of culture,

[3] On this see Brendel 1953, 32–41 = Brendel 1979, 47–68.

[4] Assmann 1997 is fundamental here.

[5] I am deliberately exaggerating the positions to an extreme degree and for this reason am abstaining from pointing out examples in the more recent archaeological literature, since given this emphasis all existing studies would certainly be treated unjustly.

an idea largely founded on the relationship to the past, a salutary general concept for human societies?

The second question, to what extent our concepts of the past are useful or should be salutary for our own time, is not usually reckoned to be among the legitimate and professional subjects of the historical disciplines. And yet, already these brief remarks on the way in which research has been formulated in the study of Roman art and its Greek traditions show how closely the positions of scholars are connected to the conditions and changes of their respective contemporary societies. The constructors of the past also contribute to the construction of their own present.

Given these premises, the historian, insofar as he understands himself as a contemporary of his own time, cannot dismiss more general questions about the concept of culture and memory.[6] Where does it lead if culture—that is, the entire structure of societal experiences and perceptions, actions and forms of behavior, values and norms—is so fundamentally and explicitly positioned in relationship to the past? If culture is founded on and legitimized through this relationship to the past? What kinds of societies are these that say, "We are what we remember," and not, "We are what we look forward to," or even, "We are what we desire," "what we hope"? Does it make sense for us today to fixate so strongly on the question of how much past a society *needs*? Is this not also about how much past a society can *tolerate* and *afford*—for the sake of the present and the future?

Even if, as a historian, one shies away from thoroughly addressing these questions for one's own time, in investigating historical periods one cannot get around the question of what specific role the past played in the cultural economy of earlier societies. To what extent was the past kept present? In what domains of cultural life? With what function? With what result?

The other question, what meaning classical pasts held for Roman culture and art in particular, can for this reason be thoroughly investigated as a test for *general* conditions. Indeed, Rome as the bearer of a specific successor culture seems particularly suited for a discussion of relevant scholarly categories. How much past did Roman culture itself consider to be present? To what ends? In which domains of life? And with what results, what gains and what losses?

Among all the periods of Roman history, that of Augustus was oriented toward cultural models from Greece to an especially high degree.[7] Central temples of the state religion were furnished with original cult images, paintings and other visual decoration from the classical period of Greece. The image of

[6] I hope to develop these questions more precisely in an essay on "Knowledge and Memory in Greek and Roman Antiquity."

[7] The most important literature on this: Borbein 1975. Gullini and Zanda 1978. Zanker 1979. Zanker 1987, especially 240–263 = (slightly altered) Zanker 1988b. Neudecker 1988. Galinsky 1996, 332–63. Landwehr 1998. Galinsky 1999. Haug 2001. Koortbojian 2002. See also Hölscher 2000, 268–71.

the emperor himself and of his family was stylized following the model of classical Greek masterpieces. On important state monuments, in architecture as in visual art, the stylistic forms of the Greek classical style were adopted and positioned as state style. In the residences and parks of the imperial family and of the wealthy upper ranks, original artworks from Greece were collected; even more frequently, copies of Greek masterpieces, often of superb quality, were put on display. Comparable phenomena are found, as it is well known, in literature, rhetoric, and other cultural domains. All this is seen by researchers in many ways as a fundamentally retrospective *habitus*, an appeal to the model of a classical *past*.

At the same time, the age of Augustus was a period that held its own *present* in view to an especially high degree, and indeed developed the confidence that the happy conditions of the present would hold for eternity. A presentness is visible in this that seems difficult to reconcile with a fundamentally retrospective orientation toward an all-dominating past.

From this contradiction arises a crucial question: how much past was in fact powerfully active in the culture and art of the Augustan period? Or, more to the point: if the culture and art of the Augustan period were so strongly shaped by classical models from Greece, how much past was there in this classical? And if the retrospective characteristics should prove to be weak, then what is the character and function of the classical elements of this culture?

In view of such questions, the idea of classicism as it is usually employed in classical scholarship proves slippery and lacking in grip. For it makes a big difference if by this one means:

- the specific reference back to a *particular* classical past, for instance, to the world of the Homeric heroes, to the patriotic ethos of the wars against the Persians, or to the spirit of Periclean Athens;
- the general reference back to an *unspecified* "great" past, for instance, to Greek tradition or to the distant Roman past;
- the reception and employment of inherited cultural materials, concepts and models, with *timeless* validity, without intended temporal references back to a past distinguished as exemplary by the present.

Clearly, these distinctions are founded on specific categories of cultural memory.

Knowledge versus Memory

The idea of cultural memory has grown into a key concept for the study of culture in the last two decades. Yet, like many concepts of this kind, cultural memory—as an increasingly successful instrument in the hands of increas-

ingly wide circles of scholars and intellectuals—tends toward strong generalization and leveling. The key risks becoming a passe partout.

In fact, the idea of cultural memory includes two very different domains of culture that stand in very different relationships to the past: *knowledge* on one side, *memory* on the other. In order to determine which meaning particular societies give their relationship to exemplary pasts, it seems to me crucial to distinguish as sharply as possible between these two concepts.[8] On the one hand, every human society rests on a shared basis of collective norms, behavioral patterns and certainties about itself, of cultural recognitions, insights, and capacities from which it draws its self-perception, the awareness of its individuality, unity, and stability over time. As a rule, such guiding ideas and achievements come into being over a long period and are handed down to a given present as traditions; they count as tried and true, and are carried out by the contemporary society in continual form. Nonetheless, no appeal to a specific past is constitutive for these normative forms of culture; they are considered timelessly valid, from time immemorial, now, and forever more. In this sense, one can speak of cultural knowledge, cultural property, whose genesis in earlier times and employment in one's own past does not necessarily establish a historical dimension. We carry out religious and societal rituals without having their origins in mind; we behave according to ethical principles without referring to their establishment by Kant; we live in a culture of books without thinking about the invention of the printing press by Gutenberg; we communicate in our language without paying attention to the origins and history of the words. All this is a fundamentally present knowledge that implicitly carries with it its genesis and proof in the past, but that does not explicitly establish a relationship to the past.

On the other hand, many societies erect for themselves, more or less plainly, a monumental and exemplary past from which they draw their behavioral patterns and counterimages, their collective utopias and nightmares, and by the measure of which they orient the present.[9] This prehistory of great figures, deeds, and events can have, in our eyes, more of the character of a primeval mythical time or a formative historical period; for their cultural meaning this makes no difference. In this sense, we speak of foundational memories, signposts of the cultural world that point back into the depths of time and describe an ideal foundation for the present in the past: the exodus for the Jews, Troy and Marathon for the Greeks, and so forth. The crucial point is that this past stands over and against the present as a great counterimage, both as example and antipode, and that the contemporary societies intentionally and explicitly place their own achievements, behavioral forms, and ethical norms in a relationship to this past.

[8] In this direction see Hölscher 1988.
[9] This is above all the theme of Assmann 1997.

In this sense, cultural knowledge is given shape, continually preserved, handed onward, and inherited down to the present in traditions, to the present that embraces the handed-down representations but *without distance in time*, integrates them into its own life experiences, and positions this amalgam as *present knowledge*. Memories, on the other hand, refer explicitly to a past that is closed off, that stands *against the present*, to which a bridge must consciously be built.

Both phenomena, cultural knowledge standing in a neutral relationship to the past and intentional memory denoting a conscious retrospective, *can* be subsumed under the rubric of cultural memory. This leads easily, though, to a very general and also unspecific concept of memory that embraces all of human culture—simply because everything humans can experience and know has been experienced in the past, stored in human memory, and can only be raised to cultural meaning by human consciousness on this basis.

However, the distinction between knowledge and memory is critical for the question of what meaning the past holds in human societies. Knowledge of traditional norms and behavioral forms is, as a rule, developed through the normal course of life and semiconsciously or even unconsciously plowed back into the continuity of that life. Memory of the founding figures and events of the primeval past, on the other hand, always has the function of emphatic, intentional challenge and argumentation. The past of tradition has the static structure of "always"; the past of myth and history has the character of "in those days."

Cultural Knowledge: Greek Art-Forms, Roman Guiding Ideas[10]

The portrait statue of Augustus from Livia's Villa at Prima Porta (fig. 7.1) is similar in its construction to the Doryphorus (fig. 7.2), the key work of the sculptor Polyclitus during the "classical" flowering of Greek art in the fifth century B.C.E.[11] The stride is a little bit wider, but it attests to a comparable harmonic balance between exertion and relaxation; the cuirass shows a similar muscular profile beneath the relief figures; the left arm is similarly bent and also held a rodlike attribute. Only the raised right arm brings a new accent to the composition. The head in particular is comparable to the classical work, with its simple curves and clear edges and flatly layered crescent locks. This new image of Augustus, created at the start of the Principate, had epochal significance. After the realistic portraits of the statesmen of the Roman Republic, here came the expression of a new idealism that largely dominated Roman ruler portraiture for almost a century and in many ways remained in force even after that. Since the Doryphorus of Polyclitus was conceived as an ideal image

[10] On the following, see in general Hölscher 1987. English edition: Hölscher 2004. Settis 1989.
[11] Zanker 1973, 44–46. Zanker 1987, 193–96. Kleiner 1992, 63–67. Boschung 1993, 179–81, cat. 171.

of masculine strength and beauty in the time of the classical Greek polis, and possibly even represented the model figure for a classical theory of art grounded in the highest ideal of the physical and ethical qualities of the citizen of the classical polis, it seems reasonable to understand the new concept of the emperor as a reference back to ideals of the classical Greek period.

But questions and contradictions remain. No ordinary viewer of this image of the emperor could have had the original work of Polyclitus so precisely in memory—weight-bearing versus free leg, position of the arm and head—as to recognize a reference to this particular classical masterpiece in the statue of the emperor. In addition, the structural similarity of the body construction of the two figures was overlain by and difficult to recognize through the iconographic differences, *especially* in the equipment of cuirass and paludamentum and the gesture of the right arm, surely the most eye-catching elements for the ordinary viewer. Even less present for the general public was the art theory of Polyclitus, by which the Doryphorus was to be understood as the model figure for an ideal human image. It is therefore hardly plausible that the specific meaning of this masterpiece was meant to be expressed once again in the portrait of the emperor.

As a consequence, it seems to be more conceivable that Roman viewers recognized the *general* stylistic forms of classical Greek art in the portrait statue of the emperor. But even this can at best have been understood by that small part of the public of high culture. Most viewers will have perceived this portrait without reminiscences of a historical period of Greek art history. They will have seen the emperor as a ruler, striding toward them with balanced bearing, with a ruler's gesture, and with ageless, clearly structured, simultaneously strong and calm facial features radiating power and authority.[12]

Indeed, the ancient sources make clear that Polyclitus's stylistic forms were understood in Roman times as an expression of the *virtus* of warriors and athletes, and of qualities like *gravitas* and *sanctitas*.[13] That is, not as a memory of the historical, classical Greek *arete*, but as elements of a thoroughly *present* and thoroughly *Roman* value system. Accordingly, they were employed in Roman art to represent an actual exemplary model of masculinity, for mythical heroes as well as for praiseworthy mortals.[14] The *classical* Polyclitan forms of the Augustus of Prima Porta must have been seen in this *contemporary* Roman sense.

A crucial point is that such messages could be understood without knowledge of the historical origin of these stylistic forms—and, as a rule, undoubtedly were understood without this kind of historical education. The dimension of the past is at most implicit in this, not explicit. It plays no appreciable role for the meaning of the portrait; indeed, it would be hard to understand the possible meaning of a retrospective reference to the full flowering of democracy in

[12] So too Zanker 1987, 192: "um die Gestalt des Siegers in eine höhere Sphäre zu heben."
[13] Quint. *Inst.* 5, 12, 20.
[14] Zanker 1974, 3–41. Hölscher 1984, 1987, 34, 38, 55. Maderna-Lauter 1990, 376–85.

the tiny Greek city-states in the programmatic portrait of the first Roman autocrat of a world-encompassing empire.[15] The represented qualities of the emperor signify nothing retrospective but relate purely to the present. The cultural memory of an authoritative past, whose values are to be conjured up and brought back into currency, is not discernible here.

Of course, guiding ideas such as *virtus* and *gravitas* are elements of the value system that the Romans themselves understood as *mos maiorum*. In this way, these concepts received a grounding in the past and a temporal dimension. It is indicative, however, that the stylistic forms of the Augustus of Prima Porta in fact do not relate to this past of the Republican ancestors, but instead originate in the very different cultural context of the classical Greek polis. In other words, the past of the ethical guiding ideas and the origin of the stylistic forms stand in no direct relationship to one another.

This is understandable and makes sense, for neither the ethical models nor the artistic styles were fundamentally and exclusively bound to particular historical periods for their meaning. The moral concepts of the *mos maiorum* were universally valid; they depicted to the Romans the unquestioned ethical yardstick of behavior, independent of historical epochs or geographically localized peoples and cultures: eternal and everywhere, and therefore, above all, here and now. The same was also true for the language of visual art, which, starting in the later Hellenistic period, had at its disposal the various stylistic forms of Greek and Roman art, from the archaic through the classical to the Hellenistic.[16] These forms were employed for specific themes and statements, each time for the expression of different ethical qualities. In this sense, the stylistic forms of (late) archaic art stood for the age-old solemnity and ritual festivity of traditional religion. The classical forms of Phidias stood for the *maiestas* and high dignity of the state gods Jupiter and Minerva; those of Polyclitus stood for the heroic *virtus* of mythological heroes and glorious mortals; those of Praxiteles for the ideals of luxurious living and charm, the *tryphe* of Dionysus and the *charis* of Apollo and Aphrodite; those of Lysippus for the agility of mortal athletes and their ideal protagonists Hermes and Heracles; those of Hellenistic art for the wildness of the giants, the world of the satyrs, bucolic landscape idylls in general, and so on. All this was a present spectrum of the actual, lived world and its ideal projections onto the stage of the gods and myth; the historical origins of the various styles played no essential role in the semantic communication. In this sense, the received formal resources of visual art represented less a return to an ideal past than an available reservoir for the generation of visual forms for themes and statements belonging to the present. Together they construct a system of forms that certainly arose historically but whose theme is not the historical appeal to earlier times but the vivid expression of contemporary concepts.

[15] Gullini and Zanda 1978, 101.
[16] Hölscher 1987. Hölscher 2004. Settis 1989. Koortbojian 2002.

This is a semantic system, analogous to language. The words and syntax of language also have a genesis and a history from the viewpoint of the analyzing historian, but the speakers and hearers, authors and readers using them ordinarily do not take this historical dimension into account—they cut this history out of their conscious intentions. We employ the concept of "religion" without reference to its prehistory and its entirely different meaning among the Romans; that of Weltanschauung without appeal to the context of its origins in Kant and the German Romantic. At most, there is the option for scientifically trained reflection to call the historical dimension of linguistic concepts into consciousness and to tap this potential for the meaning of concepts, but as a rule the praxis of linguistic communication takes place without this kind of reference to the past. Correspondingly, the scene types, figural schemata, and styles of Roman art were also undoubtedly employed without explicit historical references back to their Greek predecessors, without appeal to authoritative classical models; they were employed present-mindedly and self-assuredly.

In such examples, the culture of the historical present *implicitly* includes its genesis in the past, but it does not *explicitly* and *intentionally* build a bridge to earlier periods.

How flexibly the elements of this visual language were used can be seen in another portrait statue of Augustus, this one from the Basilica of Otricoli (fig. 7.3).[17] The naked body was served by another famous work of the Greek High Classical period (ca. 430 B.C.E.), probably depicting the hero Diomedes stealing the Palladion, the age-old cult image of Athena, and taking it away from Troy (fig. 7.4). This statue type was exceptionally popular for more than two hundred years for the representation of various Roman emperors, far more so than the Doryphorus of Polyclitus. It remains questionable whether the significance of Diomedes as rescuer of the Palladion, which eventually reached Rome and was there considered to be one of the pledges of the eternity of the Roman empire, was supposed to be transferred to the contemporary ruler in this way, for imperial portraits in this schema do not normally carry a Palladion. The contemporary relevance of this type is surely to be explained otherwise: the statue of Diomedes bound together in a unique way a classical body in the style of Polyclitus with a dynamic turn of the head, which added an impulse of energy to the ideal of general *virtus*. This model of energetic dynamism was created and brought into effect in Greece in an entirely different period: that of Alexander the Great.[18]

Alexander's portrait statues created a new image of the heroic conqueror through an impulsive turn of the head and a far-reaching gaze into the distance (fig. 7.5). Diomedes' posture, which in the context of the theft was surely meant to evoke his careful watchfulness, gained a new meaning from Alexan-

[17] Maderna 1988, 199–200, Nr. D4; in general on portrait statues of the Diomedes type pp. 56–80. Doubt is raised concerning the interpretation of the classical original as Diomedes in Landwehr 1992. *Contra*, rightly, Lehmann 1996, 68–69.
[18] Hölscher 1971, 31–35. Stewart 1993b, 161–71.

der onward. Still, this is certainly not about an explicit likening of Augustus to the model of Alexander: the turn of the head is not specific enough to make such a message comprehensible. This is a general visual formula for far-reaching energy which indeed gained acceptance through Alexander as the ideal of a ruler, but which subsequently became widely disseminated in representations of mortals, heroes, and gods. In this general sense, it was also employed for Augustus. In the figural schema of Diomedes, however, the ideal *virtus* of the Polyclitan body could be bound to the Alexander-like dynamism of the conqueror. This masterful reception of semantic elements of diverse provenance shows clearly that historical reference to the original epochs of these visual types and formulas did not belong to the message of this figure of the emperor.

This becomes clear in extreme and almost absurd fashion in the fountain sculpture of a small boy from the region of Vesuvius (fig. 7.6).[19] The childlike naked body, squatting wide-legged on the ground, with plump, soft forms, follows models from Hellenistic genre sculpture. The head, on the other hand, is given a cap of hair with highly stylized crescent locks in the classical manner of the early Polyclitus; the face mediates between these with a softly animated part around the mouth and broadly angular forms at the forehead, brows, and nose. Here it is certain that there is no reference to the ideal of a child from classical Greece. Rather, two contemporary guiding ideas are bound to one another, that of erotic *deliciae* in the body, and the adjoined and awaited *virtus* of the boy in the head.

Phenomena similar to those in the portraits of the emperor, as of private citizens, are found in scenes of state ceremonies. The procession on the great frieze of the Ara Pacis (fig. 7.7) is known to be similar in many respects to the Panathenaic procession on the Parthenon frieze: in the staggering of the figures in several layers, in the stylization of bodies and drapery, in the free-moving solemnity of the participants in the ceremony.[20] Nevertheless, it cannot be the intention here that the specific historical model of democratic citizenship in classical Athens was meant to be evoked and made current for the representatives of the *res publica*, the emperor, the priesthoods, and the imperial family, appearing in strict hierarchy. Rather, the stylistic forms of classical Athens from the circle of Phidias represented, in an ideal sense, the public *dignitas* claimed for the representatives of the Roman state and their actions.

The dignity of the public centers of Rome had repeatedly and for centuries been a goal of public measures; a programmatic intensification was attained through Augustus's decree that citizens could only enter the Forum wearing the toga.[21] Since the toga was also transformed in Augustan times into a grandiose, difficult-to-drape state dress that imposed on its wearer an impressive bearing

[19] Sapelli 1999, 102–3, no. 39. Somewhat older in age but of a similarly "Polyclitan" type is the boy's head discussed in Hölscher 1987, pl. 12.3.

[20] Borbein 1975. Hölscher 1987, 45–47. Hölscher 2004, 49–57.

[21] Suet *Aug.* 40. On the new form of the toga in the Augustan period see Goette 1990, 29–32.

and measured, controlled movements, men in the Forum must have projected an image of official dignity in their actual appearance. In the same way, the many religious rituals that strongly shaped public life in the capital under Augustus through the renewal and new foundation of many gods' cults must have been performed in forms of dignified ceremony such as these. This same ceremonious dignity is set before the eyes as a model in the friezes of the Ara Pacis, officially performed by men in the toga, whose new lavish draping is modeled here in all its variants. Here again, classical stylistic forms do not serve the retrospective remembering of an ideal of an authoritative past and its making into a measure for the present. Rather, they are deployed for the expression of a decidedly contemporary new state style.

Much that is classical but little that is specific memory of a concrete past: this seems to hold true for other phenomena of Augustan visual culture as well. A striking case of the reception of classical models from Athens is that of the caryatids in the attic of the porticos of the Forum of Augustus, representing one-to-one copies of the maidens from the Erechtheion on the Athenian Acropolis (fig. 7.8).[22] Here it would seem especially reasonable to recognize a meaningful link to classical Athens and its central cult buildings. In just this manner, Vitruvius brings into play an appeal to great historical models:[23] he grounds the naming of such support figures as caryatids in the tradition about the city of Karyai, said to have taken the side of the enemy in the Persian wars and for this reason to have been destroyed by the Greeks in revenge. Its women were sold into slavery, forced to retain their matronal clothing as a sign of their shameful history—and in this form were brought by architects into architecture as a load-bearing motif, a prime example of slavery, an *exemplum servitutis*.

Yet, despite this strong indication of historical appeals, it is extraordinarily difficult to recognize clear connections to a historical model in the support figures of the Forum of Augustus. For starters, the two clues to semantic predecessors cannot be brought into agreement: the explanation concerning enslaved women stands in striking contradiction to the meaning of the korai of the Erechtheion. Therefore, for the Augustan figures, an unambiguous reading based on the historical traditions that seem to suggest themselves is problematic at the very least: for of the two references, at best only one can be accurate, which would rule out the other. The interpretation of the Erechtheion maiden is in fact uncertain and disputed, but it must in any case be so deeply rooted in specifically Athenian cult traditions that it cannot represent a key for Augustan state architecture. Evidently Vitruvius here gestures more probably toward the intended meaning: this must be an example of power and might. On the other hand, Vitruvius's specific explanation about the sinful and punished women of Karyai cannot be accepted directly for the figures of the Forum of Augustus—

[22] Zanker 1970, 12–13. Schmidt 1973, 7–19. Wesenberg 1984, 172–85. Schneider 1986, 103–8. On the korai of the Erechtheion: Lauter 1976. Ridgway 1981. Scholl 1995.
[23] Vitr. *De arch.* 1, 1, 5.

not yet known to Vitruvius and not yet implied in his interpretation. Their upright and ceremonial appearance hardly allows one to think of punishment and enslavement; with offering bowls in their hands, they are marked as positive, beneficial elements of Roman power. In this they correspond to the divinities on the shields between the support figures, Ammon from the south and a wild god surely from the north, who draw the divine powers from the frontiers of the empire into the Roman pantheon.[24] Analogously, the female support figures have been rightly understood as symbolic representatives of the incorporated parts of the empire: essentially in the sense of the contemporary Vitruvius, but without his reductive historical connection to the women of Karyai. The figures represent the parts of the empire in a concept of pious consensus characteristic of the later Augustan period. Again, then, the reception of historical motifs has broken away from the retrospective and has become a timeless, ideal factor in contemporary "state architecture"—in the concrete as well as the metaphorical sense.

This is decisively confirmed by the reception of historical forms in an entirely different domain, also in the Forum of Augustus: the architectural ornamentation.[25] The decorative band with lotus blossoms and palmettes in the display hall next to the temple of Mars Ultor takes up Greek models of the late archaic period; other decorative profiles closely resemble ornamental forms from classical Athens. Certainly these cannot be ideological messages in the sense of a call to return to the *historical* conditions of archaic and classical Greece; no viewer could recognize the ornaments so exactly, no viewer could compare and date the forms so exactly. The decor corresponded much more to general *contemporary* ideals of a rich yet refined adornment, whose dissemination among the *present* public was assumed or was to be promoted.

In a corresponding manner, the so-called neo Attic reliefs take up figural types from various bygone periods of Greek art and compose them as appliqués with precise, fine-lined contours in harmonious array next to each other.[26] In these reliefs, too, scholars have shown a desire, again and again, to see a retrospective reception of classical masterpieces or classical stylistic forms. But here, too, this is much more about an appropriate decoration made up of materials belonging to a specific contemporary culture—altars and candelabra, luxury and votive vessels, wall reliefs, bases and fountains, marble tables and thrones—which, following *contemporary* tastes, invested wealthy Roman houses in particular with an aura of distinguished sacrality. In the process, copies of Greek originals were readily mixed with newly designed figures. This is especially striking on one of the earliest marble kraters (fig. 7.9, letter k),[27] on which a maenad type from a famous late classical cycle is

[24] On the interpretation: Zanker 1970. Spannagel 1999.
[25] On this Zanker 1970, 10–11. Ganzert 1983, 178–201. Kockel 1983, 443–46.
[26] Fuchs 1959. Cain 1985. Grassinger 1991. Cain and Dräger 1994.
[27] Grassinger 1991, 58–59; 215, Nr. 55–56. Grassinger 1994, figs. 9(k) and 30.

employed in a round of other maenads, surely not as a recognizable citation of a work of the classical past, but rather as a schema timelessly usable for impassioned dancing. In their additive composition, these reliefs orient themselves in a general sense toward works of the classical period, in which the display of figures with clear profiles and their isolation in front of the background are frequent stylistic devices. But this too can hardly have been intended as an explicit turn back toward a particular historical epoch, for these compositional forms were not especially specific to Greek classicism. Nor did they express a thoroughgoing Roman taste that could be understood in the sense of an aesthetic or ethical *habitus*, for they were deployed first and foremost for particular functions—for the decoration of splendid marble objects whose material character was emphasized through the plaquelike affixed figures. That is, the figural models and compositional forms of earlier periods were deployed with contemporary semantics and actual functions in mind. As a rule, a historical dimension is not discernible.

Visual art is not alone in this regard. In very similar ways, Roman rhetoric adopted stylistic forms from the Greek classical and Hellenistic periods and employed them next to one another.[28] For one, Hellenistic pathos and classical discipline were taught as antithetical stylistic forms and were polemically played off against each other under the rubrics of Asianism and Atticism. In the struggle between Antony and Octavian, they could even be elevated to political styles.[29] Contrasting forms of rhetoric were simultaneously contrasts in political *habitus*.[30] Then, however, as it is especially clear in Quintilian, the various historically developed stylistic forms appear next to one another as adequate devices for various parts of legal speech. Here, too, theme determines the style. And the various stylistic forms indicate not a reception of specific pasts, not a turning back to particular periods of history, but an application of cultural forms found at some point and thereafter made timelessly available. Even for the literary archaisms in authors of the second century C.E. like Fronto and Gellius, it has been convincingly demonstrated that this is "in no way a matter of a backward gazing *Weltanschauung*," but is rather "a matter of a rigorous criteria-bound selection of diction based on a detailed, critical reading of literary authors."[31] That is, the temporal dimension of the selection of received stylistic forms is relatively weakly marked; in the foreground stand supratemporal semantic functions. Most recently, it has been convincingly demonstrated that literature as a whole from the time of Augustus is a "system in movement,"

[28] Hölscher 1987. Hölscher 2004.
[29] Bowersock 1979. Gelzer 1979. Dihle 1989, 31–74. Characteristically, in the works of Gelzer and Dihle, a more widely ranging historical reference to the reception through time of the received works and stylistic forms plays a secondary role. In Bowersock, somewhat differently, one can see a noticeable gap between the analysis of the early "Atticizing" authors and the assertion of a retrospective political stance for this period.
[30] Giuliani 1986, 49–55 and passim. Zanker 1987, 248–49.
[31] Schindel 1994; citation on p. 337. (I thank J. Porter for this reference.)

constituted by various literary styles originating in various epochs of Greek culture. Similar conclusions have been drawn for the adoption of architectural forms in Vitruvius as well as in real state architecture under Augustus.[32]

In addition to art-forms of the Greek classical period, under Augustus forms from other periods of Greek art were also employed in the great monuments. On the Ara Pacis, the state procession with its official *dignitas* is performed on the great friezes in the forms of the Greek High Classical period. Next to them appears Aeneas at the sacrifice of the Lavinian sow, in scenery that follows the model of Hellenistic landscape reliefs (fig. 7.10).[33] In the same period, in a grandiose victory monument, three kneeling Orientals, evidently supporting a monumental tripod, were fashioned in the high Hellenistic manner.[34] Hellenistic forms were also employed for the figures of Muses in the parks of the emperor and his entourage.[35] In this, a retrospective option for the world of the Hellenistic monarchies or cities of citizens is certainly not discernible as an alternative to the admiration for the classical Greek polis. Rather, the forms of Hellenistic art, like those of the classical style, were employed in a semantic sense for particular themes and statements, without reference to the historical periods of their creation: for the pathos of battle, victory and defeat, for the happy idyll of primeval times, for the urbane elegance of education in the fine arts, and so forth.

The same goes for the use of forms from archaic Greek art.[36] One type of relief, created in the ambit of Augustus and used for the decoration of distinguished residences, shows the triad of Apollo, Artemis, and Leto at a ceremonial offering at which the goddess of victory pours a libation, all with archaistically stylized drapery and hair (fig. 7.11).[37] Archaistic forms were also much loved for representations of Dionysus, especially in his aspect as venerable god of nature.[38] Here too, it was not the return to a historical style that was sought, but an adequate form for particular contemporary themes and contents.

In sum, Roman art to a great extent took up and developed the artistic forms of various periods of Greek history in a very flexible manner, and this is especially clear in the time of Augustus. But no intentional return to the epochs in question and their guiding ideas were bound up in this. Rather, the received forms were deployed for specific themes, as the expression of particular contemporary values and guiding models. These forms constitute a semantic system in which the historical genesis is largely neutralized and has lost its significance.

[32] Literature: see the important essay of Schmidt 2003. Architecture: see the new approach of Haselberger 2003 (forthcoming).
[33] Simon 1967, 23–24. La Rocca 1983, 40–43. Kleiner 1992, 93–96. On this, Hölscher 1987, 48. Hölscher 2004, 81.
[34] Schneider 1986, 18–97. Schneider 2002.
[35] Häuber 1998, 106–7, fig. 8.
[36] Fundamental is Zanker 1987, 244–47. Zagdoun 1989. Fullerton 1990. Hackländer 1996.
[37] Zanker 1987, 70–72. Cecamore 2002, 123–26.
[38] Hackländer 1996.

These phenomena of Roman visual culture have as their prerequisite a specific conception of culture and history and their relationship to one another that is clearly different from modern concepts of the same. On the one hand, there was no idea in antiquity that the specific forms of cultural life and artistic production were connected to the specific structures of the same period's society and politics as coherently and exclusively as is often assumed in modern conceptions of history. The individual sectors of cultural and societal life lay rather more loosely next to one another; individual elements could more easily be carried over into other epochs and integrated into new contexts, without thereby becoming anachronistic in character. On the other hand, and connected to this, history was not understood as an all-encompassing, temporal, collective movement of the world, in which all earlier times with all their factors occupied their specific places within the space of a distant and fundamentally unrepeatable past.[39] Rather, cultural elements developed for earlier times lay ready for use as actualizable knowledge, as potentially present, so to speak, without being tied down to their past. Today, in the era of postmodern pluralism, which of course has entirely different cultural historical preconditions, at least a greater openness to the understanding of the Roman phenomena ought in principle to be possible.

Greek Artworks, Roman Use

Original Greek artworks were seen and valued accordingly in Roman times.[40] In the wake of the more or less forcible appropriation of Greek visual art by the Romans from the late third century B.C.E. onward, such artworks were partly exhibited in public plazas and central buildings, partly amassed in great private collections. The cultured elite turned toward a generally high estimation of works of art and the development of a considerable, and in part theoretically founded, art connoisseurship.

Here too, modern categories have largely shaped scholarly judgments. The collections of artworks have been seen as museums, where educated viewers could give themselves to the appreciation of art; and even the publicly displayed works of famous Greek artists have been seen above all as objects of aesthetic education. Accordingly, a specific taste for particular periods of Greek art has been attributed to the protagonists of art collecting, to which they are supposed to have oriented themselves in their aesthetic judgments as in their ethical *habitus*.[41]

That the situation has been fundamentally misunderstood becomes clear with Augustus himself, who acquired many artworks of classical Greek

[39] Koselleck 1979, 38–66.
[40] On Greek artworks in Rome in general, Jucker 1950, 46–86. Pape 1975. Hölscher 1994. Celani 1998.
[41] Especially clearly recently, Celani 1998. Differently, Hölscher 1989b. Bravi 1998.

masters and exhibited them in public places in the city of Rome. The well-known examples of Greek sculptures in temples of the city of Rome were not first and foremost examples of classical art, but had meaning related to their content. The Apollo by Scopas with the Artemis by Timotheus and the Leto by Cephisodotus in the temple on the Palatine served as cult images.[42] These statues were not selected because of a general aesthetic partiality to the art of the late Greek classical, but because in this period the most convincing visual conceptions of these divinities had been developed so as to lead from the victory over Antony to the glow of the new golden age—that of Apollo as god of (victorious) ceremony, Artemis as protagonist of virginal grace, and Leto as mother figure of nobly attractive appearance. At the same time, in the other temple of Apollo near the Circus Flaminius, an original Greek pedimental composition of the fifth century B.C.E. was reused. This composition depicted the victory of Theseus and the Athenians over the Amazons,[43] not as evidence of a generally retrospective taste for classical art, but as a mythical exemplum of the struggle against the threat from the East, against warlike women—just as Augustus had waged it against Antony and Cleopatra. The artistic forms of the Greek High Classical period were specifically appropriate for this because they represented the high ethos of *arete/virtus*.

The relationship of the content to specific places is especially clear in the paintings that Augustus placed on display in various public buildings of the city.[44] In the temple of Divus Iulius, which documented the position of the *princeps* as Divi Filius, the famous picture of Aphrodite Anadyomene by Apelles was exhibited. The picture represented Venus Genetrix as the divine ancestress of the *gens Iulia*.[45] In the Curia of the senate, Augustus had two Greek paintings brought in that, in their pairing, were related to him and had as their theme his most important legitimations as ruler:[46] An image of the personification of Nemea seated on a lion served as indicator of his victory over Antony, whose emblem was the lion; a second image depicting a father and son who resembled each other gestured toward his connection with the deified Caesar. Later, Augustus equipped his new Forum with two paintings by Apelles, both emphasizing the warlike nature of the complex: Alexander with Nike and the Dioscuri as models for himself and his adopted grandsons Gaius and Lucius Caesar, and Alexander "in triumph" on a chariot, with allegories of Bellum chained and Furor vanquished, sitting on a pile of weapons.[47] Correspondingly, after Augustus's death, his temple was adorned with two paintings by Nikias

[42] Rizzo 1932, 51–77. Zanker 1983, 33–34. Zanker 1987, 241–43. Flashar 1992, 40–49.
[43] La Rocca 1985.
[44] On the following, Hölscher 1989b.
[45] Plin. *NH* 35, 91. Strabo 14, 2, 19. Celani 1998, 146–48; 241–44 with additional references.
[46] Plin. *NH* 35, 27–28. Hölscher 1989b.
[47] Below, note 57.

referring to his divine character.[48] A picture of Danae, who became pregnant through the golden rain of Zeus, referred to Atia, by whom Apollo, in the shape of a serpent, was said to have fathered the future ruler Augustus. A representation of Hyacinthus, the young beloved of Apollo, who raised him to immortality after his death, again stood for Augustus, who had revered Apollo as his tutelary deity and now in the same way enjoyed immortality.

The purely content-driven conception of the exhibition of Greek artworks is especially clear in the Temple of Concordia, dedicated in 10 C.E., which Tiberius equipped with a large number of original statues and paintings.[49] Against the widespread view that here was created a kind of museum that represented a classicizing taste in art, recently it was rightly asserted that the visual themes all fit into the ideological framework of the Augustan period. It is even probable that the artworks, without exception representations of divinities, were installed in groups that yield a thought-out, content-rich program: Zeus/Iuppiter by Sthennis, Hera/Iuno by Baton, and Athena/Minerva by Sthennis as the Capitoline triad; Apollon/Apollo by Baton, Leto/Latona with her children by Euphranor and Asclepius/Aesculapius with Hygieia/Hygia by Niceratus as deities of religious order and bodily health; Ares/Mars by Piston and Demeter/Ceres by Sthennis as antitheses of warlike strength on the outside and rich abundance on the inside; Heracles/Hercules and Hermes/Mercury as protagonists of martial and mercantile activity; and finally, a Hestia from Paros as a Greek equivalent for Concordia. To this were added three paintings that completed the program: a bound Marsyas by Zeuxis, punished for his hubris like Antony, was a prominent offering to Apollo, the god of Augustus; Cassandra by Theodorus was a prophetess of the downfall of Troy and therefore of the future of Rome; and the scene of a bull offering by Pausias celebrated *pietas*, elevated by Augustus to an exalted political virtue.

All this is far from the concept of a museum in which an educated public concentrated on the understanding of aesthetic art-forms and their historical development. It is clear that these artworks, created between the later fifth century and the Hellenistic period, do not attest to a uniform taste for an individual period of Greek art. Yet again, they were selected and combined on the strength of their thematic statements. But how is their character as artworks to be understood given these preconditions?

Apparently it mattered to Tiberius to present the gods in famous artworks. Their artistic form and quality were therefore not at all arbitrary. He gave the commission for this not to contemporary artists, among whom outstanding experts were surely to be found, but instead selected older works by well-known

[48] Plin. *NH* 35, 131. Celani 1998, 122–23.
[49] Pliny 34, 73, 74, 80, 89–90; 35, 16, 131, 144. Dio Cass. 55.9.7. Bravi 1998. I intend to return to this subject soon.

Greek masters. From these he evidently expected an especially powerful effect. But this effect was not grounded in the forms *per se*, and it also implied no explicit return to the historical period in which the works were created. The artistic forms served the specific statement—and this statement was not at all retrospective, but contemporary and actual.

Confirmation comes from the relatively large number of original Greek reliefs, especially votive and grave reliefs, that have been found in Rome and its surroundings and that must have served essentially to adorn fashionable residences.[50] Their largely mediocre quality already speaks against the idea that the high estimation of art was a primary factor. Their chronological distribution demonstrates a certain emphasis in the fourth century B.C.E., but this corresponds to the quantitative distribution of these genres in Greece itself, and therefore shows no priority given to any particular period of art in the Romans' selection. The primary factor was the adornment of urban and suburban villas with appropriate subject matter. For this reason, the votive reliefs include above all deities of the private realm: the nymphs with Hermes, Asclepius with Hygieia, Artemis, Aphrodite, and various heroes; they impart a sacral aura of a private character to the surroundings. In addition, the reused grave reliefs also create an atmosphere of personal reflection on life and death; in this they fit into the spiritual landscape of suburbia, in which the commingling of suburban residences and graves placed the enjoyment of life before the backdrop of an ever-present *memento mori*.

Here again, the reception of Greek art is not driven by a retrospective taste in art but by contemporary representations of life. But what meaning did the use of original Greek artworks have under these conditions?

Apparently, these efforts were above all about imparting the authenticity of Greek culture to the environment of one's own home. This accords with the cargo of the Mahdia shipwreck, in which were found several very simple votive reliefs together with inscriptions from Greek sanctuaries and necropoleis, surely likewise intended for reinstallation in Roman villas.[51] Such objects, often modest, had shaped the lived culture of the Greek cities, as the elite Romans had observed it in Greece or had come to know it from reports. Some of them wanted to bring into their own sphere a reflection of this Greece that had arisen historically, true, but which was experienced as contemporary. The historical age of such cultural objects, the dimension of the past, certainly may have been perceived in part, but it remained at least subordinate. In the foreground stood not the value "former times" but the value "Greek." As with the famous masterpieces, this was not about a historical return to a classical past, but about the ennoblement of one's own living world through authentic Greekness.

[50] On the following, Kuntz 1994. On grave reliefs, see Bell 1998.
[51] Pelzl 1994.

Greek artworks and Greek art-forms in Rome were not retrospective cultural *memories* but present *knowledge*, that is, cultural property. There were assuredly only a few learned and educated people who brought the historical dimension of these Greek works and forms to consciousness. And even this kind of learned and educated exploration of ancient art was still far removed from the totalizing consequences that the modern concept of history has brought with it. At issue in ancient art historical writings were individual works and individual artists, their qualities and statements—not the way in which general art-forms were related to particular political conditions, societal structures, collective mentalities, or forms of thinking in the sense of a generalizing concept such as an epoch. There was still quite some distance to Winckelmann's conception that the art-forms of the Greek classical belong to the liberty of Greek democracy.

It was thus all the more self-evident that the works and forms of Greek visual art could be received into the contemporary praxis of Roman culture largely independent of their historical genesis.

Images and Places of Roman Memory

The past, which famously played an important role in Rome, was shown to advantage in a very different way in cultural life, not least in the artworks of the public and private realms—more concretely, and thus more specifically.

Emerging out of Greek culture, the many-sided world of myth stood before the Romans.[52] It provided a rich repertoire of social and ethical models, counterimages, images of desires and dreams. It would be worth pursuing in some depth the question of how far in this the myths' character as early history played a constitutive role at the time, or how far the dimension of the concrete past merged into a general timelessness.

Later Greek history was evoked in artworks of the Augustan period not in the sense of a universal return to a generally great classical era, but in specific situations and in a limited, focused sense. The victory at Actium against Antony and Cleopatra in 31 B.C.E. as well as the success against the Parthians were positioned as successors to the maritime victory of the Greeks against the Persians at Salamis in 480 B.C.E.[53] Thus, at the dedication of the Forum of Augustus in 2 B.C.E., the emperor staged the battle of Salamis in a great naumachia. In the same sense, members of the Roman elite employed a relief type with the goddess Victory in the furnishing of their homes (fig. 7.12). She carries a ship trophy and adorns a tropaeum with a Persian half-moon shield; in

[52] There are countless studies of various Greek myths in Roman art. A few of the more recent works of general interest: Koortbojian 1995. Muth 1998. Zanker 1999. De Angelis et al. 1999.
[53] On the following, Hölscher 1984. Schneider 1986, 63–67. Schäfer 1998, 57. The staging of the battle of Salamis: Dio Cass. 55, 10, 7. Ov. *Ars am.* 1, 171.

other words, she too celebrates the victory at Salamis. In this, Rome is not seen in a general sense as the historical successor to classical Athens—that could only have been claimed through flagrant contradictions. Rather, a specific achievement of Augustus in a specific situation, highly delimited and focused, is connected to an equally specific achievement of Athens. The fact that this reference by Augustus to Athens's victory over the Persians was made only late and for an individual occasion, and that the relief type was also not widely distributed, confirms the limited, focused character of this historical claim.

Similarly limited and focused was Augustus's reference back to Alexander the Great.[54] Only in very rare situations, and always in a specific, bounded sense, did Augustus position himself as a successor to Alexander. When he pointedly visited Alexander's grave after the conquest of Alexandria in 30 B.C.E., this homage applied above all to the founder of the city and of Greek rule over Egypt, and therefore to the liberator from despotism and the conqueror of the East.[55] It was a gesture very precisely aligned to the situation in the capital city of his vanquished opponent. Likewise, in his early days he used Alexander's portrait as an image of victory, apparently only as long as he saw his own political role primarily as warlord and world ruler—no longer than until 27 B.C.E., or until 23 at the latest.[56] Thereafter he activated the model of Alexander only once more, in 2 B.C.E., as part of the dedication of the Forum of Augustus.[57] For one, he had two figures installed in the new Forum and two more in front of the Regia that were said to be from Alexander's tent; in this way he foregrounded Alexander's qualities as general, not as warrior but as commander of armies. For another, he brought Apelles' two paintings of Alexander into the most glorious part of his Forum, and these too made clear Augustus's specific role as commander in chief. The one showed Alexander on a triumphal chariot together with the personification of (civil) war in chains—a model for the conclusive victory that both ended the war and brought peace. The other, by contrast, depicted Alexander, crowned by Nike, between the Dioscuri—an exemplum of the victorious *virtus* that leads to admission to the gods. Since Augustus, after gaining sole power, did not base his rule on his quality as a military fighter but rather on his role as paternal ruler of the empire, he could only employ Alexander as an example in very circumscribed aspects that exactly expressed his own ideology of war as the safeguard of peace and his understanding of victory as the foundation for immortality.

[54] Kienast 1969. Weippert 1972, 214–59.
[55] Kienast 1969 puts this episode at the center of his study. Weippert 1972, 214–19.
[56] Weippert 1972, 219–23. The testimonia for a connection between Augustus and Alexander after the Parthian success of 20 B.C.E., interpreted by Schneider 1986, 64–66, all make this connection only indirectly, through Herakles or Dionysus.
[57] Plin. *NH* 93–94. Schmaltz 1994. Spannagel 1999, 28–29; 203–4.

By contrast, the turn toward Rome's own past was staged very differently. The foundation period of the city and its glorious history in the time of the kings and the Republic were omnipresent. In this there were fundamentally two types of presence.[58]

For one, there were the places in which famous events and occasions had played out: the Lupercal, Romulus's hut on the Palatine, the chasm in the Forum into which the knight Marcus Curtius had fallen, and so forth. These sites were scattered throughout the city, often removed from the central spaces and buildings of political life; there they were perceived and cared for as sites of memory. They were essentially testimonials whose evidence guaranteed the reality of the often legendary traditions about the famous figures of Rome's early history. Together they combined into a topography of early times that citizens could observe and make their own through the regular performance of life, partly through religious rituals, partly also through a reverential passing by.

For another, there were the central places of public life, in which the crucial political business of the citizenry was concentrated.[59] These places were understood and fashioned as conceptual sites of political identity. The most important elements among these were political monuments, in which the great figures of Roman history and their achievements were set before the eyes as exempla for posterity. In the Forum stood images of the she-wolf with the twins as archetypes of a fortunate beginning, Marsyas as symbol of the citizens' liberty and, with these, portrait statues of famous men of older and more recent history, who embodied the high values of the Roman state ethic like *virtus*, *pietas*, *fides*, and so on. At all the meetings of the senate and the citizenry, they stood before the eyes as a model and a measure. On the Capitoline, in a central space, could be seen statues of the Roman kings together with Brutus, founder of the Republic. There, during the most ceremonial religious state rituals, in front of the Temple of Iuppiter Optimus Maximus, they represented the formation of the city and the Republican *res publica*. A concentration of monuments of martial glory took shape along the path of the triumphal procession, from the Circus Flaminius around the Palatine, across the Forum and up to the Capitoline. Here, with every new triumph, the victorious general could place himself and his soldiers in the series of earlier war deeds and experience himself as fulfilling that tradition. The erection of monuments in these places is not evidence for any topographical reality in early times. Rather, it positions a conceptual presence of history in relationship to the political praxis of the present. This emphatic presence matches the strongly conceptual character of these places and their functions.

[58] On the following, see Hölscher 2001, esp. 189–204.
[59] Sehlmeyer 1999. Papini 2004, 147–205, 359–420.

Augustus programmatically fostered both forms of presence of the Roman past. On the one hand, he restored sites of memory of early times, like the Lupercal:[60] a reverential attentiveness was secured through the ritual of the Lupercalia. On the other hand, he built into his new Forum a conceptual staging of Roman history of a complexity and coherence that had never before been expressed.[61] With Aeneas and Romulus, antipodal models of fatherly *pietas* and heroic *virtus* were established, which built up the ideological frame of the entire concept to its apex, Augustus. In this way, Augustus activated two sides of a backward reference to the past, which completed each other in an effective, complementary manner.

The sites of memory documented the reality of early times with concrete evidence: in ritual performance or emotional internalization, they were perceived and adopted essentially as a historically evolved space for life. The places of political business, by contrast, were equipped with the political claims of history: here, history was brought to the fore with ideological emphasis. Both aspects together made up the centuries-long strength of this historical-ideological *Romanitas*.

Conclusion

Cultural knowledge and cultural memory—it seems very surprising at first that these two sides of Augustan culture lie so far apart from one another. A system of forms, strongly shaped by their Greek manufacture, that has little concrete relationship to the Greek past—and a strong presence of the Roman past, which hardly allows one to expect connections to a Greek culture of forms. But precisely this fundamental dichotomy of the two phenomena was a precondition for them to complete each other complementarily and thereby be able to gain strength. Insofar as knowledge of Greek forms could be freed from its historical genesis, temporally neutralized, and deployed as a present medium for Roman guiding ideas, it became a universal cultural instrument. The historical past, however, did not become an all-encompassing Greek starting point for a generally retrospective classicism, but rather stood before the eyes as a collection of concrete examples, especially from the history of Rome, in lapidary, clearly outlined images for the present.

Today we have a harder time of it in our dealings with history. On the one hand we increasingly burden our cultural knowledge, our cultural property, with the dimension of the past. In all the elements of our culture, the objects, activities, and ideas, we see their geneses and history, which ruins them by making them into memories—like Midas, for whom everything he touched

[60] Res Gestae Divi Augusti 19.
[61] Zanker 1970. Spannagel 1999.

turned to gold, and who was threatened with starvation as a result. For this reason, it is difficult today to release the Greek forms in Roman art from the historical context of their creation and to understand them as present (Roman) cultural property. On the other hand, we have developed a concept of historical coherence according to which the various cultural phenomena of historical periods stand in a strict relationship to one another and should constitute a coherent cultural system. For this reason it is difficult for us to see the artistic forms of various periods of Greek history and the themes and representations of values from the Roman present not as a contradiction but as a flexible cultural system. I hope it has become clear that both premises are neither given nor necessary.

TRANSLATED BY JENNIFER TRIMBLE

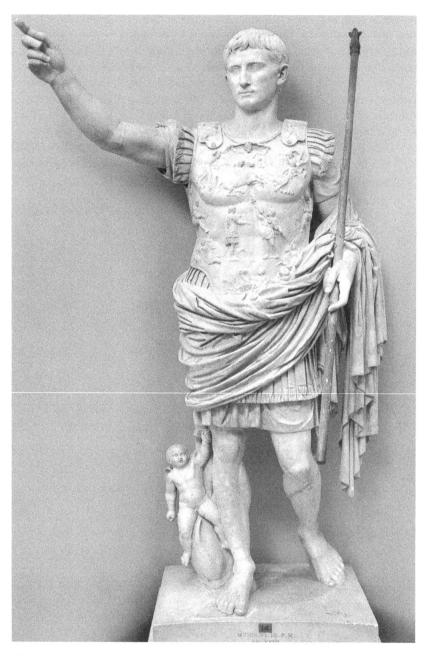

Figure 7.1. Statue of Augustus from Prima Porta. Ca. 17 B.C.E. Rome, Vatican Museum, Braccio Nuovo. Photo: Deutsches Archäologisches Institut, Rome.

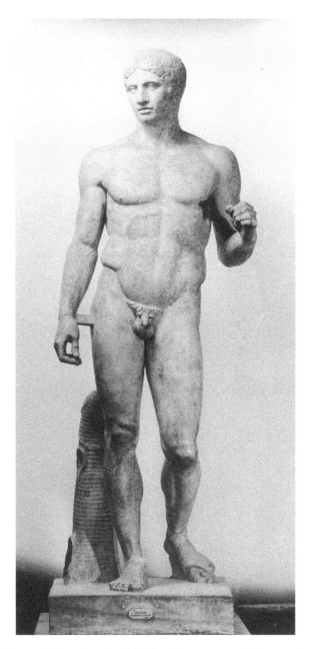

Figure 7.2. Statue of Doryphorus by Polyclitus. Roman copy of a bronze Greek original of ca. 440 B.C.E. Naples, Museo Nazionale Archeologico. Photo: Deutsches Archäologisches Institut, Rome.

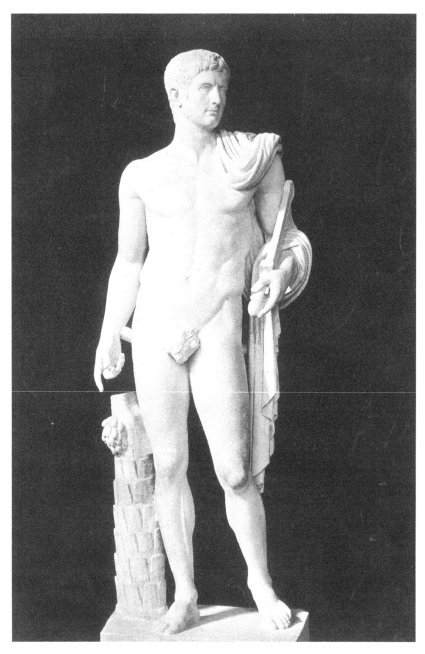

Figure 7.3. Statue of Augustus as Diomedes, from the Basilica of Otricoli. Ca. 40 C.E. Rome, Vatican Museum. Photo: Alinari.

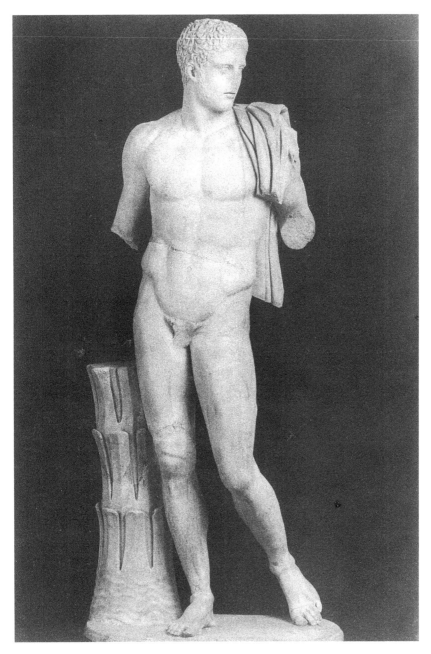

Figure 7.4. Statue of Diomedes. Roman copy of a Greek bronze original of ca. 430 B.C.E. Naples, Museo Nazionale Archeologico. Photo: Seminar für Klassische Archäologie, Universität Heidelberg.

Figure 7.5. Statuette of Alexander. Roman statuette, perhaps copy of a life-size portrait statue. Hellenistic period. Cambridge (Mass.), Fogg Art Museum. Photo: Seminar für Klassische Archäologie, Universität Heidelberg.

Figure 7.6. Statue of a boy. Augustan. From the illegal market. Photo: Seminar für Klassische Archäologie, Universität Heidelberg.

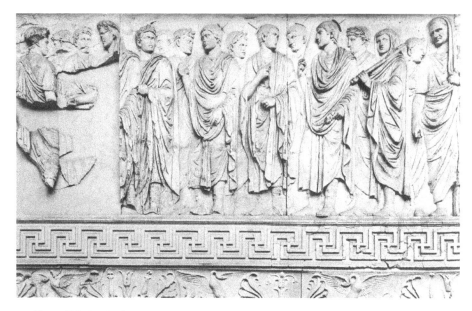

Figure 7.7. Ara Pacis Augustae, great procession. 13–9 B.C.E. Photo: Fototeca Unione, Rome.

Figure 7.8. Caryatids from Forum of Augustus, dedicated 2 B.C.E. Photo: Deutsches Archäologisches Institut, Rome.

Figure 7.9. Marble crater. Mahdia shipwreck. Beginning of the first century B.C.E. Tunis, Musée du Bardo. Photo from D. Grassinger, *Römische Marmorkratere* (1991), Abb. 62.

Figure 7.10. Ara Pacis Augustae, southwest panel with Aeneas. 13–9 B.C.E. Photo: Brogi.

Figure 7.11. Relief with Apollo, Diana, Latona, and Victoria. Augustan. Rome, Villa Albani. Photo: Alinari.

Figure 7.12. Relief with Victoria (of Salamis) and Trophy. Augustan. Rome, Villa Albani. Photo: Museo Nazionale di Roma.

Chapter 8

CLASSICISM IN ROMAN ART

Jaś Elsner

Preamble on Definitions

LET ME BEGIN with an attempt at a definition of Classicism, at least as I shall use the term for the discussion of Roman art. Historically, "Classicism" has been used in a general way to designate the pervading influence of Greek styles on Roman image-making and—more specifically—to mean the emulation of what are called the Classical Greek styles of the fifth and early fourth centuries B.C.E. (by contrast with archaic and Hellenistic styles).[1] Moreover, in the historiography of Roman art that evolved in the course of the twentieth century, Classicism occupied one pole of what has been described as a continuing dyad or dualism between stylistic tendencies that have been variously defined as anti-Classical, Plebeian, Italic, or provincial, on the one hand, and those borrowed from the Greeks (i.e., classicizing styles) on the other.[2] While some still affirm a fundamental stylistic polarity as the key factor in Roman art,[3] most scholars would now generally assent to a more pluralistic vision of formal

I am grateful to Jim Porter and Stéphanie Wyler for their very helpful and acute comments on earlier drafts. Miguel John Versluys was kind to share with me some of his (then) unpublished work on "Aegyptiaca Romana," while Grant Parker generously discussed with me some of his ideas about obelisks as they were taking shape. Versions of this paper have been delivered as the Inaugural Lecture of the Classical Society at University College Dublin, at the USC and UCLA joint conference on the Roman Iconosphere (organised by Tony Boyle) in Los Angeles, as the Donald Strong Memorial Lecture at the Society of Antiquaries in London, and in seminars at Cambridge, the University of Michigan at Ann Arbor, the University of Chicago, and the DAI in Rome. My thanks are due to those who attended and whose observations have made me think again, especially Lucia Faedo and Fernanda and Tonio Hölscher on a very hot evening in Rome.

[1] For instance, in the discussion of Augustan Classicism: Zanker 1979; Zanker 1988a, 239–63; Galinsky 1999; Galinsky 1996, 332–63; Hölscher 2000, esp. 268–71. Although not stylistic in its emphasis, Beard and Henderson 2001 maintains the Hellenocentric focus. For the two meanings of Classicism identified here, see Hölscher 1987, 13–14.

[2] For a summary of the dualist account, see Brendel 1979, 101–21, and Settis 1989, esp. 833–41. Its most prominent proponents are Rodenwaldt (in, e.g., Rodenwaldt 1939, esp. 546–47 and Rodenwaldt 1944/45, esp. 84 and 87) and Bianchi Bandinelli (e.g., Bianchi Bandinelli and Franchi Dell'Orto 1978, 19–48). In its influence on generations of students, the most significant expression of the dualist view is Bianchi Bandinelli's Marxist version in his textbook, Bianchi Bandinelli 1970, 51–105.

[3] Torelli 1996, esp. 930–31, 956–58.

appropriations in Roman image-making.[4] Not only do I fully accept the pluralism of Roman art, as well as of much else in Roman culture (such as its religious systems, to which I shall be comparing Roman visual production below),[5] but I think the affirmation of pluralism has a significant effect for the meaning of Classicism. If we take pluralism seriously, then the different elements that are pluralistically borrowed, appropriated, or combined must logically be regarded as potentially equal options within the available plurality (although I accept that Greek-derived options tended to be chosen most frequently and that the Greek-derived idioms of naturalistic representation were the dominant reflex of Roman image-makers). The emphasis on Classicism as a specifically hellenocentric set of borrowings belongs to the outmoded description of Roman art as dualistic, where one side of the polarity was "Classicizing" and the other was "everything else."

My own definition of "Classicism," then, is the "emulation of any earlier set of visual styles, forms, or iconographies, which in the very fact of their being borrowed are established as in some sense canonical (or classic)."[6] This process of later emulation is in principle applicable to all earlier arts—so that Roman Classicism is Egyptianizing and Italicizing as well as Hellenicizing, centrifugal in its dispersal among the provincial arts as well as centripetally focused on Greece. That emulation may in certain cases be regarded as a matter of influence (with the boot, as it were, placed on the foot of the earlier style and with the Roman borrower being secondary). But it can equally be a matter of appropriation (with the borrower rather than the lender empowered through the choices made about what to borrow and how).[7] It is a world of creative reformulation, of often eclectic and syncretistic admixtures of various earlier elements, of considerable connoisseurial knowledge and antiquarian esteem, of the old forms being adapted to new ends. In this definition, Classicism describes a process of relationship between the arts of the present and those of the past, with no one part of the past (that of Greece) being necessarily privileged. In fact, Roman art gestures significantly to the pre-Roman arts of Italy (which were always influenced by Greek art but never took the urge to naturalistic illusionism to be an exclusive model or value), to the antinaturalistic styles of Pharaonic Egypt (which were also fostered by the Ptolemaic court in Hellenistic times), and to various forms of eastern influence, as well as to the Greek visual tradition.[8]

[4] See Blanckenhagen 1942; Brendel 1979, 122–37; Hölscher 1987, 10, 17–19; Settis 1989, esp. 833–41.
[5] On pluralism in Roman religions, see North 1979, id. 1992; Beard et al. 1998, 245–363; Bendlin 2000. On other aspects of multicultural pluralism, especially in the city of Rome itself, see Edwards and Woolf 2003.
[6] For an interesting museological take on this issue—specifically focussing on Augustan appropriations of earlier material culture—see Haug 2001.
[7] See Nelson 1996.
[8] By "Roman Art" I mean here the range of arts produced within the empire. The very eclecticism

Classicism thus becomes not the affirmation of a particular and privileged ancestor (though I am not trying by any means to deny the extent of Greek influence in Roman culture) but rather a way of understanding cultural self-positioning through the visual, in respect of a culture's range of chosen ancestries. Roman culture is intensely classicizing in this sense—looking towards a variety of older foreign cults (Artemis of Ephesus, Jupiter Dolichenus, Serapis of Alexandria, and so forth) just as much as it looked to a range of older foreign visual styles (from archaic, Classical, and baroque in Greek art, to Egyptian, Italic, and so on in non-Greek art). What all these borrowings have in common is their assertion of empire (that is, all come from areas under Roman dominion) and at the same time their pluralistic willingness to allow the center to be colonized by the products (whether visual or religious) of its own possessions. Yet none of these products, in its Roman context, exists in the exclusive, special, or privileged state of its original creation. Canonical though Egyptian or Greek styles may be in their conscious and careful Roman appropriations, they become just one aspect to be plundered and reused at will in a pick-and-mix visual culture that is supremely defined by its eclecticism. Effectively, the visual styles that Roman Classicism adopted are not only elevated and appreciated by virtue of their being borrowed but they are also stripped of any indigenous meaning and reduced to being one further option in an empire-wide range of decorative choices. It might be added that I can think of no forms of Roman art that are not in principle subject to the process of Classicism, but at the same time I have not been able to identify in the (admittedly small) surviving Roman literature on art any specific terminology by which the Romans might have translated or defined what I call "Classicism."

Classicism in the sense of the emulation of earlier artistic forms is in fact rampant in all visual production—not least, that of the Greeks themselves. No one seriously doubts the influence of near-eastern art on the earliest Greek *xoana* and the pre-archaic Daedalic style,[9] nor the significance of Egyptian stone sculpture for the rise of archaic art—and especially *kouroi*.[10] More contentiously, there has been recent discussion of Athenian receptivity to Achaemenid culture in the Classical period.[11] Etruscan art, another of the sig-

that is characteristic of those arts has made formal definition of the "Romanness of Roman art" notoriously problematic (see Brendel 1979, 3–11). Clearly there must be some notional chronological limits to the pervasiveness of the pluralistic tendency I emphasize, but these are not easy to establish—before the late Republic (when Rome was already effectively an empire) there is relatively little surviving visual material and what there is from Italy is not easy to separate from "Etruscan art." As I shall argue below, the pluralism of Roman classicism is one of the key factors for the generation of late antique and early medieval art.

[9] See, e.g., Hurwit 1985, 125–35; Stewart 1990, 104–5, 106–8; Morris 1992, 101–49; Osborne 1998, 43–51; Boardman 2000, 85–115.

[10] Richter and Richter 1970, 2–3; Hurwit 1985, 179–202; Stewart 1990, 108–10; Osborne 1998, 76–81.

[11] For example, Miller 1997 (and *contra*, Boardman 2000, 213–17).

nificant ancestors of Roman art, was still more promiscuous in its formal borrowings. While its stylistic development is usually read in tandem with the stylistic story told of Greek art (from orientalizing, via archaic, to Classical and Hellenistic),[12] the presence of elements resistant to Hellenism—in sixth-century Canopic urns, for instance, or in the elongated votive bronzes of deities and priests that so influenced Giacometti—was persistent and has usually been put down to local or popular trends.[13] The arts patronized by the Hellenistic successors of Alexander were likewise diverse in their stylistic borrowings. Most obviously, Hellenistic art includes a series of formal developments from classical Greek art; but the Ptolemies, for instance, were also committed to the emulation of Egyptian pharaonic traditions,[14] while Antiochus I of Comagene was buried in a tomb boasting spectacular sculpture in hybrid Parthian and Greek style.[15] Roman art is in fact far more radical than any of its predecessors in its range of borrowings and in its extension of artistic ancestors to incorporate the whole cultural and territorial extent of the empire it had conquered. Its Classicism is thus a sophisticated imperial development of earlier models of artistic appropriation (some of which, like Hellenistic art, were themselves already pluralistic), with specific implications of cultural inclusivity.

My definition of Roman Classicism is therefore dependent on a cultural understanding of the Roman empire as broadly pluralist, eclectic in its tastes, and multicultural. Visual classicism is simply one expression of this set of values, just as religious pluralism and toleration is another. But it is striking how different has been the historiographic discussion of these (in my judgment) parallel phenomena. Whereas explorations of Roman art have been profoundly Hellenocentered, those of Roman religion have (until relatively recently) tended to stress the specifically Roman aspects of religious life (ancestor cult, civic religions and festivals, priesthood and divination) by contrast with—say—Greek religion.[16] Where Roman religion has been portrayed in terms of what Roman art historians would term its Italic tendencies, Roman art has—since Winckelmann—been more about the rediscovery of the lost heritage of Greek art through Roman copies than it has been an assessment of the

[12] For instance by Brendel and Serra Ridgway 1995 (revised from the 1978 edition by Serra Ridgway); Spivey 1997; Haynes 2000.

[13] Brendel and Serra Ridgway 1995, 130–32: "popular;" 330: "primitivism"; Spivey 1997, 134: "unusual local forms"; 145: "local peculiarity"; Haynes 2000, 374: "popular."

[14] For a brief synopsis, see Pollitt 1986, 259–63.

[15] See Pollitt 1986, 274–75.

[16] See, e.g., Bispham 2000, 1, against "Romano-centrism" in religious studies, and Bendlin 2000, 115–18, on the nineteenth-century obsession with an "authentic Roman religion" conceived in terms of "ethnic purity" and not yet susceptible (in the early Republican period) to external "corruption" (quotes from p. 118). I know of no full or fully satisfactory study of the historiography of Roman religion (Latte 1960, 9–17, is frankly no more than lip service to the theme), but of particular interest is Scheid 1987, who traces one (negative) aspect of the historiography of Roman religions as constructed by contrast with scholarly perceptions of Greek religions.

surviving Italic tendencies amidst the morass of Hellenism. In neither case have non-Graeco-Roman elements played a central role, though in the study of Roman religion the so-called Oriental cults have always had a significance in the discussion because of the need to explain how more than a millennium of traditional polytheism should have so swiftly succumbed to Christianity in the fourth century. What these different approaches betray is deep disciplinary biases and not always conscious, let alone articulated, agendas in the outlooks of historians of Roman art on the one hand and of Roman religion on the other. Broadly, the former group has been concerned with dependence on Greece and the latter with difference from Greece defined as a search for authentic Romanness.

But before turning to some visual evidence, it is worth pausing at the most distinguished contribution to the study of Roman visual classicism in recent years. I mean Tonio Hölscher's *Römische Bildsprache als semantisches System*, published in 1987 and just recently in English.[17] While conforming to the Hellenistic account of Classicism (and including no examination of non-Greek-influenced tendencies in Roman art), Hölscher's book attempted to move the ground of the discussion of Classicism away from issues of period style and from questions of formal influence and appropriation, to a much more integrated conception of cultural communication. He argued that Roman art was a language with its own semantic structure and a specific means of communicating cultural messages, beyond the whims of artists or patrons.[18] For Hölscher, the stylistic forms of the different periods of Greek art were adopted in order to communicate specific subjects or themes through the specific forms that were chosen. What had once been a diachronic process of stylistic evolution was now broken up and put together again as a synchronic mix of elements, each of which had a quite precise and (to use Hölscher's own terms) *semantic* meaning within the new *system*. This enabled the expression of complex abstractions and of highly effective visual communication across a large polyglot empire by means of repeated traditional visual forms (almost clichés) with precise meanings. Needless to say, this is a highly positive assessment of the specifically Roman contribution to art in the Classical tradition as well as being far more theoretically sophisticated about the workings of Classicism than any of its predecessors.

Hölscher's system is clearly open to some objections. Apart from a potential resistance to the powerful force he gives to those most traditional of analytic tools in art history—namely, style and form, one might argue that Hölscher's semantic system is too rigid and restrictive a conceptualization of how visual culture works. Another way of putting this is to say that the linguistic analogy

[17] Hölscher 2004.
[18] Hölscher 1987, 49–61, some of which I summarize below. Hölscher's semantic turn is taken up for instance by Haug 2001, 115–17 who talks of "semanticization" of styles and the "re-semanticization" of foreign artifacts in Augustan Rome.

is only an analogy and should not be taken as a model for the way the visual communicates. In particular, one might worry about the universality of a single mode of communication within the empire, that is implied by the understanding of the workings of Roman art *as a language*. Nonetheless, I would accept wholeheartedly Hölscher's picture of Roman synchronistic mixing of past styles for specific purposes of cultural communication. I would of course add more ancestors than the Greek (and hence more styles) to the mix, as we shall see. I would, then, modify Hölscher's semantic model to a more modest proposal of a cultural memory bank of numerous earlier styles and forms (eclectic and wide-ranging in type and provenance) that could be marshalled in different contexts and by different groups for a variety of different ends—or, to reemploy Hölscher's language-metaphor, to play a variety of possible language-games. This is most obvious with the arts of the various religions of the Roman world—be they initiate cults or local civic-religious associations—where specific combinations of images had meanings comprehensible within the group but not always to outsiders.[19] My modification allows Hölscher's language-system to speak with two voices at once (for instance, in conveying different messages simultaneously to an initiate group and to outsiders), but additionally it may allow images to be just decorative and not specifically meaningful also. While Hölscher writes: "The concept of eclecticism is not wrong, but it is imprecise: What prevailed was not an arbitrary relativism nor the pure preference of taste but a selection geared towards best expressing the message" (p. 49), I would myself prefer not to exclude the potential of artistic eclecticism to succumb both to relativism and to the whims of taste, while at the same time accepting the cultural demand for messages to be communicated and the force of Roman art as a means for doing so.

In the case of reference to both Greek and Egyptian styles, Roman Classicism is marked in being much more connoisseurially precise or deliberately antiquarian than anything in, for instance, recent and current postmodernism. Romans (or at least Roman artists) clearly recognized and responded to the difference between archaic, Classical, and baroque styles in Greek art and likewise to the differences between Pharaonic and Ptolemaic-Hellenstic Egyptiana. While it is occasionally the case that such reference (and the mixture of such references) created a kind of hybridity or pure surface eclecticism, the norm is for a more precise kind of referencing in which the paradigm of an older model is acknowledged, incorporated, and integrated into a new context that effectively generates its transformation.

The range of investments in Roman Classicism—from significant meaning deliberately communicated to whim or a particular chic—raises the double problem of canonicity. First, to what extent does Classicism imply that the chosen style from the past has been privileged as a canonical model? Second,

[19] See, for example, Elsner 2001, esp. 301–5.

how can we tell? In terms of the surviving evidence, Classicism is largely a matter of quotation, reference, and use. But does such allusion (which is frequent) constitute Classicism in and of itself? Does it always refer to a privileged past (a kind of deliberate antiquarian historicism) or is it sometimes (perhaps as an "ignorant" choice of a particular patron, a Trimalchio, as it were, or a Mummius) a reference to other imagery of the present, which itself may happen to look back to the past? To what extent is a culture of visual allusion one of reverence for that which is alluded to? Or does the very plethora of quotation not tend towards banality? I am not sure that these questions can be answered short of some specific ancient testimony being found, but it is worth making the point that the issues here belong much more generally to the problematic of canonicity,[20] insofar as that to which a culture finds itself constantly alluding is necessarily not only raised to a special status by such reference, but is also inevitably reduced to the banal. Think of the immense range of occasions for the modern citation of "to be or not to be"!

"EGYPTOMANIA"

To test my proposition for Classicism, let us turn to the most prevalent of non-Greek-influenced styles in the Roman world, namely those of Pharaonic Egyptian art. There is a great deal of Egyptian and Egyptianizing art in Rome, but for various reasons it has proved easily relegated to a conceptual corner where its existence fails to make an impact on the Hellenocentric picture of Roman art.[21] That the Egyptiana belong to a species of Classicism (according to my definition above) is not in doubt. Pharaonic styles (and collected Pharaonic objects) were already being used to allude to the past in Hellenistic Alexandria. Indeed the very process of amassing objects in Pharaonic style in the context of a city basically decorated in Greek-influenced styles is surely modelled on Alexandria, where recent underwater excavation has found that Pharaonic antiquities appear to have been transported to and displayed around the famous lighthouse, the Pharos.[22]

Many Egyptian objects in Rome were antiquities—imported as booty and displayed as trophies,[23] for example, most of the obelisks.[24] In this, the

[20] Tonio Hölscher tells me that his choice to move away from discussion of "Classicism" specifically in favor of the model of a communicative language was in part motivated by the wish to avoid the traditional historicist and canonical investments in the interpretation of Roman images in order to privilege their contemporary uses.

[21] An interesting recent attempt to wrestle with some of the cultural significations of the Egyptiana in Rome is Vout 2003.

[22] See, e.g., Empereur 1995, esp. 756–60; Fattah and Gallo 1998; Empereur 1998, 63–87; most recently McKenzie 2003, esp. 45–47, with further bibliography.

[23] See briefly Roullet 1972, 13–18.

[24] Pliny's account (*NH* 36.69–76) is entirely a story of the imperial center's appropriation of choice

collection and exhibition of Egyptiana in Rome resembles that of original Greek art, such as the fifth-century-B.C.E. pedimental sculptures from Greece, moved to the Augustan temple of Apollo Sosianus in the early Principate, although it is possible that there was a different balance between intimations of domination and fascination in Roman responses to imported Egyptian art on the one hand and Greek art on the other.[25] Other original Pharaonic works appear to have come for religious reasons,[26] such as the XIXth Dynasty Horus from the Isaeum Campense, which is now in Munich.[27] Much more common, especially in the second century C.E. was the creation of Egyptianizing works in Rome by artists either of Egyptian extraction or equally by locals and perhaps even by Greeks. Some such objects were dedications at Isaea, for instance, the red granite crocodile now in the Capitoline Museum,[28] but others were decorative embellishments designed to enhance an elite setting like Hadrian's Villa at Tivoli.[29] In the case of these three-dimensional finds—now scattered across the country houses and museums of Western Europe and North America—it is hard to know how the Egyptian-influenced pieces mixed with non-Egyptian-related works.[30] This isolationism of the Egyptian objects as finds means that they can be treated separately from the Hellenizing and other objects with which they once stood side by side—not only in the handbooks but also in such displays as the Vatican's Museo Gregoriano Egizio, whose collection (despite its title) is almost entirely of Roman works in the Egyptian style. Clearly in Hadrian's Villa, for example, there must have been significant eclecticism—so that Gavin Hamilton's 1769 excavation of the Pantanello (effectively a bog) included the Lansdowne head of Antinous as Osiris as well as other Egyptianizing figures in addition to numerous statues in Greek-influenced

provincial possessions. For obelisks in Rome, see D'Onofrio 1967; Iversen 1968; Roullet 1972, 67–93.

[25] See La Rocca 1985 and La Rocca 1988. For an excellent discussion of the cultural meanings of such *spolia* in the city of Rome, see Ewards 2003.

[26] The religious motivation has been questioned by M.-J.Versluys: Versluys 1997, esp. 163 and 165, who stresses exoticism over ritual and religion in the *Isaeum Campense* against, e.g., Lembke 1994, 84–132. But there can be no doubt that *some* Egyptiana must have been taken as sacred by *some* people, especially in a sanctuary: see Versluys 2002, 308–12. For an interesting account that combines exoticism with religious sincerity, using Apuleius as its mainstay, see Egelhaaf-Gaiser 2000, 116–63, 219–23.

[27] See Lembke 1994, 228 no. E.19, and Roullet 1972, 90 no. 113, both with bibliography. On the *Isaeum Campense*, see especially the study of Lembke 1994, with the useful review Versluys 1997; Malaise 1972a, 187–215, and Egelhaaf-Gaiser 2000, 175–85. For a list of excavated objects, see Lembke 1994, 214–53; on other *Isaea*, see briefly Roullet 1972, 35–39, and Egelhaaf-Gaiser 2000, 164–218.

[28] Lembke 1994, 239–40 no. E.39, and Roullet 1972, 127 no. 254.

[29] For a list of Egyptiana at Hadrian's Villa, see Roullet 1972, 51. Also Malaise 1972a, 101–11.

[30] Typically, the attempt has been made to put groups of (unprovenanced) Egyptian-style finds together to create specific Egyptian fandangos at the Villa: see, e.g., Grenier 1989, with the comments of Hales 2003, 84–86; or Ensoli 1999, 79ff., with the discussion of Newby 2002, esp. 74–78.

styles,[31] including at least two Hellenizing versions of Antinous.[32] This kind of mixing of statuary in Roman actuality (if not in modern experience) makes direct linguistic messages of the kind envisaged by Hölscher difficult to credit here, although a generalized cultural message about multiculturalism and acculturation within imperial control is clearly implicit.

The mixing of Egyptianizing and Hellenizing elements may be better tested in the arena of wall painting, where such survivals as we have are at least contextualized.[33] The room known as room 2, or the Black Tablinum, of the Villa dei Misteri in Pompeii was remodelled between about 15 B.C.E. and 15 C.E. with shiny black walls and a white mosaic floor. The walls were decorated with exquisite miniature sketches of deities and animals of Pharaonic form, though executed with the quick impressionistic brushstrokes of the Campanian muralists (e.g., fig. 8.1).[34] What is striking is that this room—with its sleek "designer" style and Egyptian taste—is directly next to, and indeed opens onto, rooms 4 and 5, which contain the villa's famous painted friezes of still undetermined subject matter with a Dionysiac twist, made about 60 B.C.E. Room 4, the one entered from room 2, with its second-style illusionistic marble revetment and its alcoves with lifelike Dionysiac figures (possibly images of statues in that they stand on bases painted as if they extend from the maroon wall panels) and small pinakes with scenes of sacrifice to Dionysus and Priapus, makes a strong contrast with room 2—not just in style (Hellenizing versus Egyptianizing) but also in religious leanings (Dionysus versus Isis).[35] Of course, one can wriggle around the problems potentially created by this contrast by arguing that the Black Tablinum was painted some fifty years later than rooms 4 and 5 as part of a programme of redecoration, and simply represents Augustan as opposed to late Republican taste in Campania.

Less easy to dismiss is the confrontation of Hellenic and Egyptian elements in a house like the Casa del Frutteto (also known as the Casa dei Cubicoli floreali) in Pompeii (I.9.5).[36] Two rooms here, both painted about 40 or 50 C.E. in the late third style (the "cubicolo celeste," cubiculum 8, and the "cubicolo

[31] See nos. I.15 and I.19–20 in Raeder 1983, 42 and 44. See Raeder 1983, 31–121, for a list of early finds, including the Pantanello cache.

[32] The Hellenizing Antinoi from the Pantanello include the Cambridge bust (Raeder 1983, 31, I.1; Meyer 1991, 116–17, III.6) and a bust in Leningrad (Raeder 1983, 37, I.8; Meyer 1991, 51–52, I.30). The Egyptianizing Lansdowne bust, subsequently in Bowood House, is Raeder 1983, 42, I.15, and Meyer 1991, 123, IV.4.

[33] Essential is de Vos and de Vos 1980. For some examples of earlier mixing of Greek and Egyptian styles in the surviving painted tombs of Ptolemaic Alexandria, see Venit 2002, 101–7 and 118 (on the Saqiya Tomb, assuming a second-century B.C.E. date) and on contemporary uses of Egyptiana in the tombs of Roman Alexandria, see Venit 2002, 119–67.

[34] On room 2 see Maiuri 1931, 201–4; de Vos and de Vos 1980, 9–12 (with earlier bibliography); Clarke 1991, 140–46.

[35] On room 4, see Maiuri 1931, 174–83; Clarke 1991, 94–97.

[36] For exemplary photographs, see de Vos 1990.

Figure 8.1. Framed Egyptianizing motif from the predella of the third-style frescoes of the Black Tablinum, Room 2, in the Villa of the Mysteries. Pompeii. Ca. 15 B.C.E.–15 C.E. Photo: DAI Inst Neg: 60.668.

nero," cubiculum 12) combine Egyptian and Graeco-Roman motifs with brilliantly eclectic panache.[37] While the latter, whose painted vault partially survives, makes reference to the cults of both Dionysus and Osiris (gods long assimilated within the culture of Hellenic religious syncretism)[38] while maintaining a broadly Graeco-Roman visual style, the former—cubiculum 8—performs a remarkable deconstruction of the logic of the naturalistic garden scene (fig. 8.2). A dense shrubbery is depicted, rising above a fence, on a light

[37] de Vos and de Vos 1980, 15–21; de Vos 1990, 15–35 and 113–34.
[38] So Hdt. II.42: "Osiris, whom they say to be Dionysus" (cf. also the discussions of Dionysus at II.47–49, 123, 144–46) and Plut. *De Iside et Osiride* 13, 356B.

Figure 8.2. Casa del Frutteto, Cubiculum 8. View of the room and its surviving wall decoration, looking east. Pompeii. Ca. 40–50 C.E. Photo: DIA Inst Neg: 64.2261.

Figure 8.3. Casa del Frutteto, Cubiculum 8. View of the upper section of the south wall. Pompeii. Ca. 40–50 C.E. Photo: DAI Inst Neg: 64.2267.

blue ground suggesting the sky. An ornamental white entablature supported by two white columns on each wall imposes the conventional tripartite division of the wall (both vertically and horizontally). This entablature itself supports various objects, including white urns and small pictures depicting deities, motifs, and animals in the Egyptian style (e.g., fig. 8.3). A smaller column rises in the center of each wall, ending in the middle of the shrubbery and holding a picture depicting a Dionysiac subject in the Hellenizing Graeco-Roman style (figs. 8.4 and 8.5). Further statues of Egyptian deities patrol the shrubbery (see fig. 8.5), while at the top of the wall in the sky are images of flying birds, wreathes, and theatrical masks. This is a brilliant version of the characteristic surrealism of Campanian wall painting with its pushing of the limits of realism to extreme ends.[39] The use of Egyptiana (always adopted here as the style for pictures or statues displayed within the world of the painting and not for the actual visual idiom chosen for the primary decoration of the room, as in the Black Tablinum of the Villa dei Misteri) and its confrontation with Graeco-Roman idioms for the Dionysiac insets only extend the complexity and play. To cope with

[39] Cf. Elsner 1995, 62–74.

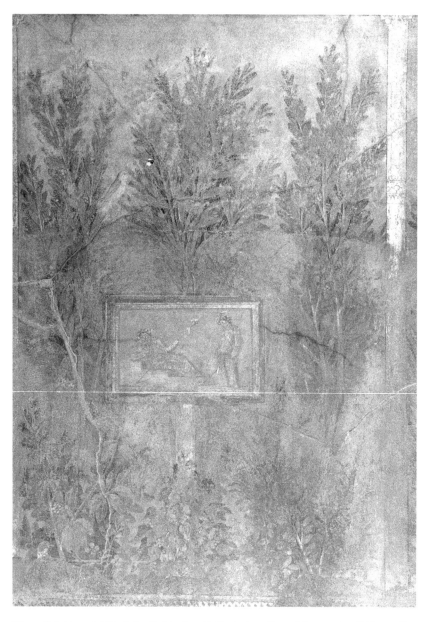

Figure 8.4. Casa del Frutteto, Cubiculum 8. Central section of the west wall. Pompeii. Ca. 40–50 C.E. Photo: DAI Inst Neg: 64.2263.

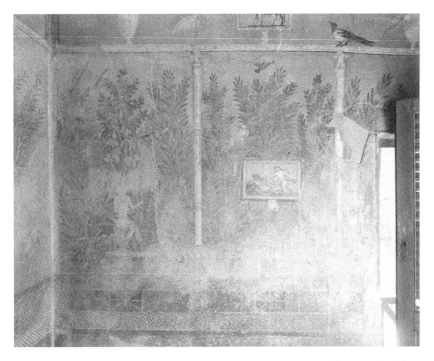

Figure 8.5. Casa del Frutteto, Cubiculum 8. View of the south wall with Egyptianizing figure and Hellenistic-style inset of satyr and nymph on a column amidst the shrubbery. Pompeii. Ca. 40–50 C.E. Photo: DAI Inst Neg: 64.2264.

such phenomena (and effectively to dismiss them) scholars have resorted to one of two views of the Egyptiana—that it had a sacred significance specific to the Roman devotees of Isis or that it was merely a form of decorative exoticism.[40] Both these lines (which might be characterized as the "between consenting adults only" view and the "faddish camp" view)—while being contrasting in the weight of meaning they ascribe to Egyptianizing imagery—conspire to insulate it from Roman art in general by giving it either the specific esoteric significance relevant only to mystic initiates or the irrelevance of kitsch.[41] Yet the very fact that the Egyptiana belongs to what might be called a chic use of

[40] For these views with bibliography on both sides of the debate see Meyboom 1995, 80 and esp. n. 2; Vout 2003, 189, and especially Versluys 2002, 322–24, 329–35, for a review of the literature. Versluys 2002, 374–76, rightly argues that the religious and decorative-exotic interpretations are not mutually exclusive, while Vout 2003, 189–94 effectively demolishes some of the wilder religious (Isiac) interpretations of Egyptiana in Rome.
[41] "Kitsch": de Vos and de Vos 1980, 76; "Chinoiserie": Ward-Perkins 1981, 368; "eastern exotica": Versluys 2002, 323.

Isiac allusion—both religious and formal—which is consistently paralleled to similar religious and formal allusions to Dionysiac cult, should serve to put the two phenomena together rather than to allow their study in isolation.[42]

Perhaps the best case for the significance of Egyptianizing Classicism and at the same time for its deliberate elision by art historians is in the visual production of Rome's most philhellenic emperor, Hadrian—whose enthusiasm for all things Egyptian is well documented.[43] As we have already seen, Hadrian's Villa provides good evidence not only for copious sculptural Egyptiana, but also for its mixing with sculptures in numerous other styles. Yet remarkably, Joachim Raeder's discussion of the statuary—while laudable in its attempt to catalogue the surviving objects by findspots—fails utterly to do justice to the Egyptianizing materials in its stylistic analysis, which assumes Greek influence as the sole interesting model for Roman artistic Classicism.[44] The supreme paradigm for the philhellenic view of Hadrianic Classicism is Jocelyn Toynbee's DPhil thesis, published in 1934 as *The Hadrianic School: A Chapter in the History of Greek Art* (my emphasis).[45] Perhaps the ultimate classicizing image type produced in this period is the series of sculptures representing Antinous, Hadrian's favorite (e.g., figs. 8.6 and 8.7).[46] Yet, given the existence of a significant group of Egyptianizing statues of Antinous (relegated to a footnote by Christoph Clairmont's catalogue of 1966, presumably in the interests of emphasizing Hellenocentric Classicism)[47] and given Antinous's death in Egypt in 130 as well as his commemoration there by Hadrian through the founding of Antinoopolis (Antinoe),[48] one might make a case for Egyptianizing Classicism as being specifically set against or beside its Hellenizing counterpart in some of the most significant image-making of Hadrian's reign.[49]

Perhaps the key test of Hadrianic Egyptianizing Classicism is the obelisk of Antinous. Though it was found outside the Porta Maggiore in Rome in the sixteenth century and transferred finally to the Pincio by Pius VII in 1822, the

[42] For a further example of the parallelism of Dionysiac and Isiac imagery, one might cite the frescoes in cubicula B and D of the villa at the Farnesina in Rome. See Bragantini and de Vos 1982, 128–233. On "Dionysism" in Roman art, I am indebted to discussion with Stéphanie Wyler.

[43] See, e.g., Desrouches-Noblecourt 1999; Grenier 1999; Ensoli 1999.

[44] Raeder 1983, 205–7.

[45] Toynbee 1934, with, e.g., Kleiner 1992, 237–38.

[46] See the catalogues, Clairmont 1966 and Meyer 1991, with Meyer 1994a. On Antinous and the Greek renaissance of the second century C.E., see Meyer 1991, 213–35.

[47] Clairmont 1966, 6, n. 3. These appear as a subgroup of "Ägyptisierende Bildnisse" in Meyer 1991, 119–24.

[48] On Antinoopolis, with bibliography, see Boatwright 2000, 190–97.

[49] For the Egyptianizing portaits of Antinous, see Roullet 1972, 86–88 and 158; Meyer 1991, 119–23. For an interesting argument about the eclecticism of the portraiture of Antinous, see Hales 2003, 89–92.

Figure 8.6. Antinous as Bacchus. Rome, Vatican Museum, Sala della Rotunda. Normally dated 130–38 C.E. Photo: Alinari / Art Resource, NY.

Figure 8.7. Antinous. From Hadrian's Villa, at Tivoli. Normally dated 130–38 C.E. Rome, Vatican Museum, Museo Gregoriano Egizio. Photo: Alinari/Art Resource, NY.

original setting of the obelisk has been much disputed.[50] Scholars have proposed various sites in Rome,[51] or the Villa at Tivoli,[52] while others—including the authors of the most recent monograph on the monument—have suggested Antinoopolis in Egypt.[53] The debate about the original location has, typically, dominated discussion. In this case, it reflects more than simply the urge to the hypothetical positivism of lost origins, for if one can banish the most significant Hadrianic monument in Egyptian style (and with an extensive hieroglyphic inscription) to Egypt, then one can maintain all the more plausibly the pure Hellenism of Hadrianic Classicism, at any rate in Rome.[54] No arguments about the original place of display are conclusive (though the Canopus at Tivoli does seem a nonstarter). But what they reveal is an implicit debate about the nature of Hadrianic Classicism with the contrasting urges to separate the Egyptiana from the Hellenica (on the part of the Antinoopolis brigade) and thus effectively to keep Classicism Greek, and (on the part of the Roman lobby) to allow a greater variety than purely Hellenic materials into the melting pot of Hadrianic cultural genuflection to the past. At any rate, it is clear that the Aswan granite monument must have come from Egypt at *some* stage in its history—either in a state from which it could be carved in Rome in the second century or as a ready-made obelisk from Antinoopolis. It appears, on both these interpretations, to have been transferred (either from Egypt itself,[55] or from elsewhere in Rome)[56] to Elagabalus's circus between the Porta Maggiore and the Amphitheatrum Castrense (near what is now Santa Croce in Gerusalemme) for the celebrations of that emperor's Isantinoea festival in about 220.

The erecting of obelisks by the second century C.E. was itself not an activity without a certain cultural charge. Whether set up originally in Antinoopolis or Rome, Hadrian's obelisk constituted an act that consciously imitated the obelisk-raising of his predecessors—both as Pharaoh and as Roman emperor. The fact that, unlike most of the other Roman obelisks, this was not a *spolium* but a new object crafted on the ancient model and with a traditional hieroglyphic inscription,[57] indicates a strongly Pharaonic religious gesture—in tune

[50] For a brief history since the sixteenth century, see Iversen 1968, 164–73, and Meyer 1994b.
[51] For example, Erman 1896 and Hülsen 1896; Iversen 1968, 162–63; Grenier and Coarelli 1986.
[52] For instance, Kähler 1975; Derchain 1975; Hannestad 1983.
[53] Beaujeu 1955, 254–55; Boatwright 1987, 250–51, 258 (cf. Boatwright 2000, 193); and esp. Kessler 1994.
[54] This is certainly the burden of Meyer's discussion in Grimm et al., eds. 1994, 153–62, and Boatwright's concession to, but explicit underplaying of, the Egyptianizing of Antinous in Boatwright 1987, 256–58.
[55] The view of Boatwright 1987, 258–59, and Kessler 1994, 148–49.
[56] The view of Kähler 1975, 41–42.
[57] Domitian's obelisk, now in the Piazza Navona, was quarried and cut for inclusion in the Iseum Campense in about 80 C.E., before being transferred to Maxentius's circus on the Via Appia in the early fourth century. Its hieroglyphic inscription reports the names of the Flavian emperors. See Iversen 1968, 80–81.

with the other activities consecrating Antinous. If raised in Rome originally, the Hadrianic dedication would inevitably have fallen into the tradition inaugurated by Augustus in bringing two obelisks from the newly conquered Egypt in 10 B.C.E. to adorn the emperor's Horologium in the Campus Martius and the central division of the Circus Maximus,[58] and followed by numerous emperors, including Gaius and Domitian.[59] If erected in Egypt, Hadrian's obelisk would not only have been a Pharaonic gesture, but would have recalled Augustus's Forum Julium in Alexandria, laid out after the fall of Antony and Cleopatra in 31 B.C.E. and adorned with the obelisk—originally from Heliopolis—that Caligula subsequently brought to Rome and is now outside St. Peter's.[60] Thus, although an obelisk was in formal and stylistic terms an Egyptianizing monument, its raising and dedication were, by the time of Hadrian, honorably traditional activities associated with Roman emperors.[61] The classicism of the obelisk (by which I mean less the object as a gesture to Classicism than the imperial act of raising an obelisk as a kind of hallowed social ritual, classicizing in its active reference to the past) was as much Roman as it was Egyptian.

The inscription of the *obeliscus Antinoi*,[62] in what is apparently a very eccentric form of hieroglyphs,[63] would clearly have been incomprehensible to almost every viewer in Rome (literate as well as illiterate) and to most—except the very learned—in Antinoopolis. However, we should not exclude the possibility that translation was provided in the form of a caption perhaps—such as the remarkable and apparently originally relatively accurate translation into Greek of an obelisk inscription (possibly that of the obelisk of Tutmosis III, erected in Rome by Constantius in 357 C.E. and now outside the Lateran) which is ascribed to Hermapion and recorded by Ammianus Marcellinus (17.4.18–23).[64] What is striking in the text of the Antinous obelisk is a prayer offered by the new god Osirantinous (that is, Antinous assimilated to Osiris)[65] for the well-being of Hadrian and Sabina on what is now the north side,[66]

[58] On the Augustan obelisks and their afterlife, see Iversen 1968, 65–75 and 142–60.

[59] See Iversen 1968, 20 and 81.

[60] See Iversen 1968, 19–21.

[61] For Hadrian's restoration works in the Campus Martius in the vicinity of the Augustan obelisk there, see Boatwright 1987, 66–73.

[62] The most recent transcription and translation (into German) is Grimm 1994, with a French version after Grimm in Charles-Gaffiot and Lavagne 1999, 350. An earlier French version is in Derchain 1991, esp. 114–16. An English version, based on A. Erman's earlier German text of 1896 and 1917 is in Boatwright 1987, 243–46.

[63] See, e.g., Iversen 1961, 55, and Iversen 1968, 161.

[64] See Iversen 1968, 66–67, with bibliography. The text has been much corrupted in the manuscript transmission and it is not certain that it translates that of the Lateran obelisk (as Ammianus tells us) or another related to it.

[65] On the traditional assimilation of a deceased person in ancient Egypt to Osiris, see Hornung 1983, 96 and 134, and of a Pharaoh to Osiris on his death, see ibid. 192–93.

[66] Boatwright 1987, 243–44; Derchain 1991, 114–15; Grimm 1994, 29–39.

followed by a series of honors and invocations for Antinous, in his form as Osirantinous, relating specifically to his cult in Egypt. In particular the west face described the cult in Antinoopolis, the city "named after his name," and mentions the "troops of Greeks that belong to it": "The temple of this god, who is there called Osirantinous the blessed, is found in it and is built of good white stone,[67] with sphinxes around it, and statues and numerous columns, such as were made earlier by the ancestors [i.e., Egyptians], and such as were made by the Greeks. All gods and goddesses give him the breath of life and he breathes as one rejuvenated."[68]

Two issues are particularly striking here in relation to Classicism. First, Osirantinous is seen as a combination of Greek and Egyptian (as indeed he was, being Bithynian by birth and Egyptian in death), whose cult center combines objects of Egyptian type (such as sphinxes) and in Egyptian style ("statues and columns such as were made earlier by the ancestors") with statues and columns in Graeco-Roman style ("such as are made by the Greeks"). This speaks beyond the account of a particular temple in Egypt to the similar combination of Hellenica and Egyptiana in Hadrian's Villa and the combination of Greek and Egyptian styles in the extant imagery of Antinous—especially from Rome and Tivoli. Second, the context of this mixed or multicultural version of Classicism is religious. Not only the temple described in the inscription (and the very founding of Antinoopolis) but also the possible tomb in Rome and the obelisk's possible relation with that tomb, and additionally the very association of Antinous's portrait with various divine figures—all are effectively located in religion.[69]

The visual associations of Antinous—as the figure around whom Hadrianic classicism can be said to climax—combine the pluralisms of Classicism (for which I have been arguing) with those of religion. It has been suggested that Hadrianic religious policy followed a triple axis around the championing of traditional Roman religions, the Greek cults (including the mysteries), and the religions of Egypt.[70] This mix—whose supreme expression might be seen as the cult of Antinous, which united aspects of Roman *consecratio*,[71] Hellenic heroization, and Egyptian rite—has been presented as operating at the expense of the eastern cults,[72] whose imperial support systematically increased under Pius and his successors.[73] Be that as it may, the religious edge in the imagery of Antinous, something rather underplayed in most discussions,[74] should

[67] I wonder if this is meant to signify "marble"—which would render the temple strongly Graeco-Roman in addition to being Egyptian. Kessler 1994, 127, interprets the "white stone" as limestone.
[68] Boatwright 1987, 246; Derchain 1991, 116; Grimm 1994, 65–67.
[69] On the cult of Osirantinous, see Hölbl 1981, esp. 168–74.
[70] See Beaujeu 1955, 116–257, esp. 220; cf. Malaise 1972b, 419–27, on Egyptian cult.
[71] On Antinous and *consecratio*, see Wrede 1981, 34.
[72] See Beaujeu 1955, 258–59; on the cult of Antinous, ibid., 242–57.
[73] See Beaujeu 1955, 312–25 (Pius); 384–94 (Commodus).
[74] Not only Clairmont 1966 and Meyer 1991, but also the recent Cambridge thesis of Vout 2000.

perhaps be given greater emphasis—with the visual associations of Classicism (looking back to a privileged heritage) carrying a certain charismatic and sacred dimension.

On the narrowly art historical side, one might argue that the Egyptiana give a general cultural referent that is much less connoisseurially and stylistically nuanced than the precise references to very different Greek styles in the Roman reworkings of Greek art. That is, Roman Hellenic Classicism has a depth and precision of reference unequalled by other Roman classicisms. This is partly true and partly because the Greek material is so much more copious. But nonetheless the Egyptiana does distinguish between Pharaonic imagery and other kinds of more Hellenistic Egyptian imagery, especially in the allusion to Nilotic scenes, the imagery of pygmies, and so forth.[75] A certain stylistic diversity (and the implicit awareness of a chronological progression?) within the Egyptiana is certainly present in Roman art, even if its references are not so precise as those of the Hellenica. This chronological and stylistic subtlety is much less obviously the case in examining Roman appropriations of the arts of the near east. At the same time it must be admitted that the Egyptiana *are* a special case in one sense at least. Whereas the vast majority of other Roman visual appropriations (of Greek or eastern or Italic motifs, for instance) are cast in the broad range of styles that look back to Greek artistic practice, the Egyptiana in their Pharaonic forms necessarily signal Egypt. Yet, when such motifs are intermixed with Greek-derived motifs with the playful panache of the Casa del Frutteto, it appears that even Egyptian forms and styles have lost any sense of historicism, to become simply a matter of taste and whimsical artistic choices.

Orientalia

If we turn from the Egyptiana to other forms of non-Graeco-Roman Classicism in the Roman world, the most obvious area is iconography with an eastern slant. Here, especially in a series of so-called Oriental cults,[76] we have clear reference to varieties of eastern (non-Graeco-Roman) artistic forms in ways that align the cult to a foreign genealogy, ancestry, or sacred center. This is a specifically religious working of the process of Classicism as defined above, with visual production effectively asserting an identity rooted (at least in some fundamental aspects) in the east. Where such orientalizing Classicism differs from the Egyptiana is that the stylistic forms of the imagery are usually within the Hellenistic inheritance of Graeco-Roman naturalism (as opposed to attempts at blending these with Pharaonic styles). But the specific implicit

[75] Versluys 2002 is an outstanding catalogue.

[76] This is the usual term—as in Vermaseren 1981, Turcan 1989, or Liebeschuetz 1992, esp. 250–61 on "il culto orientale." The critique of the terminology in Beard et al. 1998, 246–47, is well-made, but without a clear replacement term.

claims of certain iconographic traits (from Phrygian caps to all the weird sacral paraphernalia of a Mithras or Cybele) function both to differentiate the cult from more narrative Roman imagery and to locate it (or its origins) in another world to the east.

Nowhere is the conjunction of religion and visual Classicism, which we have already touched upon in looking at Isiac forms and the Antinous cult, so clear as in the arts of the eastern religions. These—large numbers of surviving votive dedications, cult images, talismans, amulets, and altars—are effectively the archaeological efflorescence of the great golden age of religious pluralism, which flourished in the second and third centuries C.E.[77] One thing that unites these (actually deeply disparate) religions is the adoption of foreign imagery and its announcement of otherness—so Mithras's iconography propounds the cult's claims to Persian origins, that of Atargatis (the Syrian Goddess) looks to Syria and specifically the cult center at Hierapolis, that of Artemis Ephesia to the core icon in Ephesus, and so forth.[78] While such claims may have little to do with the actualities of cult activity—which in any of these cases in Italy may well have been far more Italian than in any sense eastern—it had a good deal to do with the affirmation of cult identity.[79] Before dismissing the eastern reference of this imagery (on what I earlier called "the consenting adults only" view) as an essentially private phenomenon supported by small groups of mystic initiates, it is worth noting the significant public profile of some of the images connected with some of these cults.

For instance, on the central barrier (known as the *spina* or *euripus*) of the Circus Maximus in Rome, just southeast of the spot where Augustus had erected his obelisk, a larger-than-life statue group of Cybele seated on a lion was dedicated, probably in the time of Trajan.[80] The statue—very likely of gilded bronze—appears to have worn Cybele's traditional mural crown and a long dress, and to have held various cult objects, among which a sceptre, a drum, and a pine branch have been suggested.[81] The group appears on numerous depictions of the Circus Maximus—from sarcophagi and reliefs to gems and medallions, and especially on late antique mosaic floors.[82] At least one version of the type is extant—originally from Nettuno and now in the Villa Doria Pamphili.[83] The Circus Maximus is just about as public a space as Rome had to offer and the presence of Cybele there clearly indicates that orientalizing

[77] On this, see North 1992.
[78] On these claims, see Beard et al. 1998, 278–83.
[79] Briefly on this, see Elsner 1997.
[80] See Humphrey 1986, 273–75.
[81] Humphrey 1986, 273 and 275. Generally on the iconography of Cybele, see Simon 1997.
[82] See Humphrey 1986, 206, 207, 209, 210, 211, 213, 215, 228, 230. Examples illustrated there include ibid. fig. 102 (sarcophagus from Rome), 105b (gem), 107 (Silin mosaic), 115 (Piazza Armerina mosaic), 119 (Barcelona mosaic), 120 (Gerona mosaic), 121 (Foligno relief), 122 (Maffei relief).
[83] See Palma 1977, no. 117; Humphrey 1986, 274.

Classicism (in this case part of a self-consciously multicultural grouping alongside the Augustan obelisk) had a public profile in Rome. Admittedly Cybele—or the Great Mother—had long been accepted as a deity within Rome, her temple having been built on the Palatine to house her sacred black stone early in the second century B.C.E.[84] Yet while her celebration in this public way was not outrageous (as an image of Mithras or Jesus might have been), it clearly marks the pervasion of at least some kinds of religious orientalizing Classicism into the public sphere.

Beyond such religious uses, we find iconographic reference to the east employed for quite specific purposes in both public and private art. Above all, the group of Aeneas, Anchises, and Ascanius from the Forum of Augustus,[85] represented in numerous versions from Campanian paintings and parodies to the public replica recently identified from the Forum of Merida in Spain,[86] shows Ascanius—Aeneas's son and heir—in a Phrygian cap and long-sleeved costume of the sort later to be donned by Attis, Mithras, and the Magi in Christian art. This is a highly iconic reference to the east, indicating the mythical genesis of Rome itself (as well as the Julian clan) from specifically Trojan origins, as related in the *Aeneid*. It stands in direct contradistinction to many of the other uses of eastern imagery in imperial art—namely, as ways of defining the defeated and conquered foe (as the Parthians were regularly presented under Augustus, dressed in similar costume).[87]

The exotica of conquered barbarians as well as the eastern costume of a mythological prototype like Ascanius enter the private sphere in all kinds of imagery from statuettes and gems (for example, of Ganymede) to mosaic floor decorations (including Ganymede and Orpheus) to wall painting (for instance, Paris).[88] Here again the eastern origins and setting of the myth—without specifically religious connotations necessarily—are indicated by the use of iconography that is classicizing insofar as it refers to a privileged model. As with the Egyptiana—though this time through the adoption of exotic iconographies rather than a mixture of foreign iconography and foreign style—the Orientalia in Rome offer a range of classicisms, in the sense of references that privilege and evoke a specific past, that may be said to complement or to compete with the Hellenica.

[84] On the cult, see Beard et al. 1998, 96–98, with further references at n. 89. On the temple, see, e.g., Pensabene 1996 with bibliography.

[85] See, e.g., Zanker 1984, 17–18; Zanker 1988a, 201–3, 209–10; Evans 1992, 114–16.

[86] For a brief survey of the "private" versions, see Zanker 1988b; for the Merida replica, see de la Barrera Antón and Trillmich 1996 and Nogales 1997.

[87] See, e.g., Schneider 1986, 18–97; Ferris 2000 (though rather more on northern barbarians than on Parthians).

[88] For Ganymede, see Sichtermann 1988; for Orpheus, see Garezou 1994; for Paris, see Kossatz-Deissman 1994.

Late Antiquity

I hope I have established that most of what went on in Roman artistic Classicism's appropriation of things Greek was equally (if not so extensively) applied also to the appropriation of other visual forms—Egyptian, Oriental, and so forth. It might be objected that all I have done is to engineer a perverse semantic redefinition of the means of Roman cultural assimilation under the term "Classicism," which comes to have a multicultural rather than monocultural significance in the Roman context, and which is used beyond style and form for the borrowings of iconography and motif. So what is the gain in the redefinition? First, I think it helps in understanding some of the traditional issues in the historiography of Roman art.[89] Effectively, my definition of Classicism is a way of describing the process of pluralism: We need not be surprised or worried by the range of artistic forms and styles espoused by the Romans, their eclectic mixture or their creative adaptation. What was on offer was an imperial culture actively using and redefining the whole range of materials within its possession (from the inherited styles of hallowed predecessors to the appropriated forms of conquered subjects) with relatively little systematic logic but often a great deal of antiquarian, religious, and multicultural sensitivity. This is too diverse and heterogeneous a mix, in my judgment, to amount to a visual language for the systematic expression and communication of even relatively straightforward messages, as Hölscher proposed. But— and this is my second claim—Roman Classicism was an extraordinary engine for cultural change. For, as cultural genuflections became appropriations, as frequent repetition of forms became their transformation, as the mixing of diverse (and once absolutely distinct) earlier contexts became a series of new syncretisms, Roman art proved a formidable machine for the creation of new cultural forms (especially—in late antiquity—for Byzantine, early Medieval, and Ummayad art). Ultimately, it would form a remarkable reservoir for future borrowing in the repeated classicisms of the Middle Ages and the Renaissance.

To take one example of this process, the image type of Endymion lying nude on Roman sarcophagi is adapted—with breasts added, penis removed, and some necessary contextual changes—to becoming Ariadne or Rhea Silvia. Here not only is the formal resemblance strong, but there is also a thematic linkage in that in each case the sleeping figure is approached by a divine sexual predator.[90] The same type, of the sleeping figure (now male again, as Endymion) but without a predator and again with some contextual adaptations, becomes Jonah resting beneath the gourd vine after his adventure with the whale in early Christian

[89] See the selective list of items in notes 2 and 4 above.
[90] See Koortbojian 1995, 63–113, with bibliography.

art.[91] This case is an iconographic one, where the same basic image type (derived from Hellenistic origins) can be seen to acquire a fluidity of meaning in its range of Roman uses that ultimately allows for its transformative move out of pagan and into Christian mythology.

On a more formal level, late antiquity turned to the extensive use of what have (somewhat controversially) come to be labelled as *spolia*.[92] These come in many kinds but all are intensely classicizing. There is the "hidden" reuse of old columns, architectural embellishments, even marble blocks, to make a new building look as grand as its ancient predecessors. This is clearly the case with the Arch of Constantine (of 312–315 C.E.), whose builders have been shown to have recycled most of its decorative details from earlier monuments,[93] probably in aid of making it look as much like the nearby Arch of Septimius Severus (of 203–204 C.E.) as possible.[94] But such hidden use of architectural features could swiftly become a process of display—as with the expensive colored marble columns looted from earlier buildings and employed flamboyantly in the most prestigious churches—Constantine's Vatican and Lateran,[95] Justinian's St. Sophia in Constantinople.[96] Here the building of Christian churches amounted to a break with the pagan past—an erasure of the very temples out of whose columns such buildings (and other churches like Sta. Sabina and Sta. Maria Maggiore in Rome) were constructed; but at the same time the churches appropriated the fabric of rejected antiquity to incorporate it into modernity. Further, when antique objects were not available for reuse, the next stage of spoliation was their imitation,[97] a form of Classicism that would ultimately come to define the Renaissance's relationship with its antique inheritance. On a nonarchitectural level, spoliation extended to the display use of earlier sculptures in new cumulative works of art, which might be described as mini-collections of prestige objects in their own right.[98] The classic example is the Arch of Constantine, with its appropriation of sculptures from works commemorating Trajan, Hadrian, and Marcus Aurelius alongside contemporary fourth-century reliefs,[99] but the phenomenon is typical of treasures throughout

[91] See especially Gerke 1940, 120–29; also Mathews 1993, 30–33.

[92] Fundamental literature includes: Esch 1969; Deichmann 1975; Settis 1986; Poeschke and Brandenburg 1996; the various studies of Pensabene including Pensabene 1993, Pensabene 1995, and especially Pensabene and Panella 1993–94; Kinney 1995; Kinney 1997; Esch 1999; Hansen 2003.

[93] See Kähler 1953, 28–36; Pensabene 1988; Pensabene 1999; Pensabene and Panella 1993–94, 174–215; Wohl 2001.

[94] See Jones 1999.

[95] See Kinney 2001, esp. 142–45 on column displays.

[96] Mainstone 1988, 181 (with n. 28), 189.

[97] So-called *spolia in re* or "virtual spoliation," on which see Brilliant 1982; Settis 1986, 399–410; Kinney 1997, 137, and Cutler 1999.

[98] See Forsyth 1995; Siena 1999.

[99] See, e.g., Elsner 2000, with bibliography.

the middle ages, such as the ambo of the Ottonian Henry II at Aachen.[100] In all these cases, whether the initial motivations for reuse were pragmatic or aesthetic or both, there is little doubt of a general ideological dimension that gestured to the Classical heritage. Such spoliation is not simply Classicism in the sense of emulation and reference. It extends to the actual incorporation of the past (in the form of earlier pieces)—not as self-standing trophies like the obelisks or the Apollo Sosianus pediments, but as intrinsic and integral elements of a new kind of monument syncretistically constructed from prize materials of the past and present.

Both my late antique examples draw on the Graeco-Roman mainstream of Classicism in Rome, their urge being to appropriate the heritage of Roman culture for later Christian ends. But late antique Classicism also borrowed from the Orientalizing and Egyptian models on offer in Rome—not least in the iconography of the Magi, who consistently adopt the eastern dress of a Mithras in sarcophagi, paintings, and mosaics.[101] A wonderful instance of the late antique mixing of Egyptiana and Hellenica, now in a new mélange that hardly distinguishes between the two stylistically since both are rendered in the non-naturalistic expressionism of the fourth century, is the panel of Hylas and the nymphs from the Basilica of Junius Bassus from the Esquiline in Rome (fig. 8.8).[102] Here, in the *opus sectile* hardstone technique much beloved of late Roman interior wall decoration, in a highly elite context (Bassus was consul in 331 C.E.), the main scene represents Hylas dragged into the waters by the nymphs—a traditional iconography with deep roots in Roman wall painting, mosaics, and sarcophagi.[103] Below it, in what appears to be the hem of a draped cloth or curtain that seems to be hanging beneath the image, is an Egyptianizing frieze of figures.[104] Whether we can impute specific meanings beyond the decorative to this so-called vela Alexandrina, as luxury embroideries from Egypt have been named after Pliny (*HN* 8.74.196), is a moot question.[105] But in terms of the issue of Classicism addressed here, there is no doubt that an Egyptian as well as a pagan Graeco-Roman mythological reference are here intended in the context of a major monument erected by a consul late in the reign of the first Christian emperor. All these allusions strike the drum of Hellenism (as it has been called) in the Christian empire,[106] affirming

[100] See Mathews 1999.
[101] See, e.g., Vezin 1950.
[102] The principal discussion of the basilica remains Becatti 1969. On the panel, see Paris 1990; Sapelli 2000 with recent bibliography; Vout 2003, 196–200.
[103] On the theme generally, see Oakley 1990. On the wall paintings, see Ling 1979; on the mosaics, see Muth 1999.
[104] This and a parallel drape beneath the accompanying panel of a chariot rider, perhaps Bassus himself, which no longer survives, were much more extensive originally, as shown by a series of seventeenth-century drawings on velum, now at Windsor. See Becatti 1969, 191–93, and tav. LXVI.
[105] Becatti 1969, 193, looks beyond the purely decorative.
[106] See Bowersock 1990, with 42–44, 52–53, 55–69 on Egypt and objects from Egypt.

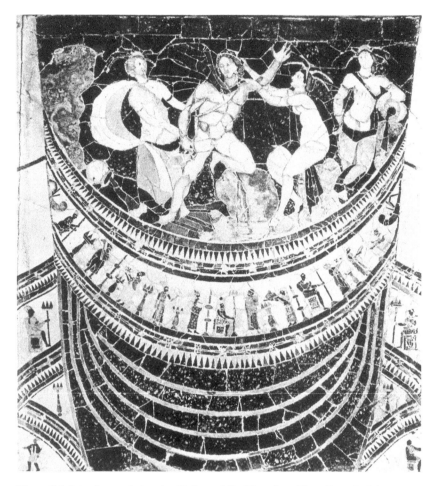

Figure 8.8. Intarsio panel showing Hylas and the Nymphs with an Egyptianizing border representing a cloth with Egyptian motifs. Made in the *opus sectile* technique of sawn marble, hard stones, and glass paste. From the Basilica of Junius Bassus, Esquiline Hill, Rome. Ca. mid-fourth century C.E. Photo: DAI Inst Neg: 78.1367.

the grandeur, antiquity, and continuity of pre-Christian traditions within the new dispensation.

This very brief account of some aspects of late antique Classicism indicates that what late Roman image-making inherited from its past was not only the objects and models out of which to fashion new images. Beyond this, it was also the *process* of this fashioning—what I have called Classicism itself— adapted to new kinds of appropriation (like *spolia*) and to new ends (like the creation of a specifically Christian art and architecture). In borrowing Clas-

sicism, late antiquity's artists took from their predecessors a fundamental methodology that would underlie their practice. My suggestion is that, although versions of Classicism existed in pre-Roman culture (especially in the arts of the Hellenistic monarchies and in Etruria) it was the Roman world's systematic development of this method that would come to establish it as so characteristic and distinctive of the western visual tradition. Within Rome, Classicism was a means of acculturation and a technique of appropriation and syncretism that allowed the invention of an imperial aesthetic suited to an empire stretching across languages and cultures from Britain to Africa, from Syria to Spain. But historically (looking backwards and from the outside as it were), Classicism constituted one of Rome's principal contributions to the visual arts. The Roman empire did not invent naturalism or any of the original Graeco-Roman innovations within the history of art; but it did perfect Classicism and bequeath the method—perhaps the most distinctive and long-lasting method of visual transmission across the centuries in the west.

PART VI

Imperial Prose

Chapter 9

FEELING CLASSICAL: CLASSICISM AND ANCIENT LITERARY CRITICISM

James I. Porter

> "Why are you silent, dearest one, and don't say anything to me?"
> "Because, Cleitophon," she said, "my voice has died before my soul has."
> —Achilles Tatius, *Leucippe and Cleitophon* 3.11.2

CLASSICISM is a troubling phenomenon. Hard to define and to get hold of in any age, is classicism something we can even grasp in antiquity? I believe we can, and that one way of approaching the problem of classicism in antiquity is through the phenomenon of its ancient apprehension. To do this, we need to ask the following kind of question: What does it feel like to be classical, or to be in the presence of whatever is felt to be classical?

A good place to begin would be with an example from the end of the fifth century B.C.E., 405 to be exact, for it was in this year that Aristophanes produced his comic play *Frogs* in the Lenaean Festival and took first prize. The second half of the play famously features two deceased tragedians, Aeschylus and Euripides, spouting their own verses and vying for first honors in posterity and the Chair of Tragedy. This spectacle has been called an inaugural moment in the sensibility of classicism, for obvious reasons. It bears all the hallmarks of classicism traditionally understood: it is retrospective, tinged with nostalgia, venerating, canonizing, and so on.[1] I do not want to deny any of these facts, but they do miss one important element of the spectacle, which goes beyond a musealizing admiration and involves a sense of vividness and presence in the face of what is definitively past.

Suppose classicism rests on this kind of illusion, the sensation that you can actually feel the presence of a classical original. In the world of literary classicism, what better way to indulge in this desire than to hear an author's original

Thanks especially to Joy Connolly, Jaś Elsner, Erik Gunderson, and Tim Whitmarsh for helpful comments on earlier versions of this essay.

[1] Cf. Schadewaldt 1931, 25; Körte 1934, 9–10.

voice, and in the case of theater, to have her before you on stage, representing and quoting herself? Indeed, what better *emblem* for this desire than the live re-performance, not of tragic plays, as in the case of the theatrical revivals that would contribute to the survival of classic plays, *but of the tragedians themselves*? With Aristophanes' *Frogs*, going to theater is like going to a museum, only the museum here is so to speak coming to its audience, live. This emblem of a classical desire is emblematized a second time within the play itself when the goal of its action is announced: to bring a dead poet back to life. There is a sly concealment of the obvious at work here. For although at first it is Euripides whose reanimation is sought while in the end it is Aeschylus who is returned to the living, having won the title to his chair (and so, curiously, made to *vacate* it), the joke of the play lies in the fact that the mere presentation on stage of either character or both of them together (depending upon one's aesthetic preferences) fulfills in reality the wish for the return of the late great tragedians even before the wish can be fulfilled in fiction.[2]

Frogs thus spectacularly expresses and fulfills the fantasy of classicism in a comic form. And, as later on, classicism is here fundamentally bound up with the dynamics of reading and performing the voice of a past author. Nor should we be fooled by the illusionism of the stage into imagining that the theater and the place of reading are distinct. The place of reading is itself a theater of classical revival. It is, after all, the desire of readers as well as viewers—Aristophanes' fifth-century Athenian audience—that *Frogs* is seeking to still. Lest there be any doubts about the matter, consider how Dionysus initially conceived his passion for Euripides:

> DIONYSUS: And, anyway, on the ship I was reading *Andromeda* to myself (πρὸς ἐμαυτόν), and suddenly my heart was struck with a longing (πόθος), you can't imagine how hard. [. . .]
> HERACLES: So you had it off with Cleisthenes, did you?
> DIONYSUS: Don't make fun of me, brother; I really am in a bad way, such is the passion (ἵμερος) that's ravaging me.
> HERACLES: What kind of passion, brother dear?
> DIONYSUS: I can't describe it; but none the less I'll explain it to you by analogy. Have you, before now, ever felt a sudden desire (ἐπεθύμησας) for pea-soup?

[2] Resuscitations are of course part and parcel of comedy's irreverent intimacy with the past. In *The Demes*, Eupolis revived Solon, Miltiades, Aristides, and Pericles; Aristophanes' *Gerytades* has Athenian poets sending an embassy on an unknown mission to Hades; Aeschylus speaks in his own voice in a fragment from Aristophanes (fr. 696 *PCG*) and in another by Pherecrates (*Crapataloi*, fr. 100 *PCG*); in 449, Cratinus's *Archilochoi* featured a contest between Archilochus (and retinue) and Homer (and possibly Hesiod); and Cratinus's *Prytine* featured himself (possibly, as Niall Slater suggests *per litt.*, either as a self-classicizing gesture, in a kind of "self-revival," or by way of resisting classicization, viz., his being cast as an exemplar of the past, in the way that Aristophanes had treated him in *Knights*). Less spectacular but no less effective as reminiscence of the past is the high frequency of allusions to tragedy in comedy, especially those to Aeschylus by Aristophanes and his rivals (Becker 1915).

HERACLES: . . . I understand perfectly.
DIONYSUS: Well, that is the kind of yearning (πόθος) that is devouring me for—
 Euripides.
HERACLES: You mean even though he's *dead*?
DIONYSUS: Yes, and no man on earth will be able to dissuade me from going in
 quest of him. (*Ran.* 52–69; trans. Sommerstein)

Dionysus is suddenly struck—with a canonical and classical desire. His disparagement of the present and his unqualified worship for the past (vv. 71–96);[3] his willingness to plunge into the dead past—Hades—in order to experience it again ("and lower down still, by Zeus, if there *is* anywhere lower," 70); and very likely his change of mind in favor of Aeschylus, are all dictated by Dionysus's classicism.

Perhaps. There is a crucial ambiguity to Dionysus's judgment: he famously can't seem to make up his mind. One of the obvious reasons has to do with the relative literary value of the two tragedians he is weighing in his mind. Another has to do with the inherent absurdity of choosing between them (although it may be that Aeschylus is more acceptably "classical" than Euripides, if that is the criterion that finally matters). But there is a third consideration. For a grotesque afterthought of the play, but one that is easily overlooked, is just how Athens would adapt to the return of Aeschylus in its midst. Revivals of Aeschylus, which are documented for the late fifth century and in the play itself ("My poetry hasn't died with me," 868), are one thing. But a full-blooded return of Aeschylus to tragic competitions would be quite another. The spectators are, as it were, protected from the return of Aeschylus by the same theatrical conventions that allow him to appear at all. Were Aeschylus actually to return to life, with his outmoded tragic idiosyncracies (the very features that make him a "classic"), a panic would ensue. How desired is he in fact? No doubt, ambivalently. Dionysus's equivocations of judgment reflect some of this ambivalence, and it would be hazardous to assume that Aristophanes is doing anything other than qualifying, if not mocking altogether, the belief that Aeschylus is the key to the resuscitation of Athenian greatness.[4] In the exact same way, classicizers who enjoy a readerly relation to their authors are protected by the disavowed

[3] Cf. vv. 92–95: today's tragic poets "are left-overs, mere chatterboxes, 'quires of swallows,' debauchers of their art, who, if they so much as get a chorus, disappear again pretty rapidly after pissing over Tragedy just once."

[4] "Since Aeschylus' career coincided with the great days of old, an error of logic which people find irresistible at a time of uncertainty and self-criticism could easily generate a belief that revival of Aeschylus would *cause* a revival of the great days of old" (Dover 1993, 23–24). Aristophanes, on my view, will have resisted this belief, and will have seen through to its underlying desperateness. And in any case the survival in question, though necessarily connected to political images (Sommerstein 1996, 9), is of "choral festivals" (ἵν᾽ ἡ πόλις σωθεῖσα τοὺς χοροὺς ἄγῃ, 1419). Protzmann 1972–73, 82, points out that the militarism of Aeschylus can only have been equivocally received by a war-weary audience.

knowledge that the presence they pursue will forever elude them. They are screened *from* their desire by the very same object that acts as the screen *of* their desire: the text they are reading. Classicism thrives on this disavowed fantasy.

Of course, Aristophanes is far from satisfying this or any classical desire *tout court*. *Frogs* is magnificently self-aware, and classicism is dished up at a price. If so, then we can say that the play is evidence not only of the early onset of classicism but also of its early critique. Metatheatrics and the comic ambience necessarily qualify the experience of classicism that the play appears to put on offer. Or perhaps we should say that Aristophanes dangles the idea of classicism before his audience, but just beyond satisfying reach: it never appears except to be withdrawn, or mocked. To be sure, the greatest source of evidence for the classicism aimed at in the play is the least recoverable. For behind everything is the lost but inferable evidence of the theatrics themselves, the tragic voicings and gestures, which would have guaranteed the authenticity of the experience to an audience bent on recapturing a former literary greatness. As Oliver Taplin points out in another context, "There was surely a tragic timbre to the voice, and a tragic poise to physical movement and posture, which comedy would also exploit. I suspect that a single gesture or a single syllable was often sufficient to indicate paratragedy." Taplin's comment is directed elsewhere, but we can well imagine how paratragic antics would have been lavished upon the performance of *Frogs*, at once satisfying and frustrating the desire to hear the voices of the past enacted on the stage.[5]

Once again we find literary criticism playing a leading role in the servicing of this desire to hear the *ipsissima verba* of an author. Although *Frogs* is hardly the first instance of literary criticism in antiquity, it is one of the most sustained early instances that we know about (a surviving hypothesis twice rightly calls the drama φιλόλογος).[6] But since the very thought of classicism (if that is what we have here) involves at least a minimal critical reflection on the question of classicism, this prominence of criticism in the play is what we should only expect to find. The sought-for voices of Aeschylus and Euripides, already contaminated by the falsetto of an actor's recreation, would have been doubly contaminated by the gimmickry of stage business, with actors hamming up their lines at every conceivable turn. Then there is the critique within the performance, the *agōn*, mercilessly whittling down to size the grandeur of both

[5] Taplin 1986, 170. Cf. Dion.Thrax. *Ars gram.* 6 on the virtues of learning delivery (*hypokrisis*): "so that we will read tragedy in a heroic manner (ἡρωϊκῶς), comedy in a lively manner (βιωτικῶς), elegy piercingly (λιγυρῶς), epic vigorously (εὐτόνως), etc." Cf. further Sch. in Dion. Thrax 16–22 Hilgard.

[6] "It has a delightful (τερπνήν) and learned (φιλόλογον) plot.... The drama is among those compositions that are both very well made and that display a love of literary learning (τὸ δὲ δρᾶμα τῶν εὖ πάνυ καὶ φιλολόγως πεποιημένων)" (Hypothesis I). The play is commonly regarded as one of the earliest instances of technical literary criticism (e.g., Russell and Winterbottom 1972, 15–38; Harriott 1969, 148–61). Dover 1993, 24–37, foregrounds the role of popular and conventional sentiment in the play (as it were, ordinary language criticism).

poets. With his ungainly compounds, his swollen verbal obscurities ("sheer massive mountains of words that it was very hard to work out the meaning of," vv. 929–30), his bag of tricks and theatrical deceptions, Aeschylus, the playwright whom the play awards as the more classical of the two authors, stands rather nakedly before the audience in the end. Worse, the play offers us competing visions of a vanished ideal of literary perfection, two forms of classical dramaturgy to choose from. Apart from the obvious absurdity of this forced choice (how can one seriously decide between two poets of comparable stature?), there is the further absurdity that classicism is itself prone to dissonance and disagreement: its consensual appearance notwithstanding, and despite the aura of sanction it everywhere carries, classicism is as we saw the breeding ground of dissension and not of agreement. Agonism (competition), which is the source of greatness, cannot help but turn against itself, leaving us with nothing but wary and uneasy ambivalence. Not ritual communion and a past unequivocally regained but unease, uncertainty, and a certain despair about the desirability even of the past, are the inevitable remainders of the play.[7]

My point is simply that if classicism has any claim to existence in the late fifth century, and if that existence is predicated on the kinds of descriptions of it that I offered above, then Aristophanes has to be seen as commenting upon the phenomenon, critically indulging in it, and distancing himself (and us) from it at a stroke. That is, Aristophanes' *Frogs* not only presupposes classicism; it also stages—puts on critical display—the ideals of classicism. To make the same point in a different way, *Frogs* is a critical study in canon formation and value determination, and in many ways it is a critique of classicism, a demonstration and an exposure of the process by which value comes to be assigned in a culture. On trial are not the relative merits of two great Athenian poets but the means by which their greatness comes, and inevitably fails, to be measured. It is a fair assumption that Aristophanes has in his sights two targets: both the general cultural mechanisms of valuation and evaluation, as it were the ideology of value found in contemporary Athens, and also the incipient arts of criticism themselves, of the sort that were being experimentally developed by the sophists and other intellectuals towards the end of the fifth century and which doubtless played a part in the justification and legitimation, but also the querying, of wider cultural values at the time. Classicism and criticism are mutually implicated from the first, as they will continue to be in the centuries to come. Intrinsically nervous about itself, classicism naturally gives rise to the critical act, which is at once validating and querying, and so classicism's double, its outward gesture and "voice."

Aristophanes allows us to begin sketching out a model for gaining access to classicism long before classicism attains the status of a concept and a name. Here, we can approach classicism as a set of feelings and attitudes towards the

[7] For a view of harmonies regained, with fleeting concessions to their illusoriness, see Segal 1961.

past. To take Aristophanes as a model for this kind of approach to the problem of classicism in antiquity involves making a few assumptions. First, and most obviously, one has to assume that classicism is indeed a part of the classical past. That is, if we are willing to grant an initial coherence to the notion of classicism, it seems fair to say that classical Greece produced a form of classicism internal to itself, at the very least by the end of the fifth century. A word we know but the ancients did not, *classicism* nonetheless designates a set of attitudes and behaviors that can be described and discussed. By this term, in what follows, I will understand the privileging of what were then (and often still are) considered to be the highest cultural achievements of the mainly Athenian fifth and fourth centuries B.C.E. and of some of their more impressive Greek predecessors. This is demonstrably the case within the field of literature and criticism, which will concern us here. My interest, however, will be centered around the more troubled aspects of classicism's definition, by which I mean its various illogicalities and its fundamental incoherence, which I believe likewise originated in antiquity and were passed on with the classical inheritance into the modern world. Attending to these less well noticed elements of classicism will help to illuminate some of the more symptomatic features of literary classicism in antiquity.

Classicism, the studied attitude of reverence to things classical, which is to say to products of culture that are felt to be exemplary and of the first order, is in any age a curious phenomenon. On the surface self-assured and Parnassian in its dictates, at a closer remove classicism reveals a number of interior fault lines. To begin with, classical values, qualities, and criteria are generally contested, and consensus is rarely achieved. Indeed, for all their seeming self-evidence, the attributes of classicism and the classical suffer from underdefinition rather than from overdefinition: they tend to be difficult to name and describe (this is the source of their ineffability), hard to locate empirically, are frequently vague, and are even more frequently incoherent, a sum whose parts fail to add up, or do so only in a quick blur. Classicism cannot escape the paradoxes of its own definition. Presenting a front of timeless durability, classical values are in fact grasped only as fleeting and ephemeral moments that can be pointed to just when they vanish ("There!"), while all that remains of them once they are gone is the empty gesture of pointing itself, which may in the end be all that classicism can rightfully lay claim to.[8] Finding an instance of a genuinely classical object, let alone an object that is fully "classical" in all of its features, can often prove an elusive task, but this elusiveness is part of the allure of classicism. That is the chief source of their mystify-

[8] The remark of Dionysius of Halicarnassus, that "there is in fact no single clear distinguishing mark (παράσημον αὐτῆς ἐκφανές)" of Demosthenes" style (*Dem.* 50), is both a confession about this indeterminacy and a claim to a higher authority in matters of taste and discrimination. The musical qualities of style come to stand in for what is most fleetingly and difficultly apprehensible in style (see below).

ing power, which is purely ideological. Indeed, the alleged self-evidence of the ideals of classicism is belied by the very lack of evidence for them. Their contingency and their particularity is absolute (they exist in matter and in time; they are steeped in cultural politics), but all of this contingency has to be erased, whether through suppression or open disavowal, for them to appear at all. Their existence is upheld by the most irrational of experiences: they simply *are*, like a revealed truth, and no amount of logic can refute or explain the fact. And yet, the very adamancy with which the truths of classicism are stated suggests the opposite of the claims: classicism is in fact always in question and uncertain of itself.

Toward a "Phenomenology" of Classicism

Given that classicism is so elusive, and that it arguably describes not a series of real properties in the world but a set of attitudes about the world, how can we ever hope to get at the phenomenon of classicism? One way is to consider its phenomenology, by asking the question that I posed above: What does it feel like to be classical, or else to be in the presence of whatever is felt to be classical? Listen to Marcus Piso, who traveled with Cicero to Athens and was struck with what happened to him when they reached the site of Plato's Academy:

> Whether it is a natural instinct (*naturane*) or a mere illusion (*an errore quodam*), I can't say; but one's emotions are more strongly aroused (*moveamur*) by seeing the places that tradition records to have been the favorite resort of men of note in former days, than by hearing about their deeds or reading their writings. My own feelings at the present moment are a case in point *(nunc moveor)*. . . . Indeed the garden close by over there not only recalls [Plato's] memory but seems to bring the actual man before my eyes. (Cic. *Fin.* 5.1.2; trans. Rackham; modified)

The reaction of Piso, a young Roman steeped in Greek learning and now embarked on the Grand Tour, was typical. Indeed, one by one Piso's friends compare notes, bashfully and proudly divulging their own epiphanic experiences in Athens and elsewhere in Greece, each moment described with intense emotion. Cicero's brother Quintus, passing through Colonus on the way to Athens, had a vision of Sophocles, then of Oedipus. Cicero looked upon the seat in which Pythagoras sat. Lucius (Torquatus) visited the places of Demosthenes and Pericles. Only the voices of these figures from the past were felt to be missing. The Roman youths vow to emulate (*imitari*) their role models.

To judge from their own accounts, it seems clear that exponents of classicism in antiquity wish, at least in appearance, to stand close to their classical forebears so as to commune with them. They wish to see themselves differently, or at the very least to let themselves be seen differently, from the way they

would appear in the absence of this connection to an exemplary past that is surrounded by "eternal perspectives" (*sub specie aeternitatis*).⁹ To take such a stance is to be ennobled by this past, becoming as it were its proud possessor and inheritor. This proximity in imagination brings with it a proximity of feeling: the feeling of nearness and of vivid presence, of identification if not also of momentary identity with the source of classical values, the classical past.¹⁰ Doubtless the identification is often strategically aimed: it is a convenient way of accumulating or spending cultural capital. And in fact a survey of typical areas of classicizing activity in Greek and Roman antiquity would be tantamount to a survey of modes of strategic identification. But we should not discount the depth or complexity of the feeling for that reason alone, however much the feeling may resemble or even be a mere ideological projection.¹¹ The point is simply that the language of classicism is steeped in the language of feeling and affect. This connection is not haphazard, and it needs to be explored.

Classicism, normatively speaking, at a minimum brings with it a feeling of being worthy of inherited classical values and at the limit of being classical oneself, of being an embodiment of classical values. This, at least, is what the ideology of classicism requires and seeks hard to achieve: it seeks to instill a feeling, the feeling of proximity to or identity with what is classical. Imitation through emulation belongs here: it is the wish to take on the qualities of whatever one reveres. But while the feeling that accompanies the appropriate stance and attitude towards the classical past is one that can be learned or put on and affected, there is another way in which the feeling of being classical comes to be assumed. For above all it happens, as it were, before one knows it: it takes place in the very presupposition of a classical past, of a past that can address itself to the present and can make its values felt and heard. For this reason, feeling classical is both an inarticulate experience of the highest order (it is felt, but not named) and the source of seemingly endless articulation (it asks to be named and described, to be put into language).

How do we gain access to this feeling? One way is to attempt to reconstruct the *habitus* of classicism. Following Bourdieu, we can understand *habitus* as a set of dispositions that organize social behavior in a way that eludes articulation (it can be nonintentional, preconscious, and often purely bodily). That is, *habitus* describes something like a map or scheme of practices, perceptions,

⁹ Cf. Nietzsche 1974, §78.

¹⁰ The same logic holds for modern identifications with the classical past. As Beard and Henderson 2001, 11, note, the discoveries at Pompeii during the eighteenth century were as powerful as they were because of the opportunities for identification they entailed: "But what caught the imagination more than any individual object was the sense that here whole cities lay buried; that here for the first time you could experience how it might *feel* to look around the ancient world" (italics in original).

¹¹ This takes us into the intricacies of the logic of self-deception and feeling, on which see Nietzsche 1967, 426–27. See further Hinds 1998, 90 (quoted in the Introduction, above).

and conceptions. It directs us to the inarticulate knowledge of the practitioners of a given social field (or "game"). And finally, but no less importantly, it designates a realm of (often unwitting or half-witting) identifications that is uniquely appropriate to the problem of classicism.[12] If only modest progress has been made in exploring classicism in these dimensions (the work that has been done in the field of Greek and Roman cultural identity is usually made in the name of Hellenism, or of Greekness and Latinity, rather than of classicism per se),[13] even less attention has been paid to the question I want to confront—namely, about the sensation one has when reading a classical author, which is to say the inculcated *habitus* of literary classicism, the feeling of being in the ambit of what is classical and at the limit of actually being classical oneself.

Now, in the realm of literary classicism, the question of what one feels is bound up with the question of how one experiences a classical text; and that, as I want to show, is bound up in the first instance with the question of what one hears or thinks one hears. If this is right, then the *habitus* of classicism in literature draws much of its force from this experience—be it had, imagined, or merely touted—of the past. Shifting our focus from texts to their experience, and from values to feelings, is one way of reorganizing our study of the classical past. To be sure, this is what studies of literary and at times philosophical feelings (pleasure, fear, catharsis, and the like) are all about. But in question here, where the domain of literature is concerned, is not the study of literary feelings per se, but their subordination to the overarching program of literary classicism and to an experience that feels distinctively classical. A close parallel might be the feeling one has when one (feels one) belongs to a certain class.[14]

Luckily, we have as it were a privileged access to this dimension of ancient experience in the realm of literature. For apart from the wide scattering of remarks made in passing by individuals who testify to their experience of written texts, to what they claim to hear and feel when they read canonical

[12] For instance, *habitus* has a historical dimension that is absolutely central to it, both as a constituent element and in being constitutively denied ("detemporalized"). "The body believes in what it plays at: it weeps if it mimes grief. It does not represent what it performs, it does not memorize the past, it *enacts* the past, bringing it back to life" (Bourdieu 1990, 73). As Bourdieu's language suggests, a subject who is inhabited by a *habitus* is both knowing and unknowing at the same time, both a strategic player and a willing dupe of the social game at which he or she excels. Cf. ibid., 53–54, 60, 76 (citing "the *gravitas* of a Roman senator"), 108–9. For a recent useful (if slightly critical) application of Bourdieuian *habitus* to Roman rhetoric, see Gunderson 2000. Dio Chrysostom's claim to weep while reading Xenophon's *Anabasis* (*Or.* 18.16) is a good example.

[13] See Saïd 1991; Gleason 1995; Porter 1999; Gunderson 2000; Alcock et al. 2001; Goldhill 2001. Exceptions include Bowie 1974; Woolf 1994; Swain 1996; and Connolly 2001; and to an extent Whitmarsh 2001.

[14] Approaching the past through its phenomenology is a tack that has been taken in archaeology (Shanks 1992; Tilley 1994), in Roman history (MacMullen 2003, but one could also point to the recent spate of studies on ancient emotions, such as shame and anger), and in early modern literature and culture (Smith 1999), although my own inspiration here has been the work of Raymond Williams.

works from the past, a large component of ancient literary criticism and theory is in fact devoted to the question of how classical texts sound. A small, seemingly marginal strand within this discipline is devoted exclusively to this question. It only remains to connect the question of sound to that of classicism again, which is what I hope to do here, by treating sound as a gateway to feeling.

Sound affords a promising entrée into the problem of classicism, because the way language sounds is in itself a marker of status. The question is directly bound up with standards of correctness and purity (as legislated by the requirements of "pure Greek": *hellenismos* and Atticism) and so too with classical models of speech and expression. Indeed, the concept of *hellenismos* contains within itself dictates of sonority: the heart of Attica, "untainted by barbarians"—which includes Pontines and Thracians, who are conceivably Greek—is where one goes to find a "language that remains uncorrupted" and a dialect that "sounds the purest strain of Atthis" (ὑγιαίνει αὐτοῖς ἡ φωνὴ καὶ ἡ γλῶττα τὴν ἄκραν Ἀτθίδα ἀποψάλλει) (Philostr. *VS* 553).[15] Such is the myth of pure Greek, or *euglōttia*. But sound promises more than this alone. Sound conjures up associations that are distinctive, in part because they are so abstract and in part because they are so basic and so pervasive. At once removed from structures of meaning, sounds create levels of coherence that run deeper than meaning—and even deeper than the more formal patterns of feeling, such as Aristotelian pity and fear, or the more diffuse moral emotions of propriety or grandeur (which they could also be felt to underlie). As we shall see, the associations that come with sound conjure up a realm of pleasures that are immediate, sensuous, and ultimately ideological.

Pleasurable associations like these reinforce the idea that classicism is itself a pleasurable practice. Indeed, in later Greece the image of pure Greek conjured up the totality of the past. As Benedict Anderson observes in a parallel context, "Nothing connects us affectively to the dead more than language. If English-speakers hear the words 'Earth to earth, ashes to ashes, dust to dust'—created almost four-and-a-half centuries ago—they get a ghostly intimation of simultaneity across homogeneous, empty time. The weight of the words derives only in part from their solemn meaning; it comes also from an as-it-were ancestral 'Englishness.'"[16] *Mutatis mutandis*, reviving the pure and correct Greek of the

[15] That pronunciation lies at the heart of *hellenismos* is plain from, e.g., Sext. Emp. *Math.* 1.227 (προοισόμεθα) and *De hellenismo et atticismo* in Koster 1975, 19, where two of the ten differentiating criteria are comprised by *ta pneumata* (rough and smooth breathing) and *tonoi* (pitches, viz., accentuation). Cf. Cic. *De or.* 3.43 ("Any uneducated Athenian will easily vanquish the most erudite Asiatics not in word-choice but in the tone of his voice, and not so much in the correctness as in the charming manner of his speech [*non verbis sed sono vocis nec tam bene quam suaviter loquendo*]"); Isid. *Orig.* 9.1.4 ("Greek is *sonantior* than Latin and all other languages"); and Wilamowitz-Moellendorff 1900, 1–4, 6–7. *Mutatis mutandis*, the same holds for Latinity (cf. Cic. *Brut.* 132–35; and Gunderson 2000, 37).

[16] Anderson 1991, 145.

Attic ancestors performs the same function for Greeks in Egypt or in Rome. Finally, or what amounts to the same thing, literary criticism based on sound (euphonism) cuts across critical genres and time periods in a way that few other forms of criticism do: from Gorgias to Longinus and beyond, no literary aesthetics denies the power, or the pleasure, of sound. Reinserting the role of sound into this history, not as a superficial feature, let alone one that can on occasion appear to be overvalued, but as a symptom of deeper tendencies that often elude straightforward expression, will bring out a hidden dimension of the whole range of ancient literary criticism. Classicism is one of the resources of this tradition, and the attention given to sound by critics, by which we have to understand the distinctive sound of classical texts, is one of its most direct expressions.

We need today to recover a sense of classicism in antiquity as a practice and a *habitus*, and not just as an attitude of mind, a style (in the formal, aesthetic sense), or a pedigree.[17] Sound, being immediately tied to feeling at its point of reception, in a *pathos* (sensation) that is *alogos* (irrational), is connected with the set of feelings that are associated with classicism.[18] That the documents of literary criticism can help illuminate the nature of classicism in the Greco-Roman world is a well-accepted fact. By focusing on the question of sound as it connects to feeling (and not merely to sensation), and by asking questions about the relationship between euphony and criticism, we can hope to locate something like the function of criticism in the ancient world, while at the same time discovering some of the broader functions of classicism in the cultural politics of Greece and Rome.[19] That, at least, is the thesis I want to begin exploring in the present chapter.

Structures of Feeling

What we have in the phenomenon of classicism, and I believe we can generalize from the particular example of classicism in letters, is in the first instance "a structure of feeling." By this—the term is both suggestive and, as we will

[17] *Habitus* is normally implicit in the description of a classical object, for instance in the attitude struck by an Apollo, an Athena, or a Pericles (serenity, *Heiterkeit*, sublimity, grandeur, etc.). Occasionally, it is explicitly invoked, as in Hölscher 1989a, 16: "einen Habitus der Besonnenheit und der affektlosen Mäßigung, eine Kunstform des harmonischen Gleichgewichts." I want to extend its reach to include the attitude of the beholder of classical objects, whom we might term the "classical subject."

[18] Cf. Kermode 1983, 15–16: "The doctrine of classic as model or criterion entails, in some form, the assumption that the ancient can be more or less immediately relevant and available, in a sense contemporaneous with modern—or anyway that its nature is such that it can, by strategies of accommodation, be made so" (cf. ibid., 73–74 on Addison). I am interested here in how the ancients experienced, expressed, and intensified this sense of immediacy and availability.

[19] Arnold 1960, 3:258–90 and Eagleton 1984, on the function of criticism; Stroux in Jaeger 1931, 6–7, connecting the rise of *kritikē* in the Hellenistic era to the buttressing and management of the classical heritage.

see, aptly vague—we should understand not a private experience like a pleasure or pain that I cannot share, but a socially conditioned one—a consciousness, experience, or feeling that, as Raymond Williams observes, is revealed at the level of "the inalienably physical, within which we may indeed discern and acknowledge institutions, formations, positions, but not always as fixed products, defining products.... It is a kind of feeling and thinking which is indeed social and material, but each in an embryonic phase before it can become fully articulate and defined exchange."[20] Williams's concept, which has a decidedly aesthetic application, is left underdefined by him, but its lack of definition is what makes it appropriate as a way of getting at the realm of ideological pleasures. When coordinated with such related categories as enjoyment (*jouissance*), interpellation, attachment, and *habitus*, structures of feeling can provide a useful index to the more insidious pressures of collective experience and of unspoken knowledge within the domain of art and culture.[21]

Feeling classical is an instance of this kind of inarticulate knowledge, and one that is all the more intriguing in the case of literary sensibility in that it brings the feeling in question, the feeling of being classical, to the very edge of language, to a point that lies on the verge between an articulation of a very high order—that of a self-conscious reflection upon linguistic processes and literary values—and everything that escapes this reflection and in escaping seems all the more to confirm the results of conscious judgment. "Structures of feeling" are exemplary and not idiosyncratic by nature: they give us a clue to the wider domain of their embedded context.[22] And so, too, the fixation with the sound of classical authors,

[20] Williams 1977, 128 and 131; cf. Williams 1966, 18, 57, 65. Williams resorts to this category throughout his career without ever fully defining it, and its meaning changes (for a critical survey, see Simpson 1995, extending the critical reading of Eagleton 1976, 32–36). I have adopted and no doubt modified Williams's concept. More work could be done to elucidate the category of "structures of feeling," which is expressed in but by no means exhausted by pleasure. Indeed, its role as a reinforcer of transmitted ideology could be made to connect up with Lacanian *jouissance*. But above all, "feeling" here is to be construed as a complex, conflicted, even contradictory experience. It is a noteworthy coincidence that Williams's thinking and writing has been construed, and criticized, for its "vocalic emphasis [and] idealism," which makes it all the more apt for present purposes (Simpson ibid., 32). See next note.

[21] Williams seems to be seeking something like a materialist theory and criticism of art, which focuses upon the materiality of art itself (cf. Williams 1977, 169), and often in terms that seem to emerge from the tradition of euphonic criticism, viz., "specific feelings, specific rhythms" and their "specific kinds of sociality" (ibid., 133); "the poem first 'heard' as a rhythm without words, the dramatic scene first 'visualized' as a specific movement or grouping," etc. (ibid., 190). Bourdieu's theory of *habitus* and of the "logic of practice" and Williams's theory of "structures of feeling" and "practical consciousness" (ibid., 132) plainly overlap. Cf. further Smith 1988, 45.

[22] "This is a way of defining forms and conventions in art and literature as inalienable elements of a social material process: not by derivation from other social forms and pre-forms, but as social formations of a specific kind which may in turn be seen as the articulation (often the only fully available articulation) of structures of feeling which as living processes are much more widely experienced" (Williams 1977, 133).

wherever we come upon it, ought to afford us a revealing glimpse of the wider phenomena of classicism and its cultural contexts. Accounts of sound, which is something simultaneously heard *and* imagined, give us a unique access to an ancient experience that is at once intimately private and utterly social. At the very least they give us access to the rules and principles, or simply the logic, of that experience in its officially recommended form. But first a little more work will be needed to help ground the assumption about the status of literary classicism as a feeling had by consumers of the classics, and to explain the link between texts and their imagined sound.

His Master's Voice: Sounding Classical

The prominence of sound is a well-known feature of the way in which the inhabitants of the classical world approached their literatures. This feature—or rather peculiarity, because Greeks and Romans pursued the sound of their language with a determination that strikes us as strange today—is generally written off as a byproduct of the way ancient texts were read, which is to say aloud, most often publicly to others (whether by designated readers, often trained slaves, or in recitals), when not to oneself in privacy.[23] I do not wish to challenge this assumption. Quite the contrary, reading and hearing have to be viewed within the context of a society that was heavily conditioned by oral practices even in times of flourishing literacy, when writing never replaced orality but both were rather mutually reinforcing, and not exclusive, categories.[24]

Nevertheless, I do think we can add to this picture by appealing to a few further documented facts that would put the act of reading *viva voce* more at the center of the practice and ideology of classicism. For surely how a text is imagined to sound has a special significance whenever one is reading a classical author, whether this happens to be Homer or Hesiod being recited or read in the fifth century, or any canonical fifth- or fourth-century author being read in subsequent centuries.[25] To hear a classical author is not merely, as it were, to hear his or her voice in one's ear. It is to invest the sound one hears with all kinds of imagined properties: the sound will have a ring of authenticity, of strangeness and of familiarity, of accessibility and inaccessibility, of immediate value and remote grandeur, and so on. The key is to lay stress on the act of imagining. It is one thing to read a text aloud, and quite another to imagine the sound one is producing and then hearing. Exactly what gets heard in a classical author? One possibility, the one I wish to consider, is that the sound heard is itself felt to be

[23] These were called *anagnōstai* or *lectores*. See Starr 1991 on the latter category. Further, Hudson-Williams 1949.

[24] See Thomas 1989.

[25] Schmid 1887–97, 1:39–40, gives us a further example: the performances of the sophists in Rome "were for the public a kind of continuation of the stage performances from happier times."

classical. It seems a fair hypothesis that classicism in letters would have had a distinct feel and sound, a specifically classical quality, even if, and possibly just because, these effects were no more than imaginary ones. Imagining, when it is tied to the act of recovering, becomes poignant and possibly stands in a category all its own. That classical texts were appreciated for their sound along with their antiquity, which is to say for the antiquity of their sound, is central to the concept of *hellenismos*, and it lies behind the *sonantia verba et antiqua* that the younger Pliny and others so admired (*Ep.* 1.16.2).

Hearing has a special place in the realm of classicism because of the apparent immediacies it involves: the experience is that of a direct contact with the voice of the past, of an immediacy of address—specifically, of an interpellation, whereby one feels oneself to be "hailed" by the past.[26] This immediacy is of course an illusion and as such it is a component of classicism in any medium, but it has a peculiar poignancy in literature. A further, commonly shared trait of classicism, even more primary than the illusion of direct contact with the past, is the feeling that makes this illusion possible at all: that of being chosen for this kind of contact, of being worthy or capable of it. In Aristotle's terms, it is a form of *megalopsuchia*, itself another form of feeling and not just of being: "The *megalopsuchos* is felt to be somebody who deems himself worthy of great things, and is this."[27]

Now, a striking feature of some ancient accounts of the way texts sound, but which is implicitly true of all such accounts, is that those texts could represent in an immediate way the voice of the authors who composed them. This is easily dismissed today as quaint phonocentrism or as a sign of naïveté, if not primitiveness, of a society slouching its way to full-fledged literacy, to the point where texts become soundless, as they are for us today (or so one might like to think). Another way of dismissing the phenomenon is to view it as an inevitable fact about the propagation of texts in antiquity, or else as a mere element of their aesthetic appreciation (a value, say, that we no longer appreciate to the same extent). Whatever else we might want to say about these approaches, what they all miss is the fact that in antiquity, prior to the invention of recording mechanisms that went beyond writing, texts were felt to be deposits from the past, and as such they could be thought of as preserving an original, and in some cases aboriginal, sound in their innermost recesses. They were, in fact, *deposits of voice*. Specifically, they contained clues to the way their authors sounded while they were alive; but if so, then they comprised that special sort of clue which is

[26] For the concept of interpellation, see Althusser 1971.
[27] δοκεῖ δὴ μεγαλόψυχος εἶναι ὁ μεγάλων αὑτὸν ἀξιῶν ἄξιος ὤν (*Eth. Nic.* 4.3. 1123b1–2). Longinus, for instance, scoffs at Caecilius of Caleacte for having lectured at great length on "what sort of thing 'the sublime' is, *as though we did not know*," but also for failing to address the more important question of "how we can develop our nature to some degree of greatness" (1.1; trans. Russell). This is Aristotelian *megalopsuchia* in the service of aesthetics. More explicitly, see ibid., 7.1–2.
[28] Peirce 1931–58, 2:283.

sometimes called an index.²⁸ To take an analogy, in the mind of an ancient a text stood to its author's voice as a footprint stands to the foot that caused the impression, or better yet as a photograph stands to the object it depicts: they both share the same light.²⁹ In each case, the communion of source and result is immediate and physical, a record of an event that is itself part of what the event was. And for that reason alone, old texts were like precious relics, virtually like old recordings that only need to be thrown on the turntable to be made to sound again. They were imagined to be voiceprints of their authors.³⁰

This accounts for some of Quintilian's statement, which is typical: *Hic enim est usus litterarum, ut custodiant voces et velut depositum reddant legentibus*, "the use of letters is to preserve vocal sounds and to return them to readers as something left [like a deposit] on trust" (1.7.31).³¹ Similarly, the elder Pliny describes libraries as places where "immortal spirits speak (*loquuntur*) to us."³² So vivid was this communication felt to be that it encouraged the practice of adorning libraries with statues and busts of authors in gold, silver, or bronze. Libraries were plainly a kind of temple to the imagination, and especially to the imagination of the vanished past.³³ The habit is as old as writing itself: the earliest inscriptions, when read, play off the fiction of reanimation, whether of the object itself or its owner, or the owner's voice; "one epitaph actually salutes the traveller in thanks for lending his voice to the name of the deceased."³⁴ To take another instance, Callimachus has Hipponax present himself to the audi-

²⁹ This last point is made by Sontag in *On Photography*, but apparently it was first made by Delacroix in 1850, at the moment of photography's discovery. See Sontag 1977, 154–58.

³⁰ The classic example of this is of course Plato's *Phaedrus*, e.g., 263e5: "Read it out (λέγε), so that I can listen to the author himself (αὐτοῦ ἐκείνου)"; cf. 228e1: "Lysias himself is present (παρόντος)." See Ferrari 1987, 208–9: "Once Socrates discovers that, as he puts it, 'Lysias himself is present,' he refuses to offer himself as audience for Phaedrus' rehearsal and demands to hear the written text read out (228d6-e2)." Plato's critique of this kind of encapsulation of the voice does not touch its premise, which he accepts: the voice fails to respond to us just because it has been encapsulated—frozen—in the text (275d). That this presence of the author is an illusion (Ferrari 1987, 211–12) does not touch my argument (nor does it seem to figure in the dialogue). All I am claiming is that the presence of the author's voice in a written text, however illusory this may have been, was a common conceit in antiquity, one that was frequently either taken for real or was pretended to be real. See further Quint. *Inst.* 11.3.162–69; Bardon 1952, 1:58; Gunderson 2000, 34–57.

³¹ Trans. Stanford 1967, 3.

³² Plin. *HN* 35.2.9–11; trans. Rackham.

³³ As is well brought out by Zeitlin 2001, 212, who observes how "there is a notable leap between envoicing the words of others and the claim that these others can actually speak": "the voiced words of dead authors which we can hear and the tangible representations of their faces which we can see might suggest an uncanny meeting between the present and the past, an encounter that brings the dead back to life, as it were, in our very presence." The library at Herculaneum is possibly another example of the same practice (see Gigante 1995, 3, 8–13), which Pliny claims is a recent practice, at least in Rome (ibid.), though Lycurgus's legislation from the 330s may have paved the way for it (see below).

³⁴ Thomas 1992, 64; *IG* 7.2852.

ence speaking and singing, book in hand, and himself a book—a veritable *oggetto parlante*: "Listen to Hipponax. . . . I come bearing an iambus that sings" (Callim. *Ia*. fr. 191.1–3).[35] Orators regularly broadcast the qualities of their own declaiming voice, like so many virtual cues meant for their readers (Cic. *Brut.* 313). For they knew that the style and *ductus* of their speech could be gathered from their writings, as Cicero observes in the cases of Quintus Catulus (ibid., 133) and Scaevola ("the simple directness of his oratory is adequately known [*habemus cognitam*] from the speeches which he left," ibid., 163). In a more technical language, that of the professional grammarians, writing is "inscribed voice" (ἐγγράμματος φωνή).[36] Renewing a practice of the later fifth century (for instance, Hippias of Thasos's discussions of alternative voicings of Homer, such as accentuation and orthography, and their implications for appreciating his poems),[37] the Alexandrian scholars could make similar points about the Homeric poems: recovering details such as breathing and intonation in the stacks of papyrus manuscripts (punctuating pauses and stops, as well as pitches, and other prosodic features) was a way of recovering some of Homer's original voice itself.[38]

To recover original sounds was felt to be a feasible goal simply because this kind of familiarity with texts was widely assumed: to read an author was to recognize his or her voice and its qualities. Tellingly, in Greek the preferred synonym for the verb ἀναγιγνώσκειν ("to read") is ἀκούειν, "to hear"; *audire* in Latin has a similar, though more restricted, range.[39] Reading is a reading aloud, or rather a *hearing* of a text that (in Roland Barthes's phrase) was originally *written aloud*.[40] To read in this way was quite literally to be aware of an author's "breath" (πνεῦμα,

[35] Ἀκούσαθ' Ἱππώνακτος· [ο]ὐ γὰρ ἀλλ' ἥκω ἐκ τῶν ὅκου βοῦν κολλύ[βου π]ιπρήσκουσιν, φέρων ἴαμβον οὐ μάχην [ἀείδ]οντα, etc. I owe this reference, and the suggestion that ἴαμβον may be a scroll, to Peter Bing. ἀκούσατε can of course be an imperative to "read," which is precisely the point: books are *oggetti parlanti* that bring the author palpably to life whenever they are read.

[36] Schol. in Dion. Thrax 120.37 Hilgard and passim; *P. Osl.* 2.13 (text of Janko 2000, 185 n. 2); Crates of Mallos (Schol. in Dion. Thrax 316.24–26; cf. Porter 1989, 171–74); DL 3.107 (τῆς τοῦ ἐμψύχου φωνῆς ἡ μέν ἐστιν ἐγγράμματος, ἡ δὲ ἀγράμματος. ἐγγράμματος μὲν ἡ τῶν ἀνθρώπων) and 7.56 (attributing the view to Diogenes of Babylonia; *Div. Arist.* 38, cols. 1.4 and 2.6 Mutschmann; etc. The idea has its origins in the sophistic movement (cf. Alcidamas *Soph.* 27–28; Pl. *Phdr.* 275d–76a) and in tragedy (Eur. *Erechtheus, TGF* 369 Nauck).

[37] Arist. *Poet.* 1461a22; see Stanford 1967, 9 and 23, n. 33.

[38] See Porter 1992, 80–82.

[39] For some striking examples, the earliest dating from Herodotus, see Hendrickson 1929; Hudson-Williams 1949; Chantraine 1950; Allan 1980; and Schenkeveld 1992. Chantraine 1950 notes how ἀναγιγνώσκειν ("to read") means in effect "to recognize" the letters and to decipher them, but as Carson 1999, 83, suggests, what is involved is in fact the recognition of *sounds* and their translation from the stone or page to the ear and mind (similarly, Rohde 1963, 294).

[40] Barthes 1975, 66. Barthes also calls this kind of writing a "vocal writing" (*écriture vocale*), because what it conveys is a voice that reaches beyond meaning and content to more tangible qualities, such as breath, tonality, "the grain of the voice," and the like. See further Theon *Prog.*

spiritus), or its lack.⁴¹ Indeed, texts could in the extreme be conceived as congelations of breath that simply needed the articulation of a reader to be stirred, dissolved, released, and heard again.⁴² Given the circumstances of ancient writing (for instance, the absence of word division and the infrequency of accents, even after their invention in the third century, to mark pitches, and of interpunction to mark clausulae), this conceit is hardly far-fetched.

The powerful conjunction of reading, hearing, and recognizing held possibilities that were easily and quickly realized. Pedagogy was one of the more immediate beneficiaries. But the same principles could be extended to professional authentication: what better criterion of authorship could there be than the signature left behind by an author in the way his or her words sounded, as the empirical faculty of hearing (*aisthēsis*) can alone detect? Not for nothing would the act of criticism define itself by the two poles of its procedures: it began in reading, correctly and aloud, with attention to the aural features of diction—melody, expression, and punctuating pauses (ἀνάγνωσις ἐντριβὴς κατὰ προσῳδίαν, καθ'ὑπόκρισιν, κατὰ διαστολήν, ἀδιάπτωτος προφορά)—and it culminated in *krisis*, or evaluation, "the finest part of all in the art of grammar" (Dion. Thrax, *Ars Gram.* 1; cf. Quint. 1.8.1). If connoisseurship was grounded in the most immediate and most sensuous properties of texts, the apprehension of which was modeled on the handling of a dimensional object, then criticism, pedagogy, and reading practices generally were modeled on the

61.28–65.25 Spengel on the virtues of reading aloud (*anagnōsis*) and listening (*akroasis*) and the identifications with the past that these practices entail. Cf. also Gunderson 2000, 38 ("the written style forms a special subset of the speaking voice"); Webb 2001, 308–09; Porter 2004.

⁴¹ Strength of breath is a sign of power that makes itself felt over the centuries. Lysias, for all his charms, is not full of breath or spirit (οὐδὲ θυμοῦ καὶ πνεύματός ἐστι μεστή) for Dionysius of Halicarnassus (*Lys.* 13, fin.), nor is the generation of historians prior to Thucydides, save Herodotus (*Th.* 23), while Demosthenes is (*Dem.* 22); Isocrates "lacks breath" for Hieronymus of Rhodes (see below). One of the guesses as to the meaning of "voice" canvassed by the scholia to Dionysius Thrax equates voice with breath: "'Voice' is defined this way: voice is a bit of breath that is fetched up from the whole organism and the blood until it reaches the tongue" (ὁρίζεται δὲ ἡ φωνὴ οὕτως· φωνή ἐστι πνεῦμά τι ἀπὸ συστήματος ἀναφερόμενον ἕως τῆς γλώττης)" (Schol. in Dion. Thrax 181.37 Hilgard; cf. 483.17–18). Further, "voice comes about when breath strikes the air; it strikes the air by issuing forth with a pitch (τόνῳ); pitch is an intensifying (τάσις) of the breath, with the result that voice cannot come about in the absence of pitch" (ibid., 478.25–28). Written language is breath transcribed, or inscribed. And so too, "inscribed voice is the final state [or "result"] of the breath that is stored within us (ἐγγράμματος δὲ φωνή ἐστιν ἀποτέλεσμα τοῦ ἐν ἡμῖν ἐντεθησαυρισμένου πνεύματος)" (ibid., 212.23–24, 353.4–5), which is another way of putting Quintilian's point. Language is in effect being defined by the scholia, remarkably, as a divided continuum of breath.

⁴² This is more complex than viewing written letters (γράμματα) as "elementary sounds" (φωναὶ πρῶται), as was frequently done, because there is more to language and to reading than the mere phonation of individual letters, whose sounds could be multiplied in the technical literature to well beyond the twenty-four letters of the Greek alphabet. Euphonist literary criticism sought to capture these extra dimensions of the voice contained in and implied by writing (see below).

discriminating connoisseur. Examining a text was a lot like examining a vase, holding it up to the light, feeling its heft, turning it this way and that. Comparison of the two kinds of art and their respective judgments are a commonplace in the critical tradition, as in the following passage from the Augustan literary critic and antiquarian, Dionysius of Halicarnassus:

> I should recommend all those who wish to understand the style of Demosthenes to do this: to form their judgment from several of its properties, that is to say the most important and significant of them. He should first consider its melody, of which the most reliable test (κριτήριον) is the instinctive feeling (ἡ ἄλογος αἴσθησις); but this requires much practice and prolonged instruction (τριβῆς). Sculptors and painters without long experience (ἐμπειρίαν) in training the eye by studying the works of the old masters (τῶν ἀρχαίων) would not be able to identify (οὐκ ἂν διαγνοῖεν) them readily, and would not be able to say with confidence that this piece of sculpture is by Polyclitus, this by Phidias, this by Alcamenes; and that this painting is by Polygnotus, this by Timanthes and this by Parrahasius. So with literature (λόγων). (*Dem.* 50; trans. Usher)[43]

By evaluation (*krisis*) was meant a judgment not only about quality, but also and above all about authenticity.[44] The two criteria, and so too their associated pleasures, were evidently linked. If to read gave pleasure, to read aloud the genuine voice of a treasured author gave this pleasure a completeness that could not be rivaled. The highest esteem went to those authors whom we would call classical but who for the most part were known simply as the "best" and the "purest" of the "ancient" writers, from Homer to Plato and Demosthenes. These were the writers who were worth emulating and whose sentences were worth analyzing, microscopically and in endless detail, in order to see how they achieved the effects they did. (Hellenistic and later authors didn't make the grade.) As the labels show, classicism was a bias that had no name. *Hellenismos* ("pure Greek") and sometimes *Attikismos* ("Atticism") or "archaism" stood in for some of this bias, but the meanings do not quite overlap with the sentiment that underlay the bias, which was at once broader and narrower than an obsession with all things Greek or Attic.

"Let us hear how he speaks (ἀκούσωμεν δὲ αὐτοῦ, πῶς λέγει)," is a standard way of introducing a quotation from a classical author.[45] The conflation of voice and text is felt to be entirely natural. But above all, it is the attitude of

[43] Similar analogies of sound to structures are found in the euphonist critics reported by Philodemus. One might speculate that at the origin of these metaphors lay not only the nascent aesthetic languages of the Greek fifth century or earlier, but also the practice of writing on objects. For a suggestive analysis, see Carson 1999, 92–93.

[44] As is evident from the ancient practice. Cf. also Schol. in Dion. Thrax 170.5, 303.28, 471.34–35, 568.15 Hilgard.

[45] Dion. Hal. *Dem.* 26, introducing a passage from Plato.

eager anticipation, the expectation of sheer aural pleasure and of an immediate contact with the past, that is remarkable in this kind of gesture. At the extreme, an author from the past will be addressed with a surprising degree of intimacy, as though he were literally present: "This seems to me to be the finest passage, Plato, that you have written in this speech."[46] The examples are again from Dionysius of Halicarnassus, whom we on occasion find waxing poetic, and nearly becoming ecstatic, at the prospect of recovering a classical author's voice, as for instance in his treatise on Demosthenes: "If, then, the spirit (or breath, πνεῦμα) with which Demosthenes' pages (τοῖς βυβλίοις) are still imbued after so many years possesses so much power (ἰσχύν) and moves his readers in this way (οὕτως ἀγωγόν), surely to hear him delivering his speeches at the time must have been an extraordinary and overwhelming experience (ὑπερφυές τι καὶ δεινὸν χρῆμα)" (*Dem.* 22). The epithets are all Longinian.[47] But the sentiment is broadly felt, as Plutarch shows in another context, which is that of the moral imagination: "What would Plato have done in this case? What would Epamonidas have said? How would Lycurgus have conducted himself, or Agesilaus?" (*Mor.* 85a). Our interest here, by contrast, is in the realm of the acoustic and aesthetic imagination. As Longinus suggests, aspiring authors should ask themselves, "How would Homer or Demosthenes have reacted to [viz., read and heard: ἤκουσεν] what I am saying, if he had been here? What would his feelings have been (πῶς ἄν ἐπὶ τούτῳ διετέθησαν)?" ([Longinus] 14.2; trans. Russell). But the contrast is only superficial, because the two spheres, aesthetics and morals, are necessarily linked within an overarching ideology of classicism, as will be seen below.

The desire to relive the authentic past through letters was widespread, literally as far-reaching as the Greek language itself. Yet the phenomenon appears in the oddest of ways wherever we encounter it. The old Borysthenian interlocutor in Dio Chrysostom's thirty-sixth Oration, living on the far-flung edges of the inhabited Greek world and in the sorriest state of primitiveness—which is to say, at once (barely) recognizable as a Greek and by the same token ironically approaching the authentic simplicity of Homer's world—nonetheless bids Dio to hold forth in purest Greek, by "aiming as closely as possible at Plato's nobility of expression (φράσιν). For if we understand nothing else, we do understand at least his language because of our long familiarity with it, for it has a lofty

[46] Ibid., 30. Similarly, Plato asks Aristides about his own writing (Arist. *Or.* 50.57 Keil). Cf. Anderson 1989, 171–79, on the vivid and intimate presence of the classical past for Second Sophistic writers; and ibid., 140: "With this sort of perspective it was easy enough to retain an 'achronological' outlook, in which the past could easily be telescoped, and the fifth and fourth centuries be felt as yesterday," though this feeling was mediated through texts, viz., through "the fact that history itself was a matter of literary and canonical authorities rather than subjects." Cf. Nilsson 1955, 92, on the Museum at Alexandria and its inhabitants: "Dort fühlten sie ihr Griechentum."

[47] Cf. [Longinus] 1.4, 8.4, 9.5, 9.13, 16.2, 22.1, 22.3, etc.

sound (οὐ σμικρόν φθέγγεται), not far removed from the voice of Homer (τῆς φωνῆς ... τοῦ Ὁμήρου)" (*Or.* 36.27).[48] The idea that Homer's verses embody Homer's voice is reflected in Plato's definition of simple narrative (*diēgesis*) as expression *in propria persona* (*Resp.* 392d–93d), a thought that the rhapsode Ion of Chios would have endorsed, at least on Plato's showing, but also would have expanded and generalized: to sing Homer's verses, any one of them, is to communicate directly with the bard himself.[49] But the thought must have predated Plato's Ion too, in a form that could have been applied to the authors of any text, and not only in the epigraphical, and especially funerary, tradition of *oggetti parlanti*, in which first-person addresses to the reader were conventional, suggesting the illusion of a speaking voice.[50] Classical texts, as receptacles of voice, were a mnemonic of the classical past.[51] Recovering their sound was a way of living, literally of experiencing, the past the way it once was. Only, the experience of the past here is of the way it once *sounded*—an experience (or

[48] Max. Tyr. 26.3b.2 would beg to differ: "Don't think that I am likening the utterances of Plato (τὰς Πλάτωνος φωνας) to those of Homer, his nouns and his verbs. These are indeed taken from him: they are the outpouring of Homer's style (ἁρμονίας), the way the Maeotis flows from Ocean, the Pontus from the Maeotis, the Hellespont from the Pontos, and the sea from the Hellespont. But when, by contrast, I compare the quality of mind (γνώμην) of the one with the other, I see the affinity."

[49] Strictly speaking, it is to communicate with the god, for "we who hear (οἱ ἀκούοντες) realize that it is ... god who speaks (ὁ λέγων) and expresses himself to us (φθέγγεται πρὸς ἡμᾶς) through them [sc., the poets]" (*Ion* 534d3–5; trans. Russell). First-person narration is an easy case for attribution. But in whose voice, one might well ask, was *mimēsis*, the imitation and impersonation of *non*-authorial voices, "heard"? There are strong reasons to say that *mimēsis* was likewise felt to belong to the voice of the poet/author, not least for reasons of attribution and judgment. Cf. Dio Chrys. 12.68, where Homer's exemplary voice is heard (or overheard) in his imitation of objects through words and sounds of his own invention (παρ' αὐτοῦ φθεγγόμενος), be they rivers, forests, winds, fire, sea, bronze, stone, animals, or pipes and reeds (οὐδενὸς φθόγγου ἀπεχόμενος, ἀλλὰ ἐμβραχυ ποταμῶν τε μιμούμενος φωνὰς καὶ ὕλης, etc.). In the case of shared language, as opposed to mere sounds, the poet's voice is overheard, like a signature (σφραγίς) marking the words (ibid.). The same would apply to, say, Lysias's logographic writing. See Dion. Hal. *Lys.* 19, where Dionysius comes close to labeling the voice of Lysias as it impresses itself audibly upon the speeches of his clients (αὐτὸς ἠθοποιεῖ, etc.), all in the distinguishing style of Lysias himself (ὁ Λυσίου χαρακτήρ, ibid., 20), which Dionysius never despairs of detecting (ibid., 14).

[50] Burzachechi 1962; Svenbro 1993, usefully complicating this model, but without convincingly dispelling the illusion; Carson 1999, 83–84 with n. 28.

[51] [Longinus] 7.3, 8.4 (ἄξιον μνήμης; a formula likewise found in Pausanias, e.g., 1.20.1, 3.6.5, etc.), 9.2, 33.3. Cf. Cic. *De or.* 3.45: for Crassus, listening to his wife's mother, Laelia, to the very sound of her voice (*sono ipso vocis*), is like listening to the authors of the classical past, e.g., Plautus or Naevius—which implies a knowledge of what it is to hear those authors themselves. For good discussion on this and on the feminine gendering of the sound of the past in Latin letters, see Farrell 2001, 65–70. As Farrell points out well, it is the sheer materiality of the voice, its euphonic properties (and, we might add, its direct availability to feeling), rather than anything it says, that does the work of capturing the past on this conceit.

illusion) that, apparently, is still to be had: "Yet one can still hear the authentic classical clarity and euphony in words like παρακαλῶ, with its rippling and superbly articulated flow," etc. (so W. B. Stanford).[52]

Perhaps the first sign of a deliberate preservation of the aural past is to be found in Lycurgus's legislation from the 330s, in which he decreed the erection of bronze statues of Aeschylus, Sophocles, and Euripides, had official copies of their texts put in a public trust, and required that "the state clerk should read them out (παραναγινώσκειν) to actors, it not being allowed to perform them deviantly" (Plut. *Mor.* 841F).[53] But this move merely recalls the institution of the Panathenaea under the Peisistratids in the late sixth century at Athens, which appears to have helped fix not only the text of Homer but also the performances of his verses. In a very real sense, this festival procedure may have been a way of preserving the *voice* of Homer, as the example of the Delian maidens in the *Hymn to Apollo* suggests, and as some scholars have recently argued: for "they [the performing, choral maidens] know how to imitate the voices (φωνάς) of all people and their clattering: everyone would say that their utterances were his own (φαίη δέ κεν αὐτὸς ἕκαστος φθέγγεσθ')," and most of all, the implication runs, "the blind man ... [who] lives in rocky Chios," Homer himself (161–72).[54] Among postclassical Greek writers, Atticism was one way of reproducing the authentic sound of a perished Greek and to police linguistic habits (see Introduction). But the surest way to revive the voice of a classical author was to impersonate it directly.

Such was the case of Herodes Atticus, one of the premier Second Sophistic rhetors, who called himself "the tongue of the Athenians" (ἡ γλῶττα τῶν Ἀθηναίων).[55] He could boast the title not because he was from Athens and a spokesman for that city, but because his *voice* was from classical Athens. Philostratus tells us that Herodes' imitation of Critias, Plato's uncle and a sophist renowned for his varied literary output, was complete, down to the qualities of breathing:

> The constituency of his style was sufficiently restrained, and it had a power which crept up on you rather than launching an assault. It combined impact with plainness, with a *sonorousness that recalled Critias* (κριτιάζουσα ἠχώ); ... his diction was pleasing and ... *his breath* (πνεῦμα) was not vehement but smooth and

[52] Stanford 1967, 65. On the difficulties of this kind of recuperative projection, see Porter 2000b, ch. 3.
[53] For discussion of this verb, see Nagy 1996a, 175 with n. 79.
[54] Trans. Barker 1984, 40. Cf. Nagy 1990, 43 n. 130 (for bibliography), 359 (the Chian rhapsode is "the idealized character of Homer himself"), 376 (calling the Deliades "mouthpieces, as it were, of the composer"); also Nagy 1996a, 80–81.
[55] Marcellus, in *Epigr. Gr.* 1046.38 = *IGR* 1.194, A.38; cf. Philostr. *VS* 598 ("tongue of the Greeks").

steady. In general, his type of eloquence was like gold dust shining beneath a silvery eddying river.... From Critias he was actually inseparable (τῷ Κριτίᾳ προσετετήκει).⁵⁶

It takes a finely tuned ear, or else a trained imagination, to detect breath in an author. But here the feat is doubled: Philostratus confirms, by repeating, Herodes' leap into an aural reality some five centuries old. How certain can Philostratus be about the quality of Herodes' voice, which he has never heard but has only read, or of Critias's for that matter? Similarly, for Philostratus the style of Dio of Prusa "has the ring (ἠχώ) of Demosthenes and Plato," though with overtones all his own (προσηχεῖ τὸ ἑαυτοῦ ἴδιον) (*VS* 487). Hearing has become the art of overhearing—of hearing the past in the present and a living voice in an inanimate text. Such were the complicities of the classical sensibility in its most daring of manifestations.⁵⁷

Now if any of this is right, if classicism is indeed invested in an aural memory, then to appreciate a classical author is not only to appreciate his or her sounds, but also to appreciate them for their pristine qualities, their authenticity, and their classicality. That is, the sound of a classical author will have been felt to be distinctly *classical*, however this comes to be defined. This last qualification is important, given the interested nature of classical literary values in antiquity. But then so is the further qualification: the debates over classical values took place in the realm of the imaginary, which was the only place they existed. And so by the problem of the sound of classical Greek we should always understand attempts to imagine and account for this phenomenon, whereas actual performances like Critias's are themselves no more than examples that are produced by such an attempt and which then come to be appreciated through another imaginary filter, that of the audience. Attending to the

⁵⁶ Philostr. *VS* 564; trans. Rutherford 1998, 22, after Wright; italics added. See Schmid 1887–97, 1:193. Herodes' desire was to be acclaimed by Greeks as "one of the Ten," viz., one of the ten canonical orators; Philostr. *VS* 564 and 565. Critias, the tainted political careerist, might seem an odd figure to identify with, nor does this oddity escape Philostratus (*VS* 501–2). But his patriotism is impeccable (cf. Crit. fr. 2 [88B2 DK], an elegy praising Marathon, Herodes' birthplace and wished-for burial place [*VS* 566]). With Philostratus, one might say that Herodes imitated Critias's tongue, not his person (*VS* 502–3).

⁵⁷ The attribution is common. Cf. Philostr. *VS* 604 on Proclus of Naucratis, an Athenian sophist from the post-Hadrianic era and otherwise unknown, who gave declamations in the style of Hippias and Gorgias (ἱππιάζοντί τε ἐῴκει καὶ γοργιάζοντι); Aelius Aristides dreamt of being Demosthenes declaiming to the Athenians (*Sacred Tales* 1.16 = Arist. *Or.* 47.16 Keil). In so doing, these later sophists were adding a dimension to the fashions of the late fifth century: cf. Philostr. *VS* 501 on the Thessalian rage for Gorgianizing. A further sign of the compelling nature of the past's sensuous immediacy is to be found in Pausanias's account of the battlefield of Marathon: "There is a separate tomb of Miltiades, son of Cimon.... Here every night you may hear (αἰσθέσθαι) horses neighing and men fighting.... The people of Marathon worship the men who fell in the battle, naming them heroes; and they worship Marathon, from whom the deme got its name; and Hercules" (1.32.4).

question of how language sounded (or was said to sound) can open up unexpectedly rich ways into the ancient practices of classicism in part just because of the fundamental link that existed between sound and the imaginary. And although the present inquiry will be limited to this feeling as it applies to language and literature, it is only natural that parallel structures of feeling should lie waiting to be found in other areas affected by classicism, from the visual arts to the more common practices that would have sustained the ancient culture of classicism, for example in pedagogy or in social comportment. This at least is the promise that looking at classicism as a lived experience and as a structure of feeling in antiquity can hold forth for us.

Classical Temporalities

Classical sounds are telling because of their peculiar status. Where do they reside? Found neither in a text as such (they exist only when they are sounded out) nor in the world at large (they are entirely artificial; an archaism and affectation, they jut out of contemporary reality like an alien body), they have an ephemeral existence that holds true only for so long as they are spoken and heard, or else replayed in memory. Thanks to these properties, classical sounds enjoy an emblematic role in classicism that needs to be brought out before we go on. They are as fleeting as the experience of the past they give rise to, and as inarticulate as the feeling for that past. They are momentary phenomena, intangible, and in themselves, oddly enough, barely audible (at least without the proper training and powers of imagination)—for in question is the classical quality of the sounds rather than the sounds per se. They reside forever in a realm between, always outrunning any attempt to locate them: between past and present, between a physical reality (what is now heard) and its ideality (what is imagined as being heard), between sound and sense (classical sounds, we shall see in a moment, do not properly belong to either realm), between texts and their experience (when they are read), between experience and its description. One is always at a loss for words when it comes to describing a classical object. But this loss is all the more poignant when the object in question is itself made of words.

Literary critics after Aristotle are keen to point all of this out. From them we know, for instance, that sounds of any kind have a distinctly irrational character: they lie below the threshold of meaning. Indeed, in and of themselves they have no meaning at all, but instead they evoke a series of feelings (which may or may not translate into emotions and ideas), and ultimately they give rise to a pleasure (*terpsis, hēdonē, voluptas*) that is all their own. This pleasure is said to be euphonic, but what is it really? Typically, the pleasure of euphony is either presented as something empirical (if not simply physiological) or else it is named without further definition, but it would be wrong to assume that this is

all there is to the pleasure (a point we will come back to further below). In any event, the apprehension of sound is uniquely a matter of feeling, not of reason. And in the case of classical sound, the force of this last point is redoubled. Strictly connotative, classical sounds are atmospheric, even auratic: they point (vaguely, to classical values) but do not say. And so, too, even as they capture in their fundamental inarticulateness something unique about classical forms of expression, what they capture is as it were the uniqueness of that expression, not the expression itself or the thing expressed. So, for instance, Demosthenes' language captures with its freedoms (and its imperiousness) the style of Greek freedom even better than the freedom it also names. And given the performance-based nature of most classical texts, we can say that sound crystallizes their essence, even among literary critics who do not stake all they have on sound. Texts that cannot be sounded or appreciated for their sound simply cannot be appreciated at all, while sound names, in a kind of technical shorthand, what is distinctive about a transmitted author: it functions as a signature of his or her style.

This being the case, saying something meaningful about literary classicism in its affective dimensions becomes a bit of a problem. Classical values as conveyed by the trappings of sound, but possibly also in general, exceed meaning in a linguistic sense, and only a devotional attitude to them—the affective value and investment they carry—is capable of communicating them. The absence of any designation for "classicism" in ancient literary criticism is undoubtedly a reflex of this limitation, even if this absence also happens to be a mere artifact of contingency. (Nor do modern designations of "classical" take home any prizes for their clarity of conception: the term is riddled with inarticulateness, and constitutionally so.) Ironically, the mere articulation of classical sound expresses, and so too justifies (or obscures), the inarticulateness of the notion of the classical that is not even formulated as a concept, let alone as an abstract ideal, in antiquity, or at best rarely so, but is only named as a feeling. In fact, the only articulation of classicism there is finally comes in the tautology of articulation itself: the most effective way to testify to classicism in letters, even outside the narrow limits of ancient euphonic criticism, is simply to allow classical authors to speak; the sheer act of repetition reinforces their canonical value as nothing else can. That is why postclassical literary criticism is generally an art of quotation and reperformance, less a parading of words than a putting on display of verbal monuments (or fragments).[58] There is an affective dimension to quotation that no amount of theorizing can rival. Dionysius of Halicarnassus takes this tendency to an extreme: long stretches of his essays

[58] For a parallel case of "the knowledgeable use of quotation" of images and motifs in the visual arts of the Imperial period, in which "classical forms [are turned] into a silent and universal linguistic code," see Maffei 1986 id.; 1994, xlvi–lv (quoted by Zeitlin 2001, 232). See also Anderson 1991, 45, on the way in which ritual hymns and national anthems "provide occasions for unisonality, for the echoed physical realization of the imagined community."

press their arguments through a kind of classicism by example, through page after page of excerpted classical writing, in a self-confirming lesson in preservation and appreciation.[59] Within the narrower context of the theory of literary sound, the quotation of classical authors has added point: it is an object lesson in euphony, and euphony (as we are about to see) uniquely captures both what is attractive in classicism and what eludes definition in the nature of classicism. Viewed in this light, reductive euphonism, which values sound over sense, is not an aberrancy of ancient literary criticism or of some extreme tendency within it but its most perfected form: euphonism isolates the very realm of feeling through which classical values are communicated. Nor is euphonism so viewed a matter of sound any longer. Cicero's ideal orator, a Platonizing conceit, is a notable exception to the rule that antiquity fails to produce something like a notion of the classical ideal (see Introduction). But not even Cicero, staking so much of his interest in the same treatise (*Orator*) on the sound of the voice, can do any better than produce an ideal of oratory "that has never existed at all"—an admission that is tantamount to saying that classical sounds are sounds you cannot hear: they are ideal sounds; in them, one "hears" the classical values that they evoke.[60] Cicero's position is in this respect perfectly representative. The essential inarticulateness of classical sound—its indescribable qualities, its irrationality, its sheer *otherness*—captures as nothing else can the inarticulateness of the classical (ideal) that nowhere gets expressed in antiquity but everywhere is felt. Classical sounds are not sounds, properly speaking. They are signifiers of value, and as such they are inaudible.[61]

Classical sounds exist in a further, significant sense in a region that is neither here nor there. Their odd status as artifacts of both history and the imagination gives them a curious appearance, which in turn reflects their peculiar temporality. Sounds from the past can never be heard quite in themselves but only as a diminished echo of their imagined former existence: they come already dated. Thus, readers and aspiring writers are frequently enjoined to appreciate "the patina of antiquity (ὁ ἀρχαῖος πίνος)"—in Latin: the *color vetustatis*— that classical words wear on their faces, like so many aged bronzes or silver.[62] (Elsewhere, architectural metaphors take the place of sculptural ones, to the

[59] Dionysius's lectures may have been orally delivered (*Schulvorträge*); see Schmid 1887–97, 1:24 with n. 22. If so, the large stretches of Greek text that he cites would have had the added bonus of being declaimed before his pupils, further reinforcing his theoretical points.

[60] *De or.* 19. "This ideal (*quod*) cannot be perceived by the eye or ear, nor by any of the senses, but we can nevertheless grasp it by the mind and the imagination.... With our minds we conceive the ideal (*speciem* [viz., "ἰδέα," ibid., 10]) of perfect eloquence, but with our ears we catch only the copy" (ibid., 8–9; trans. Hubbell). Cicero adds, "If we are unable to imitate (*exprimere*) the ideal orator—he said that a god could scarcely do that—we might be able to say, perhaps, what sort of orator he ought to be" (ibid., 19; my translation).

[61] See Porter 2001b.

[62] Dion. Hal. *Dem.* 39 (cit. n. 66, below); χνοῦς ("powder," "film," "bloom," or "down") is a frequent synonym (ibid., 38); see also n. 71, below; Fronto *Ep.* 2.19, p. 145.2 van den Hout (*colorem*

same effect.) The imperative is equivocal, because it plainly shows that to hear a classical sound is to grasp that sound not only as ancient, but also as though it were already archaizing, so to speak with an eye to its future reception; it is to hear a sound in its difference from the present and in its being destined *for* the present, just as to produce a classical (viz., classicizing) sound is to reproduce this same difference.[63] What one hears in a classical or classicizing text is thus a *relation* rather than a sound or set of sounds by itself: what is heard, above all, is *the sound of a cultural and historical difference*.[64] That difference, which is constitutive, goes all the way down: classical sounds are never unmarked by it; they must appear classical and antique, not only in the postclassical present, but also from their very first historical appearance. As we shall see, in the classicizing imagination this is exactly what classical objects do.

Archaism

These complexities of time and temporality, which are built right into the perception of classical objects, are to a large extent concentrated in the word *archaios*, which names both what is ancient, for example, "the older method of writing (ἡ ἑρμηνεία ἡ πρίν), [which] resembles ancient statues (τὰ ἀρχαῖα ἀγάλματα),"[65] and what is made to appear so (through archaism). A sought-after effect, archaism in the present is always by definition affected; conversely, the appearance of the archaic in the past inevitably has the same look of affectation even in the present. Archaism is for this reason a curious trait. Normally reserved, by critics, for earlier classical writings in the "austere" (αὐστηρός) or "grand" (ὑψηλός) style, which describes the style of Pindar through Thucy-

vetusculum adpingeres) and 4.9, p. 150.13–14 (*colorem sincerem vetustatis appingere*); Gell. *NA* 10.3.15 (*umbra et color quasi opacae vetustatis*); 12.2.10 (*aliquid antiquitatis*); 12.2.12 (*honorem coloremque veteris orationis*); 12.4.3 (*color quidam vetustatis . . . reverendus est*, like sacred laws). Cf. Cic. *De or.* 3.41–42 on the *rustica vox* that affects the sound of greater antiquity *si ita sonet*, etc.

[63] A curious possible parallel is the practice, documented for the fourth century B.C.E. and later, and seemingly for the fifth as well, of deliberately tarnishing silver. See Vickers 1985, 109–11, and Vickers and Gill 1996, 126–29. Whether this "perverted taste for tarnish" (Cook 1997, 145) could point to more than a desire for a metallic sheen and whether the Greek familiarity with oxidized bronze could point to more than "indifference" (Vickers and Gill 1996, 127) is hard to determine. A good example of a recent archaizing practice is the "perverse preference for retaining a green patina on bronze" found among modern restorers of antiquities, who polish up silver but rarely restore bronze to its original luster (Vickers 1985, 111).

[64] For the same reason, in Greek one can, without blinking, say of a fifth-century Attic author that he "Atticized," as though he were schooled in dialectal imitation like an Imperial writer: Critias "Atticized, but in moderation, nor did he use outlandish words—for bad taste in Atticizing is truly barbarous [!]—but his Attic words shine through his discourse like the gleams of the sun's rays" (Philostr. *VS* 503). The layers of historical mediation that are built into this description are so thick as to be no longer visible to a Philostratus, upon whom the Attic beauty of a Critias shines so sensibly at the end of the Second Sophistic era.

[65] [Demetr.] *Eloc.* 14; trans. Roberts.

dides but can be applied to that of later writers (for instance, Plato), archaism nonetheless is a universal trait of all the best classical writing. Compare the start of *On the Composition of Words* 11, which lists under the elements of "beauty" the qualities of "impressiveness, solemnity, seriousness, dignity, age (πίνος) and qualities like them. . . . These [among others listed in an earlier sentence] are the qualities aimed at by all serious writers of poetry . . . and of prose, and I doubt where there are any others" (trans. Usher; modified). The point to see is that archaism is a perspectival feature as much as a stylistic and periodizing one, and that from the later postclassical perspective all earlier writing into the fourth century seems broadly archaic: this is the source of the "patina" they wear. Conversely, seen through the lens of the present and contrasted with later archaizing writing, even the austere style of composition (ἁρμονία) is not so much archaic as it comes patinated with archaic hues: "its beauty consists in its patina of antiquity (τὸν ἀρχαϊσμὸν καὶ τὸν πίνον ἔχουσα κάλλος)" (ibid., 22): it *wears* its antiquity, like a costume.

The implication that not only any later classical writer employing the austere or archaic style, such as Antiphon, Plato, Antimachus, and Demosthenes, but also its first exemplars, Empedocles, Pindar, Aeschylus, and Thucydides, might themselves be archaizing and not archaic, is left teasingly open by Dionysius (or else is simply allowed).[66] It is as though any of the older, slightly oxidized styles were felt by a later reader to be *already anachronistic*—not only classical but even willfully classicizing—in their origins. The assumption is easily made, given the aim of the literary critic, which is to discover the techniques that were used to achieve a classical effect: surely the classical writers consciously sought the qualities they so splendidly achieved—at least some of the time.

Some of the time, but not all of the time, because ironically archaism is not always a good thing. From Dionysius's tardy perspective, the style of Thucydides can actually appear *marred* by its "exaggerated artificiality and remoteness from normality"(!), which is to say its archly archaic qualities (*Dem.* 15, init.); elsewhere, his writing can be "circuitous," "tortuous," and "verging on solecism"—in a word, one that Dionysius seems to have coined for the purpose, it can be willfully or excessively archaic: ἀπηρχαιομένη (*Isoc.* 2; *Thuc.* 24, 50; cf. ibid., 29–32).[67] πίνος, after all, has unwelcome connotations. Originally, it means "dirt," "filth," or "stain," before these are sublimated into

[66] As at Dion. Hal. *Dem.* 39: "Pindar's *Partheneia* and other poems of that kind require a different style [from the austere style], though even in these a certain stately nobility is still apparent, preserving the patina of antiquity (τὸν ἀρχαῖον φυλάττουσα πίνον)." This may have been a critical commonplace. Cf. *Vit. Aesch.* 331.18–21 Page: "[Aeschylus] thought that heroic grandeur (τὸ βάρος) struck the proper archaic note (ἀρχαῖον εἶναι κρινῶν), but that cunning and ingenuity and sententiousness were foreign to tragedy" (trans. Lefkowitz). As the last part of this sentence already suggests, and as the immediate sequel confirms (ibid., 21–22), an Aristophanic judgment has crept into the thought that is being ascribed to Aeschylus here.

[67] Also Dion. Hal. *Amm.* 2.2 and 2.3.

"patina"—though patina never fails to conjure up the image of incrustation.[68] Archaism, seen from the skewed perspectives of classicism, borders dangerously on barbarism, which is to say it approaches all too closely the state of *otherness* that it also embodies as part of its attraction. The danger inherent in approaching the remote past too closely is one that Dionysius's stylistic criticism unwittingly assumes for itself as well: drawn to the archaic, it is drawn into frightening proximity with the anarchic, in a way parallel to Dio's sojourn among the Borysthenians. Such is the risk of gazing unprotectedly and deeply into the classical past, for which the archaic acts as a virtual emblem (it represents the past in its pristine purity).[69] Is the archaic truly classical after all?

Dionysius's vacillations are exemplary. He acknowledges the more universal scope of "ancient patina," which can be unmoored from historical time, in particular from what we today call the archaic or early classical periods, not least of all because styles in their pure form are abstractions, while in reality they tend to be found mixed and blended together: "A style that is pure and completely uncontaminated with others is impossible to find in any author, whether of poetry or of prose. . . . The three methods of composition [sc., the austere, the polished, and the mixed] have no individual existence independently of one another" (*Dem.* 37).[70] What is more, writers after Thucydides draw on styles as from a palette, archaism (sounding old, venerable, and classical) being one of the available chromatic choices. Plato's archaism, for example, "betrays its old-fashioned quality only by the almost imperceptible patina of age (ὁ πίνος ὁ τῆς ἀρχαιότητος) that gently steals over and imparts to it a certain verdant, burgeoning bloom full of vigor (ἄνθος)" (*Dem.* 5). Plato is consciously affecting his archaism—or should we say his classicism? He is both old and yet somehow new and fresh at the same time. But how can he be both of these things at once?[71]

Elsewhere, in other writers, archaism is more freely admitted to be a mark of all classical writing. Thus, the austere style, already in Dionysius associated with elevated sublimity, eloquence, dignity, and grandeur (ὕψος, καλλιρημοσύνη, σεμνολογία, μεγαλοπρέπεια), but also with intensity, gravity, emotion, and robust spirit (τὸ βάρος, πάθος, ἐρρωμένον καὶ

[68] Demosthenes can at times lay on a "thicker incrustation of old-fashioned austerity (τῆς δὲ αὐστηρᾶς καὶ πεπινωμένης [sc., συνθέσεως] πλείω [sc., μοῖραν])" for special effects (Dion. Hal. *Dem.* 45).

[69] *Pace* Bompaire 1958, 54–55, 56 n. 1, e.g., 55 n. 1: "Voir un lien normal entre classicisme et archaïsme, c'est à notre avis méconnaître le sens même du mot classicisme," an unsustainable view, not only in view of the evidence, but also given the absence of any word for classicism in Greek. One has to look elsewhere to explain the seemingly inconsistent condemnations of archaism by classicizing authors.

[70] The various qualities of style obviously count for more than the rigid classifications of style. Cf. *On the Composition of Words* 11, just quoted.

[71] Cf. Plut. *Mor.* 395B, where the blooming sheen (τὸ ἀνθηρόν) of bronze is more typically contrasted with a dull patina (πίνος and ἰός).

ἐναγώνιον πνεῦμα),[72] is at the very least a component of the sublime tradition followed by Caecilius and Longinus, and one of its ideal forms—if not its most typical ideal form, to which all sublimity aspires: sublimity wants to appear old and venerable. Thus, in a similar vein and idiom, Longinus can write about the virtues of choosing "correct and magnificent words," a technique that "all orators and other writers cultivate intensely" because "it makes grandeur, beauty, old-world charm (εὐπίνειαν), weight, force, strength, and a kind of lustre bloom (ἐπάνθειν) upon our words as upon beautiful statues; it gives things life (ψυχήν) and makes them speak (φωνητικήν)" (30.1).[73] The quickening force of achieved classicism is like that of old statues come to life—although the point is that classically styled words are words that become and remain statues (or else architectural forms) which are now made to speak whenever they are successfully read or imitated. In one sense quickening, in another way classicism reifies and fixates: it turns language into museum objects on display. Put somewhat differently, classical words, phrases, and sounds bespeak what is unique about monumental classical forms: they are the language and discourse of the classical tradition itself, which, taken on its own, is no more than a collection of inarticulate objects—mute texts—whose sole unity resides in the structures of feeling that encompass them all.

Temporalities of different orders are at work here (the voice of the past, which is heard in the present, and so on). The competing logics of classical time, which intersect at a common point of illogic, need to be unfolded. Looking back, what we find in classicism is a museumlike admiration that complies with two related pressures: works from the past are never fully allowed *into* the present (they can only enter the present *as* classical objects); and they are never fully allowed to exist as anything but ancient, even in their past present (they are classical—and so too, antique—from birth). In a striking passage, Plutarch illustrates how prevalent this game of perspectives was in later antiquity, and how the literary critics we have been sampling are merely one of its expressions. Here is an excerpt from Plutarch's account of the construction of the Parthenon and other public monuments overseen by Phidias and funded by Pericles in the fifth century, which deserves to be quoted at some length:

> So then the works arose, no less towering in their grandeur (μεγέθει) than inimitable in the grace of their outlines (μορφῇ), since the workmen eagerly strove to surpass themselves (ὑπερβάλλεσθαι) in the beauty of their handicraft.... Each

[72] *Thuc.* 23.
[73] Longinus's last phrase, καὶ οἱονεὶ ψυχήν τινα τοῖς πράγμασι φωνητικὴν ἐντιθεῖσα, looks like a deliberate refashioning of Aristotle's famous definition of tragic *muthos*: "*Muthos* is as it were the soul (οἷον ψυχή) of tragedy" (*Poet.* 1450a38–39). Demetrius differs from both Dionysius and Longinus in contrasting the archaic style of Hecataeus, Herodotus, "and the older writers in general" with the periodic style of "the later writers" (Isocrates, Gorgias, and Alcidamas). The writing of the former "resembles ancient statues" in their severity and simplicity; the latter's style is "like the sculpture of Phidias" (*Eloc.* 12, 14; cf. 244).

one of them, men thought, would require many successive generations to complete it, but all of them were fully completed in the heyday of a single administration. . . . And it is true that deftness and speed in working do not impart to the work an abiding weight of influence (βάρος μόνιμον) nor an exactness (ἀκρίβεαν) of beauty; whereas the time which is put out to loan in laboriously creating (εἰς τὴν γένεσιν), pays a large and generous interest in the preservation of the creation (τῇ σωτηρίᾳ τοῦ γενομένου). For this reason are the works of Pericles all the more to be wondered at; they were created in a short time for much time (πρὸς πολὺν χρόνον). Each one of them, in its beauty (κάλλει μέν), *was from the very first already then antique* (εὐθὺς ἦν τότ᾽ ἀρχαῖον); *but in the freshness of its vigor* (ἀκμῇ δέ) *it is, even to the present day, recent and newly wrought* (πρόσφατόν ἐστι καὶ νεουργόν). Such is, as it were, *the bloom of perpetual newness* (οὕτως ἐπανθεῖ καινότης ἀεί τις) upon these works of his, which makes them ever to look untouched by time (ἄθικτον ὑπὸ τοῦ χρόνου), as though the unfaltering breath of an ageless vitality (ὥσπερ ἀειθαλὲς πνεῦμα καὶ ψυχὴν ἀγήρω) had been infused into them. (*Life of Pericles* 13.1–4 [= 13.1–5 Ziegler]; trans. Perrin; modified; italics added)

The compression of the work that went into the construction of the monuments of the Periclean building program ("completed in the heyday of a single administration") is in fact greater than the generations such a program would ordinarily have cost, for the time that is compressed is not one of generations but of over half a millennium (Plutarch is writing at the close of the second century C.E., the monuments date to the mid-fifth century B.C.E.). The result is the millennial perspective that is occupied by Plutarch's gaze, in the light of which the monuments could already in the fifth-century present appear antique and classical.[74] That is, the appearance of classicality was available to Pericles' contemporaries from the very first, at that time (εὐθύς, τότε): Plutarch and the fifth-century Athenians share the same view. It is as if time never passed but was simply frozen, less in a perpetual present than in a perpetual conflation of past and present, which is the timeless frame of classicism.[75]

[74] Stadter 1989, 165 (ad loc.) rightly translates ἀρχαῖος with "ancient" but glosses it with "classic," following LSJ, s.v. II.1. (Incidentally, this is the only place where LSJ acknowledges a Greek equivalent for the word "classical.") Cf. Dicaearchus fr. 49 Wehrli, along with Chiron 1993, 117 n. 237, who notes that, unlike *palaios*, *archaios* is never used in the sense of decrepit age. Rather, *archaios* stands semantically close to beginnings (*archai*), "donc ce qui est à la fois neuf, innocent, et pourvu du prestige de l'antiquité." Plutarch is activating this sense but also creating a contrast, and a conflation, of the (simultaneously) old and new. Cf. further Porter 2001a, 88 with n. 97, on the way in which Dio plays with a similar confusion ("old things were once new"), which may well point to a rhetorical topos of the Second Sophistic. But see also next note.

[75] The time frame of timelessness is of course itself inherited (cf. Loraux 1981, 125–30, e.g., 129: "intemporalité"), as is the figure of perpetual newness; cf. Lys. 2.26: "deeds of old (πάλαι γεγενημένων) . . . , as if they were still new (ὥσπερ καινῶν ὄντων ἔτι καὶ νῦν)." For a superficial resemblance, see Pater in his essay, "The Beginnings of Greek Sculpture": "In Greece all things are at once old and new" (Pater 1894, 226).

Plutarch cannot help but look upon the ancient monuments of Periclean Athens as classical whenever they appear to him, and his language betrays this. His is a classicizing gaze. But that is not all there is to his stance. For in occupying the vantage point he does Plutarch is not imposing an anachronism upon the past. He is not retrojecting his distant perspective willfully. Rather, he is merely occupying a point of view that (Plutarch can justly claim) was anticipated by the creators of the Athenian monuments and that they themselves projected into the future (into that of their own posterity) and then gazed back upon from that anticipated distance. Designed in the first instance to be lasting monuments to themselves and to their own making (τῇ σωτηρίᾳ τοῦ γενομένου), the Periclean buildings were plainly erected to "preserve the past" (the phrase can mean this as well) that they were also designed to honor.[76] And so the Athenians evidently not only had a view of their own monuments as classical; they also had a view of them as "*already at that time* antique," a view that can only be said to have been retroactively available to them in the fifth century. That such a perspective was available to them already in the fifth century is well illustrated by a much-cited thought experiment from Thucydides. The ruins of Mycenae in our own age (νῦν), he writes, are diminutive, but to leap to the conclusion that they represent what was once (τότε) an insignificant power would be a mistake. Imagine now Sparta and Athens as ruined and deserted sites, as mere temples and floor plans, and as looked upon by future beholders after much time had lapsed (προελθόντος πολλοῦ χρόνου): one would doubtless believe Sparta to have been an insignificant collection of villages, and Athens to have been twice as powerful as it in fact is (1.10.1–3). The capacity to project the present into the future as a past is obviously not beyond the reach of fifth-century Athens, any more than is a prescient critique of this kind of illusion.[77] That Athens under Pericles consciously projected an image of itself for future consumption and admiration, and that the building program was an integral element of this design, is likewise beyond doubt.[78] Here we would need to say that the classical past is not an invention of the postclassical past, as the fashionable logic of "inventions" today would have it. Rather, the reverse is true. In producing a point of view from which to be beheld, *Periclean antiquity "invented" Plutarch*, or rather it invented *Plutarch's gaze*. And that gaze is unqualifiedly universal, as is often claimed by upholders of the classical aesthetic in antiquity: anybody can occupy its point of view, and anyone with eyes for seeing—anyone with sufficient culture—does just that.

[76] Cf. Hölscher 1998, 182, on the way in which Athens, through its systematic public building program and patronage of the arts in the fifth century, "gradually developed into a monument of [its] own historical identity."

[77] Whether Thucydides is refuting a contemporary illusion about Athens and Sparta, a view held by contemporaries, is hard to say, but it is not unlikely that he is doing just this.

[78] See Introduction, above.

The Periclean buildings are, in the sense outlined in the Introduction above, proleptically classical, a *ktēma es aiei*, "a possession for all time," or as Plutarch boasts, "for much time" (πρὸς πολὺν χρόνον).[79] Longinus offers the same recommendation to aspiring writers. Anyone bent on becoming a classic must take up the Plutarchan point of view and ask him- or herself, "How will posterity (ὁ μετ' ἐμὲ πᾶς αἰών) take what I am writing?" (14.3). Needless to say, for "take" the Greek has "hear" (ἀκούσειεν). The question is as much addressed to the nature of feeling as it is to reading. Plutarch's conflation of temporalities is an index of what he feels, not what he knows.[80] In fact, he knows better, but denies himself this knowledge. Such is the *je sais bien, mais quand-même* logic of classicizing discourse, its founding gesture of disavowal, which in the present case runs, "I know very well that the Periclean monuments cannot have been old and new at one and the same time, but I will act as if they were just the same . . ."

Plutarch nicely illustrates how from a classicizing perspective antiquity cannot be conceived except as in itself always already classical, simultaneously old and new. He achieves this contradictory stance (without any hint of contradiction) simply by occupying two imaginary points of identification in his mind, that of himself in the present and that of himself transported into the past with all of his reverence for classical Athens intact. That Plutarch's conceit rhymes with the view of literary critics and other representatives of classicism in literature, at least of the Imperial period, is evident from the vocabulary they share. Conflations of past and present are the extreme case of identification. Even Herodes Atticus could be imagined as "one of the Ten," that is, one of the ten canonical Attic orators—a sum that manifestly fails to add up.[81] Consider Plutarch's aesthetic vocabulary. The Periclean monuments, in Plutarch's eyes, are done up in the severe style: they are "overwhelming in their grandeur" (ὑπερηφάνων μὲν μεγέθει), yet manage nonetheless to be gracefully beautiful (μορφῇ δὲ ἀμιμήτων καὶ χάριτι). The "abiding weight of influence" (βάρος μόνιμον) they project is a quality of *gravitas* and intensity that endures over time. The monuments are "archaic" (ἀρχαῖα), which is to say *already archaizing*. They display that "patina of antiquity" which "blooms" (ἐπανθεῖ) on their surfaces like fresh down (or dust). Full of grandeur and shapeliness, and wearing all the signs of the culture of contest that produced them (traits of rivalry and ambition and extraordinary effort [⟨τὸ⟩ ὑπερβάλλεσθαι], if need

[79] Cf. Zeuxis's retort to Agatharcus, who boasted of his speed and agility: "Mine take, and last, a long time" (Plut. *Per.* 13.4 and *Mor.* 94E).

[80] Bakhtin 1981, 18–19, notes the same mechanism: "One may, and in fact one must, memorialize with artistic language only that which is worthy of being remembered, that which should be preserved in the memory of descendents; an image is created for descendents, and this image is projected onto their sublime and distant horizon," which is to say, onto the descendants' *past*, for contemplation by the ancestors as their own future legacy. This is what Bakhtin calls "the future memory of a past" (ibid.).

[81] See n. 56, above.

be at the expense of a certain exactitude [ἀκρίβεια]—all features that will reappear in the Longinian sublime),[82] they are as though alive, animated by their own canonical qualities: finally, they "breathe" (ὥσπερ ἀειθαλὲς πνεῦμα καὶ ψυχήν). Thus do the monuments of ancient Athens speak to Plutarch at the end of the first century C.E.,[83] much as the verbal remains of classical writers could be regarded as monumental architecture or statuary by literary critics from Dionysius of Halicarnassus (if not earlier) to Longinus, archaic and blooming in the very same breath, as we have seen.[84] It is not that the critics were merely fond of searching for pictorial analogies to verbal art. The analogies they found had a specifically classicizing, which is to say ideological, function.

CLASSICAL PLEASURES AND THE FUNCTION OF CRITICISM

I hope to have made it plausible that critics who fastened onto the pleasurable sound of past authors were in fact making a statement about the classical past and its value in the present. But before turning to a closer analysis of their individual programs, a word of a more general kind about the language of classicism is needed. It is important to realize that there were no unified views about questions of classical value in antiquity. Instead, we find each critic variously defining his own stance towards the past and about the role played by criticism. Indeed, the field of literary criticism as a whole is a contentious arena that is constituted through a series of acts of self-positioning and self-definition. As a result, views quickly get quite nuanced and, what is of even greater interest, they end up complicating the stance of reverence or adoration towards classicism that does in fact characterize, but also differentiates, the literary critics.

The reason for this variety and lack of consensus within a broadly consensual domain of criticism has to do less with the subjective nature of literary criticism than with the public nature of the issues that are at stake. As mentioned, criticism was contending over structures of feeling, not private revelations.[85] The classical pleasures afforded by great literature from the past and analyzed and fought over in the present were thus decidedly public pleasures, pleasures that came freighted with a history and a context, having been already

[82] With Plutarch's ὑπερβάλλεσθαι ("eagerly strove to *surpass themselves* in the beauty of their handicraft"), compare the use of the same verb and of other ὑπέρ-compounds ("over," "beyond," "above"), all linked thematically to the underlying notion of ὕψος itself ("height," "elevation") and to the general ethic of competition in Longinus.

[83] See Jones 1966 for the date (96–99 C.E.).

[84] [Demetr.] *Eloc.* 13, 108, 183; Dion. Hal. *Comp.* 22; [Longinus] 40.4; with Porter 2001b.

[85] "... feelings which, I think, are not uniquely mine (οὐκ ἐμὸν ἴδιον μόνου) but are experienced by everyone (κοινόν τι πάθος ἁπάντων)" (Dion. Hal. *Dem.* 21, to be quoted more fully below).

sited and (re-)cited for generations.⁸⁶ The pleasures, we can safely say, were ideological ones. Below we will want to consider to what degree they reflected or simply were the pleasure of classical ideology itself. At any rate, given the public and external nature of the debate, at issue was not whether one should or should not take pleasure in literary excellence, but how one should appropriate ideological pleasures as one's own.⁸⁷ After all, it is not obvious why or even that a given text is pleasurable: pleasure is a delicate social event before it becomes an individual feeling, and the move from outside to within is fraught with entanglements and, inevitably, uncertainties and anxieties. Defining and redefining the nature and meaning of pleasure, an activity that no doubt entailed pleasures of its own, was the heart and soul of the critical enterprise (even if it was often pursued with a deadly earnest). But so was teaching students and readers how to respond to literature and to internalize critical standards: the aim of criticism was (and probably still is) to teach anyone who would listen how to *enjoy* its teachings. At bottom, these activities were a matter of cultivating a pleasurable form of attachment to history rather than to literature per se. Such was the ideological function of Greek literary criticism in its later and developed phases. It was part and parcel of a larger project of *producing* subjectivity.⁸⁸

Were there space, it would be possible to trace a general pattern in literary criticism by following one of its more curious instantiations, the pattern being more important than the actual chronology. Starting with Plato and Aristotle, then turning to Dionysius of Halicarnassus and some of his predecessors, and finally resuming with Longinus, what we would find on this approach is a con-

⁸⁶ Indeed, the epitaphic discourse of the Athenians is in many ways the paradigm and the origin of this affective tie to the past, performing, practicing, and celebrating as it did a sentiment and a public virtue that was at once private and collective—and self-effacing (cf. Loraux 1981, 105: "L'agent a vraiment disparu dans son acte")—in a kind of ecstasy, of the sort that is mocked in *Menexenus* (ibid., 270). Cf. Luc. *Merc.Cond.* 25 on "a lover of Greek learning and of beauty in education and culture" (φιλομαθὴς τῶν Ἑλληνικῶν μαθημάτων καὶ ὅλως περὶ παιδείαν φιλόκαλος).

⁸⁷ See Swain 1996, 79, for a good insight into this problematic: "The greatest importance lies in examining the cultural expectations which, once interiorized, determine why texts are pleasurable." Swain goes on to broach the topic of feeling: the past becomes "tied up with the feelings of the present day observer," pleasure being only one amongst these myriad feelings, to be sure. A good case in point, illustrating both the early date of this kind of pleasure, which as tied to classical values was decidedly Athenocentric, and a scene of its instruction, is the exhortation by the general Nicias to his allies in 413 B.C.E. (quoted in the Introduction at n. 213). Other examples include Dem. 15.35 ("Take joy in hearing [χαίρετ᾽ ἀκούοντες] someone praise your ancestors"); id. 13.12: "uplifting and puffing us up" (μετεωρίσας καὶ φυσήσας ἡμᾶς); Ar. *Ach.* 636ff.; Arist. *Rhet.* 1370a30; cf. Jost 1936, 243–44.

⁸⁸ Education in its more primary phases could, to be sure, go the other way, producing displeasure, fear, and loathing in students, often through at times brutal corporal punishment (see Connolly 2001, 368–70, for references)—which merely underscores how the pleasures discussed here are part of a *regime* that had to be *enforced*. The logic is paralleled in the case of linguistic norms; cf. Sext. Emp. *Math.* 1.194: "*Hellenismos* has met with acceptance for two main reasons: its clarity

ceptual progression that passes from a criticism based on formal rules and patterns to a criticism based on sound to one based on sheer feeling alone. At first felt to be of little or no consequence (it is generally disparaged), sound is later conceived as a more immediate and unfailing criterion, not of aesthetic and emotional qualities for their own sake (as the standard line has it), but of classicism.[89] Gradually, this "irrational criterion" (ἄλογον κριτήριον, Dion. Hal. *Thuc.* 27) transforms into a broader, more inclusive criterion of feeling about aesthetic excellence that finally sheds the constraints of sound altogether (as in id. *Lys.* 11). The arc of this progression, though peculiar to the history of euphonist criticism, maps a broader pattern in the way in which classicism comes to be conceived in literary criticism in antiquity. Classicism was always sublime, and Longinus, looking back on the tradition, does little more than provide a name and a label for this phenomenon of what was felt to be classical in antiquity, or rather for the structure of feeling that sustains classicism in its ancient forms. Without going into much detail, I want to give a quick sketch of some of the moves in this sequence, while focusing mainly on Dionysius of Halicarnassus.

Earlier, I mentioned that the line between written texts and these same texts as deposits of sound is typically blurred in ancient sources, and I adduced as an example the following from Dionysius of Halicarnassus: "Let us hear how he [sc., Plato] speaks" (ἀκούσωμεν δὲ αὐτοῦ, πῶς λέγει). With this appeal to speech, Dionysius is quietly announcing a theme, which has to do precisely with the aural qualities of Plato's diction, in contrast to his ideas (*Dem.* 25), that is, with the music and rhythm (τὰ μέλη καὶ ῥυθμούς) of the words rather than with what they say (τὴν λέξιν, ibid., 26).[90] In contrasting musicality with meaning, Dionysius is reenacting a division that had first emerged in purely formal terms during the time of Gorgias and the sophists, namely between

and agreeable (προσήνειαν) presentation of the things being indicated." The exact meaning of *prosēneia* is disputed (see Blank in Sextus Empiricus 1998, 222–23), but a subjective meaning seems plausible (Atherton 1996, 251–52, whose translation I have followed). On the production of subjectivity in the public sphere, a complex process involving a complex set of issues, see, e.g., Eagleton 1984, 115–17 (likewise approaching the topic by way of literary criticism).

[89] For a recent defense of Dionysius's irrational aesthetics, but without reference to classicism, see Damon 1991. Goudriaan 1989 relegates pleasure (*to hēdu*: the sweet, seductive, and deceptive) to a negligible if not suppressed position in the formation of Dionysius's ideal of classicism, opposing it to beauty (*to kalon*) and treating the latter as a separate category of style altogether (the hard, rough, archaic, and austere, viz., the genuinely *political* style of writing). If this were right, one would be hard-pressed to make sense of a passage like the following: "Great skill is needed here to ensure that such combinations [sc., of letters, which produce clashing, jarring effects] do not find their way in unnoticed to produce ugly or unpleasant sounds (μὴ κακόφωνοι μηδὲ ἀηδεῖς), or otherwise offend the ear. Rather they should confer a delicate bloom of antiquity (ἀρχαιοπινής) upon the passage," which is to say, "beauty (ὥρας) and individual charm" (*Dem.* 38). Cf. Goudriaan 1989, 183–84 and 215–17.

[90] Citing the phrase, "Let us hear (*akousōmen*) how he speaks," Schenkeveld (1992, 134 with n. 25 and 136) argues that the meaning of *akousōmen* has to do here, in conformity to its normal, "catachrestic" sense, with reading and not with audition, but the sequel shows that Dionysius means

sound and sense. Without doing any violence to this compartmentalization, we might easily transpose the distinction into one between texts in their quality as read aloud and texts as silently comprehended.[91] Once sundered and appreciated as an entity in its own right, language *qua* sound or voice took on a life of its own. Such a conception of language seems to have attracted independent theoretical attention early on, and eventually an entire branch of literary criticism would come to be devoted to the analysis of the way language sounds and the pleasures it affords listeners: rhythm, meter, and pitch (the prosodic features of texts) were all involved, as were the less quantifiable features of "delivery" (*hupokrisis*). Traces of this tradition can be found before Aristotle, but the evidence is spotty and difficult to reconstruct.[92]

The most extreme form of this trend, and surely one of the stranger aberrations of literary thinking in antiquity, was the euphonist criticism from the Hellenistic era, in which the emphasis upon verbal sound was converted into a radically exclusive aesthetic bias. The sole criterion of poetic excellence was on this view phonic beauty, not its dull and colorless alternative, meaning. Euphony here is an immediate, sensuous property of texts (or their effect) that appears, as it were, on their surface (*epiphainomenē*), and the production of which can be analyzed in atomistic detail. Euphony, moreover, is a property of the audible moment, a particularity (*idion*) that belongs to its momentary appearance and that cannot be transposed without damage to its idiosyncratic features. Meanings lack this trait. Justifying, in this manner, an inherited distinction (between sound and sense), the euphonist critics devoted themselves exclusively to the resources of beautiful sound, while scanting the remaining features of literary language, whether of prose or poetry, as so many accessories to what they considered the true object of aesthetic experience, aural

just what he says. It would perhaps be more correct to hold that *akouein* in the sense of "to read" standardly carries connotations of reading aloud or of reading for (or with) the sound in an era when, to take a phrase from Robert Wood, "the sense was catched from the sound" (Wood 1775, 281). Similarly, *legō* can mean "read aloud," as at Pl. *Phdr.* 263e5 (cf. ibid., e2: *anagnōmen*: "Shall we read . . . ?"). Conversely, it can mean "write"—what one says while writing (cf. ibid., 235e6). Thomas's arguments (1992) about the nonexclusivity of orality and literacy in the classical period are every bit as valid for the later, postclassical periods. Quite apart from the question of whether performance continued to play a role in the Hellenistic world (Cameron 1995), the Hellenistic vogue for emphasizing the voice of textual objects can be understood not as a triumph of writing overspeech, as is commonly thought, but as an obsession with what the shift to a textually based culture tended to paper over, whether this took the form of a nostalgia for the voices of the past or simply represented an attempt to recuperate these voices and their sound (starting above all with their prosodic features: rhythm, pitch-accent, meter, and the finer movements of breath, such as hiatus, elision, and punctuation).

[91] Cf. Arist. *Rhet.* 1405b6–8, retailing the view of Licymnius, a pupil of Gorgias, whose dithyrambs, Aristotle later says (1413b14), are more suited to reading aloud than to enacting. I agree with Crusius 1902, who points out (p. 384) that Licymnius was noted in antiquity for the musical character of his writings (he was called μελοποιός, Parth. 22).

[92] Cf. Pl. *Cra.* 426d–27c; and see Porter 2004.

pleasure. Our main witnesses to this hedonistic trend are the so-called *kritikoi*, a motley assemblage of Hellenistic critics who are vehemently attacked, and so too ironically (and uniquely) preserved, by Philodemus, the first-century B.C.E. Epicurean from the Bay of Naples. A later echo of this one-sided critical tendency is found in the stylistic essays of Dionysius of Halicarnassus, although he is far less committed to the thesis that beauty resides in sound alone than were his precursors in euphonist criticism. Still later, traces of euphonic criticism are found scattered throughout a range of writers down to and including Longinus,[93] but the fad seems to have all but spent itself by the time Dionysius arrived on the scene with his slightly compromised version of the doctrine that the value of verbal art lies in the sound and not in the sense.[94]

Euphonism is important to trawl for clues to classicism for a number of reasons. The doctrine was in some respects bound to be an element of classicism in the centuries after Plato and Aristotle, once the studied effort to preserve the original, pure articulation of the Greek language took hold under the rubrics of Atticism and *hellenismos*, and these two criteria tended to merge into a single, unified criterion (see Introduction).[95] But what evidence is there for classicism among the euphonists proper? In the case of Dionysius of Halicarnassus, who was himself already swept up by, if not a primary instigator of, Roman Hellenism, which is to say an advocate of purism in language and culture, there is, as we have already begun to see, quite a lot of evidence for an attitude that is compatible with classicism. A standard procedure of Dionysius's is to clear off the bat each of the writers he passes under review by awarding them the formulaic stamp of approval of "purity" (*to katharon*). Thus, Lysias is "completely pure (καθαρός) in his vocabulary, and the perfect model of the Attic dialect" (*Lys.* 2); Isocrates is "the purest (καθαρώτατος) of Lysias's successors in the choice of words" (ibid.; cf. *Isoc.* 2: their styles are equally "pure"); "the language of Isaeus is pure (καθαρά), precise, clear, standard (κυρία), vivid and concise" (ibid., 3); the opening to *On Demosthenes* is lost, but we are assured of Demosthenes' Lysianic purity of language nonetheless (13); Plato's language is also cleared as "pure" (5), except when he blunders (7), as are the Attic historians before Herodotus (*Thuc.* 5) and eventually Thucydides (ibid., 36), etc.[96] In the case of the *kritikoi*, reflection will show how they exhibit tendencies that in some respects are anticlassicizing while in others

[93] [Longinus] 39.1 mentions two earlier studies by him "on the composition of words" (the same title as that of Dionysius's work, which may have led to the confusion of their names in the ms. titles of *On the Sublime*), while chapters 39–41 give a taste of how he would have dealt with this theme. Cf. Quint. *Inst.* 9.4.1–44, with Janko 2000, 313 n. 2.

[94] For a summary of this development, see Porter 1995a, 106–7; Janko 2000, 176–77, 188–89 (adding Lucilius and Varro); on Cicero and Longinus, see Porter 2001b.

[95] For the link between Atticism and *Wohlklang*, see Schmid 1887–97, 1:12.

[96] For a general statement about literary purity, reckoned by Dionysius to be "the supreme virtue without which no other literary quality is of any use," viz., "language that is pure (καθαρά) in its vocabulary and preserves the Greek idiom (τὸν Ἑλληνικὸν χαρακτῆρα)," see Dion. Hal. *Pomp.* 3. On Dionysius's classicizing historical writing, see Ek 1942.

they seem classicizing. Crucial in comparing these two varieties of euphonism will be the way in which each delineates a zone of feeling that is inaccessible to reason and to meaning but which underpins an entire aesthetics of reception. Here we can begin to see most plainly of all why to read a classical author might be intimately connected with a structure of feeling that will later come to be denominated with the label of "classicism."

Dionysius of Halicarnassus and the Irrational Criterion

A passage on Lysias's style will serve as a good introduction to Dionysius's aesthetics of classicism. Having enumerated the various virtues of Lysias's style that contribute to making him "the most persuasive of all the orators," Dionysius turns to "his finest and most important quality," but also his defining quality, that which gives Lysias his peculiar and unsurpassed "character": "What is this quality? It is his charm (χάρις), which blossoms forth (ἐπανθοῦσα) in every word he writes, a quality which is beyond description and too wonderful for words (πρᾶγμα παντὸς κρεῖττον λόγου καὶ θαυμασιώτερον). . . . And where do we find [this]?" (*Lys.* 10–11). As with all other arts and realms of beauty, Dionysius writes, one discovers the intangible qualities of excellence through the senses and not through reason (αἰσθήσει καὶ οὐ λόγῳ):

> The advice which teachers of music give to those wishing to acquire an accurate sense of melody and thus be able to discern [lit., "not to fail to catch" (μηδὲ ἀγνοεῖν)] the smallest tone-interval in the musical scale (τὴν ἐλαχίστην ἐν τοῖς διαστήμασι δίεσιν), is that they should simply cultivate the ear (τὴν ἀκοὴν ἐθίζειν), and seek no more accurate standard of judgment (κριτήριον) than this. My advice also would be the same to those readers of Lysias who wish to learn the nature of his charm: to banish reason from the senses and train them by patient study (μακρᾷ τριβῇ) over a long period to feel without thinking [lit., "to train the irrational faculty of perception together with irrational feeling" (καὶ ἀλόγῳ πάθει τὴν ἄλογον συνασκεῖν αἴσθησιν)]. (Ibid., 11)[97]

Dionysius adds that it is to this faculty of irrational sensation that he makes final appeal whenever questions of attribution are in doubt: "I resort to this criterion to cast the final vote." Feeling puts one directly in touch with the qualities of an author's mind and soul (here, τῆς Λυσίου ψυχῆς, ibid., 14). It is how one verifies the experience of reading. And it is an unfailing touchstone, because it reveals a truth that is self-evident and beyond argument: "it is very easy and plain (φανερόν) for layman and expert alike to see (ὀφθῆναι), but to express it in words (λόγῳ δηλωθῆναι) is very difficult" (ibid., 10). In a word, it is the criterion of classicism.

[97] By *aisthēsis* Dionysius has in mind a developed perceptual faculty for language (cf. *Comp.* 22: οἱ μετρίαν ἔχοντες αἴσθησιν περὶ λόγους).

In classicism, feeling is everything and is so to speak in touch with itself. Consider Dionysius as he compares Demosthenes with Isocrates: "Above all, the whole of it [sc., a passage from a harangue against Philip] in its energy, vehemence and feeling (κατὰ τὸ ἐμπαθές), is wholly and entirely superior to the style of Isocrates. At any rate I propose to describe my feelings (ὃ πάσχω) when I read both orators, feelings which, I think, are not uniquely mine but are experienced by everyone (κοινόν τι πάθος ἁπάντων)" (*Dem.* 21). As the example shows, there is a continuum but also a range of feelings that runs across both ends of the literary experience, that of the author and that of the reader, who are isomorphically related to each other, if not momentarily identical.[98] The experience can be intense. But it need not be. Classicism covers a spectrum of feelings in varying degrees of intensity but with distinctive characteristics that form subgenres unto themselves. In the present case Dionysius has in mind something like a Barthesian distinction between the *lisible* and the *scriptible*, between mere literary pleasure and a more difficult and rewarding pleasure that is uncommonly superior:[99]

> Whenever I read a speech of Isocrates . . . I become serious and feel a great tranquility of mind, like those listening to libation-music played on reed-pipes or to Dorian or enharmonic melodies. But when I pick up one of Demosthenes' speeches, I am transported (ἐνθουσιῶ): I am led hither and thither, feeling one emotion after another—disbelief, anguish, terror, contempt, hatred, pity, goodwill, anger, envy—every emotion in turn that can sway the human mind. I feel exactly the same (διαφέρειν οὐδὲν ἐμαυτῷ δοκῶ) as those who take part in the Corybantic dances and the rites of Cybele the Mother-Goddess . . . , whether it is because these celebrants are inspired by the scents, <sights,> or sounds (ἤχοις) or by the influence of the deities themselves that they experience many and various sensations (φαντασίας). And I have often wondered what on earth those men who actually heard him make these speeches could have felt (πάσχειν). (Ibid., 22)

The first level of inspiration for a reader like Dionysius is in the sound. The link to the past transpires at the phonic surface of an author's writing, of a text

[98] Dion. Hal. *De imit.* 2, fr. 6.1, p. 202.20–22 U.-R.: "The soul of the reader attracts to itself, by virtue of its continuous attention to an author, an identity with the author's character of style" (ἡ γὰρ ψυχὴ τοῦ ἀναγινώσκοντος ὑπὸ τῆς συνεχοῦς παρατηρήσεως τὴν ὁμοιότητα τοῦ χαρακτῆρος ἐφέλκεται).

[99] Barthes 1975. Cf. also Barthes 1974, 5: "The writerly text is a perpetual present, upon which no *consequent* language (which would inevitably make it past) can be superimposed; the writerly text is *ourselves writing*, before the infinite play of the world (the world as function) is traversed, intersected, stopped, plasticized by some singular system (Ideology, Genus, Criticism) which reduces the plurality of entrances, the opening of networks, the infinity of languages." In contrast to Barthes, or rather to his apparent sense, I will try to show how the *jouissance* of the writerly text is not determined by an escape from ideology but by the illusion of any such escape; and how it is here, within this illusion, that ideology is most gripping and most ineluctable. This may well be what Barthes himself ultimately had in mind.

that communicates its passion directly because (in Roland Barthes's phrase) it has been *written aloud*.[100] Then somehow—Dionysius never explores this aspect of the psychology of reception or its precise mechanism—a flood of emotions is released. The chain of influences runs directly from soul to soul, from feeling to feeling, and across a commonly shared border of imagined sound: for example, Demosthenes uses "all his prestige to display his own feelings (τὴν αὐτοπάθειαν) and to bare his soul (καὶ τὸ παράστημα τῆς ψυχῆς)" (ibid.). Probably Dionysius means the two kinds of feeling, aesthetic and emotional, to be ultimately inseparable. But they are presented as being initially distinct, as are the two kinds of pleasure they involve, the pleasure of artistic appreciation (pleasure taken in the technique) and that of emotional effect. Isomorphically related, the two kinds of pleasure in the end blend into a single feeling, the feeling that is sanctioned by, and sanctions, classicism. For the very same reasons, Longinus could take an ecstatic pleasure in following the roller coaster of a hyperbatic sentence in Demosthenes, with its dizzying threats to meaning (will the sentence, stretched to a syntactic extreme, collapse before it is completed?), which vividly mimics the dangers to political coherence described by Demosthenes in his speeches:

> His transpositions produce not only a great sense of urgency but the appearance of extemporization, as he drags his hearers with him into the hazards (τὸν κίνδυνον) of his long hyperbata. He often holds in suspense the meaning which he set out to convey and, introducing one extraneous item after another in an alien and unusual place before getting to the main point, throws the hearer into a panic (εἰς φόβον) lest the sentence collapse altogether, and forces him in his excitement to share the speaker's peril (συναποκινδυνεύειν). ([Longinus] 22.3–4; cf. 20.1–3).

Where the two feelings, aesthetic and emotional, come together and become one is in the initial feeling that allows a reader to experience them at all, which is none other than the feeling of being in the ambit of classical greatness.

But there is an even more curious side to this mirroring between producer and receiver, be it one of mimesis or contagion, in classical structures of feeling, of which the case of Demosthenes is prototypical. For it is surely significant that the context of the passage from Demosthenes in the discussion by Dionysius cited earlier in the comparison with Isocrates, and in a different way that signaled by Longinus, repeat the situation of being epigonal that both critics intensely feel and fleetingly overcome in the presence of Demosthenes' resounding words. In the case of Dionysius, the comparison between the two

[100] See Barthes 1975, 66. Cf. Pl. *Phdr.* 234d1–6 on the ecstasy of reading, a clear predecessor: "I was thrilled by it. And it was you, Phaedrus, that made me feel as I did: I watched your apparent delight (γάνυσθαι) in the words as you read. And as I'm sure that you understand such matters better than I do, I took my cue from you, and therefore joined in the ecstasy (συνεβάκχευσα) of my right worshipful companion" (trans. Hackforth).

fourth-century orators turns, in fact, on their respective skillfulness in handling a theme naturally emotive for any Hellenophile, namely the contrast between the sorry state of Athenian politics in the contemporary present and its past glories. Isocrates is inept, Demosthenes skillful, in "compar[ing] the behaviour of his contemporaries with that of his ancestors" from the generation of Marathon, when "the Acropolis was full of silver and gold" but the Athenians risked life and limb rather than hiring mercenaries to fight for their freedoms against the barbarian intruders (*Dem.* 21, 20). The theme of ancestry is blameless in itself; indeed "the idea is noble and capable of stirring emotion" (20), and so in theory both Isocrates and Demosthenes ought to stand equal chances of success. But it is execution and style that count in the end. "Why is it that [Isocrates'] style lacks intensity (ἄτονος ... ἐστιν) and the power to hold the reader fast? Because it adds to the passage I have quoted a sentence like this: 'And so far are we inferior to our ancestors, both those who enjoyed the esteem of the Greeks and those who were hated by them, that whereas they...'" (ibid.). Dionysius's rather bald and unfavorable comparison simultaneously carries out a critique at another level, one that barely masks an ideological discomfort. What Isocrates should have written, Dionyius insists, is the following: "But perhaps we are worse in this respect than our ancestors (τῶν προγόνων), *but better in other respects*" (ibid.) This is *metathesis*, the literary critical technique of rearranging a text, put in the service of spin. In the end, Isocrates is assailed for his lack of concision and compactness, for his *excess* of clarity and even for having overwrought his acoustic devices (those that are meant to attract the ear), and generally for his lack of resonance and volume (he is ψοφοδεής, 18)[101] and of *pneuma*, or breath: "Well, as to the lack of life and feeling in his style (ἄψυχός ἐστι καὶ οὐ παθητική), and the virtual absence of spirit (πνεύματος), an essential quality in practical oratory..." (20). Isocrates is not an orator one wants to read *aloud*; he cannot be effectively declaimed. The complaint goes back at least to Hieronymus of Rhodes, whom Dionysius is silently quoting.[102] Demosthenes, in contrast, can be effectively read aloud and demands this.

Dionysius's choice is telling: sound is a virtual emblem for the past's resonance into the present. Why does Demosthenes fare so well in the comparison? His theme is the same, but his approach is different: "He does not set out each separate pair of actions in finicky detail (πάντα μικρολογῶν), old and new,

[101] Not translated broadly enough by Usher ("afraid of harsh sound"): Isocrates "never introduces an emphatic note" (ψοφοδεὴς καὶ οὐκ εἰσφέρεται τόνους κραταιούς). Cf. ibid., 20: Isocrates' style is too smooth and soft: "It ought to be rough and harsh, and have almost the effect of a flow, but in fact it is languid, flowing evenly and soundlessly (ἀψοφητί) through the ear like oil." Cf. [Demetr.] *Eloc.* 73 for the association of grandeur in style with volume or richness of sound (πολυηχία).

[102] Dion. Hal. *Isoc.* 13 = Phld. *Rhet.* 4 col. 16a.13–18a.8 (1:198–200 Sudhaus). The argument may have been inaugurated by Alcidamas, Isocrates' contemporary, and later picked up again by Demetrius of Phaleron (ibid., col. 16a.11–13 = fr. 169 Wehrli).

and compare them (συγκρίσει), but carries the whole antithesis through the whole theme by arranging the items in two contrasting groups (ποιούμενος τὴν ἀντίθεσιν), thus: . . ." (21). Once again, it is presentation and style, not content, that is of primary interest to the literary critic, at least on the surface. Evidently, Demosthenes builds a further contrast into his argument that is not found in Isocrates, which renders his addressees in the present into the nearly guiltless victims of a political manipulation beyond their control and even knowledge: "But now, on the contrary, the politicians have control of the prizes and conduct all the business, while you, the people, enervated, stripped of your wealth and your allies, have become like underlings and mere accessories. . . . They coop you up in the city itself, then lead you to these diversions [i.e., the theater and festival processions] and make you tame and submissive to their hands" (ibid.). But even this detail is presented as a matter of style and as a point of literary criticism. The two orators are after all expressing the same theme. But what stands out in Demosthenes' speech is the "energy, vehemence and feeling (τὸ δραστήριον καὶ ἐναγώνιον καὶ ἐμπαθές)" of his language (ibid.). And so, to the list of properties that can be identified in Demosthenes and to a lesser extent in Isocrates, and which are then available to be identified *with*, it would seem that we need to add one more: that of being a *vulnerable* classic, an author who senses the inferiority of his contemporary world to the past and strives to overcome this failing through an effort of language and imagination. Is Dionysius drawn to Demosthenes by virtue of the latter's classicality, the qualities of being a classic that he exhibits, or by virtue of Demosthenes' backward-looking and virtually nostalgic *classicism*? No wonder the feeling Dionysius has is so hard to name: it is painfully complex.

Surely the spectacle of inferiority presented by an Athens struggling with Philip has something distasteful about it for a member of the Greek cultural elite under Rome. Dionysius is not alone in being both drawn to and repelled by the image of Athens sliding inexorably into political decline and from which it would never recover. As if in reaction, he directs a harsh criticism at Isocrates that strikingly inverts for a split second Dionysius's own aesthetic program: Isocrates fails rhetorically "because he insists on making his language blossomy and showy (ἀνθηρὰν καὶ θεατρικήν) at all costs, believing that in literature pleasure should reign supreme (ὡς τῆς ἡδονῆς ἅπαν ἐχούσης ἐν λόγοις τὸ κράτος)" (trans. mod.). Worse still, "to please the ear by every means (ἡδύνειν τὰς ἀκοάς), selecting fair- and soft-sounding words (εὐφώνων τε καὶ μαλακῶν ὀνομάτων), to insist on wrapping up everything in rhythmically constructed periods, and bedecking a speech with showy figures is not, as we have seen, always advantageous" (18). This defensive gesture, which reiterates a common complaint against orators that is shared even by Isocrates (and cited at 17, init.), is oddly out of place in Dionysius's essays on rhetorical style and its readerly, and especially its acoustic, pleasures. Earlier, for instance, he lists "pleasure" as the first of a series of positive qualities that

"blossom on the surface" (ἐπανθούσης) of Lysias's writings (13). And everywhere else he is keen to point up the pleasures that a great classical text affords its attentive readers.

Pleasure is plainly not an innocent element of classicizing criticism. Pleasure alone is not a sufficient criterion of stylistic excellence; but neither is excellence, which is to say classicality, complete without its yield of pleasure. If there is something like a classical pleasure, we can be sure that it comes charged with ideological commitments, commitments that only on the surface, where they are absorbed and naturalized, risk being confused with an indulgent literary hedonism. The pleasure one takes in the classical past is a utopic, idealizing one. It is also fraught, and riddled with the very anxieties that it holds at bay. Not for nothing is it a pleasure that requires vigilant cultivation and conditioning, "much practice and prolonged instruction" (50). Classical discrimination comes in no other way. It is a pleasure that has to be learned; it must be practiced through training (*askēsis*), if it is to become naturalized in the form of a permanent *hexis*, or *habitus* (ἕξις, 52, init.).[103] Only so can its possessor gain access to the infinite riches of past literature that easily "escape the notice" of the untrained listener (48, fin.), the way the visual arts contain a wealth of detail discernible only after long training (50)—whence the power of the claim to universality that Dionysius can make for his judgments of literary value. Indeed, the whole of his program is directed at helping others attune themselves to the high-frequency transmission that we, not dissimilarly trained and habituated, call and cherish as "classical."[104]

Radical Euphonism and the Sublime

Now we turn to the so-called *kritikoi*, or critics, known to us solely through the tantalizing papyrus remains of Philodemus of Gadara. The value of poetry for these critics, who were active roughly from the beginning of the Hellenistic era down to the mid-second century (they are reported by Crates of Mallos), lies not in what poetry means but in the way it sounds and in the immediate pleasures it yields. They are euphonists, but with a vengeance. There is a stark reductionism to this theory of poetics. Its proponents speak of sounds as the

[103] Cf. Theon *Prog.* 61.30 Spengel: the soul becomes "imprinted" by the models it beholds. His work is after all entitled *Progymnasmata*, or preliminary exercises: they are a form of training (*askēsis*, ibid., 65.19), aimed at producing a *hexis* (65.24) in the student. Quint. *Inst.* 10.1.1, 59–60, equating *firma facilitas* with Greek *hexis*; and, e.g., 1.2.31 on *habitus*; and Carruthers 1990, 169, who notices the connection between *habitus* and feeling in Quintilian.

[104] Once again, many of the habits of classicism were encouraged from the start. When Pericles urged his fellow citizens to "fall in love with Athens" and its greatness (Th. 2.43.1), he was modeling the emotion of an ideology. Later commentators on Demosthenes would recognize that his aim was not impartial narration of the past but "to enthrall (*psychagōgein*) the listener through exalted models and brilliant examples of excellence" (Sch. T to Dem. 18.95, cit. Jost 1936, 184); Wohl 2002.

underlying "causes" (*aitiai*) of poetic effect; and given their absolute quality, comparisons between sounds at some point become irrelevant, and all we are left with is an unrivalled experience of aesthetic pleasure. Poems (but also works of poetic and rhetorical prose, which they treat as verses[105]) are for these critics no more than surfaces of sound that impinge on the hearing (ἀκοή). Texts are the encoding of this sound, which, when read aloud, comes to life: "when Homer's verses are read out (ἀναγινώσι|[κητ]αι), they all appear greater and more beautiful (πάντα μ[ε]ίζω | [καὶ κα]λλίω φ[αίνε]ται)."[106] For a later echo of this same thought we might compare Cicero: "Books," he writes, recalling a theme that dates back to the fourth century, "lack that breath of life (*spiritu illo*) which usually makes . . . passages seem more impressive (*maiora*) when spoken (*aguntur*) than when read (*leguntur*)" (*Or.* 130; trans. Hubbell). Encoded in a text is in fact the author's voice, which is less an authorial instance in a hermeneutic sense (the source of meaning and intention) than a place of origin and a first physical cause—a material origin—that has been incorporated invisibly, but audibly, into a palpable texture of sound. To read with care is in effect to diagnose authors physiognomically.[107] Thus, "a stammerer" or a "weak-voiced" speaker, someone who displays ἰσχνοφωνία, "will not be a good poet" (col. 96.3–6 Janko); in contrast, "grandeur of voice (μέγεθος [φ]ωνῆς)" always stands an author who is intent on *psychagogia* in good stead (Tr. A col. x Sbordone). And so, too, all that matters in the end for the euphonists, aesthetically speaking, is the experience of the reader/hearer in touch with this voice. That experience ideally will be one of sublime ecstasy effected through a kind of Longinian compulsion (ἐνθουσιῶ, [ἐ]πικρ[α|τ]ῇ ἡμῶν).[108]

It is easy to see how euphonism as extreme as this, sacrificing content to sound and pleasure, is in ways anticlassicizing. But appearances can be deceiving. In point of fact, the classicizing credentials of these euphonists are unimpeachable: they adhere to the classical canon of authors,[109] and they are staunch advocates of *hellenismos*, or pure-sounding Greek. A text from Philo-

[105] Phld. *On Poems* 1, col. 199 Janko.
[106] Ibid., col. 43.9–12 Janko.
[107] Cf. Dion. Hal. *Dem.* 50 (init.), where this very parallel is made, and where the act of penetrating an author's physiognomy is described as a *diagnōsis* and a *gnōsis*. Similar epistemological vocabulary appears in the language of the Crates of Mallos and the *kritikoi*. Perhaps a contamination of the two kinds of empirical observation took place at some point in their respective traditions, although it is worth noting that *diagignōskein* and *diakrinein* are quasi-technical literary terms already in Plato (*Ion* 538e)—in which case, the contamination, as I suspect it was, probably occurred earlier.
[108] Tr. A col. 7.8; cf. Tr. C fr. c col. ii Sbordone; cols. 114, 166 Janko; cf. ibid., col. 158; [Longinus] 39.3. Cf. Porter 1995a, 89 with n. 15 and 107; id. 2001.
[109] Euphonist criticism featured as part of its critical canon not only Homer, Archilochus, Sappho, Theognis, Sophocles, Euripides, and Chaeremon, but also Herodotus, Sophron, Antiphon, Xenophon, Demosthenes, Philiscus, Philoxenus, and Timotheus. Poets after the fourth century are not even considered.

demus attributed by Richard Janko to one of Crates' predecessors and presumably quoted by Crates makes this connection explicit:

> "So too, then, in the case of people speaking Greek the sound produces what is particular (τὸ ἴδιον) with regard to our pleasure—wouldn't it be dreadful for [the sound] to be deprived [of this particularity of pleasure] because of speaking Greek (διὰ τὸν ἑλληνισμόν)!—, but [the mind] is perhaps distracted by some other (factors)," viz., by, or towards, the sense of the words, as opposed to their phonic qualities. (Phld. *Po.* 1, col. 100 Janko)

An earlier column nearby secures the interpretation I am offering here, which connects euphonism to an account of *hellenismos*. The same predecessor critic is quoted as saying the following:

> "Some (words) are deemed anomalous by reason of their sense, others according to the sound, with laxness and tenseness, aspiration and lack thereof, lengthening and shortening (of vowels), prefixation and modification of endings. When all these things are found correctly, pure Greek is produced and there is a kind of attunement of them." (Ibid., col. 94)

And once this connection to the perception of the Greek language is made, the formerly bizarre and arbitrary exponents of poetic sound suddenly become culturally intelligible, even necessary. Euphonism is a way of defending the intuition that Greek, correctly spoken, is aesthetically pleasing: Greek sounds good for the same reasons that it sounds right. So widespread a phenomenon won't have issued out of the void: it must have existed in the earliest traditions of criticism, and in fact there is evidence to suggest it did.[110] In a word, it would be surprising if a culture as steeped in orality as Greece failed to produce a strain of criticism that could explain its own cultural obsessions. The euphonists seem to fill this gap admirably. Indeed, if they hadn't existed, somebody would have had to invent them.[111]

From another perspective, it becomes obvious that the attractiveness of classical value is not being dismissed by these exponents of poetic materialism but is only being reinforced. The sheer seductiveness of what is classical about classical literature, never previously named as such, is here being in fact

[110] Janko 2000, 136–37, 173–85; Porter 2004.

[111] The intuition seems obvious, but it is rarely stated in this way. The short anonymous treatise *De hellenismo et atticismo* (in Koster 1975, 19), for example, locates the criteria of *hellenismos* in "breath," "times," and "pitches," inter alia, which lend themselves by definition to aesthetic appreciation. And Dionysius of Halicarnassus subordinates *eklogē* (word-selection) to the criterion of euphony, as in the *De compositione* (e.g., καλῆς ὀνομασίας; λέξιν καθαρὰν καὶ καλλιρήμονα; *Comp.* 3, p. 9.10-15 U.-R.); see *De imit.* 2, fr. 6, pp. 204.6–7, 212.15–18 U.-R.; cf. Ek 1942, 2–3 and 155. Phyrnichus's criteria are likewise aesthetic: see *Ecl.* Praef. and passim, where the categories and criteria of "beauty" (*to kalon*) and "the acceptable" (*to dokimon*) in word-choice are fused together, and opposed to "ugliness" (*to aischron*) and "the unacceptable" (*to adokimon*). On the aesthetics of classical ideology, see further Introduction, n. 30.

named—as sweet sound, transport, and sublimity. Classical seductions, always irrational (a matter of feeling rather than of reason), are not being dismissed by the euphonist critics. On the contrary, they are being shown to be sublime. What remains, on this critical reduction of sense to sound is thus not only sound but also, or rather above all, the feeling that the sound both evokes and stands for. What remains, in other words, after all is said and done, is a *pure ideological effect*, absent any content, namely the ideological effect of classicism itself. Whether they are also critically highlighting the contingency of this value, in the first instance by directing attention to its material coordinates (in sound, in its existence in and for "the ear"), then to its convention-bound nature (by appealing to its underlying "nature" within the cultural specific constraints of *hellenismos*), and finally to its sheer *imaginary* value (it is no more than a *phainomenon*), is a possibility that cannot be foreclosed. Quite to the contrary.[112] What is more, by insisting upon the radically located nature of aesthetic effects—they obtain uniquely where they do, *here and not there* (they are in this exact sense *idion* to their poetic context and moment of audition)—euphonism in this form denies the possibility that what is classical has any of the properties of a universal, such as a Polyclitan-style Canon, that merely needs to be instanced in this or that work of art. So far from being an ideal, let alone an idea or a formal property of any kind, the *idion* is materially embodied and cannot be translated, whether into another context (as meaning) or into language (as description or paraphrase), without damage to its effects, nor can it be compared to anything else but itself.[113]

The euphonists isolate without naming this quality of classical literature, which can be at most felt in a passing instant as an ephemeral character of texts, as the music that the writing "contains," the very ephemerality of which stands for the intangible quality of their classicality itself (their quiddity).[114] "Euphony," "pleasure," "delight," and occasionally "ecstasy," compete with one another without providing a focused concept that would correspond to all of these terms. But not so Longinus, several centuries on, whose theory of the sublime (*hupsos*) boldly culminates the entire tradition of literary criticism that came before him.[115] No longer exclusively attached to the so-called

[112] Porter 2001b.

[113] The aversion of the euphonists to rules (precepts and generalizations about aesthetics) is a further symptom of this stance.

[114] The Greek term for this quiddity when it is located in the way a text sounds, in its sheer particularity ("this-sound-here"), is *to idion*. See Porter 1995b, 135–41. There are two aspects to this problem. On the one hand, texts are *reducible* to the *idion* of their acoustic nature, which corresponds to an *idion* in our experience of this quality of sound. But on the other hand, the *idion* of sound is *irreducible* to the textual conditions that give rise to it, and this irreducibility also applies to our experience of it. Whence the vacillation in the euphonists' program between an account that implies a mechanical kind of causation and one that embraces sheer evanescence.

[115] For links between Longinus and the euphonist critics, see Porter 2001b. The following develops Porter 2001a.

grand style of writing (Longinus eschews style terminology altogether), or even to sound alone, the Longinian sublime finally names literary excellence in its purest and most concentrated form. Indeed, the sublime appears to name the way in which the classical canon (which Longinus likewise staunchly defends) comes to be pleasurably enforced. The pleasure of sublimity is a classical pleasure in its most intense expression. And so we can say that the Longinian sublime captures the intensity, not so much of literary excellence, as of *the experience of classicism itself*. And by this we may understand both the reverence for things classical and the appropriation of those values for oneself. As Longinus says, "These great figures, presented to us as objects of emulation and, as it were, shining before our gaze, will somehow elevate our minds to the greatness of which we form a mental image (πρὸς τὰ ἀνειδωλοποιούμενα μέτρα)" (14.1). But appropriation is ultimately a form of identification, first with the capacity to acknowledge a classical value, and then with the source of that value: "It is our nature to be elevated and exalted by true sublimity. Filled with joy and pride, we come to believe we have created what we have only heard"—or read (7.1), though at this point the distinctions between hearing and reading or between oneself and another are moot, for there is nothing left besides the immediacy of the identification, in the totality of its illusionism: "many are possessed by a spirit (ἀλλοτρίῳ πνεύματι) not their own" (13.2).[116] *This* is what it is like to feel classical. Utterly possessed by the classical past, in the end one simply *is* classical. The effect is the same even if it lasts no longer than a moment, in a kind of epiphany.

Longinus's classicism, or rather his enthusiasm for the principles of classicism, has long been obvious, from Boileau's *Traité sur Longin* to the present.[117] But the connection between his critical category of choice (*hupsos*) and his classicism has never been queried. Nor have the inner tensions and complexities of his position or of his reception been adequately understood. There is, for example, something faintly disquieting about Longinus as a model literary critic that removes him from the stature of a Plato or an Aristotle: he is a bit too "enthusiastic," too unrestrained, too unmethodical, too much fixated on the exception rather than the universal, and too tolerant of mistakes and even impurities, to slot smoothly into classicism in its purest expression. Even his

[116] The passage is built on the metaphor of the vapors of Pythia (ἀναπνέον, ἀτμόν, ἐπιπνοίαν, ἀπὸ ἱερῶν στομίων ἀπόρροιαί), which spills over into the conceit of a direct audience held between past and present writers ([Longinus] 13.3–14.3). It is hard not to see writing here as a vivified and vivifying form of speech. The conventional notion of divine poetic "inspiration" may have a similar connotation too, as in Hes. *Theog.* 31–32 (ἐνέπνευσαν δέ μοι αὐδὴν / θέσπιν). See Murray 1981, 95, on the ways in which inspiration and flowing speech in poetic language seem to be traditionally bound up with the nature of orality (citing as examples Cratin. fr. 186 Kock; *Il.* 1.249; Hes. *Theog.* 39–40, 84, 96–97).

[117] Longinus's classicism, or else his "neoclassicism" (Russell in Flashar, ed. 1979, 113–14 and 117; cf. 134), is more or less accepted as a given. See Stroux 1931, 13, and, at some length, Fuhrmann 1973, 162–83.

allegiance to the principles of Atticism, in his own style and occasionally in his comments, can appear suspect. Is he possibly *too enthusiastically* a proponent of classicism to be reckoned one of its canonical instances? Has he, in other words, *overidentified* with classicism, like a kind of overheated Winckelmann from antiquity?

There is, to be sure, something impure, indeed excessive, about the pleasure Longinus calls sublime. The sublime is a matter of risks taken, of successes owing to literary failings that have been eclipsed, of imperfections made finally irrelevant. Placing all his bets on risks taken and on the impurity of the results, Longinus seemingly turns his back on the staples of literary and other forms of classicism: clarity, purity, balance, lack of excess, and unfailing success.[118] He even goes so far as to reject the very symbol of classical perfection, the Doryphorus of Polyclitus, appropriately known as the "Canon," while obscurely favoring the grandeur of "the failed Colossus" (possibly that of Rhodes, 36.3) and ultimately promoting qualities that reach well beyond both works. Indeed, only the cosmos is large enough to express sublimity truly: "Nor do we feel so much awe before the little flame we kindle, because it keeps its light clear and pure, as before the fires of heaven, though they are often obscured" (35.4). It is thanks to statements like these, and to the general hyperbolical and even baroque tenor of the sublime, that Longinus sometimes gets pegged as an exotic Asianist, the polar opposite of a pure-bred, patronizing Atticist. But the charge won't stick. Not only is Longinus's prose roughly as Atticizing as any other (roughly) Atticizing writer from the Second Sophistic (a standard that is bound to fail).[119] In every other respect he is the perfect classicist, for instance in his devotion to Hellenism (23.4, citing the sublimity of Plato's *Menexenus* 245d, with its plurals reinforcing the underlying expression, "We are pure Greeks, with no barbarian blood") or in his endorsement of the Greek classical canon in its conventionally accepted form, at least in its broadest outlines.[120]

[118] With Dionysius's moderation ("The oratory of which I most approve is that which avoids the excesses (τὰς ὑπερβολάς) of the plain and the grand style," *Dem.* 15, ad fin.), compare Longinus's identification of grandeur *with* excess (ἡ ὑπερβολὴ τοῦ μεγέθους, 9.5; cf. 33.4, 38.3, etc.).

[119] Cf. Maurer in Flashar 1979, 47 ("unklassizistisch") and Gelzer in ibid., 51–52, 173 ("baroque"). See Wilamowitz-Meollendorf 1900, 26: "What Norden calls Asianist is for the most part the quality of being cloying, or flowery, or even sublime." Wilamowitz mocks this prejudice in a footnote: "If I were a sophist I would show how περὶ ὕψους [*On the Sublime*] is Asianist in its ὑψηλά [sublimity]." Norden is not alone: "In spirit, the sophists [of the Second Sophistic] were and remained Asianist; classicism was for them a mask," etc. (Schmid 1898, 25). Exhaustively detailing the numerous Atticisms and the exceptions to Atticism in Longinus's language, Tröger 1899–1900 concludes that Longinus is "kein ausgesprochener Atticist" (64), which is to say not a militant purist, but that he exhibits strong Atticist leanings nonetheless. All of which goes to show how fragile the conceptual linkages between classicism and Atticism can be (see Introduction, above).

[120] That is, prose and poetry of major authors from Homer to the firm cut-off point of the Hellenistic era. There is, to be sure, room for disagreement in the details, with the issue of the

If with his admissions Longinus puts himself beyond the pale of earlier classicizing critics, the impurity and the sheer excesses that he makes the conditions of genuine sublimity in ways merely serve to mark the excessiveness with which classicism had always been affirmed by its champions. His notions about sublimity capture the enthusiasms of classicism. But they do more than this, for they also mark the impurities that classicism must cover over to achieve its consensual identity: the dissensions about quality, criteria, exemplifying instances, the multiple failings that classical works are in different quarters admitted or conceded to display, the sheer inconsistencies of judgment that individual ancient literary critics prior to Longinus can display, and so on.[121] On one approach, Longinus could be shown to be redeeming all the elements of classical authors that classicizing critics had variously chosen, for whatever reasons, either to contest as so many blemishes and shortcomings, or more frequently and tellingly to pass over in silence. This would not be a form of counterclassicism on Longinus's part, but a form of a classicism *redeemed*, an embracing of classicism in all of its embarrassingly flawed essence: "Need I add that every one of those great men redeems all his mistakes many times over by a single sublime stroke?" (36.2). On another approach, Longinus could be shown to be exposing and commenting on the impurities of classical ideology and of the discourses that had kept it aloft for so many centuries—the failure of critics to embrace the essentially contested nature of their values. Or perhaps he is exposing the self-deceptions—the rhetoric and the *technique*—of classical forms of identification. I am not sure that it is ultimately essential, or even possible, to decide between these alternatives. Nor need they be the whole story.

There is another side to Longinus's disregard for classicism pure and simple—which is not to say classicism impure and complex. Sublimity denotes the risk of greatness, or better yet of greatness that is forever at risk. Such is the condition of the ever vulnerable classic, which mimes the ideology of the historical (fifth-century) classical admiring gaze, the fighters at Marathon and Salamis who risked their lives in return for a "beautiful death."[122] Here, too, Longinus stands seemingly at odds with the critical tradition even as he is building on it. Excellence is in Dionysius's mind a stable quality that is unproblematically had wherever it obtains: "it is in this one respect that Plato is inferior to Demosthenes, that with him elevation of style (τὸ ὕψος τῆς λέξεως) sometimes lapses into emptiness and tedium; whereas with Demosthenes, this is never, or only very rarely so" (*Pomp.* 2; trans. Roberts). For Longinus, by

preeminence of Plato or Demosthenes being the most notable example (see Russell's commentary at [Longinus] 12.2–13.1, and the Introduction, above).

[121] Dionysius's waverings with regard to Thucydides are only one instance of these inconsistencies within an author. If more works by ancient critics survived, the examples could doubtless be multiplied.

[122] On the concept in Homer, see Vernant 1991. For its resignification in the fifth century, see Loraux 1981, 98–118, 389–96; Osborne 1987, 103–4.

contrast, literary greatness has a certain pathos to it: it is forever on the point of loss and on the edge of failure—a flawless writer cannot be sublime by definition.[123] At this exact point, the ideologies of classicism and Greek identity merge seamlessly and the Longinian returns to the fold of traditional criticism. If political virtues lend their color to literary virtues in Longinus's treatise (in which great classical writers are deemed "heroes" ([Longinus] 4.4, 36.2), the reverse is true as well: past political exploits down to Alexander, which is to say acts undertaken in the name of Athenian classical democracy (such as the battle of Marathon or the resistance to Philip and Alexander), are made to appear sublime (ibid., 16.2, 32.1–2). Literature is thus politicized while the realm of politics is either romanticized in its glories or debased in its epigonal failings.[124]

Sublimity resides less in the static moral dimensions of heroism and freedom than in the emotional experience of freedom at critical junctures (cf. 16.3).[125] If ideologies have emotions bound up with them, then sublimity would be the emotion of this particular ideological feeling—of the greatness of what it is to be Greek on the verge of the attainment or the loss of this greatness. For loss does seem in the end to be the condition of classical proximities. For all of its alleged elusive ineffability, the sublime uniquely, and adequately, names and captures this irrational quality of classicism. In his devotion to the unnamable essence of classicism, Longinus is at one with his critical forebears. In labeling the highest experience of great literature from the past, he is naming the feeling that had grounded literary criticism in its museumlike function from its beginnings. But to the extent that he is dwelling upon the conditions and limits of classicism, and especially upon the techniques by which the illusions and deceptions of sublimity come to be produced (passim), Longinus has to be reckoned one of the most critical observers of classicism in antiquity.

In literature, the sublime critics offer us, among other things, a theory of reading, a way of reading the voice buried in the voiceless script of Greek texts from the distant past. Their motivation is directly rooted in the very situation of literary criticism. But how does a *written* text *sound*? The focus on the voice as a substance that is simultaneously abstract and spiritual (a *spiritus, pneuma*, or breath) recalls the perpetual problem of ancient literary culture: how to breathe life into the lifeless matter of a text. The written, classical text has a sound that cannot be heard but can only be felt. Bringing out its hidden music while respecting its precious concealment is the difficult task of sublime criticism. The aesthetic cultures of Greece and Rome can be understood in no other way.[126]

[123] See Porter 2001a.

[124] Contrast the scorn heaped on Timaeus's praise of Alexander at ibid., 4.2; or the biting commentary on Timaeus's unsympathetic account of the Sicilian expedition of 415–13 (4.3), in contrast to Longinus's glowing (literally, hyperbolic) praise of Thucydides' account of the same (38.3).

[125] Cf. Dion. Hal. *Comp.* 22: sublimity (here, the austere style) seeks "to portray emotion (πάθος) rather than moral character (ἦθος)."

[126] Cf. Porter 2001b, 340–41; Nagy 1996b, 36.

Hearing the Classical Past: Antecedents and Beginnings

Looking back, it might appear that we have traveled some distance, as it were from the voice to the ineffable. But in other respects we have not progressed at all. This is owing to the peculiar logic of classicism, which I want to suggest is less retrospective than it is consistently *regressive*. Were there space, it would be possible to trace the trajectories mapped out in the preceding pages back in time, past the age of Demosthenes and Isocrates, which was itself classicizing, into the end of the fifth century. But just when does literary classicism begin? If the approach taken in the present chapter has any claim to plausibility, then the question can be addressed, and possibly can only be addressed, by posing a second, namely, "When did the Greeks start wishing to hear the voices of their authors from the past?" Aristophanes gave us a good starting point, but to say that he inaugurated classicism is to ignore the earlier attempts to canonize, through revival, the plays of Aeschylus, which began not long after the playwright's death. Athenians were already then yearning for the past, which in some sense they must have felt to be classical, if Aristophanes can be taken as a guide to their aesthetic reasons.

Can we go back historically to an earlier appearance of literary classicism, or of this co-implication? Undoubtedly we can. But as we move backwards in time prior to Aristophanes we nearly lose the trail. The clues become diffuse and then get lost in a morass of debatable issues that it would be pointless to enter into here. To take one example, the precursors to Alcidamas's *Contest of Homer and Hesiod*, dated by speculation to the sixth century (the so-called *Ur-Certamen* tradition), would have been responding to the very same kind of desire that Aristophanes was responding to in *Frogs*: the desire to hear Homer and Hesiod performing "live."[127] Recitation and citation, of which this tradition is an instance, were the ever-ready instruments of revival, and in particular the revival of an author's voice. Did not the rhapsodic tradition, the Homeric succession, in preserving the voice of the Bard, perform the work of classicism and of canonization prior to the invention of writing, if not afterwards as well?[128] If we define classicism as an attitude to past greatness (a structure of

[127] On the "Ur-Certamen," see Heldmann 1982. For a defense of the sixth-century date, see Richardson 1981. The desire to revive past poetic performances must, inter alia, form a stronger link with Aristophanes than the alleged contrast between speech and writing (see O'Sullivan 1992), which strikes me as forced. I hope to examine this problem on another occasion.

[128] It is worth noting that Milman Parry's deepest aesthetic insights into Homer are motivated by an attunement to this very feature of epic diction, which is to say to its quality of sound and voice, insofar as these are evocative of a "heroic" character ("the quality of epic nobility"): they are instrumental in producing what we might call an "epic-effect." Indeed, his entire conception of the rhythm of oral sounds as felt and heard is premised on an irrational aesthetics: "Poetry thus approaches music most closely when the words have rather a mood than a meaning.... Though the meaning be *felt rather than understood* it is there.... It is an *incantation of the heroic*" (ibid., 374–75; italics added). So understood, oral poetry, with its habits of audition (listening for the

feeling) rather than as a list of items determined by the features of a purportedly classical aesthetics or its canons (balance, restraint, simplicity, harmony, completeness, perfection, nobility, and so on), there may be no way of limiting the regression into the past. There is no reason to assume that classicism in any of its varieties was not at least partially present to the minds of its inaugurators, however we choose to date them.[129] But with self-awareness comes an awareness of fallibility and of risks and uncertainties, which is why classicism is unimaginable apart from criticism, and criticism apart from critique.

sound) and its reinforcing of structures of feeling at the expense of sense (ibid., 240: "scarcely heedful of their meaning"), not to mention its ideological attractions (nobility, heroic ethos), lies at the root of the later euphonist tradition, which would culminate in the inaudible sublime of Longinus—all in the name of the ideology of the classical and all that this entails. Parry's enduring "Phidian" and Winckelmannian biases are noticed by Adam Parry in the introduction to Parry 1971; see pp. xxiv–xxv, 427, 417, 424–25, 431. To this one should add Parry's ancient euphonist biases (see his ringing endorsements of Dionysius of Halicarnassus, ibid., 251–53; 262–63). His clinging to the improbable notion of Homer's singular, authentic voice ("One . . . has the overwhelming feeling that, in some way, he is hearing Homer," ibid., 378) is a further index of these aesthetic affiliations.

[129] See Introduction.

Chapter 10

QUICKENING THE CLASSICS: THE POLITICS OF PROSE IN ROMAN GREECE

Tim Whitmarsh

> The "age demanded" chiefly a mould in plaster,
> Made with no loss of time,
> A prose kinema, not, not assuredly, alabaster
> Or the "sculpture" of rhyme.
> —Ezra Pound, "Hugh Selwyn Mauberley" II.5–8

THE "'age demanded' . . . a prose kinema," writes Ezra Pound in his (self-) parodic tribute to a bloodless writer. A resonant phrase; a cliché perhaps, meriting the arms-length inverted commas. But why is it that some historical periods or societies are seen as characteristically prosaic? Why is a cultural shift towards prose so often figured as a decline from an earlier state of plenitude, the inauguration of a new aesthetic delinquency? In Pound's panorama, the new literature is to be industrially produced ("made with no loss of time"), populist ("kinema" suggests the spectacular new medium of film), and deficient ("not, not assuredly" poetical). In the course of the poem, Pound explicitly derives the shape of this narrative from the history of classical, particularly Greek, literature. "The pianola 'replaces' / Sappho's barbitos. / Christ follows Dionysus / . . . a tawdry cheapness / Shall outlast our days. / Even the Christian beauty / Defects" (III.3–14). In this miniature literary-historical narrative—a narrative, to be sure, shelled by the explosive irony of the surrounding stanzas—prose is conceived of principally as a late, lapsarian pathology. Classicism is inherently bound up with the question of poetics—and, hence, of prosaics.

Pound's principal concern is mischievously to mimic (and hence disrupt) the received Romantic narrative of the history of literature in terms of a lamentable decline, from the lofty peaks of The Classical to the sterile, industrially repetitious imitation of later centuries. This story was central not just to literary history, but also to the wider self-positioning of postindustrial, imperial Europe. In Victorian Britain, to take but one conspicuous example, jeremiads concerning the nonexistence of contemporary epic poetry constituted transfigurations of laments over the supposed weakness of contemporary nationalism

and the infiltration of society by the new middle classes.[1] Romantic poetics intermeshed with national-aristocratic politics: the lack of "inspiration" in the contemporary world indicated the passing of a golden age of social order and poetic fecundity. The period of British classicism invoked in Victorian aesthetics signified in both literary and sociopolitical terms.

To take another example, Nietzsche's *Birth of Tragedy*—like "Hugh Selwyn Mauberley" mimicking romanticism in spite of its own radicalism[2]—attributes the death of all poetry to the "Apolline spirit" (*das Apollinische*) that emerged in the late fifth century, and in particular to Euripides. Nietzsche uses the term "poetry" in an extended sense, defining it with reference not to metrical language but to Dionysiac inspiration: he is quite aware that metrical verse continues to be written after "[t]ragedy is dead! Poetry itself died with it!"[3] But it is the Apolline spirit of rationalism and self-consciousness that does for *true* poetry, the spirit embodied particularly by Euripides ("Euripides the thinker, not the poet")[4] and Socrates (that "despotic logician").[5] Furthermore, *all* artistic forms, from the death of Sophocles up until the projected rebirth of tragedy through Wagnerian opera, partake of this prosaic frigidity, which Nietzsche sees as crystallized particularly in the Alexandrian sensibility.[6] The presence of Dionysiac poetry in a given historical period indicates not only a high concentration of inspirational effluence, however, but also a vigorous nationalism: the miring of tragedy in prosaic forms results from the "senescent phase of Hellenism,"[7] just as its rebirth in the contemporary world marks the rejuvenation of the "German spirit."[8]

For Nietzsche, again, literary-historical narrativization purports to serve a self-consciously ideological and protreptic purpose.[9] This knowing interlinking of poetics and nationalism is at once foregrounded in its clarity and chilling in its implications. Yet he is not alone: the most enduring feature of post-Romantic constructions of the Classical, particularly but not exclusively in relation to Greece, is the focus upon the defining role of poetic inspiration. From "the Homeric world," through the "lyric age of Greece" and its subsequent "golden age" to the "Second Sophistic," the history of Greece has repeatedly been taxonomized in terms of its relationship, or lack thereof, with poetry.

[1] Jenkyns 1980, 21–38, esp. 22–24. I am grateful to Simon Goldhill and Jim Porter for their comments on versions of this chapter, as well as to colleagues and students at the University of Exeter.
[2] See Silk and Stern 1981, 4, on the Romantic background to the *Birth of Tragedy*. For my reading of Nietzsche here I am greatly indebted to Porter 2000a, Porter 2000b.
[3] Nietzsche 1993, 54.
[4] Nietzsche 1993, 58.
[5] Nietzsche 1993, 70.
[6] Nietzsche 1993, 86; 93.
[7] Nietzsche 1993, 56.
[8] Nietzsche 1993, 94–8; 110–13.
[9] He refers to his discussion of tragedy as a "historical example" (p. 75); see also Silk and Stern 1981, 38, on the "supra-historical" aspect of the Apollonian-Dionysiac polarity.

Such narratives, however, need reconsideration. In the first place, the opposition between poetry and prose is not as secure as separatist[10] theorists might claim.[11] As Aristotle already recognized, the definitional criterion of poetry cannot be meter alone.[12] For sure, Aristotle resisted erasing the boundary; but some thinkers, ancient and modern alike, have indeed averred that the distinction is a matter more of negotiable emphasis than of essence.[13] If we take a more relativizing, pragmatist view of the dichotomy, then it follows that what we say about prosaic and poetical periods is less a pellucid transcription of self-evident historical fact, and more a judgmental story—a story, moreover, that quickly betrays its own cultural and historical agenda.

In this chapter, I focus particularly upon the Greek literature of the first to third centuries, the period often styled (rather infelicitously) the Second Sophistic.[14] Not only did writers of this period prefer to compose in prose[15] (though poetry continued to be written[16]), they also—this will be my principal argument in this chapter—represented their age, to borrow Pound's self-consciously hackneyed phrase, as "demanding" prose. Again as with the Romantic mythology of decline traced above, the form in which these demands presented themselves was committedly ideological and political. Like Pound, however, the writers we shall discuss also drew, as we shall see, on a rich set of resources to interrogate and destabilize the myth of poetic decline that demeaned their own status as latecomers.

Scholarship throughout much of the nineteenth and twentieth centuries has (in line with the Romantic myth of decline) been too quick to fall into complicity with the most superficial reading of the prose kinematics of imperial Greek literature. The enervation of Hellenism is (we have often been told) implicated in the uninspired, prosaic literature of the period. The lack of political self-determination of Greeks under Roman rule has been held to explain the lack of power of their literature.[17] The prose texts of this period also sprang from a

[10] For this term see Turner 1990, 257.

[11] E.g., Jakobson et al. 1987, 114: poetry is characterized by metaphor/combination, prose by metonymy/contiguity. Cf. also his p. 301.

[12] "A historian is not distinguished from a poet by whether he composes metrically or not" (Arist. *Poet.* 1450a-b).

[13] Esp. Sartre 1967, 24–25 nn. 4–5 (despite the apparent contradiction on p. 10: "There is nothing in common between these two acts of writing except the movement of the hand which traces the letters"). For antiquity, see the views of Heracleodorus as denounced by Philodem. *Poet.* 1.199–204, with Janko 2000, 155–65.

[14] See Whitmarsh 2001, 42–45, for the imprecisions of this term.

[15] E.g., Bowersock 1989, 89; Whitmarsh 2001, 27.

[16] For poetry, see Bowie 1989, Bowie 1990, Bowie 2002; Hopkinson 1994. I shall address the politics of poetry in a separate study.

[17] Rohde 1914, 323, on the lack of *Kraft*; elsewhere, Rohde tells us, Greek oratory sank *mit der Freiheit* (p. 310). This theme is reprised by Groningen 1965, who refers to "an essentially weak literature. . . . The Greek literature of the second century is the work of a powerless community" (51; 55–56).

dissolution of the Hellenic tradition: Lucian's status as a Semitic interloper is a notorious theme of nineteenth-century German writing,[18] and the Greek novel, according to Erwin Rohde (an enthusiastic acolyte of Nietzsche[19]), risks embodying "something altogether ungreek" (*das ganz Ungriechische*).[20] For Rohde (who revived the use of the term) the Second Sophistic was an autumnal, and ultimately doomed flowering of Hellenism (*Griechentums*) in response to the incursion of oriental forms.[21] In particular, the Atticizing revival was prompted by the advent of Asianism, the "more weakly and effeminate daughter of the ancient, glorious, Attic art of oratory";[22] it was overly concerned with ornamentation and display, and was not manly (*männlich*).[23]

Postmodernism has its own mythologies: in our antifoundationalist, millennial age, such broad-brush categorizations of literary *Geist* are routinely viewed as the follies of a less astute age. Classical scholarship is coming to terms with the provisional, strategic relativism of all classicizations, its own and antiquity's. "Belatedness," "posterity," and "secondariness" are taken as rhetorical effects rather than as historically descriptive.[24] The entire history of Greco-Roman literature (perhaps even including "father" Homer) is late, in the sense of nonoriginary.[25] The idea that a "prosaic" period might symptomatize a decline from the Classical is uncongenial, even quaint, in this context of hypertrophic discursive self-reflexivity.

I do not wish to take issue with this critical orthodoxy, which seems both intellectually responsible and politically serviceable. But I do want to observe that, for all that scholarship in the early twentieth century may (properly) wish to distance itself from the overweening, ideological, and nationalist fervor of earlier generations, these nineteenth-century Classicizations were not concocted *e nihilo*. Nietzsche, Rohde, and the rest took over the association between literary form and identity (manliness, sociocultural integrity, political power) from ancient authors; and although for sure they inflected them with their own political preoccupations, that does not mean that they were innocent of ideology in the ancient sources. Literary-historical narratives such as the decline from poetry into prose are never simply *wrong*: they always reflect deeply, meaningfully, on the state of the world. This chapter, then, seeks to read antiquity's own version of the aesthetic and political demands of a prosaic culture.

[18] See Holzberg 1988; Baumbach 2002, 201–43; Goldhill 2002, 93–99.
[19] Silk and Stern 1981, 90–131, for Rohde's responses to the *Birth of Tragedy*.
[20] Rohde 1914, 3.
[21] Rohde 1914, 313.
[22] Rohde 1914, 310.
[23] Rohde 1914, 311–12.
[24] See esp. Hinds 1998, 52–98; Feeney 1998, 57–63.
[25] The notion of universal epigonality is already espoused by Bloom 1975, 33–34, though he does insist on the exceptional, originary status of Homer.

Diachronies: The Politics of the Past

I am going to begin by coining a term, "prosography," which I use to mean the marked, stylized use of prose (and hence also the polemical renunciation of poetry). The remainder of this chapter will be devoted to this alone. Unlike prose, which is properly the subject of stylistics in the narrowest, most formalist sense, prosography is a matter of cultural and political significance: it comports a reflexiveness about the authoritative, embedded status of language, and about the codification of the history of knowledge. To prosify is to proclaim the value of the archive, the accumulated weight of culturally sanctioned (and necessarily *written*) learning. In *The Order of Things*, his genealogy of modern thought, Michel Foucault argues (in the course of a chapter entitled "The prose of the world") for the junctural importance of the sixteenth century, as a time when the supposedly natural relationship between words and things was questioned. Language was no longer a reflection or representation of the world, but now a second-order form, enfolded upon itself: "[k]nowledge ... consisted in relating one form of language to another language; in restoring the great, unbroken plain of words and things; in making everything speak."[26] Prose became a self-conscious marker of a historically new systematicity in the perception and construction of the world.

The composition and redaction of vast tracts of prosaic text is also a hallmark of Roman Greece, itself a self-consciously posterior literary culture[27] in which language was empowered in respect of its ability to plot received knowledge.[28] The entire experiential world could be transcribed into text: landscape (Pausanias), seascape (Arrian in the *Circumnavigation of the Black Sea*), dreams (Artemidorus), physiognomy (Polemo and Adamantius), the human body (Galen), the animal kingdom (Aelian), Roman history (Dionysius, Cassius Dio, Herodian). Polymathy reigned as a form of supreme intellectual achievement (for example, the *Varied Histories* of Favorinus and Aelian; the *Sophists at Supper* of Athenaeus). It is important to remain aware of the complexity of the tessellation that comprises this picture (to avoid the rhetoric of "cultural totality" that inhabits *The Order of Things*):[29] Oppian's treatises on hunting and fishing, for example, are exceptionally composed in verse. But the exceptional status of those texts, a self-conscious innovation within this prosaic culture, serves to prove the rule; and anyhow, as an encyclopaedic writer, Oppian invests no less in prosaic values for that he employs the epic form.

[26] Foucault 1989a, 40.
[27] Whitmarsh 2001, 41–47, with further references.
[28] See Barton 1994 for a Foucauldian approach to science and power in Roman Greece.
[29] Foucault 1989b, 16: "In *The order of things*, the absence of methodological signposting may have given the impression that my analyses were being conducted in terms of cultural totality."

Prosography is born of the rhetoric of institutionalized knowledge: it insistently narrates a diachronic transition from poetry to prose, a fundamentally self-aware articulation of (amongst other things) the passage of Greek culture from orality to the world of the text. Let us begin by considering Strabo's critique of Eratosthenes (third to second century B.C.E.) in the former's *Geography* (1.2.12–15), a work of massive erudition composed in the late first century B.C.E. Strabo, a "remarkably pro-Roman author,"[30] is not only a product of Augustan Rome's imperialist drive towards global mapping,[31] but also directly synthesizing the increased geographical knowledge brought by large-scale Roman conquest.[32] Imperial conquest, underpinned by the rhetoric of civilizing humanism, invites a teleological view of history in terms of progress; and Strabo's work, eclipsing and rendering obsolete all his predecessors', is a massive monument to the triumph of historical progress.

But Strabo's self-positioning is more complex. His critique of his predecessor Eratosthenes does not simply mark the latter as primitive; he also accuses him of myopically progressivist vanity.[33] Eratosthenes' polemical approach to the Homeric texts had been to chastise them for their "lies," decrying with the supercilious confidence of a more scientific age the supposed substitution of imaginative guesswork for hard facts. "You will find the location for the wanderings of Odysseus," he had declared, "when you find the cobbler who stitched up (*surrhapsanta*) the bag of winds" (fr. a 16 Berger = Strab. 1.2.15). This clever *bon mot* subtly alludes to the figure of the rhapsode, or "stitcher of [epic] songs": implicitly, Homer the creator is correlated with a banausic functionary. More important to our purposes, however, is the argument that poetry is necessarily naïve, inviting supplantation by the intellectual superiority of posterity. It is against this position, not against any obsolescent methodology or data, that Strabo most vigorously positions himself. In his compromised, bipartisan position as a Greek intellectual in Augustan Rome, Strabo wishes to maintain *both* the intellectual dominance of the Roman present over the past *and* the deeply enshrined sanctity of ancient Greek tradition.

We shall return to Strabo's critique of Eratosthenes presently, dramatising as it does the central cultural and political tensions of the emergent Second Sophistic. But let us for now trace the beginnings of self-conscious prosography, in the Classical period. Following Bruno Snell and others, Geoffrey Lloyd has convincingly identified in the writings of the Greek scientists of the fifth century a self-consciously new cast of mind, an increasingly intense, agonistic self-positioning in opposition to mythical thought.[34] If the supposed passage

[30] Swain 1996, 313.
[31] Nicolet 1991.
[32] In particular, he extensively used Posidonius, who was deeply implicated in the imperialist projects of the early to mid-first century B.C.E.: see Momigliano 1975, 32–33.
[33] For the background to these debates, see Romm 1992, 172–214; K. Clarke 1999, 262–64.
[34] Lloyd 1987, 56–70.

from mythicism to rationality ("from *muthos* to *logos*," in Vernant's famous phrase[35]) does not have in practice the historical authority of an absolute rupture, it is nevertheless grounded in a series of insistently articulated *discursive* moves that troped prose-writing as postmythical: lucid, contemporary, ingenuous.[36] The shadowy chroniclers Hecataeus of Miletus, Acusilaus of Argos, Hellanicus of Lesbos, and others adopted prose, we can guess, as a polemical marker of their modernity. Thucydides famously stakes a claim for a text that, while it may be less pleasurable owing to its lack of mythical qualities (*to muthōdes*), is nonetheless useful (1.22.4). Plato's Socrates, even more famously, bans poets from his ideal city on the grounds that they possess only an ontologically inferior inkling of reality (*Resp.* 607b).[37]

In contemporary stylistics, poetic language was increasingly associated with obfuscation. The distinction was vigorously contested, but always significant. Modern critics usually attribute the instigation of a formal taxonomy of differences between poetry and prose to Aristotle in the fourth century:[38] in his *Rhetoric* (1404a), he avers that poetical lexis emerged first in order to conceal the foolishness of the thoughts of the earliest composers. But the parameters are clearly visible already in the fifth century. When Gorgias (in the fifth century) assimilates his prose to poetry, he is making a polemical point, that his own discourse partakes both of the hypermodernity of sophistry and the overwhelming power conventionally attributed to poetry.[39] As Aristotle later recognizes disapprovingly (*Rh.* 1404a24–29), Gorgias also imports a substantial amount of poetic *lexis* into his rhetorical discourse, a further attempt at integration of the two registers. This does not mean, however, that Gorgias (or his contemporaries) fails to distinguish adequately between poetry and prose, but that the specific genre of *epideictic* (as opposed to forensic or public) oratory was definitively hybrid, generically constituted as poetic prose.[40]

Fourth-century Athens does, however, indeed mark an important new phase in the history of prosography. This was a culture increasingly conscious of the

[35] Vernant 1980, 186–207.
[36] See most recently Thomas 2000, stressing the eclectic aspect of Herodotus's "rationalistic" drive.
[37] For the ontological argument, see 602d–603e; 605a-c.
[38] Arist. *Rhet.* 1404a-b; cf. *Poet.* 1447b13–20; 1451a36–b5. Cf., e.g., Too 1995, 32: "Prior to Aristotle, the majority of fifth- and fourth-century writers ... are so relaxed about generic differences that they even play down the gap between poetry and prose."
[39] The assimilation is conventionally (e.g., Bers 1984, 1; Too 1995, 32) argued for from Gorg. *Hel.* 11.9 D-K ("I consider and define all poetry as prose [*logos*] with meter [*metron*]"). This is best interpreted as meaning that all language is equally powerful, and that the presence or absence of meter is not intrinsically important: Gorgias is arguing from the well-known case of the impact of epic poetry upon its audience to the likely effect of Paris's persuasive (prosaic) speech upon Helen. The definition recurs at Pl. *Grg.* 502c, but here cleverly turned back upon the sophists: it is proposed by Socrates to Callicles in the course of his argument that rhetoric is no less a form of flattery than tragedy.
[40] For "poetic prose" see Dover 1997, 17–18.

burden of the (intellectual, artistic, military, and political) past, in which (for example) the focus of tragic performance now (from 386) shifted from new works to reperformed classics, in which a new breed of politician emerged (most notably in the case of Demosthenes) whose expertise lay not so much in military action as in political theory.[41] As the self-definition of Athens shifted, from the hyper-innovative democracy to historically reflexive city of the classics, prose became increasingly associated with the self-conscious posterity of an archival culture.

The central figure here is Isocrates (an important model, as we shall see presently, for later writers) in the fourth century.[42] For Isocrates, "philosophy" (the term he uses to cover his own discourse, primarily ethical and political rhetoric) is a form of poetry, both stylistically and in terms of its effect. As he asserts in the *Antidosis*, *logoi* composed by philosophers will be "very similar to musical, rhythmic compositions" (46); they use "particularly poetical and variegated lexis," and "particularly weighty and innovative ideas" (47); their speeches are listened to with no less pleasure than "compositions in meter" (47). In this respect, Isocrates is simply extending the epideictic ideals of the fifth-century Gorgias. But the *Evagoras* offers a different spin on this *topos*, constructing itself as an innovation, a prose encomium where (purportedly) previous encomiasts have used poetry (8).[43] The difficulty of the challenge, Isocrates writes, lies in the number of "adornments" (*kosmoi*, 8) granted to poets: lexical, figural, and metrical tricks help them as they "entertain" (*psukhagōgousi*) audiences (10). But these are merely superficial devices: "if one were to leave the words and thoughts of the most respected poets and take away the meter, they would be revealed as much lesser than the respect in which they are currently held" (11).

These two examples from Isocrates elucidate a crucial point. "Poetic prose" is not the result of a lack of clarity in the contemporary taxonomization of literature, and certainly does not manifest the vestiges of an archaic sensibility; it is, rather, a deliberate and artful attempt to forge a new genre, in the agonistic struggle for literary identity in the present, out of existing literary taxonomies. If Isocrates is inconsistent in his approach (sometimes appropriating, sometimes distancing himself from the power of poetry), this marks the flexibility of his methods and the malleability of his material, not the impotence of the contemporary critical vocabulary.

[41] On tragedy, see Easterling 1997, 212–13; testament to this shift is the inscription commemorating Astydamas, lamenting that he has been born later than his competitors, and cannot catch up (*FGE* pp. 33–34; Astydamas fr. 60 T 2a *TGF*). For Demosthenes and the new politicans, see Harding 1987.

[42] Too 1995, 32–34.

[43] Too 1995, 33–34, notes the conventional and rhetorical nature of such appeals to innovation in Isocrates.

Isocrates' representation of the relationship between poetry and prose also figures in his struggle with his own "anxiety of influence."[44] The supplementary addition of prose to a preexistent genre (encomium) constitutes his attempt to innovate within a tradition already freighted with (and overdetermined by) the classics.[45] Prose is necessarily the discourse of posterity; but it also, at least in Isocrates' hopes, offers the possibility of a rebirth, the (re)invention of an origin. Even the apologetic defense of prose as a suitable medium, however, marks the provocative (and no doubt ludic) tendentiousness of the claim.

To Isocrates (and to the intense literary culture that spawned him) can be attributed, therefore, the invention of a seminal discursive move: the self-reflexive meditation upon prose-writing's always-already-inscribed historical posterity. It is hard to plot the immediate impact of the fourth century, this decisive phase in the history of prosography, owing to the limited amount of Hellenistic prose that is still extant. Although the category of Hellenistic literature is sometimes limited to poetry (partly the legacy of its reception among the neoteric poets of first-century B.C.E. Rome), the increased codification and institutionalization of learning in the library and Museum of Alexandria also ascribed a new set of values to prose-writing.[46] The most significant loss (more significant, perhaps, than even the works of Eratosthenes) is Callimachus's *Pinakes* (or *Tables of all those were eminent in every kind of education (paideia) and of their writings, in 120 books*), a massive prose work to mirror the cosmic rhetoric of the Ptolemies, and the global literary appropriation symbolized by the library (for which it served as a critical inventory).[47] But prosaic voices are also discernible within the poetry of the period: the well-known self-consciousness of that verse derives from the importing of prose concerns (textual and literary criticism, but also geography, history, astronomy, medicine, animal lore, and so forth) into poetic texts. Prose jags into the mellifluous serenity of poetry, insistently reminding readers of the distance between the inspired classics of the past and their scholarly re-creations in the present, between mainland Greece and Alexandria, between Helicon and the librarian's desk.

Hellenistic Alexandria, for all that its literature is often neglected by writers of the Roman Greek period, constitutes a crucial staging post in the history of prosography, because it forged a now indissociable link between prose-writing and institutions (a process that had already begun in the fourth century with Aristotle's Lyceum, but which was elevated onto a different level in Alexandria). But let us return (or, rather, once again propel forwards) to Strabo. In this

[44] Bloom 1997.

[45] This anxiety is also expressed in poetry as early as the Classical period: see Choerilus at *SH* 317 and Astydamas at *FGE*, 33–34.

[46] E.g., Hopkinson 1988 contains only poetic works. On the library and Museum, see esp. Pfeiffer 1968, 98–104; Fraser 1972, 1.312–35; and most recently Too 1998, 117–26.

[47] The only extant fragments are snippets (frs. 429–53 Pfeiffer). See further Blum 1991, 182–88; and, for Callimachus's other prose works, Pfeiffer 1968, 134–36.

context where learning is patronized by the colonial masters, where libraries are now largely appropriated and patronized by wealthy Romans,[48] the teleological historical narrative implied by prosography is also implicated in the politics of cultural definition. For a Greek to write prose is to position oneself in a complex relationship with both the imperial, archive-controlling present and the traditional, verse-dominated, Greek past.

We recall that Strabo is criticizing his predecessor for his too brief dismissal of the intellectual value of poetry, and arguing that there is indeed a case for Homer's rationality (or "rhetoric," as he puts it, defining this as "rationality [*phronēsis*] expressed through language [*logoi*]," 1.2.5). In the course of this argument, Strabo argues for an essential continuity, along the diachronic axis, between poetry and prose:

> Prose (or at least artful prose) is, so to speak, an imitation (*mimēma*) of poetic discourse. For the art of poetry was the first to emerge into public prominence and regard. Then Cadmus, Pherecydes, Hecataeus and the like wrote, imitating them but abandoning the meter while retaining the other features of poetry. Then later generations successively stripped away some of these, and brought it down to the present state, as though from a great height. Similarly one might say that comedy took its structure from tragedy, but descended from its height into the state that is currently called "prosaic" (*logoeidēs*). (1.2.6)

This passage, with its narrative of cultural decline, positions Strabo in a double relationship with the past: condemned by history to posterity, but sensitive (unlike Eratosthenes) to the meaning and values of the classics. I shall have more to say in the next section about the vertical imagery of this passage: for now I wish to concentrate upon the temporal pattern mapped out here. In one sense, Strabo merely makes explicit what Isocrates implies in his narrative of the emergence of "artful" prose subsequent to poetry. But genealogy also has its own specific rhetoric, and it is important to consider precisely what values are being attached to poetry and prose. Strabo operates a contrast between oral and written literature: Cadmus and so forth wrote, while the phrase used of the early epicists (παρῆλθεν ἐς τὸ μέσον, translated here as "emerge into public prominence"), implies coming forward to address the assembled people. This posterior, graphematic literature is, moreover, presented as an imitation (*mimēma*), a second-order, derivative, atrophied echo of the plenitude of poetry.

The representation of poetry as the primal form of artful writing and its representation as an originally public-performative form are interrelated: both mark (in Strabo's idealization) the undefiled immediacy of poetry as the product of a community. To borrow Derrida's conceptualization in *Of Grammatology* of the relationship (according to traditional metaphysics) between speech

[48] See Diod. Sic. 1.4.2–3; Plut. *Aem. Paul.* 28; Ath. *Deipn.* 2b–3d; and further Whitmarsh 2001, esp. 9–16.

and writing, Strabo presents prose as supplementary to originary poetry.[49] This status is ambiguous: the supplement marks both the fruition and the erasure of the origin. Prose yields the rigorous argumentative resources that allow Eratosthenes to be proven wrong, and to appreciate the rhetorical qualities of Homeric poetry; but it is simultaneously an abasement and destructive stripping away of true literature.

So Strabo's narrativization entails a concomitant classicization of the poetical past in a manner unparalleled in Isocrates. For the latter, the turn to prose is a resource to facilitate the escape from the tyranny of poetic tradition: his claims to priority in his venture ("no one else before has attempted," *Evagoras* 8) may be overstated, but they do articulate the urgency of the contemporary *choice* between the two forms. Strabo, on the other hand, presents himself as irredeemably consigned by an unrelenting historical teleology to a culture of prose. For this Augustan Greek, as we have noted, prose is the defining marker of a historically determined double-bind: the massive resources of Roman imperialism make the archival project possible, but also enforce the distance between Greco-Roman present and the (imagined) self-identical self-presence of the autonomous Greek past.

This self-imposed historiographical schema is amplified in interesting new ways as the sense of the discrete secondariness of Roman Greek literary culture gradually coalesces in later writers. There are manifold ways of approaching the problem of literary posterity,[50] one of which may be simply to assert cultural continuity between the classical period and the later one. Thus Maximus of Tyre, retracing but simplifying Strabo's position, claims that Homer was a philosopher (i.e., a rationalist like "us") in every significant sense (*Orations* 4, 26), and that his adoption of poetry was merely a superficial formal technique designed to please his unsophisticated contemporaries (see esp. 4.3). Other writers, however, provide a richer and more nuanced approach to the question of cultural definition through prose. I wish to turn now to the second century C.E., and in particular to two texts, Plutarch's *On the Pythian Oracles* and Aristides' *Hymn to Sarapis*. The first is a dialogue, set in Delphi, in which the interlocutors treat primarily of the question why the Delphic oracle has ceased to prophecy in verse.[51] The second is a prose hymn to the Greco-Egyptian god, including an important, programmatic section on the reasons why verse has traditionally been adopted by hymnists.

[49] Derrida 1976, esp. 141–64. The priority of poetic discourse is also implied in the various references to the inventors of prose: Pherecydes is widely cited as having composed the first prose narrative, and Cadmus or Hecataeus the first prose history. See Plin. *NH* 7.205, Suda s.v. Ἑκαταῖος Ἡγησάνδρου, also s.v. Φερεκύδης (with Schibli 1990, 3, who explicates the Suda's confusion here).

[50] Whitmarsh 2001, 41–89.

[51] Detailed commentary in Schröder 1990. I am indebted here to Lewis 2004.

The important part of Plutarch's dialogue, for our purposes, is Theon's long speech (403a–409c) concluding the dialogue. This is not the place for a detailed treatment of the many theological and philosophical issues it raises about the nature of prophecy and inspiration.[52] What interests me in particular is Theon's (and Plutarch's) attempt to rescue prose as a medium from the opprobrium it has inherited, and simultaneously to counter the perceived preeminent status given to poetry. The butt of Theon's mild-mannered attack is Boethus the Epicurean, who (according to another speaker, Sarapion) is the only post-Empedoclean philosopher to write in verse (402e): as he comments with teasing irony, "Through you, poetry once more returns from its exile to upright, noble philosophy, castigating the young" (402f). Boethus has already been rebuked for his atheistic beliefs (396e–397e), and has visibly mocked Diogenianus, the impressive young visitor (398d): Theon's speech, while containing a series of important programmatic passages, also constitutes an *ad hominem* put-down to this outmoded exponent of verse philosophy.

Theon's central argument is that the choice of poetry or prose is made not by the god but by his human agents (404b-405a). The general[53] "change" (*metabolē*) between poetry and prose results not from any change in divine favor, but from innovations in the practice of humans (406b). Poetry is consistently represented by Theon as an accretion that is only necessary in certain circumstances. Prose offers "intelligibility and plausibility" (406f), "persuasion with clarity" (407a), "simplicity" (409c); poetry "shrouds" (407e, 408c) the simple truth in mystifying obscurity (407a-b). This change, moreover, is linked to the developing sociopolitical conditions of Greece. The "men of the past" (*hoi palaioi*) needed to disguise the oracle's meaning in verse out of fear for the "mighty cities, kings and tyrants" who approached Delphi for advice on weighty issues (407d). Theon continues:

> As for the present circumstances about which the god is consulted, I welcome and approve them: there is a profound peace and tranquillity, war has ceased and there are no longer cases of exile, civic strife and tyranny, nor indeed any other of the sicknesses and woes afflicting Greece that called for, as it were, hypersophisticated (*polupharmakōn*) and superfluous (*perittōn*) powers. (408b)

In stark contrast to Strabo, Plutarch represents *poetry* as supplementary, in the sense that the need for poetical responses symptomatizes a deviation from Greece's proper state of calm.[54] Indeed, poetry itself is a form of deviant

[52] For discussion and further literature, see Schröder 1990, 25–59 (particularly on sources, and arguing for Plutarch's eclecticism).

[53] Theon stresses that prose oracles were also given in the past, and that verse oracles are also given in the present (403f, 405e).

[54] That the focus is upon (specifically) Greece's return to a state of tranquillity does not demonstrate that this passage is "definitely not focused on Rome" (Swain 1996, 180): how could the *pax Romana* not be evoked?

excess in language. The word *pharmakon* (at the root of *polupharmakōn*, here translated "hypersophisticated") usually refers to drugs, dyes, or poisons: in general, to artificial confections. It is, moreover, the word employed by Plato to stigmatize writing in the *Phaedrus* (and a central term for Derrida's discussion of Plato's logocentrism).[55] *Perittos* is an equally eloquent term, tracing a complex semantic arc that includes notions of extravagance, conspicuousness, prodigiousness, and excess. Earlier in his speech, Theon has similarly referred to oracular practice, consequent upon the change, as having jettisoned the superfluous (*to peritton*, 406d). In that case, he develops a striking metaphor to elucidate this return to the natural: "It [oracular practice] took off its golden hairnets and doffed its soft frocks; moreover, I imagine, it cut off its hair so luxuriant and untied its tragic buskin" (406d). Superfluity is imaged as barbarian and effeminate, a deviation from the manliness of received Hellenism.

Theon's speech might be interpreted as a manifesto for a prosaic culture. Delphi is synecdochic of Greece,[56] and the failure of the Pythia to prophesy in verse is paradigmatic of the state of Hellenic culture. The common interpretation (as reported by Diogenianus) explains this phenomenon by recourse to a narrative of decline: "Either the Pythia does not approach the place in which the sanctuary is located, or the spirit (*pneuma*) of the place is absolutely quenched and its power has departed" (402b). This is a Strabonic reading of the politics of prose in terms of dissolution and decline. Theon's sparkling corrective to this common belief, however, presents both a challenge to the received privileging of poetic truth and a powerful assertion of the vigor of contemporary literary culture. Yet this should not be taken as anything as straightforward as Plutarch's belief. Embedded in a dialogue, with no authorial judgment (indeed, with no subsequent reaction at all—the dialogue just stops), this speech constitutes one of a number of voices vying in the competitive intellectual climate that Plutarch dramatizes. Though it is striking and appealing (in that it is uplifting, celebratory, and genealogically self-aware), and effectively trounces the irritant Boethus, it is nevertheless a partial and carefully circumscribed response to the issue of literary posterity.

The most robust response to the traditional prioritizing of poetry comes in the course of Aelius Aristides' *Hymn to Sarapis*, and especially in the programmatic prologue, where the orator defends the project of prosographic hymns. This text is arguably influenced by Plutarch's dialogue,[57] and certainly displays a continuity of preoccupations. In literary terms, however, its primary model is

[55] Pl. *Phdr.* 274e; Derrida 1981.
[56] Cf., e.g., ps.-Luc. *Nero* 10, with Whitmarsh 1999, 154–55.
[57] At 7, Aristides refers to prophecy, noting that most contemporary oracles are given without meter. The argument that speakers should praise the god in accordance with their own "powers" (δυνάμεις) suggests that Aristides is alluding to *On the Pythian Oracles* 404b, where Theon proposes that the form of the poetry is a function of the capacity of the god's "instrument" (ὄργανον), not of the power of the god himself.

Isocrates' *Evagoras*, discussed above: the opening *makarismos*, expressing staged envy at the liberty of the poets, builds visibly upon the fourth-century orator's account of the indulgence traditionally granted to these figures (*Evagoras* 8–11).[58] Isocrates provides Aristides with a model, legitimated by its canonical status, for the self-conscious employment of prose form as an innovative affront to tradition. The ironical *apologia* becomes (as so often) as an advertisement of idiosyncratic excellence. In that respect, Aristides articulates a position precisely analogous to that of Isocrates; but, as we shall see, the *topos* is subtly adapted to mark a different genealogical positionality.

At one crucial point, Aristides argues that prose predated poetry:

> But what is more, it is more natural for a human being to employ prose (*pezos logos*), just as it is more natural, I suppose, to walk than to be carried on a chariot. For it is not the case that verse appeared first, and then prose and dialogue were discovered, nor did poets appear first and set down the words that should be used for things; rather, the words existed, as did prose, and then for the sake of pleasure and entertainment the art of poetry (the fabricator of these things) came upon the scene later. So if we honor nature we should also be honoring the command and will of the gods; and if, as even the poets assert, that which is former and older is better, we should be according more honor if we addressed the gods—who laid all these things down—with this style of language. (8)

Aristides' argument from nature depends upon a pun on the standard Greek phrase for "prose" in this period. *Logos pezos* literally means "pedestrian language" (I shall discuss this further in the subsequent section): in matters of literature and transport alike, pedestrianism is always the more natural option. (This point is substantiated in chapter 10: prose style does not admit of superfluities, or *peritta*—the very word used by Theon in Plutarch's tract.) This ingenious, sophistical appeal to nature seeks to reinscribe prose at the origin of language, countering the traditional ascription of primacy to poetry. If we place this passage next to Strabo's account, discussed earlier, a subtle reorientation of perspective transpires: Strabo qualifies his discussion as referring specifically to artful prose, which postdates poetry in Greece's literary genealogy; whereas Aristides refers to prose *tout court*, the natural language of communication. By shifting the parameters in this way, Aristides (like Plutarch) narrativizes the phase of the dominance of poetry as an excrescent deviation from the naturalness of prose. But as ever, the appeal to the natural is conducted from an eminently sophisticated position.

Both Plutarch and Aristides testify to the second century's increasingly coalescent self-diagnosis as a discrete historical period, characterized by prosography. It is notable that this self-diagnosis is articulated in *literary* terms. Recent scholarship has tended to treat this period in terms of its political conditions,

[58] Russell 1990, 201.

in respect of the advent of Roman domination, but this does not always chime exactly with contemporary narratives. This is not to deny that there is a political aspect to these narratives. Prosography, as we have seen, is institutionalized in and mediated through the archive of knowledge, now policed, in part at least, by Rome (through libraries and patronage); and at the same time it comments (knowingly, ironically, from a distance; but also engagedly, sympathetically, passionately) upon the Greek cultural past. Prose is the literary space in which the accumulated knowledge of a tradition folds back upon itself, the medium for a self-reflexive meditation upon Greek identity. With a certain knowing wit, Plutarch and Aristides engage in revisionist history, militating against conventional accounts of the declining vigor of Greek culture. Both are, of course, learned and sympathetic classicists, in that they are (and expect their readers to be) saturated in the literature of the privileged past; but what is particularly significant is the urgent, ongoing questioning of the self-evidence of the relationship between past and present, of the contours that classicizing should adopt.

SYNCHRONIES: THE POSITIONALITY OF PROSE

The narrativization of Greek literary history is, as we have seen, political in one sense, the sense in which all historiography tells an ideologically invested story. But I want to suggest in this section that there are more political prizes at stake here, and that these become apparent if we analyze matters on the synchronic plane. What issues of *contemporary* currency (in the second century C.E.) are being transvalued into the debates over poetry and prose?

Let us begin at the borders between poetry and prose, since borders are always sites of political tension. What is at risk when transgression is threatened? I focus here primarily upon poetic prose rather than prosaic poetry (a category that does exist but is of less central importance to the present project).[59] The former is often constructed as a monstrous transgression, and (significantly) imaged often in political and ideological terms. As early as the fourth century, in a canonical discussion, Aristotle argues for the foreign or exotic (*xenos/xenikos*) inflection given to prose by the importing of poetic style (*Rh.* 1404b passim). The comparison between literary and political identities is explicit: "People have the same response to style as they do when comparing foreigners (*xenoi*) with fellow-citizens" (1404b). This response is not universal rejection, indeed wondrousness (*to thaumaston*) can be generated by this

[59] See the discussion of the Augustan Dionysius of Halicarnassus in *On the arrangement of words*: most people regard the prosaic as a fault in poetry, although a certain form of "elaborate and artistic" prosiness should be distinguished (26). It is sometimes argued (e.g., Freudenburg 1993, 183–4) that Horace's *Satires* construct themselves as prose-poetry (cf. esp. the "pedestrian Muse," 2.6.17), but a case can be made that satire and iambic are "pedestrian" in a different sense: see my discussion below of Callim., *Aet.* fr. 112.

exoticism. But such techniques must be used only subtly and in moderation. In general, the primary virtue of prose lies for Aristotle in its clarity (*saphēneia*), which is best served by the use of proper (*kurios*) or familiar (*oikeios*) words. The last two terms further enrich the subjacent seam that transvalues literary self and other into civic terms. Genres are construed as geopolitical territories, and any intermingling between the two constitutes an act of invasion.

In second-century theory, prose poetry is acceptable for erotic discourse,[60] but castigated in more serious, proper genres. Particularly relevant here is Lucian's *How to Write History*, composed (in 165 C.E.?) in the wake of the Parthian campaigns of Lucius Verus. The particular butts of Lucian's attack are the historians who commemorated these campaigns in (to his eyes) an inappropriately poetical form:

> Moreover, people of this kind seem ignorant of the fact that there are different aims and special rules for poetry and poems on the one hand and history on the other. For poetry has unalloyed[61] freedom and only one law: whatever the poet wants. For he is inspired and possessed by the Muses, and if he wants to yoke a chariot of winged horses, or if he makes others go running over water or the tops of corn, no one cavils. When the poets' Zeus drags up and suspends earth and sea on a single cord, no one fears that the cord might snap and that everything might fall down in a heap. And if he wants to praise Agamemnon, there is no one to stop him from being like Zeus in his head and eyes, and like Zeus's brother Poseidon in his chest, like Ares in his girdle: the son of Atreus and Ares has to be entirely a compound of all the gods, for Zeus, Poseidon, or Ares alone would not be enough to do justice to his beauty. If history, on the other hand, takes onboard such flattery, what does it become other than prose poetry? It is stripped of the latter's majestic sonority, but displays all the other mumbo-jumbo unclothed in metrical form, and all the more conspicuously for that. So it is a great—no, an *enormous*—wickedness if one cannot distinguish between the territory of (*khōrizein*) history and that of poetry, but imports (*epeisagein*) into history the embellishments of the other: myth, encomium, and exaggeration in these matters. It is as though one were to take one of those mighty, oaken athletes and dress him in purple and all the apparel of a courtesan, and rub red and white makeup into his face. By Heracles, how ridiculous (*katagelastos*) one would make him by besmirching him with that adornment! (8)

The territorial metaphor I proposed above ("borders") is meaningfully activated in this discussion of prose poetry: the great ("no, *enormous*") wickedness lies in a confusion of spatially demarcated properties. It is necessary to "distinguish between the territory" (*khōrizein*) of the two genres, and not to import (*epeisagein*) from one into the other. Lucian polices the boundaries with self-

[60] Isocrates also alludes to poetry's description of its subject matter using words "now foreign (*xenois*), now new, now metaphorical" (*Evag.* 9).
[61] Reading ἄκρατος with Du Soul (*fort. recte*, comments Macleod) for MSS ἀκράτης.

righteous certainty, not least because so many core cultural values are implicated. In particular, prose is here constructed as a manly form, correlated with the vigor of an athlete. Poetry, on the other hand, is repeatedly linked with (deceptive, and female) clothing and adornment, and in the concluding metaphor equates with the garb and makeup of a *hetaera*. To conflate these two would be ridiculous (*katagelastos*), as Lucian tells us in the next sentence: an index not only of the cultural importance of the barrier between poetry and prose, but also of the central role of the ridiculing satirist in maintaining it. (The author's vigorous maintenance of generic boundaries here does not, however, prevent him from crossing it himself in other literary works.)[62]

Despite its femininity, however, poetry does have a certain power, a power which is imaged in markedly political terms. It has "unalloyed freedom" (*akratos eleutheria*), and the quasi-autocratic "one law," namely the will of the poet. These phrases evoke the canonical definition of monarchy, namely, "rule without accountability" (*aneuthunos*).[63] The poet's high-handed approach towards the manipulation of plausibility and truth is linked with political authoritarianism. It is notable, in this connection, that Lucian is also accusing writers of prose poetry of toadying to emperors: autocratic writing in the service of autocrats.

This association between poetry and elite sociopolitical station ramifies into a series of puns on the Greek phrase *pezos logos*, "pedestrian speech," the standard expression from the late second century B.C.E. for prose-writing. The earliest uses of *pezos* refer apparently to poetry unaccompanied by music, and the reference to prose would seem to have been extrapolated from there.[64] But *pezos* is a neon metaphor signalling its openness to interpretation. This image tantalizes (not least with its proximity to the heavily overwrought puns upon metrical feet found in the Roman elegists—but that may be another matter).

Even in the sources using the word *pezos* in a literary sense that predate the specific reference to prose, the metaphor invites detailed unpacking. In the so-called epilogue to the *Aetia*, Callimachus writes that "I shall approach the

[62] Notably in *Zeus the Tragedian*: on Lucian's own hybrid "poetic prose" see further Camerotto 1998, 130–36; 213–18.

[63] Hdt. 3.80; Pl. *Leg.* 761e; [Pl.] *Def.* 415b; Arist. *Pol.* 1295a20; Diod. Sic. 1.70.1; *SVF* 3.267 (p. 65); 3.617 (p. 158); Dio Chr. 3.5; 56.5; 56.11 (in this last passage, as Murray 1971, 502–3, points out, Dio is overturning the accepted definition by pointing out that Agamemnon is accountable—to Nestor). "Rule without accountability" (*anhupeuthunos*) is "[t]he accepted definition of kingship by Hellenistic times" (Murray 1971, 300; see also Schofield 1991, 138–39 n. 4).

[64] For discussion and references, see Cameron 1995, 144; Asper 1997, 60. In other contexts, traveling "on foot" might even imply the deployment of verse (i.e. metrical "feet"): see Asper 1997, 33 n. 50 on Pind. fr. 206 SM (πεζὸς οἰχνέων). The earliest (though Demetr. *De eloc* 167 may be earlier) use of *pezos* to mean "prose" of which I am aware comes in the course of the recently edited verse inscription from Salmacis, where Herodotus is described as the "prose Homer of history" (Ἡρόδοτον τὸν πεζὸν ἐν ἱστορίαισιν Ὅμηρον, 43). See Isager 1998 for an *editio princeps*, and also Lloyd-Jones 1999. The inscription is dated to the second century B.C.E., probably to the later part.

pedestrian (*pezos*) pasturage of the Muses" (αὐτὰρ ἐγὼ Μουσέων πεζὸν ἔπειμι νομόν).[65] Older scholars took this as a reference to a supposed decision to write prose, but there is nothing to suggest that Callimachus gave up poetry (and this would constitute the earliest use of *pezos* in this sense by two centuries): more recent opinion has inclined towards a foreshadowing of the *Iambi*.[66] The central point here is the pronounced imagery of *social* differentiation in this statement of poetic choice. *Pezos* is a military metaphor, suggesting the infantry as opposed to the cavalry: Homeric discourse, notably, repeatedly polarizes the low-status *pezoi* and the high-status *hippēes*.[67] By marking himself out as a foot soldier rather than a cavalryman, Callimachus is emphasizing his turn towards the low and away from the lofty (in contrast with, for example, the charioteering verse of Sappho, Parmenides, and indeed what we call the prologue to the *Aetia*).[68] But the word *pezos* also deviously recaptures, as it were, the high ground: a poet is by definition a pedestrian traveler, whose paths are mapped out by metrical feet.

So for the Alexandrian poet, ironically abasing his forthcoming poetic project, *pezos* constitutes a cleverly allusive means of proclaiming (and hence revaluing) low status. By the time of Strabo, this metaphorical field polarizing charioteers and foot soldiers has been mapped securely onto the poetry-prose polarity.[69] Let us return to the passage cited in the previous section (1.2.6). Using the phrase *pezos logos*, Strabo images the decline of literary prose from its origins as an imitation of poetry as a descent "as though from a great height," just as "comedy took its structure from tragedy, but descended from its height (*hupsos*) into the state that is currently called 'prosaic'" (1.2.6). The discussion is completed with a sentence not cited in the previous section: "And the fact that language without meter is called 'pedestrian' (*pezos*) indicates that it has descended from some great height (*hupsos*) or chariot onto the ground" (1.2.6).

The dominant metaphor in Strabo's assessment of the relative merits of poetry and prose is one of height. Prose is a lesser form, according to Strabo, because of its low status. Poetry, by contrast, is associated with height or "sublimity" (*hupsos*), a term that can bespeak (for example, in the pseudo-Longinian text *On the Sublime*)[70] either literary or social grandeur. No doubt mindful of this duality, Strabo proceeds to distance poetry from social elitism by linking it with democracy and prose with oligarchy: the latter is more "useful to the people" (*dēmōphelēs*), and "capable of filling theaters," whereas philosophy

[65] Fr. 112.9 Pfeiffer, playing of course on νόμος = song.
[66] Cf. Horace's "pedestrian Muse" (*Serm.* 2.6.17), cited above n. 59; see Pfeiffer 1949, 125, and most recently Cameron 1995, 154–56; Asper 1997, 58–62.
[67] Hom. *Il.* 5.13; 8.59; 11.150; *Od.* 9.50; 17.436.
[68] Sappho fr. 1.7–12; Parm. fr.1.1–10; Callim. *Aet.* fr. 1.27.
[69] For this pervasive image, see Plut. *De aud.* 16c; Luc. *Bis acc.* 33 (a prose form—Platonic dialogue—as "charioteering"); *Pro imag.* 18; *Menipp.* 1; and further Norden 1898, 33–35 n. 3.
[70] See Innes 1995 on this equivocation.

(the subset of prosography on which he concentrates) speaks "to the few" (*oligoi*) (1.2.8). Poetry is, for Strabo, a high form—but not high in the sense that tyrants and oligarchs are high . . .

Yet as we have seen in relation to Lucian, the association between poetry and monarchy does not disappear, particularly as we approach the prosaic self-celebration of the second century C.E. In Plutarch's dialogue *On the Pythian Oracles*, Theon reinterprets the imagery of descent from the chariot as an expunging of luxuriant excess: just as prophecy "took off its golden hairnets and doffed its soft frocks," opting for simplicity instead of richness (*poluteleia*), so "history climbed down from its meters as though from a chariot, and truth was distinguished from the mythical especially by pedestrian language (*pezos*)" (406d-e). In this case, the height of poetry is closely correlated with its soft, tyrannical excesses.

The specific accusations of tyranny recur in Aristides' *Hymn to Sarapis*. Aristides too, as we have seen, reclaims the metaphorical polarity of the pedestrian and the charioteer: walking is more natural, less presumptuous (8). Poets, on the other hand, are "tyrants (*turannoi*) of ideas" (1), "emperors (*autokratores*) of whatever they wish to say" (13). The dominant force of his critique of poetry centers upon the arbitrary power conceded by society to poets: "they are permitted to set up every time whatever themes (false, and sometimes unconvincing) they like" (1); "we have yielded to them" the power to address the gods, as though they were priests (4); the right to compose hymns has been yielded to poets alone (13). Prose, on the other hand, is, for Aristides, more subject to the requirements of civic solidarity: "it is not permitted to tell the poets' riddles or anything of that kind, nor to embolden ourselves to add in material irrelevant to the matter in hand; rather, we must remain truly in a state of moderation (*metron*) and always remember ourselves, as though keeping to our station in a military campaign" (13). The image of the prosographer as a nontyrannical, responsible citizen-soldier is here underlined by the pun on the word *metron*. This is the conventional word for "meter," a definitive feature of poetry; but, Aristides tells us, it truly means "measure" or "moderation," the idealized quality of a proper Greek citizen, and is hence more appropriate to prose.[71]

At issue in these debates over the respective political affiliations of prose and poetry is the question of the civic utility of literature. Literature should be Hellenic, manly, and democratic (a term that calls for a carefully nuanced interpretation in this age of Roman-dominated oligarchy).[72] These appeals to tradition are not, however, simply inert, theoretical statements reclaiming prose from centuries of prejudice: they are also cultural performatives, strategic attempts to erect concrete definitional boundaries in the fluidity of coeval literary culture.

[71] This pun is first developed in chapter 11, a passage with numerous difficulties of interpretation. See esp. Russell 1990, 204–5 on the pun here.

[72] See, e.g., Starr 1952 for the appropriation of language of democracy to describe the Roman principate.

That is to say, the targets of this antipoetic prejudice are not straightforwardly Homer and the tragedians (who are, in general literary culture, as widely appreciated as ever), but (also) contemporary rivals whose profiles can be tainted with accusations of exoticism, effeminacy, and tyranny. Rhetoric is a zero-sum game, and the opportunity to impugn the face of others to one's own advantage is never passed up.

I have argued in this section that the poetry-prose polarity is exploited by second-century writers in order to map out contemporary cultural, sexual, and political identities. This matrix of ideologies depends upon an underlying sense of the dangerous contagiousness of alternative identities: men can be infected with femininity, Greeks with oriental barbarism, citizens with tyrannical fervor. Analogously, the frontier between prose and verse is not intraversable: certain types of text put this boundary at risk, importing from the one into the other. This shrill, dogmatic moralizing explains why prose-poeticism is rarely defended as a literary dogma. Like Asianism[73] and (to a lesser extent) sophistry,[74] poetic prose serves principally as an evanescent scare-image, a bogey serving primarily to allow the speaker to plot his own rhetorical position by contrast in the reassuringly familiar locus of traditionally regulated identities.

It would be overly simplistic, however, to claim that the prosaic culture of the second century was straightforwardly antipoetic. For a start, poetry remained the primary medium of childhood education, and even such committed prosophiles as Plutarch prescribed it as such (against Plato's advice).[75] Poetry was also the object of educated interest, with varying degrees of philosophical commitment: from Heraclitus's *Homeric Questions*, through Dio Chrysostom's eleventh oration (*That Troy Was Not Captured*) and Philostratus's *Heroic Tale* to Porphyry's *On the Cave of the Nymphs*, prosographers explored the vagaries

[73] A problematic concept: although apparently alluded to by Cicero (Swain 1996, 24), the term as such does not appear in extant literature until the late first century C.E. (Quint. *Inst. or.* 12.10.12, 14; Tac. *Dial.* 18.4). See most recently Hidber 1996, 30–44, and Swain 1996, 22–24, both with bibliography. In extant Greek, the only direct evidence is Dionysius's reference to the emergence of bad rhetoric from "an Asian pit" (*The Ancient Orators* 1.7); a pair of titles (*How Attic Emulation Differs from Asian* and *Against the Phrygians*, frr. 6, 11 Ofenloch) attributed to Dionysius's contemporary Caecilius, however, are strongly suggestive. This Atticism-Asianism contrast, however, appears to be more generally cultural than the narrowly linguistic focus of the earlier Romans. In the nineteenth century, overstated theories abounded concerning the supposed role of the latter in spurring the archaizing revolution in the Greek literature of the Roman empire (beginning with Rohde 1886, and culminating in the maximum opus of Schmid 1887–97). Wilamowitz accepted the inviting opportunity to deflate this presupposition while scoring points against his opponents (Wilamowitz-Mollendorff 1900). For a saner approach, see now Horrocks 1997, 81, arguing that Atticism and Asianism represent ever overlapping and interlaced stylistic proclivities, rather than absolute states.

[74] See Stanton 1973 on the confusions between "sophist" and "philosopher"; but see esp. Hesk 2000, 212–17 (focusing on democratic Athens), on the plasticity of "sophist" as a term of abuse.

[75] Morgan 1998, 104–18; also Whitmarsh 2001, 47–54, on Plutarch's essay *How a Young Man Should Listen to Poets*.

of the poetical canon. Some writers even composed poetry themselves.[76] Moreover, despite the apparent vehemence of the strictures against poetry, numerous prose texts from this period are highly poetical in the lexis and rhythms. This is perhaps unsurprising in the case of erotic texts like Longus's *Daphnis and Chloe*: the risqué subject matter is matched by a venture into "improper" stylistics.[77] Yet even in the more *prima facie* normative genre of oratory, poeticisms abound.[78] What the best writers know is that the thrill of literature comes from an ability to transgress the rules *and get away with it*. Such writers are what Bourdieu would call *virtuosi*:

> only a virtuoso with a perfect command of his "art of living" can play on all the resources inherent in the ambiguities and uncertainties of behaviour and situation in order to produce actions appropriate to each case, to do that of which people will say "There was nothing else to be done," and do it the right way.[79]

Virtuosi masters of the art of writing play a dangerous game, introducing poetic words and rhythms, neologisms and exoticisms into the manly austerity of Greek prose. But the more dangerous the game, the higher the stakes: the agonistic, status-dominated context of epideictic oratory was particularly susceptible to such high-risk experimentation, because sailing close to the wind makes for a more thrilling journey.

Although the prosifying culture of Roman Greece repeatedly marked the relationship between Classical and contemporary Greece in terms of the polarity of poetry and prose, it did so with a view not to repressing or expunging poetry, but rather to *reterritorialising* it.[80] In the elite culture of the second century C.E., the poetic was the locus for a complex web of concerns with ideology and identity; and that was precisely why it was needed. I hope to have shown how the diachronic narrative describing the descent of a high, classical culture of poetry into the abyss of prose also encodes synchronic preoccupations with cultural, sexual, and political identity. The creation of a Classical period is the function of a dynamic and ever unresolved struggle within contemporary culture: to inveigh against the tyranny, barbarism, or effeminacy of poetry was to seek not to replace it with prose, but to re-place it as prose's spectral but potent other. To codify poetry as a powerful, exotic, and/or whorish phenomenon is simultaneously to stigmatize it and to mark it as an object of enduring fascination, of desire even. We do not need to be thoroughgoing Lacanians to observe the centrality of this objectified, dis-placed other to the

[76] Above, n. 16.
[77] See Hunter 1983, 84–98, for detailed discussion of the definitively poetical, "sweet" style of *Daphnis and Chloe*.
[78] Norden 1898, 1.367–79.
[79] Bourdieu 1977, 8.
[80] I take this term from Stallybrass and White 1986, 104, on elite responses to the eighteenth-century carnival.

ego of Roman Greek culture: it is through this dialectical interplay between repulsion and attraction that the identity of the prosaic "I" is constituted.

This chapter has analyzed the symbolic associations of the poetry-prose dyad (each element as crystallized into iconic form) on two planes, the diachronic and the synchronic. I want to stress in conclusion, however, that although the two planes can be treated as separate for heuristic purposes, they are inseparable at the symbolic level: any stratification of contemporary society is informed by a reading of history, and any reading of history is simultaneously a retrojection of contemporary cultural concerns. That is to say, Roman Greece's ambiguous relationship to its poetical, classical past (the subject of the previous section) is isomorphic with its ambiguous relationship to poetical elements (the tyrannical, the female, the barbaric, the other) in the present. The synchronic and the diachronic re-placements of poetry are differently inflected articulations of the same lust (never fully consummated) for identity.

"The past" is not—cannot ever be—simply a historical descriptive, but (also) a function of desire, a desire that disavows even as it lusts. For second-century Greeks, prose-writing is not in any sense a simple, natural, self-evident choice: it is, rather, a self-conscious marker of the processual closing and reopening of the temporal chasm that unites and separates the Roman-dominated present from the (idealized) Greek past. Prosography is the discourse of the archive, of language marking its attainment of the second order of representation (where imitation, allusivity, commentary, and self-reflexivity are the dominant tropes), of a tradition folding back upon itself. But Roman Greek prosography is not *simply* repetitious of earlier precedents.[81] Or if it is repetitious, then we must acknowledge with Peter Brooks that "[r]epetition is . . . a complex phenomenon. . . . Is repetition sameness or difference? To repeat evidently implies resemblance, yet can we speak of resemblance unless there is difference? Without difference, repetition would be identity, which would not usually appear to be the case."[82]

Roman Greek literature confesses difference even as it advertises continuity. The advent of Roman patronal resources at once creates the political, cultural, and economic conditions for the reclaiming of the classical past, and opens up the gulf that distantiates it. The prosifying trajectory of this culture, as we have emphasized throughout, does not simply reflect a historical rupture with the classical past; rather, it constructs (provisionally, strategically, multifariously, *ad hoc*) an imaginary model of such a rupture. The polarity of prose and poetry, through which the classicizing narrative is so often articulated, is the site of a variety of competing voices, all self-interested, all charged with sociopolitical and cultural tensions. What I have sought to do here is map out these various tensions in both their diachronic and their synchronic functions.

[81] Whitmarsh 2001, 41–89.
[82] Brooks 1984, 124.

CODA

Looking Back, and Beyond

Chapter 11

ATHENS AS THE SCHOOL OF GREECE

Glenn W. Most

THESE MEN, stately, dignified, yet filled to bursting with intellectual passion and seemingly incapable of failing to inspire a similar passion in anyone who encounters them (see fig. 11.1)—we seem always already to have known them. The most prominent amongst them are for the most part easily identifiable as some of the most distinguished philosophers and scientists of Greece: Plato and Aristotle, Socrates and Pythagoras, Diogenes and Ptolemy. Whether they propound their doctrines in exposition and argument, or merely dramatize their views in their gesture and attire, so perfectly have they embodied their thoughts that we can scarcely imagine them now in any other form. They are surrounded by astonished admirers who are overwhelmed by the joy of learning; at the left edge, one youth, waved on by an older man, rushes onto the scene in uncontrollable eagerness; at the right edge, another youth, unable to contain himself any longer, rushes off in order to spread the word throughout the world. All these amazed and delighted spectators within the fresco represent the attitudes that we external viewers of the fresco are supposed to adopt to the scene it represents: the pupils within the picture program our role as pupils of the picture. Of the almost sixty humans represented, only four have managed to tear their gaze away from the dramatic scene of which they are part and to return our gaze by looking directly at us: in the left foreground, three young male figures of increasing age from left to right, first a baby held by an old man and grasping for a book, then a child peering over the shoulder of the man holding the book, and finally a beautiful youth dressed all in white; and at the edge of the right foreground, a self-portrait of the painter himself. By their uninhibited mediation, these four figures compel our participation; by their youthfulness, they remind us that we have much to learn from the older, mostly bearded adult men we see; by their increasing age, they suggest that we too will be able to make progress, if we are willing to dedicate ourselves to them. It is little wonder that, in the absence of an authentic title on the part of Raphael and despite the fact that the magnificent building which his philosophers occupy is certainly not a school but rather, if anything, a temple or a palace, nonetheless the didacticism which suffuses this image has so fully determined its reception that, at least since the seventeenth century, it has inescapably taken on the title *The School of Athens*.

The persistence of this mistitle testifies to the strength with which the idea of Athens as a school has taken hold on the European imagination. For centuries, the cultural survival of Athenian literature and philosophy has at least in

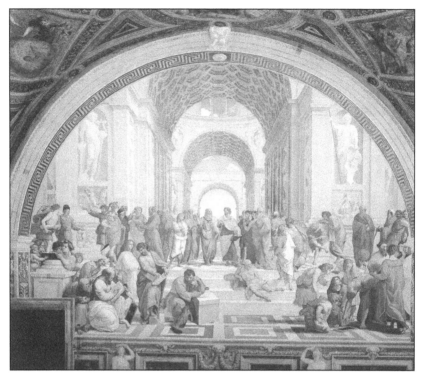

Figure 11.1. Raphael, *School of Athens*. Ca. 1509–10. Fresco in the Stanza della Segnatura, Vatican, Rome. Photo by P. Vinossi, provided by the Archivio Fotografico of the Musei Vaticani, and reprinted with the permission of the Direzione dei Musei Vaticani, Rome.

part been entrusted to a trope of reception whereby Athens is defined as the school at which all later human beings must learn if they are to recognize and develop their own humanity: by studying at the school of Athens they learn to forget how to be Romans or Italians or Germans and become instead—not so much Athenians, as rather human beings. What makes this trope all the more remarkable is the paradox that what has gone on to become a central figure for humanistic universality, propagating peaceful values of international collaboration and intellectual culture, began instead as a cliche of narrowly parochial local patriotism, emphasizing military values of warfare, competition, and self-sacrifice. One measure of this peculiar development is the shift in meaning that the prepositional phrase "of Greece" in the definition of Athens as "the school of Greece" has sometimes undergone, from its original meaning, that Greece should be a pupil studying in the school constituted by Athens (a genitive of the student: the same grammatical construction as in the title of Molière's

L'école des femmes, or *The School of Wives*), to some modern versions that suggest that Athens is the school in which Greece can teach all mankind (a genitive of the teacher: cf. Molière's *L'école des maris*, *The School of Husbands*) or that Greece is the subject matter that anyone can study in the school of Athens (a genitive of the subject matter: cf. Tony Harrison's *The School of Eloquence*).

It is surely not accidental that the earliest and most celebrated formulation of the idea of Athens as the school of Greece is found in Thucydides' version of the funeral oration Pericles delivered during the winter of the year 431/30 B.C.E.,[1] for it was no doubt the Athenian tradition of public eulogies delivered at the mass funeral of the soldiers fallen during the course of a year's warfare that provided the original context within which this idea was first developed and elaborated into a rhetorical commonplace.[2] To be sure, other genres of Athenian literature as well are no strangers to the praise of Athens—as Socrates said, it is not hard to praise Athens before an Athenian audience.[3] Thus in the *Medea*, at a moment when Euripides was worried (as it turned out, with good reason) that the twist he had given his play would end up alienating its Athenian spectators, he had the chorus sing a stasimon in honor of the city of Erechtheus, blessed since ancient times, celebrating above all its military prowess and its role as nurse of wisdom and poetry (despite which it ended up denying him the victory that year).[4] Such abstract praise could be found in any context: but a consistent and marked emphasis upon lessons to be learned required a specific institutional support, and this was supplied above all by the state funerals at Athens. For how else could the orator not only console survivors but also transform their sadness, their desire for the dead that is never concealed,[5] into an even more ferocious courage, than by admitting undeniable loss but interpreting it redemptively as a sacrificial lesson?[6] Under these circumstances, yielding to the dangerous seduction of listless mourning (to say nothing of that of mutinous resentment) would be tantamount to betraying a sacred trust that the fallen had bestowed as a legacy upon their survivors.

Since Homeric times, the battlefield had always been the place where lessons of military courage and skill were given their most severe test: the Homeric warrior's father sends him from his childhood home to the battlefield with the instruction that he must "always be the best and be better than the others";[7]

[1] Thuc. 2.41.1.
[2] The fundamental study of this tradition, from which I have learned much in general orientation and in detail, is Loraux 1981.
[3] Pl. *Menex.* 235d, 236a.
[4] Eur. *Med.* 824–32.
[5] Gorg. 82 B 6; Demosth. *Epit.* 16; Diod. Sic. 13.20.4; corrected polemically by Pericles at Thuc. 2.43.1 (see below).
[6] On the rhetorical and political tensions of such funeral orations in ancient and modern democracies, cf. Most 1994.
[7] Hom. *Il.* 6.208 (Glaucus's father Hippolochus), 11.784 (Achilles' father Peleus).

Hector has learned "to do well and to fight among the foremost Trojans" and his forlorn hope is that his own son will learn that lesson so well that all the Trojans will say that he surpasses his own father.[8] In the classical *polis* that these very orations helped to construct, individual prowess has become submerged in civic duty, but the scene of instruction has remained the same: dying is not after all a failure, but is instead the (only) proof of success, for it alone can demonstrate beyond any doubt that the soldier has indeed learned a lesson in courage from those who fell before him and can pass it on intact to those who will fall after him. This is an instruction that takes the form of teaching to imitate.[9] Hence, over and over, the funeral orators claim that the fallen soldiers had learned the lesson of courage in the present by following the example of the great dead heroes of the past;[10] that commonplace need only be inverted for the lesson imparted by the newest dead to be imposed upon the children in the audience as a duty they must go on to fulfill someday in their own future actions[11]—in the scene of the funeral oration in Euripides' *Suppliants*, Theseus tells Adrastus to direct his words above all to the young citizens present, and the very last words of Adrastus's speech are, "In this way educate your children well" (οὕτω παῖδας εὖ παιδεύετε).[12] Thus, by the mediation of the funeral oration, the dead educate the living.[13] And since the funeral ceremonies were attended not only by Athenian citizens, but also by foreigners,[14] the lessons imparted by the heroic dead were directed not only as encouragement and consolation to future Athenian soldiers, but also as an admonition and challenge to the rest of the world.[15] That is why the orators can claim that the fame of the dead they celebrate spreads through the whole world[16] and lasts forever.[17]

When Thucydides has Pericles summarize his oration by claiming that the whole city of Athens is a school for Greece (Ξυνελών τε λέγω τήν τε πᾶσαν πόλιν τῆς Ἑλλάδος παίδευσιν εἶναι),[18] he is both presupposing and subverting this by now well-established tradition. Within the limits of Pericles' speech, taken in isolation from its context within Thucydides' work, Pericles is evidently accepting the didactic mission inherent within this rhetorical genre

[8] Hom. *Il.* 6.644–45, 476–81.
[9] Pl. *Menex.* 236e; Dion. Hal. *Rhet.* 6.4.
[10] Eur. *Suppl.* 911–17; Pl. *Menex.* 240e; Dem. *Epit.* 16, 27–31; Hyp. *Epit.* 8.
[11] Lys. *Epit.* 69; Pl. *Menex.* 246b, 248e, 249a; Hyp. *Epit* 32.
[12] Eur. *Suppl.* 844–45, 917.
[13] Lys. *Epit.* 3 (παιδεύοντας ἐν τοῖς τῶν τεθνεώτων ἔργοις τοὺς ζῶντας); cf. Pl. *Menex.* 246dff., quoting the words supposedly addressed by the dead to the living.
[14] Thuc. 2.34.4, 2.36.4; Pl. *Menex.* 235b; Dem. *Epit.* 13.
[15] Lys. *Epitaph.* 6; Pl. *Menex.* 241b-c.
[16]. Thuc. 2.41.4, 43.3; Lys. *Epit.* 2, 3, 20, 26, 66, 79; Pl. *Menex.* 237c, d, 239a; Dem. *Epit.* 17, 33; Hyp. *Epit.* 30.
[17] Thuc. 2.41.4, 43.2; Lys. *Epit.* 6, 20, 23, 79, 81; Pl. *Menex.* 243c, 249b; Dem. *Epit.* 32, 36; Hyp. *Epit.* 14, 24, 30, 42; Diod. Sic. 13.20.3; Dion. Hal. *Rhet.* 6.4.
[18] Thuc. 2.41.1.

but taking great pains to redefine it. After all, in military matters the Spartans too were thought by themselves and their friends to have a lesson to teach the rest of the world;[19] and the outcome of the Peloponnesian War might well have suggested to some that they were right. Hence Pericles, who in his political activity committed himself no less forcefully to the demonstration of the cultural hegemony of Athens than to the fortification of her military strength, determines to outflank any purely military competition between Athens and Sparta in his speech by redefining the real sphere of instruction, withdrawing it from the battlefield and a particular way of death and relocating it instead within the city and a particular way of life. In so doing, he subordinates the military domain to the realm of cultural and civic life (which in fact rested upon Athens's military might), and argues implicitly against Athens's critics that the city is not, what some say, a tyrant for the rest of Greece, but rather a schoolmaster: its power over other cities is due not to brute force, but to a cultural supremacy (which results, among other things, in military superiority). Thus the whole burden of Pericles' speech is to define the peculiar characteristics of Athenian civic life in such a way that these soldiers' death becomes their willing, conscious, and definitive tribute in action to the supreme value of the city, corresponding to and thereby legitimating Pericles' own (only seemingly) more modest tribute in words, and soliciting a future tribute, again in action, from the survivors. That is why for Pericles the $\pi\alpha\rho\acute{\alpha}\delta\epsilon\iota\gamma\mu\alpha$ that Athens sets up for others to imitate is essentially political rather than military[20] and why his own teaching ($\delta\iota\delta\alpha\sigma\kappa\alpha\lambda\acute{\iota}\alpha\nu \ldots \pi\mathrm{o}\iota\mathrm{o}\acute{\upsilon}\mu\epsilon\nu\mathrm{o}\varsigma$) emphasizes, astoundingly, not the merits of the dead, but those of the living city[21]—to which he even calls upon the survivors to redirect their desire for the dead.[22]

Viewed coldly, Pericles' image of Athens reveals itself to be an impossibly utopian synthesis of irreconcilably disparate virtues: here, and only here, constraint is freely self-imposed, individuals are more fully individuals because they are entirely integrated into the community, soldiers are braver precisely because they are not obliged to be, the political life is incumbent upon no one and hence shared in willingly by all, life is so public that authentic privacy is possible, people love beauty without yielding to extravagance in expenditure and love wisdom without succumbing to weakness in action. Yet so brilliantly does Pericles put his case that the soldiers' self-sacrifice seems to compel our assent. But what in fact invalidates his vision of Athens is not so much the internal illogic of his oration as rather the narrative context into which Thucydides has ruthlessly set it. For no sooner has Pericles finished his oration than the plague of 430 B.C.E. breaks out;[23] and with it comes the total breakdown of all

[19] Thuc. 3.57.1; Isoc. *Panath.* 202.
[20] Thuc. 2.37.1.
[21] Thuc. 2.42.1.
[22] Thuc. 2.43.1.
[23] Thuc. 2.47.3.

the civic and moral virtues that for Pericles had been indissolubly woven into the fabric of the city. "The catastrophe was so overwhelming that men, not knowing what would happen next to them, became indifferent to every rule of religion or of law.... In other respects also Athens owed to the plague the beginnings of a state of unprecedented lawlessness."[24] No causal concatenation in external events compelled Thucydides to adopt this narrative sequence: it is the historian who has chosen to assign the single funeral oration he allows Pericles to the first year of the war and thereby to provoke this drastic juxtaposition, and his motivation in doing so can only have been to allow the sequence of events to demonstrate the falsity of Pericles' optimism.[25] Not only does Pericles fall victim to the plague; so too does his vision of Athens, which is revealed to be too fragile to withstand the severe testing these extreme conditions inflict upon it. If Athens is only virtuous in good health, then, Thucydides seems to be suggesting, its virtue is only skin deep; and indeed he may even be implying that, in this case too, Athenian miscalculation about the sources and limits of its own strength contributed decisively to Athens's catastrophe.

Thus, from its beginning, the *topos* of Athens as the school of Greece is shadowed by irony and paradox. This does not cease to be the case in the transformations of the *topos* by the other two major authors of Classical Greek literature who helped bequeath it to later readers, Plato and Isocrates. In Plato's *Protagoras*, the dispute between Socrates and Protagoras reaches at one point a degree of contentiousness that threatens to make it break down altogether; the other interlocutors present intervene in an attempt to calm the troubled waters and to permit the discussion to continue. Among the peacemakers is Hippias, who claims that "it would be shameful if we, while knowing the nature of things, should yet—being the wisest of the Greeks, and having met together for the very purpose in the very sanctuary of the wisdom of Greece (τῆς τε Ἑλλάδος εἰς αὐτὸ τὸ πρυτανεῖον τῆς σοφίας), and in this the greatest and most auspicious house of the city of cities—display no worthy sign of this dignity, but should quarrel with each other like low churls."[26] No longer is Athens merely a schoolroom: it has become the city hall, the seat of political power and municipal administration. Hippias's praise sounds splendid, and no doubt helped determine the transformation of an earlier scene in this same dialogue into Raphael's fresco, the so-called *School of Athens* with which we began.[27] Yet his politicization of the scene of instruction lays bare the structures of economic and military inequality that oppressed so many Greek cities at the end of the fifth century in their dealings with Athens and which Pericles' shrewd transmutation of tyranny into instruction had only partially covered up. What is more, we know from many indications how little Plato intends us to

[24] Thuc. 2.52.3–4, 53.1, trans. Rex Warner.
[25] See especially Flashar 1969.
[26] Pl. *Prt*. 337d-e, trans. Loeb.
[27] See on the relation between Raphael's painting and Plato's text: Most 1996a.

take seriously this gathering of Sophists as the genuine elite of Greek intelligentsia: Callias and his circle are politically and morally suspect throughout the Platonic dialogues; the whole scene in which Socrates viewed Protagoras, Hippias, Prodicus, and their followers for the first time in Callias's house had been a maliciously ironic pastiche of Eupolis's *Flatterers* and of Odysseus's visit to the Underworld in *Odyssey* 11, intended to suggest how vain and insubstantial the Sophists are; and Hippias himself was compared at his first mention to a mere εἴδωλον of Heracles.[28] In the end, Hippias's flattering definition of Athens as the *prytaneion* of wisdom says very little either about Athens, about whose degree of wisdom Plato's Socrates had very different views, or about the smug foreign intellectuals who have swept into the city with their spellbound retinue: instead it serves above all to characterize Hippias's own fatuously pompous pedantry.

Hippias's vanity is exposed by Plato, Isocrates'—inadvertently—by himself. In his *Panegyricus*, published probably around 380 B.C.E., Isocrates praises at great length Athens's contributions to the material and spiritual well-being of the world. In an encomium that had already attained classic status in Augustan times,[29] he races through such traditional but self-regarding *topoi* of Athenian self-celebration as her citizens' military strength, autochthony, and racial purity, in order to emphasize instead a more sociable and international dimension, the civilizing lessons that the city had received from the gods and passed on to the rest of humanity: the gifts of political order, of grain, and of the Eleusinian mysteries; the citizens' openness and hospitality; the splendid festivals. The *telos* towards which the whole encomium is directed is neither military nor material, but cultural, and in particular linguistic: φιλοσοφία (in Isocrates', not in Plato's sense) is Athens's gift to the world, and eloquence, which distinguishes men from animals and liberally educated men (τοὺς εὐθὺς ἐξ ἀρχῆς ἐλευθέρως τεθραμμένους) from uncultured ones, is honored in that city more than in any other.[30] Thus Isocrates can claim that it is above all in the domain of language that Athens has become the school for the rest of the world: "And so far has our city distanced the rest of mankind in thought and in speech that her pupils have become the teachers of the rest of the world; and she has brought it about that the name 'Hellenes' suggests no longer a race but an intelligence, and that the title 'Hellenes' is applied rather to those who share our culture than to those who share a common blood."[31]

Like Pericles' funeral oration in Thucydides, upon which this section of the *Panegyricus* is closely modelled,[32] Isocrates' panegyric emphasizes abstract cultural values but its ultimate goal is in fact more concretely military: the

[28] Pl. *Prt.* 314e–316a, cf. Hom. *Od.* 11.601.
[29] Isoc. *Paneg.* 23–50, cf. Dion. Hal. *Isoc.* 5, 14.
[30] Isoc. *Paneg.* 47–49.
[31] Isoc. *Paneg.* 50, trans. Loeb.
[32] See Buchner 1958.

speech as a whole aims at convincing the other Greek cities to grant Athens hegemony and leadership in an expedition against the Persians, which will reunite the Greeks by distracting them from their internecine warfare. But Athens's present military weakness in the wake of the Peace of Antalcidas (387 B.C.E.) deprives Isocrates of the easiest argument, that leadership should be given to the city that has the greatest military strength. Hence he must appeal to past military and cultural glories in order to justify present claims— indeed, his evident reuse of themes from Pericles' funeral oration is part of the same rhetorical strategy, designed as it is to remind fourth-century pan-Hellenic readers of Athens's fifth-century glory.

But what passes itself off here as the disinterested praise of a city is in fact the canny self-advertisement of a successful businessman, and Isocrates' climactic celebration of Athenian philosophy and eloquence is little more than a thinly disguised panegyric for what he saw as his very own contribution to Athenian, Greek, and world culture. For φιλοσοφία and eloquence were in fact the slogans of Isocrates' own educational program.[33] Isocrates, who was obliged to take students for pay after the loss of his family estate in the Peloponnesian War[34] but who became successful enough as a teacher to accumulate a large fortune,[35] taught many of his most important Athenian and non-Athenian contemporaries, not only forensic orators and politicians but also philosophers and historians—the list includes Isaeus, Lycurgus, and Hyperides, Timotheus, Speusippus, Androtion, Cephisodotus, Ephorus, and Theopompus.[36] Indeed Isocrates, who asserts that parents were glad to bring him their sons to be his pupils and to pay the fees he charged,[37] goes so far as to claim that Athens's fair reputation was at least in part due to the foreigners who came to study with him there[38]—hence he can blithely ignore the substantial non-Athenian contribution to Greek oratory.[39] Thus when he says that "Athens is looked upon as having become a school (διδάσκαλος) for the education of all able orators and teachers of oratory,"[40] he may well be speaking explicitly about the city as a whole but in point of fact he is really referring in the first instance to himself and to the school that he had founded. This marketing strategy ended up being crowned with enormous success, for, as Dionysius of Halicarnassus puts it, cultured foreigners came to regard Isocrates' school as an image of the city of

[33] Isoc. *Antid*. 270.
[34] Isoc. *Antid*. 161–62.
[35] Isoc. *Antid*. 39–41, Dion. Hal. *Isoc*. 1.
[36] Isoc. *Antid*. 93–94 gives a list of some of his early pupils. According to Cic. *Brut*. 8.32, Isocrates' "domus cunctae Graeciae quasi ludus quidam patuit atque officina dicendi, magnus orator et perfectus magister"; cf. Cic. *De or*. 2.22.94.
[37] Isoc. *Antid*. 240–41.
[38] Isoc. *Antid*. 224–26.
[39] See Harding 1986.
[40] Isoc. *Antid*. 295.

Athens itself (τῆς Ἀθηναίων πόλεως εἰκόνα ποιήσας τὴν ἑαυτοῦ σχολὴν).[41]

In the following centuries, Athens's decline in political importance—already in the first half of the third century B.C.E., the travel writer Heraclides Criticus mentions among the sights of Athens only theater and gymnasia, not political or military buildings[42]—was compensated by an inflationary generalization of the *topos* of its role as cultural teacher. From the perspective of Rome, the differences between one Greek city and another, so important for the Greeks themselves, could even come to seem almost negligible, so that the traditional prestige of Athens could shed lustre upon the whole of Greece and the trope of Athens educating Greece could be generalized to one of Greece as a whole educating Rome and the rest of the world. Sulla's philistine retort to the Athenian ambassadors who tried to persuade him to desist from his brutal siege in 87/86 B.C.E. by reminding him of Athens's noble past—"Go away, you fools, and take your speeches with you: for I was sent to Athens by the Romans not to learn history, but to destroy rebels"[43]—may have expressed sentiments widespread in the less well-educated Roman populace, but at the same time it presupposed the currency of pedagogical expectations for Athens precisely by making fun of them. Among the men who shaped Rome's culture, Sulla's remained a decidedly minority position. Cicero went as a youth to Athens to study philosophy; later he portrayed in one dialogue a group of young Romans in Athens recalling the great philosophers of the past so vividly that they ended up imagining they could see them,[44] and dedicated another dialogue to his son Marcus, who studied with Cratippus for a year in Athens so that the teacher would fortify him with knowledge and the city with examples.[45] But it was Augustan Classicism which defined itself above all as the pupil of Greece and thereby decisively transmitted the vision of the school of Greece to Western culture. Horace inverted Cato's anxiety about Greek and Asian arts and elegance, *ne illae magis res nos ceperint quam nos illas* ("lest those things capture us more than we capture them"),[46] and turned it into a defiant assertion of how the militarily superior Romans had been tamed by the culturally superior Greeks they had vanquished: *Graecia capta ferum uictorem cepit et artes / intulit agresti Latio* ("Captured Greece captured the savage victor and brought the arts into rustic Latium").[47] For Virgil, the Romans were welcome to maintain a monopoly on the *artes* of war and law, but all the others (presumably

[41] Dion. Hal. *Isoc.* 1.
[42] Pfister 1951, 72ff.
[43] Plut. *Sulla* 13.2.
[44] Cic. *Fin.* 5.1.1–2.4.
[45] Cic. *Off.* 1.1. For Cicero's praise for Athens's cultural achievements cf. also, e.g., *Brut.* 7.26–29, 13.49–50, 13.51; *De or.* 1.4.13, 3.11.43.
[46] Livy 34.4.3.
[47] Hor. *Epist.* 2.1.156–57. Cf. also *Ars P.* 268–69, 323–26.

including epic poetry) had to be conceded to the Greeks.⁴⁸ Every Augustan Latin poet sought to define himself by transforming what he had learned from some Greek model and filling out the lacunas in the system of genres of a distinctively Roman literature. In the same decades, Greek writers were busy canonizing the lessons that, according not only to them, Romans needed to learn from the Greeks in oratory, geography, and other technical fields.⁴⁹ Under the Roman Empire, then, Greek authors could continue to turn to the ancient glories of Athens as proof of a cultural vitality that, once at least, they had possessed; by now military and political issues had of course become entirely irrelevant, and the lessons that were to be learned from Athens had long since turned into lessons in the most literal sense, purely literary and rhetorical exercises for schoolboys throughout the classrooms of the Greek-speaking *oikoumene*.⁵⁰

Throughout history, other peoples, among them the ancient Hebrews,⁵¹ have claimed for themselves the privilege of instructing the rest of the world. But the fixation of both Roman and later Greek literature upon the classic Athenian authors of the fifth and fourth centuries B.C.E. and the canonization of these latter in remarkably long-lived school systems ensured that it was above all Athens that continued to provide lessons in humanity for most of the Western cultural tradition. In the second half of the eighteenth century, German humanists reactivated the potential of Greek literature, liberating it from the layer of Latinity that had encrusted it and seeking in Athens a school that could make Germans less German (and also less French) and more humane. For Winckelmann, the Greeks alone were the teachers of true beauty, and it was only by imitating them that moderns could learn to create an art worthy of being imitated in its own right; for Herder, *auch die Griechische Kunst ist eine Schule der Humanität; unglücklich ist, wer sie anders betrachtet* ("Greek art too is a school of humanity; unhappy he who looks at it differently").⁵² The passionate commitment to the educational value of the Greek model bequeathed at the turn of the nineteenth century by such very different humanistic scholars as Schlegel, Humboldt, and Creuzer⁵³ to their successors helped found an educational system, the German *Gymnasium*, and a field of scholarship, *Altertumswissenschaft*, in which that fundamental belief in timeless paradigmatic values was inextricably compounded with a deep vein of historicism, which began by enriching the paradigmatic quality of the ancient Greeks but ended

⁴⁸ Verg. *Aen.* 6.847–54.

⁴⁹ E.g., Dion. Hal. *Orat. Vett.*; Strabo (9.1.16 on Athens).

⁵⁰ E.g., Plut. *De glor. Ath.*; Ael. Arist. *Panathenaic Discourse*; Russell and Wilson, 1981, 2.392.16–17, 394.9–10, 396.26–31, 426.4–5, and especially 426.27–32.

⁵¹ St. Paul *Epist. Rom.* 2.17–21.

⁵² Herder 1795, Br. 63 (Suphan 1877–1913, 17:343).

⁵³ See, for example, Schlegel 1972; Humboldt, "Über das Studium des Altertums" and "Latium und Hellas," in Humboldt 1960–81, 2:1–64; Creuzer 1826.

up by undermining it.⁵⁴ Hence it was that, in the 1920s, a new, "third" humanism, that of Werner Jaeger, programmatically set out for one last time to rediscover the pedagogical core of the Greek image by projecting onto the Greeks themselves the didactic intention, the *Paideia*, which a later tradition had attributed to them: *Das Ziel ist, das unvergängliche erzieherische Phänomen der Antike und den für immer richtungsgebenden Anstoß, den die Griechen der geschichtlichen Bewegung gegeben haben, aus ihrem eigenen geistigen Wesen zu verstehen* ("The goal is to understand on the basis of the spiritual essence of the Greeks themselves the imperishable educational phenomenon of antiquity, and the impulse which they gave to historical movement and which indicates forever the path that must be followed").⁵⁵ Perhaps inevitably, Jaeger's general position misled him into misunderstanding both Pericles' phrase about Athens as the school of Greece as though it meant not that Athens was the school that could teach the other Greeks how to live but that Athens was the school that could teach anyone what true Greekness was, and Isocrates' remark about true Greekness as meaning not that only those Greeks were true Greeks who had acquired Athenian culture but that anyone at all could become a true Greek by acquiring Athenian culture.⁵⁶

Today it has become difficult, if not impossible, for us to share a faith like Jaeger's. Yet it seems to be very hard to do without. Isocrates' words—μᾶλλον Ἕλληνας καλεῖσθαι τοὺς τῆς παιδεύσεως τῆς ἡμετέρας ἢ τοὺς τῆς κοινῆς φύσεως μετέχοντας⁵⁷—had in fact been intended to claim that in order to be a true Greek it was not enough to be born Greek and have Greek blood in one's veins, but rather that only those Greeks were true Greeks who shared the Athenian education Isocrates was willing to sell them. But in the very same years as Jaeger was developing his unfortunately named *Dritter Humanismus* ("Third Humanism"), a misinterpretation of those words, just like Jaeger's own, as though they meant something entirely different—namely, that anyone, Greek or barbarian, could become genuinely Hellenic simply by learning a lesson in the schoolroom of Greece—became memorialized not only on paper, but also on stone. On the Gennadeion Library in Athens, across the street from the American School of Classical Studies, Isocrates' phrase, abridged, humanized, and universalized, was inscribed in 1926 in the following form: Ἕλληνες καλοῦνται οἱ τῆς παιδεύσεως τῆς ἡμετέρας μετέχοντες (fig. 11.2). What Isocrates had meant was, "[It is not enough to be born Greek if one wishes to be really Greek:] it is [only] those who share in our education who are called Greeks [in the truest sense]"; what the Gennadeion

⁵⁴ See Most 1996b, id. 2002.
⁵⁵ Jaeger 1934, 20.
⁵⁶ Ibid., 1:513; 3:139ff.
⁵⁷ Isoc. *Paneg.* 50.

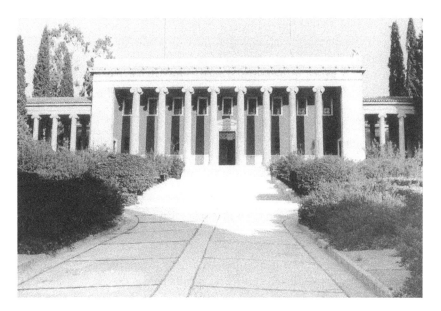

Figure 11.2. Gennadeion, The American School of Classical Studies, Athens.
Reprinted with the permission of the American School of Classical Studies at Athens.

now proclaims is, "[It is not necessary to be born Greek if one wishes to be really Greek:] it is [also] those who share in our education who are called Greeks [in the truest sense]." The shift in meaning is slight but epoch-making. Isocrates certainly did not intend to include us in his didactic program: but his formulation of that program failed to exclude us so completely as to prevent us from imposing upon him a love he may have inspired but could scarcely have imagined. The whole paradox of Athens as the school of Greece is encapsulated in that pious deformation.

BIBLIOGRAPHY

Abbenes, J.G.J., S. R. Slings, and I. Sluiter, eds. 1995. *Greek Literary Theory after Aristotle: A Collection of Papers in Honour of D.M. Schenkeveld*. Amsterdam: VU University Press.

Adams, J. N. 2003. *Bilingualism and the Latin Language*. New York: Cambridge University Press.

Albertson, F. 1993. "Pliny and the Vatican Laokoon." *RM* 100: 133–40.

Alcock, Susan E. 1991. "Tomb Cult and the Post-Classical Polis." *AJA* 95: 447–67.

———. 1993. *Graecia Capta: The Landscapes of Roman Greece*. Cambridge: Cambridge University Press.

———. 1994. "Nero at Play? The Emperor's Grecian Odyssey." In Jaś Elsner and Jamie Masters, eds., *Reflections of Nero: Culture, History, and Representation*. Chapel Hill: University of North Carolina Press. 98–111.

———. 2001. "The Reconfiguration of Memory in the Eastern Roman Empire." In Susan E. Alcock, Terence N. D'Altroy, Kathleen D. Morrison, and Carla M. Sinopoli, eds., *Empires: Perspectives from Archaeology and History*. Cambridge: Cambridge University Press. 323–50.

———. 2002. *Archaeologies of the Greek Past: Landscape, Monuments, and Memories*. Cambridge: Cambridge University Press.

Alcock, Susan E., John F. Cherry, and Jaś Elsner, eds. 2001. *Pausanias: Travel and Memory in Roman Greece*. New York: Oxford University Press.

Allan, D. J. 1980. "ΑΝΑΓΙΓΝΩΣΚΩ and Some Cognate Words." *CQ* 30: 244–51.

Althusser, Louis. 1971. *Lenin and Philosophy, and Other Essays*. Translated by Ben Brewster. London: NLB.

Amandry, Pierre, and Theodoros Spyropoulos. 1974. "Monuments chorégiques d'Orchomène de Béotie." *BCH*: 171–244.

Anderson, Benedict. 1991. *Imagined Communities*. 2nd, revised ed. London and New York: Verso.

Anderson, Graham. 1989. "Sophists and Their Outlook in the Early Empire." *ANRW* 2.33.1: 79–208.

André, Jean-Marie. 1977. *La Philosophie à Rome*. Paris: Presses Universitaires de France.

Andreae, Bernard. 1988. *Laokoon und die Gründung Roms*. Mainz am Rhein: Philipp von Zabern.

———. 1994a. "Die griechische Klassik als Durchgangsphase." In Egert Pöhlmann and Werner Gauer, eds., *Griechische Klassik: Vorträge bei der interdisziplinären Tagung des Deutschen Archäologenverbandes und der Mommsengesellschaft vom 24.–27.10.1991 in Blaubeuren*. Nürnberg: H. Carl. 295–309.

———. 1994b. "Hellenistisch-Römische Skulpturengruppen und tragische Katharsis." In A. Bierl and P. von Mollendorf, eds., *Orchestra Drama Mythos Bühne. Festschrift*

für Hellmut Flashar anlässlich seines 65. Geburtstages. Stuttgart and Leipzig: B.G. Teubner. 177–81.

———. 2001a. *Skulptur des Hellenismus.* Munich: Hirmer.

———. 2001b. "Erden, Erze, Steine im Vergleich bei Plinius, *Naturalis Historia* 36.37." In C. Evers and A. Tsingarida, eds., *Rome et ses provinces. Hommages à Jean-Charles Balty.* Brussels: Timperman. 29–48.

Annas, J., ed. 2001. *Cicero: On Moral Ends.* Cambridge: Cambridge University Press.

[Anon.], ed. 2002. *Die griechische Klassik: Idee oder Wirklichkeit.* [Gesamtorganisation: M. Maischberger. Konzeption und Leitung: W.-D. Heilmeyer.] Mainz am Rhein and Berlin: Zabern and Antikensammlung Berlin.

Antonaccio, Carla Maria. 1995. *An Archaeology of Ancestors: Tomb Cult and Hero Cult in Early Greece.* London: Rowman and Littlefield.

———. 1998. "The Archaeology of Ancestors." In Carol Dougherty and Leslie Kurke, eds., *Cultural Poetics in Archaic Greece: Cult, Performance, Politics.* Cambridge: Cambridge University Press. 46–70.

Arnold, Matthew. 1960. *Complete Prose Works.* Edited by R. H. Super. 6 vols. Ann Arbor: University of Michigan Press.

Arrowsmith, William. 1963. "A Greek Theater of Ideas." *Arion* 2, no. 3: 32–56.

Asper, Markus. 1997. *Onomata Allotria: Zur Genese, Struktur und Funktion poetologischer Metaphern bei Kallimachos.* Stuttgart: F. Steiner.

Assmann, Jan. 1992. *Das kulturelle Gedächtnis: Schrift, Erinnerung und politische Identität in frühen Hochkulturen.* Munich: C. H. Beck.

———. 1997. *Das kulturelle Gedächtnis: Schrift, Erinnerung und politische Identität in frühen Hochkulturen.* 2nd ed. Munich: C. H. Beck.

Atherton, Catherine. 1996. "What Every Grammarian Knows?" *CQ* 46: 239–60.

Auerbach, Erich. 1965. *Literary Language and Its Public in Late Latin Antiquity and in the Middle Ages.* Princeton: Princeton University Press.

Bakhtin, M. M. 1981. "Epic and Novel." In Michael Holquist, ed., *The Dialogic Imagination: Four Essays.* Translated by Michael Holquist and Caryl Emerson. Austin: University of Texas Press. 3–40.

Bardon, Henry. 1952. *La littérature latine inconnue.* 2 vols. Paris: C. Klincksieck.

Barkan, Leonard. 1999. *Unearthing the Past: Archaeology and Aesthetics in the Making of Renaissance Culture.* New Haven: Yale University Press.

Barker, Andrew. 1984. *Greek Musical Writings. Volume 1: The Musician and His Art.* Cambridge: Cambridge University Press.

Barnes, Jonathan. 1989. "Antiochus of Askalon." In Griffin and Barnes, eds. 51–96.

Barthes, Roland. 1974. *S/Z.* Translated by Richard Miller. New York: Hill and Wang.

———. 1975. *The Pleasure of the Text.* Translated by Richard Miller. New York: Hill and Wang.

Barton, Carlin A. 2001. *Roman Honor: The Fire in the Bones.* Berkeley and Los Angeles: University of California Press.

Barton, Tamsyn. 1994. *Power and Knowledge: Astrology, Physiognomics, and Medicine under the Roman Empire.* Ann Arbor: University of Michigan Press.

Baslez, Marie-Françoise, Philippe Hoffmann, and Laurent Pernot. 1993. "La Grèce antique a-t-elle connu l'autobiographie?" In *L'Invention de l'autobiographie*

d'Hésiode à Saint Augustin: Actes du deuxième colloque de l'Equipe de recherche sur l'Hellénisme post-classique. Paris: Presses de l'Ecole Normale Supérieure.
Baumbach, Manuel. 2002. *Lukian in Deutschland: Eine forschungs- und rezeptionsgeschichtliche Analyse vom Humanismus bis zur Gegenwart.* Munich: Fink.
Baumstark, Reinhold, and Peter Volk. 1995. *Apollo schindet Marsyas: Über das Schreckliche in der Kunst.* Munich: Bayerisches National Museum.
Beacham, R. C. 1991. *The Roman Theater and Its Audience.* London and New York: Routledge.
Beard, Mary. 2002. *The Parthenon.* London: Profile.
Beard, Mary, and John Henderson. 1995. *Classics: A Very Short Introduction.* Oxford: Oxford University Press.
———. 2001. *Classical Art: From Greece to Rome.* Oxford: Oxford University Press.
Beard, Mary, John North, and Simon Price. 1998. *Religions of Rome.* Cambridge: Cambridge University Press.
Beaujeu, Jean. 1955. *La religion romaine à l'apogée de l'empire.* Paris: Société d'Edition Les Belles Lettres.
Beazley, J. D. 1956. *Attic Black-Figure Vase-Painters.* Oxford: Clarendon Press.
———. 1989. *Greek Vases: Lectures.* Edited by Donna C. Kurtz. Oxford: Clarendon Press.
Becatti, G. 1969. "Edificio con *opus sectile* fuori Porta Marina." In *Scavi di Ostia VI: La basilica di Giunio Basso sull'Esquilino.* Rome: La Libreria dello Stato. 181–215.
Becker, Heinrich Theodor. 1915. *Aischylos in der greichischen Komödie.* Darmstadt: Bender.
Belger, Christian. 1899. "Schliemann als Interpret des Pausanias." *Berliner philologische Wochenschrift* 19: 1180–1215.
Bell, Malcolm, III. 1998. "Le stele greche dell'Esquilino e il cimitero di Mecenate." In Maddalena Cima and Eugenio La Rocca, eds., *Horti romani: Atti del convegno internazionale: Roma, 4–6 maggio 1995.* Rome: L'Erma di Bretschneider. 295–314.
Bender, Barbara. 1998. *Stonehenge: Making Space.* Oxford: Berg.
Bendlin, Andreas. 2000. "Looking Beyond the Civic Compromise: Religious Pluralism in Late Republican Rome." In Bispham and Smith, 115–35.
Bergmann, Bettina. 1994. "The Roman House, a Memory Theater: The House of the Tragic Poet at Pompeii." *ArtB* 76: 225–56.
Bernal, Martin. 2001. *Black Athena Writes Back: Martin Bernal Responds to His Critics.* Edited by David Chioni Moore. Durham: Duke University Press.
Bers, Victor. 1984. *Greek Poetic Syntax in the Classical Age.* New Haven: Yale University Press.
Bettini, Maurizio. 1984. "Arcaismi." In *Enciclopedia Virgiliana.* Rome: Istituto della Enciclopedia Italiana. 287–91.
Bianchi Bandinelli, Ranuccio. 1970. *Rome, the Centre of Power: Roman Art to A.D. 200.* London: Thames & Hudson.
Bianchi Bandinelli, Ranuccio, and Luisa Franchi Dell'Orto. 1978. *Dall'ellenismo al medioevo.* 1st ed. Rome: Riuniti.
Bieber, Margarete. 1960. *The Sculpture of the Hellenistic Age.* New York: Columbia University Press.
———. 1961. *The History of the Greek and Roman Theater.* 2nd ed. Princeton: Princeton University Press.

Biffino, Giovanna Galimberti. Ms. "Lineamenti dell'arcaismo nel II secolo d.c.: Aulo Gellio."
Bing, Peter. 1988. *The Well-Read Muse: Present and Past in Callimachus and the Hellenistic Poets.* Hypomnemata, vol. 90. Göttingen: Vandenhoeck & Ruprecht.
Bispham, Edward. 2000. "Introduction." In Bispham and Smith, 1–18.
Bispham, Edward, and Christopher John Smith, eds. 2000. *Religion in Archaic and Republican Rome and Italy: Evidence and Experience.* Edinburgh: Edinburgh University Press.
Blanckenhagen, Peter von. 1942. "Elemente der römischen Kunst am Beispiel des flavischen Stils." In Helmut Berve, ed., *Das neue Bild der Antike.* Leipzig: Koehler & Amelang. 310–41.
———. 1975. "Der ergänzende Betrachter. Bemerkungen zu einem Aspekt hellenistischer Kunst." In *Wandlungen. Studien zur antiken und neueren Kunst. Ernst Homann-Wedeking gewidmet.* Waldsassen-Bayern: Stiftland-Verlag. 193–201.
Bloom, Harold. 1975. *A Map of Misreading.* New York: Oxford University Press.
———. 1997. *The Anxiety of Influence: A Theory of Poetry.* 2nd ed. Oxford: Oxford University Press.
Blum, Rudolf. 1991. *Kallimachos: The Alexandrian Library and the Origins of Bibliography.* Translated by H. Wellisch. Madison: University of Wisconsin Press.
Blunt, A. 1971. "Baroque Architecture and Classical Antiquity." In R. R. Bolgar, ed., *Classical Influences on European Culture A.D. 500–1500: Proceedings of an International Conference Held at King's College, Cambridge, April 1969.* Cambridge: Cambridge University Press. 349–54.
Boardman, John. 2000. *Persia and the West: An Archaeological Investigation of the Genesis of Achaemenid Persian Art.* London: Thames & Hudson.
———. 2002. *The Archaeology of Nostalgia: How the Greeks Re-created Their Mythical Past.* London: Thames & Hudson.
Boatwright, Mary T. 1987. *Hadrian and the City of Rome.* Princeton: Princeton University Press.
———. 2000. *Hadrian and the Cities of the Roman Empire.* Princeton: Princeton University Press.
Bol, Peter C. 1990. *Polyklet. Der Bildhauer der griechischen Klassik.* Mainz: Philipp von Zabern.
———. ed. 1999. *Hellenistische Gruppen: Gedenkschrift für Andreas Linfert.* Mainz am Rhein: Philipp von Zabern.
Bompaire, Jacques. 1958. *Lucien écrivain, imitation et création.* Paris: E. de Boccard.
Borbein, Adolf Heinrich. 1975. "Die Ara Pacis Augustae. Geschichtliche Wirklichkeit und Programm." *JdI* 90: 242–266.
———. 2002. "Klassische Kunst." In [Anon.], 9–25.
Boschung, Dietrich. 1993. *Die Bildnisse des Augustus. Das römische Herrscherbild I*, vol. 2. Berlin: Gebr. Mann.
Bourdieu, Pierre. 1977. *Outline of a Theory of Practice.* Translated by Richard Nice. Cambridge: Cambridge University Press.
———. 1984. *Distinction: A Social Critique of the Judgement of Taste.* Translated by Richard Nice. Cambridge, Mass.: Harvard University Press.
———. 1990. *The Logic of Practice.* Translated by Richard Nice. Stanford: Stanford University Press.

Bowersock, G. W. 1979. "Historical Problems in Late Republican and Augustan Classicism." In Flashar, 57–78.
———. 1989. "Poetry." In *CHCL* 1.4: 89–94.
———. 1990. *Hellenism in Late Antiquity*. Cambridge: Cambridge University Press.
———. 1995. "The Barbarism of the Greeks." *HSCP* 97: 3–14.
Bowie, E. L. 1974. "Greeks and Their Past in the Second Sophistic." In M. I. Finley, ed., *Studies in Ancient Society*. London: 166–209. (= *P&P* 46 [1970] 3–41.)
———. 1989. "Greek Sophists and Greek Poetry." *ANRW* 2, no. 33.1: 208–58.
———. 1990. "Greek Poetry in the Antonine Age." In D. A. Russell, ed., *Antonine Literature*. Oxford: Clarendon Press. 53–90.
———. 1996. "Past and Present in Pausanias." In Musti and Bingen, 207–39.
———. 2002. "Hadrian and Greek Poetry." In Erik Nis Ostenfeld, Karin Blomqvist, and Lisa C. Nevett, eds., *Greek Romans and Roman Greeks: Studies in Cultural Interaction*. Åarhus: Åarhus University Press. 172–97.
Bradley, Richard. 1993. *Altering the Earth: The Origins of Monuments in Britain and Continental Europe*. Edinburgh: Society of Antiquaries of Scotland.
———. 1998. *The Significance of Monuments: On the Shaping of Human Experience in Neolithic and Bronze Age Europe*. London: Routledge.
———. 2002. *The Past in Prehistoric Societies*. London: Routledge.
Bradley, Richard, and Howard Williams, eds. 1998. *The Past in the Past: The Reuse of Ancient Monuments*. World Archaeology 30.1. London: Routledge.
Bragantini, Irene, and Mariette de Vos. 1982. *Museo Nazionale Romano: Le pitture II.1: Le decorazioni della Villa Romana della Farnesina*. Rome: De Luca Editore.
Braund, David, and Christopher Gill. 2003. *Myth, History and Culture in Republican Rome: Studies in Honour of T.P. Wiseman*. Exeter: University of Exeter Press.
Bravi, A. 1998. "Tiberio e la collezione di opere d'arte dell'Aedes Concordiae Augustae." *Xenia Antiqua* 7: 41–82.
Brendel, Otto. 1953. "Prolegomena to a Book on Roman Art." *MAAR* 21: 7–73.
———. 1979. *Prolegomena to the Study of Roman Art*. New Haven: Yale University Press.
Brendel, Otto, and Francesca R. Serra Ridgway. 1995. *Etruscan Art*. 2nd ed. New Haven: Yale University Press.
Brilliant, Richard. 1982. "I piedestalli del Giardino di Boboli: spolia in se, spolia in re." *Prospettiva* 31: 2–17.
———. 1986. "Marmi classici, storie tragiche." *Prospettiva* 46: 2–12.
———. 1994. *Commentaries on Roman Art: Selected Studies*. London: Pindar Press.
———. 2000. *My Laocoön: Alternative Claims in the Interpretation of Artworks*. Berkeley and Los Angeles: University of California Press.
Brink, Charles Oscar. 1963–82. *Horace on Poetry*. 3 vols. Cambridge: Cambridge University Press.
———. 1972. "Ennius and the Hellenistic Worship of Homer." *AJP* 93: 547–67.
Brittain, Charles. 2001. *Philo of Larissa: The Last of the Academic Sceptics*. Oxford: Oxford University Press.
Broggiato, Maria, ed. 2001. *Cratete di Mallo: I frammenti. Edizione, introduzione e note*. La Spezia: Agorà.
Brooks, Peter. 1984. *Reading for the Plot: Design and Intention in Narrative*. New York: Knopf.

Brown, Blanche R. 1973. *Anticlassicism in Greek Sculpture of the Fourth Century B.C.* New York: Published by New York University Press for the Archaeological Institute of America and the College Art Association of America.
Brunschwig, J. 1986. "The Cradle Argument in Epicureanism and Stoicism." In Malcolm Schofield and Gisela Striker, eds., *The Norms of Nature: Studies in Hellenistic Ethics*. Cambridge: Cambridge University Press. 113–44.
Brunt, P. A. 1994. "The Bubble of the Second Sophistic." *BICS* 39: 25–52.
Bryson, Norman. 1990. *Looking at the Overlooked: Four Essays on Still Life Painting*. Cambridge, Mass.: Harvard University Press.
Buchholz, Hans Günter, and Vassos Karageorghis. 1973. *Prehistoric Greece and Cyprus: An Archaeological Handbook*. London: Phaidon.
Buchner, Edmund. 1958. *Der Panegyrikos des Isokrates. Eine historischphilologische Untersuchung*. Historia Einzelschriften 2.
Bulle, Heinrich. 1907. *Orchomenos I: Die älteren Ansiedlungsschichten*. Munich: Verlag der K. B. Akademie der Wissenschaften.
Bulloch, A. W., Erich S. Gruen, A. A. Long, and Andrew Steward, eds. 1993. *Images and Ideologies: Self-Definition in the Hellenistic World*. Berkeley: University of California Press.
Burkert, Walter. 1979. "Kynaithos, Polycrates, and the Homeric Hymn to Apollo." In Glenn W. Bowersock, Walter Burkert, and Michael C. J. Putnam, eds., *Arktouros: Hellenic Studies Presented to Bernard M. W. Knox on the Occasion of His 65th Birthday*. Berlin and New York: Walter de Gruyter. 53–62.
———. 1985. *Greek Religion*. Translated by John Raffan. Cambridge, Mass.: Harvard University Press.
———. 1987. "The Making of Homer in the Sixth Century B.C.: Rhapsodes Versus Stesichorus." In *Papers on the Amasis Painter and His World*. Malibu, Calif.: J. Paul Getty Museum. 43–62.
Burnyeat, M. F. 1997. "Antipater and Self-Refutation: Elusive Arguments in Cicero's *Academica*." In Inwood and Mansfeld, 277–310.
Burzachechi, Mario. 1962. "Oggetti parlanti nelle epigrafi greche." *Epigraphica* 24: 3–54.
Cain, Hans-Ulrich. 1985. *Römische Marmorkandelaber*. Mainz am Rhein: Philipp von Zabern.
Cain, Hans-Ulrich, and O. Dräger. 1994. "Die sogenannten neuattischen Werkstätten." In Hellenkemper Salies et al., eds. 809–29.
Cajani, Guglielmino, and Diego Lanza, eds. 2001. *L'Antico degli antichi*. Rome: Palumbo.
Calboli, Gualtiero. 1986. "Nota di aggiornamento." In Eduard Norden, *La prosa d'arte antica dal VI secolo a.C. all'età della Rinascenza*. Translated by Benedetta Heinemann Campana. Rome: Salerno. 969–1185.
Calder, William M., III. 1975. "Ulrich von Wilamowitz-Moellendorff to Wolfgang Schadewaldt on the Classic." *GRBS* 16, no. 4: 451–57.
Calvino, Italo. 1999. "Why Read the Classics?" In Italo Calvino, *Why Read the Classics?* Translated by Martin McLaughlin. New York: Vintage Books. 3–9.
Cameron, Alan. 1984. "The Latin Revival of the Fourth Century." In Warren Treadgold, ed., *Renaissances Before the Renaissance: Cultural Revivals of Late Antiquity and the Middle Ages*. Stanford: Stanford University Press. 42–58.
———. 1995. *Callimachus and His Critics*. Princeton: Princeton University Press.

———. 2004. *Greek Mythography in the Roman World*. New York: Oxford University Press.
Camerotto, Alberto. 1998. *Le metamorfosi della parola: Studi sulla parodia in Luciano di Samosata*. Pisa: Istituti Editoriali e Poligrafici Internazionali.
Campbell, David A. 1989. "Monody." In *CHCL* 1.1: 162–80.
Carruthers, Mary. 1990. *The Book of Memory: A Study of Memory in Medieval Culture*. Cambridge: Cambridge University Press.
Carson, Anne. 1999. *Economy of the Unlost: Reading Simonides of Keos with Paul Celan*. Princeton: Princeton University Press.
Casevitz, M. 1991. "Hellenismos: Formation et fonction des verbes en -ίζω et de leurs dérivés." In Saïd, 10–16.
Cassirer, Ernst. 1932. *Die Philosophie der Aufklärung*. Tübingen: Mohr.
———. 1955. *The Philosophy of the Enlightenment*. Boston: Beacon Press.
Catling, H., J. F. Cherry, R. E. Jones, and J. T. Killen. 1980. "The Linear B Inscribed Stirrup Jars and West Crete." *BSA* 75: 49–113.
Cavanagh, William G., and C. Mee. 1998. *A Private Place: Death in Prehistoric Greece*. Jonsered: Paul Åströms Förlag.
Cecamore, Claudia. 2002. *Palatium. Tipologia e storia del Palatino tra III sec. a.C. e I sec. d.C.* Rome: L'Erma di Bretschneider.
Celani, Alessandro. 1998. *Opere d'arte greche nella Roma di Augusto*. Napoli: Edizioni Scientifiche Italiane.
Chantraine, Pierre. 1950. "Les verbes grecs signifiant 'lire' (ἀναγιγνώσκω ἐπιλέγομαι, ἐντυγχάνω, ἀναλέγομαι)." *Annuaire de l'Institut de philologie et d'histoire orientales et slaves* 10: 115–26.
Chaplin, J. D. 2000. *Livy's Exemplary History*. Oxford: Oxford University Press.
Charles-Gaffiot, Jacques, and Henri Lavagne. 1999. *Hadrien: Trésors d'une villa impériale*. Milan: Electa.
Chartier, Roger, and Alain Paire, eds. 1985. *Pratiques de la lecture*. Marseille: Rivages.
Cherry, John F. 2001. "Travel, Nostalgia, and Pausanias's Giant." In Susan E. Alcock et al., eds. 247–55.
Chiron, Pierre, ed. 1993. *Démétrios, Du style*. Paris: Belles Lettres.
Cicero, Marcus Tullius. 1896a. *Cicero: Pro Cluentio*. Translated by Jones Daniel Maillard. London: W. B. Clive.
———. 1896b. *De Finibus II*. Translated by Jones Daniel Maillard. London: W. B. Clive.
———. 1985. *Tusculan Disputations I*. Translated by A. E. Douglas. Chicago and Warminster: Wiltshire Aris & Phillips.
———. 1990. *Tusculan Disputations II and V*. Translated by A. E. Douglas. Warminster: Aris & Phillips.
———. 2001. *On Moral Ends*. Edited by Julia Annas. Translated by Raphael Woolf. Cambridge: Cambridge University Press.
———. 2002. *Cicero on the Emotions: Tusculan Disputations 3 and 4*. Translated by Margaret Graver. Chicago: University of Chicago Press.
Citroni, Mario. 1992. "Produzione letteraria e forme del potere. Gli scrittori latini nel I secolo dell'impero." In Momigliano and Schiavone, Vol. 2.3 (Emilio Gabba and Aldo Schiavone, eds., *La cultura e l'impero*). Turin: Giulio Einaudi. 383–490.
———. 1995. *Poesia e lettori in Roma antica. Forme della comunicazione letteraria*. Rome and Bari: Laterza.

———. 1998. "Percezioni di classicità nella letteratura latina." In Roberto Cardini and Mariangela Regoliosi, eds., *Che cos' è il classicismo?* Rome: Bulzoni. 1–34.

———. 2001. "Affermazioni di priorità e coscienza di progresso artistico nei poeti latini." In Ernst A. Schmidt, ed., *L'histoire littéraire immanente dans la poésie latine: Huit exposés suivis de discussions.* Vol. 47. Geneva: Fondation Hardt. 267–314.

———. 2003a. "I proemi delle Tusculanae e la costruzione di un'immagine della tradizione letteraria romana." In Mario Citroni, ed., *Memoria e identità: La cultura romana costruisce la sua immagine.* Firenze: Università degli Studi di Firenze Dipartimento di Scienze dell'Antichità Giorgio Pasquali. 149–84.

———. 2003b. "Politica culturale augustea e nuovo assetto dei generi poetici latini." In Renato Uglione, ed., *Associazione di Cultura Classica, Delegazione di Torino, Atti del Convegno Nazionale di Studi Intellettuali e Potere nel Mondo Antico (Torino, aprile 2002).* Alessandria: Edizioni dell'Orso. 101–22.

———. 2003c. "I canoni di autori antichi: Alle origini del concetto di classico." In Laura Casarsa, Lucio Cristante, and Marco Fernandelli, eds., *Culture europee e tradizione latina, atti del Convegno internazionale di studi, Cividale del Friuli, 16–17 novembre 2001.* Trieste: Edizioni Università di Trieste. 1–22.

———. 2004. "Martial, Pline le Jeune et l'identité de genre de l'épigramme latine." *Dictynna. Revue de poétique latine* 1: 125–53.

———, ed. 1975. *M. Valerii Martialis Epigrammaton liber primus.* Florence: La Nuova Italia.

Clairmont, Christoph W. 1966. *Die Bildnisse des Antinous.* Rom: Schweizerisches Institut.

Clarke, John R. 1991. *The Houses of Roman Italy, 100 B.C.–A.D. 250: Ritual, Space, and Decoration.* Berkeley and Los Angeles: University of California Press.

Clarke, Katherine. 1999. *Between Geography and History: Hellenistic Constructions of the Roman World.* Oxford: Clarendon Press.

Clarke, Michael. 1999. *Flesh and Spirit in the Songs of Homer: A Study of Words and Myths.* Oxford: Clarendon Press.

Classen, C. J. 1989. "Die Peripatetiker in Ciceros *Tusculanen*." In William W. Fortenbaugh and Peter Steinmetz, eds., *Cicero's Knowledge of the Peripatos.* New Brunswick, N.J.: Transaction Publishers. 186–200.

Coarelli, F. 1970–71. "Classe dirigente romana e arti figurative." *Dialoghi d'Archeologia* 4–5: 241–79.

———. 1990. "La cultura figurativa." In Momigliano and Schiavone, Vol. 2.1 (Guido Clemente, Filippo Coarelli, and Emilio Gabba, eds., *La repubblica imperiale*). Turin: Giulio Einaudi. 631–70. (= F. Coarelli. 1996. *Revixit ars. Arte e ideologia a Roma, dai modelli ellenistici alla tradizione repubblicana.* Rome: Quasar. 41–84.)

Coetzee, J. M. 2001. "What Is a Classic?" In *Stranger Shores: Literary Essays, 1986–1999.* New York: Viking. 1–16.

Cohen, Beth, ed. 2000. *Not the Classical Ideal: Athens and the Construction of the Other in Greek Art.* Leiden and Boston: Brill.

Cohen, David. 1991. *Law, Sexuality, and Society: The Enforcement of Morals in Classical Athens.* Cambridge: Cambridge University Press.

———. 1995. *Law, Violence, and Community in Classical Athens.* Cambridge: Cambridge University Press.

Cohen, Edward E. 2000. *The Athenian Nation.* Princeton: Princeton University Press.

Coldstream, J. N. 1976. "Hero Cults in the Age of Homer." *JHS* 96: 8–17.
Connolly, Joy. 2001. "Problems of the Past in Imperial Greek Education." In Too, 339–72.
Cook, R. M. 1997. *Greek Painted Pottery*. 3rd ed. London and New York: Routledge.
Courtney, Edward. 1993. *The Fragmentary Latin Poets*. Oxford: Clarendon Press.
Creuzer, Georg Friedrich. 1826. *Oratio de civitate Athenarum omnis humanitatis parente*. [N.p.]
Crielaard, Jan Paul. 1995. "Homer, History and Archaeology: Some Remarks on the Date of the Homeric World." In Jan Paul Crielaard, ed. *Homeric Questions: Essays in Philology, Ancient History and Archaeology, Including the Papers of a Conference Organized by the Netherlands Institute at Athens, 15 May 1993*. Amsterdam: J. C. Gieben. 201–88.
Crusius, O. 1902. "Die *anagnostikoi* (Exkurs zu Aristot. *Rhet*. III 12)." In Moritz von Schwind, ed., *Festschrift Theodor Gomperz: Dargebracht zum siebzigsten Geburtstage am 29. März 1902*. Vienna: A. Hölder. 381–87.
Csapo, E. 2004. "The Politics of the New Music." In Penelope Murray and Peter Wilson, eds., *Music and the Muses: The Culture of "Mousike" in the Classical Athenian City*. Oxford: Oxford University Press 207–48.
Csapo, Eric, and William J. Slater. 1994. *The Context of Ancient Drama*. Ann Arbor: University of Michigan Press.
Curtius, Ernst Robert. 1948. *Europäische Literatur und lateinisches Mittelalter*. Bern: A. Francke.
———. 1953. *European Literature and the Latin Middle Ages*. Translated by Willard R. Trask. New York: Pantheon Books.
Cutler, A. 1999. "Reuse or Use? Theoretical and Practical Attitudes towards Objects in the Early Middle Ages." *Settimane* 46: 1055–79.
D'Angour, Armand. 1997. "How the Dithyramb Got Its Shape." *CQ* 47: 331–51.
D'Onofrio, C. 1967. *Gli obelischi di Roma*. Rome: Bulzoni.
Dahlmann, Hellfried. 1953. "Varros Schrift 'de poematis' und die hellenistisch-römische Poetik." *Mainz, Akademie der Wissenschaften und der Literatur. Abhandl. der Geistes- u. sozialwiss. Kl.* no. 3. Wiesbaden: Franz Steiner.
———. 1962. "Studien zu Varro 'de poetis'." *Mainz, Akademie der Wissenschaften und der Literatur. Abhandl. der Geistes- u. sozialwiss. Kl.* no. 10. Wiesbaden: Franz Steiner.
Damon, Cynthia. 1991. "Aesthetic Response and Technical Analysis in the Rhetorical Writings of Dionysius of Halicarnassus." *MH* 48: 33–58.
Davis, Lennard J. 1997. "Nude Venuses, Medusa's Body, and Phantom Limbs: Disability and Visuality." In David T. Mitchell and Sharon L. Snyder, eds., *The Body and Physical Difference: Discourses of Disability*. Ann Arbor: University of Michigan Press. 51–70.
De Angelis, Francesco, and Susanne Muth. 1999. *Im Spiegel des Mythos: Bilderwelt und Lebenswelt: Symposium, Rom 19.–20. Februar 1998 = Lo specchio del mito: Immaginario e realtà*. Wiesbaden: Dr. Ludwig Reichert Verlag.
de Grummond, Nancy, and Brunilde Sismondo Ridgway, eds., *From Pergamum to Sperlonga: Sculpture and Context*. Berkeley and Los Angeles: University of California Press.
de la Barrera Antón, José, and W. Trillmich. 1996. "Eine Wiederholung der Aeneas-Gruppe vom Forum Augustum samt ihrer Inschrift in Mérida (Spanien)." *Rassegna Monetaria* 103: 119–38.
De Ridder, André. 1895. "Fouilles d'Orchomène. *BCH* 19: 137–224.

De Ste. Croix, G.E.M. 1981. *The Class Struggle in the Ancient Greek World from the Archaic Age to the Arab Conquests.* London: Duckworth.

de Vos, Mariette. 1990. "Casa dei Cubicoli Floreali o del Frutteto." In Giovanni Pugliese Carratelli, ed., *Pompei: Pitture e Mosaici.* Vol. 2. Rome: Istituto della Enciclopedia Italiana. 1–137.

de Vos, Mariette, and Arnold de Vos. 1980. *L'Egittomania in pitture e mosaici romano-campani della prima età imperiale.* Leiden: E. J. Brill.

Deichmann, Friedrich Wilhelm. 1975. *Die Spolien in der spätantiken Architektur.* Munich: Verlag der Bayerischen Akademie der Wissenschaften.

Denniston, J. D. 1996. *The Greek Particles.* 2nd ed. London: Gerald Duckworth.

Derchain, Philippe. 1975. "À propos de l'obélisque d'Antinoüs." In Jean Bingen, ed., *Le Monde grec (Hommages à Claire Preaux).* Brussells: 808–13.

———. 1991. "Un projet d'empereur." In Peter Behrens, Daniela Mendel, and Ulrike Claudi, eds., *Ägypten im afro-orientalischen Kontext: Gedenkschrift Peter Behrens.* Cologne: Institut für Afrikanistik Universität zu Köln. 109–24.

Derrida, Jacques. 1976. *Of Grammatology.* Translated by Gayatri Chakravorty Spivak. Baltimore: Johns Hopkins University Press.

———. 1981. "Plato's Pharmacy." In Jacques Derrida, *Dissemination.* Translated by Barbara Johnson. Chicago: University of Chicago Press. 65–171.

Desrouches-Noblecourt, C. 1999. "Hadrien à Philae." In Jacques Charles-Gaffiot and Lavagne, 63–74.

Dickinson, O.T.P.K. 1994. *The Aegean Bronze Age.* Cambridge: Cambridge University Press.

Dihle, Albrecht. 1977. "Der Beginn des Attizismus." *Antike und Abendlande* 33: 162–77.

———. 1989. *Die griechische und lateinische Literatur der Kaiserzeit: Von Augustus bis Justinian.* Munich: C. H. Beck.

———. 1994. *Greek and Latin Literature of the Roman Empire: From Augustus to Justinian.* Translated by Manfred Malzahn. London and New York: Routledge.

Dindorf, Wilhelm, and Friedrich Blass, eds. 1889. *Demosthenis Orationes.* 4th ed. Leipzig: B. G. Teubner.

Dodds, E. R. 1951. *The Greeks and the Irrational.* Berkeley and Los Angeles: University of California Press.

Dodwell, Edward. 1834. *Views and Descriptions of Cyclopian, or, Pelasgic Remains, in Greece and Italy; With Constructions of a Later Period.* London: Adolphus Richter.

Donohue, Alice A. 1995. "Winckelmann's History of Art and Polyclitus." In Warren G. Moon, ed., *Polykleitos, the Doryphoros, and Tradition.* Madison: University of Wisconsin Press. 327–53.

Dougan, Thomas Wilson ed. 1905. *M. Tulli Ciceronis Tusculanarum disputationum libri quinque.* Vol. 1. Cambridge: Cambridge University Press.

Dougan, Thomas Wilson, and Robert Mitchell Henry, eds. 1934. *M. Tulli Ciceronis Tusculanarum disputationum libri quinque.* Vol. 2. Cambridge: Cambridge University Press.

Dougherty, Carol. 2003. "Towards an Itinerary of Culture in Fifth-Century Athens." *Parallax* 29, no. 4 ("Declassifying Hellenism," Karen Bassi and Peter Euben, eds.): 8–17.

Dougherty, Carol, and Leslie Kurke, eds. 1998. *Cultural Poetics in Archaic Greece: Cult, Performance, Politics*. Cambridge: Cambridge University Press.
Douglas, A. E. 1956. "Cicero, Quintilian, and the Canon of Ten Attic Orators." *Mnemosyne* 4.9, no. 1: 30–40.
———. 1995. "Form and Content in the *Tusculan Disputations*." In Powell, 197–218.
Dover, K. J. 1977. *Greek Homosexuality*. Cambridge, Mass.: Harvard University Press.
———. 1997. *The Evolution of Greek Prose Style*. Oxford: Oxford University Press.
———, ed. 1993. *Aristophanes: Frogs*. Oxford: Clarendon Press.
Dupont, Florence. 1999. *The Invention of Literature: From Greek Intoxication to the Latin Book*. Translated by Janet Lloyd. Baltimore: Johns Hopkins University Press.
Eagleton, Terry. 1976. *Marxism and Literary Criticism*. London: Verso.
———. 1984. *The Function of Criticism: From "The Spectator" to Post-Structuralism*. London: Verso. (Reprint 1996.)
Easterling, P. E. 1996. "Canon." *OCD*. 286.
———. 1997. "From Repertoire to Canon." In Easterling, *The Cambridge Companion to Greek Tragedy*. Cambridge: Cambridge University Press. 211–27.
———, ed. 1997. *The Cambridge Companion to Greek Tragedy*. Cambridge: Cambridge University Press.
Edmonds, M. R. 1999. *Ancestral Geographies of the Neolithic: Landscapes, Monuments, and Memory*. London and New York: Routledge.
Edwards, Catharine. 2003. "The Art of Conquest." In Edwards and Woolf, 44–70.
Edwards, Catharine, and Greg Woolf. eds. 2003. *Rome the Cosmopolis*. Cambridge: Cambridge University Press.
———. 2003b. "Cosmopolis: Rome as World City." In Edwards and Woolf, 1–6.
Egelhaaf-Gaiser, Ulrike. 2000. *Kulträume im römischen Alltag: Das Isisbuch des Apuleius und der Ort von Religion im kaiserzeitlichen Rom*. Stuttgart: Franz Steiner.
Eigler, Ulrich. 2003. *Lectiones Vetustatis: Römische Literatur und Geschichte in der lateinischen Literatur der Spätantike*. Munich: C. H. Beck.
Ek, Sven. 1942. *Herodotismen in der Archäologie des Dionys von Halikarnass: Ein Beitrag zur Beleuchtung des beginnenden Klassizismus*. Diss., Lund.
Elias, Norbert. 1994. *The Civilizing Process*. Oxford and Cambridge, Mass.: Blackwell.
Eliot, T. S. 1975. "What Is a Classic?" In Frank Kermode, ed., *Selected Prose of T. S. Eliot*. San Diego: Harcourt, Brace; Farrar, Straus, Giroux. 115–31.
Else, Gerald F. 1986. *Plato and Aristotle on Poetry*. Chapel Hill: University of North Carolina Press.
Elsner, Jaś. 1994. "From the Pyramids to Pausanias and Piglet: Monuments, Travel and Writing." In Simon Goldhill and Robin Osborne, eds., *Art and Text in Ancient Greek Culture*. Cambridge: Cambridge University Press. 224–54.
———. 1995. *Art and the Roman Viewer: The Transformation of Art from the Pagan World to Christianity*. Cambridge: Cambridge University Press.
———. 1997. "The Origins of the Icon: Pilgrimage, Religion and Visual Culture in the Roman East as 'Resistance' to the Centre." In Susan E. Alcock, ed., *The Early Roman Empire in the East*. Oxford: Oxbow Books. 178–99.
———. 1998. *Imperial Rome and Christian Triumph: The Art of the Roman Empire, AD 100–450*. Oxford: Oxford University Press.

———. 2000. "From the Culture of Spolia to the Cult of Relics: The Arch of Constantine and the Genesis of Late Antique Forms." *PBSR* 68: 149–84.

———. 2001. "Cultural Resistance and the Visual Image: The Case of Dura Europos." *Classical Philology* 96: 271–306.

Empereur, J.-Y. 1995. "Alexandrie (Égypte)." *BCH* 119: 743–60.

———. 1998. *Alexandria Rediscovered*. London: British Museum Press.

Ensoli, S. 1999. "Prêtes d'Isis en marbre rouge antique: Antinoüs dans la 'Palestre' de la Villa Adriana." In Jacques Charles-Gaffiot and Henri Lavagne, 79–83.

Erman, A. 1896. "Der Obelisk des Antinous." *Rassegna Monetaria* 11: 122–30.

Erskine, A. 1997. "Cicero and the Expression of Grief." In Susanna Morton Braund and Christopher Gill, eds., *The Passions in Roman Thought and Literature*. Cambridge: Cambridge University Press. 36–47.

Esch, A. 1969. "Spolien. Zur Wiederverwendung antiker Baustücker und Skulpturen in mitteralterischen Italien." *Archiv für Kulturgeschichte* 51: 1–64.

———. 1999. "Reimpiego dell'antico nel medioevo: La prospettiva dell'archeologo, la prospettiva dello storico." *Ideologie e pratiche del reimpiego dell' alto Medioevo: Settimane di studio del Centro Italiano di Studi sull'alto Medioevo* 46: 73–108.

Ettlinger, L. D. 1961. "*Exemplum Doloris*: Reflections on the Laocoön Group." In Millard Meiss, ed., *De artibus opuscula XL. Essays in Honor of Erwin Panofsky*. New York: New York University Press.

Evans, Jane DeRose. 1992. *The Art of Persuasion: Political Propaganda from Aeneas to Brutus*. Ann Arbor: University of Michigan Press.

Farrell, Joseph. 2001. *Latin Language and Latin Culture: From Ancient to Modern Times*. Cambridge: Cambridge University Press.

Fattah, Ahmed Abdel, and P. Gallo. 1998. "Aegyptica Alexandrina: Monuments pharaoniques découverts récemment à Alexandrie." *Études Alexandrines* 1: 7–19.

Fattori, Marta, and M. Bianchi, eds. 1988. *Phantasia-Imaginatio: V. Colloquio Internazionale, Roma 9–11 gennaio 1986*. Rome: Edizioni dell'Ateneo.

Feeney, D. C. 1998. *Literature and Religion at Rome: Cultures, Contexts, and Beliefs*. Cambridge: Cambridge University Press.

Fehl, Philipp P. 1992. *Decorum and Wit: The Poetry of Venetian Painting*. Vienna: IRSA.

Ferrari, G.R.F. 1987. *Listening to the Cicadas: A Study of Plato's Phaedrus*. Cambridge: Cambridge University Press.

Ferris, I. M. 2000. *Enemies of Rome: Barbarians Through Roman Eyes*. Stroud: Sutton.

Feuerbach, Anselm. 1855. *Der vaticanische Apollo: Eine Reihe archäologisch-ästhetischer Betrachtungen*. 2nd ed. Stuttgart and Augsburg: J. G. Cotta. (1st ed. 1833, Nürnberg: Campe.)

Finley, M. I. 1983. *Politics in the Ancient World*. Cambridge: Cambridge University Press. (Reprint 1991.)

Fischer, Eitel, ed. 1974. *Die Ekloge des Phrynichos*. Berlin and New York: de Gruyter.

Fitton, J. L. 1995. *The Discovery of the Greek Bronze Age*. Cambridge, Mass.: Harvard University Press.

Flashar, Hellmut. 1969. *Der Epitaphios des Perikles: Seine Funktion im Geschichtswerk des Thukydides*. Heidelberg: C. Winter.

———, ed. 1979 *Le classicisme à Rome aux Iers siècles avant et après J.-C.: Neuf exposés suivis de discussions*. Vol. 25. Geneva: Fondation Hardt.

Flashar, Martin. 1992. *Apollon Kitharodos: Statuarische Typen des musischen Apollon.* Cologne: Böhlau.
Ford, Andrew. 2002. *The Origins of Criticism: Literary Culture and Poetic Theory in Classical Greece.* Princeton: Princeton University Press.
———. 2003. "From Letters to Literature: Reading the 'Song Culture' of Classical Greece." In Harvey Yunis, ed., *Written Texts and the Rise of Literate Culture in Ancient Greece.* Cambridge: Cambridge University Press. 15–37.
Forestier, Georges, and Jean-Pierre Néraudau, eds. 1995. *Un classicisme ou des classicismes? Actes du colloque international organisé par le Centre de Recherches sur les Classicismes Antiques et Modernes, Université de Reims 5, 6 et 7 juin 1991.* Pau: Publications de l'Université de Pau.
Forsyth, Ilene H. 1995. "Art with History: The Role of Spolia in the Cumulative Work of Art." In Kurt Weitzmann, Doula Mouriki, Christopher Frederick Moss, and Katherine Kieferet, eds., *Byzantine East, Latin West: Art-Historical Studies in Honor of Kurt Weitzmann.* Princeton: Department of Art and Archaeology Princeton University. 153–62.
Fossey, J. M. 1979. "The Cities of the Kopaïs in the Roman Period." *ANRW* 2, no. 7.1: 549–91.
Foucault, Michel. 1980–86. *The History of Sexuality.* 3 vols. Translated by Robert Hurley. New York: Vintage Books.
———. 1989a. *The Order of Things: An Archaeology of the Human Sciences.* London: Routledge.
———. 1989b. *The Archaeology of Knowledge.* Translated by A. M. Sheridan Smith. London: Routledge.
Fowler, R. L. 1987. *The Nature of the Early Greek Lyric: Three Preliminary Studies.* Phoenix. Supplementary volume: Tome supplémentaire, 21. Toronto and London: University of Toronto Press.
Fraser, P. M. 1972. *Ptolemaic Alexandria.* 2 vols. Oxford: Clarendon Press.
Frazer, James George. 1898. *Pausanias's Description of Greece.* London: Macmillan.
Frede, Michael. 1999. "Epilogue." In Keimpe Algra, ed., *The Cambridge History of Hellenistic Philosophy.* Cambridge: Cambridge University Press. 771–97.
Freudenberg, K. 1993. *The Walking Muse: Horace on the Theory of Satire.* Princeton: Princeton University Press.
Fuchs, Michaela. 1999. *In hoc etiam genere Graeciae nihil cedamus. Studien zur Romanisierung der späthellenistische Kunst im 1. Jh. v. Chr.* Mainz am Rhein: Philipp von Zabern.
Fuchs, Werner. 1959. *Die Vorbilder der neuattischen Reliefs.* Berlin: Walter de Gruyter.
Fuhrmann, Manfred. 1973. *Einführung in die antike Dichtungstheorie.* Darmstadt: Wissenschaftliche Buchgesellschaft.
Fullerton, Mark D. 1990. *The Archaistic Style in Roman Statuary.* Leiden and New York: E. J. Brill.
———. 1998a. "Description vs. Prescription: A Semantics of Sculptural Style." In Hartswick and Sturgeon, 69–77.
———. 1998b. "Atticism, Classicism, and the Origins of Neo-Attic Sculpture." In Olga Palagia and Wiliam Coulson, eds., *Regional Schools in Hellenistic Sculpture.* Oxford: Oxbow Books. 93–99.

———. Ms. "The 'Archaism' of Classicism in Greco-Roman Sculpture."
Gabba, Emilio. 1963. "Il Latino come dialetto Greco." In [Anon.], ed., *Miscellanea di studi alessandrini in memoria di Augusto Rostagni*. Turin: Bottega d'Erasmo. 188–94.
Gadamer, Hans Georg. 1986. *Wahrheit und Methode: Grundzüge einer philosophischen Hermeneutik*. 5th ed. Tübingen: Mohr. (1st ed. 1960.)
Galinsky, Karl. 1996. *Augustan Culture: An Interpretive Introduction*. Princeton: Princeton University Press.
———. 1999. "Augustan Classicism. The Greco-Roman Synthesis." In Frances Titchener and Richard Moorton, eds., *The Eye Expanded: Life and the Arts in Greco-Roman Antiquity*. Berkeley and Los Angeles: University of California Press. 180–203.
Gantz, Timothy. 1993. *Early Greek Myth: A Guide to Literary and Artistic Sources*. Baltimore: Johns Hopkins University Press.
Ganzert, Joachim. 1983. "Zur Entwicklung lesbischer Kymationformen." *JdI* 98: 123–202.
Garezou, Maria–Xeni. 1994. "Orpheus." *LIMC-7*. 1: 81–105.
Gelzer, Thomas. 1975. "Klassik und Klassizismus." *Gymnasium* 82: 147–73.
———. 1979. "Klassizismus, Attizismus und Asianismus." In Flashar, 1–55.
Gerke, Friedrich. 1940. *Die christlichen Sarkophage der vorkonstantinischen Zeit*. Berlin: Walter de Gruyter.
Gigante, Marcello. 1995. *Philodemus in Italy: The Books from Herculaneum*. Translated by Dirk Obbink. Ann Arbor: University of Michigan Press.
Gigon, O. 1989. "Theophrast in Cicero's *De Finibus*." In William W. Fortenbaugh and Peter Steinmetz, eds., *Cicero's Knowledge of the Peripatos*. New Brunswick, N.J.: Transaction Publishers. 159–85.
Giuliani, Luca. 1986. *Bildnis und Botschaft: Hermeneutische Untersuchungen zur Bildniskunst der römischen Republik*. Frankfurt am Main: Suhrkamp.
Gleason, Maud W. 1995. *Making Men: Sophists and Self-Presentation in Ancient Rome*. Princeton: Princeton University Press.
Glucker, John. 1978. *Antiochus and the Late Academy*. Göttingen: Vandenhoeck & Ruprecht.
———. 1988. "Cicero's Philosophical Affiliations." In John M. Dillon and A. A. Long, eds., *The Question of "Eclecticism": Studies in Later Greek Philosophy*. Berkeley and Los Angeles: University of California Press. 34–69.
———. 1995. "*Probabile, Ueri Simile*, and Related Terms." In Powell, 115–44.
———. 1997. "Socrates in the Academic Books and Other Ciceronian Works." In Inwood and Mansfeld, 58–88.
Goette, Hans Rupprecht. 1990. *Studien zu römischen Togadarstellungen*. Mainz am Rhein: Philipp von Zabern.
Goldhill, Simon. 1991. *The Poet's Voice: Essays on Poetics and Greek Literature*. Cambridge: Cambridge University Press.
———. 2002. *Who Needs Greek?: Contests in the Cultural History of Hellenism*. Cambridge: Cambridge University Press.
———, ed. 2001. *Being Greek under Rome: Cultural Identity, the Second Sophistic and the Development of Empire*. Cambridge: Cambridge University Press.
Goodman, Nelson. 1976. *Languages of Art*. 2nd ed. Indianapolis: Bobbs-Merrill.

Goudriaan, Koen. 1989. *Over classicisme: Dionysius van Halicarnassus en zijn program van welsprekendheid, cultuur en politiek.* 2 vols. Diss., Vrije Universiteit Amsterdam.
Grassinger, Dagmar. 1991. *Römische Marmorkratere.* Mainz am Rhein: Philipp von Zabern.
———. 1994. "Die Marmorkratere." In Hellenkemper Salies et al., 259–84.
———. 1999. "Die Achill-Penthesilea-Gruppe sowie der Pasquino-Gruppe und ihre Rezeption in der Kaiserzeit." In Bol, 322–30.
Graziosi, Barbara. 2002. *Inventing Homer: The Early Reception of Epic.* Cambridge: Cambridge University Press.
Green, J. R. 1994. *Theatre in Ancient Greek Society.* London and New York: Routledge.
Green, Peter. 2000. "Pergamum and Sperlonga: A Historian's Reactions." In de Grummond and Ridgway, 166–90.
Greenhalgh, Michael. 1990. *What Is Classicism?* London and New York: Academy Editions, St. Martin's Press.
Grenier, J. C. 1989. "La décoration statuaire du 'Serapeum' du 'Canope' de la Villa Adriana." *MÉFR* 101: 925–1019.
———. 1999. "Le 'Serapeum' et le 'Canopus': Une 'Egypte' monumentale et une 'méditerrannée.'" In Charles-Gaffiot and Lavagne, 75–77.
Grenier, J. C., and F. Coarelli. 1986. "La Tombe d'Antinoüs à Rome." *MÉFR* 98: 217–53.
Griffin, Miriam T. 1989. "Philosophy, Politics, and Politicians at Rome." In Griffin and Barnes, 1–37.
Griffin, Miriam T., and Jonathan Barnes, eds. 1989. *Philosophia Togata: Essays on Philosophy and Roman Society.* Oxford: Clarendon Press.
Grimm, Alfred. 1994. "Inschriften des Antinoosobelisken: Übersetzung und Kommentar." In Alfred Grimm et al., 27–88.
Grimm, Alfred, Dieter Kessler, and Hugo Meyer, eds. 1994. *Der Obelisk des Antinoos.* Munich: Wilhelm Fink.
Groningen, B. A. van. 1965. "General Literary Tendencies in the Second Century A.D." *Mnemosyne* 18: 41–56.
Grube, G.M.A. 1965. *The Greek and Roman Critics.* Toronto: University of Toronto Press.
Gründer, Karlfried, ed. 1969. *Der Streit um Nietzsches "Geburt der Tragödie."* Hildesheim: G. Olms.
Guillory, John. 1993. *Cultural Capital: The Problem of Literary Canon Formation.* Chicago: University of Chicago Press.
Gullini, Giorgio, and Emanuela Zanda. 1978. *Il classicismo augusteo: Cultura di regime e "dissenso." Lezioni di archeologia romana, anno accademico 1977–1978.* Turin: G. Giappichelli.
Gumbrecht, Hans Ulrich. 2003. *The Powers of Philology: Dynamics of Textual Scholarship.* Urbana and Chicago: University of Illinois Press.
Gunderson, Erik. 2000. *Staging Masculinity: The Rhetoric of Performance in the Roman World.* Ann Arbor: University of Michigan Press.
Guthrie, W.K.C. 1971. *The Sophists.* Cambridge: Cambridge University Press.
Habicht, Christian. 1985. *Pausanias' Guide to Ancient Greece.* Berkeley and Los Angeles: University of California Press.

Habinek, T. N. 1995. "Ideology for an Empire in the Prefaces to Cicero's Dialogues." In A. J. Boyle and J. P. Sullivan, eds., *Roman Literature and Ideology: Ramus Essays for J.P. Sullivan*. Bendigo, Australia: Aureal Publications. 55–67.

———. 1998. *The Politics of Latin Literature: Writing, Identity, and Empire in Ancient Rome*. Princeton: Princeton University Press.

Hackländer, Nele. 1996. *Der archaistische Dionysos: Eine archäologische Untersuchung zur Bedeutung archaistischer Kunst in hellenistischer und römischer Zeit*. Frankfurt am Main and New York: Peter Lang.

Hales, Shelley. 2003. *The Roman House and Social Identity*. Cambridge: Cambridge University Press.

Hall, Edith. 1989. *Inventing the Barbarian: Greek Self-Definition through Tragedy*. Oxford: Clarendon Press.

Hall, Jonathan M. 1997. *Ethnic Identity in Greek Antiquity*. Cambridge: Cambridge University Press.

———. 2002. *Hellenicity: Between Ethnicity and Culture*. Chicago: University of Chicago Press.

Hallett, Christopher H. 1986. "The Origins of the Classical Style in Sculpture." *JHS* 106: 71–84.

Halliwell, S. 1986. *Aristotle's Poetics*. Chapel Hill: University of North Carolina Press.

———. 2002. *The Aesthetics of Mimesis: Ancient Texts and Modern Problems*. Princeton: Princeton University Press.

Hannestad, Niels. 1983. "Über das Grabmal des Antinoos. Topographische und Thematische Studien im Canopus-Gebiet der Villa Adriana." *AnalRom* 11: 69–108.

Hansen, Dirk U., ed. 1998. *Das attizistische Lexikon des Moeris: Quellenkritische Untersuchung und Edition*. Sammlung griechischer und lateinischer Grammatiker, vol. 9, vol. Berlin and New York: Walter de Gruyter.

Hansen, E. V. 1971. *The Attalids of Pergamum*. 2nd ed. Ithaca: Cornell University Press.

Hansen, Maria Fabricius. 2003. *The Eloquence of Appropriation: Prolegomena to an Understanding of Spolia in Early Christian Rome*. Rome: L'Erma di Bretschneider.

Harding, Phillip. 1986. "An Education to All." *Liverpool Classical Monthly* 11, no. 8: 134–36.

———. 1987. "Rhetoric and Politics in Fourth-Century Athens." *Phoenix* 41: 25–39.

Harriott, Rosemary M. 1969. *Poetry and Criticism before Plato*. London: Methuen.

Hartog, François, and Michel Casevitz. 1999. *L'histoire d'Homère à Augustin: Préfaces d'historiens et texts sur l'histoire*. [Paris]: Editions du Seuil.

Hartswick, Kim J., and Mary C. Sturgeon. 1998. *ΣΤΕΦΑΝΟΣ: Studies in Honor of Brunilde Sismondo Ridgway*. Philadelphia: University Museum, University of Pennsylvania for Bryn Mawr College.

Haselberger, L. 2003 (forthcoming). "*Debent habere gravitatem*. Pyknostyle Säulenstellung und augusteische Tempelbaukunst." *RM* 110.

Haskell, Francis. 1976. *Rediscoveries in Art: Some Aspects of Taste, Fashion and Collecting in England and France*. Ithaca: Cornell University Press.

Haskell, Francis, and Nicholas Penny. 1982. *Taste and the Antique: The Lure of Classical Sculpture, 1500–1900*. 2nd, corrected ed. New Haven: Yale University Press.

Haskins, Charles Homer. 1927. *The Renaissance of the Twelfth Century*. Cambridge, Mass.: Harvard University Press.

Hatfield, Henry Caraway. 1964. *Aesthetic Paganism in German Literature, from Winckelmann to the Death of Goethe*. Cambridge, Mass.: Harvard University Press.
Häuber, Chrystina. 1991. *Horti Romani. Die Horti Maecenatis und die Horti Lamiani auf dem Esquilin: Geschichte, Topographie, Statuenfunde*. Diss., Cologne.
———. 1998. "'Art as a Weapon' von Scipio Africanus Maior bis Lucullus. Domus, Horti und Heiligtümer auf dem Esquilin." In Maddalena Cima and Eugenio La Rocca, eds., *Horti romani: atti del convegno internazionale, Roma, 4–6 maggio 1995*. Rome: L'Erma di Bretschneider. 83–112.
Häuber, Chrystina, and Franz-Xaver Schütz. 2004. *Einführung in Archäologische Informationssysteme (AIS)*. Mainz: Von Zabern.
Haug, A. 2001. "Constituting the Past—Framing the Present. The Role of Material Culture in the Augustan Period." *Journal of the History of Collections* 13: 111–123.
Hausmann, U. 1984. "Aias mit dem Leichnam Achills: Zur Deutung des Originals der Pasquinogruppe." *AM* 99: 291–300.
Häußler, Reinhard. 1991. "Il classico: l'autore classico e la classicità." *Vichiana* 2: 144–61.
Havelock, Eric. 1978. *The Greek Concept of Justice: From Its Shadow in Homer to Its Substance in Plato*. Cambridge: Harvard University Press.
Haynes, Sybille. 2000. *Etruscan Civilization: A Cultural History*. London: British Museum Press.
Hazlitt, William. [1826] 1930. "Notes of a Journey through France and Italy." In Geoffrey Keynes, ed., *Selected Essays of William Hazlitt, 1778–1830*. London: Nonesuch.
Hegel, Georg Wilhelm Friedrich. [1820–29] 1975. *Hegel's Aesthetics: Lectures on Fine Art*. 2 vols. Translated by T. M. Knox. Oxford: Clarendon Press.
Heidegger, Martin. [1927] 1962. *Being and Time*. Translated by John Macquarrie and Edward Robinson. Oxford: Blackwell.
Heldmann, Konrad. 1982. *Die Niederlage Homers im Dichterwettstreit mit Hesiod*. Hypomnemata, vol. 75. Göttingen: Vandenhoeck & Ruprecht.
Hellenkemper Salies, Gisela, Hans-Hoyer von Prittwitz und Gaffron, and Gerhard Bauchheness, eds., 1994. *Das Wrack: Der antike Schiffsfund von Mahdia*. Cologne: Rheinland Verlag.
Hendrickson, G. L. 1929. "Ancient Reading." *CJ* 25: 182–96.
Hennig, Dieter. 1974. "Orchomenos." *RE Supplementband* 14:333–55.
Henrichs, Albert. 1986. "Three Approaches to Greek Mythography." In Jan Bremmer, ed., *Interpretations of Greek Mythology*. Totowa, N.J.: Barnes & Noble. 242–77.
———. 1995. "*Graecia Capta*: Roman Views of Greek Culture." *HSCP* 97: 243–61.
Herder, Johann Gottfried. 1795. *Briefe zur Beförderung der Humanität. Sechste Sammlung*. Riga: J. F. Hartknoch.
Herington, C. J. 1985. *Poetry into Drama: Early Tragedy and the Greek Poetic Tradition*. Berkeley and Los Angeles: University of California Press.
Hesk, Jon. 2000. *Deception and Democracy in Classical Athens*. Cambridge: Cambridge University Press.
Hidber, Thomas. 1996. *Das klassizistische Manifest des Dionys von Halikarnass: Die Praefatio zu "De oratoribus veteribus." Einleitung, Übersetzung und Kommentar*. Stuttgart: B. G. Teubner.
Himmelmann, Nikolaus. 1985. *Ideale Nacktheit*. Abhandlungen der Rheinisch-Westfälischen Akademie der Wissenschaften, vol. 73. Opladen: Westdeutscher Verlag.

———. 1990. *Ideale Nacktheit in der griechischen Kunst.* Jahrbuch des Deutschen Archäologischen Instituts. Ergänzungsheft 26. Berlin and New York: Walter de Gruyter.

———. 1995. *Sperlonga: Die homerischen Gruppen und ihre Bildquellen.* Opladen: Westdeutscher Verlag.

Hinds, Stephen. 1998. *Allusion and Intertext: Dynamics of Appropriation in Roman Poetry.* Cambridge: Cambridge University Press.

Hoff, Michael C., and Susan I. Rotroff, eds. 1997. *The Romanization of Athens: Proceedings of an International Conference Held at Lincoln, Nebraska (April 1996).* Oxford, England: Oxbow Books.

Hölbl, Günther. 1981. "Andere ägyptische Gottheiten." In Maarten J. Vermaseren, ed., *Die orientalischen Religionen im Römerreich.* Leiden: E. J. Brill. 157–92.

Holford-Strevens, Leofranc. 2003. *Aulus Gellius: An Antonine Scholar and His Achievement.* Rev. ed. Oxford: Oxford University Press.

Hölscher, Tonio. 1971. *Ideal und Wirklichkeit in den Bildnissen Alexanders des Grossen. Abhandlungen der Heidelberger Akademie der Wissenschaften, phil.-hist. Klasse.* 1971, No. 2. Heidelberg: Carl Winter.

———. 1984. "Actium und Salamis." *JdI* 99: 187–214.

———. 1987. *Römische Bildsprache als semantisches System. Vorgetragen am 16. Juni 1984.* Heidelberg: Carl Winter.

———. 1988. "Tradition und Geschichte. Zwei Typen der Vergangenheit am Beispiel der griechischen Kunst." In Jan Assmann and Tonio Hölscher, eds., *Kultur und Gedächtnis.* Frankfurt am Main: Suhrkamp. 115–149.

———. 1989a. *Die unheimliche Klassik der Griechen.* Thyssen-Vorträge. Auseinandersetzungen mit der Antike, vol. 8. Bamberg: C. C. Buchners.

———. 1989b. "Griechische Bilder für den römischen Senat." In Hans-Ulrich Cain, Hanns Gabelmann, and Dieter Salzmann, eds., *Festschrift für Nikolaus Himmelmann: Beiträge zur Ikonographie und Hermeneutik.* Mainz am Rhein: Philipp von Zabern. 327–33.

———. 1993a. "Griechische Formensprache und römisches Wertesystem. Kultureller Transfer in der Dimension der Zeit." In Thomas W. Gaethgens, ed., *Künstlerischer Austausch = Artistic exchange: Akten des XXVIII. Internationalen Kongresses für Kunstgeschichte, Berlin, 15.–20. Juli 1992.* 3 vols. Berlin: Akademie-Verlag. 67–87.

———. 1993b. Rev. of Himmelmann, 1990. *Gnomon.* 86: 519–28.

———. 1994. "Hellenistische Kunst und römische Aristokratie." In Hellenkemper Salies et al., eds. 875–88.

———. 1998. "Images and Political Identity: The Case of Athens." In Deborah Boedeker and Kurt A. Raaflaub, eds., *Democracy, Empire, and the Arts in Fifth-Century Athens.* Cambridge, Mass.: Harvard University Press. 153–83.

———. 2000. "Augustus und die Macht der Archäologie." In Fergus Millar and Adalberto Giovannini, eds., *La révolution romaine après Ronald Syme: Bilans et perspectives. Sept exposés suivis de discussions, Vandœuvres-Genève, 6–10 septembre 1999.* Vol. 46. Geneva: Fondation Hardt. 237–81.

———. 2001. "Die Alten vor Augen. Politische Denkmäler und öffentliches Gedächtnis im republikanischen Rom." In Gert Melville, ed., *Institutionalität und Symbolisierung: Verstetigungen kultureller Ordnungsmuster in Vergangenheit und Gegenwart.* Cologne: Böhlau. 183–211.

———. 2004. *The Language of Images in Roman Art: Art as a Semantic System in the Roman World.* Translated by Anthony Snodgrass and Anne-Marie Künzl-Snodgrass. Cambridge: Cambridge University Press.

Holzberg, N. 1988. "Lucian and the Germans." In A. C. Dionisotti, Anthony Grafton, and Jill Kraye, eds., *The Uses of Greek and Latin: Historical Essays.* London: Warburg Institute, University of London. 199–209.

Honour, Hugh. 1968. *Neo-classicism.* Harmondsworth: Penguin.

Hood, Sinclair. 1978. *The Arts in Prehistoric Greece.* Harmondsworth: Penguin.

Hope Simpson, Richard. 1981. *Mycenaean Greece.* Park Ridge, N.J.: Noyes Press.

Hope Simpson, Richard, and O.T.P.K. Dickinson. 1979. *A Gazetteer of Aegean Civilisation in the Bronze Age.* Göteborg: Paul Åströms Förlag.

Hopkinson, Neil. 1988. *A Hellenistic Anthology.* Cambridge: Cambridge University Press.

———. 1994. *Greek Poetry of the Imperial Period: An Anthology.* Cambridge: Cambridge University Press.

Horden, Peregrine, and Nicholas Purcell. 2000. *The Corrupting Sea: A Study of Mediterranean History.* Oxford and Malden, Mass.: Blackwell.

Hornung, Erik. 1983. *Conceptions of God in Ancient Egypt: The One and the Many.* London: Routledge & Kegan Paul.

Horrocks, Geoffrey C. 1997. *Greek: A History of the Language and Its Speakers.* London: Longman.

Horsfall, Nicholas. 1993. "Empty Shelves on the Palatine." *G&R* 40, no. 1: 58–67.

Hudson-Williams, H. Ll. 1949. "Isocrates and Recitations." *CQ* 43: 64–69.

Hülsen, C. 1896. "Das Grab des Antinous." *Rassegna Monetaria* 11: 122–30.

Humboldt, Wilhelm von. 1960–81. *Werke in fünf Bänden.* Edited by Andreas Flitner and Klaus Giel. 5 vols. Stuttgart: Cotta.

Hume, David. 1998. *Selected Essays.* Edited by Stephen Copley and Andrew Edgar. Oxford: Oxford University Press.

Humphrey, John H. 1986. *Roman Circuses: Arenas for Chariot Racing.* London: B. T. Batsford.

Humphreys, S. C. 1981. "Death and Time." In S. C. Humphreys and Helen King, eds., *Mortality and Immortality: The Anthropology and Archaeology of Death.* London and New York: Academic Press. 261–83.

Hunter, R. L. 1983. *A Study of Daphnis and Chloe.* Cambridge: Cambridge University Press.

———. 1996. *Theocritus and the Archaeology of Greek Poetry.* Cambridge: Cambridge University Press.

Hurwit, Jeffrey M. 1985. *The Art and Culture of Early Greece, 1100–480 B.C.* Ithaca: Cornell University Press.

———. 2004. *The Acropolis in the Age of Pericles.* Cambridge: Cambridge University Press.

Immerwahr, Sara Anderson. 1990. *Aegean Painting in the Bronze Age.* University Park: Pennsylvania State University Press.

Innes, Doreen. 1995. "Longinus, Sublimity, and Low Emotions." In Doreen Innes, Harry Hine, and Christopher Pelling, eds., *Ethics and Rhetoric: Classical Essays for Donald Russell on His Seventy-Fifth Birthday.* Oxford: Clarendon Press. 323–33.

Inwood, Brad, and Jaap Mansfeld, eds., *Assent and Argument: Studies in Cicero's Academic Books. Proceedings of the 7th Symposium Hellenisticum (Utrecht, August 21–25, 1995)*. Leiden: E. J. Brill.
Isager, S. 1998. "The Pride of Halikarnassos: *Editio Princeps* of an Inscription from Salamakis." *ZPE* 123: 1–23.
Iversen, Erik. 1961. *The Myth of Egypt and Its Hieroglyphs in European Tradition*. Copenhagen: Gad.
———. 1968. *Obelisks in Exile*. Copenhagen: Gad.
Jaeger, Werner Wilhelm. 1925. "Einführung." *Die Antike* 1: 1–4.
———. 1931. *Das Problem des Klassischen und die Antike: Acht Vorträge gehalten auf der Fachtagung der klassischen Altertumswissenschaft zu Naumburg 1930*. Leipzig: B. G. Teubner. (Reprint 1972, Darmstadt: Wissenschaftliche Buchgesellschaft.)
———. 1934. *Paideia: Die Formung des Griechischen Menschen*. Berlin: Walter de Gruyter.
Jakobson, Roman, Krystyna Pomorska, and Stephen Rudy. 1987. *Language in Literature*. Cambridge, Mass.: Belknap Press.
Janko, Richard. 1987. *Aristotle, Poetics*. Indianapolis: Hackett Publishing Co.
———, ed. 2000. *Philodemus: On Poems, Book 1*. Introduction, Translation and Commentary. Oxford: Oxford University Press.
Jebb, Richard Claverhouse. 1905. *Homer: An Introduction to the Iliad and the Odyssey*. 7th ed. Boston: Ginn.
Jencks, Charles. 1980. *Post-modern Classicism: The New Synthesis*. London: Architectural Design.
———. 1987. *Post-modernism: The New Classicism in Art and Architecture*. New York: Rizzoli.
———. 1996. *What Is Post-modernism?* 4th rev., enl. ed. London and Lanham, Md.: Academy Editions.
Jenkins, Ian. 2001. *Cleaning and Controversy: The Parthenon Sculptures 1811–1939*. The British Museum Occasional Papers, no. 146. London: The British Museum.
Jenkyns, Richard. 1980. *The Victorians and Ancient Greece*. Oxford: Basil Blackwell.
Johnson, W. R. 1970. "The Problem of the Counter-classical Sensibility and Its Critics." *CSCA* 3: 123–51.
Jones, C. P. 1966. "Towards a Chronology of Plutarch's Works." *JRS* 56, nos. 1–2: 61–74.
Jones, M. Wilson. 1999. "Il progettazione archittettonica: Riflessioni su misure, proporzioni e geometrie." In Patrizio Pensabene and Clementina Panella, eds., *Arco di Costantino tra archeologia e archeometria*. Rome: L'Erma di Bretschneider. 75–99.
Jost, Karl. 1936. *Das Beispiel und Vorbild der Vorfahren bei den attischen Rednern und Geschichtsschreibern bis Demosthenes*. Paderborn: F. Schöningh. (Reprint 1979, New York: Arno Press.)
Jucker, Hans. 1950. *Vom Verhältnis der Römer zur bildenden Kunst der Griechen*. Frankfurt am Main: V. Klostermann.
Kähler, Heinz. 1953. *Die Gebälke des Konstantinsbogens*. Heidelberg: Carl Winter.
———. 1975. "Zu Herkunft des Antinous Obelisk." *Acta ad Archaeologiam et Artium Historiam Pertinentia* 6: 35–44.
Kahrstedt, Ulrich. 1954. *Das wirtschaftliche Gesicht Griechenlands in der Kaiserzeit*. Bern: A. Francke.

Kant, Immanuel. 1987. *Critique of Judgment*. Translated by Werner S. Pluhar. Indianapolis: Hackett.
Kaster, Robert A. 1980. "Macrobius and Servius: *Verecundia* and the Grammarian's Function." *HSCP* 84: 219–62.
———. 1988. *Guardians of Language: The Grammarian and Society in Late Antiquity*. Berkeley and Los Angeles: University of California Press.
———. 1998. "Becoming 'Cicero.'" In Peter Knox and Clive Foss, eds., *Style and Tradition: Studies in Honor of Wendell Clausen*. Stuttgart and Leipzig: B. G. Teubner. 248–63.
Kermode, Frank. 1983. *The Classic: Literary Images of Permanence and Change*. Cambridge, Mass., and London: Harvard University Press. (1st ed. 1975.)
———. 2000. *The Sense of an Ending: Studies in the Theory of Fiction*. 2nd ed. New York and Oxford: Oxford University Press.
Kessler, Dieter. 1994. "Beiträge zum Verstandnis des Obelisken." In Grimm et al., eds., 91–149.
Kienast, D. 1969. "Augustus und Alexander." *Gymnasium* 76: 430–56.
Kierkegaard, Søren. 1989. *The Concept of Irony, with Continual Reference to Socrates, together with Notes of Schelling's Berlin Lectures*. Translated by Howard Vincent Hong and Edna Hatlestad Hong. Princeton: Princeton University Press.
Kinney, Dale. 1995. "Rape or Restitution of the Past: Interpreting *Spolia*." In Susan C. Scott, ed., *The Art of Interpreting*. University Park: Dept. of Art History, Pennsylvania State University. 53–67.
———. 1997. "*Spolia, Damnatio* and *Renovatio Memoriae*." *MAAR* 42: 117–48.
———. 2001. "Roman Architectural *Spolia*." *PAPS* 145: 138–50.
Kleiner, Diana E. E. 1992. *Roman Sculpture*. New Haven: Yale University Press.
Knauss, J. 1991. "Arkadian and Boiotian Orchomenos: Centres of Mycenaean Hydraulic Engineering." *Irrigation and Drainage Systems* 5: 363–81.
Kockel, Valentin. 1983. "Beobachtungen zum Tempel des Mars Ultor und zum Forum des Augustus." *RM* 90: 421–48.
Koenen, Ludwig. 1993. "The Ptolemaic King as a Religious Figure." In A. W. Bulloch, et al., eds., *Images and Ideologies: Self-definition in the Hellenistic World*. Berkeley and Los Angeles: University of California Press. 25–115.
Koortbojian, Michael. 1995. *Myth, Meaning, and Memory on Roman Sarcophagi*. Berkeley and Los Angeles: University of California Press.
———. 2000. "Pliny's Laocoön?" In A. Payne, Ann Kuttner, and Rebekah Smick, eds., *Antiquity and Its Interpreters*. Cambridge: Cambridge University Press. 199–216.
———. 2002. "Forms of Attention: Four Notes on Replication and Variation." In Elaine Gazda, ed., *The Ancient Art of Emulation*. Ann Arbor: University of Michigan Press. 173–204.
Körte, Alfred. 1934. "Der Begriff des Klassischen in der Antike." *Berichte über die Verhandlungen der sächsischen Akademie der Wissenschaften zu Leipzig, Phil.-hist. Klasse*. 86, no. 3: 1–15.
Koselleck, Reinhart. 1979. *Vergangene Zukunft: Zur Semantik geschichtlicher Zeiten*. 4th ed. Frankfurt am Main: Suhrkamp.
Kossatz-Deissman, A. 1994. "Paridis Iudicium." *LIMC* 7.1: 176–89.

Koster, W.J.W., ed. 1975. *Prolegomena de comoedia. Scholia in Acharnenses, Equites, Nubes.* Vol. 1.A. Gröningen: Bouma.
Kristeller, Paul Oskar. 1990. "The Modern System of the Arts." In Paul Oskar Kristeller, *Renaissance Thought and the Arts: Collected Essays*. Expanded edition. Princeton: Princeton University Press. 163–227.
Kroehnert, Otto. 1897. *Canonesne poetarum scriptorum artificum per antiquitatem fuerunt?* Diss., Königsberg.
Kübler, Bernhard. 1889. "Classici." *RE* 3: 2628–29.
Kuhn, Helmut. 1931. *Die Vollendung der klassischen deutschen Ästhetik durch Hegel.* Berlin: Junker und Dünnhaupt.
Kuntz, U. S. 1994. "Griechische Reliefs aus Rom und Umgebung." In Hellenkemper Salies et al., 889–99.
Kunze, C. 1996. "Zur Datierung des Laokoon und der Skyllagruppe aus Sperlonga." *JdI* 111: 139–223.
La Penna, Antonio. 1992. "La cultura letteraria latina nel secolo degli Antonini." In Momigliano and Schiavone, Vol. 2.3 (Emilio Gabba and Aldo Schiavone, eds., *La cultura e l'impero*). Turin: Giulio Einaudi. 491–577.
La Rocca, Eugenio. 1983. *Ara Pacis Augustae: In occasione del restauro della fronte orientale.* Rome: L'Erma di Bretschneider.
———. 1985. *Amazzonomachia: Le sculture frontonali del tempio di Apollo Sosiano. Mostra Roma.* Rome: De Luca.
———. 1988. "Der Apollo-Sosianus-Tempel." In Mathias René Hofter, ed., *Kaiser Augustus und die verlorene Republik.* Mainz am Rhein: Philipp von Zabern. 121–36.
Labate, Mario. 1990. "Forme della letteratura, immagini del mondo: Da Catullo a Ovidio." In Momigliano and Schiavone, Vol. 2.1 (Guido Clemente, Filippo Coarelli, and Emilio Gabba, eds., *La repubblica imperiale*). Turin: Giulio Einaudi. 923–65.
Laclau, Ernesto, and Chantal Mouffe. 1985. *Hegemony and Socialist Strategy: Towards a Radical Democratic Politics.* London: Verso.
Lahusen, G. 1999. "Bemerkungen zur Laokoon-Gruppe." In Bol, 295–305.
Lakoff, George, and Mark Turner. 1989. *More Than Cool Reason: A Field Guide to Poetic Metaphor.* Chicago: University of Chicago Press.
Lamberton, Robert, and John J. Keaney, eds. 1992. *Homer's Ancient Readers: The Hermeneutics of Greek Epic's Earliest Exegetes.* Princeton: Princeton University Press.
Landwehr, Christa. 1992. "Juba II. als Diomedes?" *JdI* 107: 103–24.
———. 1998. "Konzeptfiguren." *JdI* 113: 133–94.
Lane Fox, Robin. 1986. *Pagans and Christians.* London: Viking.
Langlotz, Ernst. 1958. "Classico." In *Enciclopedia universale dell'arte*. Venice and Rome: Istituto per la Collaborazione Culturale. 3: 700–44.
———. 1960. "Classic Art." In *Encyclopedia of World Art*. New York: McGraw-Hill. 3: 632–73.
Lapatin, Kenneth. 2003. "The Fate of Plate: Towards a Historiography of Ancient Greek 'Minor Arts.'" In Alice A. Donohue and Mark D. Fullerton, eds., *Ancient Art and Its Historiography.* Cambridge: Cambridge University Press. 69–91.
Latte, Kurt. 1960. *Römische Religionsgeschichte.* Munich: C. H. Beck.
———. 1968. "Zur Zeitbestimmung des Antiatticista." In Kurt Latte, *Kleine Schriften zu Religion, Recht, Literatur und Sprache der Griechen und Römer.* Edited by Olof Gigon. Munich: Beck. 612–30. (= *Hermes* 50 [1915]: 373–94.)

Lauffer, S. 1974. "Orchomenos." *RE Supplementband*. 14: 290–333.
Lauter, Hans. 1976. *Die Koren des Erechtheion*. Berlin: Gebr. Mann.
Lawrence, A. W. 1972. *Greek and Roman Sculpture*. London: Methuen.
Leake, William Martin. 1835. *Travels in Northern Greece*. 4 vols. London: J. Rodwell. (Reprinted 1967, Amsterdam: A. M. Hakkert.)
Lehmann, Stefan. 1996. *Mythologische Prachtreliefs*. Bamberg: E. Weiss.
Lehnus, Luigi. 1999. "In margine a un recente libro su Callimaco." In Fabrizio Conca, ed., *Ricordando Raffaele Cantarella: Miscellanea di studi*. Bologna: Cisalpino. 201–25.
Lembke, Katja. 1994. *Das Iseum Campense in Rom*. Heidelberg: Verlag Archäologie und Geschichte.
Lessing, G. E. [1766] 1962. *Laokoon, oder über die Grenzen der Mahlerey und der Poesie*. Edited and translated by E. A. McCormick. Baltimore: Johns Hopkins University Press.
Levin, Harry. 1957. "Contexts of the Classical." In Harry Levin, *Contexts of Criticism*. Cambridge, Mass.: Harvard University Press. 38–54.
Lewis, J. A. 2004. *Greek Oracles in the Second Century C.E.* Diss., University of Exeter.
Liebeschuetz, Wolf. 1992. "La religione romana." In Momigliano and Schiavone, vol. 2.3 (E. Gabba and A. Schiavone, eds., *La cultura e l'impero*). 237–81.
Ling, Roger. 1979. "Hylas in Pompeian Art." *MÉFRA* 91: 773–816.
Lloyd, G.E.R. 1987. *The Revolutions of Wisdom: Studies in the Claims and Practice of Ancient Greek Science*. Berkeley and Los Angeles: University of California Press.
———. 1990. *Demystifying Mentalities*. Cambridge: Cambridge University Press.
Lloyd-Jones, Hugh. 1999. "The Pride of Halicarnassus." *ZPE* 124: 1–14.
Lloyd-Jones, Hugh, and Peter Parsons. 1983. *Supplementum Hellenisticum*. Berlin: Walter de Gruyter.
Long, A. A. 1995. "Cicero's Plato and Aristotle." In Powell, 37–62.
Long, A. A., and David N. Sedley. 1987. *The Hellenistic Philosophers*. 2 vols. Cambridge: Cambridge University Press.
Loraux, Nicole. 1981. *L'invention d'Athènes: Histoire de l'oraison funèbre dans la "cité classique."* Paris: Éditions de l'École des Hautes Études en Sciences Sociales.
Lord, Albert B. 2000. *The Singer of Tales*. 2nd ed. Edited by Stephen A. Mitchell and Gregory Nagy. Cambridge, Mass.: Harvard University Press.
Luck, Georg. 1958. "Scriptor classicus." *Comparative Literature* 10: 150–58.
MacCormack, Sabine. 1998. *The Shadows of Poetry: Virgil in the Mind of Augustine*. Berkeley and Los Angeles: University of California Press.
MacGillivray, J. A. 2000. *Minotaur: Sir Arthur Evans and the Archaeology of the Minoan Myth*. New York: Hill and Wang.
MacMullen, Ramsay. 2003. *Feelings in History, Ancient and Modern*. Claremont: Regina Books.
Maderna, Caterina. 1988. *Iuppiter Diomedes und Merkur als Vorbilder für römische Bildnisstatuen: Untersuchungen zum römischen statuarischen Idealporträt*. Heidelberg: Verlag Archäologie und Geschichte.
Maderna-Lauter, Caterina. 1990. "Polyklet in hellenistischer und römischer Zeit." In Bol 1990, 298–392.
———. 1999. "Überlegungen zum 'roten' und zum 'weissen' Marsyas." In Bol, 115–40.

Maffei, Sonia. 1986. "Le *Imagines* di Luciano: un patchwork di capolavori antichi. Problema di un metodo combinatori." *Studi classici e orientali* 36: 147–64.

———, ed. 1994. *Luciano. Descrizioni di opere d'arte*. Turin: G. Einaudi.

Magi, F. 1960. "Il Ripristino del Laocoonte." In *Atti della Pontificia Accademia Romana di Archeologia, Memorie 9. 1*. Rome: L'Erma di Bretschneider.

Maier, Hendrik M. J. 1988. *In the Center of Authority: The Malay Hikayat Merong Mahawangsa*. Studies on Southeast Asia. Ithaca: Southeast Asia Program, Cornell University.

Mainstone, R. J. 1988. *Hagia Sophia: Architecture, Structure, and Liturgy of Justinian's Great Church*. New York: Thames & Hudson.

Maiuri, Amedeo. 1931. *La Villa dei Misteri*. Rome: La Libreria dello Stato.

Malaise, Michel. 1972a. *Inventaire préliminaire des documents égyptiens découverts en Italie*. Leiden: E. J. Brill.

———. 1972b. *Les conditions de pénétration et de diffusion des cultes égyptiens en Italie*. Leiden: E. J. Brill.

Manieri, A. 1998. *L'immagine poetica nella teoria degli antichi: phantasia ed enargeia*. Pisa: Istituti editoriali e poligrafici internazionali.

Mannoni, Octave. 1969. "Je sais bien, mais quand même . . ." In *Clefs pour l'imaginaire, ou, L'autre scène*. Paris: Éditions du Seuil. 9–33.

Marache, René. 1952. *La critique littéraire de langue latine et le développement du goût archaïsant au IIe siècle de notre ère*. Rennes: Plihon.

Marchand, Suzanne L. 1996. *Down from Olympus: Archaeology and Philhellenism in Germany, 1750–1970*. Princeton: Princeton University Press.

Marconi, Pirro. 1930–31. "L'anticlassico nell'arte di Selinunte." *Daedalo* 8, no. 2: 395–412.

Mariotti, Scevola. 1986. *Livio Andronico e la traduzione artistica: Saggio critico ed edizione dei frammenti dell'Odyssea*. [Urbino]: Università degli studi di Urbino. (1st ed. 1952.)

Marrou, H. I. 1956. *A History of Education in Antiquity*. Translated by George Lamb. New York: Sheed and Ward.

Marszal, John. 2000. "Ubiquitous Barbarians: Representations of the Gauls at Pergamum and Elsewhere." In de Grummond and Ridgway, 191–234.

Marx, Friederich, ed. 1905. *C. Lucilii Carminum Reliquiae. Vol. 2: Commentarius*. Leipzig: B. G. Teubner.

Mathews, K. R. 1999. "Expressing Political Legitimacy and Cultural Identity through the Use of Spolia on the Ambo of Henry II." *Medieval Encounters* 5: 156–83.

Mathews, Thomas F. 1993. *The Clash of Gods: A Reinterpretation of Early Christian Art*. Princeton: Princeton University Press.

Mayer, Roland. 1982. "Neronian Classicism." *AJP* 103: 305–18.

McDonald, William A., and Carol G. Thomas. 1990. *Progress into the Past: The Rediscovery of Mycenaean Civilization*. Revised 2nd ed. Bloomington: Indiana University Press.

McKenzie, J. 2003. "Glimpsing Alexandria from Archaeological Evidence." *JRA* 16: 35–61.

Mee, Christopher and Antony Spawforth. 2001. *Greece: An Oxford Archaeological Guide*. Oxford: Oxford University Press.

Mesk, J. 1927. "Zu den Prosa- und Vershymnen des Aelius Aristides." In Agostino Gemelli, ed., *Raccolta di scritti in onore di Felice Ramorino*. Milan: Società editrice "Vita e pensiero." 660–72.
Mestre, F., and P. Gomez. 1998. "Les sophistes de Philostrate." In Nicole Loraux and Carlos Miralles, eds., *Figures de l'intellectuel en Grèce ancienne*. Paris: Belin. 333–68.
Meyboom, P.G.P. 1995. *The Nile Mosaic of Palestrina: Early Evidence of Egyptian Religion in Italy*. Leiden: E. J. Brill.
Meyer, Hugo. 1991. *Antinoos*. Munich: Wilhelm Fink.
———. 1994a. "Antinous and the Greek Renascence." In Grimm et al., 151–64.
———. 1994b. "Zur Geschichte des Obelisken und seiner Bewertung durch die klassische Altertumswissenschaft." In Hugo Meyer, ed., with contributions by Alfred Grimm, Dieter Kessler, and Hugo Meyer, *Der Obelisk des Antinoos: Eine kommentierte Edition*. Munich: Fink.
———. 1996. "The Hanging Marsyas Reconsidered: A Roman Table Leg, Early Seleukid Art, and the School of Lysippos." *BullCom* 97: 89–124.
Michel, A. 1961. "Rhétorique et philosophie dans les *Tusculanes*." *RÉL* 39: 158–71.
Michelini, Ann N. 1987. *Euripides and the Tragic Tradition*. Madison: University of Wisconsin Press.
Miller, J. Hillis. 2001. *Speech Acts in Literature*. Stanford: Stanford University Press.
Miller, Margaret Christina. 1997. *Athens and Persia in the Fifth Century B.C.* Cambridge: Cambridge University Press.
Mitchell, W.J.T. 1986. *Iconology: Image, Text, Ideology*. Chicago: University of Chicago Press.
———. 1996. "Word and Image." In Nelson and Schiff, 47–56.
Moles, John. 1999. "*Anathema kai ktema*: The Inscriptional Inheritance of Ancient Historiography." *Histos: The Electronic Journal for Ancient Historiography at the University of Durham*. Vol. 3. http:www.dur.ac.uk/Classics/histos/1999/moles.html.
Momigliano, Arnaldo. 1975. *Alien Wisdom: The Limits of Hellenization*. Cambridge: Cambridge University Press.
———. 1990. *The Classical Foundations of Modern Historiography*. Berkeley and Los Angeles: University of California Press.
Momigliano, Arnaldo, and Aldo Schiavone, eds. 1988–93. *Storia di Roma*. Turin: Giulio Einaudi.
Morgan, Teresa. 1998. *Literate Education in the Hellenistic and Roman Worlds*. Cambridge: Cambridge University Press.
Morris, Ian. 1997. "Periodization and the Heroes: Inventing a Dark Age." In Mark Golden and Peter Toohey, eds., *Inventing Ancient Culture: Historicism, Periodization and the Ancient World*. London and New York: Routledge. 96–131.
Morris, Sarah P. 1992. *Daidalos and the Origins of Greek Art*. Princeton: Princeton University Press.
Mosse, George L. 1996. *The Image of Man: The Creation of Modern Masculinity*. New York: Oxford University Press.
Most, Glenn W. 1989. "Zur Archäologie der Archaik." *A&A* no. 35: 1–23.
———. 1990. "Canon Fathers: Literacy, Mortality, Power." *Arion* 1, no. 1: 35–60.
———. 1994. "Perikles in Gettysburg." *Frankfurter Allgemeine Zeitung* 21, no. 270: L 14.

———. 1996a. "Reading Raphael: The School of Athens and Its Pre-Text." *Critical Inquiry* 23: 145–82.

———. 1996b. "Vom Nutzen und Nachteil der Antike für das Leben. Zur Modernen Deutschen Selbstfindung anhand der alten Griechen." *Humanistische Bildung* 19: 35–52.

———. 2002. "On the Use and Abuse of Ancient Greece for Life." *Cultura tedesca* 20 (ottobre): 31–53.

Mountjoy, Penelope A. 1983. *Orchomenos V: Mycenaean Pottery from Orchomenos, Eutresis and Other Boeotian Sites*. Munich: Verlag der Bayerischen Akademie der Wissenschaften.

Müri, Walter. 1976. "Die Antike. Untersuchungen über den Ursprung und die Entwicklung der Bezeichnung einer geschichtlichen Epoche." In Eduard Vischer, ed., *Griechische Studien: Ausgewählte wort- und sachgeschichtliche Forschungen zur Antike*. Basel: F. Reinhardt. 243–306.

Murray, Oswyn. 1971. *Peri Basileias: Studies in the Justification of Monarchic Power in the Hellenistic World*. Diss., University of Oxford.

Murray, Penelope. 1981. "Poetic Inspiration in Early Greece." *JHS* 101: 87–100.

Musti, Domenico. 1996. "La struttura del discorso storico in Pausania." In Musti and Bingen, 9–43.

Musti, Domenico, and Jean Bingen, 1996. *Pausanias Historien: Huit exposés suivis de discussions: Vandoeuvres-Genève, 15–19 août 1994*. Vol. 41. Geneva: Fondation Hardt.

Muth, Susanne. 1998. *Erleben von Raum, Leben im Raum: Zur Funktion mythologischer Mosaikbilder in der römisch-kaiserzeitlichen Wohnarchitektur*. Heidelberg: Verlag Archäologie und Geschichte.

———. 1999. "Hylas oder 'Der ergriffene Mann': Zur Eigenständigkeit der Mythrezeption in der Bildkunst." In De Angelis et al., 109–30.

Nagy, Gregory. 1989. "Early Greek Views of Poets and Poetry." In George A. Kennedy, ed., *The Cambridge History of Literary Criticism. Volume 1, Classical Criticism*. Cambridge: Cambridge University Press. 1–77.

———. 1990. *Pindar's Homer: the Lyric Possession of an Epic Past*. Baltimore: Johns Hopkins University Press.

———. 1996a. *Poetry as Performance: Homer and Beyond*. Cambridge: Cambridge University Press.

———. 1996b. *Homeric Questions*. Austin: University of Texas Press.

———. 1998. "The Library of Pergamon as a Classical Model." In Helmut Koester, ed., *Pergamon: Citadel of the Gods: Archaeological Record, Literary Description, and Religious Development*. Harrisburg, Pa.: Trinity Press International. 185–222.

———. 2001. "Reading Bakhtin Reading the Classics: An Epic Fate for Conveyors of the Heroic Past." In Robert Bracht Branham, ed., *Bakhtin and the Classics*. Evanston, Ill.: Northwestern University Press. 71–96.

Neer, Richard T. 2002. *Style and Politics in Athenian Vase-Painting: The Craft of Democracy, ca. 530–460 B.C.E.* New York: Cambridge University Press.

Nehamas, Alexander. 1992. "Pity and Fear in the *Rhetoric* and the *Poetics*." In Amélie Oksenberg Rorty, ed. *Essays on Aristotle's Poetics*. Princeton: Princeton University Press. 291–314.

Nelson, Robert S. 1996. "Appropriation." In Nelson and Shiff, 116–28.

Nelson, Robert S., and Richard Shiff, eds. 1996. *Critical Terms for Art History.* Chicago: University of Chicago Press.
Neudecker, Richard. 1988. *Die Skulpturenausstattung römischer Villen in Italien.* Mainz am Rhein: Philipp von Zabern.
Newby, Z. 2002. "Sculptural Display in the So-Called Palaestra of Hadrian's Villa." *RM* 109: 59–82.
Nicolai, Roberto. 1992. *La storiografia nell'educazione antica.* Pisa: Giardini.
Nicolet, Claude. 1991. *Space, Geography, and Politics in the Early Roman Empire.* Ann Arbor: University of Michigan Press.
Nietzsche, Friedrich. 1967. *The Will to Power.* Translated by Walter Kaufmann and R. J. Hollingdale. New York: Random House.
Nietzsche, Friedrich Wilhelm. 1967–. *Friedrich Nietzsche. Kritische Gesamtausgabe, Werke.* Edited by Giorgio Colli and Mazzino Montinari. Berlin: Walter de Gruyter.
———. 1974. *The Gay Science: With a Prelude in Rhymes and an Appendix of Songs.* Translated by Walter Kaufmann. New York: Vintage Books.
———. 1988. *Friedrich Nietzsche. Sämtliche Werke. Kritische Studienausgabe in 15 Einzelbänden.* Edited by Giorgio Colli and Mazzino Montinari. 15 vols. 2nd ed. Berlin: Walter de Gruyter.
———. 1993. *The Birth of Tragedy Out of the Spirit of Music.* Translated by Shaun Whiteside. London: Penguin Books.
Nilsson, Martin P. 1955. *Die hellenistische Schule.* Munich: C. H. Beck.
Nisbet, Hugh Barr, ed. 1985. *German Aesthetic and Literary Criticism: Winckelmann, Lessing, Hamann, Herder, Schiller, Goethe.* Cambridge: Cambridge University Press.
Nogales, T. 1997. In Javier Arce, Serena Ensoli, and Eugenio La Rocca, eds., *Hispania romana: da terra di conquista a provincia dell'impero.* Milan: Electa. 389–90.
Norden, Eduard. 1898. *Die antike Kunstprosa vom VI. Jahrhundert v. Chr. bis in die Zeit der Renaissance.* 2 vols. Leipzig: B. G. Teubner. (Reprint 1971, Stuttgart: B. G. Teubner.)
North, John. 1979. "Religious Toleration in Republican Rome." *PCPS* 25: 85–103.
———. 1992. "The Development of Religious Pluralism." In Judith Lieu, John North, and Tessa Rajak, eds., *The Jews among Pagans and Christians in the Roman Empire.* London: Routledge. 174–93.
Nussbaum, Martha C. 1992. "Tragedy and Self-sufficiency: Plato and Aristotle on Fear and Pity." In Amélie Oksenberg Rorty, ed., *Essays on Aristotle's Poetics.* Princeton: Princeton University Press. 261–90.
———. 1994. *The Therapy of Desire: Theory and Practice in Hellenistic Ethics.* Princeton: Princeton University Press.
O'Brien, Jay, and William Roseberry. 1991. *Golden Ages, Dark Ages: Imagining the Past in Anthropology and History.* Berkeley and Los Angeles: University of California Press.
O'Sullivan, Neil. 1992. *Alcidamas, Aristophanes, and the Beginnings of Greek Stylistic Theory.* Hermes Einzelschriften, Heft 60. Stuttgart: F. Steiner.
———. 1997. "Caecilius, the 'Canons' of Writers and the Origins of Atticism." In W. J. Dominik, ed., *Roman Eloquence: Rhetoric in Society and Literature.* London: Routledge. 32–49.
Oakley, John H. 1990. "Hylas." In *LIMC* 5.1: 574–79.

Orlandos, A. K. 1915. "Peri ton anastilotikon ergasion en Orchomenoi tis Boiotias." *ArchDelt* 1 (Parartema): 51–53.

Osborne, Robin. 1987. "The Viewing and Obscuring of the Parthenon Frieze." *JHS* 107: 98–105.

———. 1998. *Archaic and Classical Greek Art*. Oxford: Oxford University Press.

Owen, G.E.L. 1986. "Philosophical Invective." In G.E.L. Owen, *Logic, Science, and Dialectic: Collected Papers in Greek Philosophy*. Edited by Martha Nussbaum. Ithaca: Cornell University Press. 347–64.

Palagia, Olga. 1997. "Classical Encounters: Attic Sculpture after Sulla." In Hoff and Rotroff, eds. 81–95.

Palma, Beatrice. 1977. In Raissa Calza, ed., *Antichità di Villa Doria Pamphilj*. Rome: De Luca. 93–95.

Panofsky, Erwin. 1924. *"Idea": Ein Beitrag zur Begriffsgeschichte der älteren Kunsttheorie*. Leipzig: B. G. Teubner. (Reprint of 2nd ed., Berlin: Volker Spiess, 1993.)

Papalexandrou, Amy. 2003. "Byzantine Monuments as Sites of Memory: Spolia and Their 'Readers' in Central Greece." In Van Dyke and Alcock, 56–80.

Pape, Magrit. 1975. *Griechische Kunstwerke aus Kriegsbeute und ihre öffentliche Aufstellung in Rom: Von der Eroberung von Syrakus bis in augusteische Zeit*. Diss., Hamburg.

Papini, Massimiliano. 2004. *Antichi volti della repubblica. La ritrattistica in Ialia centrale tra IV e II secolo a. c.* Rome: L'Erma di Bretschneider.

Paris, R. 1990. "Il pannello con Hylas e le Ninfe dalla Basilica di Giunio Basso." *Bollettino di archeologia* 1–2: 194–202.

Parry, Milman. 1971. *The Making of Homeric Verse: The Collected Papers of Milman Parry*. Edited by Adam Parry. Oxford: Clarendon Press.

Pater, Walter. 1894. *Greek Studies: A Series of Lectures*. London: Macmillan. (Reprint, New York: Chelsea House, 1983.)

Paul, Jean. 1959–63. *Werke*. 6 vols. Edited by Norbert Miller. Munich: C. Hanser.

Pearson, Mike, and Michael Shanks. 2001. *Theatre/Archaeology*. London and New York: Routledge.

Peirce, Charles S. 1931–58. *Collected Papers of Charles Sanders Peirce*. Edited by Charles Hartshorne and Paul Weiss. 8 vols. Cambridge, Mass.: Harvard University Press.

Pelon, Olivier. 1976. *Tholoi, tumuli, et cercles funéraires: Recherches sur les monuments funéraires de plan circulaire dans l'Egée de l'age du bronze, IIIe et IIe millénaires av. J.-C.* Athènes: Ecole Française d'Athènes.

Pelzl, G. 1994. "Die griechischen Inschriften." In Hellenkemper Salies et al., eds. 381–97.

Pensabene, Patrizio. 1988. "The Arch of Constantine: Marble Samples." In Norman Herz and Marc Waelkens, eds., *Classical Marble: Geochemistry, Technology, Trade*. Dordrecht: Kluwer Academic Publishers. 411–18.

———. 1993. "Il Reimpiego nell'età costantina a Roma." In Giorgio Bonamente and Franca Fusco, eds., *Costantino Il Grande*. Vol. 2. Macerata: Università degli Studi di Macerata. 749–68.

———. 1995. "Reimpiego e nuove mode architettoniche nelle basiliche cristiane di Roma tra IV e VI secolo." *Journal of Ancient Civilization Ergänzungsband* 20, no. 2: 1076–96.

———. 1996. "Magna Mater, Aedes." In Eva Margareta Steinby, ed., *LTUR*. Vol. 3. Rome: Quasar. 206–8.

———. 1999. "Progetto unitario e reimpiego nell'Arco di Costantino." In Patrizio Pensabene and Clementina Panella, eds., *Arco di Costantino tra archeologia e archeometria*. Rome: L'Erma di Bretschneider. 13–42.

Pensabene, Patrizio, and Clementina Panella. 1993–94. "Reimpiego e progettazione architettonica nei monumenti tardo-antichi di Roma." *Rendiconti* 66: 111–283.

Perrot, Georges, and Charles Chipiez. 1894. *Histoire de l'art dans l'antiquité. Vol. VI: La Grèce primitive*. Paris: Librairie Hachette.

Petot, Jean-Michel. 1991. *Melanie Klein, vol. 2: The Ego and the Good Object, 1932–1960*. Translated by Christine Trollope. Madison, Conn.: International Universities Press.

Peyre, Henri. 1965. *Qu'est-ce que le classicisme?* 2nd ed., revised and expanded. Paris: A.-G. Nizet. (1st ed. 1933.)

Pfeiffer, Rudolf. 1949. *Callimachus*. 2 vols. Oxford: Clarendon Press.

———. 1968. *History of Classical Scholarship from the Beginnings to the End of the Hellenistic Age*. Oxford: Clarendon Press.

———. 1976. *History of Classical Scholarship from 1300 to 1850*. Oxford: Clarendon Press.

Pfister, Friedrich. 1951. *Die Reisebilder des Herakleides. Einleitung, Text, Übersetzung und Kommentar mit einer Übersicht über die Geschichte der griechischen Volkskunde*. Vienna: In Kommission bei R. M. Rohrer. (= Österreichische Akademie der Wissenschaften. Phil-hist. Klasse. Sitzungsberichte 227, no. 2.)

Pickard-Cambridge, Arthur Wallace. 1988. *The Dramatic Festivals of Athens*. 2nd revised ed. by John Gould and David M. Lewis. Oxford: Clarendon Press.

Poeschke, Joachim, and Hugo Brandenburg. 1996. *Antike Spolien in der Architektur des Mittelalters und der Renaissance*. Munich: Hirmer.

Pöhlmann, Egert, and Werner Gauer, eds. 1994. *Griechische Klassik: Vorträge bei der interdisziplinären Tagung des Deutschen Archäologenverbandes und der Mommsengesellschaft vom 24.–27.10.1991 in Blaubeuren*. Nürnberg: H. Carl.

Pollitt, J. J. 1972. *Art and Experience in Classical Greece*. Cambridge: Cambridge University Press.

———. 1974. *The Ancient View of Greek Art*. New Haven and London: Yale University Press.

———. 1986. *Art in the Hellenistic Age*. Cambridge: Cambridge University Press.

———. 2000. "The Phantom of a Rhodian School of Sculpture." In de Grummond and Ridgway, 92–110.

Porter, James I. 1989. "Philodemus on Material Difference." *CErc* 19: 149–78.

———. 1992. "Hermeneutic Lines and Circles: Aristarchus and Crates on Homeric Exegesis." In Lamberton and Keaney, 67–114.

———. 1995a. "οἱ κριτικοί: A Reassessment." In Abbenes et al., 83–109.

———. 1995b. "Content and Form in Philodemus: The History of an Evasion." In Dirk Obbink, ed., *Philodemus and Poetry: Poetic Theory and Practice in Lucretius, Philodemus, and Horace*. New York: Oxford University Press. 97–147.

———. 2000a. *The Invention of Dionysus: An Essay on the Birth of Tragedy*. Stanford: Stanford University Press.

———. 2000b. *Nietzsche and the Philology of the Future*. Stanford: Stanford University Press.

———. 2001a. "Ideals and Ruins: Pausanias, Longinus and the Second Sophistic." In Alcock et al., 63–92.

———. 2001b. "Des sons qu'on ne peut entendre: Ciceron, les 'kritikoi' et la tradition du sublime dans la critique littéraire." In Clara Auvray-Assayas and Daniel Delattre, eds., *Cicéron et Philodème: La polémique en philosophie*. Paris: Rue d'Ulm. 315–41.

———. 2002. "Homer: The Very Idea." *Arion* 10, no. 2: 57–86.

———. 2004. "Aristotle and the Origins of Euphony." In Salvatore Cerasuolo, Giovanni Indelli, Giuliana Leone, and Francesca Longo Auricchio, eds., *Mathesis e Mneme. Studi in Memoria di Marcello Gigante*. 2 vols. Naples: Pubblicazioni del Dipartimento di Filologia Classica "Francesco Arnaldi" dell'Università di Napoli Federico II 25. 1: 131–48.

———, ed. 1999. *Constructions of the Classical Body*. Ann Arbor: University of Michigan Press.

Potts, Alex. 1994. *Flesh and the Ideal: Winckelmann and the Origins of Art History*. New Haven: Yale University Press.

Powell, Barry B. 1991. *Homer and the Origin of the Greek Alphabet*. Cambridge: Cambridge University Press.

———. 2002. *Writing and the Origins of Greek Literature*. Cambridge: Cambridge University Press.

Powell, J.G.F., ed. 1995. *Cicero the Philosopher: Twelve Papers*. Oxford: Oxford University Press.

Powers, Martin J. 1991. *Art and Political Expression in Early China*. New Haven: Yale University Press.

Pratt, Norman T. 1983. *Seneca's Drama*. Chapel Hill and London: University of North Carolina Press.

Preisshofen, Felix. 1979. "Kunsttheorie und Kunstbetrachtung." In Flashar, 263–82.

Preziosi, Donald, and Louise Hitchcock. 1999. *Aegean Art and Architecture*. Oxford: Oxford University Press.

Price, Simon R. F. 1984. *Rituals and Power: The Roman Imperial Cult in Asia Minor*. Cambridge: Cambridge University Press.

Prinzen, Herbert. 1998. *Ennius im Urteil der Antike*. Stuttgart: J. B. Metzler.

Protzmann, Heiner. 1972–73. "Zeugnisse zum Stilbewußtsein in der hochklassischen Kunst." *JÖAI* 50: 68–93.

———. 1974. "Perikles und die klassische Kunstanschauung." *FuB* 16: 169–82.

———. 1977. "Realismus und Idealität in Spätklassik und Frühhellenismus: Ein Kapitel künstlerischer Problemgeschichte der Griechen." *DAI* 92: 169–203.

Queyrel, François. 1997. "La cécité de Laocoon." *Bulletin de la Société Nationale des Antiquaires de France 1997*: 88–96.

———. 2002. "Lo sguardo del Laocoonte." *Archeo* 18, no. 7: 38–43.

———. Forthcoming. "Les yeux du Laocoon." In *L'oeil dans l'antiquité romaine*. Lons-le-Saunier: 77–82.

Radermacher, Ludwig. 1899. "Studien zur Geschichte der antiken Rhetorik IV: Ueber die Anfänge des Atticismus." *RhM* 54: 351–74.

———. 1919. "Kanon." *RE* 10: 1873–78.

Raeder, Joachim. 1983. *Die statuarische Ausstattung der Villa Hadriana bei Tivoli*. Frankfurt am Main: Bern.
Rawson, Elizabeth. 1985a. *Intellectual Life in the Late Roman Republic*. Baltimore: Johns Hopkins University Press.
———. 1985b. "Theatrical Life in Republican Rome and Italy." *PBSR* 53: 97–113.
———. 1991. *Roman Culture and Society: Collected Papers*. Oxford: Oxford University Press.
Rawson, P. B. 1987. *The Myth of Marsyas in the Roman Visual Arts*. Oxford: *BAR* International Series, no. 347.
Regenbogen, Otto. 1950. "Pinax." *RE* 20: 1408–82.
Reid, James S., ed. 1885. *M. Tulli Ciceronis De Finibus*. London: Macmillan.
Reinach, Adolphe. 1921. *Textes grecs et latins relatifs à l'histoire de la peinture ancienne*. Paris: Macula.
Reinach, Adolphe, and Salomon Reinach. 1985. *Textes grecs et latins relatifs à l'histoire de la peinture ancienne: Recueil Milliet*. Paris: Macula.
Reitlinger, Gerald. 1961–70. *The Economics of Taste: The Rise and Fall of Picture Prices, 1760–1960*. 3 vols. London: Barrie and Rockliff.
Rice, E. E. 1986. "Prosopographika Rhodiaka II: The Rhodian Sculptors of the Sperlonga and Laocoon Statuary Groups." *BSA* 81: 233–50.
Richardson, N. J. 1981. "The Contest of Homer and Hesiod and Alcidamas' *Mouseion*." *CQ* 31, no. 1: 1–10.
Richter, Gisela Marie Augusta, and Irma A. Richter. 1970. *Kouroi*. 3rd ed. London: Phaidon.
Ricoeur, P. 1984–88. *Time and Narrative*. 3 vols. Chicago: University of Chicago Press.
Ridgway, Brunilde Sismondo. 1981. *Fifth-Century Styles in Greek Sculpture*. Princeton: Princeton University Press.
———. 1990. *Hellenistic Sculpture I: The Styles of ca. 330–200 B.C.* Madison: University of Wisconsin Press.
———. 2000a. *Hellenistic Sculpture II: The Styles of ca. 200–100 B.C.* Madison: University of Wisconsin Press.
———. 2000b. "The Sperlonga Sculptures: The Current State of Research." In de Grummond and Ridgway, 78–91.
Riegl, Alois. 1893. *Stilfragen. Grundlegungen zu einer Geschichte der Ornamentik*. Berlin: G. Siemens.
Riegl, Alois, and Ernst Heinrich Zimmermann. 1901. *Die spätrömische Kunstindustrie, nach den Funden in Österreich-Ungarn dargestellt*. Vienna: K. K. Hof- und Staats-Druckerei.
Riemer, Peter. 1999. "Klassizismus." *Der neue Pauly* 6: 493–96.
Rizzo, G. 1932. "La base di Augusto." *BullCom* 60: 7–110.
Rizzo, Silvia. 1986. "Il latino nell'Umanesimo." In Alberto Asor Rosa, ed., *Letteratura italiana*. Vol. 5: *Le questioni*. Turin: Giulio Einaudi. 379–408.
Robertson, Martin. 1975. *A History of Greek Art*. Cambridge: Cambridge University Press.
Rodenwaldt, G. 1939. "The Transition to Late Classical Art." In S. A. Cook, F. E. Adcock, M. P. Charlesworth, and H. Baynes, eds., *Cambridge Ancient History. Volume 12: The Imperial Crisis and Recovery, AD 193–324*. Cambridge: Cambridge University Press. 544–70.
———. 1944–45. "Zur Begrenzung und Gliederung der Spätantike." *JdI* 59/60: 81–87.

Rohde, Erwin. 1886. "Die asianische Rhetorik und die zweite Sophistik." *RhM* 41: 170–90.

———. 1914. *Der griechische Roman und seine Vorläufer*. 3rd ed. Leipzig: Breitkopf & Härtel.

Rohde, Georg. 1963. "Über das Lesen im Altertum." In Irmgard Rohde and Bernhard Kytzler, eds., *Studien und Interpretationen zur antiken Literature, Religion und Geschichte*. Berlin: Walter de Gruyter. 290–303.

Roller, Duane W. 1988. *Early Travellers in Eastern Boiotia*. Amsterdam: J. C. Gieben.

Romm, James S. 1992. *The Edges of the Earth in Ancient Thought: Geography, Exploration, and Fiction*. Princeton: Princeton University Press.

Rorty, Amélie Oksenberg, ed. 1992. *Essays on Aristotle's Poetics*. Princeton: Princeton University Press.

Rosaldo, Renato. 1989. "Imperialist Nostalgia." *Representations* 26: 107–22.

Rossiter, Stuart. 1977. *Blue Guide: Greece*. 3rd ed. London: Ernest Benn.

Rotroff, Susan I. 1997. "From Greek to Roman in Athenian Ceramics." In Hoff and Rotroff, 97–116.

Roullet, Anne. 1972. *The Egyptian and Egyptianizing Monuments of Imperial Rome*. Leiden: E. J. Brill.

Runnels, Curtis, and Priscilla Murray. 2001. *Greece Before History: An Archaeological Companion and Guide*. Stanford: Stanford University Press.

Russell, D. A. 1982. *Criticism in Antiquity*. Berkeley and Los Angeles: University of California Press.

———. 1990. "Aristides and the Prose Hymn." In D. A. Russell, ed., *Antonine Literature*. Oxford: Clarendon Press. 199–219.

Russell, D. A., and Nigel Guy Wilson, eds. 1981. *Menander Rhetor*. Oxford: Clarendon Press.

Russell, D. A., and Michael Winterbottom, eds. 1972. *Ancient Literary Criticism: The Principal Texts in New Translations*. Oxford: Clarendon Press.

Rutherford, Ian. 1998. *Canons of Style in the Antonine Age: Idea-Theory in its Literary Context*. Oxford: Clarendon Press.

Saïd, Suzanne. 2001. "The Discourse of Identity in Greek Rhetoric from Isocrates to Aristides." In Irad Malkin, ed., *Ancient Perceptions of Greek Ethnicity*. Washington, D.C., and Cambridge, Mass.: Center for Hellenic Studies, Trustees for Harvard University. 275–99.

———, ed. 1991. *ΈΛΛΗΝΙΣΜΟΣ. Quelques jalons pour une histoire de l'identité grecque: Actes du Colloque de Strasbourg, 25–27 octobre 1989*. Leiden and New York: E. J. Brill.

Sainte-Beuve, Charles-Augustin. [1850] 1946. *Qu'est-ce qu'un classique? Suivi de deux autres traités*. Edited by U. Mönch. Heidelberg: Carl Winter.

Salowey, C. A. 1994. "Herakles and the Waterworks: Mycenaean Dams, Classical Fountains, Roman Aqueducts." In Kenneth A. Sheedy, ed., *Archaeology in the Peloponnese: New Excavations and Research*. Oxford: Oxbow Books. 77–94.

Sapelli, M. 1999. "Catalogo." In A. La Regina, ed., *Il museo ritrovato. Archeologia*. Rome.

———. 2000. In Serena Ensoli and Eugenio La Rocca, eds., *Aurea Roma: Dalla città pagana alla città cristiana*. Rome: L'Erma di Bretschneider. 534–36.

Sartre, Jean-Paul. 1967. *What Is Literature?* Translated by Bernard Frechtman. London: Methuen.

Sblendorio Cugusi, Maria Teresa, ed. 1982. *M. Porci Catonis orationum reliquiae.* Turin: G. B. Paravia.
Schachter, Albert. 1981. *Cults of Boiotia. 1, Acheloos to Hera.* BICS Supplement 38, no. 1. London: University of London Institute of Classical Studies.
———. 1986. *Cults of Boeotia 2, Herakles to Poseidon.* BICS Supplement 38, no. 2. London: University of London Institute of Classical Studies.
———. 1994. *Cults of Boiotia. 3, Potnia to Zeus: Cults of Deities Unspecified by Name.* BICS Supplement 38, no. 3. London: University of London Institute of Classical Studies.
Schadewaldt, Wolfgang. 1931. "Begriff und Wesen der antiken Klassik." In Jaeger, 15–32.
———. 1970. "Furcht und Mitleid? Zur Deutung des aristotelischen Tragödiensatzes." In *Hellas und Hesperien. Gesammelte Schriften zur Antike und zur neueren Literatur in 2 Banden.* 2nd ed. Zurich: Artemis-Verlag. 1: 194–236.
Schäfer, Thomas. 1998. *Spolia et signa. Baupolitik und Reichskultur nach dem Partherefolg des Augustus.* Göttingen: Vandenhoeck & Ruprecht.
Scheid, John. 1987. "Polytheism Impossible; Or the Empty Gods: Reasons Behind a Void in the History of Roman Religion." *History and Anthropology* 3: 303–25.
Schenkeveld, Dirk. 1992. "Prose Usages of AKOYEIN 'To Read.'" *CQ* 42, no. 1: 129–41.
Schibli, Hermann S. 1990. *Pherekydes of Syros.* Oxford: Clarendon Press.
Schindel, Ulrich. 1994. "Archaismus als Epochenbegriff: Zum Selbstverständnis des 2. Jhs." *Hermes* 22: 327–41.
———. 1997. "Neues zur Begriffsgeschichte von Archaismus." *Hermes* 125: 249–52.
Schindler, W. 1988. "'Klassizismus'—ein Krisensymptom des 3. Jhs." In *Krise, Krisenbewußtsein, Krisenbewältigung: Ideologie und geistige Kultur im Imperium Romanum während des 3. Jahrhunderts. Konferenzvorträge.* Halle (Saale): Martin-Luther-Universität Halle-Wittenberg. 76–88.
Schlegel, Friedrich von. 1972. "Über das Studium der griechischen Poesie." In Friedrich von Schlegel, *Schriften zur Literatur.* Munich: Deutscher Taschenbuch-Verlag. 84–192.
———. 1979. *Kritische Friedrich-Schlegel-Ausgabe.* Vol. 1: *Studien des klassischen Altertums.* Edited by Ernst Behler with Jean Jacques Anstett and Hans Eichner. Paderborn: Ferdinand Schöningh.
Schliemann, Heinrich. 1881a. "Exploration of the Boeotian Orchomenos." *JHS* 2: 122–63.
———. 1881b. *Orchomenos: Bericht über meine Ausgrabungen im böotischen Orchomenos.* Leipzig: F. A. Brockhaus.
Schmaltz, Bernhard. 1994. "Ein triumphierender Alexander?" *RM* 101: 121–29.
Schmalzriedt, Egidius. 1971. *Inhumane Klassik: Vorlesung wider ein Bildungsklischée.* Munich: Kindler.
Schmid, Wilhelm. 1887–97. *Der Atticismus in seinen Hauptvertretern von Dionysius von Halikarnass bis auf den zweiten Philostratus.* 5 vols. in 2 Stuttgart: W. Kohlhammer.
———. 1898. *Über den kulturgeschichtlichen Zusammenhang und die Bedeutung der griechischen Renaissance in der Römerzeit. Akademische Antrittsrede gehalten am 3. Februar 1898 in Tübingen.* Leipzig: Dieterich.

Schmidt, Erika. 1973. *Die Kopien der Erechtheionkoren*. Berlin: Mann.
Schmidt, Ernst A. 2003. *Augusteische Literatur: System in Bewegung. Vorgetragen am 19. Juni 1998*. Heidelberg: Carl Winter.
Schmitz, Thomas. 1997. *Bildung und Macht: Zur sozialen und politischen Funktion der zweiten Sophistik in der griechischen Welt der Kaiserzeit*. Zetemata, vol. 97. Munich: C. H. Beck.
Schnapp, Alain. 1996. *The Discovery of the Past: The Origins of Archaeology*. London: British Museum Press.
Schneider, Rolf Michael. 1986. *Bunte Barbaren: Orientalenstatuen aus farbigem Marmor in der römischen Repräsentationskunst*. Worms: Wernersche Verlagsgesellschaft.
———. 2002. "Nuove immagini del potere romano. Sculture di marmo colorato nell'impero romano." In Marilda De Nuccio and Lucrezia Ungaro, eds., *I marmi colorati della Roma imperiale*. Venice: Marsilio. 83–105.
Schofield, Malcolm. 1991. *The Stoic Idea of the City*. Cambridge: Cambridge University Press.
———. 2002. "Academic Therapy: Philo of Larissa and Cicero's Project in the *Tusculans*." In Gillian Clark and Tessa Rajak, eds., *Philosophy and Power in the Graeco-Roman World: Essays in Honour of Miriam Griffin*. Oxford: Oxford University Press. 91–109.
Scholl, Andreas. 1995. "Choephoroi. Zur Deutung der Korenhalle des Erechtheion." *JdI* 110: 179–212.
Schröder, Stephan. 1990. *Plutarchs Schrift De Pythiae Oraculis: Text, Einleitung und Kommentar*. Stuttgart: B. G. Teubner.
Schuchardt, Karl. 1891. *Schliemann's Excavations: An Archaeological and Historical Study*. Translated by Eugénie Sellers. London: Macmillan.
Schweitzer, Bernhard. 1930. "Zu den Anfängen des Klassizismus in der griechischen Kunst." *Forschungen und Fortschritte* 6, no. 32 (10 November): 413–15.
———. 1932. *Xenokrates von Athen: Beiträge zur Geschichte der antiken Kunstforschung und Kunstanschauung*. Schriften der Königsberger Gelehrten Gesellschaft. Geisteswissenschaftliche Klasse, vol. 9.1. Halle (Saale): Max Niemeyer.
Schwindt, Jürgen Paul. 2000. *Prolegomena zu einer "Phänomenologie" der römischen Literaturgeschichtsschreibung: Von den Anfängen bis Quintilian*. Hypomnemata, Heft 130. Göttingen: Vandenhoeck & Ruprecht.
Scodel, Ruth. 2003. "'Young Men of Sidon,' Aeschylus' Epitaph, and Canons." *Classical and Modern Literature* 23, no. 2: 129–41.
Scranton, Robert Lorentz. 1941. *Greek Walls*. Cambridge, Mass.: Harvard University Press.
Sedley, David N. 1989. "Philosophical Allegiance in the Greco-Roman World." In Griffin and Barnes, 97–119.
Segal, Charles. 1961. "The Character and Cults of Dionysus and the Unity of the *Frogs*." *HSCP* 65: 207–42.
———. 1989. "Archaic Choral Lyric." In *CHCL* 1.1:124–60.
———. 1992. "Bard and Audience in Homer." In Lamberton and Keaney, 3–29.
Sehlmeyer, Markus. 1999. *Stadtrömische Ehrenstatuen der republikanischen Zeit: Historizität und Kontext von Symbolen nobilitären Standesbewusstseins*. Stuttgart: Franz Steiner.
Seidensticker, Bernd. 2002. "Wie die Tragiker zu Klassikern wurden." In [Anon.], 526–29.

Selden, Daniel L. 1998. "Alibis." *CA* 17, no. 2: 289–412.
Settis, Salvatore. 1986. "Continuità, distanza, conoscenza. Tre usi dell'antico." In Salvatore Settis, ed., *Memoria dell'antico nell'arte italiana*. Turin: Giulio Einaudi. 3: 375–486.
———. 1989. "Un'arte al plurale. L'impero romano, i Greci e i posteri." In Arnaldo Momigliano and Aldo Schiavone, eds., *Storia di Roma*. Volume 4. *Caratteri e morfologie*. Turin: Giulio Einaudi. 827–78.
———. 1998. In Matthias Winner, Bernard Andreae, and Carlo Pietrangeli, eds., *Il Cortile delle Statue: Der Statuenhof des Belvedere im Vatikan. Akten des internationalen Kongresses zu Ehren von Richard Krautheimer, Rom, 21.–23. Okt. 1992*. Mainz am Rhein: Philipp von Zabern.
———. 1999. *Laocoonte, Fama e Stile*. Rome: Donzelli.
———. 2002. "Der Klassizismus und das Klassische: Ein Durchgang im Rückblick." In [Anon.], 26–53.
———. 2004. *Futuro del "classico."* Turin: Giulio Einaudi.
Sextus Empiricus. 1998. *Against the Grammarians (Adversus mathematicos I)*. Translated with an Introduction and Commentary by D. L. Blank. Oxford: Clarendon Press.
Shanks, Michael. 1992. *Experiencing the Past: On the Character of Archaeology*. London and New York: Routledge.
Sichtermann, H. 1988. "Ganymedes." *LIMC* 4.1: 154–69.
Siena, S. L. 1999. "Considerazioni sul reimpiego di manufatti nell'Alto Medioevo: Dagli oggetti d'uso ai Preziosi." *Settimane* 46: 751–84.
Silk, M. S., and J. P. Stern. 1981. *Nietzsche on Tragedy*. Cambridge: Cambridge University Press.
Simon, Erika. 1967. *Ara Pacis Augustae*. Tübingen: Wasmuth.
———. 1982. *The Ancient Theatre*. Translated by C. E. Vafopoulou-Richardson. London and New York: Methuen.
———. 1997. "Kybele." *LIMC* 8.1: 744–66.
Simpson, David. 1995. "Raymond Williams: Feeling for Structures, Voicing History." In Christopher Prendergast, ed., *Cultural Materialism: On Raymond Williams*. Minneapolis: University of Minnesota Press. 29–50.
Skidmore, C. 1996. *Practical Ethics for Roman Gentlemen. The Work of Valerius Maximus*. Exeter: University of Exeter Press.
Skinner, Q. 1994. "Moral Ambiguity and the Renaissance Art of Eloquence." *Essays in Criticism* 4: 267–92.
Skutsch, Otto, ed. 1985. *The Annals of Q. Ennius*. Oxford: Clarendon Press.
Small, Jocelyn Penny. 1982. *Cacus and Marsyas in Etrusco-Roman Legend*. Princeton: Princeton University Press.
———. 2003. *The Parallel Worlds of Classical Art and Text*. Cambridge: Cambridge University Press.
Smith, Barbara Herrnstein. 1988. *Contingencies of Value: Alternative Perspectives for Critical Theory*. Cambridge, Mass.: Harvard University Press.
Smith, Bruce R. 1999. *The Acoustic World of Early Modern England: Attending to the O-Factor*. Chicago: University of Chicago Press.
Smith, Philippa R. 1995. "A Self-Indulgent Misuse of Leisure and Writing?" In Powell, 301–24.
Smith, R.R.R. 1991. *Hellenistic Sculpture*. New York: Thames & Hudson.

Snell, Bruno. 1953. *The Discovery of the Mind: The Greek Origins of European Thought.* Translated by T. G. Rosenmeyer. Oxford: Blackwell.

Snodgrass, Anthony M. 1980. *Archaic Greece: The Age of Experiment.* Berkeley and Los Angeles: University of California Press.

Sommerstein, Alan H., ed. 1996. *Aristophanes, Frogs. The Comedies of Aristophanes*, Vol. 9. Warminster: Aris & Phillips.

Sontag, Susan. 1977. *On Photography.* New York: Farrar, Straus, Giroux.

Spannagel, Martin. 1999. *Exemplaria principis: Untersuchungen zu Entstehung und Ausstattung des Augustusforums.* Heidelberg: Verlag Archäologie und Geschichte.

Spivey, Nigel Jonathan. 1997. *Etruscan Art.* New York: Thames & Hudson.

———. 2001. *Enduring Creation: Art, Pain, and Fortitude.* Berkeley and Los Angeles: University of California Press.

Spyropoulos, G. 2001. *Drei Meisterwerke der griechischen Plastik aus der Villa des Herodes Atticus zu Eva, Loukou.* Frankfurt am Main: Peter Lang.

Spyropoulos, Th. 1974. "To anaktoron tou Minyou eis ton Boiotikon Orchomenon." *AAA* 7: 313–25.

Stadler, Peter Bruno. 1959. *Wilhelm von Humboldts Bild der Antike.* Zürich: Artemis-Verlag.

Stadter, Philip A. 1989. *A Commentary on Plutarch's Pericles.* Chapel Hill: University of North Carolina Press.

Stallybrass, Peter, and Allon White. 1986. *The Politics and Poetics of Transgression.* London: Methuen.

Stanford, W. B. 1967. *The Sound of Greek: Studies in the Greek Theory and Practice of Euphony.* Berkeley and Los Angeles: University of California Press.

Stanton, G. R. 1973. "Sophists and Philosophers: Problems of Classification." *AJP* 94: 350–64.

Starr, C. P. 1952. "The Perfect Democracy of the Roman Empire." *AHR* 58, 1–16.

Starr, Raymond J. 1991. "Reading Aloud: *Lectores* and Roman Reading." *CJ* 86, no. 4: 337–43.

Steinmetz, Peter. 1964. "Gattungen und Epochen der griechischen Literatur in der Sicht Quintilians." *Hermes* 92, no. 4: 454–66.

———. 1982. *Untersuchungen zur römischen Literatur des zweiten Jahrhunderts nach Christi Geburt.* Wiesbaden: Franz Steiner.

Stemmler, M. 2000. "*Auctoritas exempli.* Zur Wechselwirkung von kanonisierten Vergangenheitsbildern und gesellschaftliche Gegenwart in der spätrepublikanischen Rhetorik." In Bernhard Linke and Michael Stemmler, eds., *Mos Maiorum: Untersuchungen zu den Formen der Identitätsstiftung und Stabilisierung in der römischen Republik.* Stuttgart: F. Steiner. 141–206.

Stenzel, Hartmut. 2000. "Klassik als Klassizismus." In *Der neue Pauly* 14: 887–901.

Stephanis, I. E. 1988. *Dionysiakoi Technitai: Symvoles sten Prosopographia tou Theatrou kai tes Mousikes ton Archaion Hellenon.* Herakleion: University of Herakleion Press.

Stephens, Susan A. 2003. *Seeing Double: Intercultural Poetics in Ptolemaic Alexandria.* Berkeley and Los Angeles: University of California Press.

Stewart, Andrew. 1979. *Attika: Studies in Athenian Sculpture of the Hellenistic Age.* London: Society for the Promotion of Hellenic Studies.

———. 1990. *Greek Sculpture: An Exploration*. 2 vols. New Haven: Yale University Press.
———. 1993a. "Narration and Allusion in the Hellenistic Baroque." In Peter J. Holliday, ed., *Narrative and Event in Ancient Art*. Cambridge: Cambridge University Press. 130–74.
———. 1993b. *Faces of Power: Alexander's Image and Hellenistic Politics*. Berkeley and Los Angeles: University of California Press.
———. 1997. *Art, Desire, and the Body in Ancient Greece*. Cambridge: Cambridge University Press.
———. 1998. "Nuggets: Mining the Texts Again." *AJA* 102: 271–82.
———. 2004. *Attalos, Athens, and the Akropolis. The Pergamene "Little Barbarians" and Their Roman and Renaissance Legacy*. Cambridge: Cambridge University Press.
Stinton, T.C.W. 1975. "*Hamartia* in Aristotle and Greek Tragedy." *CQ* 25a: 221–54.
Stokes, Michael C. 1995. "Cicero on Epicurean Pleasures." In Powell, 145–70.
Stoneman, Richard. 1987. *Land of Lost Gods: The Search for Classical Greece*. London: Hutchinson.
Strassburger, Hermann. 1958. "Thukydides und die politische Selbstdarstellung der Athener." *Hermes* 86: 17–40.
Straume-Zimmermann, Laila, Ferdinand Broemser, and Olof Gigon, eds., 1990. [Marcus Tullius Cicero.] *Hortensius, Lucullus, Academici Libri: Lateinisch-Deutsch*. Munich: Artemis.
Striker, Gisela. 1997. "Academics Fighting Academics." In Inwood and Mansfeld, 257–76.
Strobel, Claudia. Forthcoming, 2005. "Which Lexica Did Athenaeus (not) Read?" In Christian Jacob, ed. *La cuisine du savoir: grammairiens, philosophes et cuisiniers dans les Deipnosophistes d'Athénée*. Grenoble: Jérôme Millon.
Strocka, V. M. 1999. "Zur Datierung des Sperlonga-Gruppen und des Laokoon." In Bol, 307–22.
Stroux, J. 1931. "Die Anschauungen vom klassischen im Altertum." In Jaeger, 1–14.
Stubbings, Frank H. 1972. *Prehistoric Greece*. London: Rupert Hart-Davis.
Suerbaum, Werner. 1968. *Untersuchungen zur Selbstdarstellung älterer römischer Dichter: Livius Andronicus, Naevius, Ennius*. Hildesheim: G. Olms.
Suphan, Bernhard, ed. 1877–1913. *Herders sämmtliche Werke*. 33 vols. Berlin: Heidmann.
Svenbro, Jesper. 1993. *Phrasikleia: An Anthropology of Reading in Ancient Greece*. Translated by Janet Lloyd. Ithaca: Cornell University Press.
Swain, Simon. 1996. *Hellenism and Empire: Language, Classicism, and Power in the Greek World, AD 50–250*. Oxford: Clarendon Press.
Taplin, Oliver. 1986. "Fifth-Century Tragedy and Comedy: A *Synkrisis*." *JHS* 106: 163–74.
Tarrant, Richard J. 1978. "Senecan Drama and Its Antecedents." *HSCP* 82: 213–63.
Tatarkiewicz, Wladyslaw. 1958. "Les quatre significations du mot 'classique.'" *Revue Internationale de Philosophie* 12, no. 43: 5–22.
Taylour, Lord William. 1983. *The Mycenaeans*. Rev. ed. New York: Thames & Hudson.
Thomas, Richard F. 1983. "Callimachus, the Victoria Berenices, and Roman Poetry." *CQ* 33: 92–113.

Thomas, Rosalind. 1989. *Oral Tradition and Written Record in Classical Athens*. Cambridge: Cambridge University Press.
———. 1992. *Literacy and Orality in Ancient Greece*. Cambridge: Cambridge University Press.
———. 2000. *Herodotus in Context: Ethnography, Science, and the Art of Persuasion*. Cambridge: Cambridge University Press.
Tilley, Christopher Y. 1994. *A Phenomenology of Landscape: Places, Paths, and Monuments*. Oxford and Providence: R.I.: Berg.
Tobin, Jennifer. 1997. *Herodes Attikos and the City of Athens*. Amsterdam: Gieben.
Too, Yun Lee. 1995. *The Rhetoric of Identity in Isocrates: Text, Power, Pedagogy*. Cambridge: Cambridge University Press.
———. 1998. *The Idea of Ancient Literary Criticism*. Oxford: Clarendon Press.
———, ed. 2001. *Education in Greek and Roman Antiquity*. Leiden and Boston: Brill.
Torelli, Mario. 1996. "Roman Art, 43 B.C.–A.D. 69." In Alan K. Bowman, Edward Champlin, and Andrew Lintott, eds., *The Cambridge Ancient History. Volume 10, The Augustan Empire, 43 B.C.–A.D. 69*. Cambridge: Cambridge University Press. 930–58.
Toynbee, Jocelyn M. C. 1934. *The Hadrianic School: A Chapter in the History of Greek Art*. Cambridge: Cambridge University Press.
Traill, David A. 1993. *Excavating Schliemann: Collected Papers on Schliemann*. Atlanta: Scholars Press.
———. 1995. *Schliemann of Troy: Treasure and Deceit*. New York: St. Martin's Press.
Trendall, A. D., and T.B.L. Webster. 1971. *Illustrations of Greek Drama*. London and New York: Phaidon Press.
Tröger, Gustav. 1899–1900. *Der Sprachgebrauch in der pseudolonginianischen Schrift Περὶ ὕψους und deren Stellung zum Atticismus, I. Teil*. Programm des Königl. humanistischen Gymnasiums Burghaus, 1899/1900. Burghausen: Leo Russy.
Tsountas, Christos, and J. Irving Manatt. 1897. *The Mycenaean Age: A Study of the Monuments and Culture of Pre-Homeric Greece*. Boston and New York: Houghton, Mifflin. (Reprint 1969, Chicago: Argonaut.)
Tucker, Robert C., ed. 1978. *The Marx-Engels Reader*. 2nd ed. New York: Norton.
Turcan, Robert. 1989. *Les cultes orientaux dans le monde romain*. Paris: Belles Lettres.
Turner, J. G. 1990. "The Poetics of Engagement." In David Loewenstein and James Turner, eds., *Politics, Poetics, and Hermeneutics in Milton's Prose: Essays*. Cambridge: Cambridge University Press. 257–75.
Uría Varela, Javier. 1998. "Classicus adsiduusque scriptor (Gell. XIX 8. 15)." *Estudios Clásicos* 113: 47–58.
Van Dyke, Ruth, and Susan E. Alcock, eds. 2003. *Archaeologies of Memory*. Malden, Mass.: Blackwell.
Venit, Marjorie. 2002. *The Monumental Tombs of Ancient Alexandria*. Cambridge: Cambridge University Press.
Vercellone, Federico. 1988. *Identità dell'antico: L'idea del classico nella cultura tedesca del primo ottocento*. Turin: Rosenberg & Sellier.
Vermaseren, Maarten J., ed. 1981. *Die orientalischen Religionen im Römerreich*. Leiden: E. J. Brill.
Vermeule, Emily. 1972. *Greece in the Bronze Age*. Chicago: University of Chicago Press.

———. 1986. "Priam's Castle Blazing: A Thousand Years of Trojan Memories." In J. Lawrence Angel and Machteld J. Mellink, eds., *Troy and the Trojan War: A Symposium Held at Bryn Mawr College, October 1984*. Bryn Mawr, Pa.: Bryn Mawr College. 77–92.

Vernant, Jean-Pierre. 1980. *Myth and Society in Ancient Greece*. Translated by Janet Lloyd. Atlantic Highlands, N.J: Humanities Press.

———. 1991. "A 'Beautiful Death' and the Disfigured Corpse in Homeric Epic." In J.-P. Vernant, *Mortals and Immortals: Collected Essays*. Edited by Froma I. Zeitlin. Princeton: Princeton University Press. 50–74.

Vernant, Jean-Pierre, and Pierre Vidal-Naquet. 1988. *Myth and Tragedy in Ancient Greece*. New York and Cambridge, Mass.: Zone Books, MIT Press.

Versluys, M. J. 1997. "The Sanctuary of Isis on the Campus Martius in Rome." *BABesch* 72: 159–69.

———. 2002. *Aegyptiaca Romana: Nilotic Scenes and the Roman Views of Egypt*. Leiden: E. J. Brill.

Versteegh, Kurt. 1987. "Latinitas, Hellenismos, 'Arabiyya.' " In Daniel J. Taylor, ed., *The History of Linguistics in the Classical Period*. Amsterdam and Philadelphia: John Benjamins Publishing Co. 251–74.

Vezin, Gilberte. 1950. *L'Adoration et le cycle des Mages dans l'art chrétien primitif: Etude des influences orientales et grecques sur l'art chrétien*. Paris: Presses Universitaires de France.

Vickers, Michael. 1985. "Artful Crafts: The Influence of Metalwork on Athenian Painted Pottery." *JHS* 105: 108–28.

———. 1987. "Value and Simplicity: Eighteenth Century Taste and the Study of Greek Vases." *P&P* no. 116: 98–137.

———. 1990. "The Impoverishment of the Past: The Case of Classical Greece." *Antiquity* 64: 455–63.

Vickers, Michael, and David W. J. Gill. 1996. *Artful Crafts: Ancient Greek Silverware and Pottery*. 2nd ed. Oxford: Clarendon. (1st ed. 1994.)

Vogt, Joseph. 1968. "Dämonie der Macht und Weisheit der Antike." In Hans Herter, ed., *Thukydides*. Darmstadt: Wissenschaftliche Buchgesellschaft. 282–308.

von Staden, Heinrich. 1997. "Galen and the Second Sophistic." In Richard Sorabji, ed., *Aristotle and After*. *BICS Supplement* 68. 33–56.

Voßkamp, Wilhelm, ed. 1993. *Klassik im Vergleich: Normativität und Historizität europäischer Klassiken. DFG-Symposion 1990*. Stuttgart and Weimar: J. B. Metzler.

Vout, C. 2000. *Objects of Desire: Eroticised Political Discourse in Imperial Rome*. Diss., Cambridge: University of Cambridge.

———. 2003. "Embracing Egypt." In Edwards and Woolf, 177–202.

Walbank, F. E. 1955. "Tragic History: A Reconsideration." *BICS* 2: 4–14.

———. 1960. "Tragedy and History." *Historia* 9: 216–34.

Wallace, Paul W. 1979. *Strabo's Description of Boiotia: A Commentary*. Heidelberg: Carl Winter Universitätsverlag.

———. 1985. "The Tomb of Hesiod and the Treasury of Minyas at Orkhomenos." In J. M. Fossey and H. Giroux, eds., *Proceedings of the Third International Conference on Boeotian Antiquities*. Amsterdam: J. C. Gieben. 165–79.

Wallace-Hadrill, Andrew. 1989. "Rome's Cultural Revolution." Rev. of Paul Zanker, *The Power of Images in the Age of Augustus*. *JRS*. 79: 157–64.
Walsdorff, Friedrich. 1927. *Die antiken Urteile über Platons Stil*. Bonn: Universitäts-Buchdruckerei G. Scheur.
Ward-Perkins, J. B. 1981. *Roman Imperial Architecture*. 2nd ed. New Haven: Yale University Books.
Warren, Peter. 1975. *The Aegean Civilizations*. Oxford: Elsevier.
Watson, Gerard. 1988. *Phantasia in Classical Thought*. Galway: Galway University Press.
Webb, Ruth. 2001. "The *Progymnasmata* as Practice." In Too, ed., *Education in Greek and Roman Antiquity*, 289–316.
Webb, Timothy. 2002. "Appropriating the Stones: The 'Elgin Marbles' and English National Taste." In Elazar Barkan and Ronald Bush, eds., *Claiming the Stones/Naming the Bones: Cultural Property and the Negotiation of National and Ethnic Identity*. Los Angeles: Getty Research Institute. 51–96.
Weber, Max. 1920. *Die protestantische Ethik und der Geist des Kapitalismus*. In *Gesammelte Aufsätze zur Religionssoziologie*. 3 vols. Tübingen: Mohr. 1: 17–206.
Webster, T.B.L. 1966. *The Art of Greece: The Age of Hellenism*. New York: Crown Publishers.
Wehrli, F. 1967. *Die Schule des Aristoteles I*. 2nd ed. Basel: Schwabe.
Weippert, Otto. 1972. *Alexander-Imitatio und römische Politik in republikanischer Zeit*. Augsburg: [S.n.].
Weis, H. A. 1992. *The Hanging Marsyas and Its Copies*. Rome: L'Erma di Bretschneider.
———. 1998. "Pasquino and Sperlonga: Menelaos and Patroklos or Aeneas and Lausus (*Aen*. 10.791–832)?" In Hartswick and Sturgeon, 255–86.
———. 2000. "Odysseus at Sperlonga: Hellenistic Hero or Roman Heroic Foil?" In de Grummond and Ridgway, 111–65.
Wellek, René. 1970. "The Term and Concept of 'Classicism' in Literary History." In René Wellek, *Discriminations: Further Concepts of Criticism*, New Haven and London: Yale University Press. 55–89.
Wesenberg, B. 1984. "Augustusforum und Akropolis." *JdI* 99: 161–85.
West, M. L. 1981. "The Singing of Homer and the Modes of Early Greek Music." *JHS* 101: 113–29.
———. 1999. "The Invention of Homer." *CQ* 49, no. 2: 364–82.
West, Stephanie. 1988. In Alfred Heubeck, Stephanie West, J. B. Hainsworth, et. al., eds., *A Commentary on Homer's Odyssey*. 3 vols. Vol. 1: *Introduction and Books i–viii*. Edited by Alfred Heubeck, Stephanie West, and J. B. Hainsworth. Oxford: Clarendon Press.
White, Donald O. 1992. "Werner Jaeger's 'Third Humanism' and the Crisis of Cultural Politics in Weimar Germany." In William M. Calder III, ed., *Werner Jaeger Reconsidered: Proceedings of the Second Oldfather Conference, Held on the Campus of the University of Illinois at Urbana-Champaign, April 26–28, 1990. ICS*, Supplement 3. Atlanta: Scholars Press. 267–88.
White, Stephen A. 1995. "Cicero and the Therapists." In Powell, 219–46.
Whitmarsh, Tim. 1999. "Greek and Roman in Dialogue: The Pseudo-Lucianic Nero." *JHS* 119: 142–60.
———. 2001. *Greek Literature and the Roman Empire: The Politics of Imitation*. Oxford: Oxford University Press.

Wickhoff, Franz. 1895. *Die Wiener Genesis.* Vienna: F. Tempsky.
Wilamowitz-Moellendorff, Ulrich von. 1900. "Asianismus und Atticismus." *Hermes* 35: 1–52. Reprinted in U. von Wilamowitz-Moellendorff, *Kleine Schriften* 3. Berlin: Akademie-Verlag, 1969.
———. 1921. *Geschichte der Philologie.* Leipzig and Berlin: B. G. Teubner. (= *Einleitung in die Altertumswissenschaft*, Alfred Gercke and Eduard Norden, eds., 3rd ed., vol. 1 [1927].)
Williams, Bernard. 1993. *Shame and Necessity.* Berkeley and Los Angeles: University of California Press.
Williams, Raymond. 1966. *Modern Tragedy.* Stanford: Stanford University Press.
———. 1973. *The Country and the City.* New York: Oxford University Press.
———. 1977. *Marxism and Literature.* Oxford: Oxford University Press.
Winckelmann, Johann Joachim. [1764] 1972. *Geschichte der Kunst des Altertums.* Darmstadt: Wissenschaftliche Buchgesellschaft.
———. [1755] 1987. *Gedanken über die Nachahmung der griechischen Werke in der Malerei und Bildhauerkunst.* Edited and translated by Elfriede Heyer and Roger C. Norton. La Salle, Ill.: Open Court.
Winner, Matthis, Bernard Andreae, and Carlo Pietrangeli, eds. 1998. *Il Cortile delle Statue = Der Statuenhof des Belvedere im Vatikan: Akten des internationalen Kongresses zu Ehren von Richard Krautheimer, Rom, 21.–23. Okt. 1992.* Mainz am Rhein: Philipp von Zabern.
Wise, Jennifer. 1998. *Dionysus Writes: The Invention of Theatre in Ancient Greece.* Ithaca: Cornell University Press.
Wisse, Jakob. 1995. "Greeks, Romans and the Rise of Atticism." In Abbenes et al. 65–82.
Wohl, B. L. 2001. "Constantine's Use of *Spolia*." In Jens Fleischer, John Lund, and Marjatta Nielsen, eds., *Late Antiquity: Art in Context.* Copenhagen: Museum Tusculanum Press, University of Copenhagen. 85–116.
Wohl, Victoria. 2002. *Love among the Ruins: The Erotics of Democracy in Classical Athens.* Princeton: Princeton University Press.
Wolf, F. A. 1831–35. *Vorlesungen über die Alterthumswissenschaft.* Edited by J. D. Gürtler. 5 vols. Leipzig: A. Lehnhold.
———. 1869. *Kleine Schriften in lateinischer und deutscher Sprache.* Edited by Gottfried Bernhardy. 2 vols. Halle: Verlag der Buchhandlung des Waisenhauses.
Wölfflin, Heinrich. 1948. *Die klassische Kunst: Eine Einführung in die italienische Renaissance.* 8th ed. Basel: Benno Schwabe & Co. (1st ed. 1898.)
Wollheim, R. 1980. *Art and Its Objects.* 2nd ed. Cambridge: Cambridge University Press.
Wood, Michael. 1985. *In Search of the Trojan War.* London: BBC Books.
Wood, Robert. 1775. *An Essay on the Original Genius & Writing of Homer. With a Comparative View of the Ancient & Present State of the Troade.* Rev. ed. London: Printed by H. Hughs for T. Payne & P. Elmsly. (1st ed. 1769; reprint, Washington, D.C.: McGrath Publishing Co., 1973.)
Woolf, Greg. 1994. "Becoming Roman, Staying Greek: Culture, Identity and the Civilizing Process in the Roman East." *PCPS* 40: 116–43.
Wrede, Henning. 1981. *Consecratio in Formam Deorum.* Mainz am Rhein: Philipp von Zabern.
Wright, M. R. 1990. *On Stoic Good and Evil: De finibus Bonorum et Malorum, Liber III, and Paradoxa Stoicorum.* Warminster: Aris & Phillips.

Wülfing-von Martitz, Peter. 1972. "Ennius als hellenistischer Dichter." In Otto Skutsch, ed., *Ennius: Sept exposés suivis de discussions*. Vol. 17. Geneva: Fondation Hardt. 253–89.
Wünsche, R. 1991. "Pasquino." *MüJB* 42: 7–38.
———. 1995. "Marsyas in der antiken Kunst." In Baumstark and Volk, 19–47.
Zagdoun, Mary Anne. 1989. *La sculpture archaisante dans l'art hellénistique et dans l'art romain du haut-empire*. Athens and Paris: Ecole Française d'Athènes and De Boccard Dépositaire.
Zanker, Graham. 2004. *Modes of Viewing in Hellenistic Poetry and Art*. Madison: University of Wisconsin Press.
Zanker, Paul. 1970. *Forum Augustum: Das Bildprogramm*. Tübingen: E. Wasmuth.
———. 1973. *Studien zu den Augustus-Porträts I. Der Actium-Typus*. Göttingen: Vanderhoeck & Ruprecht.
———. 1974. *Klassizistische Statuen: Studien zur Veränderung des Kunstgeschmacks in der römischen Kaiserzeit*. Mainz am Rhein: Philipp von Zabern.
———. 1979. "Zur Funktion und Bedeutung griechischer Skulptur in der Römerzeit." In Flashar, 283–314.
———. 1983. "Der Apollotempel auf dem Palatin." In *Città e architettura nella Roma imperiale*. Analecta romana Instituti Danici, Suppl. Vol. 10. 21–40.
———. 1984. *Il foro di Augusto*. Rome: Fratelli Palombi Editori.
———. 1987. *Augustus und die Macht der Bilder*. Munich: C. H. Beck.
———. 1988a. *The Power of Images in the Age of Augustus*. Translated by Alan Shapiro. Ann Arbor: University of Michigan Press.
———. 1988b. "Bilderzwang: Augustan Political Symbolism in the Private Sphere." In *Image and Mystery in the Roman World: Three Papers Given in Memory of Jocelyn Toynbee*. Gloucester: A. Sutton. 1–21.
———. 1988c. "Klassizismus und Archaismus. Zur Formensprache der neuen Kultur." In *Kaiser Augustus und die verlorene Republik*. Mainz am Rhein: Philipp von Zabern.
———. 1999. "Mythenbilder im Haus." In *Classical Archaeology towards the Third Millennium. Proceedings of the 15th International Congress of Classical Archaeology*. Amsterdam. 40–48.
Zeitlin, Froma I. 2001. "Visions and Revisions of Homer." In Goldhill, 195–266.
Zeller, Hans. 1955. *Winckelmanns Beschreibung des Apollo im Belvedere*. Zürich: Atlantis Verlag.
Zerner, Henri. 1988. "Classicism as Power." *Art Journal* 47: 35–36.
Zetzel, James. 2003. "Plato with Pillows: Cicero on the Uses of Greek Culture." In David Braund and Christopher Gill, eds., *Myth, History and Culture in Republican Rome: Studies in Honour of T. P. Wiseman*. Oxford: Clarendon Press. 119–38.
Ziegler, Konrat. 1934. *Das hellenistische Epos: Ein vergessenes Kapitel griechischer Dichtung*. Leipzig and Berlin: B. G. Teubner. (2nd ed. 1966.)
———. 1950. "Plagiat." *RE* 20: 1956–97.
Žižek, Slavoj. 1989. *The Sublime Object of Ideology*. London and New York: Verso.

CONTRIBUTORS

Armand D'Angour has been Fellow and Tutor in Classics at Jesus College, Oxford, since 2000. His research interests include various aspects of Greek language and literature, psychology, and cultural history. He has published articles on ancient Greek music and on Roman poetry, and was commissioned by the International Olympic Committee to compose a Pindaric *Ode to Athens* for the 2004 Olympic Games. He is currently working on two books, *The Greeks and the New* (on ancient Greek responses to novelty and innovation) and *Aristophanes and Athenian Society*.

Susan E. Alcock is John H. D'Arms Collegiate Professor of Classical Archaeology and Classics at the University of Michigan. She is the author of *Graecia Capta: The Landscapes of Roman Greece* (1993) and *Archaeologies of the Greek Past: Landscape, Monuments and Memories* (2001), and has edited or coedited several other volumes. Her current research interests include the Hellenistic and Roman Eastern Mediterranean and Caucasus, landscape archaeology, and the archaeology of imperialism. She is a 2001 recipient of a MacArthur Fellowship from the John D. and Catherine T. MacArthur Foundation.

John F. Cherry is Professor of Classical Archaeology and Greek, Curator at the Kelsey Museum of Archaeology, and Director of the Interdepartmental Program in Classical Art and Archaeology at the University of Michigan. He has directed or codirected several archaeological survey projects in Greece, and has also been involved in fieldwork in the UK, USA, Italy, and (most recently) Armenia. He has coauthored or edited a dozen books, the most recent of which are *Side-by-Side Survey: Comparative Regional Studies in the Mediterranean World* (with Susan E. Alcock, 2004) and *Explaining Social Change: Studies in Honour of Colin Renfrew* (with Chris Scarre and Stephen Shennan, eds., 2004), and has been coeditor of the *Journal of Mediterranean Archaeology* since 1990.

Mario Citroni is Professor of Latin Literature at the University of Florence. He is the author of *M. Valerii Martialis Epigrammaton liber I* (1975) and of other works on the Latin epigram. He has studied the relationship between author and public (*Poesia e lettori in Roma antica. Forme della comunicazione letteraria*, 1995), and is editor of *Memoria e identità. La cultura romana costruisce la sua immagine* (2003). He is currently at work on a book on the concept of the "classic" in Latin literary culture.

Jaś Elsner is Humfry Payne Senior Research Fellow at Corpus Christi College, Oxford, and Visiting Professor of Art History at the University of Chicago. He has worked extensively on receptions and responses to Classical culture, of which he believes Classicism to be a supreme instance. His next project is a book on the viewing of Roman art, tentatively entitled *Roman Eyes*.

John Henderson is Professor of Classics at the University of Cambridge and a Fellow of King's College, Cambridge. Among his numerous writings on classical studies are *Morals and Villas in Seneca's Letters: Places to Dwell* (2004), *Aesop's Human Zoo* (2004), and *HORTVS: The Roman Book of Gardening* (2004).

Tonio Hölscher is Professor of Classical Archaeology at the University of Heidelberg, and has held visiting professorships at the University of Naples, Columbia University, and at the German Archaeological Institute in Rome. His main research interests are in political monuments, urbanism, and art theory in Greek and Roman antiquity. His major publications include *Victoria Romana* (1967); *Griechische Historienbilder des 5. und 4. Jahrhunderts v. Chr.* (1973); *Römische Bildsprache als semantisches System* (1987; English translation: *The Language of Roman Art* [2004]); and *Öffentliche Räume in frühen griechischen Städen* (1997).

Glenn W. Most is Professor of Greek Philology at the Scuola Normale Superiore in Pisa and Professor on the Committee on Social Thought at the University of Chicago. He has written widely on ancient and modern literature, philosophy, scholarship, and art. His most recent publications include *Doubting Thomas* (2005) and a translation of Sebastiano Timpanaro's *The Genesis of Lachmann's Method* (2005). He is currently coediting *The Classical Tradition: A Guide* with Anthony Grafton and Salvatore Settis, which is scheduled for publication in 2007.

R. A. Packham studied Classics at Christ's Hospital and Cambridge University, U.K., before choosing to live permanently in Italy. He is an English Language Lecturer at the University of Pisa, and specializes in translation work in the fields of classical studies and scientific disciplines.

James I. Porter is Professor of Greek, Latin, and Comparative Literature at the University of Michigan, and has been Visiting Professor at Bristol and Princeton. His research interests include literature and philosophy, literary theory and aesthetics, and cultural and intellectual history. He is author of *Nietzsche and the Philology of the Future* (2000) and *The Invention of Dionysus: An Essay on* The Birth of Tragedy (2000) and editor of *Constructions of the Classical Body* (1999). His current projects include two studies, *The Material Sublime in Greek & Roman Aesthetics* and *Homer: The Very Idea*.

Andrew Stewart is Professor of Ancient Mediterranean Art and Archaeology in the Departments of History of Art and Classics at the University of California at Berkeley. He specializes in Greek art, in the Greeks in the Levant before and after Alexander, and in the Renaissance and later reception of ancient sculpture; and excavates at the Phoenician, Israelite, Persian, Greek, and Roman harbor town of Dor in Israel. His recent publications include *Greek Sculpture: An Exploration* (1990); *Faces of Power: Alexander's Image and Hellenistic Politics* (1993); *Art, Desire, and the Body in Ancient Greece* (1997); and *Attalos, Athens, and the Akropolis: The Pergamene Little Barbarians and Their Roman and Renaissance Legacy* (2004). He spends what little free time he has sailing on San Francisco Bay.

Yun Lee Too has taught classics at the University of Liverpool and at Columbia University. She has authored seven books, including *The Rhetoric of Identity in Isocrates: Text, Power, Pedagogy* (1995) and *The Idea of Ancient Literary Criticism* (1998). She is the editor of *Education in Greek and Roman Antiquity* (2000).

Jennifer Trimble is Assistant Professor of Classics at Stanford University, where she teaches Roman art and archaeology. Currently finishing a book called *Replicating Women: Portrait, Place and Power in the Roman Empire*, she also codirects Stanford's Digital Forma Urbis Romae Project, focusing on the Severan Marble Plan of Rome, and is a codirector of the IRC-Oxford-Stanford excavations in the Roman Forum *post aedem Castoris*.

Tim Whitmarsh is Reader in Greek Literature at the University of Exeter. A specialist in the literature of Imperial Greece, he is the author of *Greek Literature and the Roman Empire: The Politics of Imitation* (2001) and *Ancient Greek Literature* (2004). He is currently working on a book on cultural technologies in the ancient Greek novel.

INDEX

Page numbers in bold indicate figures.

Aachen, ambo of Henry II, 295
Academy, 178, 179, 180, 181, 184, 185, 186, 187, 196, 197, 199
Accius, 216, 218, 219, 224n, 225
Achaemenids, 272
Achilles, 136–38, 141, 142, 152, 153
Achilles and Penthesilea sculpture group, 135, 136, 141–42, 148, 151, 152–53, 154, **161, 162, 163**
Acropolis, 31
Actium, victory at, 255
Acusilaus of Argos, 359
Adamantius, 357
aeidō, 103
Aelian, 357
Aelius Herodian, 37n, 38n
Aeneas, 250, 258, **267**
Aeschines, 121, 122; *Against Ctesiphon,* 35n; *Against Timarchus,* 112n
Aeschylus, 51n, 91; in Aristophanes, 57n, 93, 301, 302, 303, 304, 305; and austere style, 327; and canon, 129, 351; classical properties of, 23; and Homer, 129; and Lycurgus, 129, 321; revivals of, 54; and "The Problem of the Classical" conference, 2
Aesop, 222
aesthetics: and the classical, 2, 5, 11–12; and classicism, 312; of Dionysius of Halicarnassus, 340; discrimination in, 97–98; and education, 94; and emotion, 340; and euphonism, 344, 345, 346; in Hegel, 40; in Homer, 100; and ideology, 11–12; impoverished vocabulary of, 26; Nietzsche on, 11; in Plutarch, 332; and religion, 96; of sound, 314; and Winckelmann, 13, 26. *See also* beauty
Afranius, 217, 218, 219
Ajax, 136, 137, 138, 139, 153
Albani. *See* Villa Albani
Alcaeus, 91, 222, 223, 225
Alcamenes, 129, 134, 138; statue of Procne, 139, **157**
Alcidamas, 42, 316n; *Contest of Homer and Hesiod,* 351
Alcman, 102

Alexander the Great, 31, 36, 245–46, 256, **264,** 273
Alexandria, 17–18, 31, 37, 48–49, 276, 361
Alexandrian poetry, 370
Alexandrian scholars, 30, 58, 212, 215, 222, 223, 231, 316
Alexandrian sensibility, 354
altar, of Lucius Verus at Ephesus, 135. *See also* Ara Pacis Augustae
Altar of Pergamum, 17, 128, 129
anachronism, 331
Anacreon, 91
anarchy, 328. *See also* politics
ancestors, 30, 59, 69, 341
Anderson, Benedict, 310–11
Androtion, 384
Antaeus, 127
Anthologia Latina, 142
Anthologia Palatina, 45n
Anthologia Planudea, 134n
Antimachus, 327
antinaturalism, 271
Antinoopolis, 287, 289
Antinous, sculptures of, 277, 278, 284, **285, 286,** 287–88, 289, 291
Antiochus of Ascalon, 178, 179
Antiochus of Comagene, 273
Antiphanes, 129, 133
Antiphon, 327
antiquarianism, 2, 73, 275, 276
antiquity: as classical, 3–6; the classical in, 8–9, 27; and classicism as historically incoherent, 26; classicism in, 29–65, 60, 69; classicizing view of, 5; deception in aesthetics of, 27; evidence for, 39; lack of terms for classical in, 89; late, 6, 293–97; multiculturalism in, 31; Nietzsche on, 30; postclassical, 4; self-conception of, 19, 30–32; as term, 12; understanding of society and culture in, 251; Winckelmann on, 13
Antonaccio, Carla Maria, 82
Antonius, Marcus, 174, 249, 252, 253, 255
aoidē, 94, 101, 103
aoidos/aoidoi, 93, 100

Apelles: picture of Alexander in triumph, 252, 256; picture of Alexander with Nike and Dioscuri, 252, 256; picture of Aphrodite Anadyomene, 252
Aphrodisias, baths at, 152–53
Apollo, 142, 143, 144
Apollo Belvedere, 7, 27
Apollodorus, 147n
Apolonius of Tyana(?): *Epistles,* 45n
Apuleius, *Florida,* 143n, 154n
Apulian vase painting, 129
Ara Pacis Augustae, 246, 247, 250, **266, 267**
Aratus, 224n
Arcesilas, 181, 186
archaeology, 71, 73–79, 80, 81, 83, 85, 237
archaism, 17n, 34n, 37n, 57, 134, 225, 249, 318, 326–33
Archelaus, 81
Archilochus, 55n, 95, 96, 222
architecture, 6, 21–22, 24–25, 71, 227, 247–49, 252, 253, 255, 256, 257, 258, 266, 288, 291–92, 294, 295–96
Arch of Constantine, 294
Arch of Septimius Severus, 294
Arctinus of Miletus, *Aethiopis,* 141
arētē, 89, 243, 252
Argo, story of, 99
Arion, 91
Aristarchus of Samothrace, 36n, 210, 212–13, 218n
Aristides, Aelius, 12, 322n, 367; *Hymn to Serapis,* 363, 365–66, 371; *Orationes,* 12n, 31n, 319n; *Panathenaicus,* 31, 59n, 386n
Aristophanes, 92n; Aeschylus in, 93; canon in, 351; classical properties of, 23; discovery of classical era in, 18; and education, 95; Euripides in, 95; Hesiod in, 95; on Phrynichus, 94; and Roman canon, 226; valuation in, 305. *Works: Acharnians,* 54n, 334n; *Banqueters,* 91; *Clouds,* 95; *Frogs,* 51n, 54n, 57n, 91, 95, 212, 301–4, 351; *Gerytades,* 302n; *Ranae,* 51n; *Wasps,* 91
Aristophanes of Byzantium, 212–13, 218n
Aristotle, 209n, 310, 323; in Cicero, 181, 193; and *classical* as term, 14; and classicism, 31, 132, 229; and Dicaearchus of Messana, 132; on epic, 93; and feeling of classicism, 314; and Hellenistic sculpture, 129, 131, 132–33, 140, 141, 148; on Herodotus, 96; Homer in, 227, 227n, 229; and Horace, 229, 232, 233–34; literary criticism in, 334; and Longinus, 347; Lyceum of, 361; on poetry, 96, 355; on poetry and prose, 359, 367–68; Raphael's depiction of, 377; rhetoric in, 114; and Roman canon, 230; on tragedy, 129, 132–33, 228; on word and image, 155. *Works: Ethica Nicomachea,* 45n, 112n, 119, 139n; *Metaphysics,* 42n, 140n; *Poetics,* 9n, 31n, 32n, 56n, 93, 115, 131, 132–33, 134n, 138n, 139n, 140n, 141, 147n, 148n, 228n, 229, 316n, 329n, 355n; *Politics,* 116, 134n, 369n; *Rhetoric,* 35n, 63n, 115, 134n, 140n, 334n, 336n, 359; *Topics,* 114, 115
Aristoxenus, 104
Arrian, 357
art: in Athens, 5; in Augustan Rome, 237–69; Augustus's acquisition of, 251–53; and changes in iconography, 293–94; cumulative works of, 294–95; cycladic, 26n; debate over, 5, 7; deception in, 27; Egyptian, 271, 272; figurative, 231, 233; geometric, 26n; *gravitas* in, 243, 244; Greek styles of, 270, 272, 274; historians of, 20, 21; idealism in, 42; Italic, 271, 272; and language, 245, 274–75; and literature, 135; mannerism in, 225, 229; modern experience of, 251; as museum, 251; neo-Attic style in, 37; pluralism in, 270–71, 272, 273; public, 21–22; Roman collection of Greek, 240; Roman sources for, 270–97; self-conscious classicism in, 61–62; stylistic polarity in, 270, 271; and theater, 134; as transcendent, 42. *See also* architecture; literature; music; painting; sculpture; *specific works and artists*
Artemidorus, 357
Artemis-Iphigenia sculpture group, 154
Artemis of Ephesus, 272, 291
Asianism, 34, 35, 36, 37, 38, 231, 249, 356, 372
Atargatis, 291
Athenaeus, *Deipnosophistai,* 104, 357, 362n
Athenocentrism, 6, 31, 62, 129
Athenodorus of Rhodes, 144, 149
Athens: in Aristides, 12; arts in, 5; and Augustan literature, 385–86; in Cicero, 183, 385; as classical, 61–62, 65, 107; classical era discovered in, 17–18; classical period of, 4, 5; and classics, 360; and competition, 378; cultural superiority of, 107–8, 381, 383–84, 385, 386; degeneration in, 112; deliberative discourse in, 111; and democracy, 360; in Dionysius of Halicarnassus, 342; and Egyptianism, 5; and euphemism, 109, 123; in Euripides, 379; and Hellenistic sculpture, 128; and Hellenocentrism, 5; and humanism, 378; instability of, 112–13; in Isocrates, 106–8, 112–13, 119, 120, 383–85; language of, 117; in Longinus,

350; and mediated classicism, 58; military aspects of, 378, 379–80, 381, 382, 383–84, 386; and myth of cultural plenitude, 9; and Orientalism, 5; and Parthenon frieze, 246; Periclean, 14, 55, 56n, 61–62; and Periclean building program, 329–33; in Pericles' funeral oration, 62, 379, 381, 382, 383, 387; in Plato, 382–83; political decline of, 342, 385, 386; as political model, 381; politics in, 360; and regressive classicism, 54, 55; religion of, 247–48; rhetoric in, 119; Roman perspective on, 385; as school of Greece, 62, 377–87; study of, 22; as teacher, 107; tragedy of, 130–35; as tyrant, 381, 382; as verbal community, 113
Atilius, 217
Atta, 217, 218
Atticism. *See under* Greek
Attic red-figure vase-painting, 21
Atticus, Titus Pomponius, 178, 183
Attis, 292
audience: of Aristophanes, 301; and the classical, 91; and classics, 92; as determining text, 132; and Hellenistic rhetoric, 128; of Hellenistic sculpture, 128, 133–34, 136, 143, 147–49, 151; of Homer, 100, 102; of music, 104; of Roman art, 243; of tragedy, 133; and Treasury of Minyas, 71
Augustan literature: and archaic canon, 220–24, 225, 226, 227, 230; and Athenian education, 385–86; classicism of, 232; evolution of, 249–50; new synthesis of, 233–34; and Roman canon, 226, 231
Augustan Rome, 14; as classical period, 4; geography in, 358; Greek art and styles in, 237–69; retrospection in, 240; study of, 22
Augustine, 182; *Contra academicos,* 175n
Augustus, 291, 292; and Alexander, 246, 256; and art placement, 251–53; and Cicero, 174; depictions of, 6, 239–40, 242, 243, 245–46, **260, 262**; ideology of, 255–58; and Marc Antony, 249; *Res Gestae Divi Augusti,* 258n; and sites of memory, 258; and Treasury of Minyas, 79
Aurelius Opillus, *Pinaks,* 215
austerity, style of, 51, 56n, 326–27, 328, 335n, 350n, 373

Babylon, 84
Bacchylides, 103
Bakhtin, M. M., 131, 155
balance. *See under* classical (the)
baroque, style of, 17, 127–70, 229, 230, 231, 232, 348

Barthes, Roland, 316, 340
Basilica of Junius Bassus, Esquiline Hill, Rome, 295–96, **296**
Baton: Apollon/Apollo, 253; Hera/Iuno, 253
Beard, Mary, 14
beauty: ancient definitions of, 42; and austere style, 327; in canonical works, 51; and classical ideal, 43; in Dionysius of Halicarnassus, 338; Isocrates on, 42; in Plato, 41–42. *See also* aesthetics
Bellori, Giovanni Pietro, 41
Belvedere Torso, 26
Beroaldo, Filippo, the elder, 208
Black Tablinum of Villa dei Misteri, 278–79, **279,** 281
Blind Homer, 135, 146, 152, **158**
Bloom, Harold, 93–94
Boeotia, 71, 79, 81, 82
Boileau-Despréaux, Nicolas, 2; *Traité sur Longin,* 347
Bourdieu, Pierre, 52, 308, 373
Bradley, Richard, 83
Brilliant, Richard, 145
British Museum, 7
Bronze Age, 4, 6, 56, 71, 80, 83
Brutus, Lucius Iunius, 174, 198, 199, 257; *De virtute,* 174n
Brutus, Marcus Iunius, 174–75
bucolic poetry, 221, 222
Bulle, Heinrich, 75, 78, 86
Burkert, Walter, 62
Byzantine art, 293

Caecilius, 35, 37, 51, 216, 217, 218, 219, 314n, 329
Caesar, Gaius Julius, 174, 175
Callimachus, 49, 222, 223, 224n, 225, 230, 231, 233, 315–16; *Aetia,* 369–70, 370n; *Iambi,* 370; *Pinakes,* 209, 212, 361
Callistratus, 127
Callixenus, 127
Calvino, Italo, "Why Read the Classics?", 14
canon, 89; and Aeschylus, 351; archaic, 220, 221, 223n, 224, 225, 226, 227, 230; in Aristophanes, 301, 305; aspiration to inclusion in, 211, 220, 222; of Attic tragedy, 130–35; and Cicero, 177; and the classical, 50–53, 204–32; and competition, 90–91; as established by classicism, 128; and euphonism, 344n, 346; formation of, 94; Greek, 219, 220, 226, 386; and Library at Alexandria, 32–33; Longinus on, 348; of Lycurgus, 18, 51, 91, 105, 129, 321; and pluralism in Roman art, 275–76; in

canon (*continued*)
 Plutarch, 332–33; and regressive classicism, 55; and Roman art appropriation, 272; and Roman literature, 204–32. *See also* classics
Capitoline, 257
Capitoline triad, 253
Caracalla's Baths, sculptures from, 135
Carneades, 183, 190, 199
Carneia, 90
Casa del Frutteto (Casa dei Cubicoli floreali), 278–79, **280, 281, 282, 283,** 290
Cassandra, painting of (Theodorus), 253
Cassius Dio, 357
Cato, 175, 183, 185, 189, 190, 191–92, 205
Catullus, Gaius Valerius, 220–21, 225, 225n, 231, 232
Catulus, Quintus Lutatius, 231, 316
Cephisodotus, 384; statue of Leto, 252
Chaeremon, 141
Charisius, Flavius Sosipater, *Grammatica Latina,* 207, 207n
China, 15, 48n
Choerilus of Samos, 94
Christianity, 274, 293–94, 295–96
Chrysippus, 205
Cicero, Lucius Tullius, 183
Cicero, Marcus Tullius, 372n; and Athens, 183, 385; and Bellori, 41; canon in, 216n; classical texts in, 320n; and classicism, 58, 175, 176, 177, 183; *classicus* in, 205, 207; comedy in, 217; daughter of, 173–74; death in, 173–74, 175, 194, 195, 196; on Democritus, 10n; and euphonism, 344; on Isocrates, 121; as kitsch, 52; and literary canon, 225; and mediated classicism, 60; and past, 44; philosophy in, 173–203; rhetoric in, 121, 233; and Roman canon, 215, 216, 217, 222, 223, 226–27, 230; voice in, 316. Works: *Academica,* 10n, 173, 174n, 176, 178–89, 205, 216n; *Brutus,* 37n, 51n, 56n, 121, 174n, 209n, 216n, 217, 310n, 316, 384n, 385n; *Consolation,* 173, 196; *De divinatione,* 216n; *De finibus,* 44n, 173, 174n, 181, 183, 186, 188n, 189–91, 193, 195, 201, 216n, 217, 307, 385n; *De inventione rhetorica,* 42n; *De legibus,* 58, 152; *De natura deorum,* 177; *De officiis,* 216n, 385n; *De optimo genere oratorum,* 216n, 217; *De oratore,* 121, 215, 216n, 217, 310n, 320n, 325n, 326n, 384n, 385n; *De republica,* 207; *Epistulae ad Atticum,* 37n, 130n, 151n; *Epistulae ad familiares,* 130n, 151n, 178–79; *Hortensius,* 173, 175, 194, 212n; *Orator ad M. Brutum,* 37n, 42n, 121, 216n, 325, 344; *Topica,* 207; *Tusculanae disputationes,* 173, 174n, 175n, 181, 183, 192–202, 216n, 224
Cicero, Marcus Tullius (son), 385
Cicero, Quintus Tullius, 183, 307
Cinesias, 103
Circus Flaminius, 252, 257
Circus Maximus, 291–92
Citroni, Mario, 20
Clairmont, Christoph W., 284
clarity. *See under* classical (the)
classic: and aesthetics, 2, 11; and antiquarianism, 2; and belletrism, 2; Herodotus as, 96; instant, 91–92; modern, 91–92; and religion, 96; teleology of, 11
classical (the): abstraction of, 11; and aesthetics, 11–12; anatomy of term, 13–15; ancient movements counter to, 33, 38; in antiquity, 8–9; antiquity as, 3–6; appearance of, 25; and Aristotle, 105; Athens as, 61–62, 65, 107; attribution in, 17; and audiences, 91; balance as aspect of, 14, 24, 43, 94, 136, 140, 227, 228, 232, 234, 348, 352; as best, 12, 318; and canons, 50–53, 204–32; in China, 15, 48n; clarity as aspect of, 6, 14, 136; and classicism, 11, 60–61, 306; and competition, 90, 105; completeness as aspect of, 352; as constituted by interpreters, 52; as constructed, 43; as contested, 22, 28, 306–7; as contrastive term, 15; and culture as organic, 6, 28, 29, 41; as derivative, 15–16; discovery of, 17–18; discrimination in, 97–98; and embodiment of values, 308; as emulation, 270, 271; as epiphenomenon of classicism, 60–61; etymology and history of term, 8–9, 12–13, 204–9; and form, 136, 227–34, 244; in France, 14; Fronto's definition of, 10; grandeur in, 328; grand style in, 326; harmony as aspect of, 14, 16, 24, 26, 43, 94, 228, 232, 352; and Hellenistic sculpture, 140; as hierarchical, 89; historicization of, 19; holism of ideal, 28; humanity in, 11; ideal in, 10, 11, 28–29, 39–43; and ideology, 53, 307; incoherent idea of, 53; inconsistent notions of, 89; as indeterminate in antiquity, 52; ineffability of, 52; innovation in, 93; and Isocrates, 106–7; as label acquired and lost, 18–19; as label unjustified, 22; Laocoön as, 145; in Malaysia, 15; measure/mean as aspect of, 14, 42, 43, 227, 234; as model, 89; as multi-form, 86; Nietzsche on, 30; nobility as aspect of, 352; and past, 11; and past accomplishments, 89;

perfection as aspect of, 26, 352; Plato's influence on, 105; and politics, 12; postclassical as invention of, 331; as postclassical invention, 17; post-Romantic constructions of, 354; as preservation, 94; and "Problem of the Classical" conference, 1–2, 6, 23; procedures of, 30; as projected effect, 17, 56, 60, 61, 62, 63, 131, 308, 320n, 331, 332, 387; properties of, 22–26, 30, 94, 136, 140, 306; as property, 6, 7, 14; proportion as aspect of, 6, 228; real and ideal in, 10; restraint as aspect of, 14, 352; as retroactive effect, 53; and retrospection, 17, 53, 93–94; and reverence, 306; in Roman literature, 204–32; scholarship on, 356; self-identification as, 60; as self-invention, 61; sensibility of, 6; simplicity as aspect of, 14, 352; in song culture, 93; sound of, 325–26; symmetry as aspect of, 6, 14, 24, 42, 227, 228; as term, 12, 13–17, 89; as term lacking focus, 26; terms for lacking in antiquity, 89; time element in, 17; as timeless, 96; as traditional, 89; as transcendent, 89; and Treasury of Minyas, 86; typological meaning of, 228; as underdefined, 306; Winckelmann on, 13

classicism: as acculturation, 297; as adopted to face problem, 48; as aesthetic, 352; and aesthetics, 312; affective dimensions of, 324; in Alexandria, 48–49; ancient *vs.* modern forms of, 39–40, 44; in antiquity, 29–65, 60, 69, 329–33; as appreciation for classical, 4; of Aristophanes, 301–4; and Aristotle, 31, 132, 229; and Atticism, 34–39; as attitude, 307; of Augustan poets, 232; Bronze Age, 56; and Cicero, 58, 175, 176, 177, 183; and the classical, 11, 306; classical as epiphenomenon of, 60–61; as contested, 28; Corinthian, 56; deception in, 27, 349; decorum as aspect of, 6, 140; definitions of, 270–76; of Demosthenes, 58; dignity as aspect of, 94, 328; dissent about, 349; as emulation, 272, 308; as emulation that establishes canonical/classic, 128, 271; and euphonism, 337–38, 344–45, 346; and examples, 150; extent of past in, 240; as feeling, 15n, 47–48, 140, 301, 305–6, 307–8, 311–13, 324, 329, 334, 338–40, 347, 350, 351; as fetish, 8n, 34, 42n, 49n; filtering for, 8; and freedom, 49; geometric, 56; as *habitus*, 45–50, 238, 308–9, 311, 343; and Hellenistic sculpture, 140; as Hellenocentric borrowing, 271; as historically incoherent, 26–29; historicization of, 19; Homeric, 56; as idealist, 131; and identification, 53, 57, 58, 59–60, 308, 309, 348; and ideology, 308, 312, 334, 349; illogic of, 306; and illusion, 26–28, 53, 64–65, 301, 314; and imagination, 313, 314, 322; as imitation, 183; as imitation through emulation, 308; as inarticulate experience, 308, 325; as inarticulate term, 324; incoherence of, 29–34, 53, 306; as intertextual, 131; and Isocrates, 120–23; and language, 33, 34–39, 293, 333; and Longinus, 346–50; mechanisms of, 53–65; mediated, 57–60, 64, 132; metaphorical quality of, 123; modern, 27, 30; and modern German identity, 1–2; and neoteric poets, 232; and nostalgia, 30, 48, 73, 155, 301; and painting, 32; as part of past, 306; and Pasquino group, 136; past recuperated in, 131; and patina of archaic, 327, 328, 332; of Pausanias, 72; as perception of world, 16; and performance, 324; and Periclean Athens, 331–32; phenomenology of, 307; philosophical, 37; pleasure in, 8, 59, 310, 323–24, 333–50; in Pliny the Elder, 32; and pluralism, 293; plural series of, 22; possession in, 347; prospective (proleptic), 60–63; purity in, 348, 349; rationalism in, 234; and realism, 61–62; as regressive, 29–30, 54, 55; as rehistoricizing gesture, 106; as reifying and fixating, 329; relativism of, 356; as retroactive effect, 53; and retrospection, 11, 16, 29–30, 53–54, 60, 61, 63–64, 301, 351–52; as reverence for the classical, 306; and Roman Greece, 367, 373, 374; and sculpture, 32, 127; as seen *sub specie aeternitatis,* 308; selective emphasis of, 80; single form *vs.* varieties of, 50; of Sophocles, 16; as style, 15; as sublime, 335; symptomatic reading of, 48; synechdochal quality of, 123; as tautology, 8; and Temple of Concord, 253; temporal perspective in, 329–30; as term, 12, 15–17, 306; term lacking for, 60; time in, 323–24; as tradition, 15; and transference, 54, 64, 123; and utopia, 131; in Victorian Britain, 353–54

classics: and Athens, 360; and excellence, 89, 90, 95, 98; as models, 89; morality in, 94–95; in Roman education, 213–14; in Strabo, 362; and "The Problem of the Classical" conference, 1–2. *See also* canon

classicus, 8–9, 10, 204–9, 228

Cleanthes, 205

Cleisthenes, 108, 111, 113, 120, 123

Cleopatra, 252, 255

Coetzee, J. M., "What Is a Classic?", 14
Colossus, 348
comedy, 213, 216, 217, 219, 221, 225. *See also* drama/theater
competition, 90–91, 105, 305, 332, 378
Constantinople, St. Sophia, 294
Constantius, 288
Corcyra, 110, 111
Corinthian classicism, 56
Crates of Mallos, 39n, 316n, 343, 345
Cratinus: *Archilochoi*, 302n; *Prytine*, 302n
Crete, 80
Creuzer, Georg Friedrich, 386
Critias, 321, 322
cultural knowledge, 241, 242, 258–59
cultural memory, 238, 240–41, 242, 258–59
culture: ancient understanding of, 251; and Athens, 9; and Atticism, 37–38; change in Roman, 293; and the classical as elite, 10; classical developments in non-ancient, 14–15; and classical typology, 227, 228; conflict in, 22; decline of, 353–56, 362; hybridity in, 5, 17; idea of, 238–39; and identity, 238; and Library at Alexandria, 32; and memory, 239; modern concepts of, 251; narrative forms of, 241; and plenitude, 8–9; and plurality, 237; politics in, 362; and power, 33; and prose, 363; and purism, 5; and Roman inclusivity, 273; and self-positioning, 272; in Strabo, 362; values in paradigms of, 5. *See also* Greeks/Greek culture; *habitus*; Romans/Roman culture
cup: Foundry, 42–43; Nestor's, 92
Curtius, Marcus, 257
Cybele, 291
Cycladic classicism, 56
Cyriac of Ancona, 73–74

Dark Age Greece, 4
De hellenismo et atticismo, 310n, 345n
Delos, 84
Delphic oracle, 363, 364, 365
Demetrius of Phaleron, 341n; *De elocutione*, 139n, 326n, 329n, 333n, 341n
democracy, 109, 110, 111, 113–14, 119, 121, 123, 124, 246, 255, 350, 360
Democritus, 10n, 205
Demosthenes, 59n, 334n; Aelius Aristides on, 322n; ancient criticism of, 51; and Atticism, 37; and austere style, 327; and Cicero, 121, 224; and *classical* as term, 14; as classicizer, 58; and Dionysius of Halicarnassus, 60, 122, 306n, 317n, 328n, 339, 340, 341, 342; *Epitaphius*, 379n, 380n; and Isocrates,

64; and Longinus, 58, 340; as politician, 360; and regressive classicism, 55; and retrospective classicism, 64; and Roman canon, 215, 225; voice of, 319, 322, 324
Derrida, Jacques: *Of Grammatology*, 362–63
Dicaearchus of Messana, 330n; *Tales from Euripides*, 132; *Tales from Sophocles*, 132
Dinarchus, 51, 51n, 121
Dio Cassius, 253n
Dio Chrysostom, 31; *Orationes*, 36n, 48n, 51n, 309n, 319, 320n, 369n, 372
Diodorus Siculus, 144, 205n, 362n, 369n, 379n
Diogenes Laertius, 209n, 377
Diogenes of Babylonia, 316n
Diomedes, depiction of, 245, 246, **263**
Dionysiac Artists, 129
Dionysius, 96, 250, 278, 279, 281, 284, 302, 303
Dionysius (historian), 357
Dionysius of Halicarnassus, 52; aesthetics of, 340; ancestry in, 340–41; Athens in, 342; and Atticism, 35; classical status of, 51; and classicism, 333; classicism in, 338–43; and Demosthenes, 60, 122, 306n, 317n, 328n, 339, 340, 341, 342; excerpts in, 324–25; feeling in, 338–40; form in, 233; and Greeks as models, 31; Isocrates in, 122–23, 337, 339, 340, 341, 342, 384–85; on language, 34n; literary criticism in, 334, 335; Lysias in, 317n, 320n, 337, 338, 343; meaning in, 341; and mediated classicism, 58; past in, 339; Pindar in, 327n; pleasure in, 340, 342–43; on prose, 367n; and retrospective classicism, 64; self-identification as classical by, 60; sound in, 335, 337, 339, 340, 341, 342, 344n; voice in, 318, 319. Works: *Ars rhetorica*, 380n; *De Demosthene*, 45n, 54n, 306n, 317n, 325n, 327n, 328, 333n, 335, 337, 339, 341, 344n; *De imitatione*, 34n, 218n, 339n, 345n; *De Isocrate*, 327, 341n, 383n, 384n, 385n; *De Lysia*, 320n, 338; *De oratoribus veteribus*, 32n, 386n; *De Thucydide*, 327, 328n, 335, 337; *Epistula ad Ammaeum*, 327n; *Epistula ad Pompeium*, 337n, 349; *On the Composition of Words*, 327, 328n, 333n, 338n, 345n, 350n, 367n
Dionysius Thrax, 304n; *Ars Grammatica*, 317; *Ars Grammatica* [scholiast in], 316n
Dio of Prusa, 322
Domitian, 287n, 288
Domitius Marsus, 225
Doria Pamphili. *See* Villa Doria Pamphili

Dörpfeld, Wilhelm, 75, 78, 86
Doryphorus (Polyclitus), 54–55, 151, 348
drama/theater: and art, 134; and Augustan poets, 232; and baroque sculpture, 138; Latin, 222; Latin as substitute for Greek, 214; and Lycurgus, 105; and Roman canon, 225, 230; and Roman emulation of Greeks, 217. *See also* comedy; tragedy

education: and aesthetics, 94; and Aristophanes, 95; by Athens, 107; and Athens as school of Greece, 62, 377–87; in Cicero, 181, 183; curriculum in, 135; and Dicaearchus of Messana, 132; examples in, 149; Greek, 214; in Isocrates, 118, 384–85; mythography in, 129; and pleasure in classicism, 334; poetry in, 372; Roman, 213; and voice, 317
Egypt, culture of, 5, 271, 272, 275, 276–90, 292, 295
Elgin, Thomas Bruce, earl of, 7, 74, 86
Eliot, T. S., 16; "What Is a Classic?", 14
Elsner, Jaś, 73, 85, 128
emotion, 131, 133, 135, 340
Empedocles, 327
Endymion, image type of, 293
Ennius, 17n, 130, 213, 214, 215, 216, 218, 220, 224, 233
Ephesus, 128; altar of Lucius Verus, 135
Ephorus, 121, 384
epic: and Altar of Pergamum, 128; Aristotle on, 93; Hellenistic, 230n; and Hellenistic sculpture, 129, 153; Latin, 218, 221, 222; Roman emulation of Greek, 217; in Victorian Britain, 353–54
Epicharmus, 216n, 219
Epicureanism, 179, 180, 182, 184, 187, 189, 192
Epicurus, 41, 185, 186, 187, 188, 195, 196
epigonism, 226
epigram, 222
Erasmus, 208
Eratosthenes, 39, 358, 362, 363
Erechthion, maidens of, 247
Etruscans, 272–73
etymology, 114–15, 119
euphemism, 109, 123, 335
euphonism, 311, 323, 325, 336–37, 343–47. *See also* sound
Euphranor, 136; Leto/Latona with her children, 253
Eupolis: *The Demes,* 302n; *Flatterers,* 383
Euripides, 51n, 55n; in Aristophanes, 95, 301, 302, 303, 304, 305; in canon of Lycurgus, 129; as classical, 6; classical properties of, 22–23; and classicism, 31; and Lycurgus, 321; in Nietzsche, 354. Works: *Bacchae,* 96–97; *Erechtheus,* 316n; *Medea,* 379; *Phoenissae,* 138; *Suppliants,* 380
Euryalus, 153
Evans, Sir Arthur, 74n
examples, 149–54, 210
excellence, idea of, 89, 90, 95, 98, 100, 211, 212, 213, 214, 216, 221, 227, 229
Exekias, 129, 138, **156**

Favorinus, 357; *Corinthian Oration,* 46–47
Festus, 205–6, 207n
fetish, 8n, 34, 42n, 49n
Feuerbach, Anselm: *Der vaticanische Apollo,* 27
Flashar, Hellmut, *Le classicisme à Rome,* 20
Flavian age, 135, 226
Fonesca, bishop of Toledo, 208
form, 136, 227–34, 244
Forum, 257
Forum Julium in Alexandria, 288
Forum of Augustus, 255, 256, 258, 292; caryatids in, 247–48, **266**
Forum of Merida (Spain), 292
Foucault, Michel: *The Order of Things,* 357
Foundry Cup, 42–43
France, 14–15
Frazer, James George, 81
Fronto, Marcus Cornelius, 9, 10, 12, 18, 226, 227, 249; *Epistulae,* 325n; *scriptor classicus* in, 206, 208–9, 210, 211
Fundanius, 221

Gabriel, Ange-Jacques, 17
Gaius (emperor), 288
Gaius Gracchus, 215
Galen, 38, 357; *De differentia pulsuum,* 45n; *De placitis Hippocrati et Platonis,* 42n
Gallus, 224n
Gardens of Maecenas, 151
Gauls, Large and Small, sculptures, 135, 143
Gellius, Aulus: archaism in, 249; *classicus* in, 205; and discovery of classical era, 18; and Fronto, 10; *Noctes Atticae,* 9, 17n, 206–7, 207n, 326n; and retrospection, 10; and Roman canon, 226, 227; *scriptor classicus* in, 206–8, 209, 210, 211
Gelzer, Thomas, 227
Gennadeion Library, Athens, 387–88
Gigantomachy, Altar of Pergamum, 128, 129
Goethe, Johann Wolfgang von, 2, 155
Gorgias, 42n, 113, 311, 335, 359, 360, 379n; *Encomium of Helen,* 134n, 359n

Greece: archaic period of, 4; in Aristides' *Panathenaic Oration,* 31; and the classical, 4, 9; classical periods of, 4–5; and *classical* as term, 14; classicism internal to, 306; discovery of classical era in, 17–18; Hellenistic period of, 4; naïveté of early, 26; in Plutarch, 365; pre-classical, 4; Ptolemaic period, 4; Winckelmann on, 13

Greek: and Atticism, 34–39, 46, 121, 122, 123, 249, 310, 318, 326n, 337, 348; Doricisms in, 36; and *hellenismos* (pure Greek), 8n, 35–36, 38, 310, 314, 318, 337, 344–45, 346; Ionic, 38, 39; Ionicism in, 36; Latin as dialect of, 36; Latin translation of, 130, 131; pure and correct, 35–36; sound of, 310–11

Greek Anthology, 144

Greek novel, 356

Greeks/Greek culture: Athens as school of, 62, 377–87; and Cicero, 176; classicism of, 69; decline of, 355–56, 367; emulation by, 272; heritage of, 174; identity from, 238; Isocrates on true, 387–88; orality and text in, 358; post-Romantic view of, 354; retrospection in, 30–32; and Roman culture, 4, 33, 44, 174, 212–14, 215–16, 217, 218, 219, 220, 221, 222, 223–26, 232, 237–69, 270, 271, 275, 385; under Roman rule, 355–56, 357; studied through Roman culture, 273–74. See also *habitus*

Green, Peter, 137

Greenhalgh, Michael: *What Is Classicism?,* 14

Guillory, John: *Cultural Capital,* 14

habitus, 45–50, 140, 238, 240, 249, 308–9, 311, 343. *See also* culture

Hadrian, 82, 152, 226; Antinous obelisk erected by, 287–88; and classical art, 6; and classical *habitus,* 45; Villa at Tivoli, 6, 277, 284, 286, 287, 289

Hagesander of Rhodes, 144, 149

Halliwell, S., 141

Hamilton, Gavin, 277

Hanging Marsyas sculptures. *See* Marsyas, sculptures of

Harrison, Tony, *The School of Eloquence,* 379

Häuber, Chrystina, 145n

Hazlitt, William, 7n

Hecataeus of Miletus, 359

Hegel, Georg Wilhelm Friedrich, 33; *Lectures on Aesthetics,* 40

Hegesias of Magnesia, 37

Heidegger, Martin, 98

Heliodorus, 35n

Hellanicus of Lesbos, 359

Hellenism, 274, 284, 348, 355, 356

hellenismos. See under Greek

Hellenistic Asia Minor, 129

Hellenistic grammarians, 212

Hellenistic period, 4; art of, 250; Athenocentrism of, 129; and Atticism, 37; Attic tragedy in, 130–35; classicism in, 49; and classicism in language arts, 34; critics in, 336, 337; examples in, 151; genre sculpture in, 246; genres of, 222; and Greek and Roman art, 244; Homer in, 229, 233; innovation in, 228–30; mediated classicism in, 58; and Pasquino group, 136; Roman involvement in culture in, 213; Rome in, 136; sculpture in, 127–70; and Treasury of Minyas, 81, 82, 84

Hellenocentrism, 5, 31, 33

Henderson, John: *Classics,* 14

Henry II, 295

Heracleodorus, 355n

Heraclides, 104

Heraclides Criticus, 385

Heraclitus, 94–95; *Homeric Questions,* 372

Hera Teleia, 79, 82, 83

Herculaneum, library at, 315n

Hercules, sculpture of, 253

Hercules Tunicatus, 130, 150, 154

Herder, Johann Gottfried, 386

Hermes/Mercury, 253

Hermogenes, 58

hero: in baroque sculpture, 136, 137, 139, 141, 142, 144, 147, 148, 150, 151, 153, 154; in Hesiod, 98; in Homer, 98, 99, 100, 101; in music, 80, 82, 83; in Nietzsche, 63; in Orchomenos, 80, 82, 83

Herodes Atticus, 321–22, 332; villa of at Loukou, 136–37, 152, 153

Herodian, 357

Herodotus, 36, 38, 96, 225, 279n, 316n, 369n

Hesiod, 89, 92, 95, 98, 224n, 351; *Theogony,* 347n

Hieronymus of Rhodes, 317n, 341

Hippias of Elis, 382, 383

Hippias of Thasos, 316

Hipponax, 315–16

Historia Augusta, 226

historians, 139, 140, 217

historical distance, 9, 42, 44, 63

historical narrative, 362, 367

historicism, 19

history: of classical identifications, 64–65; and classicism, 26–29; examples from, 149, 150; modern concept of, 255, 258; in Pau-

INDEX 443

sanias, 73; portraits of famous men from, 257; in Roman use of Greek art, 246, 249, 250, 254–55; and self-conception of antiquity, 19; staging of Roman, 257; and Treasury of Minyas, 73, 83
Hölscher, Tonio, 278, 293; *Die unheimliche Klassik der Griechen,* 20; *Römische Bildsprache als semantisches System,* 274–75
Homer, 370; in Aeschylus, 129; in Alcidamas, 351; and archaeology of Bronze Age, 80; and Argo story, 99; in Aristotle, 228, 229; audience of, 100, 102; and Augustan poets, 232; as canonical, 224n, 228–29; as classical, 6, 89; classical properties of, 23, 29–30; critiques of, 39; in Dio Chrysostom, 320n; and education, 94; Eratosthenes on, 358; and euphonism, 344; examples from, 149; as exemplary, 98; formal qualities of, 228, 229; Greek of, 36, 38; in Hellenistic period, 229, 233; and Hellenistic sculpture, 136; and Herodotus, 96; *Iliad,* 72n, 134n, 213n, 370n, 379n, 380n; irregularities in, 228; in Longinus, 52, 63; Maximus of Tyre on, 363; military aspects of, 379–80; morality in, 95; *Odyssey,* 98–102, 370n, 383; Panathenaiac performance of, 56n, 91, 321; Plutarch *vs.* Longinus on, 52; and political context, 372; as postclassical, 99; prestige of, 213, 218n; and regressive classicism, 55; and Roman canon, 212, 213–14, 215, 216, 218, 220, 221, 222, 224, 225, 230; and Schliemann, 74, 75; song and singer in, 99–102; sound of, 93; Strabo on, 362, 363; and "The Problem of the Classical" conference, 2; Thucydides on, 62; tragic sensibility in, 131; verse composition of, 92; voice of, 316, 319–20, 321
Homeric *Hymn to Aphrodite,* 90
Homeric *Hymn to Apollo,* 56n, 62, 321
Horace, 17n; and Aristotle, 229, 232, 233–34; and literary canon, 212, 213, 218, 219, 220, 221, 222, 223, 224, 225; originality in, 102. Works: *Ars Poetica,* 221, 229, 232, 385n; *Carmina,* 222n, 224; *Epistles,* 213n, 219, 220, 222, 222n, 223, 224, 385n; *Letter to Augustus,* 218; *Odes,* 212, 221; *Satires,* 221, 222, 367n, 370
House of the Tragic Poet, 130, 150
humanism, 1, 209, 237, 238, 358, 378, 386–87
Humboldt, Wilhelm von, 2, 12n, 28–29, 41, 386
Hume, David, 52n
Hyginus, *Fabulae,* 144n, 147n
Hyperides, 121, 122, 384; *Epitaphius,* 62, 63n, 380n

Ibycus of Rhegium, 90
ideal/idealization, 10, 11, 28–29, 39–43, 234, 242
identification: and classicism, 53, 57, 58, 59–60, 308, 309, 348; history of, 64–65; in Longinus, 348; and Roman canon, 223; strategic, 30
identity: and Atticism, 38; civic, 83, 84; in classicism as *habitus,* 45–50; from Greek models, 238; in Isocrates, 117; and past, 238; and Roman education in classics, 214; through monuments, 84; and Treasury of Minyas, 83, 84, 85
ideology, 9, 10, 307; and aesthetics, 11–12; Augustan, 251–53, 255–58; and classical feeling, 308; and classicism, 312, 334, 349; and euphonism, 346; incoherence as, 53; and pleasure, 342–43; and poetry *vs.* prose, 372
imperialism, 48, 362, 363. *See also under* Romans/Roman culture
innovation/novelty, 93, 94–97, 99–102, 103, 117
Ion of Chios, 320
Isaeus, 122, 337, 384
Isidore of Seville: *Origines,* 207n, 310n
Isis, 278, 283, 284, 291
Isocrates: ancient criticism of, 51; Athens in, 106–8, 112, 119, 120, 383–85; beauty in, 42; Cicero on, 121; and *classical* as term, 14; and classicism, 120–23; democracy in, 119, 121, 123; and Demosthenes, 64; in Dionysius of Halicarnassus, 122–23, 337, 339, 340, 341, 342, 384–85; education in, 384–85; in Hieronymus of Rhodes, 317n; imitation in, 59n; language in, 106–24, 383; metaphor in, 106, 115, 116; morality in, 112–13; past in, 120; poetry *vs.* prose in, 360–61, 368n; and prose, 363; reason in, 107, 108, 109, 119, 120; rhetoric in, 117–18, 360; self-advertisement of, 384–85; and Strabo, 362, 363; on true Greekness, 387–88. Works: *Against the Sophists,* 117; *Antidosis,* 107, 112, 113, 114, 115, 116, 117, 118–19, 120, 360, 384n; *Areopagiticus,* 111, 113, 114, 115, 119, 120, 122; *Busiris,* 118n; *Contra sophistas,* 42; *Evagoras,* 115, 116–17, 360, 366; *Helen,* 113, 118; *Nicocles,* 107, 117, 118, 119; *On the Peace,* 117; *Panathenaicus,* 117, 118n, 120; *Panegyricus,* 56n, 109, 117, 122, 383–85, 386n; *To Nicocles,* 117
Italic art, 271, 272, 274

Jaeger, Werner Wilhelm, 1–3, 23, 24n, 26n, 387
Jesus, 292
Jonah, depiction of, 293–94
Jost, Karl, 54
Jupiter Dolichenus, 272
Justinian, 294

Kant, Immanuel, 40
Kermode, Frank: *The Classic,* 14
kitsch, 52, 283
Klassik/Klassizität/Das Klassische, 12. See also classical (the)
Knifegrinder (sculpture), 142, 143
knowledge: in Foucault, 357; and memory, 240–42, 243–44, 245, 246, 247, 248, 249, 251, 258–59; and prosography, 358; in Roman Greece, 367
koinē, 36
Körte, Alfred, 2, 23
kritikoi, hoi, 337, 343

Labate, Mario, 221
Laevius, 231
language: archaism in, 326–33; in Aristotle, 114, 115; and art, 245, 274–75; of Athens, 117; and Atticism, 34–39, 46, 121, 122, 123, 249, 310, 318, 326n, 337, 348; and classicism, 33, 34–39, 293, 333; and community, 118; context of, 117; and Corcyra, 110, 111; and deed, 110; and democracy, 109, 110, 124; and euphonism, 344–45, 346; of feeling and affect, 308; Foucault on, 357; and *hellenismos,* 8n, 35–36, 38, 310, 314, 318, 337, 344–45, 346; in Isocrates, 106–24, 112, 383; in Longinus, 347, 348; in Plato, 109–10; policing of, 321; and political stability, 106, 109–14, 116, 117, 120; and prosography, 357; and rationality, 110; Roman art as, 274–75, 278; and Roman Atticism, 121, 122, 123; in Roman Greece, 357; sense of, 335–36; transference in, 106, 110, 112, 113, 114, 115, 118, 123; transformation in, 106. See also literature; rhetoric; sound
Laocoön sculptural group, 7, 26, 128, 131, 135, 144–49, 151, 154, **168–70**
Large and Small Gauls sculptures, 135, 143
Lasus of Hermione, 103
Lateran church, 294
Latin, 17n, 36, 130, 131. See also language
law, 107, 118; XII Tables, 207
Leake, William Martin, 74
Lesches, *Little Iliad,* 136, 137
Lessing, G. E., 145, 147, 155

Levin, Harry: "Contexts of the Classical," 14
library/archive, 223, 224, 362, 363, 367. See also museum
Library of Alexandria, 31–32, 361
library of temple to Apollo Palatinus, 222–23
Licinius Calvus, 231
literature: and archaic canon, 220–24, 225, 226, 227, 230; and art, 135; and Athenian education, 385–86; Augustan, 220–50, 385–86; civic utility of, 371; criticism of, 50–51, 301–52, 323, 325, 327, 333–50; discrimination in, 97–98; early Greek, 89–105; formal qualities of, 228; Fronto's definition of, 10; of Greek novel, 356; Hellenistic, 361; history of, 20; national, 221; neoteric, 220–22, 231–32, 233; nobility in, 234; oral, 362; Plato's banishment of, 116; prose, 92, 353–74; Roman, 204–32, 249–50, 385–86; in Roman Greece, 357; Roman use of Greek, 212–14, 215–16, 217, 218, 219, 220, 221, 222, 223–26, 232, 249, 385–86; second-order, 362, 363; written, 362. See also comedy; drama/theater; language; poetry; prose; rhetoric; tragedy
Livius Andronicus, 17n, 212, 213, 214, 218, 220
Livy, 149, 150, 225, 385n
Lloyd, G.E.R., 358
logos, 107–9, 116, 119, 120
logos pezos, 366
Longinus, 344; and Asianism, 37, 140n; Athens in, 350; Atticism in, 348; on Caecilius, 314n; on canon, 348; classical status of, 51, 60; classical texts in, 320n; and classicism, 335, 346–50; democracy in, 350; and Demosthenes, 58, 63, 340; and euphonism, 311, 337, 346–47; feeling in, 350; and Hellenism, 348; Herodotus in, 96; on Homer, 52, 63; identification in, 348; literary criticism in, 334–35; and monumental, 333; on Plato, 348; pleasure in, 340; and Plutarch, 333n; poetry in, 370–71; politics in, 349–50; posterity in, 332; and self-identification as classical, 60; and sublime, 63, 149, 328–29, 333, 347–49, 350, 355; on Thucydides, 63; and voice, 319
Longus, *Daphnis and Chloe,* 373
Loraux, Nicole, 54
Loukou. See Villa at Loukou
Lucian, 34, 39, 59, 356, 371; *Adversus indoctum,* 32n; *Bis accusatus,* 370n; *De mercede conductis,* 334n; *Dialogi deorum,* 144; *How to Write History,* 368–69; *The Ignorant Book Collector,* 49n; *Imagines,* 42n, 51n;

INDEX 445

Lexiphanes, 39n; *Menippus sive Necyomantea,* 370n; *Pro imaginibus,* 370n; *Pseudologista,* 39n; *Pseudosophista,* 39n; *Rhetorum praeceptor,* 46n; *Zeus the Tragedian,* 369n
Lucilius, 213, 218
Lucretius, 224n, 225, 225n
Lucullus, Lucius Licinius, 130, 150, 178
Lupercal, 257, 258
Lupercalia, 258
Lyceum, 31, 361
Lycurgus, 18, 32, 51, 56n, 91, 105, 121, 129, 321, 384; *Against Leocrates,* 59n
Lysias, 37, 51, 59n, 317n, 330n, 337, 338, 343; *Epitaphius,* 380n
Lysippus, 27, 32, 51, 244

Maecenas, 221, 222, 234; Gardens of, 151
Magi, iconography of, 292, 295
Mahdia shipwreck, 254; marble krater, 248–49, **267**
Malaysia, 15
Manilius, 225
Manlius Torquatus, L., 185, 186, 187, 188
Marathon, glorification of, 59
Marcellus, 321n
Marconi, Pirro, 33n
Marsyas, painting of (Zeuxis), 253
Marsyas, sculptures of, 135, 142–44, 148, 151–52, 154, **164–67,** 257
Martial, 209n, 225–26, 225n
Marx, Karl, 8n, 53n, 213n, 270n
Maximus of Tyre, *Orations,* 363
Megalopolis, 84
Melanchthon, 208
Melanippides, 103
Melissus, 113
melos, 99, 105. See also *mousikē;* song
memory, 255–59; as conscious retrospection, 242; and culture, 239; foundational, 241; and knowledge, 240–42, 243–44, 245, 246, 247, 248, 249, 251, 258–59; and monuments, 69; musical, 92; in Roman art, 243; and Treasury of Minyas, 72–73, 83. *See also* past
Menander, 36n, 216n, 217, 218, 219, 221, 224n, 225
Menelaus, 136
metabolē, 364
metaphor, 106, 107, 114–16, 115, 118–19, 123. *See also* language
Mimnermus, 223
Ming, emperor, 48n
Minyans, 73, 86
Minyas, 72, 73, 80, 82, 83, 86

Mithras, 291, 292
modernity, 27, 29, 30, 39–40, 44, 59, 91–92, 229, 251, 253, 258. *See also* present
monuments, 69, 83n, 84, 150, 240, 250, 255, 257. *See also* architecture; sculpture
morality, 94–95, 110–11, 112–13, 120, 128, 148, 149–50, 175, 244–45, 310
mosaic, 130, 150
Moschus, 49
Mount Dourdouvana, 72
mousikē, 89–105
multiculturalism, 31, 278, 289, 293
Musaeus, 95
museum, 253, 301, 329. *See also* library/archive
Museum at Alexandria, 31, 361
music, 90–91, 93, 102, 104
Mycenae, 74, 75, 79, 84, 85
myth, 73, 79, 81, 82, 83, 136–37, 150, 255, 358–59
mythography, 129, 131, 132

Naevius, Gnaeus, 17n, 213, 217, 218, 220
nationalism, 238, 354
naturalism, 21, 61–62, 271, 290, 297
naturalness, 228
Naucrates, 121
Neer, Richard T., 21
Nemea, personification of, 252
neoclassicism, 32, 33, 131
Neoplatonism, 41
neoteric literature, 220–24, 231–32, 233
Nero, age of, 226
Nestor's cup, 92
Nettuno, 291
New Music, 103, 104–5
Niceratus, Asclepius/Aesculapius with Hygieia/Hygia, 253
Nicias, 32
Nietzsche, Friedrich Wilhelm, 11, 23, 27, 30, 44, 63; *Birth of Tragedy,* 354; *Wir Philologen,* 30
Nike of Samothrace, 128
Nikias: picture of Danae, 253; picture of Hyacinthus, 253
Nineveh, 84
Niobids (Uffizi), 143
Nisus, 153
Nonnus, *Dionysiaca,* 144
nostalgia, 30, 48, 73, 155, 301
Numenius of Apamaea, 35

obelisk(s), 284, 287–88, 291
Oppian, 357

orality, 89, 93, 101, 313, 345, 358, 362
oratory, 58, 325, 359, 380. *See also* rhetoric
Orchomenos, 72, 74, 75, 81, 84, 85
Orientalism, 5
Orlandos, A. K., 75, 86
Orpheus, 95
Osirantinous, sculpture of, 288, 289
Osiris, 279
Ovid, 138; *Amores,* 224n, 225; *Ars amatoria,* 224n; *Fasti,* 143n, 154, 225n; *Medea,* 221, 225; *Metamorphoses,* 144, 218; *Remedia amoris,* 224n; *Tristia,* 138n, 224n, 225

Pacuvius, 216, 218, 219, 225
painting, 21, 32, 129, 252, 253, 256, 278–84, 290
Palatine, 252, 257
Panathenaia, 56n, 91, 321
Panhellenism, 38
Pantanello, 277
Parmenides, 370n
Parry, Milman, 351n
Parthenon, 6, 7, 8, 17, 24–25, 246, 329–30
Parthian art, 273, 292
Pasquino sculptural group, 17, 128, 135, 136–41, 148, 151, 152–53, 154, **159, 160**
past: and archaism, 327–28; as archive, 362, 363; burden of, 360; and Cicero, 44; and the classical, 11, 89; and classicism, 240, 306; as counterimage of present, 241–42; cultural identity from, 238; cultural knowledge as neutral toward, 242; and desire, 374; in Dionysius of Halicarnassus, 339; ennoblement by, 308; as exemplary, 241; and feeling, 306; generation of, 30–31; and *habitus,* 45; identification with, 308; immediate contact with, 319; in Isocrates, 120; in Plutarch, 331; present use of, 239, 247; proximity to, 44; and Roman art, 239, 248, 249; and Roman Greece, 373, 374; Roman view of Greek, 258; in Strabo, 362; text as deposit from, 314–15; text as mnemonic of, 320; in Thucydides, 331; and Treasury of Minyas, 73, 84. *See also* memory; retrospection
patina, of archaic, 327, 328, 332
Patroclus, 136
Paul, *Epistle to the Romans,* 386n
Paul, Jean, *Vorschule der Ästhetik,* 23–24
Pausanias, 32, 33, 54n, 57, 74, 81–82, 84–85, 86, 96, 144n, 320n, 322n, 357; *Description of Greece,* 33, 71–72, 73
Pausias, painting of bull offering, 253
Peisistratids, 321
Pergamum, 17, 49, 128

Pergamum, Altar of, 17, 128, 129
Pericles, 108; building program of, 329–33; democracy in, 123; and emotion of ideology, 343n; funeral oration of, 62, 379, 381, 382, 383, 387; Isocrates on, 120; and language-deed relation, 110–11; and posterity, 63; and Roman Atticism, 123; in Thucydides, 343n. *See also under* Athens
Peripatetic school, 190, 197, 199, 200, 201
perittos, 365, 366
Persia, 291
pezos logos, 369–70
Pfeiffer, Rudolf, 208; *The History of Classical Scholarship,* 204, 205
Phaedrus, 222
pharmakon, 365
Pherecrates, 103–4, 302n
Phidias, 11, 51, 56n, 128, 152, 244, 246
Philip II, 80
Philistus, 121
Philodemus of Gadara, 337, 343; *On Poems,* 344n, 355n; *Rhetorica,* 341n
Philo of Larissa, 178, 179, 181, 195
philosophy, 173–203, 217, 385
Philostratus, 119n; *Heroic Tale,* 372; *Imagines,* 129, 134n, 142, 144; *Vita Apollonii,* 54n; *Vita sophistarum,* 33n, 45n, 153n, 310, 321–22, 326n
Philoxenus of Alexandria, 36
Philoxenus of Cythera, 56n, 103, 104
Phrynichus, 94; *The Capture of Miletus,* 91n
Phrynichus of Bithynia, *Selection of Attic Nouns and Verbs,* 34, 36n, 37, 38n, 345n
Phrynis, 103
Pindar, 45n, 55, 93, 97, 101, 102, 223–24, 326, 327
Piso, M. Pupius, 44, 183, 184, 185, 307
Piston, Ares/Mars, 253
Plato, 44; ancient criticism of, 51; archaism of, 328; Athens as school in, 382–83; and austere style, 327; beauty in, 41–42; and Bellori, 41; in Cicero, 173, 179, 180, 181, 187, 192, 194, 199; and *classical* as term, 14; Dionysius of Halicarnassus on, 328, 337; and Homer, 39, 319–20; influence on the classical, 105; language of, 337; literary criticism in, 334–35; and Longinus, 347, 348; morality in, 110; on New Music, 104–5; poetry in, 116, 359, 372; politics and language in, 109–10; in Raphael, 377; on song, 96n; sound of, 335; and voice, 319–20, 322; on word and image, 155; on writing, 365. *Works: Apology,* 117; *Cratylus,* 140n, 155n, 336n; *Gorgias,* 359n; *Hip-*

parchus, 56n; *Ion,* 320, 344n; *Laws,* 205n, 369n; *Menexenus,* 59n, 62, 334n, 348, 379n, 380n; *Phaedrus,* 41n, 109, 140n, 315n, 316n, 365; *Protagoras,* 35n, 382–83; *Republic,* 109–10, 116, 205n, 320, 359; *Symposium,* 41, 144n
[Plato], *Definitiones,* 369n
Platonism, 41
Plautus, 216n, 217, 218, 219, 225
Pliny the Elder: art in, 32, 42n, 51n, 127, 130n, 134n, 144n, 145, 146n, 149, 150n, 151, 151n, 252n, 253n, 256n, 276n; Homer in, 56n; literature in, 363n; on tragedy, 129; voice in, 315
Pliny the Younger, 37, 314; *Epistles,* 37n, 225, 225n, 226
pluralism, 251, 270–71, 272, 273, 289, 293
Plutarch, 59n, 208; and Greeks as models, 31; on Homer, 52; and Longinus, 333n; and mediated classicism, 59; Periclean program in, 329–33; poetry in, 364–65, 366, 367, 372. Works: *Aemilius Paulus,* 362n; *Alcibiades,* 143n, 154n; *Brutus,* 130n, 134n, 151n; *De gloria Atheniensium,* 386n; *De Iside et Osiride,* 279n, 370n; *De musica,* 104; *Life of Pericles,* 329–30; *Life of Solon,* 109; *Moralia,* 37n, 45n, 46n, 319, 321, 328n, 332n; *On the Pythian Oracles,* 363–65, 371; *Sulla,* 385n
poetry: in Aristides, 365–66; Aristotle on, 96, 355, 367–68; decline of, 355; in education, 372; Eratosthenes on, 358; and Gorgias, 359; Homeric, 92–93; in Isocrates, 360–61; Latin, 220–24; in Lucian, 371; lyric, 222; as *mousikē,* 89; and Nietzsche, 354; oral, 89, 101; in Plato, 372; in Plutarch, 364–65, 366, 367, 372; and prose in Roman Greece, 358–74; in Strabo, 362–63, 366. *See also* language; literature
politics: ancient understanding of, 251; in Aristotle, 367; Athenian, 360; and Cicero, 174, 175; and the classical, 5, 12; in culture, 362; degeneration in, 106, 107, 112; and democracy, 119; examples of, 150; and Hellenistic sculpture, 128; and language, 106, 109–14, 116, 117, 120; and *logos,* 107, 109; in Longinus, 349–50; in Lucian, 369, 371; in Plato, 109–10, 382; and poetry *vs.* prose, 371; and rhetoric, 107–10; and Roman Greece, 367; and Roman sites of memory, 258; stability in, 106, 109–14, 116, 117, 120; in Thucydides, 116
Pollio, Gaius Asinius, 221, 225
Pollitt, J. J., *Art and Experience in Classical Greece,* 14

Polybius, 56n, 140, 140n
Polycles of Athens, 127
Polyclitus, 38, 42, 51, 56n, 128, 244, 246; Doryphorus, 54–55, 151, 242–43, 245, **261**
Polydorus of Rhodes, 144, 149
polymathy, 357
Polyxena, 153
Pompeii, artworks in, 130, 150, 278–84
Pontines, 310
Porcia, 130, 133, 150
Porphyry, *On the Cave of the Nymphs,* 372
portraiture, Roman, 242–43
Posidippus, 37n, 38n
postclassical, 4, 17, 57, 58, 326, 331
postclassicism, 54
posterity, 61, 63, 89, 90, 92, 94, 358, 361, 362
postmodernism, 2, 238, 251, 356
Pound, Ezra, 353, 354, 355
Powell, Barry B., 92
Praxiteles, 51, 244
present, 240, 241–42. *See also* modernity
primae classis, 206. *See also* classical (the), etymology and history of term
Priscian, *Commentarii grammatici,* 207n
"Problem of the Classical, The" (conference), 1–2, 6, 23
Procne (Alcamenes), 139, **157**
projection, 17, 56, 60, 61, 62, 63, 131, 308, 320n, 331, 332, 387
Propertius, 222, 222n, 224n
prose, 92, 353–74. *See also* language; literature
prosography, 357, 358, 359, 361, 362, 365, 366, 367, 371, 372, 374
Pseudo-Lucian, *Nero,* 365n
Pseudo-Plutarch, 109; *De fluviis,* 144n; *Lives of the Attic Orators,* 121–22
Pseudo-Seneca, 135
Ptolemies, 31, 271, 273, 275, 361
Ptolemy, 377
public sphere, 21–22, 90, 257, 333, 334
Pythagoras, 377
Pythia, 90
Pythias, 127
Pythocles, 127

Querelle des Anciens et Modernes, 2, 28, 38
Quintilian: and Asianism, 372n; and baroque, 139n, 140n, 143, 150n; and the classical, 17, 32n, 39n, 51n, 207–8, 212, 213n, 218n, 222, 225, 243n; and feeling, 343n; and *habitus,* 249; and sound, 315, 337n, 343n; and voice, 315, 317
Quintus of Smyrna, *Posthomerica,* 146–47

Raeder, Joachim, 284
Raphael, *The School of Athens,* 377, **378,** 382
rationality, 21, 24, 110, 140, 227, 229
reason, 107–9, 116, 119, 120, 187, 338, 359. See also *logos*
religion: Athenian, 247–48; classical aspects of, 5; and classicism, 49; and devotion to gods, 112; events in, 90; innovation in, 97; and morality, 95; pagan, 49; and pluralism in Roman art, 270, 273; Roman, 247, 274, 275, 277; Roman use of Greek models in, 239; and self-positioning, 272; tradition in, 96–97; and Treasury of Minyas, 79, 80, 81, 82
Renaissance, 10, 13n, 208, 209, 229, 293, 294
retrospection: and Alexandrians, 30; in Aristophanes, 301; of Augustan period, 240; and the classical, 17, 53, 93–94; and classicism, 11, 16, 29–30, 53–54, 60, 61, 63–64, 301, 351–52; and Gellius, 10; in Greek culture, 30–31; and historical distance, 42; and intentional memory, 242; in Pausanias, 73; in Roman art, 243–44, 247, 248; in Roman use of Greek art, 254–55; and Treasury of Minyas, 71. See also past
Rhea Silvia, 293
Rhenanus, Beatus, 208
rhetoric: and ancient canon, 51; and ancient taste, 43; and Asian orators, 128; and Atticism, 36–37, 121, 122, 123, 231; Cicero on, 121, 233; of classicism, 52; and community, 118; and Hellenistic sculpture, 128, 139, 140; Isocrates on, 106, 107, 108, 109, 113, 114, 116, 117–18, 119, 120, 121, 122, 123, 124; of Lysippus, 27; as mutable, 109–10; of permanence, 52; of personal interest, 114; and politics, 107–10; and redescription, 109, 110, 111; Roman use of Greek, 217, 249; Strabo on, 362; and Treasury of Minyas, 71. See also language; literature; oratory
Rhetorica ad Herennium, 140n, 150n, 215
Rhode, Erwin, 356
Riace Warrior A, 136
Riegl, Alois, 237
Robertson, Martin, 54–55
Roman Greece, 367
Romans/Roman culture: allusion in, 276; and antiquarianism, 275, 276, 293; art sources of, 270–97; Athens from perspective of, 385; and Atticism, 38, 121, 122, 123; and change, 293; and the classical, 4, 5, 9, 17–18; and classic as term, 14; classicism in, 31, 49; and Egyptian art, 271, 272, 275, 276–90, 292, 295; geography in, 358; and Greek culture, 4, 33, 44, 174, 212–14, 215–16, 217, 218, 219, 220, 221, 237–69, 270, 271, 275, 355–56; Greeks studied through, 273–74; Hellenism in, 278, 281, 284, 287, 289, 290, 295; and Hellenistic sculpture, 127, 128, 153; and Hellenistic world, 136; and Hellenocentrism, 5, 271, 276; imperial, 79, 82–83, 135, 242–43, 273, 278, 292, 293, 363; kitsch in, 283; and Laocoön, 145; and literature, 204–32, 249–50, 385–86; multiculturalism in, 273, 278, 289, 293; and naturalism, 271, 290, 297; Orientalism in, 290–92; painting in, 278–84; and past, 239; patronage in, 276; *pietas* in, 257, 258; pluralism in art of, 270–71, 272, 273, 289, 291, 293; and religion, 275, 277, 278, 283, 284, 288, 289–90, 291, 293, 294, 295; and rhetoric, 121; and Strabo, 363; study of, 273–74; and synchronistic mixing of artistic styles, 275; syncretism in, 293, 295, 297; and Treasury of Minyas, 79, 80, 81, 82–83, 84
Romantic period, 354, 355
Rome: Attic tragedy in, 130–35; Augustan, 4, 14, 22, 237–69; in Cicero, 174; and classical period, 4; geography in, 358; Greek art and styles in, 237–69; public space in, 246–47, 291–92; retrospection in, 240; study of, 22; Winckelmann on, 13
Romulus, 257, 258
Rosaldo, Renato, 48

Sabina, 288
Sainte-Beuve, Charles-Augustin, *Qu'est-ce qu'un classique?,* 14
Salamis, battle of, 256
Sallust, 224–25, 226–27
sanctitas, 243
Sappho, 55, 370n
sarcophagus, Roman, 293
satire, 221, 222
Scaevola, 316
Schachter, Albert, 72
Schadewaldt, Wolfgang, 1, 8
Schlegel, Friedrich von, 23, 386
Schliemann, Heinrich, 72, 74–78, 79–80, 85n, 86
Schliemann, Sophie, 75
Schmalzriedt, Egidius, *Inhumane Klassik,* 14, 20
Schütz, Franz Xaver, 145n
Scopas, statue of Apollo, 252
scriptor classicus, 206–11
sculpture, 6, 7, 17, 21–22, 26, 32, 51–52, 54–55, 127–70, 228, 242–54, 255, 257,

260–69, 277, 278, 284, 285, 286, 287–88, 289, 291. *See also specific works*
Second Sophistic, 4, 9, 31, 33, 49, 321, 348, 355, 356, 358
senate, meetings of, 257
Seneca, 17n, 41, 139; *De tranquillitate animi,* 212; *Dialogorum libri XII,* 144n, 153n; *Epistulae,* 154n, 212n; *Hercules furens,* 138n; *Hercules Oetaeus,* 138n, 144n, 154; *Troades,* 136–37, 153, 153n
Serapis of Alexandria, 272
Servius, 147n
Settis, Salvatore: "Der Klassizismus und das Klassische," 14
Sextus Empiricus, *Adversus mathematicos,* 37n, 38n, 310n, 335n
sexuality, 139, 142, 246
Skripou, 74; church of the Virgin, 85n
Snell, Bruno, 358; *The Discovery of Mind,* 115, 116
society, 205, 238, 241, 251
Socrates, 173, 180, 194, 197, 199, 354, 377, 383
Solon, 91, 107, 108, 111, 113, 114, 119, 120, 121, 123
song, 89–90, 92, 93, 99–101. See also *melos*
sophistry, 372
sophists, 118–19, 119, 335, 383
Sophocles, 2, 8, 16, 23, 24, 36n, 129, 136, 221, 224n, 226, 228, 307, 321; *Laocoön,* 147
sound, 92, 93, 104, 310–11, 312–26, 333, 335–38, 340, 341, 342, 343–47, 350
Sperlonga marbles, 135
spoliation, 294, 295, 296
St. Sophia, Constantinople, 294
Stanford, W. B., 320
stasis, 110, 111
Statius, *Thebaid,* 154n
Stesichorus, 96
Sthennis: Athena/Minerva, 253; Demeter/Ceres, 253; Zeus/Iuppiter, 253
Stilo Praeconinus, Lucius Aelius, 207
Stoicism, 152, 153, 154, 175, 179, 181, 184, 185, 187, 189, 190, 195, 196, 197, 198, 199, 200, 201
Strabo, 23n, 150, 361–63, 365, 370–71, 386n; *Geography,* 358
sublime, 43, 51, 60, 63, 149, 328–29, 333, 335, 346–49, 350
Suda, 34n, 38n, 109n, 205n, 363n
Suetonius, 209n, 214, 214n; *Divus Augustus,* 246n
Suicidal Gaul (sculpture), 141

Sulla, 21n, 81, 183, 385; age of, 231
syncretism, 47, 271, 293, 295, 297

Tacitus: *Agricola,* 143n; *Dialogus de oratoribus,* 372n
Taplin, Oliver, 304
Telephus of Pergamum, 38
Temple of Apollo (near Circus Flaminius), 252
Temple of Apollo (Palatine), 6, 252; library of, 222–23
Temple of Concord, 253
Temple of Divus Iulius, 252
Temple of Iuppiter Optimus Maximus, 257
Temple of Mars Ultor, 248
temples, 239
Ten Attic Orators, 51
Terence, 216n, 217, 218, 219, 221, 225
testis classicus, 206
text, 314–15, 326, 358
thaumata, 72, 73, 81, 83
Theagenes of Rhegium, 39, 94
Thebes, Boeotian, 80, 84
Thebes, Egyptian, 84
Themistocles, 108, 123
Theocritus, 49n, 222, 225
Theodorus, painting of Cassandra, 253
Theognidea, poet of, 120–21
Theognis, 91
Theon of Alexandria, *Progymnasmata,* 316n, 343n
Theopompus, 121, 384
Thracians, 310
Thucydides, 31n, 59n; Athens in, 62, 379, 380–82, 383; and austere style, 327; conscious classicism in, 61, 62; Dionysius of Halicarnassus on, 51n, 328, 337; and language-deed relation, 110–11; language in, 36n; in Longinus, 63; morality in, 110–11; and myth, 359; past in, 331; Pericles in, 343n; Pericles' funeral oration in, 62, 379, 381, 382, 387; political transformation in, 116; and Roman canon, 225; style of, 326; as timeless, 95–96
Tiberius, 253–54
Tibullus, 224n
time, 323–24, 362. *See also* past
timelessness, 95–96, 102, 103, 330n
Timocles, 127
Timotheus, statue of Artemis, 252
Timotheus of Miletus, 56n, 103, 104, 384
Tiryns, walls of, 72, 84
Titinius, 217
Tivoli. *See* Villa at Tivoli (Hadrian)
Toynbee, Jocelyn, *The Hadrianic School,* 284

Trabea, 217
tradition, 93, 94–97, 101
tragedy: in Aristotle, 129, 132–33, 228; and Atticism, 36; canonization of, 130–32; catharsis in, 134; change in, 133, 139, 141, 148; character in, 131, 133; emotion in, 131, 133, 138, 152; fear and pity in, 131, 133, 141, 142, 148, 149, 310; folly in, 153; fortitude in, 153; fortune in, 133, 141, 143, 148; and Hellenistic sculpture, 128, 129, 136, 137, 138, 139, 140, 141, 142, 143–44, 147, 148, 149, 152, 153, 154–55; ignorance in, 131, 141, 148; Latin, 130; and Library at Alexandria, 32; and Lycurgus, 18; mistake in, 133, 138, 139, 147, 148; and narrative artworks, 134; in Nietzsche, 354; in painting, 129; passion in, 138, 140, 141, 153; performance of, 91, 360; prestige of Greek, 213; recognition in, 141; reversal in, 133, 139, 141, 148; and Roman canon, 216, 219, 225, 230; suffering in, 139, 140, 149; in visual arts, 132. *See also* drama/theater; literature
Trajan, 291
Treasury of Atreus at Mycenae, 71, 75, 85
Treasury of Minyas at Orchomenos, 69–86, **70, 76, 77**
Troy, 74, 84, 292
Tutmosis III, obelisk of, 288

Uffizi Niobids, 143
Uría Varela, Javier, 205n
utopia, 131, 343

Valerius Maximus, 149–50
Varius Rufus, *Thyestes,* 221, 225
Varro, Marcus Terentius, 179, 180–81, 209n, 216, 217, 218, 219; *Saturae Menippeae,* 213n
Varro Atacinus, 225n
vase painting, 21, 129
Vatican church, 294
Velleius Paterculus, 217, 224–25
Vernant, J.-P., 359
Verus, Lucius, 368; altar at Ephesus of, 135

Villa Albani: relief of Victoria, **269**; relief with Apollo, Diana, Latona, and Victoria, 250, **268**
Villa at Loukou, 136–37, 152, 153
Villa at Tivoli (Hadrian), 6, 277, 284, 286, 287, 289
Villa Doria Pamphili, 291
Virgil, 2, 17n, 153, 154, 224n, 225, 226, 227, 228, 385–86; *Aeneid,* 145, 147n, 148, 154n, 221, 222, 292, 386n; *Bucolics,* 222; *Eclogues,* 221, 222n; *Georgics,* 222, 224
virtus, 243, 244, 245, 246, 252, 257, 258; in Cicero, 174, 188, 192, 199, 201
Vita Aeschyli, 51n, 54n, 327n
Vitruvius, 42, 247–48, 250; *De architectura,* 37n, 247n
voice, 314–22, 344. *See also* sound
Volcacius Sedigitus, 216–17; *De poetis,* 215

Wallace, Paul W., 78
Wickhoff, Franz, 237
Wilamowitz-Moellendorff, Ulrich von, 23; *Geschichte der Philologie,* 1
Williams, Raymond, 47, 312
Winckelmann, Johann Joachim: aesthetics of, 26; and classic, 2, 7, 8, 12–13, 26n, 43n, 55n, 61n; classical ideal in, 40, 41, 43; Greek art in, 255; Greek education in, 386; inimitability in, 60; and Laocoön, 145, 146, 147, 151; and Longinus, 348; mediated view of, 44; and Roman art, 237; and study of Romans, 273
Wolf, F. A., 28
Wölfflin, Heinrich, 16n
writing, 93, 313, 362, 365

Xenocrates, 32
Xenophanes, 94–95
Xenophon: *Anabasis,* 35n, 309n; *Memorabilia,* 42n; *Symposium,* 91

Zeno, 113, 181, 182, 185, 187, 192
Zeuxis, 332n; painting of Marsyas, 253
Zoilus, 39

Lightning Source UK Ltd.
Milton Keynes UK
UKHW010126311020
372527UK00004B/270